IN AUGUST COMPANY

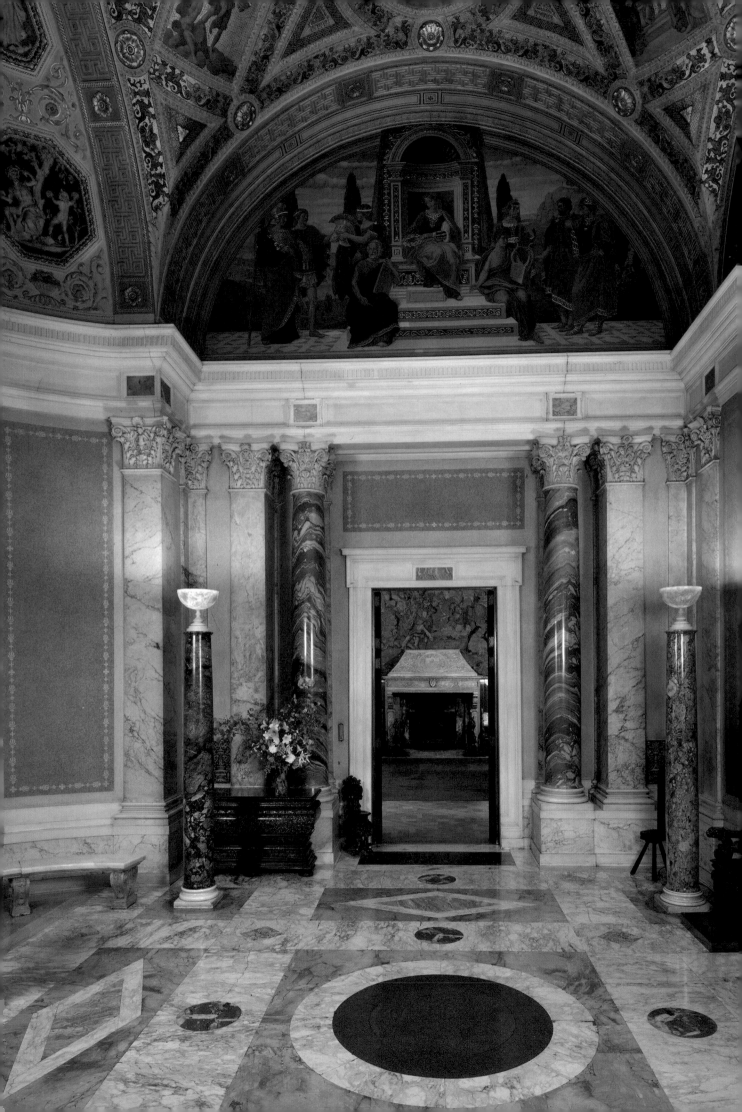

IN
AUGUST COMPANY

The Collections of
The Pierpont Morgan Library

THE PIERPONT MORGAN LIBRARY · NEW YORK

In association with Harry N. Abrams, Inc., New York

The production of this book
has been made possible by a grant from
THE CARL AND LILY PFORZHEIMER FOUNDATION, INC.

Cover illustration:
Blanche of Castile and King Louis IX of France;
Author Dictating to a Scribe,
Moralized Bible, France, ca. 1230. M 240, f. 8

Frontispiece:
View of the Rotunda

All photography is by David A. Loggie
except pages 6, 12, 15, 67, and 258

The publication of this book
was coordinated by Kathleen Luhrs

Library of Congress Cataloguing in Publication Data
Pierpont Morgan Library,
In august company:
the collections of the Pierpont Morgan Library
p. cm.
Includes bibliographical references.
ISBN 0-87598-093-7
1. Pierpont Morgan Library 2. Rare book libraries—
New York (N.Y.) 3. Research libraries—New York (N.Y.)
4. Library resources—New York (N.Y.) I, title.
2733.P588P53 1992
026.09'09747'1—dc20
91-66326 CIP

ISBN 0-87598-093-7 (paper)
ISBN 0-8109-3863-4 (Abrams: cloth)

Clothbound edition distributed by
Harry N. Abrams, Incorporated, New York
A Times Mirror Company

Printed in the United States of America

Contents

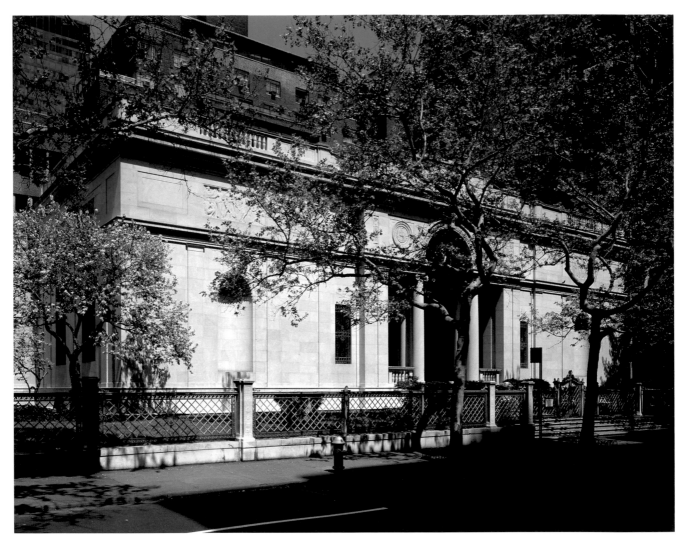

Façade of the McKim, Mead & White building

DIRECTOR'S FOREWORD

THE MORGAN LIBRARY, once the private domain of the financier-collector Pierpont Morgan (1837-1913), is now a public research library, a museum, an architectural landmark, and a historic site. The collections are vast and eclectic, representing the combined and evolving tastes of Pierpont Morgan, his son, J. P. Morgan, Jr., and a succession of other collectors, Library directors, and curators down to the present day.

Chronologically, the sweep extends from the first written civilizations of ancient Mesopotamia to the modern era. For purposes of access, the collections are organized into the following categories: ancient seals and texts, medieval and Renaissance manuscripts, early and later printed books and fine bindings, children's books, autograph manuscripts, music manuscripts, prints and drawings, Gilbert and Sullivan materials, art objects, and the Morgan archives. Accordingly, we have generally followed the same structure in the organization of the present volume. Cutting across these categories, however, is an almost limitless array of different areas of inquiry and study—art, literature, science, mathematics, history, philosophy, religion, law, education, theater, opera, linguistics, music, astrology, paleography, navigation, medicine, witchcraft, gardening, and this list is far from complete.

One quality that nearly all of these diverse materials have in common is their physical fragility, which requires that they be protected from prolonged exposure to the damaging effects of light and the atmosphere. For reasons of conservation more than limitations of physical space, only the merest fraction of the collections can be on public view at any given time. While there are numerous exhibition catalogues, facsimiles, and other publications devoted to specific aspects of the collections, until now there was no single volume that provided a general, well-illustrated overview of the entire holdings. In this book, we have singled out what we consider to be some of the finest and most representative objects from each of the Library's collections. Over two hundred works are reproduced and discussed. The short introductory essays preceding each section are intended to give a general idea of the scope of the collections and how and why they were formed. It is worth noting that many of the objects included were acquired in the last twenty years, an indication of the degree to which, despite ever increasing prices, the Library continues to grow and build upon existing strengths.

This volume also marks an important moment for this institution. In the fall of 1991, the Morgan Library completed the most extensive expansion and renovation program in its history. The project, initiated in 1988 with the purchase of the former house of J. P. Morgan, Jr., involved the restoration of historic spaces and the creation of new ones. To celebrate this event, we presented "Masterpieces of the Morgan Library," the largest exhibition of the collections ever shown. For three months, from October 1 through January 5, visitors had the rare opportunity to see over 275 objects from each of the fields in which we collect. As Michael Kimmelman, chief art critic of the *New York Times*, observed in his review, "Never has the word masterpieces been more a matter of fact and less a matter of hype." With only one or two exceptions, each of the works illustrated and

discussed in this book were on display at that time. It follows, of course, that any publication which presents a selection of objects from such wide-ranging fields will be of limited value to the specialist. Rather it has been our aim to provide an introduction to the collections that will be read and enjoyed by all who have an interest in the Library and in the history of art and ideas.

Our choice of the title *In August Company* may at first appear to be somewhat self-congratulatory. It is in fact the phrase that Mark Twain, one of the most acute critics of his age, used to describe the Library's collections almost a century ago in a letter to Pierpont Morgan. I like to think that Twain would be quite pleased to see his remark appropriated in this way.

In August Company represents the collaborative efforts of almost the entire staff of the Morgan Library. John Plummer, curator of Medieval and Renaissance Manuscripts and Research Fellow at the Library, served as general editor. Information on the collections and individual objects was provided by the curatorial staff: Edith Porada, curator of Seals and Tablets; Peter Dreyer, Cara D. Denison, Stephanie L. Wiles, and Evelyn Phimister, in the Department of Drawings and Prints; William M. Voelkle and Roger S. Wieck, in the Department of Medieval and Renaissance Manuscripts; H. George Fletcher, Anna Lou Ashby, Hope Mayo, Eugenia Zazowska, and Eve Cohen Pasternak, in the Department of Printed Books and Bindings; Robert Parks and Christine Nelson, in the Department of Autograph Manuscripts; J. Rigbie Turner, in the Department of Music Manuscripts and Books; Fredric Woodbridge Wilson, curator of the Gilbert and Sullivan Collection; and D.W. Wright, in the Office of the Registrar and Archivist.

Kathleen Luhrs, the Library's publications coordinator, oversaw all phases of editing, design, and production. She was assisted by Elizabeth Gemming, Mimi Hollanda, Sandy Opatow, Carol Wenzel-Rideout, and Elizabeth Wilson. Unless otherwise indicated, all photographs are by David A. Loggie, with the assistance of Edward J. Sowinski. Nancy Schmugge and Marilyn Palmeri in Photographic Services were constantly helpful. In addition, we are grateful for the cooperation and support of the Library's Reading Room, cataloguing, conservation, bindery, development, and public affairs staffs.

Special thanks are due to Klaus Gemming, the designer of the catalogue, who guided the book's production. We also wish to thank William Schlicht at Finn Typographic Service, where the type was set, and Tony Lalli at Van Dyck/Columbia Printing.

We feel fortunate indeed that John Russell, formerly chief art critic of the *New York Times,* has provided the delightful foreword to this book. We are also grateful to Harry N. Abrams, Publishers, and in particular Mark Greenberg, for patience and support in this undertaking.

And finally, on behalf of the entire staff and Trustees of the Library, I should like to express my deepest thanks to The Carl and Lily Pforzheimer Foundation, Inc., and especially Carl H. Pforzheimer, Jr., for the generous financial assistance for this project.

Charles E. Pierce, Jr., Director

FOREWORD

WHEN FAR FROM HOME, I often dream of a way station on the slopes of Murray Hill in New York City. Its name is the Pierpont Morgan Library, and it stands on Madison Avenue at 36th and 37th streets. Fundamental to my dream is the idea that a second life might one day be granted to me.

In that life, I would haunt the Morgan Library, day by day and year after year, without interruption. By the end, I would be privy to every one of its secrets.

Of the 1,157 ancient Near Eastern cylinder seals that were assembled for Pierpont Morgan between 1885 and 1908, every single one would be as familiar to me as the key to my own front door. If someone were to refer in conversation to Etana, the Mesopotamian shepherd king, I could say "Why, of course! Etana, who flew to Heaven on an eagle to procure the plant of easy birth for his wife." And all present would roll on the ground in amazement.

If in Carnegie Hall one of the French horns were to fluff an entry in Arnold Schoenberg's *Gurrelieder,* I would spot it at once, even though "Gurrelieder" is a colossal score and one not heard every day. Thanks to the manuscript in the Morgan Library, not a note on the specially made forty-eight-stave paper that Schoenberg used would be unfamiliar to me.

If an uppity child were to misbehave at table, I could whip out a line or two from the fifteenth-century French treatise on table manners for children that can be perused in the Morgan Library. (The treatise is in verse, by the way, and I would have had myself coached by a *sociétaire* of the Comédie-Française.)

In the matter of bookbindings, I was inspired in first youth by G. D. Hobson, the ranking English authority in such matters. Since then I have learned much from my contemporary and lifelong friend, his son A. R. A. Hobson, who is the current president of the International Association of Bibliophiles.

From the Hobsons I have learned that Pierpont Morgan did a very good day's work when in 1899 he bought what was called "the library of leather and literature" of a London bookseller called James Toovey. This initial foray into the field of fine bindings resulted eventually in the arrival of a whole hoard of books in which text and binding are memorably connected.

As is said elsewhere in this book, we are here talking not of the hideous and trumpery glued bindings of the 1990s, but of "books made of real animal skins, prepared by hand, or of real paper, made by hand, one sheet at a time, written by hand, one stroke at a time, or printed from real type, cast and set by hand, one character at a time."

Though not quite extinct, this most humane of activities is by now very rare. Blessed, therefore, is the Morgan Library, in which so large a role has always been allotted to books in which—again I quote from a later page—"hands gathered the sheets and folded them; fingers pushed needles and thread to gather the pages together; hands pared boards, shaved leather, hammered metal, and stamped and painted, or on occasion embroidered, the outer surfaces."

If any one reader could go through the Morgan Library, book by book, reading and

re-reading the text and noting the congruence (or lack of it) of the distinguished binding, he might well claim the title, so much coveted in the sixteenth century of "humanissimus vir." (Happy are our own times, in which women may claim the title at least as often as men!)

In physical terms, even with its current enlargement, the Morgan will never be—nor wish to be—a mammoth among libraries. Nor will it have delusions of being all things to all people. In some areas, it has dug deep and, to this day, digs even deeper. Others it leaves untouched and untapped.

It is a private and a personal place, though one to which we all of us can ask access. It bears the stamp (above all in the East and West Rooms) of the redoubtable human being whose name it bears. (I dare to add that Pierpont Morgan had the misfortune to sit for one of the least gifted of all English portrait painters, Frank Holl.)

It could also be said that initially the collections were made in the image of Pierpont Morgan himself and included those kinds of things that were most to the fore in his lifetime. If he often bought in bulk, it was because that was the way buying was done.

The Morgan Library has never lacked for scholars on its staff nor has it lacked, since 1949, for Fellows who bring their own enthusiasms—and bring them at white heat, as often as not. Oftentimes, individual unaffiliated collectors have also decided that, all things considered, the Morgan Library was where they would most like their possessions to be.

Thus it is that Kenneth Clark left some of the finest of his books to the Morgan Library. Thus it is that the Library has acquired major holdings of Charles Dickens and Charlotte and Emily Brontë among novelists, of Samuel Taylor Coleridge among poets, of John Ruskin among aestheticians, and of Edouard Manet among painters.

Common to all the collectors in question was the passion to have, and to hold, and eventually to pass on to others, that animated so many Americans at the start of our century. One of them was Harry Elkins Widener, a twenty-seven-year-old Harvard graduate who in 1912 picked up in London a copy of Francis Bacon's *Essays*, printed in 1598.

"I think I'll take that with me," he said to Quaritch, the great London bookseller. "If I'm shipwrecked, it will go down with me." Quaritch doubtless took it as a young man's joke, but Widener was booked on the *Titanic*, and Bacon's "Essays" did go down with him, just as he had said.

Solace and quiet are fundamental to the Morgan Library, but it is of course by no means the only library of which that can be said. What is special to the Morgan Library is the omnipresent sense that this is a place in which the truth is everywhere at home.

In its every domain it will be found to have pushed a little harder and reached a little further than many a larger and more talked-of institution. There are great individual works of art in the Morgan Library—illuminated manuscripts, paintings, and old master drawings, above all—but minor art can also engender a special tenderness, and I for one shall never forget the Arthur Sullivan exhibition in 1975. Nor shall I forget the P. G. Wodehouse and Beatrix Potter celebrations of more recent date. There, too, truth resided.

When we climb higher, the Morgan Library will not let us down. Are we keen to consult the Rubens drawing of a seated youth, the only existing manuscript text of Book I of Milton's *Paradise Lost,* or the manuscript of Schubert's *Winterreise?* Do we wish to lay hands (in white gloves, of course) on every imaginable edition of *Alice's Adventures in*

Wonderland, on the manuscript of Thoreau's diary for the years from 1837 to 1861 (complete with the original pine box in which it was stored), or on the "aesthetic teapot," made in Worcester in 1882 and ornamented with key figures from Gilbert and Sullivan's *Patience?* In every case, it is in the Morgan Library that these rarities are niched.

When in the national library in Vienna, I have occasionally wished to lay hands on the magical glass acquired by the Emperor Rudolf II that empowers us "to see Apparitions and converse with Spirits." But I have never felt the lack of that glass when in the Morgan Library. How could I, in a place where both apparitions and spirits greet the visitor on every hand?

Hospitality and trust are fundamental to the Morgan Library, and we cannot imagine that Willibald Pirckheimer, the boot-faced friend of Albrecht Dürer, would ever be turned away at the door, as he once was at the library in Bamberg.

Nor do ancient and peremptory loyalties dictate the Morgan's arrangements, as they do in the library at the Escorial, near Madrid, in which every book stands with its fore-edge outwards, in deference to the wishes of its founder, Philip II.

Such is the relative youth of the Morgan Library that it cannot be said of it, as it was of Lord Spencer's library at Althorp, that in May 1763 the author of *The Decline and Fall of the Roman Empire* had knocked himself out in a single morning by going through seventy-eight incunable editions of Cicero. But we can relive that kind of experience in domain upon domain at the Morgan Library.

As will be clear from the entries in this publication that relate to illuminated manuscripts, the Morgan's collections are catalogued with an exemplary care. But it cannot quite rival in that regard the Herzog August Bibliothek in Wolfenbüttel, where the author catalogue was set out in alphabetical order by the foremost European intellectual of his day, Gottfried Wilhelm Leibnitz, when he was in charge of it from 1690 to 1716. (His catalogue is still in use, by the way.)

As the buildings that I so often dream of had their beginnings in 1906, they cannot whisk us way, way back in time. Though unfeignedly grand, they are grand in the style of Pierpont Morgan's own day. In the Louvre in Paris, panels of Irish bog-timber and brass window-grilles were set up in the fourteenth century to protect books from decay, rain, rats, mice, and the intrusion of big-beaked birds. Within the Morgan Library, no such tales can be told.

But the difference is that, unlike some of its counterparts in other countries, the Morgan Library has never been more alive and will become even more so now with its scenic enlargement. In particular, its permanent collections are more accessible, on a rotation basis, to the casual visitor.

Walking from house to house, with an ingenious garden niched between the two, we have time to sit, to breathe, and to dream. We are able to rack up our impressions, one by one. We can feel apart from the world, but not excluded from it. The blessings of daylight and skylight are not withheld from us, and we can also count on one of the most seductive museum shops in the United States.

It is a magical prospect. Even if a second life is not ours for the asking, the first one is looking better by the hour.

John Russell

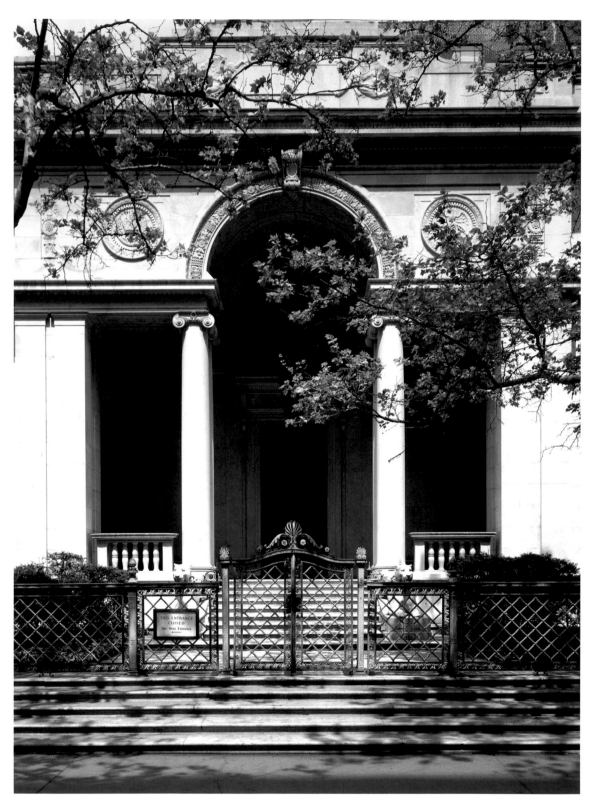

Entrance to the McKim, Mead & White building

INTRODUCTION

I N 1910, Pierpont Morgan received a letter from Mark Twain, responding to his request for the author's manuscript of *Pudd'nhead Wilson*. "One of my high ideals is gratified," replied Twain, "which was to have something of mine placed elbow to elbow with that august company which you have gathered together to remain indestructible in a perishable world." The "august company" to which Twain referred was the group of books, manuscripts, and drawings which Morgan had begun to assemble in the 1890s and which he kept in his white marble library building on East 36th Street in New York. At that time, it was called simply Mr. Morgan's Library and was generally regarded as one of the finest private libraries in the world.

In the creation of this collection, Morgan had been inspired by the European model of a "gentleman's library," acquiring medieval and Renaissance illuminated manuscripts, early and rare printed books, fine bindings, literary and historical autographs, and old master drawings. While the focus was primarily on Western European materials, room was also made for important American authors and historical figures. Twain's *Pudd'nhead Wilson*, for example, joined autograph manuscripts by Cooper, Hawthorne, and Thoreau as well as letters from Washington and Hamilton.

When Morgan died in 1913, the Library and its contents passed to his only son, J. P. Morgan, Jr., who in 1924 established the library as a public institution in memory of "my father's love of rare books and his belief in the educational value of the collection." Since then, The Pierpont Morgan Library has operated as an independent research library and museum devoted to the arts and the humanities. While the collections have increased several times over, the basic categories and chronological limits established by Pierpont Morgan have been largely maintained. The Library's physical space has almost tripled in size, but the elegant library designed for Morgan by McKim, Mead & White has been carefully preserved and remains the heart of the institution.

Pierpont Morgan, Financier and Collector

WHEN PIERPONT MORGAN began to collect, he was already in his fifties and internationally regarded as one of the leading bankers and financiers of his day. He was born in Hartford, Connecticut, on April 17, 1837, into an old and distinguished New England family. Young Morgan, known as "Pip" to his childhood friends, was raised in an atmosphere of wealth, privilege, and refinement. When he was seventeen, the family moved to London, where his father, Junius Spencer Morgan, became a partner in the American-owned investment house of George Peabody & Co. (later to become J. S. Morgan & Co.). Pierpont was sent to boarding school in Switzerland and attended the prestigious University of Göttingen in Germany. Holidays were spent sightseeing in England and on the Continent. A family visit to the Duke of Devonshire's renowned library at Chatsworth may have sown the seed for its counterpart a half century later on

36th Street. In any event, during his formative years Morgan was exposed to an array of cultural experiences unusual for an American boy of his day.

Morgan returned to New York in 1857 and began his business career; four years later he became the American agent for his father's firm, securing and protecting overseas investments in the burgeoning railroad, coal, and steel industries. During the turbulent "boom" years following the Civil War, the house of Morgan gained a reputation for stability and integrity, and Pierpont Morgan emerged as a powerful and respected businessman in his own right. Between 1893 and 1895 he reorganized six of the nation's railroads and maintained a controlling interest in all. In 1895, he halted an impending gold crisis by forming a syndicate to exchange bonds for gold. In 1901, he bought out Andrew Carnegie and launched the U.S. Steel Corporation, the largest corporate enterprise the world had ever known. During the Panic of 1907, he raised $25 million in one afternoon to halt a run on the banks. As one biographer succinctly put it, Morgan essentially operated as a "one-man federal reserve bank."

Of Morgan's private life and personal thoughts regarding his business or collecting ambitions, we know very little. He assiduously shunned publicity and was portrayed by colleagues as brusque, somewhat distant, and often abrupt. One of the few surviving portraits of Morgan is the well-known photograph of 1903 by Edward Steichen, who later likened encountering Morgan's gaze to watching the oncoming headlights of an express train. With friends and family, however, he was relaxed and convivial, entertaining frequently and on a lavish scale. Morgan's first marriage, to Amelia Sturges, ended when she died of tuberculosis four months after their wedding. Three years later, in 1865, he married Frances Louisa Tracy, the daughter of a prominent New York lawyer. They had three daughters, Louisa, Juliet, and Anne, and a son, also named John Pierpont Morgan.

Morgan's life-style was suitably grand and comfortable, but notably unostentatious. In 1880, he changed his New York residence, moving to a large but undistinguished brownstone at 219 Madison Avenue on the corner of 36th Street. He spent several months of each year abroad and was frequently at his father's London town house at Princes Gate and at Dover House, the family estate at Roehampton. He was equally at home in London, Rome, and New York. He seemed to enjoy traveling and on several occasions organized boating parties up the Nile for his American friends.

During his years as a rising young businessman, Morgan exhibited an occasional interest in books and manuscripts and acquired a small group of historical and literary autographs. It was the death of his father in 1890, however, that signaled the beginning of his collecting in earnest. Some biographers have suggested he may have put off collecting out of deference to his father, who was himself a collector of autographs and rare books. More importantly, however, it was only upon his father's death that Pierpont Morgan had the financial resources to build a collection on a truly grand scale. Junius Morgan's estate was valued at roughly $12.4 million, and, in addition, the son assumed leadership of his father's highly profitable London banking house. That Pierpont Morgan should have used a portion of this wealth to collect was not entirely surprising. The rapid economic growth of the country during the 1870s and 1880s had been followed by a keen awareness of the need to enrich the cultural and intellectual lives of the American people as well. Increasingly, it was regarded as the duty of leading Americans to contribute to the creation of a

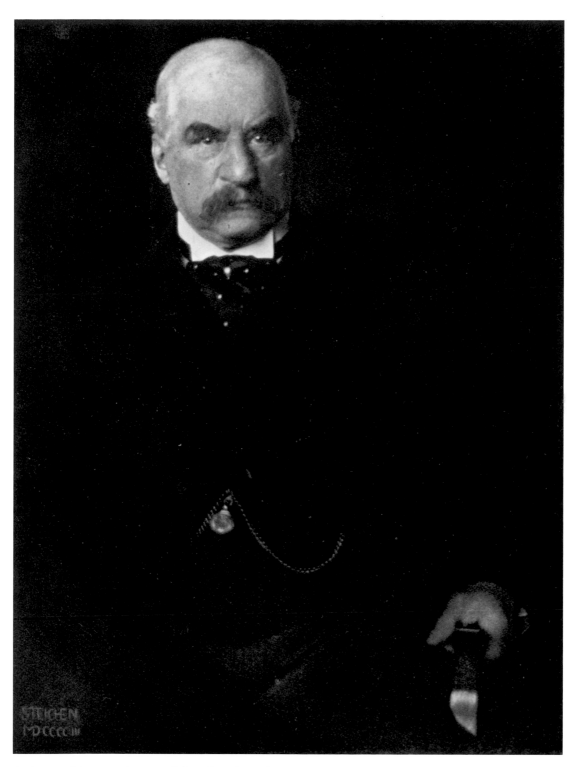

J. Pierpont Morgan, photograph by Edward Steichen
Courtesy of Joanna T. Steichen and George Eastman House

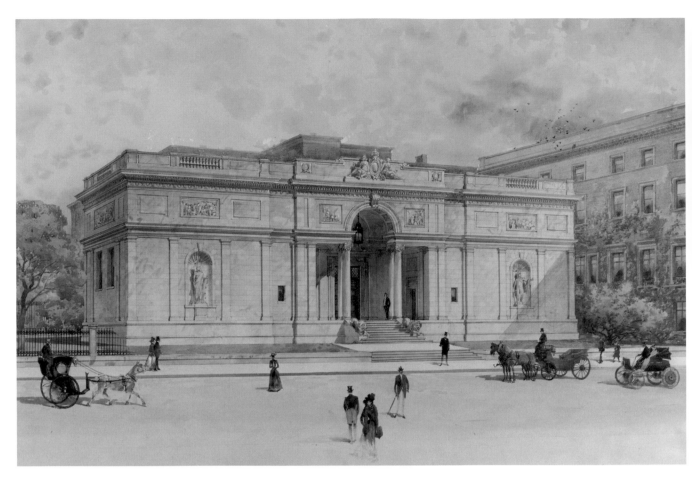

Watercolor rendering from the office of the architects McKim, Mead & White, ca. 1902

great republic which could compete culturally with Europe. At this period, art collecting was perceived not merely as a pastime but as a matter of national pride, and many of the great private collections of European old master paintings and sculpture – such as those of Isabella Stewart Gardner, Henry Walters, and Joseph P. Widener – were formed. In March of 1880, ten years after its founding, New York's Metropolitan Museum of Art was finally established in permanent quarters in Central Park. Morgan was elected a trustee of the museum in 1888, and from 1904 until his death he served as its president. Under his leadership, the museum embarked upon an ambitious program of acquisitions. He was also a major benefactor of the Wadsworth Atheneum in his native Hartford, for which he built the Morgan Memorial building, dedicated in 1910 to the memory of his father.

Morgan's rare books, manuscripts, and autographs – his so-called literary collections – were but one aspect of his collecting interests. He acquired on a vast scale both in quantity and scope. Art objects numbering in the thousands ranged from ancient Egyptian tomb sculpture and Chinese bronzes to Meissen porcelain and paintings by Raphael, Vermeer, and Fragonard. "No price," he was once reported to have said, "is too high for an object of unquestioned beauty and known authenticity."

Mr. Morgan's Library

As he set about the formation of his library, Morgan concentrated primarily on the growth of his autograph collection, which he had begun, albeit modestly, when he was a boy in Hartford. Here as elsewhere he followed a pattern of buying individual items as well as entire collections. In the former category were such prizes as the manuscript of Keats's *Endymion* and Dickens's *A Christmas Carol*. Major purchases of collections included Sir James Fenn's English historical autographs and Stephen Wakeman's over two hundred and fifty American literary autographs, which contained Hawthorne's notebooks and Thoreau's journals.

Morgan was encouraged to collect in the areas of early printed books and illuminated manuscripts by his scholarly nephew Junius Morgan. Here again, there were notable individual purchases, such as the splendid Lindau Gospels, Morgan's first major medieval manuscript acquisition, and the very rare Mainz Psalter of 1459, for which he paid $50,000, at that time the highest price on record for a book. Breadth, however, was achieved through a succession of several astute purchases of entire collections – the James Toovey collection of rare books and bindings; the library of books and manuscripts formed by the American collector Theodore Irwin; and, above all, the Richard Bennett collection, which Morgan acquired in 1902. This group of over seven hundred volumes, including about one hundred illuminated manuscripts and no fewer than thirty-two Caxton imprints, is considered the nucleus of the Morgan Library's printed book and illuminated manuscript collections. Morgan became a serious collector of drawings only toward the end of his life, when he purchased the Charles Fairfax Murray collection. It comprised roughly fifteen hundred works dating from the Renaissance to the eighteenth century and is generally regarded as the first "classic" collection of old master drawings in the United States. As with the Bennett collection, that of Fairfax Murray formed the core of the Library's holdings in this field.

Generally speaking, Morgan's collecting followed accepted patterns of the day, which favored the older historical periods and schools of Western Europe. At times, however, he ventured into areas where few collectors on either side of the Atlantic had gone. In 1911, for example, he purchased most of the group of some sixty Coptic manuscripts that had been discovered the year before in the ruins of a monastic library near the Egyptian village of Hamouli in the Fayum. Another unconventional interest was represented by his impressive collection of ancient Near Eastern cylinder seals, which at his death numbered upwards of twelve hundred items. Given the size of the collections and the speed with which they were formed, the number of "mistakes" Morgan made was remarkably low. Wisely, he sought out the advice of some of the most eminent experts of his day – Sir Hercules Read, Wilhelm von Bode, Sydney Cockerell, Montague Rhodes James, and Bernard Quaritch, to name but a few. And, although Morgan was neither a scholar nor a connoisseur in the strict sense of the word, he seems to have had an intuitive eye for quality. Evidently he was not one to be meddled with in these matters. As George Hellman, a dealer who sold Morgan a number of books and autographs, explained, "The abruptness of Morgan's query and the piercing quality of his dark eyes did not tempt one to circumvention."

Beginning in 1905, Morgan had the able assistance and advice of Belle da Costa Greene

as his librarian and general aide de camp. Barely twenty when Morgan hired her, Miss Greene had little training other than a brief apprenticeship at the Princeton University Library. Nevertheless, she soon demonstrated intelligence, enthusiasm, and energy and became capable of the same swift and single-minded tactics in making acquisitions as her employer. To cite but one example, on a buying trip to London in 1907 she swept up Lord Amherst's Caxtons in private negotiations the night before they were to be sold at auction, thereby adding seventeen Caxtons to Morgan's already outstanding holdings.

A Masterpiece by McKim

THE SHEER QUANTITY of Morgan's collections posed considerable logistical and organizational problems. As a general practice, he kept his art collections in England. Most of these objects had been bought abroad, and, until 1909, there was a daunting tax of twenty percent on art and antiques imported into the United States. The London town house at Princes Gate he had inherited from his father was enlarged and became a showcase for many of his finest paintings, sculpture, and decorative arts. Some of the collections were also kept at Dover House, and a substantial number of objects were on loan to the South Kensington (later to become the Victoria and Albert) Museum.

Initially, Morgan's books and manuscripts were divided between his residences in England and his Madison Avenue brownstone in New York. In time, a storage room in the cellar of the brownstone had to be commandeered for his burgeoning literary collections as well. Still more books were kept in storage at the Lenox Library on Fifth Avenue and 70th Street.

By 1900 Morgan was formulating plans to build a separate structure on the property he had acquired to the east of his house, along 36th Street. At first he considered erecting a small museum or picture gallery on this site. But ultimately he decided on a building that would be more or less exclusively devoted to his literary collections. The extraordinary time, care, and expense that he lavished on this project went far beyond the practical considerations of safe and proper storage. Morgan was forming a great library, and he apparently felt that it demanded a building that bespoke the importance and value of the objects it would house.

Morgan chose as architects for his library McKim, Mead & White, one of the nation's most prestigious firms and the acknowledged leaders of the American Renaissance movement. The epoch-making Villard Houses in New York (1882-86) had been their first major statement of this new aesthetic, which sought to revive the ennobling spirit of Renaissance art and humanism on American soil. Since then the firm had continued to create buildings, monuments, and public spaces that adapted Italian Renaissance prototypes to American purposes. Morgan's singling out of Charles F. McKim (1847-1909) as principal architect for the project was logical. His reputation as a scholar-architect and his grave and serious-minded demeanor appealed to Morgan. The two men knew and respected each other. Morgan's support had helped McKim to establish the American Academy in Rome, where American students could study first hand the great works of the Renaissance and classical antiquity.

Following a meeting in April 1902, McKim submitted two designs for Morgan's

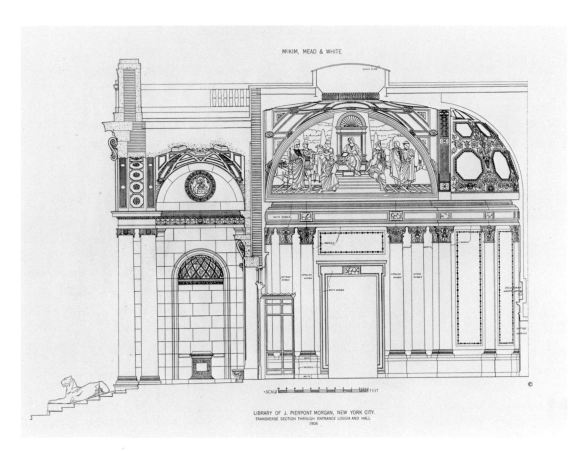

Transverse section showing the entrance loggia, from volume III of
Monograph of the Work of McKim, Mead and White (New York, 1915)

consideration: one was derived from Palladian villas, with a wide, projecting porch surmounted by a pediment; the other combined features of Italian Renaissance garden casinos and urban palazzi. The latter design was accepted with minor alterations and construction got under way in the fall of 1902. In Morgan, McKim had a client who was not only sympathetic to his designs but also willing and able to pay for the finest craftsmen and materials to realize them. As the work was about to begin, he shared with Morgan his dream of one day building a structure in the manner of the classical Greeks—with each block fitted to the next by means of carved grooves instead of mortar. McKim recounted how, during a visit to the Erechtheum in Athens, he had found the carving and craftsmanship so precise that he had been unable to insert a knife blade between the stones. Admitting that the results would not be apparent to the eye and that it would be extremely costly, he nevertheless asked if he might use such a technique for the Library. Intrigued, Morgan inquired about the additional cost. Fifty thousand dollars, was the reply. Morgan's response was a terse but affirmative, "Go ahead." In the end, a small amount of mortar and lead sheeting had to be used along the interlocking grooves, but the construction is essentially faithful to the classical dry-joint method. Completed in 1906, at a cost of approximately $1.2 million, the Morgan Library ranks among the most successful and fully realized examples of American Renaissance architecture and interior design.

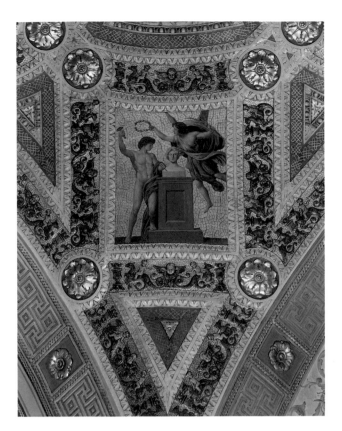

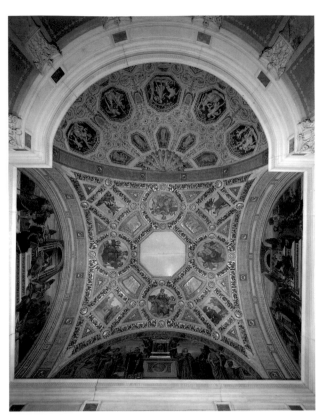

Detail from the Rotunda ceiling (north portion) by H. Siddons Mowbray shows Art crowned

Rotunda ceiling. The central portion was inspired by Raphael's ceiling decorations for the Stanza della Segnatura in the Vatican

McKim concerned himself with virtually every aspect of the project, including the planning and supervision of the interior decorations. The Library would be an expression of the Renaissance philosophy of the unity of all the arts, combining architecture, painting, and sculpture into a harmonious whole. And if McKim cast himself in the role of a great Renaissance architect at work on his magnum opus, then Morgan undertook the role of a great Renaissance patron with equal seriousness. "I am in no way committed to any drawings," read a memorandum to McKim, "nor do I wish anything done until I have definitely decided upon same." The decorative program of the Library is notable not only for its learned use of distinguished Italian Renaissance models, but for the ingenious manner in which they have been adapted to refer to Morgan, his library, and his collections.

The Library was constructed of the finest pinkish-white Tennessee marble. McKim's design, essentially a rectangle with a recessed portico, is of classic simplicity. Doric pilasters decorate the façade, and pairs of double Ionic columns frame the entrance. The design of the arched portico combines two sixteenth-century Italian sources: the garden loggia of the Villa Giulia, designed by Bartolommeo Ammanati, and the entrance of the Villa Medici, designed by Annibale Lippi. For the exterior decoration McKim assembled a distinguished group of craftsmen and sculptors. Andrew O'Connor (1874-1941), later commissioned to create the doors of St. Bartholomew's Church, executed the lunette above the Library's entrance doors that depicts two putti bearing a wreath with the emblem of the great Italian Renaissance printer Aldus Manutius. (Morgan's recent

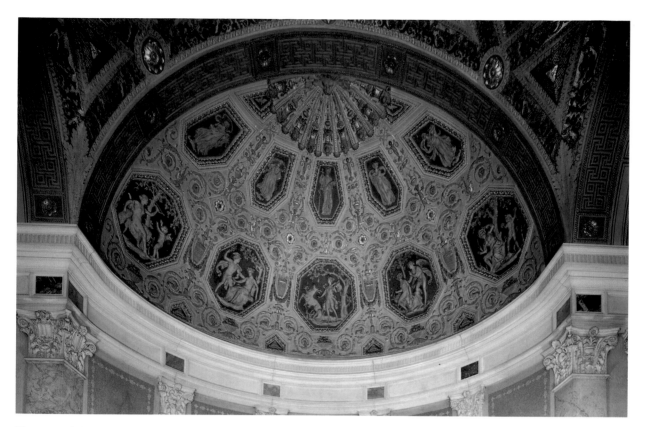

The apse of the Rotunda is decorated with stucco reliefs modeled after Raphael's designs
(done in collaboration with Peruzzi) for the Villa Madama

acquisition of a large number of Aldine imprints from the Bennett collection no doubt
inspired the creation of this design.) Adolph Weinman (1870-1952), a protégé of the
well-known sculptor Augustus Saint-Gaudens, carried out the rectangular panels on
either side of the entrance, with allegorical figures relating to learning and the arts. The
sleek lionesses guarding the entrance are the work of Edward Clark Potter (1857-1923),
who was then working in the studio of Daniel Chester French. Later Potter would create
the majestic pair of maned lions for the steps of the New York Public Library.

In dazzling contrast to the serenity of the exterior, the interior decoration is richly
colored and ornamented. Nevertheless, the entire program is carefully orchestrated to
give the impression of harmony and balance, in conformity with McKim's oft-quoted
credo that the interior of a library should "whisper and not shout." His plan for the
interior consisted of three rooms leading off the east, north, and west sides of a domed
entrance foyer. The largest of the three, the East Room, was designed for book storage and
displays. The West Room was Morgan's private study. The North Room, the smallest of
the rooms, was the librarian's office. (It remains in use today as the director's office.)

Of all the rooms, the vaulted entrance foyer of the Library, known as the Rotunda, is
the most monumental in design and feeling. Pilasters of Skyros marble decorate the walls,
and free-standing columns of green-veined Cippolino marble flank the doorways leading
to the East and West Rooms. The marble floor, with a large red porphyry disc embedded
in the center, is modeled after the floor of the Villa Pia in the Vatican gardens. For the
painted and stucco decorations, McKim retained a kindred spirit, the artist H. Siddons

Mowbray (1858-1928), who from 1903 to 1904 had served as director of the American Academy in Rome. When construction began on the Morgan Library, he was completing a series of decorations for another McKim, Mead & White project in New York, the library of the University Club. There his decorations were based on Pinturicchio's paintings for the Borgia apartments in the Vatican. For both McKim and Mowbray, the two Renaissance artists deemed most worthy of emulation were Raphael and his fellow Umbrian, Pinturicchio. Accordingly, both figure prominently as sources for the decorations of the Morgan Library's Rotunda and East Room.

The impressive East Room is by far the largest and grandest of the rooms. The walls, reaching to a height of thirty feet, are lined floor to ceiling with triple tiers of bookcases made of inlaid Circassian walnut. (A staircase concealed behind one of the floor-level bookcases provides access to the upper levels.) Morgan purchased the large Brussels tapestry over the fireplace in 1906. Designed by the sixteenth-century Flemish artist Pieter Coecke van Aelst, it depicts (some would say, ironically) the triumph of avarice. The ceiling paintings, with their classical imagery and lofty references to great cultural luminaries of the past, were intended to awe and inspire scholars at work. They were also intended to create the illusion that they and the room were indeed part of the past. Not only is there the expected reliance on fifteenth- and sixteenth-century Italian prototypes, but in a letter Mowbray explained that "the color used will be very much suppressed, so that the work, when completed, may have the softened harmony and patina of an old room...gold used throughout will be given as nearly as possible the tonal qualities of an old Florentine frame." Here Mowbray's attitude exemplifies that distinctive blend of scholarship and romantic sentiment which characterized so much of the American Renaissance movement.

The West Room, which served as Morgan's private study, is the most sumptuous and yet personal of the Library's rooms. Ranged along the bookshelves are sculpture, porcelain, and other objets d'art from Morgan's collections, and the walls are hung with Renaissance paintings. Perhaps the most extravagant feature of the room is the antique wooden ceiling, which was purchased in Florence and reconstructed under McKim's supervision. During Morgan's day the room served as a meeting place for leaders and notables from the various worlds in which he moved. Here, surrounded by favorite objects from his collections, he received scholars, dealers, and statesmen, as well as business colleagues and friends. Morgan also spent long quiet hours here, sitting by the fire, smoking his cigar, and playing his favorite game of solitaire. As Herbert Satterlee, Morgan's son-in-law and first biographer, later recalled, "No one could really know Mr. Morgan at all unless he had seen him in the West Room. This was because the room expressed his conception of beauty and color in varied and wonderful forms."

The final years of Morgan's life were in many ways trying ones. The U. S. Steel Corporation, which Morgan had founded, was sued under the new antitrust laws, and he himself was summoned to Washington in 1912 to testify before the Pujo Committee regarding money-trust allegations. These events took their toll, and, in January of 1913, when he sailed to Egypt, Morgan was in failing health. From Luxor, he proceeded to Rome, where he died on March 31, 1913, a few weeks before his seventy-sixth birthday. His body was returned to the United States and interred in the family plot in Hartford.

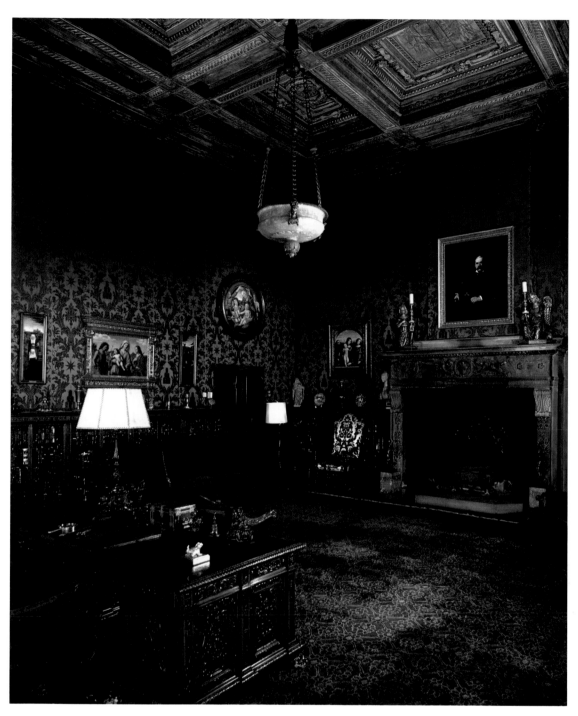

The West Room, which was Pierpont Morgan's study, still contains
many of his favorite paintings and art objects

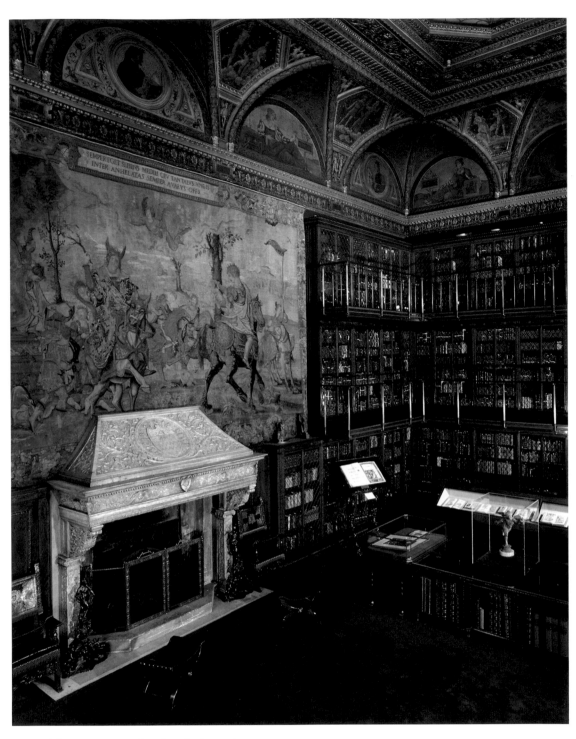

View of the East Room, showing the Brussels tapestry
designed by Pieter Coecke van Aelst

J. P. Morgan, Jr.

MORGAN'S ESTATE was valued at about $128 million, roughly $60 million of which was represented by his art and book collections. He left virtually everything to his only son, J. P. Morgan, Jr., expressing in his will the hope that there would be some disposition of the collections "which would render them permanently available for the instruction and pleasure of the American people." Precisely how this was to be done was left entirely to his son.

By the time of Pierpont Morgan's death nearly all of the paintings, sculpture, and decorative arts that he had kept in England were in New York in a basement storeroom at the Metropolitan Museum. In 1909 the U.S. import duty on art had been abolished (owing in large measure to Morgan's influence), and the same year England had substantially increased death duties. These two circumstances seem to have been the primary incentive for his decision to set in motion the complicated process of transporting his vast collections to New York. The packing and shipping went on continuously for an entire year, beginning in February of 1912. In all there were some 351 cases.

Understandably, the Metropolitan, to which he had been so generous during his life, hoped to receive the entire collection. J. P. Morgan, however, was obliged to sell a number of his father's art objects to pay taxes and maintain the liquidity of the estate. Among these were the beautiful Fragonard *Progress of Love* panels and Rembrandt's portrait of Nicholas Rut, now in New York's Frick Collection. A large group of Chinese porcelains was sold to John D. Rockefeller, Jr. But about forty percent of the collection—between a staggering six to eight thousand objects—was eventually given to the Metropolitan Museum. This gift included Egyptian artifacts, early medieval and Gallo-Roman objects, and a number of Renaissance and baroque paintings, among them Raphael's *Colonna Madonna*. The Wadsworth Atheneum received slightly more than a thousand objects, consisting largely of ancient bronzes, majolica, and French and German porcelain. Some of the art objects that Morgan kept in his Library were also sold. But the collections of books, manuscripts, and drawings remained intact. The decision to maintain the Library and its collections was no doubt forcefully urged by Belle Greene, whose devotion to the Library—and powers of persuasion—rivaled those of Pierpont Morgan himself. But it is also true that J. P. Morgan had always had a special regard for the Library and appreciated it more than any other of his father's collections. Like his father, he was well educated with a thorough grounding in literature, including Greek and Latin classics. Also, since 1904, J. P. Morgan had resided in the brownstone on the corner of 37th Street and Madison Avenue within a few steps of his father's house.

In the years immediately following his father's death, the Library temporarily assumed a secondary role to the more pressing concerns of settling the estate and then arranging financial assistance for the Allies in the early years of World War I. In 1915, however, Belle Greene was able to write to the London book dealer Quaritch: "I am glad to tell you that he [has] a strong interest in the Library and promised that I may go on collecting books and manuscripts when the war is over." The following year Morgan purchased the beautiful thirteenth-century French Old Testament Miniatures, thereby initiating the second great period of growth of the Library's collections. In all, the younger Morgan added 206 illuminated manuscripts to the Library, roughly a third as many as his father.

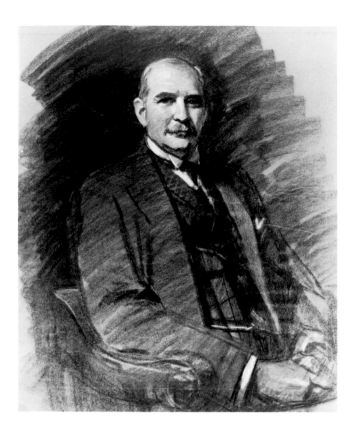

J. P. Morgan, Jr. (1867-1943), charcoal study for an oil portrait by Frank O. Salisbury, 1928

In the area of printed books, he added half as many incunables, including an indulgence printed by Gutenberg, bringing the total to about two thousand. Among the notable autographs he acquired were Thackeray's delightful *The Rose and the Ring* and Balzac's *Eugénie Grandet,* as well as a group of some 173 letters from Thomas Jefferson to his daughter Martha. Additions to the collection of old master drawings were modest but included fine drawings by such artists as Reynolds and Ingres.

From Private Library to Public Institution

THE MOST far-reaching consequence of J. P. Morgan's stewardship was his decision to establish the Library as a public institution. When Pierpont Morgan had first formed his library, there were only a handful of scholars, most of them in Europe, who specialized in rare books, manuscripts, and drawings. Now American as well as European scholars in ever growing numbers were pursuing research in these fields. The Library's collections were often central to these studies, and requests to consult them had steadily increased. On February 15, 1924, Morgan transferred ownership of the Library to a board of trustees along with an endowment of $1.5 million to provide for its maintenance. The indenture of trust provided for the use of the collections for research, the establishment of a "gallery of art," and other such activities as the trustees deemed appropriate and desirable. Shortly thereafter, the Library was established as a public reference library by a special act of the legislature of the State of New York.

Belle Greene was named the first director of the Library, and it was primarily she who effected the transition from private collection to public institution. Almost immediately,

and with an energy that awed and occasionally exasperated her colleagues, Miss Greene took on the myriad tasks involved in properly realizing the institution's new role: organizing graduate studies, lectures, exhibitions, and loan procedures. Under her twenty-four-year directorship forty-six exhibitions were mounted, including a comprehensive display of the collections on the occasion of the New York World's Fair in 1939. But Miss Greene's principal allegiance was to the scholars and to the Library's role as a place of research. She began to build a more comprehensive reference collection; saw to it that slides and photographs could be made for those unable to visit the Library; and produced a series of catalogues, facsimiles, monographs, and other publications devoted to the collections.

Within a few years of the Library's incorporation, it became clear that the new, more public role of the institution could not be properly carried out within the confines of McKim's structure. Not only were there scholars conducting research to be accommodated, but there were also a growing number of the merely curious who came to see the sanctum sanctorum of the legendary Pierpont Morgan. Thus Pierpont Morgan's neighboring brownstone was demolished, and on the site a new wing (the "Annex") was constructed that virtually doubled the size of the Library. Completed in 1928, the addition consisted of a large entrance foyer, a reading room for scholars, and an exhibition hall. The new structure was joined to the original library by means of a connecting gallery called the cloister. The architect retained for the project was Benjamin Wistar Morris, who some twenty years before had designed the Morgan Memorial for the Wadsworth Atheneum. (McKim had died in 1909.) Morris's additions were similar in layout and materials to the original Library and were designed to integrate the two buildings as closely as possible. H. Siddons Mowbray was recalled to provide the ceiling paintings for the Annex.

Belle da Costa Greene (1883-1950),
black, red, and white chalk portrait
by Paul-César Helleu, 1912

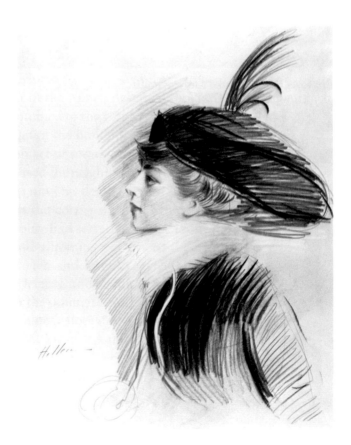

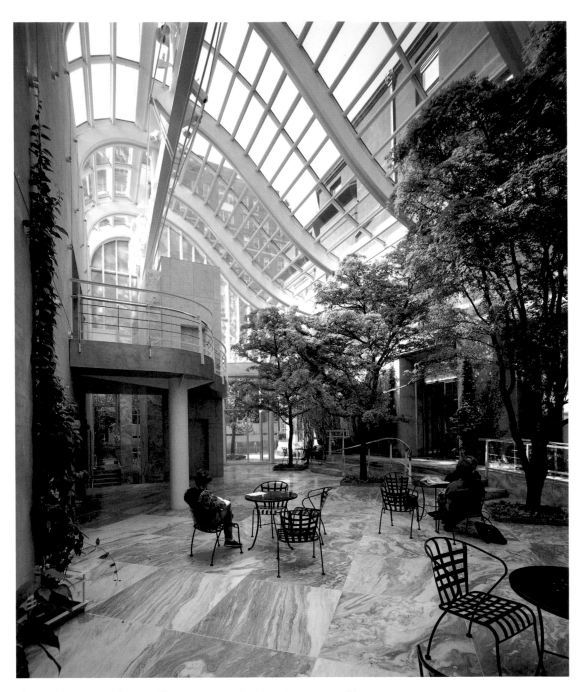

The Garden Court, designed by Voorsanger & Associates, opened in 1991

public garden. Architects for the project were Voorsanger & Associates, who earlier had carried out the restoration of McKim, Mead & White's Villard Houses in New York.

Once again, the Morgan Library has doubled in size and now occupies almost half a city block. By conscious design, however, the new spaces, whether modern or restored, function on a human scale. The Morgan Library continues to be a place in which the great achievements of the past seem not only clearly at home but a vital part of the present.

The Collections of
The Pierpont Morgan Library

1 Paintings and Art Objects

THE PAINTINGS AND ART OBJECTS that remain in the Library, of which a sampling follows, were with a few exceptions acquired by its founder, Pierpont Morgan. Quantitatively this collection represents the merest fraction of his original holdings, most of which were sold or given away following his death in 1913. The largest group, chiefly consisting of several thousand ancient and medieval objects, was given to the Metropolitan Museum of Art in 1917. The Wadsworth Atheneum in his native city, Hartford, was another important beneficiary. Nevertheless, some pieces, many of them Morgan's favorite objects, have remained in the Library to the present day. The value of the collection lies not only in the importance and beauty of so many of these works, but in the degree to which they represent the art Morgan so prodigiously acquired in the last twenty years of his life. The chronological span is impressive, ranging from early Mesopotamian and Egyptian culture through Graeco-Roman, the Middle Ages, the Renaissance, and beyond. Art of the ancient world is represented by Near Eastern figurines, Egyptian statuettes, a Roman bronze statue of Eros, a pair of silver cups from the time of the Emperor Augustus, and a vividly engraved Etruscan cista. The collection even includes two objects from the Far East, a Chinese bronze vessel and the oxblood vase known as the Morgan Ruby, the only remaining example in the Library of Morgan's once extensive collection of Ching porcelain.

Impressive as some of the ancient antiquities are, the core of the collection is a small but precious hoard of medieval pieces, reflecting Morgan's immense interest in art of this period. That taste is, of course, evident in the Library's great collection of illuminated manuscripts, and it is only appropriate that such incomparable Romanesque metalwork as the Stavelot Triptych and Malmesbury Ciborium and such exquisite Gothic treasures as the Basin Reliquary and Lichtenthal Casket have remained at the Library.

Morgan also greatly admired Renaissance and baroque art. Although he collected some very fine old master paintings, represented here with examples by Memling, Perugino, and Cima, he seems to have focused on the plastic arts and had a strong affinity for fine small objects. There is, for example, a pair of rare Saint-Porchaire ceramics, Cranach's roundel portraits of Martin Luther and his wife, as well as a few remaining examples of Morgan's collection of miniatures on ivory. The bas relief of the Virgin and Child, a particularly important example of the work of the fifteenth-century Florentine sculptor Antonio Rossellino (1, 9), is typical of his taste.

Detail from Perugino [9]

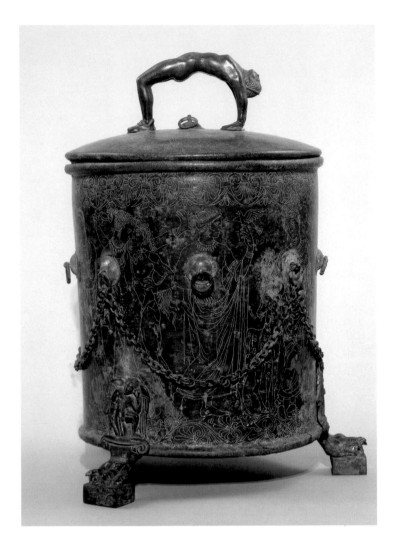

1 Cista with cover

1 ᴥ

CISTA WITH COVER

Etruscan, ca. B.C. 200. Bronze. Height (from foot to top of the handle of the lid): 14¼ in. (362 mm) diameter (at top of cylinder): 8¹¹/₁₆ in. (221 mm) and (at base of cylinder): 8⅛ in. (206 mm). Purchased by Pierpont Morgan, 1907.

According to Morgan's sale document, the cist was found at Palestrina, the site in the Apennines southeast of Rome known in ancient times as Praeneste. Cylindrical boxes such as this seem to have been popular during the final, Hellenistic period of Etruscan art between the fourth and first centuries B.C. A variety of engraved objects including vases, urns, sarcophagi, and mirrors are especially interesting for what they reveal about Etruscan life and art. Here, however, the scenes depict figures, some of which are identified by engraved names suggesting a connection with the events of the Trojan War. The most likely date for the Morgan cist is the end of the third century, or about 200 B.C.

Boxes like these were probably made to contain women's toilet articles and jewels. Included in the decoration of the cylinder itself are what appear to be triumphal figures, some in a chariot being greeted by a woman carrying a dove. The handle of the cover is in the form of a naked female acrobat. There is something curiously "modern" about the forms evoked by the simple line engraving. Artists like Picasso sometimes took their inspiration from the art of earlier times, including objects from the Graeco-Roman world, notably vase painting and possibly even engravings like these.

2 ❧

Two Double Cups

Roman, ca. first century A.D. Silver. Height: 4⅛ in. (105 mm); diameter: 3½ in. (89 mm). Purchased by J. P. Morgan, Jr., before 1913.

These two graceful silver cups date from the time of the Emperor Augustus. Each cup consists of an inner and outer part: the inner is the liner to which the rim is attached while the outer serves as the ground on which the ornament is worked. There can be no question that they were conceived as a pair: the scenes of cranes feeding among wheat and poppies are complementary and the construction and dimensions of both cups are identical. Their condition is extremely good, but we must still imagine how they would have originally appeared; handles would have been affixed on either side (the solder marks are still visible), possibly in the form of rings attached to the rim, which would have nicely complemented the graceful curving lines of the cup and its decoration; the cups also would have been decorated in silver gilt which is now largely worn away.

The cups were found in Rome, but there is good reason to assume that they are the work of a Greek craftsman. The guide marks indicating the placement of the handles are in Greek letters. Moreover, it is well known that much of the best silver owned by Romans during this period was made in Italy by Greek artisans. Indeed, Pliny the Elder, writing in the 1st century A.D., comments at some length on the great vogue among Roman patricians for silver of Greek make, which included tableware as well as cups and other vessels and utensils.

The decoration is of the highest quality and is carried out in repoussé (in which the design is hammered from the inside out). The motif of birds feeding was a popular one of the day. The poses of the cranes feeding are carefully designed as mirror images of one another. In each scene the artist has arranged the plant forms to continue or repeat the elegant line of the birds' necks. In the cup on the left, for example, the distended neck of the crane eating a snake or lizard is echoed in the drooping stalk of wheat.

2 Two double cups

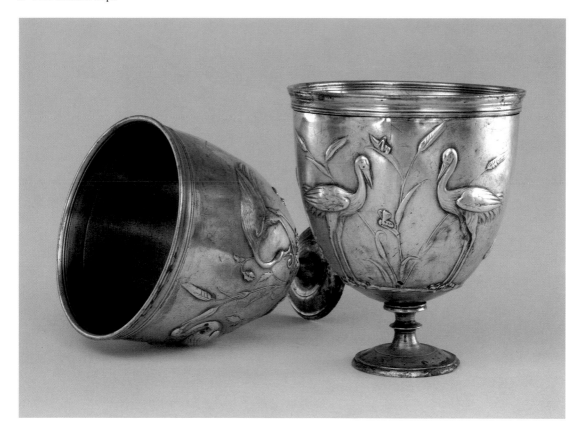

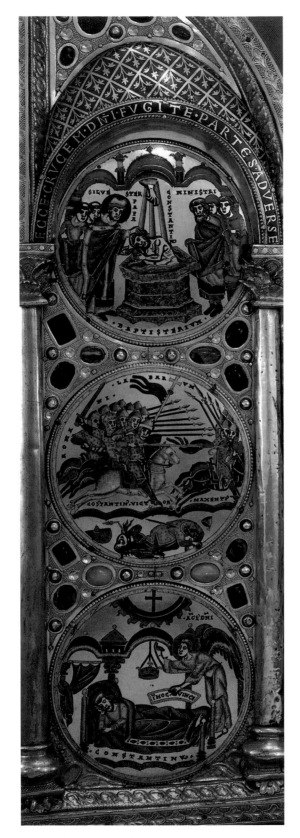

Wing with the story of Constantine's conversion

STAVELOT TRIPTYCH

Belgium, 1150s. Copper and silver gilt, cloisonné and champlevé enamel. Open, 19¹⁄₁₆ x 26 in. (484 x 660 mm). Purchased by Pierpont Morgan, 1910.

Even in an age which excelled in the use of precious and costly materials, the Stavelot Triptych, the most important art object in the Library, must have appeared as a work of astonishing richness. Its sumptuousness is no doubt a reflection of its important function as a reliquary of the True Cross, perhaps the most sacred of all Christian relics. These wooden fragments are visible in the very center of the main panel, arranged in the shape of a cross and held in place by two pearl-headed pins. Appropriately, the six roundels on the outer wings narrate the Legend of the True Cross. Originally, the triptych was probably more dazzling, for there is evidence that the portions of the central area now covered in velvet were once gold and also studded with gems and semiprecious stones.

The Stavelot Triptych actually comprises three triptychs. The two small ones in the center are Byzantine and date from the late eleventh or early twelfth century. The larger triptych which houses the Byzantine works is Mosan and dated in the 1150s. The term Mosan refers to the art produced along the Meuse or Maas River, especially within the ancient diocese of Liège. Mosan art of this period decisively influenced styles in Germany, France, and even England (see I, 4). The roundels on the wings of the Stavelot Triptych are among the finest and best preserved of all twelfth-century Mosan enamels.

The Stavelot Triptych takes its name from the great imperial Benedictine Abbey of Stavelot, in present-day Belgium. Although there is no early documentation linking this work directly with Stavelot, it is known that the triptych was in the possession of the abbey's last prince-abbot when he fled during the French Revolution in 1792. Moreover, the style and technique of the triptych suggest that it came from the same workshop responsible for two other works most assuredly made for Stavelot, the Pope Alexander Head Reliquary (now in Brussels) and the Remaclus Retable of 1145 (destroyed in the eighteenth century). Both of these objects were commissioned by Abbot Wibald, the famous ecclesiast and art patron who headed the abbey from 1130 to 1158. It is possi-

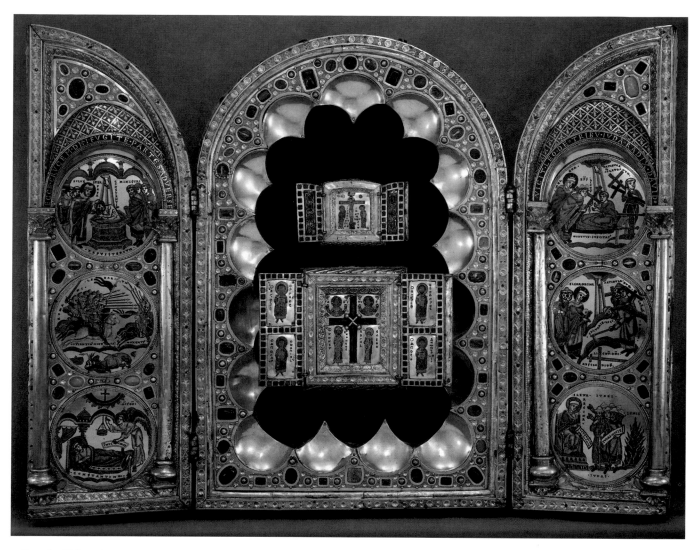

3 Stavelot Triptych

ble that the Stavelot Triptych was made for Wibald as well. He acted as adviser and agent for three successive Holy Roman Emperors and made several visits on their behalf to Constantinople. He may have received the two Byzantine triptychs as gifts on one of these visits. Upon his return, Wibald could have commissioned this magnificent gold and jeweled reliquary to display and preserve them.

In the smaller Byzantine triptych, Mary and John are shown beside the Crucifixion. In the larger triptych below, the four standard military saints of Byzantium appear on the inner wings: George and Procopius on the left, Theodore and Demetrius on the right. In the center, beneath busts of the Archangels Gabriel and Michael and flanking the cross composed of

the relic itself, are the Emperor Constantine and his mother, Empress Helena. It was not until Constantine's conversion that Christianity became the official religion and the cross became the public symbol of the Christian faith. According to legend Helena discovered the True Cross and brought back a part of it to her son. The placement of the figures of Constantine and Helena clearly dictated the arrangement of the narrative roundels on the wings of the reliquary.

The three on the left, reading from bottom to top, narrate the story of Constantine's conversion. At the bottom is the Dream of Constantine, in which the flaming cross appeared with the legend "By this conquer"; above is his defeat of Maxentius; and at the top his legen-

4 Malmesbury or Morgan Ciborium

dary baptism by Pope Silvester. The scenes on the right are devoted to Helena. In the first roundel, she is told by one of a group of Jews threatened with fire that a certain Judas knows the location of the True Cross; in the second, Judas digs up three crosses; in the third, Bishop Macarius identifies the True Cross following its miraculous restoration of a dead man to life. The power of the Cross, as well as the triptych's liturgical function, is affirmed by the inscriptions above the roundels: "Behold the Cross of the Lord. Flee, you hostile powers. The Lion of the Tribe of Judah, the Root of David has conquered." These are taken from an antiphon of the Divine Office sung on the feast days of the Discovery (May 3) and Exaltation (September 14) of the True Cross.

The enamels of the Byzantine triptychs are all of the cloisonné type, in which the design is formed by narrow gold strips, called cloisons, joined together to form compartments for the enamel. The result is a flat and linear design of strong, pure color. The enamels of the Mosan roundels are champlevé, which differs from cloisonné in that the enamel is contained in cavities hollowed out of a thick copper plate. In these, as in most Mosan enamels, two or more colors, usually including white, were often mingled in the same cavity to modulate the color and suggest modeling. This is used to good effect in the enthroned figure of Helena in the first roundel on the right. In his striving for an even greater sense of realism, the artist has placed bits of metallic foil beneath the enameling for the flames in this scene to suggest a flickering fire.

The various elements of the Stavelot triptych, including the classical gems set into the frame, provide a meeting ground for East and West. The Eastern symbolic representation of Con-

stantine and Helena is juxtaposed to the Western narrative mode, and Byzantine liturgy and hagiography (where Constantine is a saint) are contrasted with their Western counterparts. The triptych, the earliest True Cross reliquary decorated with scenes from the Legend of the True Cross, is a key monument of the Renaissance of the twelfth century.

4 ❧

MALMESBURY OR MORGAN CIBORIUM

England, ca. 1160-70. Copper gilt and champlevé enamel. 7¾ x 5⅞ in. (200 x 155 mm). Purchased by Pierpont Morgan, 1911.

A ciborium is a vessel made to contain consecrated eucharistic wafers and therefore would have been made with the finest available material and workmanship. This ciborium is no exception and is believed to have come from the great Romanesque abbey at Malmesbury in Wiltshire, England. It is closely related in style, date, technique, and iconography to the Balfour and Warwick ciboria, both now in the Victoria and Albert Museum in London. All three show direct influences from a Mosan workshop in the diocese of Liège, providing yet another example of the enormous influence which Mosan art had on the rest of Europe during the twelfth and thirteenth centuries. Although some scholars thought that the ciboria were actually produced in Liège, their English origin is confirmed by the Latin verses on the works. These are verses identical to a twelfth-century poem, copied from murals of that period, that once adorned the chapter house at Worcester, fifty miles north of Malmesbury.

On the inside cover is a scene of Christ Blessing and on the interior of the bowl, where the Hosts would have rested, is a bleeding Lamb of God. Adorning the exterior of the bowl are six Old Testament scenes paired with the six New Testament events on the cover that they were believed to have mystically prefigured. It was a commonplace of medieval thought and scriptural exegesis that the coming of Christ was the fulfillment of the old covenant and hidden within it. Visible in this photograph is the flowering of Aaron's rod, which is juxtaposed to the Nativity; the sacrifice of Cain and Abel is paired with Christ's Presentation in the Temple; the Circumcision of Isaac to Christ's Baptism; Isaac's carrying wood to sacrifice to Christ's Bearing the Cross; Moses and the Brazen Serpent to the Crucifixion; and Samson's escape from Gaza to the Three Marys at the Tomb.

5 ❧

BASIN PORTABLE SHRINE

France, Paris, ca. 1320-40. Silver gilt, translucent enamels, and gems. Open: 10 x 4⅞ in. (254 x 124 mm). Purchased by Pierpont Morgan, 1911.

The gently swaying gilt Madonna and the delicate shrine in which she is housed embody the courtly elegance of fourteenth-century Parisian sculpture. She is enclosed by walls of transparent enamel which enfold and protect her like the stained-glass windows of a miniature Gothic chapel. When closed, the exterior wings of the shrine form a Last Judgment; when

Backview of the Basin Portable Shrine

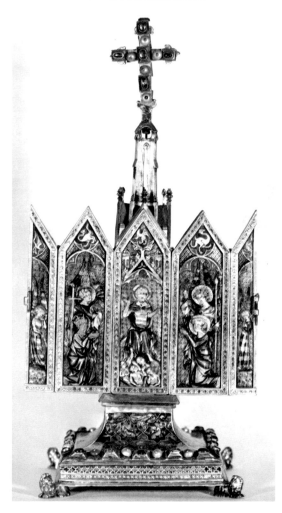

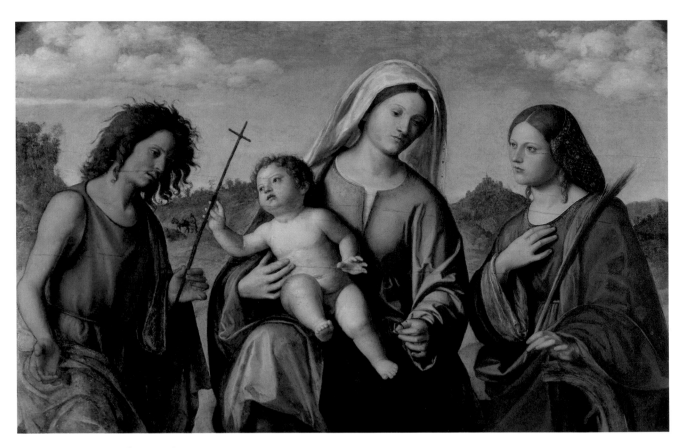

10 Painting by Cima da Conegliano

10 ❧

CIMA DA CONEGLIANO

Virgin and Child with St. Catherine and St. John the Baptist. Venice, ca. 1515. Oil on panel, 37¹¹/₁₆ x 24⁹/₁₆ inches (957 x 624 mm). Purchased by Pierpont Morgan, 1911.

The paintings of Cima da Conegliano (1460–1517-18) exhibit the serene Venetian feeling so characteristic of the paintings of Giovanni Bellini. It is not certain where or from whom Cima, essentially a conservative painter, received his early training, but in addition to Bellini, his paintings show that he studied the work of Antonello da Messina, whose affinity for sculptural forms and jewel-like surfaces was important for the early development of Bellini as well. Cima's later paintings show the influence of Giorgione.

This painting is of the devotional type known as the *sacra conversazione,* in which the Virgin and Child are shown in the company of saints, with whom they appear to be conversing

or in silent communion. Here, the young Madonna holds the Infant Christ who offers a reed cross to a youthful John the Baptist. The lovely female saint on the right rests her hand on a wheel, identifying her as St. Catherine of Alexandria, who was tortured on a spiked wheel for refusing to renounce her faith and marry the Emperor Maxentius. The Virgin presents a ring to Catherine, presumably a reference to the legend of the Mystic Marriage of St. Catherine, in which the saint was borne aloft to heaven and betrothed to Christ.

The Library's *sacra conversazione* is remarkably direct, with the figures very close to the picture plane, separated from the viewer by a marbleized ledge. (The piece of paper with the artist's signature affixed to the ledge was a favorite trompe l'oeil device of the time.) A sense of stillness emanates from the figures, and the distant landscape view adds a poetic quality to the painting. The composition and format are close to Bellini's *Virgin and Child with St. John the Baptist and St. Catherine* (ca. 1500, Accademia, Venice).

Cima's works are often difficult to date. The art historian Bernard Berenson, noting the similarities between Catherine's headwear and that worn in Bellini's *Woman at Her Toilet* of 1515, now in Vienna, suggested that the Library's painting was probably executed a few years later. Cima's late paintings (he died about 1517 or 1518) show an interest not only in light and atmosphere, which he tended to emphasize in mid-career, but in a rich full-bodied coloring. The painting was purchased by Pierpont Morgan from the Charles Fairfax Murray collection, the source of approximately 1500 old master drawings that established the core of the Library's collection of drawings and prints.

11 &

HANS DAUCHER

The Meeting of Emperor Charles V and His Brother Ferdinand I, King of Bohemia. Augsburg, 1527, honestone bas-relief. 6 15/16 x 8 3/4 in. (173 x 219 mm). Purchased by Pierpont Morgan, 1906.

The relief depicts the Roman Emperor Charles V and his brother Ferdinand, king of Bohemia and Hungary, who would later succeed his brother as emperor. Charles, on the left, is identified by his imperial eagle, and Ferdinand, on the right, is identified by the Bohemian lion on his horse's armor. The composition is based on a section of Albrecht Dürer's 1515 woodcut *The Triumphal Arch of the Emperor Maximilian.* Maximilian was Charles's grandfather and predecessor. The section of the scene that Daucher based his relief on represents the meeting between Maximilian and Henry VIII of England. Daucher's relief was thought to represent a meeting between the two brothers on the Brenner Pass in 1530, when they were on their way to the Diet of Augsburg. The date 1527, which is scratched on the plaque, was thought to be a later addition. Recently Thomas Eser, a Daucher scholar, authenticated the date, pointing out that the forms of the numbers are consistent with those on other reliefs by the sculptor. Thus the occasion for the plaque is open to interpretation.

Daucher, who is documented as a sculptor working in Augsburg from 1514, was particularly skilled at small-scale relief carving. Under the influence of Dürer and Italian art he developed a style of subtle delicacy. Most of his plaques are meticulously worked and finely finished. This relief is cut from fine-grained honestone, a medium ideally suited to the carving of delicate and intricate detail.

11 Bas-relief by Hans Daucher

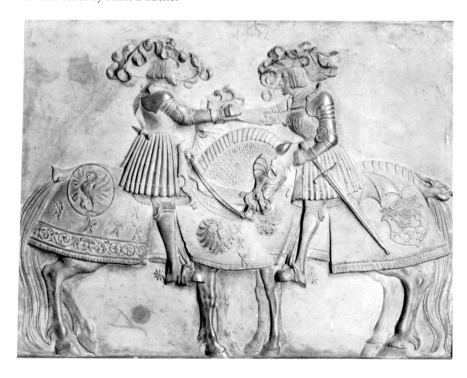

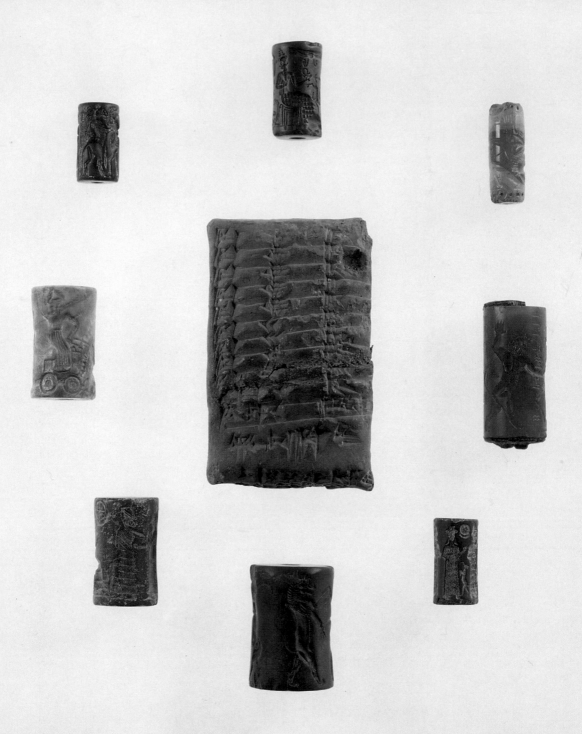

Contest frieze [2] Animals slain in the hunt [13] A centaur and a lion [12]

Libation [4] Multiplication tablet [18] A winged hero [11]

Worshiper led before a god Confronted pairs [3] Presentation scene [8]

II ANCIENT NEAR EASTERN SEALS AND TABLETS

S EALS, that is stones incised with a design that leaves an impression on plastic material, like damp clay, were produced more or less continuously for a period of about 5,000 years in the region the ancient Greeks called Mesopotamia—"the land between two rivers." The area, drained by the Tigris and Euphrates and their tributaries, roughly corresponds to most of Iraq, and borders on Iran, Syria, and Turkey. It is a land of geographic and climatic extremes, lacking mineral resources. Nevertheless, the peoples of ancient Mesopotamia succeeded in creating the first great civilization in western Asia. The earliest settlements date from the sixth millennium B.C. By about 3400 B.C. an urban culture had evolved in the south of which the most important feature for posterity was the invention of writing.

Each decade brings to light new archaeological finds, and research increasingly affirms the extraordinary intelligence, inventiveness, and artistic sensibilities of these peoples. And yet, particularly in the case of both architecture and sculpture, many periods remain poorly documented or not represented at all. Engraved seals, however, constitute the only type of work for which we have enough examples to reconstruct the history sequence from the end of the fifth millennium B.C. to the time of the Persian empire in the fifth century B.C.

The American collector William Hayes Ward (1835-1916) was among the first to recognize the importance of seals for a knowledge of ancient Near Eastern art and culture. Between about 1885 and 1908, he assembled, probably on Pierpont Morgan's behalf, the great collection of 1,157 seals which forms the core of the Morgan Library's collection. Two major gifts have subsequently been received: 74 cylinder seals and 70 stamp seals collected by Robert F. Kelley and given by his sister in 1977, and a study collection of 480 cylinder and 230 stamp seals given by Jonathan P. Rosen in 1986. The Morgan Library's seal collection is today one of the most important in the world. It covers the significant styles of Mesopotamian engraving from the Chalcolithic to the classic Greek as well as the styles of the other countries of the ancient Near East. Pierpont Morgan also acquired fine ancient cuneiform tablets. Most of these are now in the Babylonian collection at Yale, but a small number was retained at the Morgan Library and includes accounts of various myths and legends, religious and administrative practices, and even personal correspondence (see II, 18).

The seals discussed below have been selected to give some idea of the quality and scope of the Library's holdings. Although they span a period of several thousand years, it is possible to identify certain consistent or recurring features regarding their functions, techniques, materials, styles, themes, and subjects. The seal design was made by engraving in reverse on a small stone using metal tools and simple bow drills. The function of seals was both practical, as a means of identification, and amuletic, that is the engraved design was intended to protect or benefit the owner in some way. Most seals are quite small, measuring only an inch or so in height. As objects in and of themselves, they are often unimpressive looking, but when one sees the positive impression of the engraved design, it is readily apparent that seal carvers were frequently craftsmen of extraordinary techni-

Examples from the collection

cal facility who had innate artistic gifts. Indeed, the images produced from seals often appear so vivid that the world of the ancients seems tantalizingly close and within our grasp.

In the earliest periods, comparatively soft stones, such as serpentine or marble, were used; while harder materials, such as hematite, prevailed in the first part of the second millennium, followed by jasper, chalcedony, and the like. The choice of materials was not only governed by the technical abilities of the engraver, but by the magical quality considered inherent in the various stones. For example, we learn from an Assyrian text that "If someone carries a seal of lapis lazuli, he will have protection and his god will rejoice in him," and "if someone carries a seal of serpentine, it shall be granted him to live surrounded by devoted obedience."

The first seals were in the form of stamps and were produced in an area that stretched from Turkey to Iran. These stamp seals were impressed on clay lumps slapped over strings that secured the cover of a jar or on the clay placed on the door of a storeroom. Some of the stamps had figural shapes that must have had a beneficial meaning, for example the abbreviated female body of a seal amulet in the Rosen gift, dated about 5000 to 4500 B.C. During the middle of the fourth millennium, when the transformation from village to urban civilization was beginning at some sites, seals in cylindrical form appear, probably

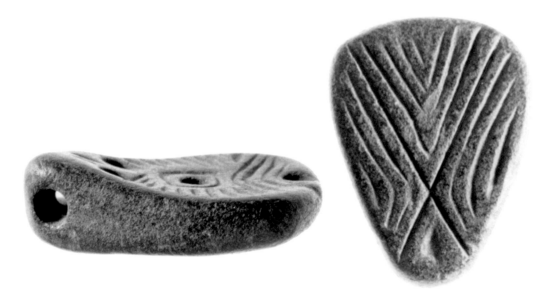

Seal amulet, Gift of Jonathan P. Rosen, 1986-87

first at Uruk, the major site of southern Mesopotamia, or at Susa, in southwest Iran. When a cylinder is rolled out, it covers more surface than a stamp, and this surely was one reason for the adoption of this new form. Officials used their seals to authenticate tablets recording the movement of foodstuffs and goods needed for the growing economy of urban institutions, palaces, and temples. We do not know whether these first cylinder seals were also used as the personal seals of individuals, but this certainly became a part of their function by about 2600 B.C., when inscriptions naming the seal owner were occasionally

carved on the cylinder. At certain times every person of consequence in the Mesopotamian settlements had a cylinder seal. As a rule, they were perforated lengthwise, so that a wire or string could be passed through the hole and then fastened to the necklace or bracelet on which the seal was usually worn. Frequently the cylinders were set between caps of gold, silver, or copper. Beginning in the third millennium it became a common practice to bury seals with their owners; thus each generation had to have cylinders made, and the designs naturally reflect the regional style and period of carving. There are probably more than 30,000 known today.

At first, seal designs were abstract ornamentation, then came animals, and finally humans, gods, and demons. Most of the inscriptions on cylinder seals identify the owner, usually giving his name and perhaps his title or occupation. But it is rare for the inscriptions to have any direct connection with the seal design. Many of the images were intended to influence nature in an almost magical way. The artist drew that which he wanted to become real, for example, the overpowering of dangerous beasts, a flourishing herd of animals, or the desired consequence of an action, such as a sacrifice or prayer offered to a god. As a general rule, there was no attempt at foreshortening or rendering figures in perspective. The artist did not try to make a naturalistic rendering of a particular figure at a particular moment; rather he sought to cast the idea represented by a figure into a permanent form. It is this struggle to find the appropriate permanent form that we can follow through the millennia of Mesopotamian art; at times it was sought using representational forms, at others the lines and shapes almost create abstractions. Human beings are characteristically shown in profile view, but with the shoulders and thorax seen from the front, as for example in Egyptian art. The repertory of gestures is small and the figures are rather stocky and clad in heavy garments from which head and limbs protrude as from a tube. Gods are distinguished from mortals only by their clothing, such as a miter with one or more pairs of bulls' horns. The representation of deities reflects the way in which gods were thought of: they were believed to have eternal life, but otherwise resembled earthly rulers. Even divine bakers and barbers are mentioned in Mesopotamian texts.

There is somewhat more freedom and variety in the representation of animals. The frontal-profile convention is occasionally broken, and postures vary considerably. They are often used to express unleashed fury or pitiful suffering—in contrast with the emotionless faces and rigid bodies of human beings. Monsters can be part human, part animal, or a combination of several beasts, such as lions, eagles, and bulls, embodying the forces of all. Figures like the griffin, which combines a bird of prey and a lion, are astonishingly convincing. Such creatures made a deep impression on later cultures, surviving in art and imagination to the present day.

The scenes represented on seals may be gathered into three broad categories: ritual, mythological, and contest. Toward the end of the third millennium and earlier part of the second, ritual scenes usually show the worship of gods and vary from the bearing of offerings to the mere gestures of prayer in their presence. They illustrate the religious life of the Mesopotamians, which was expressed in continuous appeasement of the gods and frequent efforts to obtain their goodwill. In such scenes the owner probably believed that he had placed himself for all time before the gods in worship or sacrifice. Mythological themes were probably intended to glorify the gods and are most common in the period of the Semitic dynasty of Akkade (about 2340-2150 B.C.).

Contests are a predominant subject on seals during the so-called Early Dynastic period, the time of the Sumerian city states (about 2900-2400 B.C.) and during the Dynasty of Akkade. Typically, they show a human, or superhuman, hero competing against or overpowering an animal or monster. Such scenes may reflect the eternal conflict in which the Mesopotamians saw themselves as the defenders of order and civilized life against the chaotic forces of nature that surrounded them. Rather than conceiving of this conflict in abstract, philosophical terms, they seem to have thought of each force separately and in concrete terms. Thus the lion, as a menace to human life and livestock, was a very real opponent. The various monsters represent fearsome dangers equivalent to those posed by natural predators. The lion griffin, for example, probably represented the destructive aspects of weather, such as lightning or ravaging storms. The protagonists were often heroes, the most important of which was shown as a muscular man with symmetrical curls and a full beard; another protective figure is a man whose lower body is that of a bull and who has magnificent horns rising above his long curls. Precise identifications of such hero types are only gradually being discovered by scholars, but their appearance in scenes of violent combat was surely meant to protect the seal owner in a supernatural way.

It is important to bear in mind that these scenes were not meant to be understood in one glance as a single pictorial entity. Instead, they were to be read element by element, and each had a fixed meaning. The primary aim of the carver was not aesthetic; nevertheless he had a sense of form and space, of balance and rhythm, so he articulated the figures on the cylinders in friezes, using only the band of the cylinder mantle as the surface on which to draw his design. The compositional principle of the frieze was not limited to seals, of course. Bands, in which figures follow each other in rhythmic succession or are assembled according to other schemes, again rhythmically organized, are found throughout the art of the region. Probably the most significant of the schemes is called "heraldic." It consists of a central element, which may be a bird or a hero, dividing a symmetrical pair of figures, often horned animals. These compositions create a feeling of permanence: nothing can alter the symmetrical balance without destroying the composition. Long after the civilizations of the ancient Near East ceased to exist, friezes and heraldic schemes were used in which animal forms were rigidly subjected to laws of composition. They are Mesopotamia's greatest artistic achievement, and, in their influence on the later art of Europe, its most important aesthetic legacy.

Engraved cylinder seals are not only a valuable record of Mesopotamian artistic precepts and practices of the time; they can reveal something about the life, costumes, and furnishings of the period as well. Many of the images symbolize human qualities and intellectual concepts that passed into the literature and art of the Middle Ages and beyond. In the past decades well-documented archaeological material from the ancient Near East has substantially increased, and the study of seals now seems only at the beginning.

Chronology

5000–4500	Halaf Period
4500–3500	Ubaid Period
3400–3000	Uruk Period
2900–2400	Early Dynastic Period
2340–2150	Dynasty of Akkade
2112–2004	Third Dynasty of Ur
2000–1800	Dynasties of Isis and Larsa
1894–1595	First Dynasty of Babylon
1600–1450	Hittite and Mitannian rule in Syria and North Mesopotamia
1430–1155	Kassite kings in the south
1430–1050	Middle Assyrian kings
1157–1026	Second Dynasty of Isin
1025–648	Different dynasties, including Assyrian rulers
1049–609	Neo Assyrian kings
538–331	Persian rulers

1 🐚

SCENE IN A LEATHER WORKSHOP (?)

Uruk period (ca. 3300 B.C.). Greenish black serpentine, h. 29.5 mm, d. 25 mm. Cylinder No. 1.

Ancient Uruk, notable for its great ziggurat, was the site of one of the earliest Sumerian city-states. Few cylinder seals from the Uruk period have been recovered, although a large number of seal impressions on clay tablets has survived and attests to the rapid and widespread adoption of this "new" type of seal. The style of the engraving on this rare example of

about 3300 B.C. is lively and naturalistic. Two nude craftsmen appear to be active with tools in two rooms of what may have been a workshop. A boot is visible in one of the rooms, and for this reason it has been suggested that the men are leather workers. The rooms are framed by delicately carved feline figures with entwined serpents' necks. These composite beings, combining the powers of two dangerous beasts, were probably thought of as being protective of the building and warding off evil forces. Thus, the scene may have had some ritual significance.

The serpent-necked monsters are related to similar creatures in contemporary Egyptian representations on the so-called hunting pallettes and remind us that relationships with Egypt at the dawn of civilization must have been closer than once thought.

2 🐚

CONTEST FRIEZE

Early Dynastic period (ca. 2450 B.C.). Lapis lazuli, h. 24 mm, d. 12 mm. Cylinder No. 80.

This seal shows a nude bearded hero with a dagger and curved weapon attacking a leopard, who in turn menaces one of two horned animals protected by a second hero with upright curls. It was created about 2450 B.C. during the Early Dynastic period, so called because for the first time there are inscriptions giving the names of kings then ruling over Uruk, Ur, and other small city states in southern Mesopotamia. This seal is inscribed for a man, possibly a prince, called Lugal-la (?)me(?) from Uruk. It is made of lapis lazuli, which came only from

1 Scene in a leather workshop (?)

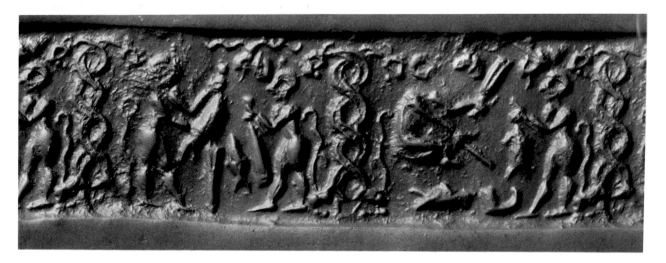

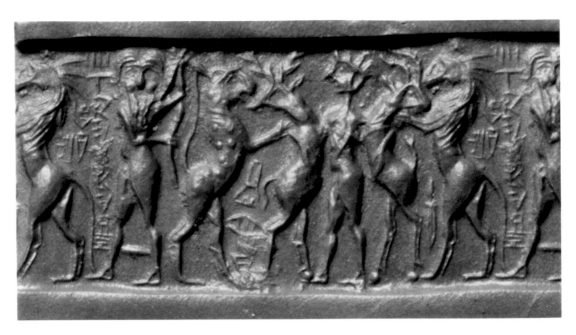

2 Contest frieze

northern Afghanistan and was probably the most precious stone of the time.

During the Early Dynastic period, the protection of flocks and herds, artistically expressed in friezes of animal contests such as these, was a predominant subject for seal engravers. The hero on the right exemplifies the comparatively schematic approach to the human body and face found in Early Dynastic seals, with the pupil of the eye represented by a small drilling set in a hollow surrounded by an oval or rhombic rim. Also characteristic of the period is the convention of portraying animals standing upright on their hind legs. In the case of lions or other feline creatures, it makes them appear semi-human and doubly dangerous. Horned animals, like sheep and goats, also stand on their hind legs, which gives an otherworldly atmosphere to these contests.

3 🐌

CONFRONTED PAIRS:
A NUDE HERO AND A BULL-MAN
WRESTLING WITH ANIMALS

Akkade period (ca. 2240 B.C.). Black serpentine (damaged), h. 36 mm, d. 25-24 mm. Cylinder No. 159.

During the years ascribed to the reign of the Akkadian king Sargon and his successors, a fundamental change took place in Mesopotamian art. The dream-like designs of the Early Dynastic period were succeeded by dynamic, realistic works which seem to reflect the tremendous energy and power that drove the Akkadians to their conquests.

In this seal of the fully developed Akkadian style, we can observe the continuation of the animal-contest theme of the Early Dynastic period, now transformed according to the new modes of representation. There is a heightened feeling for the musculature and structure of both human and animal forms; in the face of the hero shown in profile on the right, the eye is now properly sunk between the lids and cheekbone. On the left, a nude bearded hero grapples with a water buffalo, a newcomer to the repertory of animals shown on seals (the head has been damaged). The bull man on the right grasps the forepaws of a powerfully built, open-jawed lion.

The format, in which the pairs of figures are presented in heraldic fashion on either side of a central element, is also characteristic of Akkadian seal designs. In some cases the central axis is taken up with an inscription; here, the artist places a tree on a mountain, possibly meant to suggest the gigantic scale in which the figures should be imagined. Earlier writers once identified the nude bearded figure and bull man of Mesopotamian seals with the epic heroes Gilgamesh and his companion, Enkidu, who lived

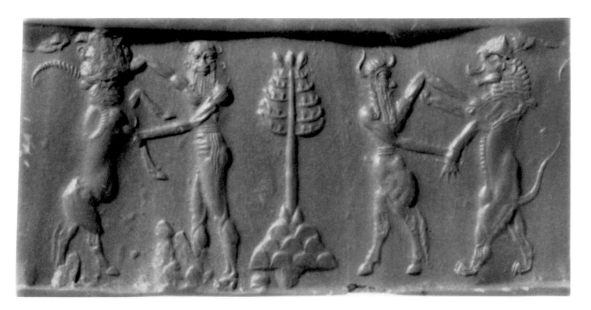

3 Confronted pairs: A nude hero and a bull-man wrestling with animals

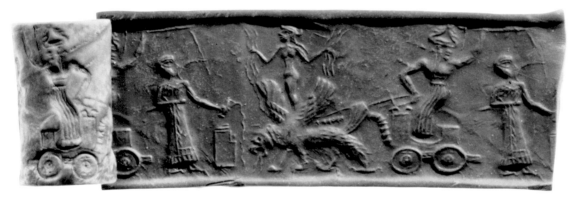

4 Libation before the storm god and rain goddess

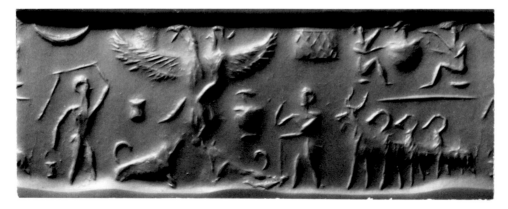

5 Etana's flight to heaven on the back of an eagle; shepherds with flocks

with the beasts of the field. This does not, however, agree with the preserved texts of the Gilgamesh epic, and at present the nude hero is linked with a group of figures associated with the water god.

During the Akkadian period, Mesopotamian art reached a height rarely if ever attained in its subsequent development. This seal and the following two seals are particularly fine examples of this great age of seal engraving.

4 ❧

LIBATION BEFORE THE STORM GOD AND RAIN GODDESS

Dynasty of Akkade (ca. 2240 B.C.). Shell, h. 24.5 mm, d. 16 mm. Cylinder No. 220.

In this splendid seal from the dynasty of Akkade, the storm god rides in a chariot drawn by a fire-spitting lion griffin. In one hand the storm god holds the reins that guide the monster; in the other a whip. His consort, the rain goddess, stands between the wings of the lion griffin, holding bundles of rain. As if to honor these deities, a worshiper on the left pours a libation over the altar.

This seal is but one of various representations of Akkadian weather gods. Such scenes on Akkadian cylinders are important sources for the knowledge of Mesopotamian mythology.

5 ❧

ETANA'S FLIGHT TO HEAVEN ON THE BACK OF AN EAGLE; SHEPHERDS WITH FLOCKS

Dynasty of Akkade (2340-2150 B.C.). Black serpentine, h. 36.5 mm, d. 28-26 mm. Cylinder No. 236.

A myth represented on several Akkadian cylinders is the story of Etana, the shepherd king, shown here flying to heaven on the back of a giant eagle to get the plant of easy birth for his wife. By placing the scene of the shepherds and their flocks on the ground, the artist has made the flight of Etana and the eagle to the upper sphere appear credible. This is one of the few instances in which we can find parallels for subjects on seals in ancient Mesopotamian texts. Indeed, a clay tablet in the Library's collection contains the beginning of the Epic of Etana. This story must have had some propi-

tious meaning to explain its presence on a cylinder seal.

Use has worn away some of the sharpness of the impression, but the cylinder does not appear to have been very carefully engraved in the first place.

6 ❧

A LION-HEADED EAGLE BETWEEN TWO MOUNTAIN GOATS

Post-Akkadian period (after 2150 B.C.). Gray steatite, h. 30 mm, d. 17 mm. Cylinder No. 267.

Despite the downfall of the Akkadian dynasty in about the middle of the twenty-second century B.C., some of the southern centers of culture continued to preserve the high standards of Akkadian art. In this unique cylinder of a heraldic composition, a lion-headed eagle has two kneeling mountain goats in his grasp. The modeling follows the best tradition of Akkadian plastic art, though the figures are even more delicately worked—probably through the use of finer instruments. The composition is notable for the beautiful balance achieved between the design and the inscription, which informs us that the seal was created for a minor priestly official, the scribe of a purification priest of the goddess Shara. The seal was probably carved at Lagash, where Shara was considered the consort of the chief god Ningirsu and the lion-headed eagle was a favored image.

7 ❧

WORSHIPER LED BEFORE A DEIFIED KING

Third Dynasty of Ur (2038-2004 B.C.). Black steatite, h. 25 mm, d. 13.5 mm. Cylinder No. 292.

The introduction of deified kings in worshiping scenes was an innovation of the so-called Third Dynasty of Ur, which assumed rule of Mesopotamia about 2112 B.C. Like Naram-Sin, a famous king of the Akkade Dynasty, the kings of Ur were deified during their lifetime. In this seal created for Ursakkud, an official of Ibi-Sin, the last king of Ur, a goddess introduces the worshiper to the seated personage. That he is a king rather than a god is shown by his attire. Instead of the horned miter and flounced robe of a god, he wears a round cap with an upturned brim and a bordered mantle. Further-

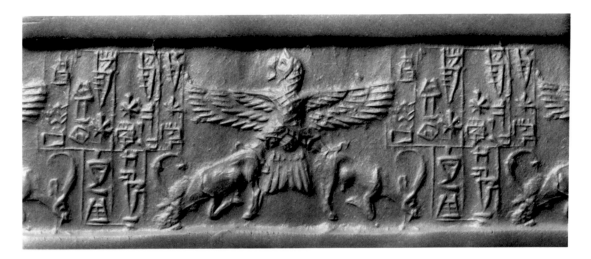

6 A lion-headed eagle between two mountain goats

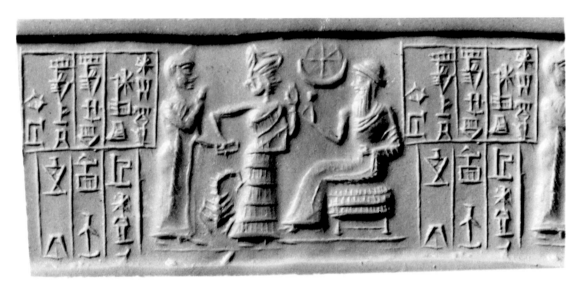

7 Worshiper led before a deified king

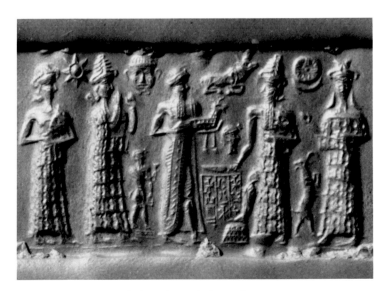

8 Presentation scene before the god Shamash

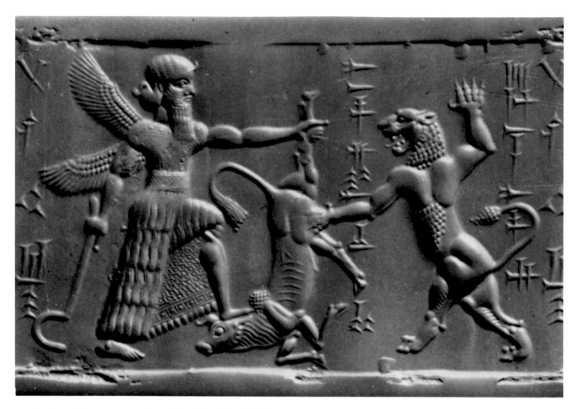

11 A winged hero contesting with a lion for a bull

Babylonian art of the ninth to seventh century B.C., is this Neo-Babylonian seal stone inscribed with the name of the seal owner. In the small space of the cylinder surface, the artist has created a contest of monumental proportions: a demonic lion faces a winged super-human hero. The lion's threatening gestures and the tension in the span of his sharp claws suggest his evil power. But the hero will be the victor; taller than the lion he acts with a calm force, and the bull, the victim of this contest, remains in his power. As the hero extends his step the smooth muscular forms of the human figure are set off by the carefully detailed flounced garment which opens to reveal its fine inside ornamentation. Motion in the lion's body is indicated by a similar contrast in patterning. Despite the violence of the action the figures seem frozen in time, a result of the symmetry. The elegance and refined execution of this seal are characteristic of the Neo-Babylonian style of this period. Also typically Neo-Babylonian are the pointed diadem worn by the hero and the position he takes with one foot on the victim's head.

12 ꙮ

A Centaur and a Lion

Neo-Babylonian (ca. 800-650 B.C.). Banded agate, h. 30 mm, d. 9-11 mm. Cylinder No. 749.

This cylinder of the eighth to seventh century B.C. shows a centaur with bow and arrow aiming at a fleeing lion. The centaur probably represents the constellation we know by its Latin name, Sagittarius. With modifications this image was handed down to the Greeks, in turn to the Romans, and on to the present day. Images of constellations may have been produced earlier in Syria. The representation of a nude bearded hero with two stars over his shoulder in another seal in the Library's collection might be interpreted as the equivalent of the constellation we know as Aquarius.

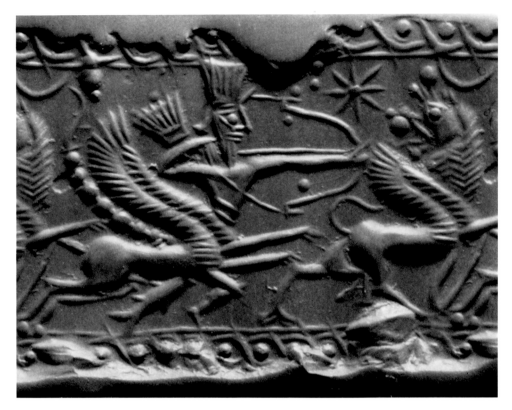

12 A centaur and a lion

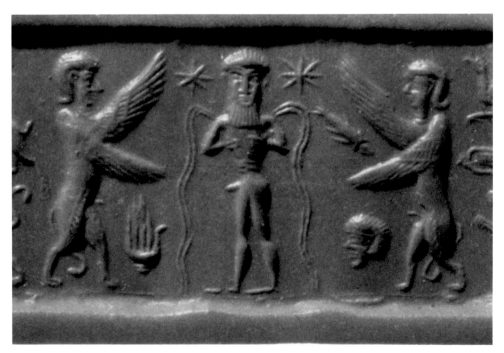

A nude bearded hero from a seal similar to 12

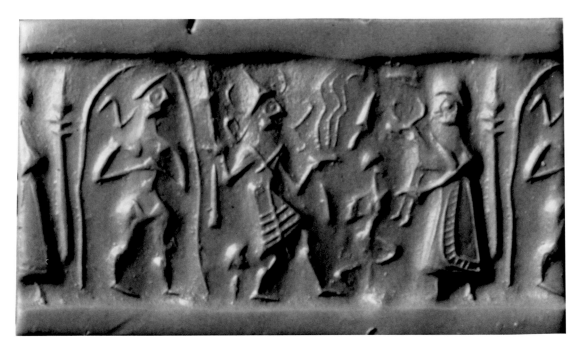

15 A nude goddess and weather god being approached by a worshiper

16 🍂

TWO STAMP SEALS FROM NINEVEH (OR NIMRUD)

Nineveh or Nimrud (7th century B.C.). Seal A: brown and white agate, l. 21 mm, w. 15.4 mm. Seal B: blue chalcedony, l. 15.8 mm, w. 9.4 mm (not illustrated). Gift of Mrs. Paul G. Pennoyer.

Shown here is one of two seals "presented to Mr. Kellogg by A. H. Layard, Esq." according to the note which accompanied them. That would have been either between 1845 and 1847 when Sir Austen Henry Layard excavated at Nimrud Kalah, which he originally took to be Nineveh, or between 1849 and 1850, when he actually did excavate the ruins of Nineveh at the modern site of Kuyunjik.

Both seal stones are octagonal with a slightly convex base; they originally would have been pyramidal with a slightly rounded top, the common shape for Neo-Assyrian and Neo-Babylonian stamp seals. Both stones, however, were chipped down almost to the size of ring stones. This may have been done after the Assyro-Babylonian period. The carving on the base of the agate seal seen here was done with much use of a mechanical drill. A worshiper is shown before the symbols of the gods Marduk and Nabu on a platform which rests on the back of a recumbent snake dragon. There is a moon crescent in the sky. The carving on the base of the chalcedony seal is delicately modeled. There the worshiper, in Babylonian dress, appears before the symbols of Marduk and Nabu on an altar.

16 Stamp seal A

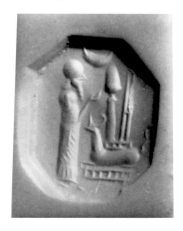

Inscribed Lapis Disk

Akkade Dynasty (ca. 2070 B.C.). Lapis lazuli, 26 mm diam., h. 8 mm, inner diam. 25.2 mm, string hole 4 mm. Promised gift of Mr. and Mrs. Jonathan P. Rosen, 1991.

The lapis lazuli disk with relief carving on both sides is an object that has been tentatively located as coming from the southeastern part of Iran. In antiquity lapis lazuli was very valuable because of its blue color and supposed magic qualities. Lapis lazuli mines are located in the mountains of northeast Afghanistan, ancient Bactria.

Written in cuneiform signs on one side of the disk is the name Rimush. He was the second king of the Akkade Dynasty which established the first historically known empire in Asia. Rimush reigned from about 2278 to 2270 B.C. and doubtless acquired the disk in the course of his recorded military campaign in Iran. The style of the engraving is about two hundred years older than the date of Rimush. The same patina covers the entire disk indicating that the inscription is ancient, not modern.

On the side of the disk bearing the inscription is a seated figure in the style of Mesopotamian reliefs of about 2450 B.C. The figure probably represents a king because only figures of major importance, such as rulers, were represented seated. On the other side is a man-headed eagle grasping two horned animals, probably a symbolic representation of victory. This is a recent acquisition, the promised gift of Mr. and Mrs. Jonathan P. Rosen for the opening of the Library's new building in 1991.

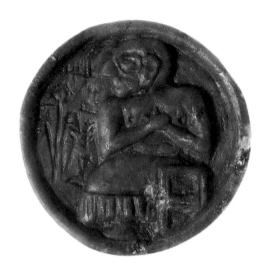

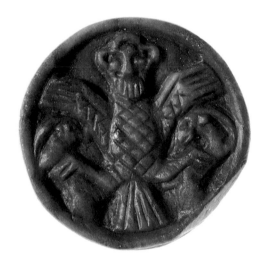

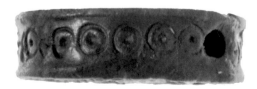

Two Clay Tablets

Texts on clay tablets are an invaluable source of information on the economic and political institutions as well as beliefs and practices of the Mesopotamian people. The Library's collection includes portions of the myth of Adapa, a wise man who failed to gain immortality when he refused to eat the bread of life, and of the shepherd king Etana. The collection also includes the second tablet of the "Deluge Story," which corresponds to a second chapter and prefigures the Noah motif. In addition, there is "An Exorcists Almanach," the name given by modern scholars to a collection of texts to be followed by the exorcist throughout

the year. The Almanach also provided astronomical data for each specified day. Another tablet contains a "Ritual for an Eclipse of the Moon" and shows that the eclipse was considered the "death" of the moon, nature, and man. It details the ritual necessary to ensure revivification.

Commerce was an extremely important part of Mesopotamian life. An "Old Babylonian Mathematical Table" of reciprocals of the number 60, which is shown here, and an "Old Babylonian Multiplication Table" were probably similar to aids that accountants have used throughout history. After about 1800 B.C. most commercial deals had to be recorded and sealed before witnesses, thus a "Sealed Tablet with a Record of Sale of a Field" is one of the thousands of documents which modern scholars have used to attempt to reconstruct the economy of the end of the Old Babylonian period. Other relics of the carefully regulated economic system are a "Promissory Note" and a "Receipt for Interest." Marriage and inheritance were regulated with similar precision as is shown opposite by a "Marriage Contract" from Hana in the Middle Euphrates region.

The Babylonians believed that some deities, on the proper form of request, were willing to communicate with mortal priests through the medium of the body of a specially slaughtered animal. Future events could be discerned in the designs of the livers of sheep and these are discussed in "A List Of Liver Omens" of about 214 B.C.

18 Two sides of mathematical tablet

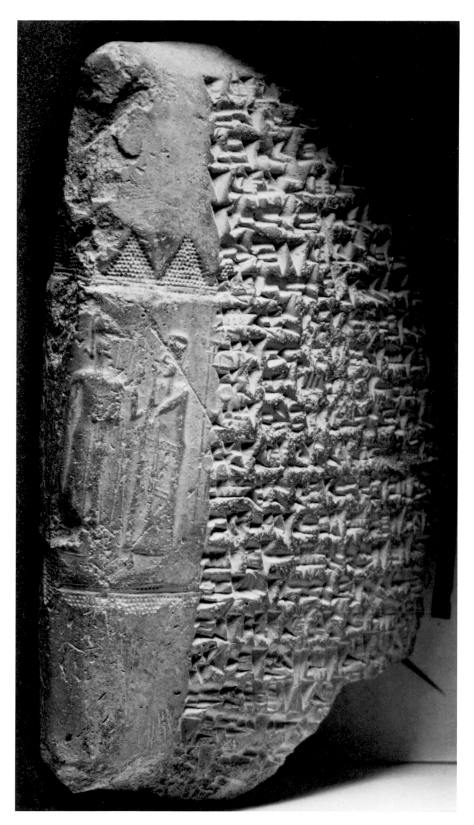

18 Marriage contract from Hana

III · MEDIEVAL AND RENAISSANCE MANUSCRIPTS

W HEN PIERPONT MORGAN acquired his first medieval manuscripts in the last year of the last century, he laid the foundation for a collection that would contribute substantially to their study and appreciation. It became the finest private collection of manuscripts in the world, numbering about six hundred volumes at the time of his death in 1913. It was inherited by his son, J. P. Morgan, who had added about two hundred manuscripts by 1937, when the eminent bibliographer Seymour de Ricci described the collection as the "most extensive and beautifully selected series of manuscripts existing on the American continent, and . . . superior in general quality to all but three or four of the greatest national libraries of the Old World." About the same time Charles Rufus Morey, the noted scholar of medieval illumination, observed that "there is scarcely a phase of the art...which can be fully illustrated and understood at present without reference to the Morgan manuscripts. The importance of this collection lies not only in its extent, but in the first-rate quality of its specimens." Now, with nearly 1,250 manuscripts, not counting its important Egyptian, Greek, and Coptic papyri, the Library is even richer and more extensive than when de Ricci and Morey wrote over fifty years ago. Written by hand and often sumptuously painted or illuminated, manuscripts are our best surviving link with the religious, intellectual, and artistic life of Europe before and for some time after the development of printing. For a period of more than a thousand years they served as the principal carriers of the ideas and images that were essential to the development of Western civilization. Only a small number can be introduced here, and their selection has been limited to the especially fine and more elaborately illuminated ones. Often commissioned by leaders of church and state, these works were frequently made of rare and precious materials and required the combined skills of parchment maker, scribe, editor, illuminator, and binder, sometimes taking many years to complete.

But it should be kept in mind that the collection also includes many significant unilluminated manuscripts. Most of ancient literature has survived only through medieval copies, as is the case with Pliny's *Natural History*. The Library's copy of this famous encyclopedia was written at Lorsch, near Worms, about 830 or 840, and is one of the earliest known copies of the text. Equally important are the many examples of early vernacular literature, such as Chaucer's *Canterbury Tales* and Dante's *Divine Comedy*, to mention only two of the best known texts. While primarily made up of Western manuscripts, the collection also has significant examples of Armenian, Syriac, Coptic, Ethiopian, Arabic, Persian, Turkish, and Sanskrit manuscripts, as well as a large number of Indian miniatures.

Of all the tangible artistic expressions of this age—sculpture, architecture, metal work, enamels, ivories, panel paintings, and tapestries—the illuminated manuscripts are the most numerous and usually the best preserved. Closed up and protected by sturdy bindings, many manuscripts have been spared the damaging effects of exposure to light and air and the altering hands of restorers. Often their intricate decorations and exquisite miniatures, painted in vivid colors and brightened by burnished gold, appear little

Nativity in an initial *P* [20]

3 🍃

St. Luke

Gospels. M.728, f.94v (303 x 258 mm).
France, Reims, ca. 860. Purchased, 1927.

The most distinctive and perhaps the most in-
fluential of all the Carolingian schools of paint-
ing was that of Reims, which produced the
Utrecht Psalter (Utrecht, University Library,
Script. eccl. 484), one of the most famous of all
medieval manuscripts. These schools—others
were at Aachen, Metz, Corbie, Tours, and St.
Gall—flourished from the late eighth to the
middle of the tenth century during the reigns of
Charlemagne and his successors. This copy of
the four Gospels, one of the most important
productions of the Reims school, is the only
one written in gold, and is, in terms of illumina-
tion, the finest of the dozen Carolingian manu-
scripts in the Morgan Library. It was probably
made about 860 at the Abbey of St. Remi in
Reims itself, which was then under the brilliant
political and cultural leadership of Archbishop
Hincmar (845-82), counselor of Charles the
Bald. The manuscript remained at the abbey
until the end of the eighteenth century.

As is usual in Gospel Books with miniatures,
each of the four Gospels is preceded by a por-
trait of the appropriate evangelist. Such author
portraits were derived from models found in
the ancient Latin classics. Indeed, at Reims and
other monastic schools, which were important
centers of learning, classical traditions were
revived and conserved. Thus it is not surprising
to see Luke wearing a Roman toga and to find,
in the basket, numerous scrolls, the standard
book form in antiquity. Luke, of course, is not
an actual portrait, but he can be identified by
his symbol, the ox, and by the text that follows.

4 🍃

Vision of the Heavenly Jerusalem

Maius. Beatus of Liébana, *Commentary on the
Apocalypse.* M.644, f.222v (385 x 200 mm).
Spain, province of León, probably San Sal-
vador de Tábara, middle of the tenth century.
Purchased, 1919.

The Apocalypse, or Book of Revelation, is not
only the last Book of the New Testament but is
also the most difficult, puzzling, and terrifying.
According to the text, it was written on the
island of Patmos by a man named John, who,
from the second century, was traditionally

identified with the "beloved" apostle of Christ
and the author of the fourth Gospel.

Beatus was a monk at the Liébanese monas-
tery San Martín de Turieno in northern Spain.
He completed his twelve-book *Commentary
on the Apocalypse* about 776. The long cycles
of pictures accompanying this commentary, of
which about twenty illustrated copies survive,
constitute the greatest achievement of medieval
Spanish illumination. The present manuscript
is the earliest substantially complete copy, dat-
ing about 950. The colophon states that it was
written and illuminated by an artist-scribe
named Maius at the request of Abbot Victor
for a monastery of St. Michael. This is probably
the monastery at Escalada, consecrated in 913.
Maius, however, apparently worked in the
scriptorium of San Salvador de Tábara, where
he died in 968 and was buried. Although he
based his copy on a now lost model, Maius also
made important contributions of his own, such
as the prefatory evangelists' portraits, genea-
logical tables, and especially the frames and
colored backgrounds. He was regarded by his
student as "archipictor," master painter. The
manuscript contains 110 miniatures, including
some illustrating Jerome's *Commentary on
Daniel,* a second text frequently attached to
the Beatus commentary. This text can also be
found in the Library's later Beatus, dated 1220.

Following the ominous and threatening de-
pictions of the end of the world comes this
representation of the Heavenly Jerusalem as a
medieval city, complete with turrets and crene-
lations. In its twelve gates, topped by horseshoe
arches derived from Islamic architecture, apos-
tles stand beneath disks representing the gems
that are cited in the biblical text. Within the
walls of the city itself are the Lamb of God, the
author John holding a book, and the angel
measuring the city with a golden reed.

5 🍃

St. Mark

Gospel Lectionary. M.639, f.218 (332 x 255
mm). Constantinople, end of the eleventh
century. Purchased, 1919.

This Lectionary, which contains the Gospel
readings for the Mass arranged according to
the liturgical year, contains the finest illumina-
tion of the dozen or so Byzantine manuscripts
in the Morgan Library. Five large miniatures
act as highly finished headpieces, marking the

5 St. Mark

7　Circumcision, Presentation, and Christ among the Doctors

illustrations from the life of Christ. The minia-
ture here, which includes three of the seven
episodes preceding the Gospel of Luke, depicts
the Circumcision (where the Christ Child re-
treats in fear from the circumcising knife), the
Presentation of Christ in the Temple, and Mary
and Joseph's finding Christ among the Doctors.

Although the Canon Tables, the portrait of
Matthew, and a few of the larger initials were
completed, all the scenes from the life of Christ
remain in the unfinished state illustrated here.
The miniatures were first drawn in brown ink;

gold was applied to halos, hems, and architec-
tural elements, which were then outlined with
red. The final application of color, for reasons
unknown, was not carried out. In spite of its
incomplete state, the quality of the drawings
alone would rank these Gospels among the
masterpieces of Italian Romanesque art. In-
fluenced by Ottonian illumination in Germany,
the style of Mathilda's Gospels, with its ani-
mated figures and their flowing drapery, marks
a break with Byzantium's hold on Italian art.

ST. JOHN

Gospels of Judith of Flanders. M.709, f.122v (293 x 191 mm). England, 1051-64. Purchased, 1926.

This and another luxury Gospels in the Morgan Library (M.708), as well as two others, were made for Judith of Flanders between 1051 and 1064, when she was in England. The daughter of Count Baldwin of Flanders, she was married about 1051 to Tostig, the son of Earl Godwin and brother of King Harold of England. These books, among the finest surviving Anglo-Saxon manuscripts, exhibit the essentially linear drawing style that ultimately derived from the famous Utrecht Psalter (see III, 3). It is difficult to know exactly where the books were made, especially since their scribes and artists may have traveled as part of Judith's entourage. There is no doubt, however, that she owned the two Morgan Gospels, for in 1094 she bequeathed them to Weingarten Abbey, the ancestral monastery of her second husband, Duke Welf IV of Bavaria, and her burial place. (Judith's son, Welf, at age seventeen, married one of the most distinguished and powerful of her female contemporaries, Countess Mathilda of Tuscany; see III, 7.) The Gospels remained at Weingarten Abbey until 1805, and their influence can be seen on a number of manuscripts produced there in the twelfth and early thirteenth centuries, such as the Berthold Sacramentary (III, 13), the masterpiece of Weingarten illumination.

Shown here is the portrait of John, who is writing the first words of his Gospel in gold, "In principio erat verbum" (In the beginning was the word). In his hands he holds a pen and knife, the latter to sharpen his quill and to scrape away errors. In addition to the expected portraits of the three other evangelists, there is a full-page Crucifixion at the beginning of the book. A small figure kneeling at the foot of the cross and embracing it has been identified as Judith herself.

8 St. John

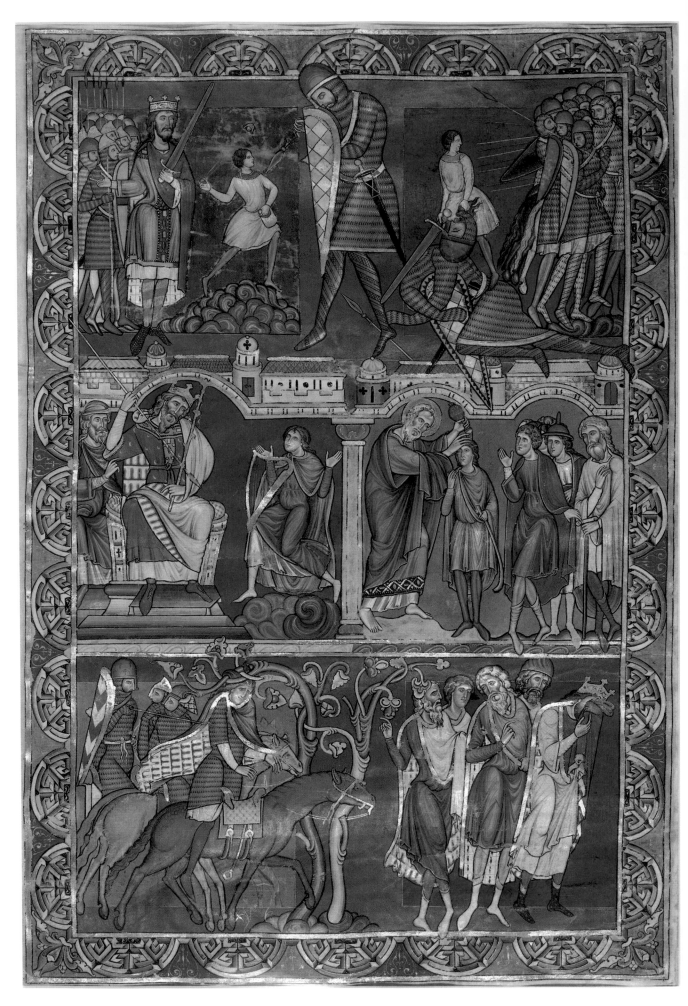

11 Scenes from the Life of David

artist is named after the St. Alexis cycle he painted in the famous St. Albans Psalter, now in Hildesheim. He skillfully combined Anglo-Saxon, Ottonian, and Byzantine influences to paint, often in long narrative cycles, in what can be called England's earliest Romanesque style. The St. Albans Psalter cycle differs somewhat in color and modeling from the Morgan miniatures, and it has been suggested that the Morgan miniatures were drawn by the Alexis Master but painted by an assistant.

In the miniature eight thieves attempt to break into St. Edmund's burial place, a Romanesque church with round arches. While the thieves were busy at work, a marvelous miracle occurred: through the posthumous intervention of St. Edmund, they were suddenly paralyzed until the following morning so they were all caught red-handed. Arrested and brought before Bishop Theodred, all eight thieves were ordered hanged from a single pole.

11 &

SCENES FROM THE LIFE OF DAVID

Master of the Morgan Leaf. Single leaf from a Bible. M.619, verso (580 x 390 mm). England, Winchester, Cathedral Priory of St. Swithin, ca. 1160-80. Purchased, 1912.

This large glorious leaf was probably created for the Winchester Bible, the most ambitious and finest of all English Romanesque Bibles. This giant Bible, originally in two volumes but now in four, was begun around 1155-60. Its elaborate historiated initials, which introduce the Prologues and Books of the Bible, were the work of at least five artists who labored for more than twenty years. Even so, as indicated by many unfinished initials and blank spaces, the illumination was never completed. At some point after production was under way, a number of full-page frontispieces for individual books was added; two of them, for the books of Judith and Maccabees, survive as unpainted drawings in the manuscript.

The present leaf, the frontispiece to 1 Samuel, is painted, and, if ever inserted in the manuscript, was subsequently removed. Beginning on the other side of the leaf, scenes from the life of David continue here with (top) Saul watching David slay Goliath, (middle) Saul hurling a spear at David and Samuel anointing David, and (bottom) Joab killing Absalom caught in the tree and David mourning the death of his son.

Called one of the finest English paintings of the twelfth century, this leaf is the work of an artist nicknamed the Master of the Morgan Leaf. He was one of the principal artists of the Winchester Bible, working in the period of around 1170-85. On this leaf he painted over drawings by another artist, the so-called Master of the Apocrypha Drawings, a painter whose work dates to an earlier campaign, around 1155-60, and who was also responsible for drawing the two other frontispieces. The Morgan Leaf Master respected his predecessor's drawings on the recto of the leaf, but here, on its verso, he reveals his own distinct style that, especially in its interpretation of drapery, has a softness and fluidity that anticipate the Gothic art of the next century. Nowhere else in the Bible does the power and beauty of his art reach this height. Also attributed to this painter are the magnificent but largely destroyed frescoes from the chapter house of the nunnery at Sigena in Spain; they are now in Barcelona.

12 &

FLIGHT INTO EGYPT

Miniatures of the Life of Christ. M.44, f.3 (340 x 222 mm). France, ca. 1200. Purchased, 1902.

This manuscript contains a series of thirty large and impressive pictures, but no text. In all probability the illustrations were originally part of a Psalter, for often such manuscripts, used as prayer books by the laity as well as the ordained, had elaborate picture cycles preceding their texts. This series illustrates the life of Christ from the Annunciation to Pentecost, and concludes with a Last Judgment, Christ as Judge, and the Coronation of the Virgin. Here we see the Holy Family fleeing after Herod commanded the slaughter of all children up to two years of age. A worried attendant hurries the ass with a whip while an angel swinging a censer offers guidance.

The deep glowing colors of the miniatures recall those of stained glass and have led some scholars to compare them to the early windows (ca. 1150-60) of Chartres Cathedral. The classicistic drapery, however, has been compared by others to the early thirteenth-century sculpture of that same church. Still others have noted the similarity of the miniatures and their borders to painted and relief enamels produced at the same time in Limoges; and, indeed, the manuscript has been said to come from the Collegiate Abbey of St. Martial at Limoges. What-

ever their origin and source, these miniatures fall into that fascinating period of transition from Romanesque to Gothic. They have a warmth and charm that is rare in religious art of the Middle Ages.

13 &

ADORATION OF THE MAGI

Master of the Berthold Sacramentary. Berthold Sacramentary. M.710, f.19v (293 x 204 mm). Germany, Weingarten Abbey, 1200-32. Purchased, 1926.

The Berthold Sacramentary, named after the abbot of Weingarten who commissioned it between 1200 and 1232, is without question the masterpiece of the Weingarten school of painting. A major monument of Romanesque art, it is possibly the finest and most luxurious thirteenth-century manuscript produced in Germany. Indeed, it occupies a position comparable to that of the twelfth-century Gospels of Henry the Lion (Herzog August Bibliothek, Wolfenbüttel), the masterpiece of the Helmarshausen school, another important monastic center. Unlike the latter, however, the Morgan manuscript still has its original jeweled binding (see VI, 4), which includes depictions of the abbot and the patron saints of Weingarten. Although the codex was formerly known as the Berthold Missal, it is in fact a Sacramentary. Unlike the Missal (which has all of the texts recited at Mass), the Sacramentary contains only those for the celebrant of high Mass.

Most of the Sacramentary's twenty-one full-page miniatures are by an exceptionally forceful and expressive artist who has been named the Master of the Berthold Sacramentary, after this book. Although some antecedents have been suggested for his Adoration of the Magi, the miniature transcends them in every way. At the top the Magi, guided by the star, arrive; the

12 Flight into Egypt

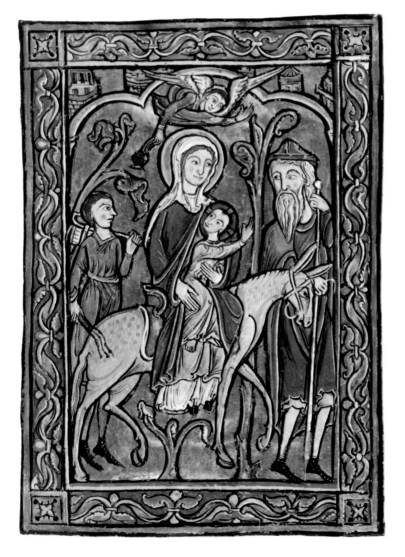

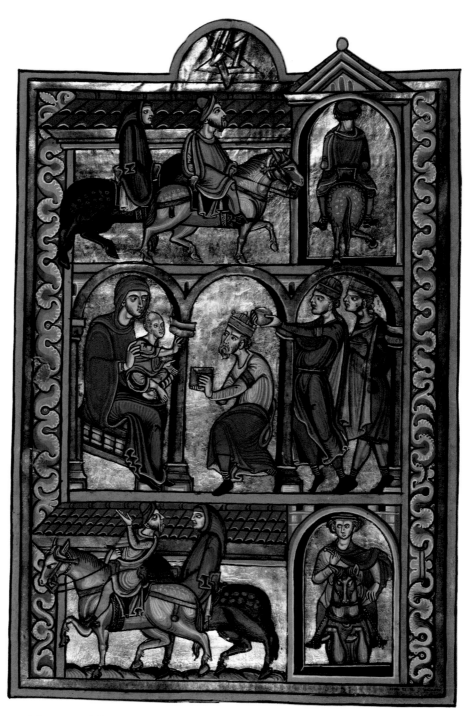

13 Adoration of the Magi

first king is seen turning to ride into the gold
background. In the middle the Magi present
their gifts to Christ, while at the bottom they
emerge from the gold background and discuss
what they have seen. Although the makers of
the Berthold Sacramentary, in both miniatures
and binding, were influenced by the manu-
scripts in the treasury at Weingarten, such as
the two Gospels of Judith of Flanders (see III,
8), they clearly succeeded in creating a monu-
ment for Berthold that surpassed them all.

14 ঌ

CORONATION OF DAVID

Hachette Psalter. G.25, f.4 (225 x 157 mm).
England, perhaps London, ca. 1225.
William S. Glazier Collection; deposited in
1963, given in 1984.

The decorative program in this majestic Psalter
consists of six large pictures that form an im-
pressive pictorial prelude to the whole volume,

a full-page initial *B* introducing Psalm 1, and a series of ornamental and historiated initials marking the liturgical divisions for the psalms. Unlike the customary narrative cycle illustrating the life of Christ (like III, 12), the six pictures are arranged as three diptychs, each devoted to the Virgin, Christ, and King David. In each pair the figure is shown on the left in a scene of humility (the Annunciation, Crucifixion, and David threatened by Saul) and, on the right, of glory (the Virgin and Child Enthroned, Christ in Majesty, and the Coronation of David). Reproduced here is the Coronation of David, as the scroll held by the two angels informs us. Because the two figures crowning David are represented as bishops in contemporaneous ecclesiastic costume, the miniature has been thought by some to reflect a specific coronation or to relate to a historical controversy over the ecclesiastical power of the king.

The style of the attenuated and somewhat angular figures, with their deep drapery folds outlined in black, is characteristic of the early

Gothic in England. It can be compared with the earlier English Romanesque style of the Morgan leaf with scenes from the life of David (III, 11) and with that of the Gothic Apocalypse, executed about a generation later (III, 17).

15 &

Blanche of Castile and
King Louis IX of France and
Author Dictating to a Scribe

Moralized Bible. M.240, f.8 (375 x 262 mm). France, probably Paris, ca. 1230. Purchased, 1906.

The present manuscript, containing only eight leaves, was originally the final portion of a monumental three-volume Moralized Bible, today in the library of Toledo Cathedral in Spain. Developed in the early thirteenth century during the reign of Philip Augustus of

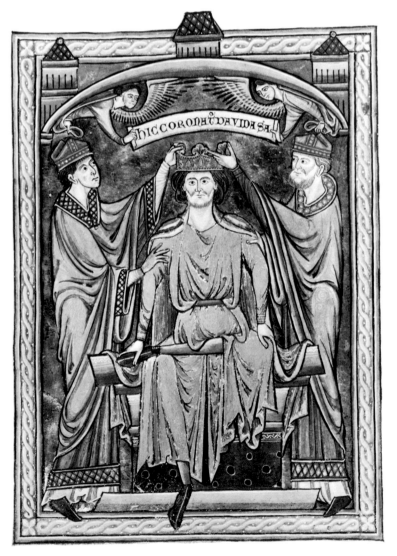

14 Coronation of David

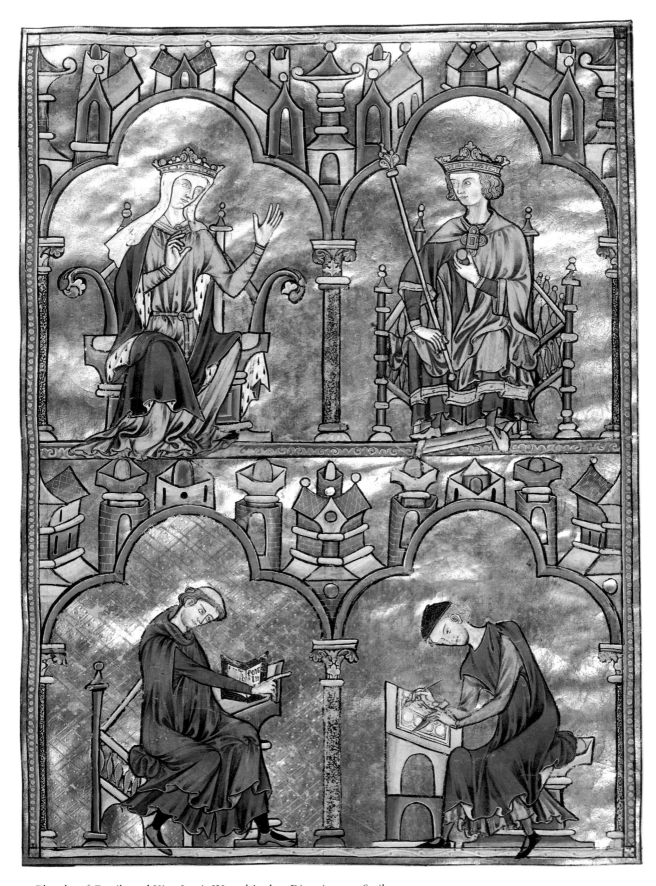

15 Blanche of Castile and King Louis IX *and* Author Dictating to a Scribe

France, the Moralized Bible illustrates the biblical text in great detail, each picture and its biblical passage being accompanied by a second, interpretive or moralizing scene with its textual commentary. For the Toledo volumes with the Morgan fragment, the result is a grand total of some five thousand pictures arranged in medallions.

This large full-page miniature, which occurs at the end of the manuscript, functions as a pictorial colophon for the volumes. At the top are Blanche of Castile (Philip's daughter-in-law) and her son, King Louis IX of France, later canonized as St. Louis. Below her is an ecclesiastic, the editor or "iconographer" of the enterprise who selected the texts and moralizations for this copy and directed the artists. He dictates to a scribe who busily writes in the narrow columns allotted for the text. The leaf on which the scribe works shows the layout of a typical page in the book, consisting of two columns of medallions resembling stained glass and accompanied by narrow columns of text. The picture not only offers portraits of its editor and scribe but also suggests that Blanche, as patron, commissioned the book for her son.

Since Louis ascended the throne of France in 1226 at the tender age of eleven and Blanche was regent until 1234, the manuscript has been dated to the early years of Louis's reign. The queen regent is shown raising her hands toward her son, depicted as a young man, in gestures of instruction and admonition. These edifying gestures parallel those of the author below her. The instructional motif that infuses both registers of the miniature is appropriate for the didactic function of the Moralized Bible. The book would have offered many hours of instruction to the young ruler.

16 🎔

Scenes from the Life of Saul

Old Testament Miniatures. M.638, f.23v
(390 x 300 mm). France, Paris, 1240s.
Purchased, 1916.

This magnificent leaf shows Saul destroying Nahash and the Ammonites and, below, Saul anointed by Samuel and the sacrifice of peace offerings. It is but one of eighty-six full-page miniatures in the manuscript. In all, nearly three hundred episodes from the Old Testament, from the Creation to the story of David, are represented. The miniatures, among the finest of all thirteenth-century French painting,

are unrivaled in their inventiveness, dramatic narrative, and attention to expressive and realistic detail. The vigorous figures are beautifully drawn, as are the keenly observed costumes, armor, and animals, and the vivid battle scenes are among the finest from the Middle Ages. Although the miniatures may have been planned as part of a luxurious Psalter, it seems more likely that they were made as a lavish Picture Bible.

The manuscript was probably created for Louis IX of France during the 1240s, the same decade in which he was constructing Sainte-Chapelle as a royal preserve for the recently acquired relics of Christ's Passion. The six or seven artists employed in the manuscript may have been mural painters, for the monumentality and breadth of expression of these miniatures—especially the grand battle scenes—relate more to large-scale painting than to manuscript illumination. Scholars have even attributed some murals and stained-glass designs in Sainte-Chapelle to painters of this manuscript.

As a work closely associated with Louis IX, the manuscript can be seen in the context of his ardent crusading interests. The picture cycle emphasizes the battles fought by the Hebrews for the Holy Land, but shows the armies as composed of French knights and infantry. Pictorially, a parallel is suggested between the Hebrews' conquest of the Holy Land and French attempts at its reconquest.

No less extraordinary than the quality of the pictures is the history of the manuscript. It is conjectured that around 1300 the book was taken from Paris to Naples, where the Latin descriptions of the scenes were added. By the early seventeenth century the book, having come north, was in the possession of Cardinal Bernard Maciejowski, bishop of Cracow, duke of Siewierz, and senator of the kingdom of Poland. By 1608, however, the volume was in Persia, having been brought to Isfahan as Maciejowski's gift to the monarch, Shah Abbas the Great, on a mission dispatched by Pope Clement VIII. (The purpose of the mission was to foster the shah's toleration of Christians and to devise military action against the Turks.) The shah had Persian descriptions of the pictures written into the margins. Later in the century, Judeo-Persian transliterations of these descriptions were also added to most leaves. Over two centuries later the book became the property of the noted antiquarian Sir Thomas Phillipps. It was regarded as one of the greatest manuscripts in his collection of some sixty thousand books and manuscripts. Finally, at

16 Scenes from the Life of Saul

the great urging of Belle da Costa Greene, it was purchased in 1916 from Phillipps's heirs by J. P. Morgan.

17 &

WOMAN CLOTHED WITH THE SUN and ST. MICHAEL BATTLING THE DRAGON

Apocalypse Picture Book. M.524, f.8v (271 x 195 mm). England, London, probably Westminster Abbey, ca. 1255-60. Purchased, 1908.

In the late twelfth century the monk Joachim of Fiore predicted that the world would end in 1260. The circulation of his and similar proph-ecies, as well as the perception of Emperor Frederick II (1194-1250) as the anti-Christ and the threat of the Tartars in eastern Europe, produced an atmosphere that encouraged be-liefs in an approaching final destruction. In this environment, around the middle of the thir-teenth century, a new and consequential cycle of Apocalypse illustration was invented in En-gland. Regarded as that country's most impor-tant pictorial contribution to the late Middle Ages, the series survives in over seventy exam-ples. It continued to influence Apocalypse illus-tration in the fifteenth century, when the cycle was used in the first block book, and into the sixteenth century.

The Morgan Apocalypse is one of the four earliest examples produced in the 1250s. Three

17 Woman Clothed with the Sun *and* St. Michael Battling the Dragon

18 First Kiss of Lancelot and Guinevere and Senechal Conversing with the Lady of Malohaut and Laura of Carduel

of these contain cycles of tinted drawings and apparently derive from the same prototype, created shortly before 1250. The Morgan manuscript is thought to be the most accurate reflection of this lost model. The manuscript is in the form of a picture book with double scenes filling each page; biblical quotations or commentaries are inserted into blank spaces in the background or on scrolls. Of the Apocalypses with tinted drawings, the Morgan manuscript is, stylistically, among the most refined and courtly. There is a subtlety of facial expression, pose, and gesture, and the pale washes of the tinting are of remarkable delicacy.

Although the details of the prophecy do not fit exactly, the woman clothed with the sun was identified with the Virgin, the child with Christ, and the dragon with Satan. Representations of the Virgin with the moon under her feet, surrounded by golden rays, and wearing a crown of stars—an iconographic type that would become especially popular in Renaissance and baroque painting—are based on this text.

18 ∂∿

FIRST KISS OF LANCELOT AND GUINEVERE AND SENECHAL CONVERSING WITH THE LADY OF MALOHAUT AND LAURA OF CARDUEL

Le Roman de Lancelot du Lac. M.805, f.67 detail (346 x 255 mm, leaf size). Northeastern France, early fourteenth century. Purchased on the Lewis Cass Ledyard Fund, 1938.

Between the years 1275 and 1330 Arthurian manuscripts were at the height of popularity, and many illustrated cycles were produced, mostly in lay workshops outside of Paris. The finest and most important depicting the Lancelot legend is this manuscript, which was made in northeastern France, perhaps at Amiens, in the early fourteenth century. The story of Lancelot, one of the most famous knights of King Arthur's Round Table, became especially important when Chrétien de Troyes (about 1170) transformed him into the chivalric lover of Queen Guinevere, the wife of King Arthur.

The present manuscript, with its 39 large miniatures and 107 historiated initials, is a pictorial encyclopedia of medieval chivalry. Not only are there tournaments, battles, kidnappings, and journeys, but also elegant and quieter scenes of banquets and chess playing. The book's best known miniature shows the first kiss of Lancelot and Guinevere, who are accompanied, if not encouraged, by Galehot, the arranger of the meeting. The first kiss was immortalized in Dante's *Divine Comedy* (*Inferno*, Canto V, 127-38), where Francesca da Rimini tells Dante how Paolo, her adulterous lover, was so moved during their reading of the episode that he was compelled to kiss her. They read no more that day, a fact lamented by Dante; otherwise they would have learned of the tragic end of Lancelot and Guinevere and perhaps their own unfortunate demise might have been avoided. (Dante consequently called *Lancelot du Lac* and he who wrote it a *galeotto*, a pimp.)

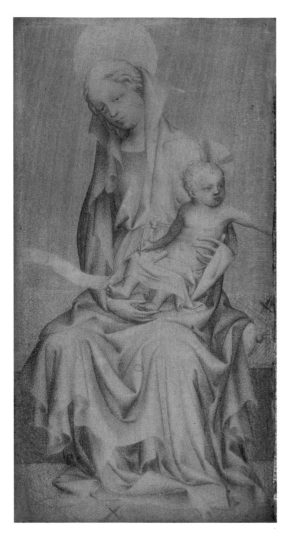

21 Virgin with the Writing Christ Child

ings in the sketchbook have led to their attribution to Jacquemart de Hesdin, who was active from 1384 to 1413 and who worked for Jean, duc de Berry, the uncle of Charles VI. The Virgin and Child drawing is certainly similar to a miniature of the same subject—including the rare motif of the writing Christ—in the duc de Berry's *Très Belles Heures* of the late fourteenth century (Brussels, Bibliothèque Royale, Mss. 11060-61). But while documents connect that Book of Hours with Jacquemart, its miniature of the Madonna, which is dated about 1385, was inserted into the slightly later manuscript and is not by him. Certain drawings in the sketchbook, on the other hand, resemble the work of André Beauneveu, a sculptor active in the second half of the fourteenth century and employed by the duc de Berry as an illuminator. Precise attributions are made difficult by the fact that more than one hand was involved; also ultraviolet light reveals that some sketches were erased and others were added on top at slightly later dates.

22 &

Making Snares and Feeding Dogs

Gaston Phébus, *Livre de la chasse.* M.1044, f.45 (385 x 287 mm). France, Paris, ca. 1410. Bequest of Miss Clara S. Peck, 1983.

Gaston III (1331-91), count of Foix-Béarn, nicknamed Phébus because of his golden hair or handsome appearance, wrote his famous *Book of the Chase,* the most popular and influential medieval treatise on hunting, between 1387 and 1389. The text is divided into four books: 1) On gentle and wild beasts, 2) On the nature of dogs and their care, 3) On the instruction of hunters and hunting with dogs, 4) On hunting with traps, snares, and cross-bow. The unusual emphasis on dogs is striking; it is a subject on which Phébus was expert, for he, according to the famous chronicler Jean Froissart, bred various kinds of hunting dogs and kept kennels for at least 1,600 hounds. The miniature reproduced here (from Book 2) depicts different types of rope snares, but it also includes two men feeding dogs, though they are not mentioned in the accompanying text. The eighty-seven miniatures of this manuscript unfold, like a series of tapestries, to show us the appearances and habits of the numerous animals, the variety of apparatus and maneuvers involved in the hunt, and the costumes of both the aristocratic hunters and their servants.

fifteenth-century sketchbook executed by the Flemish artist Jacques Daliwe (Berlin, Deutsche Staatsbibliothek, A 74). The Morgan sketchbook consists of six panels: four thin "leaves" and two thicker covers. It contains the Virgin and Child illustrated here, a jousting scene, courtly figures, numerous heads (of which two have been tentatively identified as Charles VI of France and his wife, Isabeau of Bavaria), and some half-length figures, some of which are thought to depict the "wild men" costumes worn by courtiers at a celebrated masked ball in 1393. Another drawing of a Virgin and Child on a single piece of boxwood, also in the Morgan Library, has recently been identified as also coming from the sketchbook.

The delicacy and high quality of the Virgin with the Writing Christ Child and other draw-

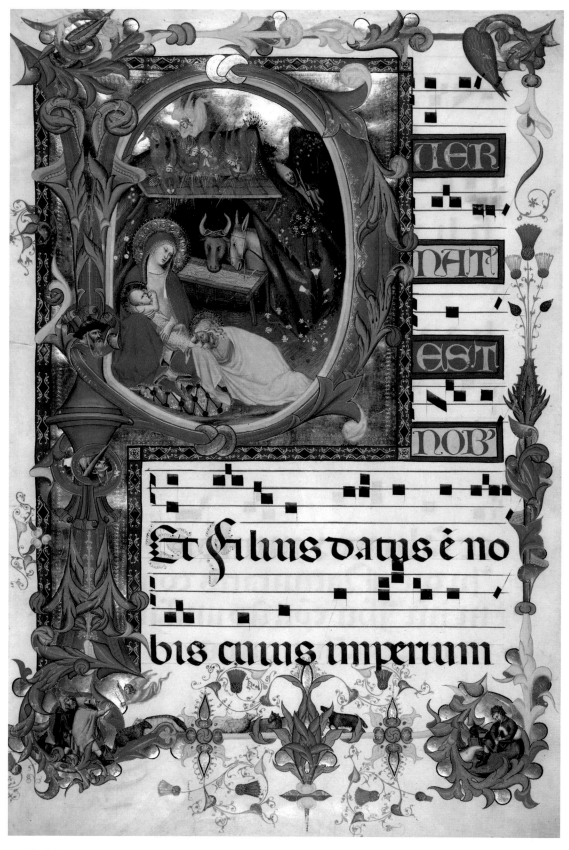

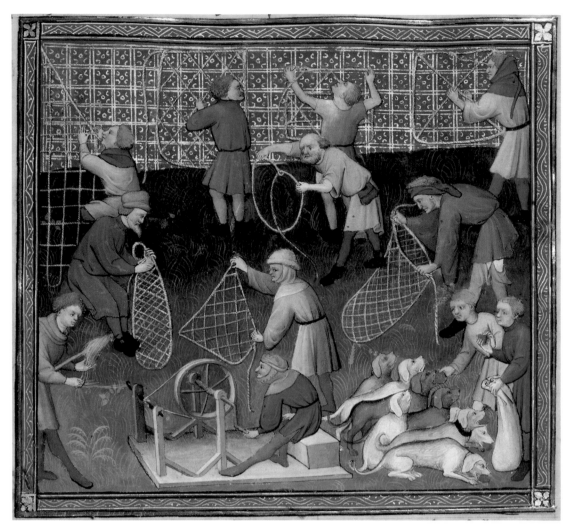

22 Making Snares and Feeding Dogs

The *Livre de la chasse* survives in forty-six manuscripts of which four, including this one, are the oldest and textually the most reliable. Another of the four, a manuscript in the Bibliothèque Nationale in Paris (fr. 616), is a sister manuscript and contains the same number of miniatures (87). Both were painted in the same workshop within a few years of each other and together are regarded as the most beautiful copies of the work.

The manuscript contains the arms of Brittany and may have been made for John the Good, duke of Brittany from 1399 to 1442. It was subsequently owned by Ferdinand and Isabella of Spain, who had a lavish full-page miniature of their coat-of-arms added at the beginning of the book.

23 🐚

St. Luke Painting the Virgin

Michelino da Besozzo. Prayer Book. M.944, f.75v (170 x 120 mm). Italy, Milan, ca. 1420. Purchased with the generous assistance of Miss Alice Tully in memory of Dr. Edward Graeffe, 1970.

Between the covers of this small prayer book are most of the surviving paintings by Michelino Molinari da Besozzo, a leading Lombard painter of the early fifteenth century. He was highly regarded by his contemporaries, who referred to him as the "supreme painter" and "the most excellent of all the painters in the world." Although Michelino came from nearby

Pavia, he worked most of his life in Milan, where he is mentioned as a master of stained glass and a painter of frescoes in the documents of that city's cathedral between 1398 and 1443. This versatile artist was also an illuminator, a panel painter, and perhaps an architect. He was especially famous for his lifelike renderings of animals. In about 1400 the Milanese humanist and scribe Uberto Decembrio wrote that Michelino made precocious animal studies before he could even speak. Most of Michelino's works, however, no longer survive, and his only signed work, a panel in Siena of the Mystic Marriage of St. Catherine, is the basis of all attributions to him.

Of his few surviving manuscripts, this prayer book is clearly his masterpiece. The twenty-two remaining miniatures betray an assurance and virtuosity that place them among Michelino's mature works, as do the breadth and modeling of the figures. The miniatures and their accompanying prayers are arranged according to the liturgical year, beginning with the Nativity and prayers for Christmas. In the miniature of St. Luke, the evangelist is putting the finishing touches on a small panel of the Virgin and Child. This is one of the earliest Western depictions of St. Luke painting the Virgin, which became especially popular later in the century because Luke was the patron saint of painters and painters' guilds.

23 St. Luke Painting the Virgin

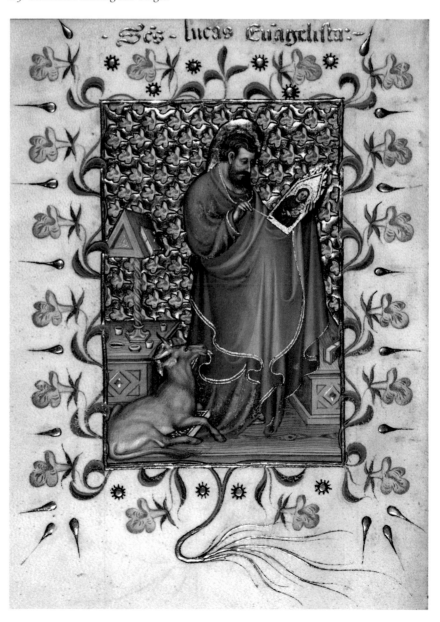

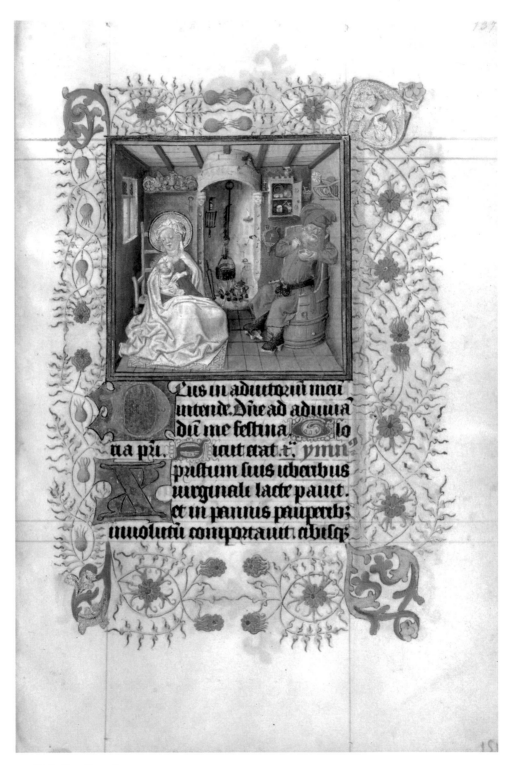

24 Holy Family at Supper

HOLY FAMILY AT SUPPER

Master of Catherine of Cleves. Hours of
Catherine of Cleves. M.917, p.151
(192 x 130 mm). The Netherlands, Utrecht,
ca. 1440. Purchased on the Belle da Costa
Greene Fund and with the assistance of the
Fellows, 1963.

The Master of Catherine of Cleves was, with-
out question, the most gifted and original artist
of the "Golden Age" of Dutch manuscript
painting. This Book of Hours, painted about
1440 for Catherine of Cleves and after which
he is named, is his masterpiece. Because the
thirteen other manuscripts in which he partici-
pated range in date from 1430 to 1460, it is
even possible to follow his stylistic develop-
ment. His early works are draughtsmanlike
and thinly painted, while in his mature phase,
which includes the Cleves Hours, figures and
compositions are more balanced and solidly
painted. In his late works the supple drapery
becomes harder, more angular, and mannered.
The richness of his palette, his extraordinary
powers of observation (in which the most mi-
nute details are captured), the everyday realism
of his biblical scenes, and his complex icon-
ography serve to rank the Cleves Master with
the greatest of all illuminators.

Over a century ago a dealer divided the then
complete manuscript into two parts, each of
which he subsequently sold as complete. Ac-
quired at different times from different sources,
both parts are once again reunited under the
same roof. Their 157 miniatures (a few have
been lost) form numerous cycles, many of
which are not only unusual, but also without
precedent. Their artistic sources are not re-
stricted to earlier Dutch traditions but include
French illumination, Flemish panel painting,
and engravings. The resulting manuscript is
one of the richest of all Books of Hours and is
a key monument in the history of this kind of
manuscript.

Though not a full-page miniature, the repro-
duced Holy Family at Supper is one of the most
intriguing miniatures in the book, for it antici-
pates the genre scenes of the great Golden Age
of Dutch painting by such seventeenth-century
artists as Vermeer. Especially attractive is the
coziness of the little kitchen with its superbly
observed fireplace and the finely painted wisps
of smoke. The Virgin, nursing her Child, sits on
a mat, while Joseph, resting on a chair that he
presumably cut from a barrel, spoons soup.

ST. MATTHEW

Barthélemy van Eyck. Book of Hours. M.358,
f.17 (250 x 180 mm). France, Aix-en-Provence,
ca. 1445. Purchased, 1909.

This St. Matthew and some other miniatures in
this unfinished Book of Hours have recently
been attributed to Barthélemy van Eyck, court
painter and *"varlet de chambre"* to King René
d'Anjou (1409-80). Although his name indi-
cates that he may have come from the same
region as Jan van Eyck, Barthélemy was not a
blood relative of the much more famous Flem-
ish painter. In a way, however, Jan van Eyck
served as Barthélemy's artistic parent, for it is
clear that the latter knew Jan's work and was
indebted to him for aspects of style and, at least
in one case, iconography. Eyckian in this minia-
ture are the minutely observed facial features
of Barthélemy's evangelist and the meticulous
treatment of drapery. The lavish attention Bar-
thélemy bestows on the gilt and painted diaper
background, too, recalls Jan's fascination with
and careful rendering of jewels and metalwork.

Barthélemy was in the service of René d'An-
jou from at least 1447 until his death in 1475/
76. As a high ranking official—and a much
appreciated one—he accompanied René on his
travels from Provence, visiting Naples, Switzer-
land, and Burgundy. As was typical of talented
court artists in the fifteenth century, Barthé-
lemy did not confine his talents to a single
medium. He also painted panels (such as the
famous *Aix Annunciation*, 1443-45, for Pierre
Corpici, René's wealthy cloth merchant), as
well as pictures on cloth, watercolors, cartoons
for murals, and designs for embroidery. Per-
haps the finest of his illuminations is the series
of enchanting, often reproduced, pictures he
painted in the *Coeur d'amour éspris*, a poem
written by René himself (Vienna, Österreich-
ische Nationalbibliothek, Cod. 2597), and after
which the artist was once known as the Master
of the *Coeur d'amour éspris*.

Collaborating with Barthélemy and execut-
ing three miniatures in the Morgan Hours was
the French painter Enguerrand Quarton, best
known for his panel called the *Avignon Pietà*.
Because the manuscript remained unfinished
(on the Matthew page, for example, the figures
in the borders were drawn but never painted),
it provides a fascinating record of illuminators'
working procedures.

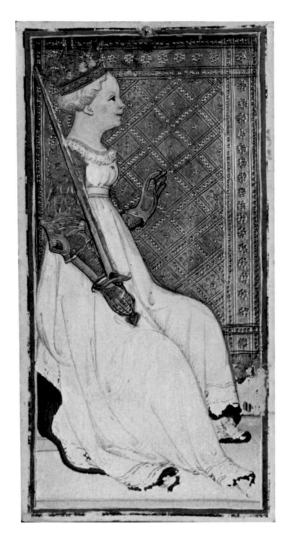

26 Queen of Swords

divided into four fourteen-card suits (cups, staves, coins, and swords). Each suit was made up of ten number cards plus four picture cards (page, knight, queen, and king).

In the Renaissance tarot cards were not the paraphernalia of fortune tellers but were used in a normal card game enjoyed by the nobility. The game, the rules of which have been lost, was invented in northern Italy, probably in Milan or Ferrara, in the second quarter of the fifteenth century. The astrological use of tarot cards derives from scholarly misinformation published by Antoine Court de Gébelin in 1781. He traced their origin to ancient Egypt, identifying them with the Book of Thoth (see III, 1), the scribe of the Egyptian gods.

All three of the earliest decks have been attributed to the Cremonese painter and illuminator Bonifacio Bembo (active 1440-80). More recently, however, the Morgan deck has been given to Francesco Zavattari (active 1417-83), the slightly older illuminator and fresco painter in whose circle Bembo worked. Six cards in a different style, which are apparently replacements, were painted by Antonio Cicognara at the end of the fifteenth century.

This deck may have been made for Bianca Maria Visconti and Francesco Sforza, whose betrothal (1432) and marriage (1441) united the two families. In any case the emblems of both families, intermingled on the cards, reveal that they were made for some member of the Visconti-Sforza family.

27 🫐

ANNUNCIATION

Jean Fouquet. Book of Hours. M.834, f.29 (108 x 80 mm). France, Tours, ca. 1460. Purchased with the assistance of the Fellows, 1950.

The greatest French painter of the fifteenth century was unquestionably Jean Fouquet of Tours. Although he painted important portraits of Charles VII and others, most of his painting is to be found in manuscripts. The most impressive of these was the Book of Hours in Chantilly (Musée Condé) made for Etienne Chevalier (ca. 1410-74), treasurer of France from 1452. Aside from the Chevalier Hours, which was probably executed between 1452 and 1456, the Morgan manuscript and a recently discovered fragment now in the J. Paul Getty Museum (MS 7) are the only other Books

26 🫐

QUEEN OF SWORDS

Bonifacio Bembo or Francesco Zavattari. Visconti-Sforza Tarot Cards. M.630, no. 23 (173 x 87 mm). Italy, Milan, ca. 1450. Purchased, 1911.

Fifteenth-century painted tarot cards of Italian origin are exceedingly rare, and no complete deck has survived. The thirty-five cards in the Morgan Library, twenty-six in the Accademia Carrara in Bergamo, and thirteen owned by the Colleoni family of Bergamo form the most complete and one of the most important sets known. A complete pack consisted of seventy-eight cards: twenty-one trump (tarot) cards, one wild card (the Fool), and fifty-six cards

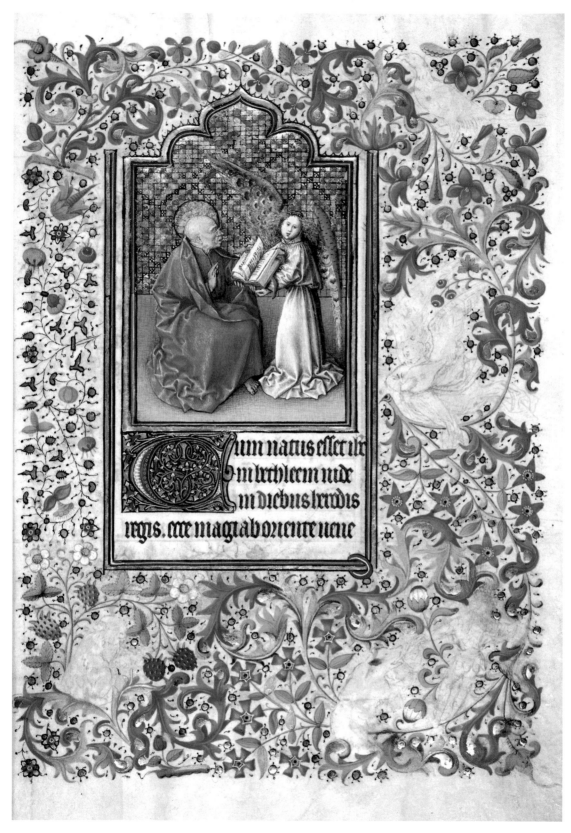

25 St. Matthew

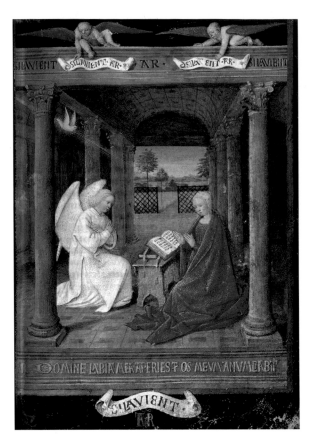

27 Annunciation

surrounding vellum has been painted to suggest a black marble wall.

28 ❧

Frontispiece with St. Jerome, King Corvinus of Hungary, and Queen Beatrice of Aragon

Monte di Giovanni del Fora. Didymus Alexandrinus, *De spiritu sancto,* and other texts. M.496, f.2 (345 x 230 mm). Italy, Florence, dated 1488. Purchased, 1912.

Humanism entered Hungary under the great bibliophilic King Matthias Corvinus (1443?-90). His large library at Buda was thought to have contained several thousand manuscripts, and his goal, as related by his Italian librarian, Bartholomaeus Fontius, was to outshine every other monarch with his collection. To date, alas, only 216 codices, mostly manuscripts, have survived from the Bibliotheca Corviniana. The Morgan Library owns two splendid manuscripts from that library, a humanist copy of the works of Cicero that Corvinus acquired second hand, and this volume, which was made for him and is by far the more important of the two. Dated 4 December 1488, it was written and signed by Sigismundus de Sigismundis in Florence; it was illuminated by Monte di Giovanni del Fora. A total of five surviving codices, all dated 1488, were illuminated by Monte and his brother Gherardo for Corvinus.

The opening text, Jerome's preface to the Didymus text, is embellished by a grand trompe-l'oeil architectural frame decorated with gilt classical trophies, antique reliefs and medallions, and festooned with garlands. At the center, depicted as a humanist scholar, Jerome sits, peering out at the viewer as if through a circular window. Behind him rises a view of Florence, including the cathedral and its baptistery. Above and below the window, and simulating carved inscriptions, are the title and opening words of the preface written in gold against purple. Above the top panel hovers an illusionistically rendered dove, symbol of the Holy Spirit and subject of the Didymus text. Behind the left column kneel Matthias Corvinus and, behind him, his son with his tutor, Taddeo Ugoleto, who was the king's librarian before Fontius. At the right kneels Corvinus's queen, Beatrice of Aragon, and two members of her family.

of Hours to which we know Fouquet contributed miniatures.

This book was left unfinished by Fouquet and his assistants about 1460, being completed about 1470 by Jean Colombe for its second owner, Jean Robertet. The initials *AR* and motto "S'il avient" (Behold, he arrives) occur on the Annunciation and point to the original owner as possibly Antoine Raguier, who died in 1468. In this Annunciation, the finest of the eight miniatures attributed to Fouquet himself, the event no longer takes place in the interior of a Gothic chapel, as in the Chevalier Hours, but in a Renaissance passageway. Architecture, stone inscriptions, classical putti, and perspective betray the influence of Italian art. Fouquet had firsthand knowledge of that art, for between 1443 and 1447 he visited Rome, where Pope Eugenius IV commissioned a portrait from him. The Annunciation marks the beginning of Matins, the first of the Hours of the Virgin; the opening words, "Domine labia mea aperies" (Lord, Thou shalt open my lips), are carved in relief on the architectural base. The

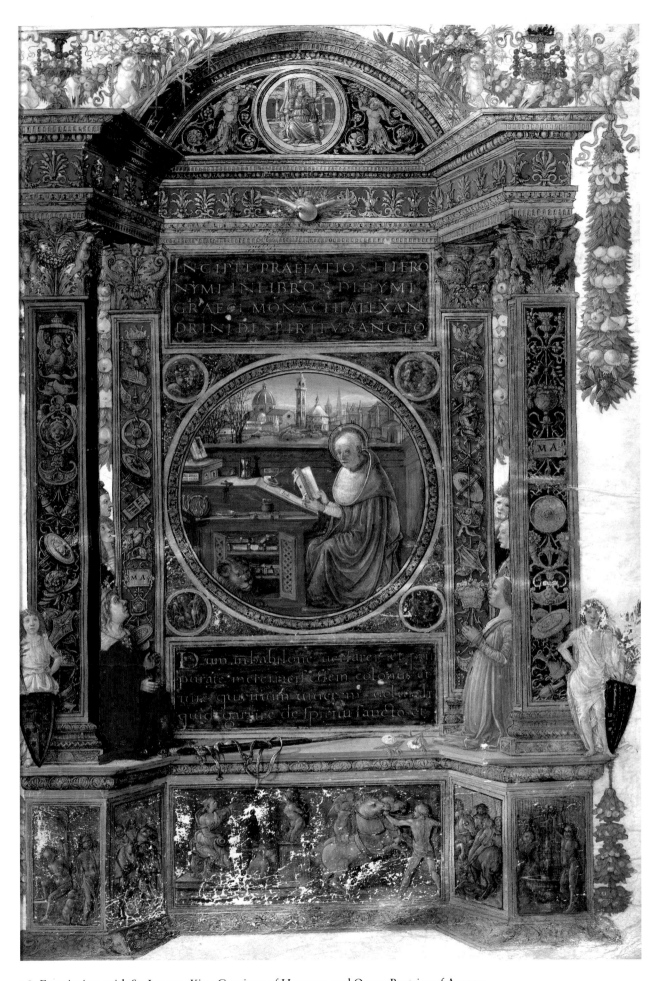

28 Frontispiece with St. Jerome, King Corvinus of Hungary, and Queen Beatrice of Aragon

29 Annunciation

ANNUNCIATION

Jean Poyet. Book of Hours. H.8, f.30v (256 x 180 mm). France, Tours, ca. 1500. Dannie and Hettie Heineman Collection; deposited in 1962, given in 1977.

Until just a few years ago any French illumination of high quality from around 1500 (including this manuscript) was attributed to Jean Bourdichon, an artist working in Tours and known for the fine books he painted for the French court (see III, 30). Working in Tours at the same time and often for the same patrons was another artist, Jean Poyet, who was as famous in his own day as Bourdichon but later fell into obscurity. Poyet's patrons included Charles VIII, Anne de Bretagne (queen to two kings of France, Charles VIII and Louis XII), and the Lallemant family of Bourges, discriminating patrons of illumination. Although the evidence for attributing these works to Poyet is circumstantial, his fame, gleaned from contemporaneous documents, matches in time and place the large body of consistently high-quality illumination that has grown up around his name in the last ten years.

This Book of Hours, perhaps Poyet's masterpiece, contains a rich cycle of fifty-four miniatures, many of which are accompanied by marginal scenes painted in monochromes of blue, purple, red, or brown, highlighted with gold. The Annunciation, shown here, is typical of Poyet's novel treatment of a traditional subject. The illuminator places the moment of Christ's Incarnation within an open portico; our gaze is gently led from the foreground, by means of the orthogonals formed by the gold tiles, through the tall arches, and on to the carefully depicted plots of vegetation in the garden (Poyet was famous for his mastery of perspective). Our eye examines the pale walls of the distant city before continuing on to the even more distant mountains, whose blue echoes that of the Virgin's mantle and Gabriel's wings and stole. This royal blue, plus plum, pale pink, and dusty gold are typical colors from Poyet's palette. Also characteristic are the restrained intensity in the faces of Mary and Gabriel and the quiet grandeur of the setting.

According to a tradition that goes back to the eighteenth century, this book was given to Henry VIII of England by Emperor Charles V. The metal clasps of its eighteenth-century binding bear the name, arms, and motto of that English king.

NATIVITY

Jean Bourdichon. Book of Hours. M.732, f.31v (302 x 200 mm). France, Tours, ca. 1515. Purchased, 1927.

The masterpiece of Jean Bourdichon and one of the most famous manuscripts of the Renaissance is the *Grandes Heures* of Anne de Bretagne in Paris (Bibliothèque Nationale, lat. 9474). Anne, queen to two kings of France (Charles VIII and Louis XII), paid Bourdichon the sum of 1,050 *livres tournois* or 600 *écus* of gold in 1508, a staggering amount at that time for a book. On the basis of Bourdichon's documented connection with Anne's manuscript, a large number of other works have been attributed to him, although these often include works from his prolific shop, followers, or various contemporaries. Among the surest attributions to Bourdichon is the present fragmentary Book of Hours, the surviving portions of which closely resemble the *Grandes Heures* itself. If, like that work, it also had forty-nine full-page miniatures (only eight remain), it too must have been made for an equally high ranking patron.

As in the *Grandes Heures,* the miniatures are conceived as close-up icon-like images in which the narrative element has been largely eliminated. In the Nativity, for example, the devotional character of the miniatures is further enhanced by their strongly projecting Renaissance frames, which do not occur in the *Grandes Heures.* The white porcelain-like face of the Virgin is a hallmark of Bourdichon's style, as is his interest in differing light sources. Here, for example, the scene is bathed in light from the star, the lantern held by Joseph, and the rays emanating from the Christ Child.

Although it has been suggested that this book was made shortly before and as preparation for the *Grandes Heures,* it was more likely made afterwards. Frames comparable to those here, for example, are found in two other Books of Hours by Bourdichon that are regarded as late works. The artist lived until at least 1520, when he contributed decorations for the famous meeting of Francis I of France and Henry VIII of England at the Field of the Cloth of Gold, but by 29 July 1521 he was dead.

30 Nativity

31 April: Farmyard Scene

31 🙠

APRIL: FARMYARD SCENE

Simon Bening. Da Costa Hours. M.399, f.5v
(172 x 125 mm). Belgium, Bruges, ca. 1515.
Purchased, 1910.

Calendars in Books of Hours, beginning even
with the earliest examples in the late thirteenth
century, were sometimes illustrated by vi-
gnettes depicting the "labors of the months."
These were the seasonal activities, usually rural
and performed by peasants, that took place
throughout the course of each year: shearing
sheep in June, mowing hay in July, reaping
wheat in August, for example. Throughout the

fourteenth and most of the fifteenth century,
calendrical illustrations were usually small, but
by the end of the fifteenth and early sixteenth
centuries, these secular subjects received great-
er artistic attention, especially from Simon
Bening.

A Flemish illuminator working in Bruges in
the early sixteenth century, Simon Bening was
both the son of, and a father to, an illuminator.
His father, Alexander, was one of the leading
illuminators in Flanders of the late fifteenth
century, and his daughter, Lavinia, was to take
her skills as a portrait miniaturist to the court
of Henry VIII of England in the mid-sixteenth
century. Of this family of painters, however,
Simon's fame is the most enduring. Having

died in Bruges before 1561, he is usually regarded as the last great Flemish illuminator. His works were highly sought after, not only in Belgium, but also in Italy, Portugal, and Germany. The present Hours, for example, was made for a member of the Portuguese Sá family, from whom it passed to King Manuel's armorer, Alvaro da Costa, after whom the manuscript takes its name.

Bening was especially known for the sensitively rendered landscapes in his cycles of full-page calendar illustrations. Such cycles had not occurred in manuscripts since their initial and singular appearance, almost exactly a hundred years earlier, in the *Très Riches Heures* of the duc de Berry. That celebrated manuscript, which was then in the library of Margaret of Austria in Malines, provided the stimulus to Bening for these cycles, of which this example is the earliest. Bening, however, also added to their complexity and scope. April, for example, is full of activity: men taking their sheep to pasture, a woman milking, a second woman leading a cow to graze, and a third one churning. The winding road, delicately flowering trees, and pale blue, atmospheric sky make the painterly and poetic achievements of this miniature akin to those of a large-scale landscape.

32 ❧

ADORATION OF THE MAGI and SOLOMON ADORED BY THE QUEEN OF SHEBA

Giulio Clovio. Farnese Hours. M.69, ff. 38v-39 (each folio 173 x 110 mm). Italy, Rome, dated 1546. Purchased, 1903.

"There has never been, nor perhaps will there ever be for many centuries, a more rare or more excellent miniaturist, or we would rather say, painter of little things, than Don Giulio Clovio." With this sentence Giorgio Vasari begins his account of the artist's life in the second edition of *Lives of the Painters* (1568). Vasari, a contemporary of Clovio (1498-1578), held the Farnese Hours—the artist's undisputed masterpiece—in such high esteem that he felt obliged to describe it in considerable detail, arguing that in this way such a private treasure might be shared with everyone. Clovio, though born in Croatia, made his career as an illuminator in Italy, mostly in Rome. The colophon states that he completed this monument (*"Monumenta Haec"*) in 1546 for his patron Cardinal Alessandro Farnese. Vasari tells us the work was finished after nine years and "required such study and labor that it would never be possible to pay for it . . . all is executed with such beauty and grace of manner that it seems impossible that it could have been fashioned by the hand of man. Thus we may say that Don Giulio has surpassed in this field both the ancients and the moderns, and that he has been in our times a new, if smaller, Michelangelo."

The Farnese Hours, justly regarded as the last great Italian manuscript, is also a superb mirror of Mannerist art: here one can see, for example, the *figura serpintinata* of Michelangelo and the elongated and sinuous forms of Pontormo. Mannerist, too, are the seemingly indefatigable love of surprise, the novelty, ingenuity, virtuosity, rampant complexity, scintillating color, and spatial effects, all of which appealed to connoisseurs of the day.

Most of the twenty-six full-page miniatures are grouped typologically, pairing a New Testament event with its Old Testament antecedent. Here, for example, the Magi's visiting Christ has been paired with the queen of Sheba's visit to Solomon. The latter scene contains two portraits, those of Cardinal Farnese (as Solomon) and the unidentified dwarf who, wearing painter's clothes, becomes a kind of pun, for he is actually a "miniature" painter. Solomon's Temple is shown with the twisted columns that, according to legend, were subsequently used in Old St. Peter's.

32 Adoration of the Magi *and* Solomon Adored by the Queen of Sheba

Aurelij Augustini epi de ciuitate dei
liber primus feliciter incipit.

NTEREA CUM RO
ma gotthozz irruptioe agen
tium sub rege Alarico atqz
ipetu magne cladis evsa est:
eius euersione deozum falso
zz:mutozuqz cultozes:quos
usitato noie paganos uoca
mzz:i christiana zligione zfer
re conates:solito acerbzz z a
marizz dezz uezz blaffeare ce
perut.Uzz ego exardesces ze
lo dom zi:aduzus eozz blasphemias
uel errozes:libros de ciuitate dei scri
bere institui.Quod opus per aliquot
annos me tenuit:eo qz alia multa inz
currebat:que differri non opozteret:
z me prius ad soluendu occupabant.
Hoc autem de ciuitate dei grade opzz
tandem.xxij.librzis est terminatu:quo
rzz quinqz primi eos zfellunt: qui res
hzzanas ita,pspezari uolut:ut ad hoc
mutozz deozz cultu:quos pagai cole
psueuerut:necessariu ez arbitrez.z qz
phibez:mala zsta exoziri atqz abudaz
contendunt.Sequentes autem quiqz
aduersus eos loquuz:q fatez hec ma
la nec zfuisse uzz nec defuza mztalibzz
z ea nuc magna nuc pua locis tpibus
psonisqz uariari.Sed deozz mutozuz
cultu quo eis sacrificat:ppter uitaz
post moztem futuram esse utilem dis
putant.his ergo.x.librzis due iste ua
ne opiniones christiane religioni adv
sarie refellunt.Sed ne quisqz nos alie
na tantum redarguisse: non autez nzza
asseruisse reprehenderet:id agit pars
altera operis huius:que.xij.librzis cz
tinez.Quazz ubi opus ez:z in pozibus
.x.que nostra sunt asseramus:z i.xij.
posteriozibus zdarguamus aduersa.
Duodecim ergo librozz sequztium pz
mi quatuoz continez exoztum duaruz
ciuitatum:quarum est una dei:altera

huius mundi.Secudi quatuor excuz
sum eazz seu procursum.Tertij uero:
qui z postremi:debitos fines.Ita om
nes.xxij.librzi cum sint de utraqz ciui
tate conscripti:titulu tame a meliore
acceperunt:ut de ciuitate dei potizz uo
carent.In quozz decimo librzo nz de
buit pro miraculo poni:in Abrae sa
crificio flammam celitus factam inz
diuisas uictimas cucurrisse:qm hoc
illi i uisione monstratum est.In.xzz.li
bzo quod dictum est de Samuele:nz
erat de filijs Aazon:dicenduz potius
fuit:non erat filius sacerdotis.Filios
quippe sacerdotuz defunctis sacerdo
tibus succedere magis legittimi mo
ris fuit.Nam in filijs Aaron reperiz
pater Samuel: sed sacerdos nz fuit:
nec ita i filijs ut eu ipe genuezit Aazz:
sz sicut omis illzz popli dzz filij israel.

De aduersarijs nois Lhzisti:qbzz i
uastatioe urbis ppz Lhzistu barbari
pepercerunt uictis capitulum primuz

Lozosissimz ciuitatez
dei:siue i hoc tpozum
cursu cu iz ipios pegzi
naz ex fide uiuez: siue
i illa stablitate sedis e
zne:qua nuc expectat p patietia: quo
adusqz iustitia zuertat i iudiciu:dein
ceps adeptura p excellztia uictozia ul
tia z pace pfecta:hoc ope ad te istitu
to:z i ea pmissioe debito:defzdz adv
sus eos q zditozi ezz deos suos prefe
runt fili carissme Marcelline:suscepi
magnu opzz z arduu:sz zs adiutoz nz.
Naz scio quibus uiribus opus sit:ut
persuadeatur superbis quanta sit uir
tus humilitatis:qua fit ut omnia ter
rena cacumina temporali mobilitate
nutantia:non humano usurpata fa
stu:sed diuia gratia donata celsitudo
transcendat.Rex enim z conditoz ci
uitatis huizz:z qua loq istituimus: in

IV PRINTED BOOKS

T HE MORGAN LIBRARY'S collection of printed books may justly be characterized as choice and diverse. It has always been a relatively modest collection in size, but it is noteworthy in the large number of high points in the history of printing, often the only surviving copy or a copy that is perfect in every way. Apart from some of the more recent books in our holdings, we are considering here books made of real animal skins, prepared by hand, or of real paper, made by hand, one sheet at a time, written by hand, one stroke at a time, or printed from real type, cast and set by hand, one character at a time. Volumes that are added to the Library are scrutinized on their individual merits first and then on the particular way in which they enhance the collection. For example, we hold three copies of the first printed book, the Gutenberg Bible, but each copy has particular elements that make it different from the other two, so the assemblage permits scholarly research at one time and place, which in this instance no other institution in the world can provide.

The Library's collection of incunables—books printed in the cradle days of the art, from the 1450s to 1501—is very important, in terms not of numbers of books but of superior or unique copies that represent the work of individual printers and locales prominent or obscure. Some are printed in the major early centers, such as Mainz, Strassburg, Paris, Lyons, and Venice; some are from the relative typographic backwaters of Oudenaarde, Châlons-sur-Marne, Besançon, Albi, and even Constantinople. It is particularly striking that many of these books were made in places that, even today in the midst of instantaneous worldwide electronic communication, are inconsequential locales. But it is precisely these locales that are important for us as indicators of the need for the new craft and the rapid spread of the new technology.

This new technology was the perfection of printing from movable type, enabling one printer to produce in a day what a scribe had heretofore taken a year to accomplish. The achievement was the triumph of a Mainz goldsmith named Johann Gensfleisch, who is known by the name of his family house, the Hof zum Gutenberg. From the 1430s to the 1450s he spent vast sums of other people's money to develop the method to reproduce the same letters countless times over, so that they might be used in endless variations, their shapes transferred in ink to paper and animal skins. He based his work on earlier principles that were well enough known, if to the select few: the cutting of letters in metal, the transfer of images from raised surfaces by means of a press common to such as bookbinders and vintners, and the making of paper or the preparation of animal skins as writing surfaces. The intervening and precision stage was the realm of the skilled goldsmith, accustomed to producing very fine and accurate results in metals. This consisted in moving from the hard steel punch, on which the letter was carved in reverse, to softer copper, into which the punch was struck, to produce an incised, now right-reading form of the letter. This was the matrix, and the goal was much closer. Into the cavity in the matrix would be poured a liquid amalgam based in large part on lead, which would be the actual printing surface. The crucial item was the type mold, holding the copper matrix, into which molten lead was poured and out of which raised letters, again in reverse, were

Augustine's *City of God*, frontispiece
by Girolamo da Cremona [see 5]

extracted, to go into the type case, to be combined into words, and placed in the printing press, to print books quickly.

A particular feature of Gutenberg's genius was how he developed the mold to adjust to the relative size of the particular letter or even group of characters: the mold could cast an i and then be quickly changed to fit an *m*, then perhaps to an *l* or a *t*, and possibly even to *ffl*. One feature of equal importance to the revolutionary method was the result: a potentially limitless number of copies of the same text, so that readers anywhere would have exactly the same wording to see and, if they wished, to dispute. The invention of printing from movable type in the West produced widespread literacy, expanded the human mind, and changed the world forever.

The Library uses the term "printed books collection" as a portmanteau word, since our holdings comprise many individual collections of considerable importance and scope. We have the third largest collection in the world of the works of William Caxton, England's first printer, and the largest outside Britain itself. Pierpont Morgan's purchases of the libraries of such earlier collectors as James Toovey, Theodore Irwin, and Richard Bennett brought in many of the earliest printed books, the books of the Aldine Press, the private library of William Morris, important bindings, and many examples of the best work of the finest printers during these past five centuries. In addition the Library continues to expand its renowned collection of children's books (see v). The Dannie and Hettie Heineman Collection is a treasure house of highlights on the intellectual and scientific history of Europe, with particular strengths in French and German works. The Paul Mellon gift is a distinguished collection of European books. It is particularly rich in illustrated books on architecture and ornament, artists' manuals, costume, travel, and topography. The Gordon N. Ray bequest recently and instantaneously made the Library an important source for the history of eighteenth- and nineteenth-century literature, particularly as reflected in illustrated books of the period. Certain of the Library's author collections are particularly strong: Francis Bacon, Molière, Racine, John Bunyan, Rousseau, Blake, Sir Walter Scott, the English romantic poets, and the major Victorian writers.

The Library's printed book collections enable scholars, not only of early printing, but of the development of thought, literature, the arts, and history, to do productive research in one place, by consulting originals that answer their questions and permit them to advance knowledge. We are also able, through the judicious exhibition of selected books, to show significant works representative of the human intellect to a wider public.

The printed book has gone through good and bad times over the years, and regular cycles can be charted. The Morgan Library safeguards representatives of the best of the book arts down the years. If our strengths are generally and rightly perceived to lie in the earlier centuries of printed books, additional strengths will soon be apparent to the careful reader of these pages.

GUTENBERG BIBLE

Biblia Latina. [Mainz: Johann Gutenberg & Johann Fust, ca. 1455]. F°. PML 818. Purchased by Pierpont Morgan in 1897.

The Gutenberg Bible is the first book printed from movable type. Popularly named for Johann Gutenberg (d. 1468), the Mainz goldsmith who invented the mechanical process that made printing possible, it is also called the 42-line Bible, from the average number of lines of type on a page. The copy at the Bibliothèque Nationale in Paris, once owned by Cardinal Mazarin, carries a rubricator's date of August 1456, which helps to date the completion of printing. Gutenberg and his colleagues probably printed the book between 1453 and 1455, in two massive volumes of 324 and 318 leaves, respectively. Certainly printing was under way by the autumn of 1454, when an Italian humanist in Germany, Aeneas Sylvius Piccolomini (the future Pope Pius II), saw sample leaves and reported enthusiastically on them to a friend in Rome. He was the first of a long line of viewers to be overwhelmed by the elegance and beauty that printing could achieve. Intact and fragmentary copies still existing imply that some one hundred and eighty Bibles were completed, of which forty-eight survive, in varying degrees of completeness. This Bible mirrors the style of Rhenish liturgical manuscripts of the period, which made it acceptable in the marketplace and suitable for its intended audience.

Illustrated here is Jerome's preface to Luke and the opening of the Gospel according to Luke in the second volume of the Gutenberg Bible. This vellum copy is illuminated in a style that has been attributed to Bruges. The Gutenberg Bible is both a typographic masterpiece and the harbinger of what has become the greatest revolution in the history of the West and arguably in the history of mankind: the wide dissemination of knowledge through printing. In its day, moreover, the Gutenberg Bible represented the culmination of perhaps twenty years of experimentation in perfecting the design and production of movable type, and it cost a prodigious amount of money. Indeed, it bankrupted Gutenberg, who saw his enterprise foreclosed and taken over by his business partner and principal financial backer, Johann Fust. Clearly the cornerstone in the history of printing and of any collection of printed books, the Gutenberg Bible has for cen-

turies been a treasure of legendary rarity and value. The Morgan Library is unique in possessing three copies, one on vellum and two on paper. Each copy possesses important features of decoration, and of variants in printing, lacking from the other two. It is significant for scholarly research that all three are variants and do not replicate one another, and our vellum copy is one of only eleven to survive complete.

THE BENEDICTINE OR MAINZ PSALTER

Psalterium Benedictinum (Bursfeld Congregation). Mainz: Johann Fust & Peter Schoeffer, 29 August 1459. F°. PML 14. Purchased by Pierpont Morgan, ca. 1900.

A splendid two-color initial opens the first line of text of Psalm 1 in the Benedictine Psalter printed at Mainz in 1459. Also known as the Mainz Psalter or the Latin Psalter, it is a direct descendant of the Gutenberg Bible. The Psalter represents an immediate technical advance, being set in two sizes of type (whereas the 42-line Bible was set in a single font), and a great technological leap, as the first instance of three-color printing. There are two editions or printings of the Psalter, from 1457 and 1459, and they constitute the first and second printed books issued with a date. Both are of extreme rarity, and the Morgan Library possesses the only copy of the 1459 edition in the United States. This book was produced by Gutenberg's former partner Fust and the printer Peter Schoeffer, who had been Gutenberg's foreman and who continued the Western world's first printing firm for many years.

A psalter is a liturgical service book containing the Psalms. The large format of this copy indicates that it was intended for use by more than one reader simultaneously and from something of a distance, as in congregational choral readings. In the beginning of Psalm 1, note the opening bars of plainchant, with the neumes or notes added by hand, that set the tone for the singers in this Gregorian chant. Note also that nothing is perfect in life: on line eight, the proper reading *erit* appears as the typographical error *eit;* moreover, and what is probably worse, it was correctly set in the 1457 edition, from which this version was set.

This psalter was printed for Benedictine monks of the Bursfeld Observance. It is distinguished for its handsome typography, and par-

Vcas sirus natõne anthi
ocensis arte medic disci
pulus apostolox postea
paulū secut usq3 ad con
fessionē ei seruiens dño sine crimine:
nam neq3 vxorem unq3 habuit neq3 fi
lios: septuaginta et quatuor annox
obijt in bithinia plen spiritu sancto.
Qui cū iam scripta essent euāgelia p
matheū quidē in iudea p marcū aūt
in italia: sancto instigante spiritu in
achaie partibz hoc scripsit euangeliū:
significans etiā ipe in principio ante
suū alia esse descripta. Cui extra ea q
ordo euāgelice dispositionis exposci
ra maxime necessitas laboris fuit: ut
primū grecis fidelibz omni phetati
one venturi in carnē dei cristi manife
stata humanitate ne iudaicis fabulis
attenti: in solo legis desiderio tenere
tur: vel ne hereticis fabulis et stultis
solicitationibz seducti reciderent a ve
ritate elaboraret: dehinc ut in princi
pio euangelij iohānis natiuitate pre
sumpta cui euangelium scriberet et in
quo elect scriberet indicaret: potestās i
se cōpleta esse q essent ab alijs inchoa
ra. Cui ideo post baptismū filij dei a
psectione generatõnis i cristo implere
repetēde a pricipio natiuitatis huma
ne potestas pmissa ē: ut requirentibz
demonstraret in quo apprehendēs e
rat per nathan filiū dauid introitu re
currentis i dñu generationis ad misso
indisparabilis dei pdicās in homini
bus cristū suū pfecti opus hois redire
in se p filiū faceret: qui per dauid patē
venientibus iter phebat in cristo. Cui
luce non immerito etiā scribēdorum
actuū apostolox potestas i ministerio
datur: ut deo in dñu pleno et filio pdi
tionis extincto oratione ab apostolis

facta sorte dñi electionis numer
compleretur: sicq3 paulus cōsumma
tione apostolicis actibz daret quē diu
cõtra stimulū recalcitrantē dñs elegis
set. Quod et legentibz ac requirentibz
deū et si per singula expediri a nobis
utile fuerat: sciens tamē q operātem
agricolā oporteat de suis fructibus e
dere vitauim publicā curiositatem:
ne nõ tā volentibz deū demōstrare vide
remur quā fastidientibus prodidisse.
Explicit pfacio Incipit euangelium
secundum lucā Prohemium ipsi
us beati luce in euangelium suum

Voniā quidē multi co
nati sūt ordinare nar
rationes q i nobis com
plete sūt rex sicut tradi
derūt nobis q ab inicio
ipi viderūt et ministri
fuerūt sermonis: visū ē et michi assecuto
omnia a pricipio diligēter ex ordie tibi
scribere optie theophile: ut cognoscas
eox verbox de qibus eruditus es veritatē.
Vit in diebus herodis re
gis iudee sacerdos quidam
nomine zacharias de vi
ce abia et vxor illi de filia
bus aaron: et nomen eius elizabeth.
Erant autem iusti ambo ante deum:
incedentes in omnibus mandatis z
iustificationibus domini sine quere
la. Et non erat illis filius eo q es
set elizabeth sterilis: et ambo proces
sissent i diebz suis. Factū est aut cū sa
cerdotio fungeretur zacharias in ordi
ne vicis sue ante deū: scdm cõsuetudi
nem sacerdotij sorte exijt ut incensum
poneret ingressus in templū domini.
Et omnis multitudo ppli erat orãs fo
ris hora incensi. Apparuit autem illi
angelus dñi: stans a dextris altaris

Eatus
vir ā Seruite dño·Evovae·
qui nō abijt in cōsilio im-
pioꝝ: �213 in via peccatoꝝ nō
stetit: et in cathedra pestilē-
tie nō sedit, Sed in lege
dñi volūtas eius: �213 in lege ei⁹ meditabiꞇ die
ac nocte, Et eit tanꝗ lignū qd plantatū est
secus decursus aꝗrū: qd fructū suū dabit in
ꞇꝑe suo, Et foliū ei⁹ nō defluet: �213 oīa quecūꝗ
faciet pspᵉrabunꞇ, Non sic impij nō sic: sed
tanꝗ puluis quē proicit ventus a facie terre,
Ideo nō resurgūt impij in iudicio: neꝗ pᶜcᵒ-
res in cōsilio iustoꝝ, Qm̄ nouit dñs viā iu-
stoꝝ: et iter impioꝝ pibit, ꝶ ꞇa pᶒ, Pfdd
Vare fremuerūt gētes: �213 pꝉi meditati
sūt inania, Astiterūt reges ꞇre et prin-
cipes ꝯueneꞇt in vnū: adūsus dñm ꝛ adūsus
ꝓm ei⁹, Dirūpam⁹ vincla eoꝝ: ꝛ piciam⁹
a nobis iugū iꝓoꝝ, Qui habitat in celis irri-
debit eos: et dñs subsannabit eos, Tūc lo-
queꞇ ad eos in ira sua: et in furoꝛe suo cōtur-
babit eos, Ego aūt cōstitutus sū reꞅ ab eo

ticularly for its ornamented initials. These very large initials are printed from two-component metal type, including the decorative elements. Irregularities in their positioning in different copies have suggested that these initials and decorations were printed separately from stencils after the text type was printed. Scholars who have been involved in modern attempts to re-create the process (for example, at the Gutenberg Museum in Mainz) are convinced that this represents the first—and very successful—instance of multicolored printing. According to this interpretation, all three colors were printed in one pass through the press after the elements carrying color were separately inked by hand and then inserted back in the form.

3 ❧

BLOCKBOOK

Canticum canticorum. [Blockbook; Netherlands, ca. 1465]. F°. PML 21990. Purchased by J. P. Morgan, 1923.

The Morgan Library has a very fine collection of blockbooks, and the *Canticum canticorum* is widely held to be the most beautiful of the genre. It portrays, in word and image, a graceful allegory in thirty-two scenes of Solomon's Song of Songs that depicts the wedding of the Virgin with the Church. The quality of the art is particularly accomplished in its graceful delineation. At the other end of the aesthetic spectrum, the banderolles, as the long furled scrolls of paper with their snippets of biblical dialogue are called, are the distant ancestors of the so-called speech balloons of comic strips with which we are so familiar.

Blockbooks constitute a somewhat strange form of printing, having more to do with graphics than typography. They are not, in fact, printed from movable type, or indeed from movable anything. Nor are they produced on a printing press. Both text and illustration are carved in relief on a wood block and then transferred, through friction, by the process of rubbing the blank side of the paper placed on the inked block. Thus both text and image, lacking the pressure of the printing press, tend to be slightly fuzzy and imprecise. The ink, which is a sort of dye rather than the paint derivative of printer's ink, tends to verge upon the brownish, when compared to the brilliant black of contemporary printed books.

This somewhat crude appearance led bib-

3 *Canticum canticorum*, folio 3v-4r

Secuntur misse speciales. In festo na
tiuitat dñi. Inprimo gallicantu Intro

Ominus dixit ad me fi
lius meus es tu ego ho
die genui te ⸰ Quare fre
muerūt gētes ⁊ ppli me
tati sūt inania ⸰ Gloria i excelsis deo

eus qui hāc sacra tissimā noc
tē veri luminis fecisti illustra
tione clarescere da qñs ut cui⁹ lu
cis misteria in terra rognouim⁹ ei⁹
quoq̃ gaudijs i celo pfruam̄ ⸰ Qui
et dicit dñs ⸰ lcō ysaie ppħe

Opulus gētiū q̃ ābulat in te
nebris : vidit lucē magnā. Habitā
tibus in regione vmbre mortis : lux
orta est eis ⸰ Paruulus eni nat⁹ est
nobis : et filius datus est nobis, Et

4 *Missale speciale*, folio 1r

Here begynneth the volume intituled and named the recuyell of the historyes of Troye / composed and drawen out of dyuerce bookes of latyn in to frensshe by the ryght venerable persone and worshipfull man. Raoul le ffeure . preest and chapelayn vnto the ryght noble gloryous and myghty prynce in his tyme Phelip duc of Bourgoyne of Brabande &c. In the yere of the Incarnacion of our lord god a thousand foure honderd sixty and foure / And translated and drawen out of frensshe in to englisshe by Wylliam Carton mercer of y[e] cyte of London / at the comaundement of the right hye myghty and vertuouse Pryncesse hys redoubtyd lady . Margarete by the grace of god . Duchesse of Bourgoyne of Lothryk of Braband &c / Whiche sayd translacion and werke was begonne in Brugis in the Countee of Flaundres the first day of marche the yere of the Incarnacion of our sayd lord god a thousand foure honderd sixty and eyghte / And ended and fynysshid in the holy cyte of Colen the . xix . day of septembre the yere of our sayd lord god a thousand foure honderd sixty and enleuen &c .

And on that other syde of this leef foloweth the prologe

6 Caxton, *Recuyell*, folio 2r

Augustine's *City of God* (1475) and Aristotle's *Works* (1483). The latter was called by an earlier owner, Henry Yates Thompson, "the most magnificent book in the world."

6 🙜

CAXTON'S *RECUYELL*

Raoul Le Fevre, *Recuyell of the Histories of Troy* (translated by William Caxton). [Bruges: William Caxton, ca. 1474]. F°. PML 771, fol. 2r. Purchased by Pierpont Morgan from Lord Amherst of Hackney, 1908.

The *Recuyell of the Histories of Troy* is both the first printed book in the English language and the first book printed in Bruges. The translator and printer, William Caxton (ca. 1422–ca. 1491), was an English merchant long resident in Bruges. He spent much of 1471 and 1472 in Cologne, in exile from Flanders, and it must have been while he was in Cologne that he came in contact with the still new invention of printing from movable type. He returned eventually to Bruges, where he set up a printing shop. He was back in his native London in 1476, and settled in Westminster. When he opened a printing establishment, At the Sign of the Red Pale, within the confines of Westminster Abbey, he became England's first printer. In the illustration here William Caxton explains how Raoul Le Fevre wrote the *Recuyell of the Histories of Troy*, and how he, a "mercer of the City of London," came to translate it into English at Bruges and Cologne between 1468 and 1471.

Caxton has remained an engaging figure, though much of our current knowledge of him is now based on scholarly research, rather than on the romantic writing of an earlier day. He was both a man of business and for some time a person of political importance to the English community in the Low Countries. He dedicated his translation of the *Recuyell* to his patroness, the duchess of Burgundy, who was Margaret of York, sister of Edward IV of England. Caxton states that she kept after him to finish it, and he did so over some three years or more, 1468 to 1471, in Bruges, Ghent, and Cologne. The reasons for his travels are most likely found in the bloody struggles between the houses of Lancaster and York, the so-called War of the Roses. Since Caxton had tied his fortunes to those of Margaret of York, upon whom he was dependent for much of his wherewithal, he stayed with her court in these

arose to purchase this gorgeous copy on vellum. It is volume two; the companion first volume is in the Bibliothèque Nationale in Paris. Both of them contain the arms of the Agostini family of Venice, found in at least eight other luxurious, specially illuminated Venetian incunables from the 1470s and in one Milanese incunable of 1475. The Agostini were involved in the paper trade, and, given the high cost of paper at the time, they became very wealthy and may well have invested their excess capital in these special luxury copies as a commercial enterprise.

The Library's volume has a magnificent illuminated frontispiece that has been convincingly identified as by Girolamo da Cremona (active in the second half of the fifteenth century), whose work was influenced by his sometime colleague Andrea Mantegna, and whose last years were spent in Venice. Girolamo also painted frontispieces in two other Venetian incunables on vellum in the Morgan Library:

years of danger as it moved to safer locales. Only after the ensuring of greater political stability in England did he feel it safe enough to return home.

Caxton invented a new and successful career for himself as a translator and printer of popular works, both on the Continent and in England. His typeface reflects the tastes of court life, but this *bâtarde* never took permanent hold because of its relatively fussy fashion. Caxtons themselves, however, have always been among the most keenly collected of rare books. The Morgan Library has an extremely important collection of editions printed by William Caxton, and more extensive gatherings can be found only at the British Library and at the John Rylands University Library in Manchester.

7 ❧

ULM AESOP

Aesop. *Vitae et fabulae.* Ulm: Johann Zainer, [ca. 1476]. F°. PML 23211. Purchased by J. P. Morgan, 1925.

The raven garbed in peacock's feathers forms the focal point of this woodcut in the Ulm Aesop (fol. 98v). The fables gathered together under the name of Aesop have been a perennial favorite. They readily lend themselves to illustration, and indeed the earliest Greek and Latin fable manuscripts contain pictures (the earliest Greek manuscript is in the Morgan Library). The first printed book to contain illustrations also derives from Aesop: a moralizing collection of fables in verse, printed in 1461 and surviving in a single copy in Germany.

When this method of combining text and illustration was applied to Aesop, the combination in many ways achieved perfection virtually from the beginning. The Latin-German Aesop we see here was undertaken by Heinrich Steinhöwel, an Ulm town physician, who had studied and taught at Padua for several years, and who became one of the most important mediators of Italian and classical literature to the German-speaking peoples. Besides the Aesop, he translated and published Petrarch, Boccaccio, and Apollonius of Tyre, and he compiled a German chronicle and a treatise on the plague. He was a financial patron of Johann Zainer's press, and it is probably a reflection of his taste that most of his translations appeared in illustrated editions. The text of the present book comprises a core of Aesop stories supple-

7 Page of the Ulm Aesop

mented by a large stock of additional fables drawn from late classical, medieval, and Italian Renaissance sources. The woodcut illustrations, filled with character and action, are probably the work of several hands. At least the best of them are possibly the work of Jörg Syrlin the Elder, who carved the choir stalls for the cathedral at Ulm that was completed in 1474.

The Ulm Aesop is arguably the finest and unquestionably the most influential of the fifteenth-century German books illustrated with woodcuts. The fineness of line in the illustrations harmonizes perfectly with the weight of the typography. Before the end of the fifteenth century, more than thirty editions of Aesop were published in a variety of languages, with illustrations using and reusing either the original Ulm woodcuts or copies of them.

The Morgan Library has a fine and extensive collection of Aesops. This is the only copy in this country with the Ulm woodcuts.

GEOFFREY DE LA TOUR-LANDRY

Geoffroy de la Tour-Landry. *Der Ritter vom Turn*. Basel: Michael Furter for Johann Bergmann, 1493. F°. PML 39058. Purchased in 1947.

This is a German version of French moral tales for young ladies composed by an Angevin seigneur, Geoffroy de la Tour-Landry (de la Tour = vom Turn), who had fought in several campaigns of the Hundred Years' War. He wrote the book about 1371 for the edification of his daughters, and his most interesting stories come from his recollections of recent events and society, giving a vivid picture of upper-class manners in late medieval France. This first German edition was translated by Marquart von Stein (ca. 1430–ca. 1496), a German count who in his youth had spent time at the Burgundian court. The book continued to be more popular in Germany than in France, where no edition prior to 1514 is known.

The *Ritter vom Turn* is particularly celebrated for its illustrations and universally acknowledged to be one of the finest books illustrated by woodcuts of northern origin produced in the fifteenth century. There are forty-five cuts, of which one is repeated; competent authority attributes them to the young Albrecht Dürer (1471-1528). Here we see the title page with Dürer's woodcut illustration. This is the first edition; it is also the first book to contain extensive illustration by Dürer, then twenty-two and residing in Basel. The woodcuts, which were copied closely in several editions subsequently published at Strassburg, were perhaps the most graceful and sophisticated to appear in a printed book up to that time. They have a depth of coloring and a strength of line typical of Dürer's work, showing his sure hand even at this early stage in his career. The vigor of the woodcuts required a corollary usage on the title page, as illustrated. To harmonize with the graphic strength of the woodcut, Furter has printed the title zylographically—that is to say, not from movable metal types but in letters carved from a single block of wood and printed directly from the block at the same time as the woodcut illustration.

8 Title page of *Der Ritter vom Turn*

LANGRES MISSAL

Missal, Use of Langres. [Paris: Jean du Pré, ca. 1491]. F°. PML 46713. Purchased as the gift of the Fellows, 1955.

Among the specialties of the Parisian printing shops during the experimental years of the late fifteenth century were finely printed and finely illustrated editions of Missals and other service books, as well as smaller-format Books of Hours for private use. Among the most elegant of these is a small group of liturgical books, including the present Langres Missal, in which Jean du Pré experimented with printing in color. This sumptuous book is another example of a novel attempt that achieved immediate perfection—in this case, the printing of line-cut illustrations in color. The year before, du Pré had ventured a first attempt with the line-cut illustrations in a Book of Hours, and the Langres Missal is only his second try. The first illustration in the volume, reproduced here, is not merely a metal engraving but the first metal cut used in Paris. It is printed in light blue, the decorative border pieces in red, and the text in lustrous black. The delineation is theologically interesting too, since it portrays the doctrine of

9 Page of the Langres Missal

transubstantiation: the change of the bread and wine into the body and blood of Christ at the Consecration of the Mass.

The Morgan Library copy is one of two perfect copies known; two other surviving copies are imperfect. Our copy is of further significance because the other complete copy, specially printed on vellum for presentation to the Bishop of Langres, has the cuts painted over by hand with miniatures, thus concealing the color printing. Illustrated here is the Mass for the first Sunday of Advent depicting transubstantiation during the consecration of the host.

10 🙠

ABBEVILLE AUGUSTINE *CITY OF GOD*

Augustine. *De la cité de Dieu*. Abbeville: Pierre Gérard & Jean du Pré, 24 November 1486–12 April 1486/87. F°. PML 343. Purchased by Pierpont Morgan with the Bennett Collection, 1902.

This French edition of Augustine's *City of God* represents at least two areas of particular strength in the Morgan Library's collection of incunabula: individual distinction and geo-

10 Page of Abbeville Augustine, *City of God*

graphical origin outside the typographical mainstream. This large-folio edition can lay strong claim to being the most splendid fifteenth-century French imprint. It is one of only three books printed at Abbeville in the fifteenth century, two of which were extraordinary productions in format and decoration. Illustrated here, within medieval walls, is the creation of Eve in the Garden of Paradise.

Jean du Pré, whose work we have just considered (No. 9), is found in only this one of the three books. He was busy in his own establishment at Paris, where he seems to have been successful enough to venture afield in one way or another. It seems likely that his true presence was in financing Gerard's shop rather than in working there himself. The type used to set the three Abbeville books is du Pré's. Another indicator of the Parisian underpinning of the Abbeville venture may be found in the illustrations. The beautiful woodcuts were almost certainly made in Paris; at least, they show up there in the stock of the printer Antoine Vérard.

The Abbeville Augustine has an additional significance for us. It represents Pierpont Morgan's acquisition of the Bennett Collection, the foundation of the Library's outstanding collection of incunabula. And the Bennett Collection itself has another claim in the history of books and printing because it included much of the library of William Morris, one star item of which was in fact the Abbeville Augustine.

11

ALDINE ARISTOTLE

Aristotle. [*Works.* (Greek)]. Venice: Aldus Manutius, 1 November 1495-June 1498. F°. PML 1126. Purchased by Pierpont Morgan with the Toovey Collection, 1899.

The central achievement of the Renaissance in Italy was the reintroduction in the original language of the literary and learned works of Greek antiquity. The works of Aristotle were the first major prose texts to be printed in the original Greek, thanks to Aldus Manutius, the first and the most important of the great humanist scholar-printers. Like Gutenberg, Aldus spent his earliest years as a publisher doing purely experimental and developmental work; in his case it culminated in this first, or Aristotle font, of four Greek typefaces. The Greek alphabet, with its varied forms, accents, and breathings, presents many more obstacles for development into type than the Latin alphabet. Aldus was successful by 1495, and he set out to publish all the important Greek classics, beginning with Aristotle.

The Aristotle appeared in five large volumes, which Aldus issued in two groups. First came the *Organon*, comprising the six treatises on logic. Then came the rest of the Aristotelian corpus, containing the works in pure philosophy, issued in four volumes from 1497 to 1498. Bibliographers tend to describe the entire series as one group of five volumes, but Aldus, who, like his fellow scholars, firmly distinguished between Aristotelian logic and philosophy, listed his edition as being in one and four volumes, respectively. The Morgan Library possesses very fine copies of the entire work. The illustration seen here is the opening of chapter two (fol. K4r) of Aristotle's *Prior Analytics* in the 1495 Aldine edition, decorated in the Byzantine Hellenistic style. It is taken from the *Organon*. In the preface to this volume Aldus wrote to his patron and former pupil Alberto Pio da Savoia, prince of Carpi, of his publishing plans: to provide the world with the entire corpus of ancient Greek learning, despite the turbulence of times that were more favorable to weapons than to books.

This earliest and in many ways most important of the Aldine Greek folios heralded the achievement of the Aldine Press over many decades. The Morgan Library has an extensive collection of Aldine books.

11 Aldine Aristotle, opening to chapter 2

12

CONSTANTINOPLE *ARBA'A TURIM*

Jacob ben Asher. *Arba'a Turim* (Hebrew; vol. III only). Constantinople: David & Samuel ibn Nachmias, 13 December 1493. F°. PML 77122. Purchased on the Fellows Fund and the Fellows Capital Fund, 1981.

This is the only book printed in Constantinople in the fifteenth century, and it has generated much argument among scholars. It also shows the fertile ground awaiting Jewish and non-Jewish bibliographers working together. The *Arba'a Turim* ("Four Pillars" [of Hebrew law]) treats religious law, civil law, marriage and

לא טוב היות האדם
לבדו אעשה לו עזר
כנגדו א

divorce, and the right conduct of life. This volume, the third of the four that treated one "Pillar" apiece, is on marriage and divorce. On the page we see here (fol. aleph 3v, Hebrew style), Jacob ben Asher, taking as his point of departure God's word that "it is not good for man to be alone" (Genesis 2:18), begins his discussion of marriage; an early reader comments in the margin that he would not have used the author's phraseology.

This fourteenth-century codification of Hebrew law is dated on Friday, the 4th of Tebeth, 5254, which corresponds with 13 December 1493 in the Christian calendar. But no other Constantinople printing can be found before 1505, when the printers of the book began an extensive program of publishing for the needs of the Jewish communities of the East. Since Constantinople is the farthest east and most remote of the incunable printing towns, and its name is absent from all the standard lists and histories of printing, a corrected date of 1504 or 1505 was long suggested. Recent scholarship has shown conclusively, however, that the *Arba'a Turim* is printed on 1490s Venetian paper (which thereafter, for many years, could not be exported to Constantinople because of warfare and trade embargo). It is also partially printed from type available in the Soncino shop in Naples in 1492, which reinforces the 1493 date.

It is likely that the printers David and Samuel ibn Nachmias were Sephardim expelled from Spain following the *Reconquista* of 1492, and that they were in the entourage of the Jewish philosopher-banker Isaac Abravanel. Abravanel's group made its exodus from Valencia to Naples in the summer of 1492, and there met Joshua Solomon Soncino, whose specialty was printing in Hebrew. The two brothers must soon have sailed for the eastern corner of the Mediterranean, where they set up the shop that produced this clean and neat edition of a substantial text.

The Morgan Library has a small but select gathering of Hebrew incunables, including a monument deserving something of the status of a national treasure: the sole American copy of the first complete edition of the Hebrew Bible, printed in 1488. The *Arba'a Turim* enhances this collection by being the first book printed in Constantinople and the only one printed there in the entire incunabular period.

13 🐾

COMPLUTENSIAN POLYGLOT

[Biblia Sacra Polyglotta]. *Vetus testamentum multiplici lingua nunc primo impressum.... Nouum testamentum grece et latine in academia complutensi nouiter impressum.* Alcalá de Henares: Arnão Guillén de Brocar, 1514-1517 [1522]. F°. PML 812. Purchased by Pierpont Morgan, 1906.

This monument to the so-called New Learning of ecclesiastical and biblical reform sweeping Europe in the early part of the sixteenth century was produced in six massive volumes in a small university town near Madrid. The town's Latin name is Complutum; hence this quadrilingual Bible is commonly known as the Complutensian Polyglot. It was sponsored by the cardinal primate of Spain, Francisco Ximénez de Císneros, who was also the founder of the university and lived just long enough to see the completion of the printing.

The Bible was not published for some five years after the completion of printing, until papal sanction was given on 15 March 1522 and privilege granted for the issuance of six hundred copies. During the intervening period Erasmus's Greek New Testament was published in 1516, two years after the completion of printing of the Complutensian New Testament but six years before it could be consulted by the learned. As a result, much early Protestant biblical scholarship was based on Erasmus's translation, which was much less sound than the Complutensian. Not until 1550, when Estienne's *textus receptus* of the Greek New Testament, based on the Complutensian's readings rather than those of Erasmus, was published, did the Complutensian properly come into its own. Thereafter it formed the basis of New Testament criticism for the following three hundred years, and with justification, since the Complutensian had been prepared over the course of fifteen years by a group of scholars working from a large variety of manuscripts gathered from a wide number of sources throughout Europe. It has been suggested that Erasmus, aware of the completion of work in Alcalá, rushed his own edition and translation through to win the prize of first publication. It may also be that the exclusive imperial privilege granted Erasmus's New Testament for four years kept the Complutensian unavailable for the years from 1516 to 1520.

The Complutensian is the first of the great polyglot Bibles, furnishing Jerome's Latin Vul-

Tex.Heb. (Hebrew column)

אֶל־מֹשֶׁה אֶת־הָאֹהֶל וְאֶת־כָּל־
כֵּלָיו קְרָסָיו קְרָשָׁיו בְּרִיחָו וְעַמֻּדָיו
וַאֲדָנָיו וְאֶת־מִכְסֵה עוֹרֹת הָאֵילִם
הַמְאָדָּמִים וְאֶת־מִכְסֵה עֹרֹת
הַתְּחָשִׁים וְאֵת פָּרֹכֶת הַמָּסָךְ אֶת־
אֲרֹן הָעֵדֻת וְאֶת־בַּדָּיו וְאֵת הַכַּפֹּרֶת אֶת־הַשֻּׁלְחָן אֶת־כָּל־כֵּלָיו
וְאֵת לֶחֶם הַפָּנִים אֶת־הַמְּנֹרָה
הַטְּהֹרָה אֶת־נֵרֹתֶיהָ נֵרֹת הַמַּעֲרָכָה
וְאֶת־כָּל־כֵּלֶיהָ וְאֵת שֶׁמֶן הַמָּאוֹר
וְאֵת מִזְבַּח הַזָּהָב וְאֵת שֶׁמֶן הַמִּשְׁחָה
וְאֵת קְטֹרֶת הַסַּמִּים וְאֵת מָסַךְ
פֶּתַח הָאֹהֶל אֵת מִזְבַּח הַנְּחֹשֶׁת
וְאֶת־מִכְבַּר הַנְּחֹשֶׁת אֲשֶׁר־לוֹ אֶת־
בַּדָּיו וְאֶת־כָּל־כֵּלָיו אֶת־הַכִּיֹּר וְאֶת־
כַּנּוֹ אֵת קַלְעֵי הֶחָצֵר אֶת־עַמֻּדֶיהָ
וְאֶת־אֲדָנֶיהָ וְאֵת הַמָּסָךְ לְשַׁעַר
הֶחָצֵר אֶת־מֵיתָרָיו וִיתֵדֹתֶיהָ וְאֵת
כָּל־כְּלֵי עֲבֹדַת הַמִּשְׁכָּן לְאֹהֶל מוֹעֵד
אֶת־בִּגְדֵי הַשְּׂרָד לְשָׁרֵת בַּקֹּדֶשׁ
אֶת־בִּגְדֵי הַקֹּדֶשׁ לְאַהֲרֹן הַכֹּהֵן
וְאֶת־בִּגְדֵי בָנָיו לְכַהֵן כְּכֹל אֲשֶׁר־
צִוָּה יְהוָה אֶת־מֹשֶׁה כֵּן עָשׂוּ בְּנֵי
יִשְׂרָאֵל אֵת כָּל־הָעֲבֹדָה וַיַּרְא
מֹשֶׁה אֶת־כָּל־הַמְּלָאכָה וְהִנֵּה
עָשׂוּ אֹתָהּ כַּאֲשֶׁר צִוָּה יְהוָה כֵּן
עָשׂוּ וַיְבָרֶךְ אֹתָם מֹשֶׁה׃

Radix heb. (margin roots)

כָּסָה
אָדַם עוּר
סָכַךְ
אֲרוֹן עַד
פָּנָה נוּר
עָרַךְ
אוֹר
זָבַח
מָסַךְ
כָּבַר
אֲדַן
יָתֵר
בָּרַךְ

Trasla.B.Hiero.

& ᵐtectū & ᵒ vniuersam
ᶠsupellectilem:ᵠanulos
ᵗtabulas:ᵛvectes:ᶜcolum
nas:ᵃᶜbases: ᵒpertori
um ᵖde pellibus ᵃrietum
rubricatis:& aliud ᵒ
perimentum de
hyacinthinis ᵖpellibus:
ᵗarcam:ᵛvectes:
ᵖpropiciatorium:ᵐmen
sam cum ᵛvasis suis:
& ᵖpropositionis pani
bus:ᶜcandelabrum:
lucernas.
& ᵛvtensilia earum ᵐcum
oleo:
ᵃaltare ᵃaureum & ᵛvn
guentum
& ᵗthymiama ex aroma
tibus:& ᵗtentorium in
introitu ᵗtabernaculi:
ᵃaltare ᵉeneum
ᵗreticulum:
ᵛvectes:& ᵛvasa eius om
nia.ᵗlabrum cum
ᵗbasi sua:ᵗtentoria ᵃatrii
& ᶜcolumnas
ᶜcum basibus suis.ᵗten
torium ᶦin introitu
ᵃatrii ᶠfuniculos ᶠfilius
& paxillos.Nihil ex ᵒ
ᵛvasis defuit que in ᵐmi
nisteriū tabernaculi & ᶦi
tectū federis iussa fuē fie
ri.ᵛVestes quoque quibus
sacerdotes vtuntur ᶦin
sanctuario ᵃaarō scilicet
& ᶠfilii eius:
ᵒobtulerunt ᶠfilii israel:
ᶠsicut ᵖpreceperat ᵈdomi
nus.Que postꝗ
ᵐmoyses ᶜcūcta vidit cō
pleta:
et fuꝛt facientes ea quēadmodū pꝛecepit dn̄s m̄
ꝭ sic fecerint ea: & bn̄dixit eis moyses.
ᵇbenedixit eis.

Ca.xl.

Radix chal. (left margin)

קַנָא בַּרְפָּא
סְמַךְ
נוּר עֲרַךְ נְהַר
דְּבַח

Interp.chal.

ad moysen τ omnia vasa eiusdē tabernaculi: fibulas
eius:tabulas eius:vectes eius:τ colūnas eius:τ ba
ses eius:τ opertorib́ de pellibus arietum rubricatis:
et opertorib́ de pellibus hyacinthinis: velū ꝗᵈ ꝗᵈ ex
tendatur: arcam testimonij: τ vectes eiᵒ: τ propicia
rium: mensam: τ oīa vasa eiᵒ: τ panē propositionis:
candelabru mundissimu: τ lucernas que ordinantur
et omnia vasa eiᵒ: τ oleum ad illuminandū: altare
aureū τ oleum vnctionis:thymiama aromatū. Ten
toriusꝗ quod erat in ostio tabernaculi:altare eneum:
et reticulū eiᵒ eneum:vectes eiᵒ τ oīa vasa eiᵒ.
ꝉabium τ basim eiᵒ:coztinas atrii cū colūnis suis
et cum basibus suis:velum quoq ad ostiū atrū:fu
niculos eiᵒ τ parillos eiᵒ τ omnia vasa ministerij
tabernaculi federis:vestes quoꝗ ministerij ad mini
strandū in sanctuario:vestes sanctas aaron sacer
dotis τ vestes filioꝛ eiᵒ vt ministrent.iuxta omne
que precepit dn̄s moysi: ita fecerunt filii israel omne
opus. Auditꝗ moyses omne opus τ ecce fecerant il
lud sicut preceperat dominus ita fecerunt: benedixit
꙰ eis moyses.

Ca.40.

Trasla.Gre.lxx.cū interp.latina.

ad moysen: τ oīa vasa eius:
πρὸς μωυσῆν, καὶ πάντα τὰ σκεύη αὐτῆς:τ
anulos eius: et colīnas eius:τ
τοὺς δακτυλίους αὐτῆς, καὶ τοὺς ξύλους εἰus:
vectes eius:τ parillos eius:
τ μοχλοὺς αὐτῆς, καὶ τοὺς πασσάλους eius:
τ bases eius:τ opimēta pelles
καὶ τὰς βάσεις αὐτῆς, καὶ τὰς δίφθέρας δέρματα
arietū rubricatas:τ cooptoria pel
κριῶν ἠρυθροδανωμένα, καὶ τὰ κατακαλύμματα δέρ-
les hyacinthinas:τ velū τ
ματα ὑακίνθινα, καὶ τὸ κατα πέτασμα, καὶ τὴν ὑ
cam testimonij:τ vectes eius:τ
κιβωτὸν τοῦ μαρτυρίου, καὶ τοὺς διωστῆρας αὐτῆς:τ
ppiciatorii:τ mēsam:τ oīa vasa
τὸ ἱλαστήριον, καὶ τὴν τράπεζαν, καὶ πάντα τὰ σκεύη
eius:τ panes ppositiōis:τ τὰς
αὐτῆς, καὶ τοὺς ἄρτους τῆς προθέσεως, καὶ τὴν λυ-
labrū purū:τ lucernas eius lucernas
χνίαν τὴν καθαρὰν, καὶ τοὺς λύχνους αὐτῆς λύχνους
incēdij:τ oīa vasa eius: et ole
τῆς καύσεως, καὶ πάντα τὰ σκεύη αὐτῆς, καὶ τὸ ἔλαι
um luminis: et altare aureū:
ον τοῦ φωτός, καὶ τὸ θυσιαστήριον τὸ χρυσοῦν,
oleū vnctiōis: et thymiama cōpositio
τὸ ἔλαιον τῆς χρίσεως, καὶ τὸ θυμίαμα τῆς συνθέ-
nis: et velū porte tabnaculi:τ
σεως, καὶ τὸ ἐπίσπαστρον τῆς θύρας τῆς σκηνῆς, καὶ
altare eneū: et craticulā eius
θυσιαστήριον τὸ χαλκοῦν, καὶ τὴν ἐσχάραν αὐτοῦ τὴν
eneā: et vectes eius: et oīa
χαλκῆν, καὶ τοὺς ἀναφορεῖς αὐτοῦ, καὶ πάντα τὰ
vasa eius: et labrū: et basim eius: et
σκεύη αὐτοῦ, καὶ τὸν λουτῆρα, καὶ τὴν βάσιν αὐτοῦ, καὶ
cortinas atrii: et colūnas eius:τ bases eius:
τὰ ἱστία τῆς αὐλῆς, καὶ τοὺς ξύλους αὐτῆς, καὶ τὰς βάσεις αὐτῆς
velum porte atrii: et funiculos eius:τ
τὸ καταπέτασμα τῆς πύλης τῆς αὐλῆς, καὶ τὰ χονία αὐτῆς, καὶ τὰ
parillos eius: et oīa instrumēta ad op̄
πασσάλους αὐτῆς, καὶ πάντα τὰ ἐργαλεῖα τὰ εἰς τὰ ἔργα
tabernaculi testimonij: et vestes ministratorias ad
σκηνῆς τοῦ μαρτυρίου, καὶ τὰς στολὰς τὰς λειτουργικὰς εἰς τὸ
ministrandū in eis in scuario:vestes scuarii ꝗ sūt
λειτουργεῖν ἐν αὐταῖς ἐν τῷ ἁγίῳ,στολὰς τῶν ἁγίων, αἱ εἰσιν αα-
ron: et vestes filioꝛ eius in sacerdotii:sm̄ oīa
ρὼν, καὶ τὰς στολὰς τῶν υἱῶν αὐτοῦ εἰς τὴν ἱερατείαν:κ̄τὰ πάν-
nia pc̄pit dn̄s moysi: sic fecerūt filii isr̄l
τα ὅσα συνέταξε κ̄ τῷ μωυσῆ, οὕτως ἐποίησαν οἱ υἱοὶ ἰσρα
el oē apparatū. et vidit moyses oīa
λ ὅσην τὴν παρασκευήν. καὶ εἶδε μωυσῆς πάντα τὰ ἔργα
et fuēt facientes ea quēadmodū pc̄pit dn̄s m̄
ὅσαν πεποιηκότες αὐτὰ ὃν τρόπον συνέταξε κ̄ τῷ μ̄
sī: sic fecerūt ea: & bn̄dixit eis moyses.
σῖ, οὕτως ἐποίησαν αὐτά, καὶ εὐλόγησεν αὐτοὺς μωυσῆς.

Transla.Chal.

תִּשְׁמְשָׁה יָת מַשְׁכְּנָא וְיָת כָּל־מָנוֹהִי פּוּרְפוֹהִי דַּפּוֹהִי עַבְּרוֹהִי וְעַמּוּדוֹהִי וְסַמְכוֹהִי וְיָת
חוֹפָאָה לְמִשְׁכֵי דְדִכְרֵי מְסַמְּקֵי וְיָת חוֹפָאָה לְמַשְׁכֵי דְסַסְגוֹנָא וְיָת פָּרוּכְתָּא דִפְרָסָא
תִּרְעָא וְחָדְוָתָא וְיָת אֲרִיחוֹהִי וְיָת כַּפּוּרְתָּא וְיָת פָּתוֹרָא וְיָת כָּל־מָנוֹהִי וְיָת לֶחֶם
אַפַּיָא וְיָת מְנַרְתָּא דְּכִיתָא וְיָת בּוֹצִינָהָא בּוֹצִינֵי דְסִדְרָא וְיָת כָּל־מָנָהָא וְיָת מְשַׁח
אַנְהָרוּתָא וְיָת מַדְבְּחָא דְדַהֲבָא וְיָת מְשַׁח רְבוּתָא וְיָת קְטֹרֶת בּוּסְמַיָּא וְיָת פְּרָסָא
דִּתְרַע מַשְׁכְּנָא וְיָת מַדְבְּחָא דִנְחָשָׁא וְיָת סְרָדָא דִנְחָשָׁא דִּילֵיהּ יָת אֲרִיחוֹהִי וְיָת כָּל־
מָנוֹהִי יָת כִּיּוֹרָא וְיָת בְּסִיסֵיהּ יָת סְרָדֵי דַרְתָּא יָת עַמּוּדָהָא וְיָת סַמְכָהָא וְיָת פְּרָסָא
דִּתְרַע דַּרְתָּא יָת אַטּוּנוֹהִי וְסִכַּיְהָא וְכֹל מָאנֵי פּוּלְחַן מַשְׁכְּנָא לְמַשְׁכַּן זִמְנָא וְיָת לְבוּשֵׁי
שִׁמּוּשָׁא לְשַׁמָּשָׁא בְקוּדְשָׁא יָת לְבוּשֵׁי קוּדְשָׁא לְאַהֲרֹן כַּהֲנָא וְיָת לְבוּשֵׁי בְנוֹהִי
לְשַׁמָּשָׁא כְּכֹל דְּפַקֵּיד יְיָ יָת מֹשֶׁה כֵּן עֲבָדוּ בְנֵי יִשְׂרָאֵל יָת כָּל פּוּלְחָנָא וַחֲזָא מֹשֶׁה יָת
כָּל עֲבִידְתָּא וְהָא עֲבָדוּ יָתַהּ כְּמָא דְפַקֵּיד יְיָ כֵּן עֲבָדוּ וּבָרֵיךְ יָתְהוֹן מֹשֶׁה׃

Ca.xl.

13 Complutensian polyglot Bible page

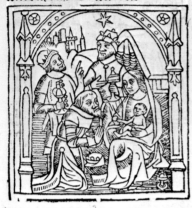

14 Two French noël title pages and the reverse of another
(l. to r.) PML 75870, 75869, 75871

gate with texts of the Hebrew Old Testament, the Septuagint translation of the Old Testament into Greek, the original Greek New Testament, and the "Chaldean" or Aramaic version of the Old Testament, along with interlinear or parallel Latin translation of the other languages. It was a staggering technological feat. Here we see a typical text page (from Exodus 39), showing the complex settings of five languages in several sizes of type.

14 ❧

FRENCH NOËLS

Les Noelz Nouueaulx….[Paris: Widow of J. Trepperel, ca. 1515]; Les grans noelz nouueaulx….Paris: A lenseigne de lescu de France [Widow of J. Trepperel, c. 1515]; Les noelz notez….[Paris: Widow of J. Trepperel, ca. 1515]. PML 75870, 75869, 75871. 8°. Purchased on the Cary Fund, 1979.

These three small books are among the earliest printed texts of French colloquial noëls or carols. Each is the only known copy to survive. Although noëls are now associated exclusively with Christmas, the term was originally simply an expression of Christian joy, and noëls were sung on feast days and other occasions. During the Middle Ages local songs and verses were often adapted to Christian themes and incorporated into the Church services, bringing the Christian message closer to the people. Similarly, popular songs were included in the cycles of "mystery plays." Beginning in the late fifteenth century these songs, or noëls, were collected and written down. By the early sixteenth century inexpensive printed collections began to appear, and it was not unusual for French families to sing noëls together in the evenings. By the end of the century, the custom had dwindled to Christmas eve.

The Library's noëls were all printed at the Paris printing shop established by Jean Trepperel, which specialized in pamphlets for popular consumption. Following Trepperel's death in 1511 or 1512, his widow carried on his trade, and it is her imprint that appears on these books. Tiny ephemeral pamphlets such as these preserve the historic regional patois of France; they are also important as unique examples of early French printing and as early musical sources. These books were previously owned by the distinguished Geneva collector Edmée Maus. Her collection of thirty-five unique copies of the earliest French popular farces and plays, also printed by the Trepperels, is now in the Bibliothèque Nationale.

15 Title page from Ronsard's *Amours* 16 Page from Spenser, *The Shepheardes Calender*

15 ❧

RONSARD'S *AMOURS*

Pierre de Ronsard. *Les Amours*. Paris: Widow of Maurice de la Porte, 1552. 8°. Heineman 210. Dannie and Hettie Heineman Collection, donated in 1977.

Pierre de Ronsard (1524-85) was the central figure of the Pléiade, the circle of seven poets who revivified and redirected French literature in the mid-sixteenth century under the influence of classical and Italian models. His *Amours* is a collection of love sonnets in the style of the Italian *canzoniere* written to several women, most notably Cassandre Salviati, daughter of a Florentine banker resident in Paris. She is portrayed voluptuously in her twentieth year in an engraving in this elegant little book. She and Ronsard, shown crowned with the poet's laurel in his twenty-seventh year, gaze at each other across the pages. Couplets in Greek by Ronsard's fellow-poet Jean-Antoine de Baïf complement the classical attire of the lovers. (A third member of the Pléiade was Jean Dorat, the brilliant tutor who taught Ronsard Greek.)

Like others of Ronsard's early collections,

this is a striking piece of printing from a time when Parisian book production was the most beautiful in Europe. It was issued by the widow of Maurice de la Porte, a printer who provided books for the University of Paris, which is reflected in the technical achievement of the extensive appendix of musical notation, giving settings by several composers for a number of the sonnets. But this technological accomplishment only enhances the overall feel of elegance that the book epitomizes. With true Gallic bibliophilic verve, the book is contemporaneously ruled throughout in red borders on every page, including the blanks.

The book is of great rarity: we know of no other copy in the United States. This copy itself was formerly owned by Prosper Blanchemain, the nineteenth-century scholar who brought Ronsard's work back to the prominence it now holds after several centuries of neglect.

16 ❧

SPENSER, *SHEPHERD'S CALENDAR*

Edmund Spenser. *The Shepheardes Calender Contayning Twelue Aeglogues Proportionable to the Twelue Monethes*. London: Hugh

Singleton, 1579. 4°. PML 127066. Purchased on the Gordon N. Ray Fund, 1990.

Edmund Spenser (1552-99) was the most important English poet after Chaucer. In *The Shepheardes Calender* he set the tone for other poets of his time, which they might ignore only at their peril. His pastoral theme of love debated by shepherds is based upon Virgil's *Eclogues,* but his models were varied. In the illustrated November eclogue, for instance, he says that he used Clément Marot's lament for a dead queen of France, but his moral is that death has no sting. In the leafless month of November, we see a funeral procession symbolic of the dying year winding its way to church, behind a shepherd crowning his friend who plays the pipes (fol. L4r).

This is the first edition of Spenser's first major work, which he dedicated to Sir Philip Sidney, the author of *Arcadia.* This is one of only seven known copies of the first edition. It was previously owned by the important American bibliophile Henry Bradley Martin. The first folio edition of Spenser's collected poetry appeared in 1611, and before that time five editions of *The Shepheardes Calender* had been published in quarto, all of which are in the Morgan Library. The Morgan Library has strong collections of Spenser and of English literature in first and significant later editions.

17 ❧

BIBLE

The Holy Bible…Newly Translated out of the Originall Tongues. London: Robert Barker, 1611. F° PML 5460. Purchased by Pierpont Morgan, date unknown.

This is the first edition of the Bible in English, known alternatively as the Authorized Version or the King James Bible. From the time of its publication in 1611 to the late nineteenth century, it remained the only English translation of the Bible used in the service of the Anglican Church. It is still today the form of the scriptural text most familiar to the English-speaking world, cherished equally for its spiritual and literary qualities. In the words of the English historian Thomas Macaulay, it is "a book which if everything else in our language should perish, would alone suffice to show the extent of its beauty and power."

The motivation for the creation of this Bible was part of an effort by James I to achieve a compromise between the High Church and the Puritans. Almost immediately after his accession to the throne in March 1603, he was presented with a petition by a thousand dissenting Puritan ministers. Well aware that they were a strong group in Parliament, James called a conference of Puritan and Anglican divines which met under his personal chairmanship at Hampton Court in January 1604. On balance, the Puritans were dissatisfied with the results of the conference, which led many to emigrate to Holland and ultimately to America. One point of agreement, however, was the decision to prepare a new version of the English Bible. For this purpose a team of forty-seven revisers, drawn almost equally from both parties, was created. The aim of the revisers was to produce a text that could be understood by all, scholar and plowboy alike, and still be authoritative and accurate.

17 Title page from the King James Bible

Selection of the team and rules for revision alone took five months. The revisers worked in six groups, each of which was allocated a certain portion of the biblical text to work on, and then drafts were circulated among them all. A wide array of important editions of the Bible in English and other languages was consulted. The initial work was completed in two years; the final text was hammered out by a committee of six who sat in London every day for nine months. To protect the theological compromises made by both sides, almost no records of the enterprise or the discussions were kept. The result of their efforts was, according to the *Oxford History of English Literature,* "the noblest monument of English prose." The vocabulary is relatively small, but great use is made of rhythm and cadence. It is certainly the only literary masterpiece ever produced by a committee.

18 &

SIR FRANCIS BACON

[Novum organum]. Francisci de Verulamio,… Instauratio magna. London: B. Norton and J. Bill, 1620. F° PML 42969. Purchased as the gift of Roland L. Redmond, 1952.

This is the first edition of *Novum organum,* the "new organum or instrument" in which Francis Bacon (1561-1626) sets forth his theory of scientific method designed to impart "true directions concerning the interpretation of nature." The engraved frontispiece shows a ship in full sail passing through the Pillars of Hercules from the old world to the new. It is an emblem of the ambitions of the author, who wished to achieve nothing less than *Instauratio magna,* a "great instauration or establishment," that would be "the total reconstruction of the sciences, arts and human knowledge." This large philosophical work was intended to be in five parts, only three of which were completed. The *Novum organum* is the first. The Library also owns copies of Bacon's *The Advancement of Learning* (1605), in which he first addressed the classification of knowledge. Bacon's work set a model for many later attempts at classification; in the eighteenth century it was the foundation on which the French *philosophes* constructed the *Encyclopédie.*

Francis Bacon contended that it was impossible to continue to accept that all knowledge had been discovered by Aristotle or could logically be deduced from his writings. Instead, he proposed that knowledge be based on direct observation of perceived facts, regardless of whether this contradicted the authority of the ancients. His emphasis on direct observation from available evidence had a profound influence in grounding the next generation of English scientists, or natural philosophers as they were then called, in the experimental method.

Bacon was born into the highest ranks of Tudor civil service; his father was lord keeper and his uncle was Elizabeth I's chief minister. He trained as a lawyer and had an unparalleled belief in his considerable abilities. Bacon's great political opportunities came in the reign of James I. He was appointed attorney general in 1613, and his contemporaries were often shocked by his fierce prosecution of cases. He rose to the lord chancellorship in 1618, by which time he had made many enemies. His public life came to an abrupt end in 1621 when he was convicted of taking bribes. The remaining five years of his life were devoted to writing. He died in 1626, the result of a chill caught while stuffing a chicken with snow to observe the effects of cold on the preservation of the flesh. It is telling of Bacon's character that he describes his method of experiment thus: "Nature, like a witness, when put to the torture would reveal her secrets."

He is seen to best advantage as a writer and student of human nature in his essays, which appeared between 1597 and 1625 and set the English pattern for short prose pieces. The Library's extensive holdings of Bacon were built on the foundation of the gift in 1942 of Roland L. Redmond's important collection. The Library owns copies of all the essays issued during Bacon's lifetime from the third edition and many other works including his *History of Henry VII,* notable for being an early history rather than a simple chronicle.

19 &

FIRST FOLIO

William Shakespeare. *Mr. William Shakespeares Comedies, Histories, & Tragedies.* London: Isaac Jaggard & Edmund Blount, 1623. F°. PML 5122. Purchased by Pierpont Morgan with the Toovey Collection, 1899.

Across the centuries, Shakespeare stares at us in Droeshout's famed portrait on the title page of the First Folio, and yet, as Ben Jonson wrote,

18 Title page from Bacon's *Novum organum*

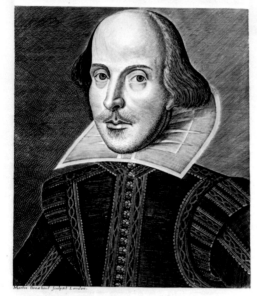

Mr. WILLIAM
SHAKESPEARES
COMEDIES,
HISTORIES, &
TRAGEDIES.

Published according to the True Originall Copies.

LONDON
Printed by Isaac Iaggard, and Ed. Blount. 1623.

19 Title page of the First Folio

Thou art a Moniment, without a tombe
And art still alive, while thy Booke doth live.

This monument more lasting than bronze has been fundamental in keeping alive Shakespeare's genius, from the day it was published some seven years after his death. One of the great landmarks in English literature, it is likewise a monument in the history of the English language as we have spoken, written, and developed it over the past four centuries. The great moments and characters in Shakespeare's plays are more real to us than the history books.

This first collected edition of Shakespeare's plays is universally known from its format as the First Folio. Three more would follow over the years, and *Pericles* would not appear in print until the Third Folio, of 1664. About half the plays had been issued before 1623 in single, small quarto editions, selling for about six-

pence apiece. Not all of them, however, were based upon authoritative texts. The texts for the First Folio, for all their faults, established standards and were supplied by Shakespeare's old acting company, which drew on a mixture of sources: various of the quarto editions, occasionally with manuscript revisions; manuscript prompt books; even Shakespeare's final drafts. The First Folio may fairly be described as the single greatest printed book in the English language. This volume is one of the very few survivors of the first printing, without *Troilus and Cressida*.

20 &

The Eliot Indian Bible

*Mamusse wunneetupanatamwe up-biblum god....*Ne quoshkinnumuk nashpe Wuttinneumoh Christ nob asoowesit John Eliot. *The Holy Bible: containing the Old Testament and the New.* Translated into the Indian Language....Cambridge: Printed by Samuel Green and Marmaduke Johnson, 1663 [& 1661]. 4°. PML 5440. Purchased by Pierpont Morgan with Theodore Irwin's library, 1900.

The first Bible produced in North America was printed in the Massachusetts Bay Colony not in the language of the English colonists but in the Massachuset language, an Algonquin Indian dialect. This copy of the first edition of 1663 is inscribed: Thomas Shepard's Book 2.6.1666 ye gift of ye Revd. Translator. The "Revd. Translator" was John Eliot (1604-90), a Puritan minister living in Roxbury, Massachusetts, who began to learn the Indian language in about 1643 and by 1648 was preaching to the Indians in their native tongue.

Eliot, who had been educated at Cambridge, arrived in Boston in 1631 on the same ship with the wife and children of John Winthrop, the governor of Massachusetts Bay Colony. The following year he was appointed teacher in the Roxbury church, a post he held to the end of his life. Almost immediately he began to show concern for the temporal as well as spiritual welfare of the Indians. He encouraged the formation of self-governing settlements and worked to secure clothing, housing, and other necessities for them.

He probably began his translation of the Bible around 1646; it was completed by 1658. The task of setting the translation into type was the most ambitious printing project then undertaken in the English colonies. The first

press in the colonies had arrived from England in late 1638 and was set up in Cambridge, Massachusetts. Its first printer was Stephen Daye. In 1639, Eliot had helped to edit the so-called Bay Psalm Book. In 1649, Samuel Green acquired the press from Daye (or possibly from his son Matthew), and it was he who undertook the monumental task of printing Eliot's Indian Bible. The project was underwritten by the recently formed Corporation for Promoting and Propagating the Gospel of Jesus Christ in New England, the first English missionary society. The corporation sent paper, types, and an assistant printer named Marmaduke Johnson from London in 1660. The Indians played important roles in making the Bible. Eliot was helped with his translation by John Nesutan, a native preacher who had studied at Harvard, and Green and Johnson were assisted in the production by a Nipmuck tribesman named James Printer. By the summer of 1661, 1,500 copies of the New Testament were complete. Five hundred were distributed and the balance held back to be bound with the Old Testament and published in 1663. The Library's copy is a complete first edition with both Old and New Testaments. Most of the copies of the Bible were destroyed during King Philip's War (1675-76), which caused other losses: John Nesutan, who served in the colonial forces against his own people, was killed;

James Printer left his trade to fight the colonists but later returned.

Eliot, often referred to as the Indian apostle, is regarded as one of the most dedicated and compassionate of the colonial missionaries. Just before his death, he donated seventy-five acres of land for the "teaching of Indians and Negroes." Cotton Mather, not noted for the generosity of his judgment, wrote, "He that would write of Eliot must write of charity or say nothing."

21 &

ISAAC NEWTON

Philosophiae naturalis principia mathematica. London: Joseph Streater, for the Royal Society, 1687. 4°. PML 78144. Purchased by the Heineman Foundation for the Dannie and Hettie Heineman Collection, 1984.

The *Principia* has been described as the greatest work in the history of science. In it, Newton (1642-1727) provided for the first time a mathematical description of his law of universal gravitation and demonstrated that all the motions of the universe could be explained by the application of this single principle. The circumstances leading to its publication effectively began with a wager made by Sir Christopher

20 First title page of 1663 Eliot Indian Bible

21 Title page of Newton, *Principia*

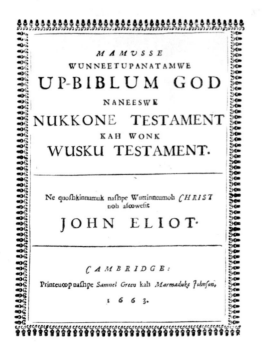

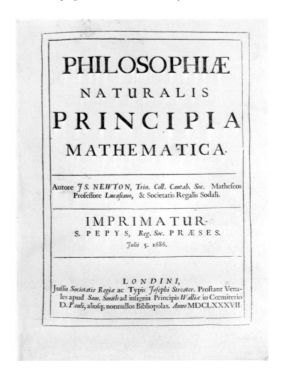

Wren that no one could prove the motion and orbits of the planets. Edmund Halley, the astronomer royal, went to Cambridge to consult Isaac Newton in August of 1684. Because Newton was known to be reclusive – difficult but brilliant – Halley came to the point immediately: "What would the curve be described by the planets supposing that gravity diminished as the inverse square of the distance?" "An ellipse," Newton replied, to Halley's amazement, "I have calculated it." The problem was of such insignificance to Newton that he had not bothered to keep the formal proof. Moreover, after the controversy surrounding the publication of his earlier papers on optics, he never intended to make any of his discoveries public. At Halley's urging, Newton rewrote the proof and also prepared lectures on planetary motion. Writing the *Principia* took precisely twenty-one months. Only after great encouragement from Halley, including correcting the printer's proofs and underwriting the cost of printing, were 300 or so copies of the first edition published in 1687. The premises of Newton's theories of the physical universe remained unchallenged until the twentieth century and provided the model for all fields of scientific thought for the next two hundred years and more.

Isaac Newton was born on Christmas day 1642, the premature, posthumous child of an illiterate farmer. He was not expected to live, being, in his own words, "so small that I might have been put in a quart mug." He received some elementary education, but spent more time hiding under hedges with his books and calculations than learning farming. At an uncle's suggestion, he was sent to Cambridge in 1661. In 1665 he returned home because of the plague. Before his return to Cambridge in 1667, Newton devised, in addition to numerous mathematical discoveries, his "fluxions," which we know as calculus, discovered white light to be a compound of the colors of the spectrum, and first conceived his universal law of gravitation. One of the greatest mathematicians of all time, he spent the vast portion of his life involved in the study of alchemy and problems of theology. Idolized by his own country and revered by the world, he died at age eighty-four and was buried in Westminster Abbey.

22 🙢

PHILLIS WHEATLEY

Poems on Various Subjects, Religious and Moral. London: For A. Bell, 1773. 4°. PML 77263. Bequest of Miss Tessie Jones in memory of her father, Herschel V. Jones, 1968.

Phillis Wheatley (ca. 1753-84), the first black American poet, arrived on a slave ship in Boston harbor in 1761, when she was about eight years old. She was purchased by John Wheatley, a prosperous Boston merchant, whose family taught her to read and encouraged her literary ambitions. By the age of about twelve or thirteen, she was writing occasional verse. This is the first edition of her collected poems, published in London in 1773. The Library's copy has the author's signature on the verso of the title page. The frontispiece includes an engraved portrait of the author by Scipio Moorhead, a slave owned by a Boston minister. Phillis's poem, "To S. M.: A Young African Painter, On Seeing His Works," is among the thirty-nine poems in this volume. The Library also has the first American edition of her collected poems, published posthumously *(Phillis Wheatley. Poems on Various Subjects, Religious and Moral.* Philadelphia: Joseph Crukshank, 1786. 12°. PML 127050. Purchased on the Gordon N. Ray Fund, 1990).

Prior to the London publication of her collected works, several of her poems had appeared in print in America and had brought her considerable recognition among Boston intellectuals. Her principal themes, learning, virtue, and redemption through Christ, were influenced by her extensive reading of Alexander Pope. Her efforts to raise subscriptions in

22 Author's signature on flyleaf of *Poems*

Entered at Stationer's Hall.

Phillis Wheatley

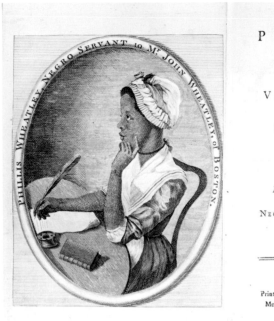

Published according to Act of Parliament, Sept.ʳ 1.1773 by Archᵈ Bell.
Bookseller Nº 8 near the Saracens Head Aldgate.

22 Frontispiece and title page of Wheatley's *Poems*

America for the publication of a volume of collected works failed, however, to generate sufficient response, and she attempted a British publication. The project was brought to fruition when she was able to travel to London in 1772 with Wheatley's son Nathaniel. The London edition is dedicated to Lady Huntingdon, a prominent English Methodist who was instrumental in obtaining support for the book. *Poems on Various Subjects, Religious and Moral* was finally published in September of 1773, a few months after Phillis's return to America. That same fall she was legally freed.

In 1778 she was married to a free black man, who, according to a contemporary memoir, was "disagreeable and unable to give Phillis the care she needed." Always physically frail, she died alone and in poverty in 1784, at the age of about thirty. Her achievements were cited as proof of antislavery arguments that blacks had intellectual capacity and could profit by education, something doubted by many during the eighteenth century.

23 ❧

ENCYCLOPÉDIE

Denis Diderot, editor, *Encyclopédie; ou, Dictionnaire raisonné des sciences, des arts et des métiers, par une société des gens des lettres.* Paris: Chez Briasson, David l'aîné, Le Breton,

Durand, 1751-80. F°. PML 78072-78106. Purchased on the H. S. Morgan Fund and the General Book Fund, 1984.

Far from being a neutral compendium of useful knowledge, Diderot's *Encyclopédie* was, at the time of its publication, tantamount to a political manifesto. Its thirty-five folio volumes, published over a period of twenty-nine years, were an attempt on the part of radical French intellectuals to establish their authority—by virtue of their superior reason and intellect—to provide a "systematic account of order and concatenation of human knowledge."

The Tree of Knowledge in volume one, illustrated here, was adapted as a visual metaphor for their revolutionary approach to the world as "natural." The device is derived from Bacon, but with significant variation: Where Bacon had divided human knowledge into Memory, Imagination, and Reason, he also allowed for divine learning to account for revelation. In the hands of the encyclopedists, the largest part of human understanding is defined as the domain of "Philosophy," and they did not allow of any knowledge that was not empirical. This classification held that it was not tradition, church, government, or royal academies that defined the world, but experience and reason. Worse still, church and government were subject to criticism by reason, i.e. the encylopedists.

The project began innocently enough with a

23 Frontispiece to the *Encyclopédie*, engraved by
B. L. Prevost after a design by C. N. Cochin, fils

d'Alembert, who resigned from the project in
1758. In 1759, the seven volumes that had ap-
peared to date were banned by the government
and placed on the index by the pope. For the
next twenty years Diderot carried on alone,
writing countless small articles and many
major ones, while dealing with the editorial
business and the unremitting attacks of
enemies. It is hard to believe that so substantial
a work was an "underground publication."
Any ordinary man would have been worn out,
but Diderot had at least two other simulta-
neous careers. His salons made him the virtual
founder of French art criticism and, though he
published almost nothing in his lifetime, he is
now considered a major creative writer.

24 ❧

THE DECLARATION OF INDEPENDENCE

"In Congress, July 4, 1776. A Declaration."
Philadelphia: Printed by John Dunlap, [1776].
F° broadside. PML 77518. Gift of the Robert
Wood Johnson, Jr., Charitable Trust, 1982.

The Declaration of Independence is the formal
statement by the Continental Congress an-
nouncing the separation of the thirteen colo-
nies from Great Britain and the birth of the
United States. This is one of twenty-five re-
corded copies of the first printing of this most
timeless and eloquent of American historical
documents. In June of 1776 a Committee of
Five was chosen to draft Congress's resolution
to break from Great Britain. Thomas Jefferson
wrote the rough draft, which was then slightly
revised by the other members of the committee
in the weeks following Congress's meeting in
Philadelphia. The Declaration was approved
on July 2, and over the next two days it was
again revised before the committee was autho-
rized to print the corrected text. On the evening
of July 4, a manuscript copy of the Declaration
was taken to the printing shop of John Dunlap,
a short walk from the State House in Phila-
delphia. He spent the night setting type, and
printed copies were ready for delivery in the
morning. The broadside was sent to "the sev-
eral Assemblies, Conventions & Committees
or Councils of Safety and to the several Com-
manding Officers of the Continental troops"
and soon appeared in newspapers throughout
the colonies. Perhaps no piece of American
news had been so widely or urgently dissem-
inated.

The Library's copy belonged to Benjamin

proposal to publish a French translation of
Chambers's *Cyclopaedia* (London, 1728). The
plan changed, however, as the printer Le Breton
took in several partners and the brilliant young
Denis Diderot (1713-84) as editor. At the time,
Diderot was in prison, the consequence of one
of several skirmishes with government censors.
His release was obtained through the influence
of the publishers with the promise that the first
volume would be dedicated to the royal direc-
tor of publications. Diderot proceeded to enlist
the aid of the eminent mathematician Jean
d'Alembert (1717-83). Together they recruited
almost every French intellectual radical of the
day, including Voltaire, Montesquieu, and
Rousseau. Each volume was a *succès de scan-
dale* throughout Europe. The number of sub-
scribers jumped from one to four thousand.
The court, the church, and the judiciary were
outraged. The struggle proved too much for

In CONGRESS, July 4, 1776.

A DECLARATION

By the REPRESENTATIVES of the

UNITED STATES OF AMERICA,

In GENERAL CONGRESS ASSEMBLED.

WHEN in the Course of human Events, it becomes neceſſary for one People to diſſolve the Political Bands which have connected them with another, and to aſſume among the Powers of the Earth, the ſeparate and equal Station to which the Laws of Nature and of Nature's God entitle them, a decent Reſpect to the Opinions of Mankind requires that they ſhould declare the cauſes which impel them to tl e Separation.

We hold theſe Truths to be ſelf-evident, that all Men are created equal, that they are endowed by their Creator with certain unalienable Rights, that among theſe are Life, Liberty, and the Purſuit of Happineſs—-That to ſecure theſe Rights, Governments are inſtituted among Men, deriving their juſt Powers from the Conſent of the Governed, that whenever any Form of Government becomes deſtructive of theſe Ends, it is the Right of the People to alter or to aboliſh it, and to inſtitute new Government, laying its Foundation on ſuch Principles, and organizing its Powers in ſuch Form, as to them ſhall ſeem moſt likely to effect their Safety and Happineſs. Prudence, indeed, will dictate that Governments long eſtabliſhed ſhould not be changed for light and tranſient Cauſes; and accordingly all Experience hath ſhewn, that Mankind are more diſpoſed to ſuffer, while Evils are ſufferable, than to right themſelves by aboliſhing the Forms to which they are accuſtomed. But when a long Train of Abuſes and Uſurpations, purſuing invariably the ſame Object, evinces a Deſign to reduce them under abſolute Deſpotiſm, it is their Right, it is their Duty, to throw off ſuch Government, and to provide new Guards for their future Security. Such has been the patient Sufferance of theſe Colonies; and ſuch is now the Neceſſity which conſtrains them to alter their former Syſtems of Government. The Hiſtory of the preſent King of Great-Britain is a Hiſtory of repeated Injuries and Uſurpations, all having in direct Object the Eſtabliſhment of an abſolute Tyranny over theſe States. To prove this, let Facts be ſubmitted to a candid World.

He has refuſed his Aſſent to Laws, the moſt wholeſome and neceſſary for the public Good.

He has forbidden his Governors to paſs Laws of immediate and preſſing Importance, unleſs ſuſpended in their Operation till his Aſſent ſhould be obtained; and when ſo ſuſpended, he has utterly neglected to attend to them.

He has refuſed to paſs other Laws for the Accommodation of large Diſtricts of People, unleſs thoſe People would relinquiſh the Right of Repreſentation in the Legiſlature, a Right ineſtimable to them, and formidable to Tyrants only.

He has called together Legiſlative Bodies at Places unuſual, uncomfortable, and diſtant from the Depoſitory of their public Records, for the ſole Purpoſe of fatiguing them into Compliance with his Meaſures.

He has diſſolved Repreſentative Houſes repeatedly, for oppoſing with manly Firmneſs his Invaſions on the Rights of the People.

He has refuſed for a long Time, after ſuch Diſſolutions, to cauſe others to be elected; whereby the Legiſlative Powers, incapable of Annihilation, have returned to the People at large for their exerciſe; the State remaining in the mean time expoſed to all the Dangers of Invaſion from without, and Convulſions within.

He has endeavoured to prevent the Population of theſe States; for that Purpoſe obſtructing the Laws for Naturalization of Foreigners; refuſing to paſs others to encourage their Migrations hither, and raiſing the Conditions of new Appropriations of Lands.

He has obſtructed the Adminiſtration of Juſtice, by refuſing his Aſſent to Laws for eſtabliſhing Judiciary Powers.

He has made Judges dependent on his Will alone, for the Tenure of their Offices, and the Amount and Payment of their Salaries.

He has erected a Multitude of new Offices, and ſent hither Swarms of Officers to harraſs our People, and eat out their Subſtance.

He has kept among us, in Times of Peace, Standing Armies, without the conſent of our Legiſlatures.

He has affected to render the Military independent of and ſuperior to the Civil Power.

He has combined with others to ſubject us to a Juriſdiction foreign to our Conſtitution, and unacknowledged by our Laws; giving his Aſſent to their Acts of pretended Legiſlation:

For quartering large Bodies of Armed Troops among us:

For protecting them, by a mock Trial, from Puniſhment for any Murders which they ſhould commit on the Inhabitants of theſe States:

For cutting off our Trade with all Parts of the World:

For impoſing Taxes on us without our Conſent:

For depriving us, in many Caſes, of the Benefits of Trial by Jury:

For tranſporting us beyond Seas to be tried for pretended Offences:

For aboliſhing the free Syſtem of Engliſh Laws in a neighbouring Province, eſtabliſhing therein an arbitrary Government, and enlarging its Boundaries, ſo as to render it at once an Example and fit Inſtrument for introducing the ſame abſolute Rule into theſe Colonies:

For taking away our Charters, aboliſhing our moſt valuable Laws, and altering fundamentally the Forms of our Governments:

For ſuſpending our own Legiſlatures, and declaring themſelves inveſted with Power to legiſlate for us in all Caſes whatſoever.

He has abdicated Government here, by declaring us out of his Protection and waging War againſt us.

He has plundered our Seas, ravaged our Coaſts, burnt our Towns, and deſtroyed the Lives of our People.

He is, at this Time, tranſporting large Armies of foreign Mercenaries to compleat the Works of Death, Deſolation, and Tyranny, already begun with circumſtances of Cruelty and Perfidy, ſcarcely paralleled in the moſt barbarous Ages, and totally unworthy the Head of a civilized Nation.

He has conſtrained our fellow Citizens taken Captive on the high Seas to bear Arms againſt their Country, to become the Executioners of their Friends and Brethren, or to fall themſelves by their Hands.

He has excited domeſtic Inſurrections amongſt us, and has endeavoured to bring on the Inhabitants of our Frontiers, the mercileſs Indian Savages, whoſe known Rule of Warfare, is an undiſtinguiſhed Deſtruction, of all Ages, Sexes and Conditions.

In every ſtage of theſe Oppreſſions we have Petitioned for Redreſs in the moſt humble Terms: Our repeated Petitions have been anſwered only by repeated Injury. A Prince, whoſe Character is thus marked by every act which may define a Tyrant, is unfit to be the Ruler of a free People.

Nor have we been wanting in Attentions to our Britiſh Brethren. We have warned them from Time to Time of Attempts by their Legiſlature to extend an unwarrantable Juriſdiction over us. We have reminded them of the Circumſtances of our Emigration and Settlement here. We have appealed to their native Juſtice and Magnanimity, and we have conjured them by the Ties of our common Kindred to diſavow theſe Uſurpations, which, would inevitably interrupt our Connections and Correſpondence. They too have been deaf to the Voice of Juſtice and of Conſanguinity. We muſt, therefore, acquieſce in the Neceſſity, which denounces our Separation, and hold them, as we hold the reſt of Mankind, Enemies in War, in Peace, Friends.

We, therefore, the Repreſentatives of the UNITED STATES OF AMERICA, in GENERAL CONGRESS, Aſſembled, appealing to the Supreme Judge of the World for the Rectitude of our Intentions, do, in the Name, and by Authority of the good People of theſe Colonies, ſolemnly Publiſh and Declare, That theſe United Colonies are, and of Right ought to be, FREE AND INDEPENDENT STATES; that they are abſolved from all Allegiance to the Britiſh Crown, and that all political Connection between them and the State of Great-Britain, is and ought to be totally diſſolved; and that as FREE AND INDEPENDENT STATES, they have full Power to levy War, conclude Peace, contract Alliances, eſtabliſh Commerce, and to do all other Acts and Things which INDEPENDENT STATES may of right do. And for the ſupport of this Declaration, with a firm Reliance on the Protection of divine Providence, we mutually pledge to each other our Lives, our Fortunes, and our ſacred Honor.

Signed by ORDER and in BEHALF of the CONGRESS,

JOHN HANCOCK, PRESIDENT.

ATTEST.
CHARLES THOMSON, SECRETARY.

PHILADELPHIA: PRINTED BY JOHN DUNLAP.

Chew (1722-1810), chief justice of Pennsylvania. Folded neatly and filed among his private papers, it was preserved—clean and fresh as the day it was printed—until it was auctioned in New York in 1982. Ironically, perhaps, Chew did not show a conspicuous enthusiasm for the patriot cause. Despite his friendship with Washington, he was relieved of his public posts and remained for some while under house arrest.

25 ❧

WILLIAM BLAKE

Songs of Innocence. The Author & Printer W. Blake, 1789. [Relief etching with added watercolor, etched 1789, printed about 1794.] Copy D. PML 58636. Bequest of Miss Tessie Jones in memory of her father, Herschel V. Jones, 1968.

For all the scholarly disagreement over the poet and mystic William Blake (1757-1827), he remains a highly important figure in the development of the book arts. "The Lamb" is among the best known of Blake's group of poems,

25 From Blake's *Songs of Innocence*

which appeared as *Songs of Innocence* (1789) and *Songs of Innocence and of Experience* (1794). It expresses his mystical faith in the unseen and the unknowable. As a youth, he apprenticed under the engraver James Basire and for about thirty years was best known as the engraver of other artists' work. In 1789, however, Blake broke new ground with *Songs of Innocence*, the first of his illuminated books. These were produced using a new etching technique, which he believed had been communicated to him by his deceased younger brother in a dream. Blake drew the text and design on the surface of the plate and then etched away the surrounding areas, leaving the printing surface in relief. After printing the plates, he and his wife added color and gold by hand. Each printed volume is therefore a unique copy, with variations in ink and coloring. To make books in this way took great amounts of time, and copies of these texts were assembled as required by patrons. They were not published in the usual sense.

This copy of *Songs of Innocence* is among the earliest issued by Blake. It was owned by Ann Flaxman, wife of the painter John Flaxman, one of Blake's few close friends and supporters. She and her husband financed his first and only typographically conventional book of poetry, *Poetical Sketches*, published in 1783. The Library's collection of Blake, which was already major, became even more renowned in 1972 with the addition of Mrs. Landon K. Thorne's collection. The holdings include original drawings and manuscripts as well as multiple copies of various illuminated books.

26 ❧

JOHANN WOLFGANG VON GOETHE

Zur Farbenlehre. Tübingen: J. G. Cotta, 1810. 8°. 2 v. + 2 v. plates. Heineman 663. Dannie and Hettie Heineman Collection, donated in 1977.

For many, Goethe (1749-1832) is best known as a literary figure, the author of *Faust* and *The Sorrows of Young Werther.* He possessed a great intellectual energy and curiosity, however, and wrote extensively on art theory and criticism, geology, archaeology, botany, and physics. During the course of his long life he produced fourteen volumes of scientific writing. *Zur Farbenlehre (On the Theory of Colors)* is his fierce and in many ways misguided attack on Newton's discovery, pub-

26 Plate I from Goethe, *Zur Farbenlehre*

lished more than a century earlier, that white light is a composite of various colors that can be separated through a prism. Before Newton, scientists had considered white light to be pure. Goethe held to the older idea, asserting that colors result from the mixing of light and darkness and that all things are sufficiently turbid to create color. Nevertheless, his theory is not without merit as a study of the psychology of color perception: Goethe identified the three primary colors—yellow, blue, and red—as the most pure color sensations. His idea that the human brain responds to color as emotion and will generate compensatory sensations to balance the effect of color was to be remarkably influential in subsequent German philosophy and psychology.

Goethe's interest in the natural sciences was stimulated when as a young man he became a minister of state to the duke of Weimar. In the execution of his duties he instructed himself in agriculture, horticulture, and mining, all of which were of paramount importance to the economy of the duchy. His discovery in 1785 of formations in the human jawbone analogous to those in apes prefigured the insights of Darwin. In 1791, he published his studies in plant morphology which were even more important for the development of the science of botany. All the time he was working on his novel *Wilhelm Meister Lehrjahre* (1795-96) and completing the first part of *Faust* (1808), generally regarded as one of the classics of world literature.

Zur Farbenlehre is among the number of important printed books and manuscripts collected by Dannie and Hettie Heineman. Dannie Heineman was especially interested in Goethe, and the collection contains a number of early editions (including four presentation copies) as well as manuscript portions of *Faust,* Part II, and "Die wandelnde Glocke." Other strengths of the Heineman collection are science and philosophy, ranging from works by Galileo to Einstein, French and German literature of the eighteenth and nineteenth centuries, and music manuscripts.

27 ❧

Pierre-Joseph Redouté

Les Roses, par P. J. Redouté, peintre de fleurs....Avec le texte par Cl. Ant. Thory.... Paris: Firmin Didot, 1817-24. PML 45395-45397. Estate of Mrs. J. P. Morgan; gift of Junius S. Morgan and Henry S. Morgan, 1953.

Les Roses is the most celebrated and reproduced of all flower books. It was produced following the surge in natural history studies of the eighteenth century, when the creation of lavishly illustrated plant and animal books was greatly in vogue. Redouté's work represents a pinnacle of excellence in the specialized field of flower illustration. The 169 engraved plates of *Les Roses* comprise virtually all the important varieties then known.

Reproduced here is the *Rosa centifolia bullata,* engraved by Langlois, one of the most famous in the series and a superb example of Redouté's art and of stipple engraving, which he fostered. This painstaking technique, which he may have learned in England, produces images of unrivaled delicacy and precision. It was achieved by puncturing the plate using either indented tools, individual points of a needle, or etched dots to create an infinity of small recesses of varying sizes and depths, each of which would hold a minute quantity of ink. This allowed the engraver to reproduce the slightest nuance of tone in the original drawings. The printing in colors was usually done from a single plate; the colors were applied individually with a rag ball and the plate re-inked before each impression. The Library's copy of *Les Roses* is one of a few with the plates printed on large paper and in both colored and uncolored states. The color printed set has been finished with additional hand-coloring, which may be by Redouté himself. In addition, the Library has two signed watercolors on vellum from which the engravings were made.

Pierre-Joseph Redouté (1759-1840), born in Luxembourg, spent most of his life in France. In Paris he trained with the great Dutch flower painter Gerard van Spaendonck, under whose supervision he painted over six thousand watercolors for the collection of the Muséum National d'Histoire Naturelle. His career was greatly assisted by his ability to attract influential patrons. Just prior to the Revolution, he was appointed draughtsman to the cabinet of Marie-Antoinette (while imprisoned in the Temple she reportedly sent for him to paint a cactus which had particularly taken her fancy). As the "official painter" to the Empress Josephine, Redouté was commissioned to commemorate the species of lilies and other flowers in her garden at Malmaison. The Library also has *Les Liliacées* (1802-16), a sumptuous production of 503 plates. With the end of imperial patronage, following Napoleon's defeat at Waterloo, Redouté began to publish

Rosa centifolia Bullata.

Rosier à feuilles de Laitue.

P. J. Redouté pinx.

Imprimerie de Remond

Langlois sculp.

27 *Rosa centifolia bullata*, engraving after Redouté from *Les Roses*

Les Roses, in parts, each containing six plates. In this way he capitalized on his reputation and continued to live the lavish way of life to which he had become accustomed. Redouté was prodigal with money, however, and despite his fame and skill, he died in poverty.

The Library owns all of Redouté's major works. *Les Roses* was among the large and important group of garden and horticultural books formed by Mrs. J. P. Morgan.

28 ≥

ANTHONY TROLLOPE

The Small House at Allington. London: Smith, Elder and Co., 1864. 2v. 8°. GNR 2175. Bequest of Gordon N. Ray, 1987.

Anthony Trollope (1815-82), whose many novels deal with life in the Victorian era, is credited with having created the English multi-novel series. *The Small House at Allington* (1864) is set in the cathedral town of Barchester. Many of the same characters weave in

28 Wood engraving after J. E. Millais, from Trollope, *The Small House at Allington*

"HE IS OF THAT SORT THAT THEY MAKE THE ANGELS OF," SAID THE VERGER.

and out of four other novels, which were later issued as a collected edition – the Chronicles of Barsetshire. Besides some half a dozen books from the library of Trollope's son Henry, the Morgan Library has the autograph manuscripts of two of Trollope's works as well as some letters. Among the letters are several from the correspondence of the artist John Everett Millais, the illustrator of this edition of *The Small House at Allington*. Here we see an example of Millais's effective style of characterization. Between September 1862 and April 1864, the book was serialized in the *Cornhill Magazine,* where Millais also included historiated initials that do not appear in the book.

The Morgan Library has a strong collection of Victorian literature, including books in parts, the form in which many of the novels of the period were first issued, autograph manuscripts, and presentation copies. Among the popular authors particularly well represented are Dickens, Thackeray, Ruskin, and Trollope. This volume has a bright green embossed and gilt publisher's binding.

29 ≥

EDGAR ALLAN POE

Le Corbeau. The Raven. Poëme par Edgar Poe, traduction française de Stéphane Mallarmé, avec illustrations par Edouard Manet. Paris: Richard Lesclide, Éditeur, 1875. GNR Fr. 277. Bequest of Gordon N. Ray, 1987.

Edouard Manet and Stephen Mallarmé met in Paris in the latter part of 1873 and were constant companions until the poet's death in 1883. *Le Corbeau,* Mallarmé's translation of Poe's *The Raven,* with lithographs by Manet, appeared in 1875 and was completely unlike anything that had been conceived before. It is the first collaboration of writer and painter to produce a book that was consciously developed as a total work of art. As such, *Le Corbeau* stands at the head of the tradition of the *livre de peintre,* one of France's most distinctive contributions to the history of the book.

In his rendering of the poem, Mallarmé did not attempt to produce a literal translation of the original. Rather he has used Poe's verse as a vehicle for his own allusive mode of expression: "To paint not the thing," as he once explained, "but the effect it produces." That he should have turned to the work of Poe for inspiration is not surprising. His great mentor was the French symbolist poet Baudelaire, whose own

29 Illustration by Manet for the
French edition of *The Raven*

translations of Poe formed half of his collected works. Manet's lithographs, while realistic in form and faithful to the content of the text, were intended to elicit the eerie mood and irrational sensations evoked by the words on the page.

Le Corbeau was published in a deluxe format in an announced edition of 240. In fact, many fewer copies were produced. The Library's copy is number 80 and is signed by both Manet and Mallarmé. Two types of paper were used for the publication: chine, a thin, soft, coated paper that receives printing particularly well; and, as in the present case, hollande, a slightly stiffer, laid paper with a yellowish cast. As a commercial venture, *Le Corbeau* was a failure. As a consequence, plans for a second collaboration were abandoned.

The Library's copy was one of some 17,000 volumes received in the bequest of Gordon N. Ray, an eminent scholar and collector of French and English illustrated books. In Ray's estimation *Le Corbeau* ranks as one of the one hundred outstanding illustrated books produced in France before World War I.

30 ቕ

Geoffrey Chaucer

The Works of Geoffrey Chaucer. Hammersmith: The Kelmscott Press, 20 June 1896. F°. PML 76889 (paper copy; presentation to Sydney Cockerell). The gift of John M. Crawford, Jr., 1975.

The Works of Geoffrey Chaucer is the masterpiece of the Kelmscott Press, the printing establishment founded in 1891 by William Morris and named after his Oxfordshire home, Kelmscott Manor. Rejecting what he perceived to be the "decay" of printing and the increasing shoddiness and mechanization of nineteenth-century book production, Morris advocated a return to fifteenth-century techniques and standards of craftsmanship, quality, and design. The Chaucer, five years in planning and execution, was intended to be the "ideal" book and, in Morris's own words, "essentially a work of art." He designed all the decorations: title, borders, frames, and large initials (sixteen of his original drawings for the Chaucer are in the Morgan Library). Many of these are modeled after examples found in Morris's own important collection of medieval manuscripts and early printed books, some of which are also at the Morgan Library. The pre-Raphaelite artist Edward Burne-Jones, a friend and aesthetic collaborator of Morris since their student days at Oxford, provided the drawings for the eighty-seven woodcut illustrations. Shown here is the first page of the prologue to *The Canterbury Tales*.

That the culmination of Morris's endeavors in the art of the book should be the works of Geoffrey Chaucer came as no surprise to his circle of friends and admirers. Many of Morris's own literary works were patterned after Chaucer, whom he had referred to in print as "my Master." The Kelmscott Chaucer is, moreover, reflective of the contemporary Victorian rediscovery of his works and early English literature in general. Much of the credit for this revival is given to Morris's friend F. J. Furnivall, who founded the Chaucer Society in 1868 "to do honour to Chaucer...and to see how far the best unpublished manuscripts of his works differ from the printed texts." The text and spelling of the Kelmscott Chaucer follows that of Skeat's monumental six-volume edition of Chaucer's works which had appeared in 1894 and was meant to reflect a collation of all authoritative manuscripts.

The Library also has another copy bound in

30 Page from the Kelmscott Chaucer

a white pigskin binding designed by Morris and patterned after a fifteenth-century German binding in his collection. The copy pictured here has unique associations, being the one Morris inscribed and gave to Sydney Cockerell, secretary of the press and administrative head of the enterprise. The inscription is dated July 7, 1896, a month after the first bound volumes were delivered. Morris's health had been declining for some time, and he died in October. With this copy is a wrapper of Morris-designed chintz, which his wife Jane had given to Cockerell. Following Morris's death, Cockerell completed the books in production and organized the gradual closing down of the press. He went on to become the director of the Fitzwilliam Museum at Cambridge, and was a trusted friend and adviser to Belle Greene in the formation of the Morgan Library's book and manuscript collection.

JORIS KARL HUYSMANS

A rebours. Deux-cent-vingt gravures sur bois en couleurs de Auguste Lepère. Paris: Les cent bibliophiles, 1903. GNR Fr 328. Bequest of Gordon N. Ray, 1987.

The novel *A rebours* by Joris Karl Huysmans (1848-1907), generally translated as *Against Nature,* was a sensation when it first appeared in Paris in 1884. It is the strange story of des Esseintes, a wealthy, cultivated man who seeks to escape from the world in which he lives through dreams. Each chapter relates his experiments with a different "specialty"—literature or precious gems, art, or perfumes. None of these experiences, however, saves him from complete boredom and disaffection. *A rebours* was treated as a guide to the true attitudes of modern French artists and has been called the bible of the late nineteenth-century Symbolists and Decadents. The book was greatly admired by Oscar Wilde, who introduced it into *Dorian Gray* as the yellow book Lord Henry Wotton hands to young Dorian.

The Library's copy is one of 130 specially produced copies which appeared in 1903 with woodcut illustrations by August Lepère (1849-1918). At the time, Lepère was best known for scenes of Paris and the provinces. In this book, however, he was dealing with one of France's most subtle writers. Lepère's designs are allusive rather than literal, and they frequently contain witty references, by way of tribute, to other artists. Where des Esseintes muses on foreign travel, Lepère's designs look like the Japanese prints of Hokusai. Where the refer-

31 Pages from *A rebours,* illustrated by Lepère

V CHILDREN'S BOOKS

LITERATURE for the instruction and diversion of children is a wide and varied field. It is also one in which the survival rate is poor. Passed from hand to hand, often inexpensively produced and treated roughly, these works are ephemeral. Fragile in nature, they are, however, enduring in thought and spirit, the popular ones being reprinted and re-illustrated to inform and delight generation after generation of children. In the world of scholarship, the study of children's books is a comparatively recent development. The production of books designed specifically for children only became widespread in the eighteenth century. Today, scholars and students in increasing numbers are exploring the ways in which the development of children's literature and book publishing intersects with social, economic, literary, and art history. The Morgan Library is fortunate in having been able to participate in this fascinating field of inquiry.

Except for the acquisition of the manuscript of Thackeray's *The Rose and the Ring* (V, 7) and some books and manuscripts for young adults, the collection of children's books at the Library really began with the gift in 1965 of a substantial portion of Elisabeth Ball's English and French children's books. Miss Ball's collection in turn was built on two famous collections acquired by her father in the 1930s: the Gumuchian collection (a French bookseller) and that of the English collector Charles T. Owen. The Library received several thousand volumes from Miss Ball. In the 1970s she endowed a fund that allows for additions to the collection. It provided, for example, for the purchase of the Wilbur Macey Stone-Gillett G. Griffin collection of American children's books in 1970. Miss Ball died in 1982.

While the Library contains several major groups of drawings and exceptional autograph manuscripts in the realm of children's literature, the collection is primarily composed of printed books. The period covered is roughly from the early sixteenth century to the late nineteenth century, with an emphasis on the eighteenth and nineteenth centuries. Recently the nineteenth-century holdings have been expanded by the addition of the Thomas Balston section of the Gordon N. Ray bequest and the Lewis Carroll collection of Arthur A. Houghton, Jr. We have also benefited from the generosity of several Fellows, in particular the English and American collection formed by Mrs. Sherman P. Haight and the acquisitions support of Miss Julia P. Wightman, who in 1991 gave the Library her major collection of children's books, a gift of about 1500 volumes.

The changed attitude toward children that came about in England and much of the rest of Europe in the late seventeenth and early eighteenth centuries resulted in a wealth of books made especially for the young. It is here that the collection is particularly strong, with books by such well-known English printers as Thomas Boreman, the Newberys, Harris, Tabart, Kendrew of York, and Lumsden of Glasgow. Illustrators represented in the collection range from anonymous carvers of crude woodcuts to the very famous and talented, such as Caldecott, Cruikshank, Greenaway, and Potter. American holdings include New England primers, colonial books for children, a large number of books printed by Munro and Francis and the Babcock family, books illustrated by the New York

Folio 166 of manuscript for
The Little Prince [12]

2 Pages in Latin and German of Comenius, *Orbis sensualium pictus*

most ambitious and influential of these early efforts. Only one year after publication of the book, an English translation by Charles Hoole appeared and remained in use by children in the English-speaking world well into the nineteenth century. A copy of the first American edition (New York, 1810) is one of a variety of translations and editions of Comenius's work in the Library available for comparative study.

3 &

AESOP

Aesop's Fables with His Life: in English, French & Latin. Illustrated by Francis Barlow. London: William Godbid for Francis Barlow, 1666. F°. PML 64797. Gift: Mrs. G. W. P. Heffelfinger, 1974.

The fables of Aesop are perhaps the most frequently read and illustrated of all books for children. Their enduring appeal undoubtedly derives from the vigor and simplicity of the stories, while the moralizing purpose of the fables has endeared them to parents. It was recognized early on that the familiarity and clarity of the tales also made Aesop a useful text for teaching foreign languages, particularly when accompanied by illustrations. This seventeenth-century polyglot Aesop in English, French, and Latin is notable for the handsome engravings after Barlow, who was regarded in his day as one of the finest English draughtsmen of animal scenes. Indeed, his series of 112 engravings for Aesop inspired, directly or indirectly, English book illustrations of the text for the next two centuries.

"Do not the humble with neglect despise" is the moral for the fable of the lion and mouse illustrated here: the tiny mouse, by methodically gnawing through the ropes, has rescued a lion trapped in a net. The English and Latin versions of the story appear below. Barlow paid for the publication of the book himself, and his introduction specifies that he intended it to help young people learn languages in a congenial way. Thomas Philpot supplied the English text and Robert Codrington provided the French and Latin. This is one of only about a dozen copies of the first edition to survive, most having been destroyed in the great fire of London which swept over the printer's premises in 1666. In 1687 Barlow published a second edition, with a much improved English text by Aphra Behn.

The original texts of the fables of Aesop do

not exist. Indeed, it is unlikely that the famed storyteller, supposedly born in Thrace in the early sixth century B.C., ever wrote his fables down. The earliest reference to a written version of Aesop is a fourth century B.C. prose verse in Greek by one Demetrius of Phalerum. This too has been lost, but served as a source for various other copies of the stories that do survive. Prominent among them is the Library's papyrus fragment from the third or fourth century A.D., which is the earliest surviving Greek text for three of the fables set down by the poet Babrius. Of equal, if not greater, importance is the Library's ninth-century A.D. manuscript, the Codex Pithoaenus, the earliest known collection of Aesop's fables rendered in Latin verse by the Roman poet Phaedrus. The Library also has a copy of the Aesop printed in Ulm about 1476, which is the first printed version known to contain pictures.

3 Polyglot edition of Aesop

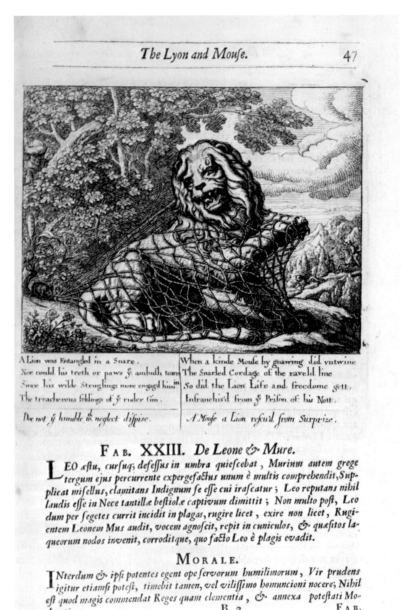

Verscheyde Soorten van Gedierten.

6 Dutch catchpenny print

only four years later by the patriot printer Isaiah Thomas, who moved his press during the American Revolution from Boston and re-settled in Worcester, Massachusetts, where he later founded the American Antiquarian Society. This is the first edition of the first hiero-glyphic Bible printed in the United States. Only six other copies have been reported.

The Library has recently acquired the German prototype for these Bibles designed for children (*Geistliche Herzens-Einbildungen inn zweihundert fünfzig biblischen Figur-Sprüchen* by Melchior Mattsperger, Augsburg, 1699).

6 &

Dutch Catchpenny Print

Verscheyde Soorten van Gedierten.
Haarlem: Margareta van Bancken, 1690.
Single sheet, 35.5 x 29 cm. PML 84761.
Purchase: Ball Fund, 1985.

Since the early blockbooks, illustration has been an integral part of popular literature. The earliest examples were created from wood-blocks, but changing technology created more sophisticated methods, such as copper plates.

Catchpenny prints—originally a derogatory term—constituted one part of a popular genre that included broadside ballads, slip songs, and chapbooks. These inexpensive, single sheets were sold in toy shops and bookshops, and by hawkers and peddlers as well. They were so popular that at one point toward the end of the nineteenth century, when wood engravings had replaced copper engravings, as many as 250,000 copies of some broadsides were sold.

Catchpenny prints were popular in the Netherlands from the seventeenth century through the nineteenth. In the Low Countries, popular prints continued to be made from woodcuts. The same blocks were often kept, sold from publisher to publisher, and reused, sometimes over centuries. After printing, Dutch woodcuts were frequently colored by hand in a distinctive style, which came to be called "colorier à la manière hollandaise." Patches of blue, red, and yellow were applied at random with a dabber or the thumb, and pink, green, or other colors were sometimes used as well.

From the late seventeenth century, broad-sides intended for children were printed in the Netherlands and peddled for small sums or given as prizes in school. The early prints were simple, often merely pictures of objects or crea-tures with their names as captions, and may have been used for instruction as well as amuse-ment. This sheet of animals printed from twen-ty-four small woodblocks by or after Dirk de Bray (fl. 1651-78) is one of the earliest dated Dutch prints. From its Haarlem printer, Mar-gareta van Bancken, only two prints are known, each in only two copies.

Dutch books and bindings are of special in-terest to the Library, and this print is one of several from the Van Veen collection that offer a fascinating array of popular images ranging from animals and street cries to folktales, in-cluding versions of the tales of Robinson Cru-soe (in which the children's book collection is particularly strong), William Tell, and Red Rid-ing Hood.

7 &

Heinrich Hoffmann

*[Der Struwwelpeter]. Lustige Geschichte und drollige Bilder....*Frankfurt am Main: Litera-rische Anstalt (J. Rütten), [1845]. PML 84753.
Gift: Mr. H. P. Kraus, 1984.

Struwwelpeter (shock-headed Peter; or sloven-ly Peter) occupies roughly the position in German children's literature that Alice does in English: one of the small group of classics im-mediately recognized by a single name. Both have become immortal. Its author was a Frank-furt doctor who wrote and illustrated a small album of vividly cautionary tales in 1844 as a Christmas present for his young son. He later showed the manuscript to a publisher friend, who insisted that it be printed. This, the first edition, has chromolithographic illustrations that closely follow Hoffmann's original draw-ings. Not only did Hoffmann insist that his drawings be copied line-for-line, he also in sisted that the binding be flimsy—this was *sup-posed* to be a short-lived book. It was published in an edition of 1500 copies. The book was an immediate and enduring success, and countless editions poured out in the next decades. Its original title, *Lustige Geschichte und drollige Bilder*, which the English translated as "Jolly Tales and Funny Pictures," was not changed to Struwwelpeter until the third edition.

The first edition is of great rarity; this is one of a handful of copies to have survived. Hoff-mann's original manuscript is now one of the treasures of the Germanisches Nationalmu-seum, Nuremberg, who generously lent it to the Morgan Library's exhibition of children's literature in 1954.

7 Page from Hoffmann, *Der Struwwelpeter*

In addition to this first edition and the third, the Library owns an 1876 edition, several editions of an American version called *Slovenly Peter*, an edition in Hebrew, and an Egyptian *Struwwelpeter* published in London about 1899. The book is only one of the Library's classic German children's books.

8 ❧

WILLIAM MAKEPEACE THACKERAY

The Rose and the Ring. Autograph manuscript, with pen and ink sketches, 1853-54. MA 926. Purchased by J. P. Morgan, Jr., 1915.

The manuscript of *The Rose and the Ring* by William Makepeace Thackeray (1811-63), with the author's own delightful illustrations, is one of the great documents of all children's literature. For the first time a major English author had created a full-length story simply for the amusement and joy of children, rather than for their edification.

The story was begun during the Christmas-Epiphany season of 1853-54, when Thackeray and his family were in Rome where he was working on the novel *The Newcombes*. In tra-

8 Thackeray, illustration for *The Rose and the Ring*

ditional English fashion, they celebrated the end of the holiday with a Twelfth-Night party, for which Thackeray had to design the figures because none were available in Italy. Around the figures of King and Queen, Lady and Lover, Captain and Dandy, Thackeray developed a tale set in the kingdoms of Paflagonia and Crim Tartary. An American child, Edith Story, had to miss the party because she was recuperating from malaria. Thackeray continued to develop

8 Thackeray, illustration for *The Rose and the Ring*

the story and read it to her daily. "It is wonderful how easy this folly trickles from the pen," reads an entry in his diary for March 2. He had completed *The Rose and the Ring* in Naples by November, after which his daughters copied the text and he added illustrations. It was published as a Christmas book, dated 1855 for the new year, and has remained in print to this day.

The Library has a strong representation of nineteenth-century English literature and of Thackeray. J. P. Morgan, Jr., acquired this manuscript in 1915 and the printed edition which Thackeray presented to Edith Story. A facsimile edition of the manuscript was published by the Morgan Library in 1947 with an introduction by the Thackeray scholar Gordon N. Ray.

9 ❧

LEWIS CARROLL, PEN NAME OF CHARLES LUTWIDGE DODGSON

Alice's Adventures in Wonderland. London: Macmillan and Co., 1865. 8°. Bound in full red morocco by The Doves Bindery. Three letters from T. J. Cobden-Sanderson to the previous owner laid in. AAH 36. Gift: Arthur A. Houghton, Jr., 1987.

Alice's Adventures in Wonderland—indisputably one of the two or three greatest children's books ever written—had a somewhat inauspicious beginning. All two thousand copies of the first edition were withdrawn by the author before publication because of bad printing and poor reproductions. Only twenty-three copies of this "suppressed" edition of 1865 are known to survive, all richly prized by collectors. The Library's copy is notable for its handsome red morocco binding tooled with hearts and roses by the prominent English binder T. J. Cobden-Sanderson. A small sheet laid in contains the holograph of Robert Southey's poem "The Old Man and His Comforts," which Carroll parodies in his book as "You Are Old Father William."

Charles Dodgson (1832-98), who wrote under the nom de plume of Lewis Carroll, was an Oxford don and mathematician. The story of *Alice's Adventures Underground*, as it was first called, began as an extemporaneous tale he invented one afternoon to entertain the three daughters of Dean Liddell of Christ Church, Oxford, during a picnic on the river. It was to please one of the girls, Alice, that he wrote the story down. Carroll was a ruthless perfectionist. His instructions to John Tenniel, whom he retained to illustrate the book, required that the artist conform in every detail to the exact vision of the characters and settings in the author's mind. "Lewis Carroll is impossible," Tenniel confided to his friend Harry Furniss. In the event, however, it was Tenniel who considered the reproductions of the first edition unacceptable and urged Carroll to have the work redone. The new improved version, which pleased both author and illustrator, carried the publication date 1866. Many of the rejected copies were sent to Appleton's in New York, where they were issued with a new title page.

This copy was the gift of Arthur A. Houghton, Jr., who built one of the great Alice collections. It contains not only first editions of the Alice books, but also every translation he could find, Dodgson's mathematical treatises and ephemeral publications, his pocket watch, many of his original photographs of children, and related manuscript material. Given to the Library in 1987, this collection added to an already significant group of Lewis Carroll books and related illustrations.

9 From Lewis Carroll's *Alice's Adventures in Wonderland*

"You are old," said the youth, "as I mentioned before,
 And have grown most uncommonly fat;
Yet you turned a back-somersault in at the door—
 Pray, what is the reason of that?"

"In my youth," said the sage, as he shook his grey locks,
 "I kept all my limbs very supple
By the use of this ointment—one shilling the box—
 Allow me to sell you a couple."

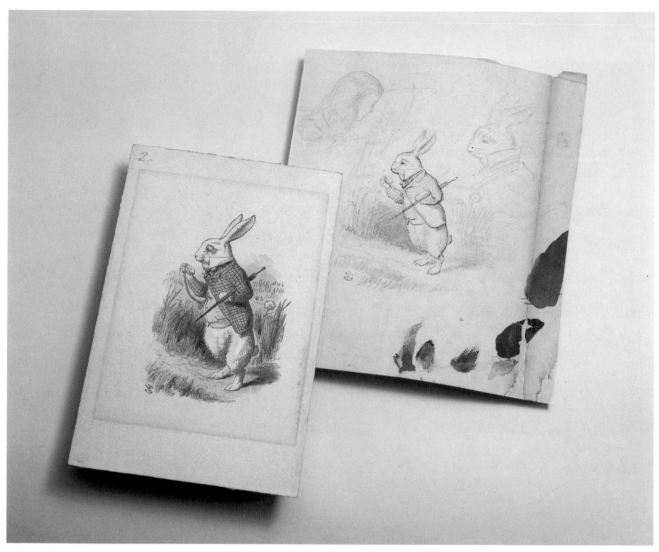

9 Proof of John Tenniel's illustration for the *Nursery Alice* at left (Houghton 590.2)
 and one of his original drawings of the White Rabbit (Gift of Mr. and Mrs. Benjamin Gale, 1982.11:1)

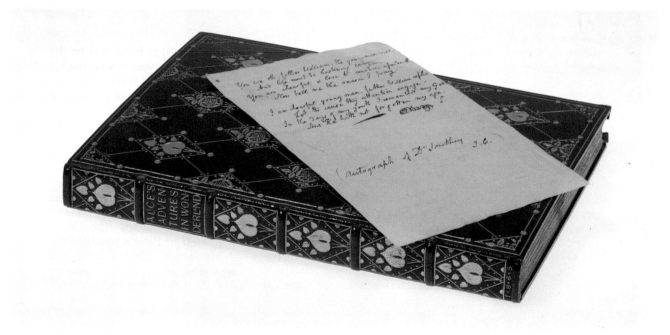

9 Doves Bindery *Alice* and holograph of Southey poem

11 Kate Greenaway, watercolor for *The Pied Piper of Hamelin*

The children's book collection contains Greenaway's small almanachs, published from 1883 to 1895, and other books, and the Library's Autograph Letters and Manuscript Department contains almost six hundred letters written to her from the artist and author John Ruskin. In some of these Ruskin advises her on her drawings.

He thought that the Pied Piper was her best work.

12 &

ANTOINE DE SAINT-EXUPÉRY

Le Petit Prince. Autograph manuscript with illustrations by the author, ca. 1943. Purchased for the Elisabeth Ball Collection, 1968.

This is the original 176-leaf manuscript, written in pencil and illustrated with the author's sketches, of *Le Petit Prince (The Little Prince).*

The book is a fantasy about an aviator forced down in the Sahara desert where he is befriended by a young prince who is on a visit to Earth from another planet. Saint-Exupéry (1900-44) was himself an aviator and produced a number of novels based on his experiences as a pilot, such as *Vol de Nuit (Night Flight;* 1931) and *Pilote de Guerre (Flight to Arras;* 1942).

Although *The Little Prince* may have been written as an allegory for adults, it has been adopted and loved by children everywhere. Indeed it has a very broad appeal and is among the most widely translated books in the world. Not the least of its interest is the fact that in relatively few decades since its composition we Earthlings have come to take astronauts and space travel very much for granted. Perhaps we have mythologized.

The book was written while the French author was in the United States. Most of the manuscript and illustrations were produced during the summer of 1943 when he was living

in a rental cottage on Long Island. The following year he was lost in a reconnaissance mission over the Mediterranean. *The Little Prince* was published in both English and French editions in 1943. The manuscript is of particular interest in that it contains text and several drawings that were not used in the published version. The scene shown here, of the Little Prince floating about the earth, for example, does not appear in the published book.

Saint-Exupéry's other books are represented in the printed books collection, as are those of many other French writers.

12 Saint-Exupéry, illustration for *The Little Prince*, folio 170

VI BINDINGS

WHAT WE KNOW TODAY as conventional twentieth-century binding has more to do with gluing machines than with people. But in the bindings shown here we are talking about the real thing. Hands gathered the sheets and folded them; fingers pushed needles and thread to gather the pages together; hands pared boards, shaved leather, hammered metal, and stamped and painted, or on occasion embroidered, the outer surfaces. Whether the production of one or many, whether the work of a past master or an inspired neophyte, they are the products of human hands, and they speak to us accordingly.

Bindings came into existence with the adoption of the codex, the standard book form, nearly two thousand years ago. Unlike the scroll, which it supplanted, the codex consists of sheets held together by sewing and/or gluing into a book block. The earliest bindings were devised to hold these gathered sheets together in a practical instrument that would last and protect the contents. The oldest surviving examples date from the fourth century of our era. The evidence of these examples suggests that early on, perhaps from the very beginning, bindings were conceived not merely as a protection but as decoration and adornment as well.

The materials used to create the bindings have remained essentially unchanged: thread, boards of wood or other stiff matter, coverings of skin, metal, or fabric. Down through the centuries, many binders have developed a style that has become art of a high order, contributing materially to the decorative arts in a functional way. The bindings that protect books are often a window into the books themselves or the motives of their makers or owners. Modest or forceful, plain or flamboyant, they often mirror their contents. Our interest in bookbinding, however, goes well beyond its status as one of the decorative arts. The history of bookbinding sheds much light on the original ownership and localization of copies, the history of libraries and of book collecting, as well as the marketing of books. These considerations may add considerably to, and often eclipse, the significance of a binding as a decorative object.

The Morgan Library's collection has been formed and added to with the express intention of including historically and artistically significant bindings over a wide range of countries and periods. It is among the finest collection of bookbindings in this hemisphere, equally strong in quantity and quality over the more than fifteen centuries it surveys. We continue to acquire in the areas of our traditional strength, as grounded in the collections of Pierpont Morgan himself—English, French, and Italian bindings of the sixteenth through the early nineteenth century—but we concurrently seek to broaden the collection. It may fairly be said that one of the special qualities of the Morgan Library's collection of bindings, matched by few others, is its diversity.

The collection has grown gradually over nearly a hundred years. The famous Lindau Gospels, purchased by Pierpont Morgan in 1899, was his first truly significant acquisition in the field of medieval manuscripts. But the value of the manuscript itself is rivaled if not surpassed by the jeweled covers that enclose and protect it. They are judged to be the

Central panel from English embroidered binding,
ca. 1640-50 [9]

Library's most important examples of the binder's art. The first major addition to the Library's binding collection that same year came with Morgan's purchase of the "library of leather and literature" of the late London bookseller James Toovey. It included the library of the third earl of Gosford, and the Gosford-Toovey holdings were particularly rich in Aldines and other early printed books, many of them in contemporary bindings. The next largest was the "Rahir Fifty," comprising the bindings sold to Morgan in 1907 by Édouard Rahir. Another notable acquisition was the purchase in 1911 of most of the group of ancient Coptic codices—many still in their original bindings—that had been discovered the year before at Hamouli in the Fayum. Single items were bought steadily by Morgan's librarian and first director, Belle da Costa Greene, and by his son, J. P. Morgan, Jr. Subsequently, in 1926, in the course of developing the Library's collection of medieval manuscripts, the remarkable Weingarten Abbey bindings were purchased from the earl of Leicester. Then, in the early 1950s, the Library's second director, Frederick B. Adams, Jr., began a vigorous program of acquiring bindings that continues to this day. Mr. Adams was in a very real sense the Library's first curator of bindings, enthusiastically devoting much of his energy to this area, in the midst of his overall responsibilities. In more recent years, a trustee of the Library, Miss Julia P. Wightman, has demonstrated particular concern for the enhancement of the bindings collection and has supported its development munificently. She is, in truth if not in actual title, the current honorary curator of bindings.

In the section that follows, you see a sampling of the results of human ingenuity over the course of more than a millennium and a half. Some of the bindings are easily seen to be masterpieces, but not all of them bespeak everyone's taste at all times, and doubtless some of them have languished on occasion. Fortunately, we see the intrinsic beauty of these works, and we strive to keep away the tooth of time.

1 ❧

COPTIC TRACERY BINDING

Egypt, the Fayum, seventh or eighth century. Cover of a Gospels, Monastery of Holy Mary Mother of God, Perkethoout, the Fayum, seventh or eighth century. M.569 (385 x 295 mm). Purchased by Pierpont Morgan, 1911.

The Copts were native Egyptians who played an important role in the history of Christianity. Their greatest contribution was the development of monasticism. When, in 1911, Pierpont Morgan purchased most of the sixty Coptic manuscripts found a year earlier in Hamouli (III, No. 2), he acquired the largest, oldest, and most important group of Sahidic manuscripts with a single provenance, the nearby Monastery of St. Michael in the Fayum district of Egypt. Almost all were found with their bindings, and they constitute an essential collection for the study of Coptic bookbinding. Because of the fragile condition of both manuscripts and bindings, it was necessary to detach and preserve them separately. Unfortunately some information about the methods of sewing was thereby lost.

This cover is regarded as the finest surviving Coptic bookbinding. At its center is a cross surrounded by interlace designs composed of two intertwined squares within a circle. All these were cut from a single piece of red leather and sewn over gilt parchment. In addition, white vellum strips were woven into the borders marking the broad decorative areas and the large circle. Small colored circles, with bright red centers, punctuate the arms of the cross, the perimeter of the large circle, and the bottom border. The use of leather tracery over a gilded ground is earlier than this binding, for the identical technique is found on Coptic shoes usually dated to the sixth and seventh centuries.

The manuscript of the Gospels this cover protected, however, was not made at the Monastery of St. Michael. According to its colophon, the manuscript was originally owned by

1 Coptic tracery binding

the neighboring Church of the Blessed Mary Mother of God at Perkethoout. Later the Monastery of St. Michael added its ex-libris—also made of red leather letters sewn onto gilt parchment on the inside of the front cover.

2 ↩

GILT SILVER, ENAMEL, AND JEWELED BOOKCOVER

South Germany?, late eighth century. Rear cover of Lindau Gospels, Abbey of St. Gall, Switzerland, late ninth century. M.1 (350 x 275 mm). Purchased by Pierpont Morgan, 1899.

This cover was about one hundred years old when the Lindau Gospels was written in the late ninth century, and thus was not made for the manuscript. Whether it was intended to be a bookcover is uncertain, nor is anything known about its history before it was enlarged and restored, probably in 1594, the date stamped on the volume's leather spine.

The design is arranged around a cross of the *pattée* type whose arms broaden at their ends. Extending from the central square are four busts of Christ in champlevé enamel framed by garnets, as are other elements in the cross. Between the arms of the cross are four silver-gilt panels engraved with animal interlace. The cloisonné frames at the top and left of the binding are original, while the borders on the right and bottom are late sixteenth-century replacements. The medallions depicting the

2 Evangelist medallion is a later addition

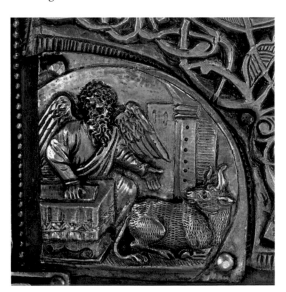

evangelists, trimmed to fit the corners, were also added in the sixteenth century and were pressed from the same stamp as those in another binding dated 1594—one made in Prague for the twelfth-century Gospels of Henry the Lion.

The date and origin of this cover remain uncertain, mainly because its components point to different times and places. The general design has been compared to Hiberno-Saxon decorative schemes, especially to the carpet pages of the Lindisfarne Gospels of about 700. The two gilt silver medallions in the vertical arms of the cross have stylistic resemblances to Viking animal ornament, the earliest examples of which date about 800. The enamel beast and bird forms on the cross and frame are similar to Merovingian art produced in France in the middle of the eighth century. The garnets and champlevé birds within the cross are closest to those on the lid of the so-called Agate Casket, of uncertain origin, in Oviedo Cathedral.

3 ↩

REPOUSSÉ GOLD AND JEWELED BOOKCOVER

Court School of Charles the Bald, ca. 880. Front cover of Lindau Gospels, Abbey of St. Gall, Switzerland, late ninth century. M.1 (350 x 275 mm). Purchased by Pierpont Morgan, 1899.

Like the back cover (No. 2), the front cover is one of the most important of all medieval jeweled bindings. It is dominated by the large gold repoussé figure of Christ crucified within a jeweled cross. Surrounding Christ are ten repoussé figures in lower relief, all in mourning poses. Above the head of Christ are personifications of the moon and sun. In the upper quadrants are four angels; in the lower quadrants are the Virgin and John above, and below two women, perhaps Mary Magdalene and Mary, wife of Cleophas. The raised arcades of the borders are visible from an angle, and the jeweled bosses resemble towers. These architectural forms may allude to the jeweled city of the Heavenly Jerusalem.

This cover is one of the three contemporary pieces of Carolingian goldsmiths' work ascribed to the so-called court school of the Emperor Charles the Bald, grandson of Charlemagne. Where this workshop was located is uncertain, although some scholars have argued for the Abbey of St. Denis, near Paris, where

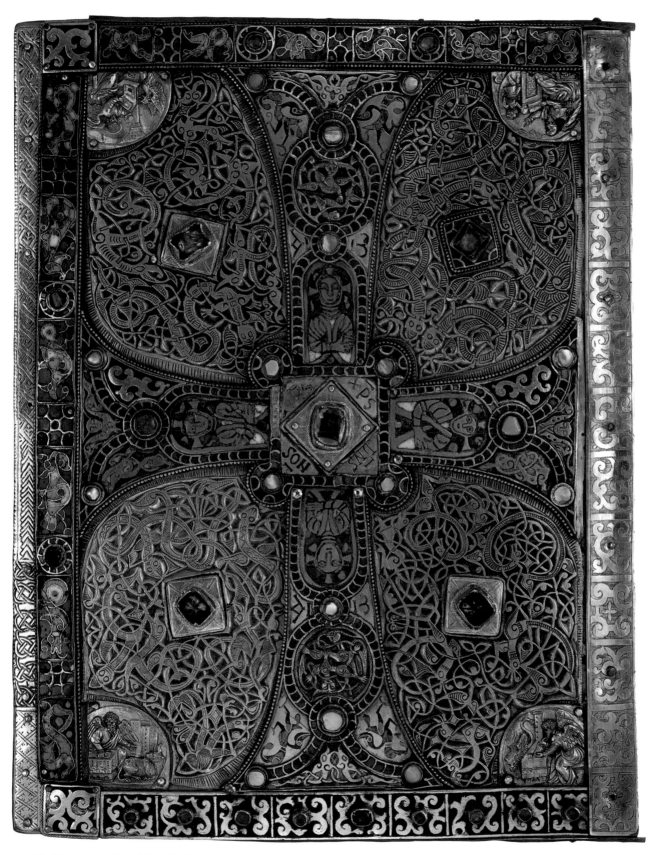

2 Gilt silver, enamel, and jeweled bookcover

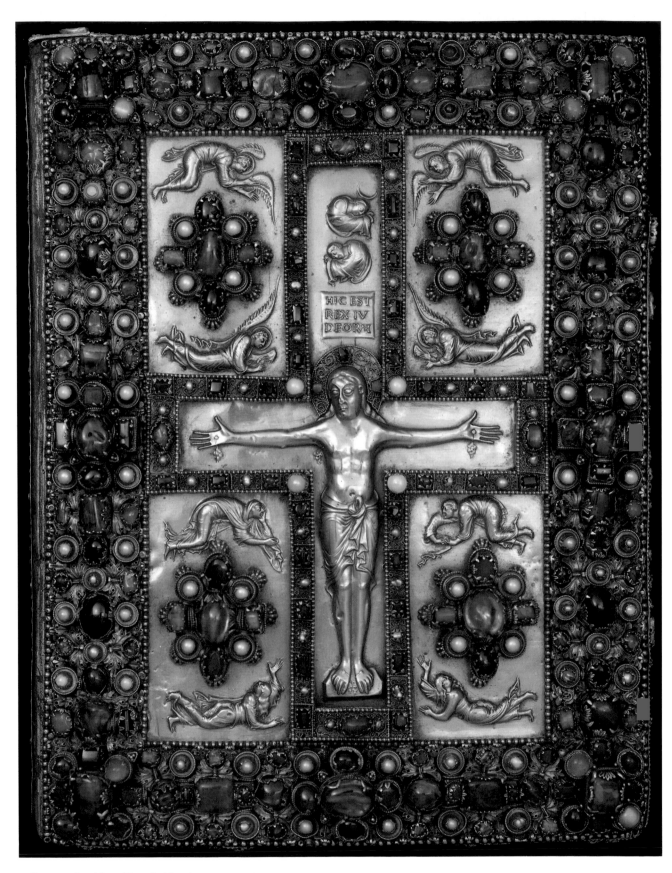

3 Repoussé gold and jeweled bookcover

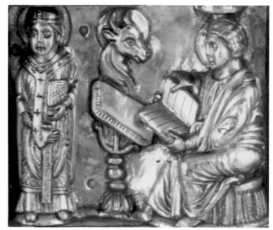

4 Details show St. Mark and Abbot Berthold, St. Nicholas and St. Luke

Charles was secular abbot from 867 until his death in 877.

Although written at the Abbey of St. Gall in the late ninth century, the manuscript has no documented provenance before the seventeenth century, when it belonged to the Convent of Lindau on Lake Constance, where it remained until the convent's secularization in 1803. Although finely written and decorated, the manuscript has no evangelist portraits and seems relatively modest when compared to its binding. Neither cover was originally made for the manuscript, but both were presumably present in 1594, the date stamped on the spine.

4

GILT SILVER AND JEWELED BOOKCOVER

Weingarten Abbey, about 1215. Cover of the Berthold Sacramentary, Weingarten Abbey, Germany, 1200-32. M.710 (300 x 210 mm). Purchased by J. P. Morgan, 1926.

Like the jeweled covers of the Lindau Gospels, this binding also ranks as one of the finest examples of medieval metalsmiths' work. Indeed, its artistic importance rivals the Sacramentary for which it was made (see III, 13). The cover was commissioned by Abbot Berthold (1200-32), perhaps between 1215, when fire damaged the abbey church, and 1217, when it was rededicated. No dedication feasts, however, are included in the book's calendar. Although likely, there is no firm evidence that the binding was made in the abbey itself.

Embellished with almost one hundred gems and intricate filigree work, the cover is dominated by a silver-gilt statuette of the Virgin and Child that is anchored into place by a framed cross. The Virgin's right hand, which originally held a scepter, is missing. Surrounding the Virgin, whose prominence reflects the importance of her cult at Weingarten, are twelve repoussé figures identified by inscriptions. In the four corners are the evangelists with their symbols. Flanking the cross and arranged in pairs from top to bottom are: the Archangels Michael (to whom an altar was dedicated at the abbey) and Gabriel; personifications of Virginity and Humility referring to the Virgin; Saints Oswald and Martin (patrons of the abbey); and Abbot Berthold and St. Nicholas.

This is one of the few medieval bindings that also served as reliquaries. According to the inscription running around the sides of the cover, relics of the Virgin Mary and Saints George, Oswald, Bartholomew, Thomas, Peter, Paul, and James were contained beneath the metalwork.

5

CUIR-CISELÉ BINDING

Austria, possibly monastery of Göttweig, ca. 1390. Cover of the Gospel of Luke, with the commentary of Nicolaus de Gorran and other texts, Monastery of Göttweig, Austria, ca. 1390. M. 822 (310 x 235 mm). Purchased, 1947.

The great majority of *cuir-ciselé* bindings, that is, bindings of cut-leather, date from the fifteenth century, but this is one of about two dozen that survive from the second half of the

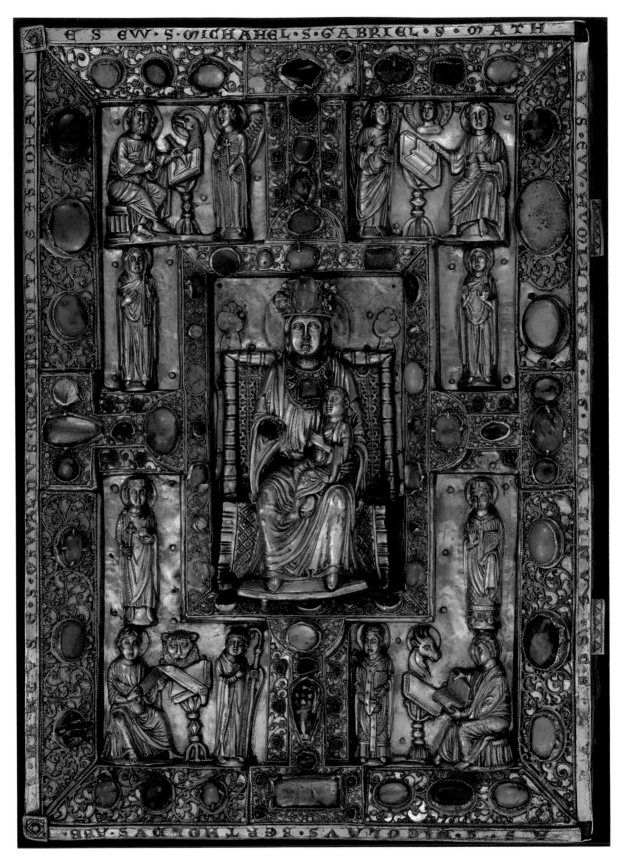

4 Gilt silver and jeweled bookcover

5 Cuir-ciselé binding

fourteenth century, when the technique first became popular. Basically the pattern is inscribed on the leather with a sharp tool, such as a knife. Most of the examples come from Germany, Bohemia, or Austria.

The fourteenth-century examples share many features, and the present binding is characteristic. A central rectangular field is surrounded by a narrow border that, in this case, also contains the Latin title of the manuscript, "ewangelium luce cum glosa gorre." While hu-

man figures are rare, the floral and leaf patterns often contain natural or fabulous animals. Here six grotesque wyvern- or dragon-like creatures inhabit the six circles of the rectangular field. Dotted backgrounds make the design easier to read. The binding, which is from the Benedictine monastery of Göttweig, some forty miles west of Vienna, is very similar to one with eight medallions, each with a beast, still preserved there. Both bindings house paper manuscripts of the late fourteenth century.

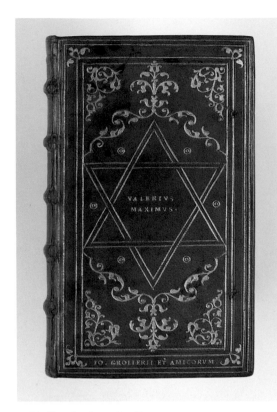

6 Binding for Jean Grolier

7 Roman binding with Apollo and Pegasus
medallion

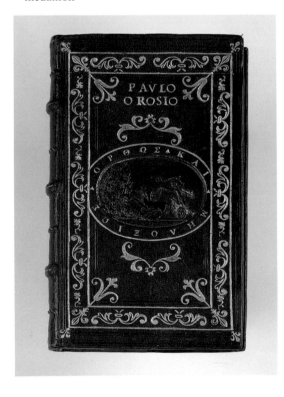

BINDING FOR JEAN GROLIER

Paris, ca. 1540. On: Valerius Maximus. Venice:
Heirs of Aldus, 1534. 8°. PML 75174. Gift of
Mrs. Francis Kettaneh in memory of her hus-
band, 1977.

The French royal treasury official Jean Grolier
(1479 [1486?]-1565) is the single best-known
patron of luxury bookbindings, and his name
continues to be synonymous with the love of
books. He commissioned most of his fine bind-
ings from a number of Parisian shops between
the late 1530s and the mid-1550s. Because of
the interlacing nature of the gold tooling on
such bindings as the present one, this and simi-
lar bindings were assigned to the "Entrelac
Binder," working in Paris in the period from
1540 to 1543 and formerly identified with the
atelier of Claude de Picques. It is now believed,
however, that the binder of this book is Jean
Picard, active in Paris for some years at this
time before he decamped to avoid his creditors
in the early fall of 1547.

The Morgan Library owns sixteen of Gro-
lier's books, thirteen of them in the original
bindings he commissioned, which is by far the
largest single collection of Grolier bindings in
this country. Typically the bindings have an
elegant austerity about them: very fine but
plain brown morocco leather (imported goat-
skin, apparently rare in Paris at the time), re-
strainedly tooled in gold, with a minimum of
lettering. This lettering tends to fall into two
groups—the work's title in brief, and Grolier's
mottos. His ownership mottos usually take the
form "Io. Grolierii et amicorum" (Jean Gro-
lier's and his friends') on the upper cover, with
a phrase from Psalm 141, "Portio mea Domine
sit in terra viventium" (Lord, may my share be
in the land of the living), on the lower cover.

Grolier often owned multiple copies of what
were long taken to be favorite works. Presum-
ably one copy was to be read, one was to be
safeguarded, and one was to lend to friends—
this in keeping with his bibliophilic motto. Re-
cent scholarship, however, has argued convinc-
ingly that these multiple copies reflect nothing
more noble than a commercial venture, linking
the contacts of his many years in Italy with a
perceived market in his native France. The var-
ious well-bound books would show customers
copies ready for sale as well as samples from
binders awaiting their patronage.

7 ❧

Roman Binding with Apollo and Pegasus Medallion

Rome, ca. 1546. On: Paulus Orosius. *Historie* [Italian]. Trans. Giovanni Guerini. [Toscolano]: Paganinus & Alexander de Paganinis, [ca. 1527-33]. PML 50667. Gift of the Fellows, 1960.

Examples from a group of Roman sixteenth-century gold-tooled bindings decorated with an impressed medallion of Apollo and Pegasus have been prized by connoisseurs for more than a century. Some one hundred and forty-four examples are known, and the Morgan Library possesses five, four in brown morocco, and the present one, in red morocco, with the central device painted in colors rather than stamped entirely in gilt. The presence of the medallion in colors is scarcer by far than in the all-gilded form. Works in Latin were bound in black and dark shades of brown or green, while red was reserved for works in the vernacular. The medallion shows Apollo in a chariot driving the two horses of the sun toward the steep cliff of Mount Parnassus, on whose summit Pegasus stands poised for flight. It is impressed in blind, painted in green and black with gilt highlights, and surrounded by a Greek motto, "Straight and not crooked," in gold.

Decades of inconclusive scholarship were set aside by Anthony Hobson in an elegant study that showed that all the bindings in this group are on a Renaissance "gentleman's library." The books were assembled in Rome between 1545 and 1547 for Giovanni Battista Grimaldi (ca. 1524–ca. 1612), a youthful member of a Genoese patrician family, by the eminent humanist-poet Claudio Tolomei. Tolomei had the books bound in three shops, and Mr. Hobson has assigned our book to Maestro Luigi (Luigi de Gave or de Gradi), who had a long career as a binder to several popes and other important patrons. Tolomei, it seems, also chose the medallion—the ascent to Parnassus through the practice of virtù—as a suitable device for a young man of wealth with an interest in literature. Tolomei, the founder of the Accademia della Virtù, saw Grimaldi as a youthful Apollo.

8 ❧

Roger Bartlett Mosaic Binding

Oxford, 1678. On: The Holy Bible. London: J. Bill, C. Barker, R. T. Newcomb, & H. Hills, 1678. 4°. PML 59412. Purchased as the gift of Miss Julia P. Wightman, 1969.

The Restoration, the period following the return of the English monarchy to the throne in

8 Roger Bartlett mosaic binding

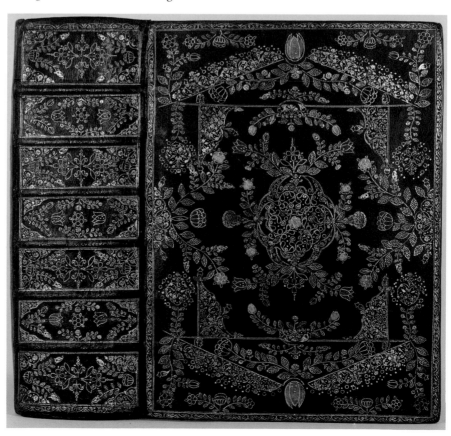

1660, was the grand era of English bookbinding. Perhaps the best-documented binder of that age was Roger Bartlett, who was originally a binder in London. After the Great Fire of 1666, he moved to Oxford, working there until his retirement about 1690. He died in his native Watlington in 1712.

One of the finest of Bartlett's works is this Bible, bound in red with colored leather onlays in black, white, and brown, showing the use of nearly a score of his tools in the gilding. The cottage-roof or split-pediment pattern is characteristic of his bindings. Of particular interest is the fore-edge painting, visible when the leaves are fanned, a medallion portrait of a young woman enwreathed with flowers. Perhaps the subject is the book's first owner, who carefully signed her name on the title page both as Mary Alston and as Mary Clayton, with the date 1678. The change of name in the ownership inscription makes one suspect that this binding was a present for her marriage.

9 ❧

EMBROIDERED BINDING

English, ca. 1640-50. On: The Bible. London: Deputies of Christopher Barker, 1599. 4°. PML 17197. Purchased by Pierpont Morgan, 1910.

There was a considerable fashion in England for embroidered covers on Bibles and small prayer books in the first half of the seventeenth century. Most of them were worked by professional embroiderers, and they were customarily sold from milliners' shops rather than by the stationers who were the licensed booksellers of the time.

The present spectacular example seems to be the product of a very talented and inspired amateur. She identified herself with a rhyming couplet:

> Anne Cornwaleys Wrought me
> now shee is called Anne Leigh.

Anne Cornwallis Leigh (1612-84) was the daughter of Thomas Cornwallis and his wife Anne, the daughter of Samuel Bevercotes of Ordsall; she married Thomas Leigh of Rushall, Staffordshire, about 1650, and the binding is attributed to this period.

It is a particularly superb example of the genre, in an excellent state of preservation, the colors still fresh and bright, the figures rendered in very high relief. The upper cover portrays Adam and Eve flanking the Tree and Serpent in the Garden of Paradise in a central panel, surrounded by all of creation, from a lobster, a fish, a crab, and a mermaid in the sea, through an elephant, an alligator, and a unicorn, to the birds of the air (including some

9 Embroidered binding

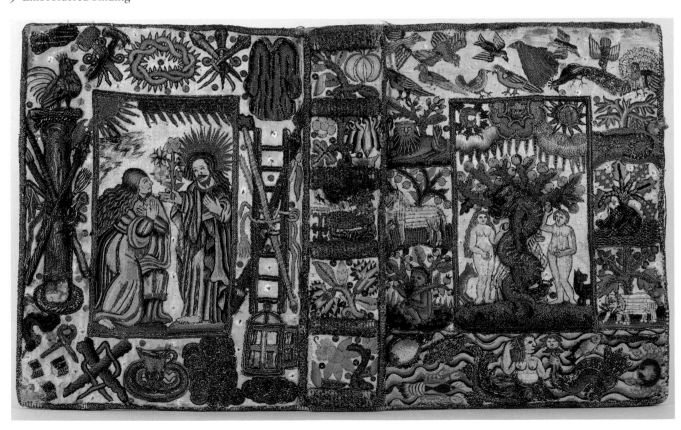

patriotically colored ones in red, white, and blue!). The spine carries flora and the Lamb of God as a symbol of Christ. The lower cover portrays Christ with Mary Magdalene after the Resurrection, in a central panel, surrounded by the symbols of the Passion carried out in great detail.

10 &

BINDING FOR QUEEN CHRISTINA OF SWEDEN

Paris, 1646. On: Publius Terentius Afer. *Comoediae*. Paris: Typographia Regia, 1642. F°. PML 77230. Purchased as the gift of Miss Julia P. Wightman, 1981.

A handsomely bound volume has always been considered an appropriate token in the quest for royal favor or patronage, and this one was seen as part of the perfect gift for New Year's 1647. Queen Christina of Sweden (1626-89), who had just passed her twentieth birthday, was the object of yet another political quest by Louis XIV's prime minister, Cardinal Mazarin. He had intended at first to compliment her with gifts thought appropriate to her age and sex: some small riding horses, and perfumed lingerie (Mazarin was, after all, both Italian by birth and French by conviction). But his ambassador to the Swedish court, Pierre Chanut, was aware that Christina was devoted to books and learning. He advised that she be given a selection of the imposing publications of the recently founded Imprimerie Royale, finely bound with her arms embossed in gilt on the covers. Mazarin was agreeable; he was, after all, a very learned man and a bibliophile (we have already seen that his copy of the Gutenberg Bible is crucial to dating its completion).

So it was done: a group of books, including the eight-volume Vulgate Bible and the editions of Tasso, Horace, Suetonius, and our Terence, were uniformly bound and sent to Stockholm for Chanut to present to Christina, complete with a fulsome dedicatory inscription in each volume, on 2 January 1647. Christina was delighted with the books, and most of them moved with her and the balance of her huge library to Rome in the next decade. She would be of material assistance later to Mazarin in his plans for the Kingdom of Naples, but that is a story for another time.

10 Binding for Queen Christina of Sweden

11 Portuguese binding for the Marquês de Pombal

11 Detail: arms of the Marquês de Pombal

11 🍂

PORTUGUESE BINDING FOR THE MARQUÊS DE POMBAL

Lisbon, ca. 1776. On: Ferreira da Graça, Francisco. *Estatutos literarios dos religiosos carmelitas calçados da provincia de Portugal.* Lisbon: Regia Officina Typografica, 1776. PML 78284. Purchased as the gift of Miss Julia P. Wightman, 1984.

This Portuguese binding, in red morocco with gilt arms and a dominant border in dentelle or lace style, nonetheless shows a strong French influence in its execution. This influence happens to be appropriate to the person for whom the binding was made, perhaps for presentation to him as a gift. The arms are those of Sebastião de Carvalho, marquês de Pombal (1699-1782), a successful politician and diplomat. The marquês, who spent long periods at foreign courts and returned to Portugal with imported ideas for change, ruled Portugal as virtual sovereign—some say as dictator—from 1750 to 1777. These *Statutes* of the Discalced Carmelites of Portugal constitute their official acts and end with the usual governmental and royal privileges of the time.

12 🍂

BINDINGS BY COBDEN-SANDERSON, 1887-91

Binding dated 1889 on William Morris, *The Story of Sigurd the Volsung and the Fall of the Niblungs.* London: Reeves & Turner, 1887. 4°. PML 2109. Purchased by Pierpont Morgan, probably in 1901. Binding dated 1887 on William Morris, *Love Is Enough.* London: F. S. Ellis, 1873. PML 77075. Gift of John A. Saks, 1981. Binding dated 1891 on Dante Gabriel

Rossetti, *Poems.* London: F. S. Ellis, 1870. 8°. PML 7242. Purchased by Pierpont Morgan, apparently with George B. De Forest's library, ca. 1902. Binding dated 1890 on Matthew Arnold, *Selected Poems.* London: Macmillan & Co. 1878. 8°. PML 2110. Purchased by Pierpont Morgan with Theodore Irwin's library, 1900.

The twentieth-century revival of the book arts that has brought so much pleasure to so many people is in very large part attributable to the inspiration of the skilled circle around William Morris, active in England in the last two decades of the nineteenth century.

A neighbor of William and Jane Morris at Hammersmith in the early 1880s was a barrister named Thomas James Sanderson, who upon his marriage in 1882 to the daughter of the wealthy statesman-industrialist Richard Cobden became T. J. Cobden-Sanderson and retired from the law. At the suggestion of Jane Morris in 1883, he took up bookbinding, first in apprenticeship to the prominent London binder Roger De Coverly, and then as an independent practitioner. He bound with his own hands until 1893, after which he founded a shop with workers, the Doves Bindery, confining himself thereafter to design and supervision.

12 Binding on Morris, *Love Is Enough*

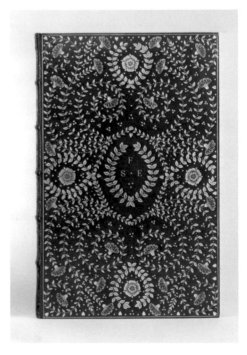

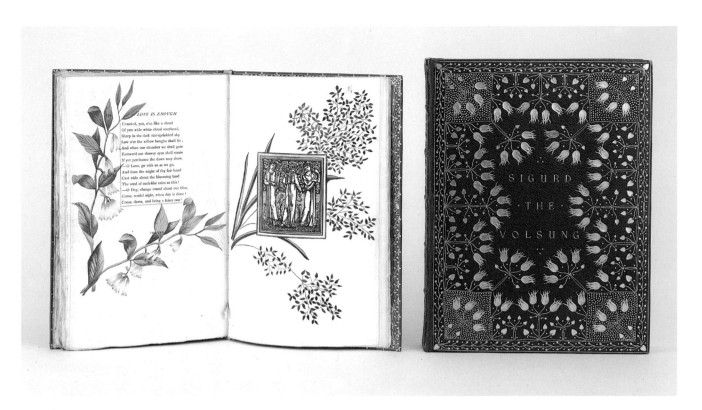

12 Left: Morris, *Love Is Enough* and right: Morris, *The Story of Sigurd*

12 Left: Arnold, *Selected Poems* and right: Rossetti, *Poems*

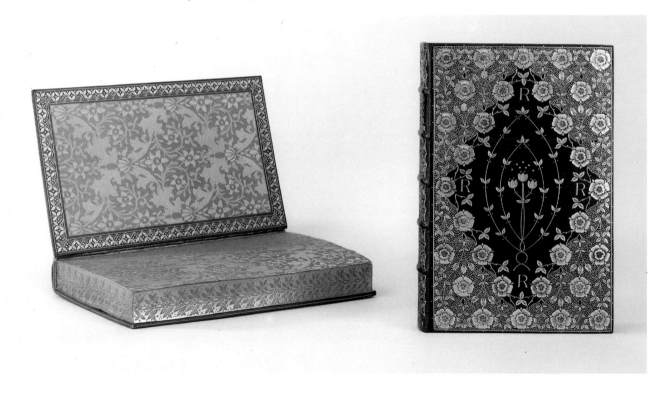

This suite of representative bindings by T. J. Cobden-Sanderson from the years 1887-1891 gives a good picture of his taste in fine leathers, chaste decoration, and precision in tooling, which revolutionized fine bookbinding. Cobden-Sanderson's tools and layouts, which broke decisively with the current fashions for "retrospective" bindings—pseudo-Gothic extravaganzas enjoyed a particular vogue, to cite one extreme example— revolutionized the aesthetic of fine bookbinding. The delicate, small floral tools that he designed himself are related to, yet not copied from, William Morris's own masterful floral decorations in various forms as cloth and type.

The Story of Sigurd the Volsung…is bound in red morocco, gilt, with gilt edges and signed 18 C*S 89 on the lower rear turn-in. The large paper copy, specially decorated with floral borders by Beatrice Pagden, of *Love Is Enough* was bound for Morris's friend and sometime publisher, F. S. Ellis, in tan morocco, and signed 18 C-S 87 on the lower rear turn-in. The original invoice from Cobden-Sanderson to Ellis, dated 5 and 7 January 1888, for 20 guineas is still in the book. Rossetti's *Poems*, bound in blue morocco, gilt, with gilt and gauffered edges, and with endleaves of Morris silk brocade, is signed at foot of spine: 18 C*S 91. The book carries the inscription at the back:

> Rossetti's Poems
> Bound by me at
> Goodyers Hendon 1891
> T. J. Cobden-Sanderson.
> "She had three lilies in her hand,
> And the stars in her hair were seven."

Selected Poems, bound in pale-green morocco, gilt, with gilt and gauffered edges, and with endleaves of Morris silk brocade, is signed on the lower rear turn-in: 18 C S 90. This volume was bound for the London bookseller Bain, who served as a kind of agent for Cobden-Sanderson's work. Bain sent this volume to the New York book firm of Dodd, Mead; the collector Theodore Irwin of Oswego bought it for $160 and exhibited it immediately at the Grolier Club.

13 &

BINDING BY PAUL BONET, 1959

On: André Suarès. *Cirque*. (Illustrated by Georges Rouault.) Paris: Ambroise Vollard, 1939 [but unpublished]. F°. PML 76385. Purchased as the gift of Mr. and Mrs. Hans P. Kraus, 1979.

The combination of book and binding makes this the most splendid *livre d'artiste* in the Morgan Library's collections. The term may be taken several ways: the book contains much original work by the artist, in the form of aquatint—that is, producing the effect of a drawing in watercolor or india ink—and woodcut illustrations, but the entire book itself, from its enormous scale to the quality of its paper and presswork, is a work of art in its own right.

Georges Rouault worked on the series of illustrations over many years for Vollard to enhance Suarès's writings. In the end, though, the resultant book was never formally published, and it is likely that most of the few surviving sets of pages of text and illustrations vary in their makeup. The present copy contains a large number of proofs of the illustrations. While working on Suarès's *Cirque*, Rouault wrote his own text, calling it *Cirque de l'étoile filante*, partly using existing illustrations, and partly creating new ones. Vollard published this new work in 1938 in the same format as the abortive *Cirque*.

Paul Bonet, the great innovator in French luxury bindings and the best-known of the twentieth-century French art binders, eventually executed a number of bindings both for *Cirque* and for *Cirque de l'étoile filante*. These bindings were all variants on a single decorative theme, a style that Bonet called "à decor rayonnant," noting that his intention had been to evoke the blaze of radiating circus lights. Our volume, bound in black morocco, with onlays of variously colored calf, and gold-tooled in a sunburst pattern, succeeds brilliantly in achieving his intent.

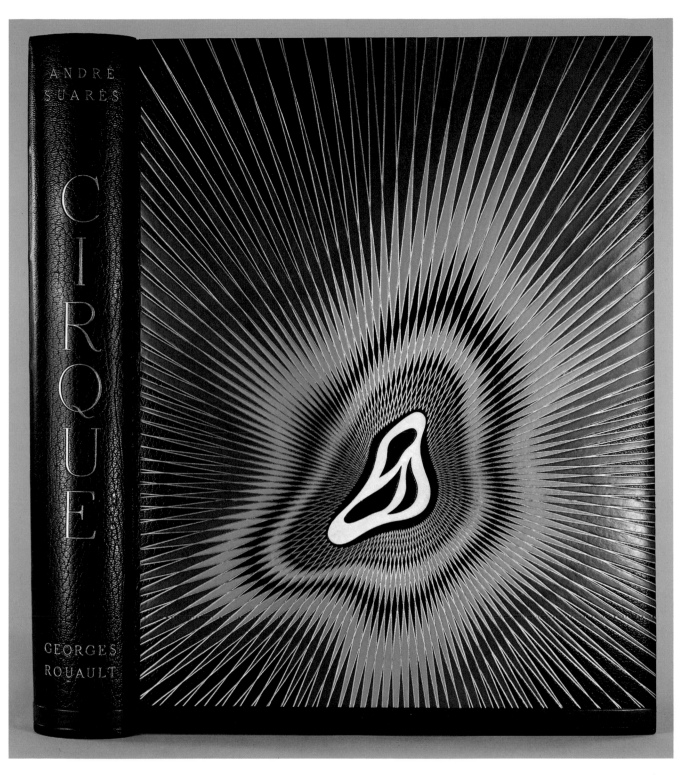

13 Binding by Paul Bonet

P.mi 11:6

Signore

Dalle ultime nuove ricevute dai viaggiatori Dilettanti delle Arti venuti da codesta Città abbiamo inteso con nostro sommo piacere la grata nuova della sua ristabilita salute. Bisogna però avvertir bene a conservarla; perche se l'entrapresa viaggio di Sicilia a costato qualche Disgrazia: qualche altra intrapresa non abbia a costare delli svantaggi alle sue premurose attenzioni, scoperte, ed osservazioni non solo sulle antichità esistenti e non movibili, ma anche sopra di quelle, che l'intendente Sig: Townly và acquistando di giorno in giorno, per arrichire la sua Patria. Fra l'altre si dice qui che il nostro gran Dilettante con le sue conoscenze del disegno abbia acquistato un busto di eccellente maniera, il che ci à molto vale legrati. Napoli, Napoli stà in cervello: perche se tu non apprezzi, per tua Disgrazia v'è chi ti dà il castigo. Più in Roma al presente siamo senza veri conoscitori, e Dilettanti.

Sò bene, che siete nemico dell'adulazione, perche niente volete che si dica di voi. Ma qualche volta permettete ad un vostro predicante, che dicendo il vero si sfoghi, altrimenti fà il crepaccio.

Ritorna in Napoli il Sig: ____ uomo così già conosciuto per le opere fin ora pubblicate. La domanda onestissima che mi a fatto, fondato sulla fama che vi siete acquistato di Protettore delle Arti che io l'accompagnassi con una lettera, per il desiderio di venire a voi, sicuro di rincontrare nei vostri meriti quella fama che dal publico con stima ed onore di voi si decanta. E siccome tutti quelli che anno fatta qualche intrapresa giovevole al publico l'accarezzate e l'incoraggite, così questo domanda di essere ammesso fra gl'altri.

VII AUTOGRAPH MANUSCRIPTS

I THOUGHT, I knew the complete story by heart, but I did not know there was so much in the manuscript which was never printed," remarked J. P. Morgan, Jr., in 1915 when purchasing the autograph manuscript of Thackeray's *The Rose and the Ring* (v, 8). In the ensuing decades, the Library has continued to add materials which contribute to the complete stories of the creation of great literary works, the biographies of notable individuals, and events of historical significance. Among the additions have been letters of artists from the Renaissance through the twentieth century and manuscripts and letters of humanists and rulers of the Italian Renaissance. While the collection has grown to the tens of thousands since the days of Pierpont Morgan and J. P. Morgan, Jr., the emphasis has continued to be on individual works of importance rather than comprehensiveness in any particular field.

The general pattern of the collection was established by Pierpont Morgan, who by his death in 1913 had obtained important autograph representations of the work of most major British and American writers of the eighteenth and nineteenth centuries. Though interested primarily in the authors of generations previous to his own, he did acquire several contemporary literary manuscripts, including that of a controversial novel of his day, Emile Zola's *Nana*. The manuscripts of Mark Twain's *Pudd'nhead Wilson* (VII, 19) and Thomas Hardy's "The Romantic Adventures of a Milkmaid" he purchased directly from the authors. In collecting historical documents, Morgan's focus was on traditional areas such as English rulers and the American founding fathers. As with literary manuscripts, he did, however, acquire a few timely items, including two of Emile Zola's public letters written in defense of Alfred Dreyfus at the turn of the century.

Broad and eclectic, the collection is plentiful in single manuscripts which not only crystallize moments in history and the creative lives of writers but also evince the particular human immediacy of handwritten documents of the past. The witch hysteria in Salem in 1692 becomes very personal to us through the entreaty of one of its victims, Rebecca Eames. Her petition to the governor of Massachusetts describes vividly the duress under which confessions were extracted from those accused. For some documents the compelling dimension is provided by our awareness of what transpired after they were penned. Abraham Lincoln's handwritten notes for a speech in 1858 in which he hopes that "not bloody bullets, but peaceful ballots" will resolve the national conflict over slavery are especially moving in the context of our knowledge of the tragic war which was to come. Similarly, our familiarity with an author's life affects our response to a literary manuscript. Sylvia Plath's childhood notebook of carefree poems about tea parties, playmates, and holidays evokes great poignancy because of what we know of her brief and unhappy adult years.

The collection is rich in authors' drafts and revisions, fascinating for the glimpses they give of "the story-weaver at his loom," to use Charles Dickens's telling phrase. The manuscript of Dickens's own *Our Mutual Friend* makes palpable his method of composition: great rushes of writing, followed by slower, more careful drafting, then sudden

Among many artists' letters in the collection is one from Piranesi to Charles Townley of 1772 showing the famous Warwick Vase excavated in Italy in 1771.

Page from Alberti's *De re aedificatoria* (1452), annotated by an early reader, PML 44056

record by Alberti himself on the plans for the Tempio—is particularly revealing, since it addresses precisely those features of the church which were never executed. The small but telling drawing, for example, shows a volute intended to decorate the straight sloping walls of the actual structure, contradicting the image of curved elements on de' Pasti's medal. Even in its unfinished state, the Tempio was hailed by Vasari as "one of the foremost temples in Italy" and has since been acclaimed as a superb embodiment of Renaissance architectural theory.

The Morgan Library's fine collection of artists' letters spans the Italian Renaissance to the present and has been substantially augmented over the past twenty years by several important acquisitions. Among them are art historian John Rewald's letters of impressionist and post-impressionist artists, art dealer Paul Rosenberg's collection of some 450 letters and documents of twentieth-century artists, and the Tabarant archive of Edouard Manet papers and photographs, purchased as a Charles W. Engelhard memorial gift.

2 ❧

HISTOIRE NATURELLE DES INDES

Illustrated manuscript, ca. 1586. MA 3900.
Bequest of Miss Clara S. Peck, 1983.

It was not mere zeal for adventure but the promise of enrichment which drove Elizabethan explorers to the Americas. Nevertheless, the encounter with a vast new world of alien cultures and uncharted landscapes offered these early navigators a freshness of experience far beyond the practical. This remarkable manuscript, identified as "Histoire naturelle des Indes" (Natural History of the Indies) on its title page, is a systematic catalogue of some of the earliest European observations of West Indian flora, fauna, and native and colonial customs. The 199 colored drawings are naive but buoyant, and with the accompanying French descriptive text they provide perhaps the most extensive portrait in existence of the late sixteenth-century Caribbean world. The entry reproduced here is entitled "How the Indian Women Suffer Labor Pains":

When the Indian women are in labor, the Indian men gather with their musical instruments and walk around the house, called *la bouhie*, dancing, making as much noise as possible and singing loudly, saying that this way the woman's pain will go away.

If the anonymous author of this natural history was neither a sophisticated botanist nor schooled ethnographer, he was certainly a studious observer, versed in Caribbean lore and attuned to local custom. The manuscript begins with botanical illustrations which document the infinite variety of tropical vegetation, from the sweet onions which the Indians eat "as we eat apples" to the mensenille tree, so poisonous "that if a person looks up at it, he will be blinded for three hours afterwards." The creative husbandry of the natives is noted in descriptions of medicinal remedies and culinary practices. A catalogue of West Indian fauna is followed by over forty entries depicting native life—hunting, healing, cooking, sewing—as well as colonial employment of natives and slaves for mining and smelting. At the conclusion of the manuscript the author presents an engaging narrative of a courtship culminating in a wedding celebration set in lush, tropical abundance.

The work has been informally dubbed the "Drake manuscript" because the English explorer Sir Francis Drake is twice named in the

Cõme lac femmes yndiennes sont en paine
d'enffam

Les yndiennes estans en trauail' d'enffans, lac yndar
s'assemblem, auec leurz Justrumens & seys bons a l'entour
de la maisoy qui s'appelle la bougie en danssans faisans le plus
grand bruit quilz penum Chantens a haute boix disans &
par tel moyy la doulleur de lac femme se passe

2 Folio 107 of Histoire naturelle des Indes

text and the some thirty geographical references match his ports of call. We know that he often employed shipboard artists, and indeed he himself painted as he traveled. Yet aside from a few scattered maps and sketches, this manuscript may be the most substantial surviving visual record of these early explorations. It is the combined work of at least two scribes and two artists. Aside from its obvious visual charm and historical allure, the Drake manuscript offers rich primary source material from the anthropological to the linguistic to the ethnobotanical. Because the manuscript was unknown to scholars until 1867 and in private hands until it was acquired by the Morgan Library in 1983, these possibilities have only begun to be addressed.

3 ❧

JOHN MILTON

Paradise Lost. Manuscript of Book I, ca. 1665. MA 307. Purchased by Pierpont Morgan, 1904.

The centerpiece of the Library's collection of literary manuscripts is, without a doubt, this

Milton at the age of ten, oil on wood, by an unidentified artist

only surviving manuscript portion of Milton's grand epic poem, transcribed and corrected at his direction. This is the copy of Book I that Milton's printer, Samuel Simmons, used to set the type for the first edition, as the ink smudges and signature marks on its nineteen leaves confirm. Blind since 1651, Milton (1608-74) relied on a number of amanuenses to transcribe the verses he composed during the night, when, as he writes, his "celestial patroness…/dictates to me slumb'ring, or inspires/Easy my unpremeditated verse" (*Paradise Lost*, Book IX). The verses were then read back to him and corrected, in this case by at least five different hands, one of which has been identified as that of his nephew Edward Phillips. Shown here is the opening of the poem, in which Milton invokes his celestial muse.

The verso of the first leaf bears the imprimatur of the licenser, Thomas Thomkyns, chaplain to Gilbert Sheldon, Archbishop of Canterbury, authorizing the printing of the poem. Over twenty years before, in his *Areopagitica*, Milton had argued against "this plot of licensing" books, on the grounds that "it hinders and retards the importation of our richest merchandise, truth," and he issued his early pamphlets on divorce without seeking the requisite license. An early biographer of Milton reports that, in fact, there was some trouble over the licensing of *Paradise Lost*—Thomkyns apparently felt that Milton's Satan shone too brightly in the first book. But Thomkyns signed the imprimatur, and the poem was printed in 1667.

The young scholar Thomas Ellwood, who often read to the blind poet in exchange for Latin lessons, recounts that he visited Milton at Chalfont St. Giles in August of 1665: "After some common Discourses had passed between us, he called for a manuscript of his; which being brought he delivered to me, bidding me take it home with me and read at my leisure." It was not until two years later, after the effects of the great plague had subsided and Milton returned to London, that the manuscript was delivered to his printer. Simmons later sold the copyright (along with the licensed manuscript of Book I) for twenty-five pounds to the London bookseller Brabazon Aylmer, who in turn sold it to another bookseller, Jacob Tonson. The manuscript remained in the hands of Tonson's descendants until it was purchased by Pierpont Morgan in 1904.

Illumine, what is low raise & support;
That to the highth of this great argument
I may assert th'eternal Providence,
And justifie the wayes of God to men.

Say first, for heav'n hides nothing from thy view
Nor the deep tract of hell, say first what cause
Mov'd our grand parents in that happie state,
favour'd of heav'n so highly, to fall off
from thir Creator, & transgresse his will
for one restraint, Lords of the world besides?
Who first seduc'd them to that fowle revolt?
Th'infernal Serpent; hee it was, whose guile
Stirr'd up with envy & revenge, deceav'd
The Mother of Mankind; what time his pride
Had cast him out from heav'n; with all his host
Of rebell Angells, by whose aide aspiring
To set himselfe in glory above his peeres,
Hee trusted to have equall'd the most High,
If he oppos'd; & with ambitious aime
Against the throne & Monarchy of God,
Rais'd impious warr in heav'n & battell proud,
With vaine attempt. Him the Almighty power
Hurld headlong flameing from th'etheriall skie
With hideous ruine & combustion downe
To bottomles perdition, there to dwell

3 Opening page of *Paradise Lost*

Pope. Moving beyond the simple panegyric and overt didacticism which had characterized earlier lives, Johnson combined extensive biographical detail with discerning literary criticism to produce an insightful portrait. Johnson's esteem for the biographical arts was well-known from a 1750 *Rambler* essay in which he argued for honesty uncolored by homage: "If we owe regard to the memory of the dead," he wrote, "there is yet more respect to be paid to knowledge, to virtue, and to truth." The fifty-two essays of his *Lives of the Poets* set a precedent for truth in biography to which even Boswell was indebted.

Johnson was engaged to write the *Lives* by a cartel of leading London booksellers who proposed a multi-volume edition of the works of English poets from 1600. In an attempt to foil a similar plan by a Scottish publisher, the cartel approached him with a proposal that he write what Johnson airily described as "Little Lives, and little Prefaces, to a little edition of the English Poets." He accepted eagerly. While many of the lives remained "little," a few—the "prefaces" for Pope, Swift, Milton, and Dryden, for example—grew into full-scale literary biography, complete with critical evaluation.

In the *Life of Pope*, the longest of the lives and Johnson's last major work, the biographer is unsparing in his description of Pope's acquisitiveness and self-importance, but extravagant in his praise of Pope's literary genius. It was Pope's intellectual diligence which most impressed Johnson, and in the passage shown he does a bit of textual editing to show how Pope carefully refined his translation of the *Iliad*. Like modern textual scholars, Johnson "delights to trace the mind from the rudeness of its first conceptions to the elegance of its last," so much so that the manuscript employs at least twice as many examples of Pope's revisions as the printed *Life*. The heavily revised manuscript of Pope's *Essay on Man*, also in the Morgan Library, reveals how he labored to perfect his verse, with results that Johnson likened to "a velvet lawn, shaven by the scythe, and leveled by the roller."

6 ❧

GEORGE WASHINGTON

Autograph letter signed, 20 May 1792, to James Madison. MA 505. Purchased by Pierpont Morgan.

Planning to retire at the end of his first term as

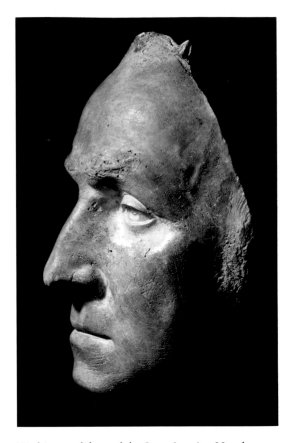

Washington life mask by Jean-Antoine Houdon

president, Washington (1732-99) requested James Madison, then a representative from Virginia, to draft for him a "valedictory address...in plain and modest terms." His suggestions for the content included his hope that the new government of the United States "may by wisdom, good disposition and mutual allowances; aided by experience, bring it as near to perfection as any human institution ever ap[p]roximated." Washington was persuaded to stand for another term, and there was no need for a "Farewell Address" until 1796. Alexander Hamilton assisted in the final formulation of that address. The counsel of Madison and Hamilton certainly contributed to the immense success of the "Farewell Address," but, as this letter indicates, the general design and fundamental ideas came directly from Washington. Reprinted in nearly all the nation's newspapers soon after its delivery, the valedictory brought forth emotional tributes from many of Washington's countrymen. John Quincy Adams wrote to the retired president that he prayed the address would "serve as the foundation upon which the whole system of

[the country's] future policy may rise." For John Adams, the speech exemplified Washington's mastery of the theatrics of politics. In a letter to Dr. Benjamin Rush now in the Library, Adams noted a "strain of Shakespearean excellence" appropriate to "dramatical exhibitions" and confided that "if [Washington] was not the greatest President, he was the best actor of Presidency we have ever had."

The first president's life and hopes are further revealed in the Library's over one hundred manuscripts by and relating to Washington. Reflecting the absorbing interest in American history of Junius, Pierpont, and J. P. Morgan, Jr., the Americana collection includes autograph representations of other founding fathers and presidents, as well as substantial documentation of the American Revolution and the early decades of the republic. There are letters concerning Benedict Arnold's treason and John Paul Jones's victory in the *Bon Homme Richard*, letters from Cornwallis asking Washington for terms of surrender and from Burgoyne sending the terms for the surrender at Saratoga, a contemporary manuscript of the Articles of Confederation, Jefferson's letter informing the speaker of the House of Delegates of the "ratification of the Confederation of the thirteen United States of America," and the first printed draft of the Constitution heavily annotated by Abraham Baldwin, one of the more influential members of the Continental Congress.

6 Washington to Madison, 20 May 1792

7 Jane Austen to Martha Lloyd, 16 February 1813

7 ❧

JANE AUSTEN

Autograph letter signed, 16 February [1813]
to Martha Lloyd. MA 2911. Bequest of Mrs.
Alberta H. Burke, 1975.

Letter writing was central to the development
of Jane Austen (1775-1817) as an artist. The
epistolary novel was at its height of popularity
during her youth, and she experimented with
the form in two early works: *Elinor and Mari-
anne,* which was extensively revised to become
Sense and Sensibility, and *Lady Susan,* which
was unpublished during her lifetime. As an ar-
tistic form, the novel-in-letters evidently tried
her patience. *Lady Susan* concludes abruptly,
"This Correspondence, by a meeting between
some of the Parties & a separation between the
others, could not, to the great detriment of the
Post office Revenue, be continued longer." In
her own life, nevertheless, she was in accord
with Jane Fairfax in *Emma,* who proclaimed,
"The post-office is a wonderful establishment."

Jane Austen devoted a significant portion of
each day to correspondence, and through her
frequent letters to relatives and friends she re-
fined her craft.

The intelligence, wit, and moral sensibility
of her heroines appear in her own corre-
spondence. The letter shown exhibits the skep-
ticism of authority which informs her novels.
Writing to one of her dearest friends, Martha
Lloyd, she comments on the scandalous affairs
of the prince regent, later George IV, and his
wife, the Princess of Wales, and alludes to a
public letter which the princess had written to
the prince:

I suppose all the World is sitting in Judgement upon
the Princess of Wales' letter. Poor woman, I shall
support her as long as I can, because she IS a woman,
and because I hate her husband—but I can hardly
forgive her for calling herself 'attached and affec-
tionate' to a man whom she must detest...but if
I must give up the Princess, I am resolved at least
always to think that she would have been respect-
able, if the Prince had behaved only tolerably by her
at first.

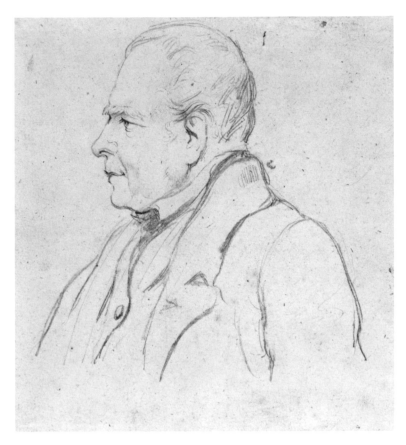

Sir Walter Scott by Daniel Maclise, 1825, pencil on light gray paper
Gift of Charles Ryskamp in memory of Benjamin Sonnenberg, 1978.31

Of the several thousand letters that Jane Austen must have written, just over one hundred thirty survive. Of these, some fifty reside in the Morgan Library, making it the largest single collection. No complete manuscripts have been located of her six major novels. Of the extant manuscripts, the Morgan Library holdings include *Lady Susan,* the first six leaves of *The Watsons,* and the satirical "Plan of a Novel."

8 ❦

SIR WALTER SCOTT

Ivanhoe. Autograph manuscript of surviving portions of volumes II and III, [1819]. MA 440. Purchased by Pierpont Morgan, 1901.

Sir Walter Scott's imaginative integration of romantic plot and faraway time codified a new genre of fiction—the historical novel. Invitingly adaptable, the model inspired novelists through the remainder of the century, notably

Thackeray, Dickens, Pushkin, Tolstoy, Stendhal, and Balzac. In *Ivanhoe,* Scott (1771-1832) wrote for the first time in his career about a time—the fifteenth century—and a place—the heart of England—some distance from the Scottish settings of his earlier successes. Steeped in the history and lore of Scotland, he had applied his erudition first to a series of immensely popular verse romances. Such works as the verse romance *The Lady of the Lake* and the novels *Waverley, Guy Mannering,* and *Rob Roy* entranced his readers with authentic depictions of Scottish rural life and replications of regional speech. With *Ivanhoe,* he left the Scottish scene to create a colorful story of a remote era of battling knights, elaborate tournaments, besieged castles, and captive maidens rescued by their champions. The manuscript reveals that he wrote freely, concentrating on the narrative and showing little concern for the niceties of punctuation and paragraphing. As was customary for his novels, a transcriber attended to these details before the preparation of proofs.

unkindness let us put the Jew to ransom since the Leopard will not change his spots and a Jew he will continue to be." — "The priest said Clement is not half so confident of the Jews conversion since he received that buffet on the ear" "Go to know what prevails them of conversions — What is there no respect — all masters no men — I tell you fellows I was seneschal at Colherst when I received the good knights courtesy as I had kept my ground under it — But on those prated more of it there shall learn I can give as well as take — " "Peace all said the Captain and there few thanks of thy ransom: Men — needst not be told that they thy race are held accursed in all Christian communities and trust me that we cannot endure thy presence amongst us think therefore of an offer while I examine a prisoner of another cast — " "were many of Front-de-Boeufs men taken" demanded the knight "None of note enough to be put to ransom answered the Captain — a set of hireling fellows there were whom we dismissed to find them a new master — enough had been done for revenge and for profit the bunch of them were not worth a card : en. The prisoner I speak of is better booty — a jolly priest riding to visit his leman as I may judge by his horse-gear and wearing apparel — here cometh the worthy prelate as pert as a pyot." And between two yeomen was brought before the sylvan throne of the Outlaw chief our old friend Prior Aymer of Jorvaulx.

<div style="text-align:center">Chapter V.</div>

Geminius Flower of warriors

Now at with Titus Lartius

Marcius: As with a man busied about decrees

Condemning some to death and some to exile

Ransoming him, or pitying, threatening the others.

 The captive Priors features and manner exhibited a whimsical mix-ture of offended pride deranged foppery and bodily terrors — "Why how now my masters" said he with a voice in which all these emotions were blended — "what order is this among ye. Be ye Turks or Christians that handle a churchman. Know ye what it is manus imponere in servos Domini — ye have plundered my mails torn my cope of curious cut &c lace which might have served a Cardinal — Another in my place would have been at his Excommunicabo vos But I am placeable and if ye order forth my palfreys release my priests and restore my mails, and with all speed an hundred crowns to be expended in masses at the high altar of Jorvaulx abbey and make your vow to eat no venison untill next Pentecost it may be you shall hear little more of this mad frolic." — "Holy Father said the Chief Outlaw it grieves me to think that you I have met with such usage from any of my followers as calls for your fatherly reprehension" — "Usage" echoed the Priest encouraged by the mild tone of the sylvan leader it were usage for no hound of good race much less for a Christian far less for a priest and least of all for the Prior of the holy community of Jorvaulx. Here is a profane and drunken Minstrel called Allen a Dale — nebulo quidam — who has menaced me with corporal punish-ment nay with death itself an I pay not down five hundred crowns of ransom besides all the treasure of which he hath me — gold chains and gymmal rings to an unknown value besides what is broken and spoiled among their rude hands as my pomancte box and silver crisping tongs — "It is impossible that Allen a Dale can have thus treated a man of your reverend bearing" replied the Captain "It is true as the gospel of Saint Nicolas meer said the Prior he swore with many a cruel North country oath that he would hang me up on the highest tree in the greenwood — "Did he so in very deed Nay then reverend father I think you were better comply with his demands for Allen a dale is the very man to abide by his word when he has so pledged it — "You do but jest with me" said the astounded Prior "and I love a good jest at my breast. But ha ha ha when it has lasted the livelong night it is time to be grave in the morning — "And I am as grave as a father confessor" replied the Outlaw "you must pay a round ransom Sir Prior or your Convent is likely to be called to a new election for your place will know you no more — "Are you Christians" said the Prior and hold this language to a church-man" — "Christians aye

To emphasize the novelty of *Ivanhoe*, Scott insisted that it be published on finer paper and in a larger format than his previous novels. Known at the time anonymously as "the author of *Waverley*," he sought also to have the work appear under the pseudonym Laurence Templeton. His publisher acceded to the new format but persuaded Scott not to disappoint the avid followers of "the author of *Waverley*." Public response to the novel was enthusiastic, and the first printing of 10,000 was exhausted in two weeks. On the Continent, the astounding success of *Ivanhoe* can be gauged not only by the various translations but also by its frequency as a subject for the lyric stage. Of the seventeen Scott novels that became operas, *Ivanhoe* was one of the most attractive to librettists. Operatic treatments include a pastiche of Rossini's music staged in Paris, Marschner's *Der Templer und die Jüdin*, Nicolai's *Il templario*, as well as works by Giovanni Pacini and Sir Arthur Sullivan which retained the novel's title.

The Morgan Library preserves an unrivaled number of Scott's novels in manuscript, among them *The Antiquary, Guy Mannering, Old Mortality, Peveril of the Peak, St. Ronan's Well,* and *Woodstock*. Of the verse romances, the Library holds the complete manuscripts of *The Lady of the Lake* and *Rokeby* and portions of *The Bridal of Triermain* and *The Lay of the Last Minstrel*.

about its indelicacy. "You shan't make *Canticles* of my Cantos," Byron wrote to Murray, "The poem will please if it is lively—if it is stupid it will fail—but I will have none of your damned cutting and slashing."

Murray was concerned not only about the comically frank portrayal of Juan's exploits, but also about Byron's unabashed ridicule of the poet Robert Southey (the "Sir Laureat" of the first stanza shown here) in his mock dedication to the poem. In the end Byron agreed to the anonymous publication of the first two cantos and suppressed the bold dedication. "I won't attack the dog so fiercely without putting my name," he wrote to Murray. Southey was not the only subject of Byron's satire in the suppressed verses. Wordsworth and the "Lake Poets" were blasted for what Byron saw as their limited perspective, in which poetry indulges private "reveries" rather than engaging its audience: "There is a narrowness in such a notion,/which makes me wish you'd change your lakes for ocean." *Don Juan* was Byron's ambitious answer to this important new poetic school.

The Morgan Library's collection of Byron manuscripts is one of the most extensive. Besides Cantos I-V and XIII of *Don Juan*, it in-

Watercolor on ivory,
miniature portrait of Lord Byron

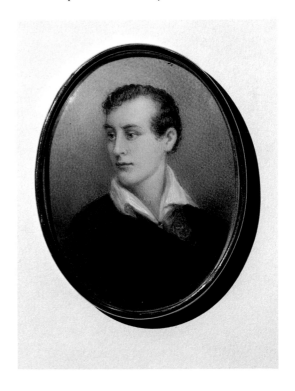

9 ℰ

LORD BYRON
GEORGE GORDON NOËL BYRON

Don Juan. Autograph manuscript of Cantos I-V, 1818-20. MA 56-57. Purchased by Pierpont Morgan, 1900.

Byron (1788-1824) detested what he called "sweating poesy"—overworking and revising verse—and his manuscript indeed reveals a fluid hand, often working with little revision to achieve a swift, conversational pace. Autograph stanzas like those pictured here, however, belie the poet's avowed facility of composition. The writing of this sprawling, episodic poem in the complex *ottava rima* stanzaic form was hardly effortless, despite the effect of comic ease which makes *Don Juan* eminently readable. But if textual revision was acceptable to Byron, self-censorship was quite another matter, and he refused to modify his poem when publisher John Murray expressed anxiety

2./

Meantime — Sir Laureate — I proceed to dedicate
In honest simple verse this song to you —
And if in flattering strains I do not predicate
'Tis that I still retain my "Buff & Blue" —
My Politics as yet are all to educate —
Apostasy's so fashionable too
~~Leave forms will ~~~ but ~~~ I will get through~~
~~I have it yet but should be glad to learn~~
~~Meantime ~~~~~~~~~~~~~~ you see~~
To keep one's creed's a task grown quite Herculean
Is it not so my Tory Ultra=Julian ?

I want a hero — an uncommon want —
When every Year or Month sends forth a new one
Till after cloying the Gazettes with cant
The Age discovers he is not the true one
Of such as these I should not care to vaunt
I'll therefore take our ancient friend Don Juan —
We all have seen him in the Pantomime
Sent to the Devil — somewhat ere his time

2. VI
Most epic Poets plunge in "Medias res"
Horace commends it as the safest road —

9 Folio from Canto 1 of Byron's *Don Juan*

cludes *Beppo, The Corsair, Manfred, Marino Faliero, Mazeppa,* "Morgante Maggiore," *The Prophecy of Dante, Werner,* numerous short poems, and over seventy letters. Other major poets of the English Romantic period are also represented. In the collection are the Pickering manuscript of William Blake; the Coleorton papers of William and Dorothy Wordsworth; one of the largest collections of Coleridge letters; Southey's *Life of Cowper* and *Life of Bunyan;* and Keats's "Endymion," "Ode to Psyche," and "On First Looking into Chapman's Homer."

10 &

CHARLOTTE BRONTË

The Poetaster. Autograph manuscript, 1830. MA 2696. The Henry Houston Bonnell Brontë Collection. Bequest of Mrs. Bonnell, 1969.

In her biography of Charlotte Brontë (1816-55), Elizabeth Gaskell writes, "I have had a curious packet confided to me, containing an immense amount of manuscript, in an inconceivably small space; tales, dramas, poems, romances, written principally by Charlotte, in a hand which it is almost impossible to decipher without the aid of a magnifying glass." Gaskell's packet was the Brontë juvenilia, a remarkable assemblage of miniature manuscripts bound by hand as tiny books, chronicling the social and political history of the imaginary African kingdom of Angria. Both Charlotte and her brother Branwell enthusiastically record the day in 1826 when their father brought home a set of twelve toy soldiers, a gift which inspired years of imaginative play and

engendered the Angrian cycle of romance and intrigue. Drawing on the political events and literary figures of the day, Charlotte and Branwell constructed an elaborate saga based in an exotic geography, peopled by a huge cast of characters whose actions were directed by the supernatural Genii—the all-powerful child authors.

The manuscript reproduced here—one of over twenty juvenile compositions in the Library's Brontë collection—measures just 2.5 x 4.5 centimeters. Its sixteen pages of microscopic text constitute the second half of Charlotte's only full-scale play, *The Poetaster.* (The first half is in the Amy Lowell collection of the Harvard College Library.) Written when she was only fourteen, it satirizes the Romantic conception of poetic genius in the character of Henry Rhymer, an airy young poet who insists, "The thoughts should come spontaneously as I write or they're not the inspirations of genius." Like Ben Jonson in his *The Poetaster,* on which her play is based, Charlotte opposes two concepts of poesy in a dramatic dialogue. Rhymer's pomposity is offset by the caution of established poet Captain Tree, whose own method of composition involves careful textual revision: "How most people in general are deceived in their ideas of great authors. Every sentence is by them thought the outpourings of a mind overflowing with the sublime and the beautiful. Alas, did they but know the trouble it often costs me for me to bring some passage neatly to a close,...to polish and round the period." The Morgan Library's rich collection of Brontë manuscripts was augmented in 1969 with the addition of the Henry Houston Bonnell Brontë collection.

 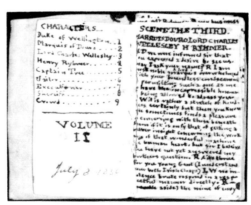

10 Pages from Brontë, *The Poetaster* (shown actual size)

HENRY DAVID THOREAU

Autograph journal, 1837-61. MA 1302.
Purchased by Pierpont Morgan, 1909.

Walden Sat. July 5th-45
Yesterday I came here to live. My house makes me
think of some mountain houses I have seen, which
seemed to have a fresher auroral atmosphere about
them as I fancy of the halls of Olympus.

For readers of *Walden*, this simple entry for 5
July 1845 in Thoreau's journal is charged with
artistic and spiritual promise. If *Walden* charts
a single year of life in the Concord woods, the
journal builds season upon season, year upon
year, offering close to a lifetime of Thoreau's
careful observations of the natural world. From
1837, shortly after his graduation from Har-
vard, until 1861, a few months before his death,
Thoreau (1817-62) kept a journal which was to
become the central literary endeavor of his life.
For the Transcendentalists with whom he was
allied during his early years, journal-keeping
offered a powerful means of self-cultivation. It

was probably Emerson who encouraged Tho-
reau to begin the work, as reported in his very
first entry for 22 October 1837: "'What are
you doing now?' he asked, 'Do you keep a
journal?'—So I make my first entry today." The
bulk of the manuscript—over two million
words in forty volumes—resides in the Morgan
Library, housed in the stout pine box built by
Thoreau to preserve his notebooks.

In his entry for 9 February 1851, Thoreau
writes, "I do not know where to find in any
literature whether ancient or modern—an ade-
quate [ac]count of that Nature with which I am
acquainted. Mythology comes nearest to it of
any." If anyone has come close to providing an
"adequate account" of Nature it is Thoreau,
not only in *Walden* but in his lifelong verbal
rendering of the New England landscape. The
journal did more than provide grist for Tho-
reau's few published works, including *A Week
on the Concord and Merrimack Rivers* and
Walden. It is a comprehensive literary medita-
tion in its own right, having little in common
with the daily jottings of most diarists.

The eleven manuscript volumes of Thoreau's

Thoreau's journals and box

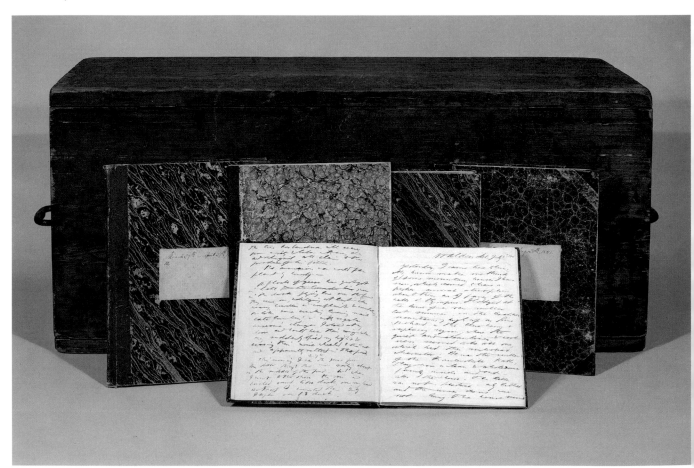

11 Entry from Thoreau's journal, 5 July 1845

unpublished "Indian notebooks" (*Extracts from works relating to the Indians*) are also in the Morgan Library, along with a number of poems, essays, and letters. The Thoreau journals came to the Library in 1909 when Pierpont Morgan purchased the Stephen H. Wakeman collection of American authors, with important representations of Emerson, Hawthorne, Poe, Whittier, Lowell, Holmes, Bryant, and Longfellow.

12 🐚

HONORÉ DE BALZAC

Eugénie Grandet. Autograph manuscript and corrected galley proofs, 1833. MA 1036. Purchased 1925.

In the example shown, what appears to the literary scholar as compelling evidence of Balzac's creative exuberance seemed to his printers

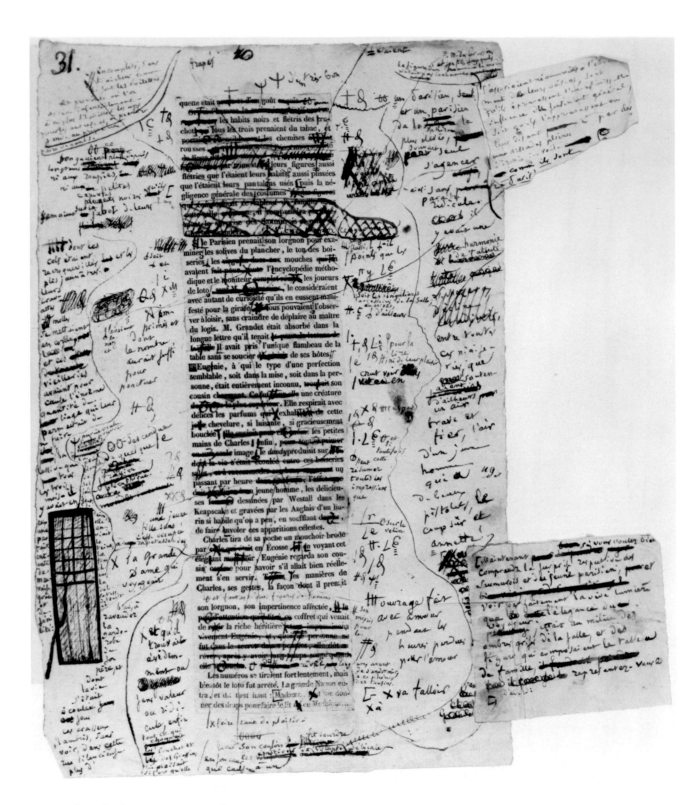

12 A galley of Balzac, *Eugénie Grandet*

a frustrating demonstration of carelessness. A tortuous mass of rapid writing, corrections, additions, and forty-one leaves of corrected galley proofs bound in, the manuscript of *Eugénie Grandet* is a typical example of Balzac's method of composition. Customarily, Balzac (1799-1850) would shift whole chapters about as well as revise practically every passage with his nearly indecipherable scribblings. He would then call for fresh proofs. Sustained by innumerable cups of strong coffee, he would work through the night and devastate yet another set of proofs with a morass of further emendations. This extravagant process considerably reduced his earnings and added to his ever-present financial woes.

Eugénie Grandet is one of the "Scènes de la vie de province" within the series known collectively as the *Comédie humaine*. Balzac's ambitious sequence of ninety-one interconnected works populated by more than two thousand characters remains a cornerstone in the history of the European novel. Combining a scientist's concern for objectivity, a historian's interest in accuracy, and a great novelist's attentiveness to the creation of a believable fictional world, Balzac constructed his magnificent, elaborate narrative of French society. As in so much of the *Comédie humaine*, the plot of *Eugénie Grandet* is propelled by the centrality of money in personal and social relations. The novel stands apart, however, for its small number of characters, economy of incident, and unity of setting. No melodramatic events or philosophical digressions impede the progression of this bourgeois tragedy of avarice and betrayal in which once hopeful Eugénie, the daughter of the miser Grandet, is rejected by her greedy, ambitious lover and doomed to a passive existence of lonely piety.

Balzac presented this manuscript of one of his greatest and most popular novels to Mme Eveline de Hanska, a wealthy Polish countess whom he befriended and eventually married a few months before his death. In addition to Balzac, several other major French writers of the nineteenth century are represented in the Morgan Library. Autograph holdings include Anatole France's *Thaïs*, Zola's *Nana*, Maupassant's *Boule-de-suif, Fort comme la mort,* and *Bel-Ami,* as well as representations of Dumas père, Dumas fils, and Victor Hugo.

13 ❧

CHARLES DICKENS

A Christmas Carol. Autograph manuscript, 1843. MA 97. Purchased by Pierpont Morgan.

Dickens (1812-70) so artfully expressed the unique blend of nostalgia, joy, and hope which gives the Christmas season its special meaning that some would give him credit for inventing the holiday. Scrooge's regretful confrontation with the miserliness of his past, the Cratchits' modest Christmas dinner enriched by the family's good humor and love for one another, and Scrooge's reformation as the benefactor of the Cratchits continue to evoke great emotion in readers. From 1843 until 1847, Dickens delighted and touched his public annually with eagerly awaited Christmas stories, but the first, *A Christmas Carol,* has remained the most powerful of his seasonal creations. The tale is imbued with his own character and social attitudes. Like Bob Cratchit, he had known poverty and eked out a living as a clerk. Like Scrooge, he lived in great fear of financial ruin. His natural sympathy for the less fortunate inspired the benevolence which suffuses the work.

Dickens's note on title page of manuscript

From its inception, the work had particular significance for him. In 1843, he was concerned about his earnings. His family was growing and his most recent novel, *Martin Chuzzlewit,* did not sell well. Determined to achieve a monetary success, he planned a single volume work on a Christmas theme to be sold at a reasonable price and available in time for the holidays. Once he began writing in mid-October, he was consumed by the ghostly plot and extraordinary characters and completed the work in six weeks. By Christmas Eve, 6,000 copies had been sold. Though popular with holiday shoppers, the work earned Dickens far less than he had expected. The costs of producing an attractively bound and illustrated, yet affordable, volume cut deeply into profits. He did, however, capitalize on his readers' affection for

Stave I.

Marley's Ghost.

[Dickens's heavily revised manuscript text, largely illegible handwriting with numerous deletions and insertions]

13 Page from Dickens's *A Christmas Carol*

the book by making it a centerpiece of the immensely successful public readings which he gave for the rest of his life.

The manuscript enables us to peer over the author's shoulder and observe him at work. The heavily corrected text, a morass of crossed-out and inserted words, reveals a scrupulous author who revised continuously. He presented the manuscript as a gift to his friend and solicitor Thomas Mitton. It passed through several hands before being acquired by Pierpont Morgan around the turn of the century. Besides *A Christmas Carol*, the Morgan Library has the manuscripts of two of Dickens's other Christmas books, *The Cricket on the Hearth* and *The Battle of Life*, as well as *Our Mutual Friend* and *No Thoroughfare*, which he wrote with Wilkie Collins for the 1867 Christmas issue of *All the Year Round*. There are also over 1,300 autograph letters.

14 ❧

WILLIAM MAKEPEACE THACKERAY

Autograph letter signed, 10 January 1841, to Edward FitzGerald. MA 4500. Bequest of Gordon N. Ray, 1987.

One of Thackeray's favorite correspondents was his friend Edward FitzGerald, renowned for his translation of *The Rubáiyát of Omar Khayyám*. FitzGerald burnt many of his letters from Thackeray (1811-63), but this particularly poignant one survived. Writing when he was first becoming known to the public for his humorous articles, the author confided his private anguish. His wife, Isabella, had suffered a mental breakdown. Thackeray had taken her to France to place her in the famed Maison de Santé of Dr. Esquirol, where patients were reputed to receive the most enlightened treatment

Caricature of Thackeray (left) and Dickens (right) by Alfred Bryan. Gift of Miss Caroline Newton, 1974.7

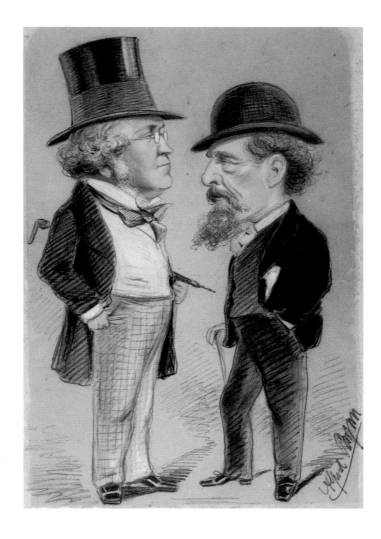

Avenue Ste. Marie. Faubourg du Roule
10. January. 1841.

My dear old Edward. Your letter though it has not been
answered till now gave me a great pleasure — I mean yours
are the only letters that were always welcome to me, for
they always contain something hearty wh. makes me happier
when I am happy, and consoles me when I am dull.
this blow that has come upon me has played the deuce
with me that is the fact, and I don't care to write to any
friends and pour out lamentations wh. are all the news I
have to tell. I saw my dear little woman yesterday for the
first time for six weeks, since wh. time she has been at
Esquirol's famous maison de santé. Esquirol is dead since
she went there, & the place conducted by his nephew. who
is Mitivié a famous name in his profession. He says
Elle doit guérir, and I think so too : at first she was in a fever
and violent, then she was indifferent, now she is melan-
choly & silent and we are glad of it. She bemoans her condition
and that is a great step to a cure, she knows every body
and recollects things but in a strange confused sort of way.
She kissed me at first very warmly and with tears in her
eyes, then she went away from me, as if she felt she was
unworthy of having such a God of a husband. God help her.
 My father brother and cousin are all going off to Italy
in this dreadful weather, to meet a brother of the governors'

that medical science could then provide. Thackeray reported some improvement:

At first she was in a fever and violent, then she was indifferent, now she is melancholy & silent and we are glad of it. She bemoans her condition and that is a great step to cure. She kissed me at first very warmly and with tears in her eyes, then she went away from me, as if she felt she was unworthy of having such a God of a husband. God help her.

Isabella Thackeray was never cured, and her condition was a great sadness for the author. She eventually returned to England, where she died some thirty years after her husband.

Though one of the most famous of Victorian authors during his lifetime, Thackeray the person remained enigmatic until well into the twentieth century. He had no Boswell, and, indeed, expressed his hope to his daughter Anne that no biography would ever be written of him. When the first volume of Gordon Ray's monumental edition of the correspondence appeared in 1945, three-fifths of the some 1,600 surviving letters were unpublished. When completed, the four volumes revealed for the first time the full richness of Thackeray's personality. The edition also established Thackeray as one of the greatest English letter writers. Employing the correspondence as the "indispensable foundation of intimate biography," Gordon Ray went on to write the authoritative life of the author.

Among the several thousand autograph representations of English, French, and American authors and artists bequeathed to the Morgan Library by Gordon Ray are substantial groups of correspondence and manuscripts centering around Thackeray and his family. The Library's Thackeray holdings also include the manuscripts of *Denis Duval, Lovel the Widower, The Rose and the Ring, Vanity Fair,* and *The Virginians,* 185 autograph letters, and numerous drawings.

15 &

GEORGE ELIOT
PEN NAME OF MARIAN EVANS

Scenes of Clerical Life. Autograph manuscript, 1856-57. MA 722. Purchased by Pierpont Morgan, 1911.

George Henry Lewes submitted Marian Evans's (1819-80) first fictional effort to *Blackwood's Edinburgh Magazine* in 1856 as the initial story in a series by an anonymous friend. He assured the editor that the series "will con-

sist of tales and sketches illustrative of the actual life of our country clergy about a quarter of a century ago; but solely in its *human* and *not at all* in its *theological* aspect." It does seem surprising that Evans—editor, translator, freethinker and non-believer—should have chosen as her first fictional subject the quiet lives of provincial clergy, making her entrée as novelist with a title as innocuous as *Scenes of Clerical Life.* But it was precisely that "human aspect" of her unlikely protagonists which Evans aimed to explore in her series of "sketches." Just a few days before beginning the clerical scenes, Evans completed an article entitled "Silly Novels by Lady Novelists," decrying the sentimentality and melodrama of popular Evangelical literature of the "White Neck-cloth School" with its backdrop of aristocratic gentility. When she tried her hand at fiction the following week, adopting the masculine pen name George Eliot, she proved that a realistic treatment of religious life among "commonplace people" can be far from silly.

At the start of Chapter 5 of "The Sad Fortunes of the Rev. Amos Barton," George Eliot wonders if "perhaps I am doing a bold thing to bespeak your sympathy on behalf of a man who was so very far from remarkable,—a man whose virtues were not heroic,…but was palpably and unmistakably commonplace." In the passage reproduced here, George Eliot steps in to offer an authorial apostrophe on behalf of her inarticulate heroes, with "their unspoken sorrows, and their sacred joys…Nay, is there not a pathos in their very insignificance—in our comparison of their dim and narrow existence with the glorious possibilities of that human nature which they share?" If her later novels were often told through vehicles more exceptional than Amos Barton's "dull grey eyes," George Eliot's social tragedy continued to derive from her characters' common humanity.

The manuscript of *Scenes of Clerical Life* is notably free of substantial emendation, for Eliot stood firm against the "cramping influence" of her editor John Blackwood. When he suggested that one character might be given a bit more "dignity," she refused to alter the manuscript: "My artistic bent is directed not at all to the presentation of eminently irreproachable characters, but to the presentation of mixed human beings in such a way as to call forth tolerant judgment, pity, and sympathy. And I cannot stir a step aside from what I *feel* to be *true* in character" (18 February 1857, National Library of Scotland).

is more or less halt & disjointed. Yet these common place people
— many of them — bear a conscience, & have felt the sublime
prompting to do the painful right; they have their unspoken
sorrows, & their sacred joys; their hearts have perhaps gone
out towards their first born, & they have mourned over the
irreclaimable dead. Nay, is there not a pathos in their
very insignificance, — in our comparison of their dim &
narrow existence with the glorious possibilities, of that
human nature which they share?

Depend upon it, my dear lady, you would gain un-
speakably if you would learn with me to see some of the
poetry & the pathos, the tragedy & the comedy, lying in the
experience of a human soul that looks out through dull
grey eyes & that speaks in a voice of quite ordinary tones.
~~In those daily actions the recording angel probably
enters into the celestial ledger simply by the word ditto.~~
In that case, I should have no fear that you would not
care to know what further befel the Rev. Amos, or that
you would think the homely details, I have to tell at all
beneath your attention. As it is, you can, if you please,
decline to pursue my story further, & you will easily find
reading more to your taste, since I learn from the newspapers,
that many remarkable novels, full of striking situations,
thrilling incidents, & eloquent writing, have appeared only
within the last season.

Meanwhile, readers who have begun to feel an interest
in the Rev. Amos Barton & his wife will be glad to learn
that Mr. Oldinport lent them twenty pounds. But twenty

15 Folio 60 of Eliot, *Scenes of Clerical Life*

JOHN RUSKIN

The Stones of Venice. Autograph manuscript
[1851-53]. MA 398-400. Purchased by
Pierpont Morgan, 1907.

When the adolescent Ruskin (1819-1900) and
his parents embarked on a continental trip in
1835, their final stop was the city which had
entranced the English since the Middle Ages.
To the pilgrims who passed through on their
way to the Holy Land, Venice was the embodi-
ment of luxury and power. By Ruskin's time,
the city had become a powerful symbol of
decay. The majesty and ornate beauty of her
churches and palaces, nevertheless, continued
to lure, enthrall, and inspire English visitors.
No exception, Ruskin drew on his six separate
journeys spread over seventeen years to record
his own multiple impressions in *The Stones of
Venice*. "To see clearly is poetry, prophecy, and
religion—all in one," he had written in *Modern
Painters*. Ruskin's magnificent study of Vene-
tian architecture, with plentiful evidence of his
sharp, critical eye and his deep sense of moral
purpose, explores the possibilities of that as-
sertion.

16 Page 1 of Ruskin, *The Stones of Venice*

Ruskin, *Self-portrait in Blue Neckcloth*, watercolor. Gift of the Fellows, 1959.23

In the opening paragraphs, he sets forth his argument in his characteristically rich, impressionistic prose. The decline of Venice is linked to the lost glory of ancient Tyre, and England is admonished to heed the lesson of their tragic falls. Whereas now vanished Tyre can only be studied in the words of the Biblical prophets, he notes, slowly deteriorating Venice remains for our observation and edification:

Her successor, like her in perfection of beauty, though less in endurance of dominion, is still left for our beholding in the final period of her decline: a ghost upon the sands of the sea, so weak—so quiet,—so bereft of all but her loveliness, that we might well doubt, as we watched her faint reflection in the mirage of the lagoon, which was the City, and which the Shadow.

I would endeavour to trace the lines of this image before it be for ever lost, and to record, as far as I may, the warning which seems to me to be uttered by every one of the fast-gaining waves, that beat like passing bells, against the STONES OF VENICE.

The Morgan Library owns a superb collection of Ruskin manuscripts, including *Modern Painters* and the collections of Ruskin materials formed by F. J. Sharp and Helen Gill Viljoen. The holdings of Ruskin correspondence in-

clude almost six hundred of his letters to the children's book author and illustrator Kate Greenaway.

17 ❧

WILLIAM MORRIS

News from Nowhere: Being Some Chapters from a Utopian Romance. Autograph manuscript [1889–90]. MA 4591. Purchased on the Gordon N. Ray Fund, 1989.

"Society is to my mind wholly corrupt, & I can take no deep-seated pleasure in anything it turns out, except the materials for its own destruction in the shape of discontent and aspiration for better things," wrote William Morris (1834-96) in a letter to the printer and bookbinder T. J. Cobden-Sanderson. In his own life, certainly, "aspiration to better things" had informed the immensely diverse and remarkably energetic Morris's accomplishments as writer, designer, craftsman, printer, and political theorist. In his final decade, he drew on his multiple interests to create several visionary works which allowed his idealism and literary imagination free rein. These extraordinary works include the historical romances *The House of the Wolfings, The Story of the Glittering Plain,* and *The Well at the World's End,* as well as two fantasies, *A Dream of John Ball* and *News from Nowhere.*

News from Nowhere was Morris's direct response to the Utopian romance *Looking Backward* (1888) by the American novelist and political theorist Edward Bellamy. In Bellamy's Utopia, social justice and culture thrive in an industrial, urban setting. Morris envisions instead a more pastoral society in which rural and urban values are carefully balanced, technology operates harmoniously with nature, and daily labor permits creativity. Social salvation is possible when the patterns of art are applied to everyday life. *News from Nowhere* is presented as a dream of London and the English countryside in the future. During his reverie, the narrator is advised, "Go on living while you may, striving with whatsoever pain and labour needs must be to build up little by little the new day of fellowship and rest and happiness." When he awakes, he vows to share the possibilities which he has glimpsed: "If others can see it as I have seen it, then it may be called a vision rather than a dream." Morris's culminating work first appeared serially in *Commonweal,* the organ of the Socialist

or lying down I could not tell ✗ ✗ ✗ ✗ ✗
✗ ✗ ✗ ✗

I lay in my bed in ~~Ham~~ my dingy house at
Hammersmith thinking about it all; and
trying to think if I was overwhelmed with despair
at finding I had been dreaming a dream.
Or indeed was it a dream? If so, why was I so
conscious all along that I wa's really seeing all
that new life from the outside, still wrapped up in
the prejudices, the anxieties, the distrust of this time
of doubt and struggle?
All along, though those friends were so real to me, I
had been feeling as if I had no business amongst them,
as though the time would come when they would reject
me, and say as Ellen's last mournful look seemed —
say: "No, it will not do, you cannot be of us: you
belong so entirely to the unhappiness of the past that
our happiness even would weary you. Go back
again now you have seen us, and your outward eyes
have learned that in spite of all the infallible maxims of your
day there is yet a time of rest in store for the world,
when mastery has changed into fellowship — but not
before — Go back again then, and while you live you
will see all round you ~~the piteously~~ people engaged
in making others live lives which are not their own,
while they themselves care nothing for their own real
lives — men who hate life though they fear death.
Go back and be the happier for having seen us, for
having added a little hope to your struggle: go on
~~Striv~~ living while you may striving ~~little by little~~
with whatsoever pain and labour ~~needs~~ needs must
be to build up little by little the new day of fellowship,
and rest and happiness."
Yes surely! and if others can see it as I have seen it then it may
be called a vision rather than a dream. William Morris
 The End.

Please send proofs to
Kelmscott Lechlade.

17 Folio 266 of Morris, *News from Nowhere*

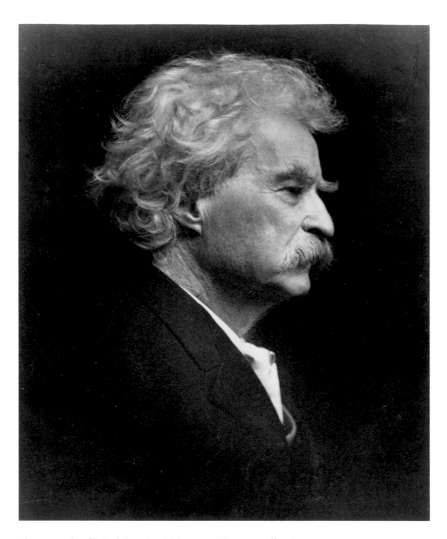

Photograph of Mark Twain, MA 1950, Harper collection

when in doubt, strike it out"). In a final court-room scene, Wilson lives down his nickname and solves a murder by employing the then unheard-of technique of fingerprinting.

The murderer is Tom Driscoll, a cowardly gambler raised as the son of a wealthy southern aristocrat but actually the son of a slave girl, Roxana, who switched her own baby with her master's to save him from the indignity of slavery. In a lengthy passage excised from the printed novel but reproduced here, Tom contemplates the debasing effect of slavery after learning of his own parentage:

Whence came that in him which was high, and whence that which was base? That which was high came from either blood, and was the monopoly of neither color; but that which was base was the *white* blood in him debased by the brutalizing effects of a long-drawn heredity of slave-owning, with the habit of abuse which the possession of irresponsible power always creates and perpetuates, by a law of human nature.

Twain, a friend of the family and a visitor to Morgan's library, wrote to Pierpont Morgan on the occasion of his purchase of the manuscript, "One of my highest ambitions is gratified—which was, to have something of mine placed elbow to elbow with that august company which you have gathered together to remain indestructible in a perishable world." Elbow to elbow with that august company are also the manuscripts of *Life on the Mississippi, The Man that Corrupted Hadleyburg, A Double-barrelled Detective Story,* several letters, and short pieces.

XX 241

In his broodings in the solitudes,
he searched himself for the reasons
of certain things, & in toil & pain
he worked out the answers:

Why was he a coward? It was
the "nigger" in him. The nigger
blood? Add it Yes, the nigger blood
degraded from original courage
to cowardice by decades & gene-
rations of insult & outrage in-
flicted in circumstances which
forbade reprisals, & made mute
endurance
& meek acceptance the only refuge
& defence.

Whence came that in him which
was high, & whence that which was
base? That which was high came
from either blood, & was the mo-
nopoly of neither color; but that
which was base was the white
blood in him debased
by the brutalizing effects of a

19 Folio 241 of Twain, *Pudd'nhead Wilson*

lielmo Marconi on wireless telegraphy, notes by Robert Fulton on the steamboat and proposals for methods of launching torpedoes, and a diagram and description by Samuel F. B. Morse of the original telegraph.

21 🐚

JOHN STEINBECK

Travels with Charley. Autograph manuscript, [ca. 1961]. MA 2199. Gift of the author, 1962.

Accepting the 1962 Nobel Prize for literature, John Steinbeck (1902-68) declared that literature was not "a game for the cloistered elect, the tinhorn mendicants of low calorie despair. It grew out of human need for it, and it has not changed except to become more needed." For almost forty years of professional writing, he exemplified this credo in a remarkable variety of forms—novel, short story, nonfiction, journalism, drama, and screenplay. Steinbeck shared the social concerns of many writers of his generation, but he roused the emotions of millions of American readers much more forcefully than did most of his contemporaries. His compassionate renderings of the plight of farmers and fruitpickers in works such as *The Grapes of Wrath* evoked great sympathy for all victims of the Dust Bowl and the Depression. Throughout his career, he condemned greed and exploitation, extolled loyalty and gallantry, and offered acute observations of the American land and its inhabitants in realistic, vigorous prose.

Shown here are the opening paragraphs of *Travels with Charley* (1962), including one which does not appear in the published volume. In initial sales *Travels with Charley* was more successful than any of Steinbeck's other books. In it, he recounts the rambling journey he made with Charley, his French poodle and inseparable companion, across the United States and back in a three-quarter-ton pickup truck named Rocinante. Throughout the book, the vivid descriptions of the terrain and its inhabitants reveal a writer long in love with the American landscape and uniquely attuned to the people's mores. There is exuberance in his portrayals of the uninhibited energy of Texans and the neighborliness of the people of Montana. Much of what he observes, though, invokes sad reflections on American restlessness and the waste and destruction wrought by progress in the twentieth century. In New Orleans, his characteristic outrage at social injustice comes to the fore, and he angrily depicts the taunting of a little black girl attempting to integrate a grammar school.

Steinbeck enjoyed a close association with the Morgan Library. He spent many hours consulting books and manuscripts at the Library when he was working on his rendering of *The Acts of King Arthur and His Noble Knights*. Many of the Library's Steinbeck manuscripts were given by him. In addition to *Travels with Charley*, the collection includes the manuscripts of his Nobel Prize address, *The Short Reign of Pippin IV*, *The Winter of Our Discontent*, *America and Americans*, the script of the film *Viva Zapata!*, as well as journals and correspondence.

1.

When I was very young and the urge to be some place else was on me, I was assured by mature people that maturity would cure this itch. Still having it when years described me as mature the prescribed remedy was middle age. In middle age I was assured that greater age would calm my fever and now at fifty eight perhaps senility will do the job. Nothing has worked. Four hoarse blasts of a ship's whistle still raises the hair on my neck and sets my feet to tapping. The sound of a jet, an engine warming up, even the clopping of shod hooves on pavement brings on the ancient shudder, the dry mouth and vacant eye, the hot palms and the churn of stomach high up under the rib cage. In other words, I don't improve; in further words, once a bum always a bum. I fear the disease is incurable. I set this matter down, not to instruct others but to inform myself.

In a long and wandering life, some verities have forced themselves on me. Perhaps those among my readers who bear vagrant blood will find echoes of experience in a few generalities.

When the virus of restlessness begins to take possession of a wayward man, and the the road away from Here seems broad and straight and sweet, the victim must first find in himself a good and sufficient reason for going. This to the practical bum is not difficult. He has a built in garden of reasons to choose from. Next he must plan his trip in

21 First page of Steinbeck's *Travels with Charley*

letters of Mozart, written to his mother and sister in 1769 when he was thirteen years old.

An account of the Library as a major repository of music manuscripts begins in 1962, when the collection of books and manuscripts of the Heineman Foundation was placed on deposit. Between the two world wars Dannie Heineman and his wife, Hettie, built an outstanding collection of printed books and autograph letters and manuscripts of which the music section, although relatively small, was exceedingly well chosen. Among the notable manuscripts are the only extant portions of Bach's Cantata 197a (*Ehre sei Gott in der Höhe*), Mozart's Piano Concertos in C, K. 467, and D, K. 537 (*Coronation*), and his D-major piano rondo, K. 485, four early songs of Wagner, Chopin's Polonaise in A-flat, op. 53, Brahms's arrangement for piano four-hands of his String Sextet op. 18, and Mahler's *Klagende Lied*. In 1977 the collection was given to the Morgan Library, one of the most important and valuable gifts since the Library was founded.

The second major event in the history of the collection occurred in 1968, when the Trustees of the Mary Flagler Cary Charitable Trust donated Mrs. Cary's collection of music manuscripts, letters, and printed scores. One of the greatest collections of its kind, public or private, in the country, it was formed by Mrs. Melbert B. Cary, Jr., with the example and encouragement of her father, Harry Harkness Flagler. Mrs. Cary's collecting interests were firmly rooted in the Austro-Germanic traditions and in the nineteenth century. Fully three quarters of the manuscripts she acquired come from that period, and often from the pens of its luminaries. Her collection included Beethoven's *Geister* Trio, Schubert's *Schwanengesang* and String Quartet in D Minor (*Der Tod und das Mädchen*), Mendelssohn's *Meeresstille und glückliche Fahrt*, Chopin's Mazurkas op. 50, Bruch's Violin Concerto in G Minor, Brahms's First Symphony, and Richard Strauss's Songs op. 10 and *Don Juan*. Earlier autographs, although relatively few in number, were carefully selected, and included Bach's Cantata 112 (*Der Herr ist mein getreuer Hirt*), an early copyist's manuscript of Handel's *Messiah*, portions of Gluck's *Orfeo ed Euridice* and *Iphigenie auf Tauris*, Mozart's Violin Sonata in F, K. 376, and Haydn's Symphony no. 91.

One of the first large purchases the Library made after receiving the Cary Collection was an important group of Italian manuscripts, including works of Bellini, Cimarosa, Donizetti, Giordano, Mascagni, Pacini, Ponchielli, Puccini, Rossini, Spontini, and Verdi. Only a few of these composers were already represented, and none by a significant manuscript. The acquisition of these Italian manuscripts—in fact that of nearly every manuscript bought since 1968—was made possible through funds provided by the Mary Flagler Cary Charitable Trust. Notable among these are Brahms's Hungarian Dances for piano four-hands, Mahler's Fifth Symphony, Mozart's *Haffner* Symphony, K. 385, *Schauspieldirektor*, K. 486, and earliest known works, K. 1a-d, Pergolesi's Mass in F, Schoenberg's *Gurrelieder* and *Erwartung*, Schubert's *Winterreise* and eight Impromptus for piano, D. 899 and 935, Strauss's *Tod und Verklärung*, Stravinsky's *Perséphone*, Sullivan's *Trial By Jury*, and Weber's *Aufforderung zum Tanze*. It is in large part because of the continued growth of the Cary Collection that the Library has attracted so many other important gifts and collections on deposit.

Music scholars can also study manuscripts from one of the world's finest private collections of music manuscripts, the Robert Owen Lehman Collection, placed on deposit in the Morgan Library in 1972. Welcome not only for the singular distinction of its contents, this collection complements areas that are poorly represented in the Cary and

Heineman collections. The nucleus of the archive is a splendid group of manuscripts belonging to the eminent French pianist Alfred Cortot; it is especially strong in French music, notably Debussy, Ravel, Fauré, and Franck. To this core Mr. Lehman has added ten major Mozart autographs, several outstanding Mahler manuscripts, and a large number from the so-called second Viennese school of Schoenberg, Berg, and Webern. Mr. Lehman has, moreover, given the Library many manuscripts from his collection.

The Frederick R. Koch Foundation has purchased many important music manuscripts and letters, all of which are on deposit in the Library. Among the autograph manuscripts acquired by the foundation are the short score of Debussy's *Pelléas et Mélisande*, Berlioz's *Roi Lear* overture, Boccherini's Quintets for piano and strings op. 57, Mozart's Gavotte for orchestra, K. 300, large portions of Offenbach's *Contes d'Hoffmann*, a draft of Schubert's Fantasie in F Minor for piano four-hands, D. 940, the librettos of Verdi's *Ernani* and of Wagner's *Siegfried's Tod* (later *Götterdämmerung*) and *Lohengrin*, and over seventy William Walton manuscripts. The Frederick R. Koch Foundation deposit also includes large collections of letters by Offenbach, Poulenc, Puccini, Ravel, Saint-Saëns, Verdi, and Weber.

Music manuscripts are part of our musical heritage; each one is a unique record that transmits to us, however imperfectly, a written account of its author's passage through his compositional stages, from early sketch to final copy. It is argued that when new critical editions of works are published they diminish the need for these manuscripts and reduce their value; but even the most scrupulously prepared edition rarely, if ever, answers all the questions we may have about a work. To be sure, the manuscripts themselves leave us with uncertainties of meaning and ambiguities of interpretation, but without them an irreplaceable link in the documentary chain would be lost forever, and we would be the poorer for it.

I 🐌

JOHANN SEBASTIAN BACH

Cantata 112. *Der Herr ist mein getreuer Hirt.* Autograph manuscript, 1731. Mary Flagler Cary Music Collection.

Cantata 112 is one of three cantatas that Bach (1685-1750) composed for the second Sunday after Easter (*Misericordias Domini*). It was first performed, in Leipzig, on 8 April 1731; while it is probable that the entire manuscript was written around the same time, close study of it suggests that the first movement, notated in Bach's most elegant calligraphy, had been composed some time before, possibly as early as April 1725, and recopied into the 1731 manuscript. Bach frequently used previously composed music in his cantatas (and in other works), a reasonable economy given the large quantity of music he was required to produce and the often short amount of time he had to write it. The text of *Der Herr ist mein getreuer Hirt* (The Lord is My Faithful Shepherd) is a version, by Wolfgang Meuslin, of the Twenty-third Psalm. Both the Epistle and the Gospel for *Misericordias Domini* have to do with sheep gone astray and with the Good Shepherd.

The Cantata opens with a festive chorus based on the chorale "Allein Gott in der Höh sei Ehr," a melody that appears in varied form in other movements as well. The second movement ("He leadeth me beside the still waters"), for alto and oboe d'amore, flows with a steady, reflective pace that conveys the calm assurance of the text. In the recitative for bass that follows ("Yea, though I walk through the valley of the shadow of death") the thematic interplay, heard now in the voice, now in the instrumental continuo, may suggest, as the noted Bach scholar Alfred Dürr observes, that the wanderer has not been abandoned. The fourth movement ("Thou preparest a table before me"), a duet for soprano and tenor, is a cheerful bourrée that celebrates God's care for man.

technically assured artist. Beginning with the concerto in E-flat Major, K. 271 (*Jeunehomme*), he wrote a series of works that are among the sovereign masterpieces in the genre. As the noted pianist and writer Charles Rosen has observed, "Mozart's most signal triumphs took place where Haydn had failed: in the dramatic forms of the opera and the concerto, which pit the individual voice against the sonority of the mass."

Mozart apparently completed the great Piano Concerto in C Major, K. 467, in just four weeks. It was probably begun in mid-February 1785 and was finished by 9 March. For richness and diversity of melodic and motivic material, the first movement has few parallels among the concertos. In the outer movements the piano part makes formidable demands on the soloist's technique—the English writer C. M. Girdlestone calls one passage in the first movement "the thickest scrub of arpeggios and broken octaves that Mozart has ever set up before his executants"—but the virtuosity is always at the service of the music and never suggests self-indulgent display. Never, that is, so long as conductor and pianist choose a sensible tempo. The first movement is rare in Mozart's autographs in that it lacks a tempo direction. The first edition, published in 1800, prescribed "Allegro." For the true tempo marking we must go to the *Verzeichnüss aller meiner Werke*, the catalogue Mozart kept of his works from 1784 until his death, where we find "Allegro maestoso." The sustained reverie of the second movement is justly famous, and has survived the myriad adaptations and transcriptions—including koto ensemble—to which it has latterly been subjected. It possesses the noble bearing of an aria from the later operas and of the late symphonic slow movement (the Andante cantabile of the *Jupiter* comes to mind).

6

Ludwig van Beethoven

Violin Sonata no. 10 in G Major, op. 96. Autograph manuscript, 1815. Purchased by Pierpont Morgan in 1907.

Beethoven (1770-1827) composed his first nine sonatas for violin and piano between 1797 and 1803. This is the autograph manuscript of the tenth, and last, of his violin sonatas, written in 1812, the year in which he completed the Seventh and Eighth symphonies. The sonata was written for Pierre Rode, the greatest French violinist of his day, and was first performed by Rode and Archduke Rudolph, to whom the work is dedicated. In late December 1812, a few days before the performance, Beethoven wrote to the archduke:

5 Page 1 from Mozart, Piano Concerto in C Major, K. 467, 1785

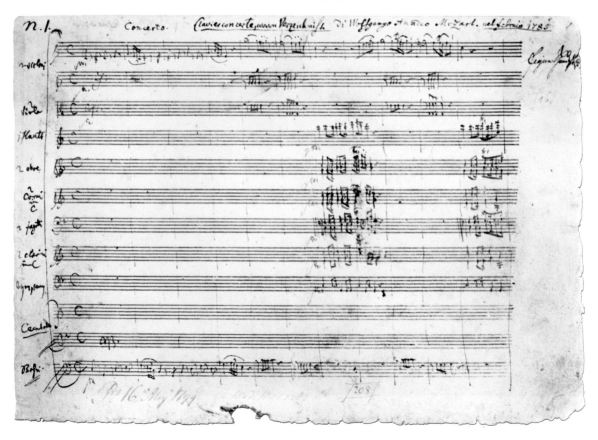

6 Page 1 from Beethoven, Violin Sonata no. 10 in G Major, op. 96, 1815

The copyist will be able to begin work on the last movement very early tomorrow morning. Since in the meantime I myself have been engaged on several other works, I have not hurried unduly to compose the last movement merely for the sake of being punctual, the more so as in view of Rode's playing I have had to give more thought to the composition of this movement. In our Finales we like to have fairly noisy passages, but R[ode] does not care for them — and so I have been rather hampered.

Despite Beethoven's having tailored the music to Rode's style, the violinist's skill had greatly deteriorated, and Beethoven expressed disappointment in the performance.

Although the sonata itself dates from 1812,

this manuscript was most likely written in early 1815 and transmits a revised version of the original work. When he made this copy Beethoven was unsure of when he had composed the sonata, and thus dated the manuscript "im Februar 1812 oder 13." The type of paper on which the sonata is written is very rarely found in Beethoven manuscripts; only thirty-three leaves are known, over half of them in the opus 96 autograph.

Pierpont Morgan bought this manuscript in Florence in 1907; it was the only major music manuscript he ever acquired and the first important Beethoven autograph to come to this country. In addition to this sonata, the Library owns the autograph manuscript of the Piano Trio op. 70, no. 1 (*Geister*), several of the *Schottische Lieder,* and sketches for the Piano Concerto no. 5 (*Emperor*), Piano Sonata op. 106 (*Hammerklavier*), String Quartet op. 95 (*Quartetto serioso*), and Piano Trio op. 97 (*Archduke*), as well as seven autograph letters and a manuscript leaf from Beethoven's kitchen account, with additions in his hand.

7 &

Carl Maria von Weber

Aufforderung zum Tanze. Autograph manuscript, 1819. Mary Flagler Cary Music Collection.

Two entries in Weber's diary for 1819 record the composition of this piece. "July 23: Invitation to the Dance. D-flat Major. Draft completed." "July 28: Invitation to the Dance. Rondo for pianoforte. D-flat Major. Completed." In these brief entries Weber (1786-1826) noted the creation of his most famous composition for solo piano. It has been called an epoch-making work in the piano literature. Instantly successful, it has remained popular to the present day. Weber's series of exhilarating waltzes connected by more tranquil interludes, all in the form of a single-movement rondo, was without precedent. In this work, written in Weber's most brilliant pianistic idiom, can be traced the antecedents of Chopin's concert waltzes and of the waltz suites of Johann Strauss, Jr.

Weber dedicated *Invitation to the Dance* to his wife, the soprano Caroline Brandt. When Friedrich Wilhelm Jähns was compiling the first thematic catalogue of Weber's works, she told him that when Weber first played the work for her he provided a running commentary during the slow Introduction and Coda, describing the dancers' movements in almost balletic terms:

First approach of the dancer (bars 1-5) to whom the lady gives an evasive answer (5-9). His more pressing invitation (9-13: the grace note C and the long A flat are significant here); her actual acceptance of his request (13-16). They now converse in greater detail; he begins (17-19); she answers (19-21); he with heightened expression (21-23); she responds more warmly (23-25); now for the dance! His direct remarks concerning it (25-27); her answer (27-29); their coming together (29-31); their going forward; expectation of the beginning of the dance (31-35). The Dance. End: his thanks, her reply, and their parting. Silence.

Like many popular works, *Invitation to the Dance* has been arranged numerous times for other instruments, among them solo flute, zither, and two pianos, eight hands. It was orchestrated by Berlioz and performed as ballet music in his 1841 production of Weber's *Freischütz* in Paris. The work is probably best known today in this orchestral version. It is also familiar to the world of dance through *Le spectre de la rose,* the 1911 ballet by Diaghilev and Nijinsky.

The Library also has the autograph manuscript of an insert aria Weber wrote for the opera *Ines de Castro* (the composer has not yet been identified), and has on deposit the autograph of the Second Clarinet Concerto and sixty-two Weber letters.

8 &

Franz Schubert

Winterreise, D. 911. Autograph manuscript of the song cycle, 1827. Mary Flagler Cary Music Collection.

In his "Reflections and Notes on My Friendship with Franz Schubert," published in 1858, Joseph Spaun wrote of his longtime friend Schubert (1797-1828):

For some time Schubert appeared very upset and melancholy. When I asked him what was troubling him, he would say only, "Soon you will hear and understand." One day he said to me, "Come over to Schober's today, and I will sing you a cycle of horrifying songs. I am anxious to know what you will say about them. They have cost me more effort than any of my other songs." So he sang the entire *Winterreise* through to us in a voice full of emotion. We were utterly dumbfounded by the mournful, gloomy tone of these songs, and Schober said that only one, "Der Lindenbaum," had appealed to him. To this Schubert

7 Page 1 from Weber, *Aufforderung zum Tanze*, 1819

replied, "I like these songs more than all the rest, and you will come to like them as well."

The twenty-four songs in *Winterreise,* settings of poems by Wilhelm Müller, form what many consider the greatest song cycle ever written. The songs did indeed cost Schubert considerable effort, evidence of which can be found in this manuscript, which actually consists of two separate documents. Part I, comprising the first twelve songs, is dated February 1827, and is a mixture of fair copies and heavily emended first versions. The twelve songs found in the second half of the *Winterreise* manuscript, the first of which is dated October 1827, are entirely in fair copy, and reveal none of the correc-

tions and revisions such as those found in the first half. Part I was published by Tobias Haslinger in January 1828; Part II, the proofs of which Schubert corrected on his deathbed, was announced for sale in December 1828, soon after the composer died, on 19 November.

In addition to *Winterreise,* the Morgan Library's Schubert collection includes his earliest known work, the Fantasie for piano four-hands, D. 1; *Erlkönig,* D. 328, and other songs; the String Quartet in D Minor, D. 810 (*Death and the Maiden*); the Rondo for violin and piano in B Minor, D. 895; the eight Impromptus for piano, D. 899 and 935; and *Schwanengesang,* D. 957.

8 Page 1 from Schubert, *Winterreise*, D. 911, folio 31, 1827

9 🕭

HECTOR BERLIOZ

Mémoires. Part of the autograph manuscript of Chapter 26, 1830. The bequest of Sarah C. Fenderson.

Berlioz's memoirs, the main source for our knowledge of his life, are among the most moving, revealing, and without doubt most readable of any artist's. They were begun in 1848, largely completed by 1855, and first published (at his request) posthumously. They will consist, Berlioz (1803-69) wrote in the Preface, of "those things in my arduous and turbulent career which I believe may be of interest to lovers of art," and will "afford me the opportunity to give a clear idea of the difficulties confronting those who try to be composers at the present time, and to offer them a few useful hints." The *Mémoires* begin prosaically

enough: "I was born on 11th December 1803 in La Côte Saint-André, a very small French town in the department of Isère between Vienne, Grenoble and Lyons." They end with a moving meditation on two motifs that sound in counterpoint throughout his book and his life: "Love or music—which power can uplift man to the sublimest heights? It is a large question; yet it seems to me that one should answer it in this way: Love cannot give an idea of music; music can give an idea of love. But why separate them? They are the two wings of the soul."

The page reproduced here describes the composition of the work by which Berlioz is probably still best known, the *Symphonie fantastique:*

Immediately after the composition of the *Faust* pieces [*Huit scènes de Faust*], and still under the influence of Goethe's poem, I wrote my Fantastic Symphony: very slowly and laboriously in some

Immédiatement après cette composition sur Faust et toujours sous l'influence du poëme de Goëthe, j'écrivis la Symphonie Fantastique, avec beaucoup de peine pour certaines parties, avec une facilité incroyable pour d'autres. Ainsi l'adagio (Scène aux champs) qui impressionne toujours si vivement le public et moi même, me fatigua pendant plus de trois semaines, je l'abandonnai et le repris deux ou trois fois; la marche au supplice au contraire fut écrite en une nuit. J'ai néanmoins beaucoup retouché ces deux morceaux et tous les autres du même ouvrage pendant plusieurs années.

Le théatre des Nouveautés s'étant mis depuis quelque temps à jouer des opéras comiques avait un assez bon orchestre dirigé par Bloc. Celui-ci m'engagea à proposer ma nouvelle œuvre aux directeurs de ce théatre et à organiser avec eux un concert pour la faire entendre. Ils y consentirent, séduits uniquement par l'étrangeté du programme de la symphonie, qui leur parut devoir exciter la curiosité de la foule. Mais voulant obtenir une exécution grandiose j'invitai au dehors plus de quatre-vingts artistes qui, réunis à ceux de l'orchestre de Bloc, formaient un total de cent trente musiciens. Il n'y avait rien de préparé dans ce théatre pour y disposer convenablement une pareille masse instrumentale; ni la décoration nécessaire, ni les gradins, ni même les pupitres. Avec ce sangfroid des gens qui ne savent pas en quoi consistent les difficultés, les directeurs répondaient à toutes mes demandes à ce sujet : «Soyez tranquille, on arrangera cela, nous avons un machiniste intelligent.» Mais quand le jour de la répétition arriva, quand mes cent trente musiciens voulurent se ranger sur la scène, on ne sut où les mettre. J'eus recours à l'emplacement du petit orchestre d'en bas; mais ce fut à peine si les violons seulement purent s'y caser. Un tumulte à rendre fou un auteur même beaucoup plus calme que moi éclata sur le théatre. On demandait des pupitres; les charpentiers cherchaient à confectionner précipitamment quelque chose qui put en tenir lieu; le machiniste jurait en cherchant ses fermes et ses portants; on criait ici pour des

9 Page from chapter 26 of Berlioz, *Mémoires*, 1830

Caricature of Berlioz leading an orchestra in 1846 by Andreas Geiger, engraved by Cajetan. Bequest of Sarah C. Fenderson

parts, with extraordinary ease in others. The adagio (the Scene in the Country), which always affects the public and myself so keenly, cost me nearly a month's arduous toil; two or three times I gave it up. On the other hand, the March to the Scaffold was written in a night. But I continued to make considerable changes in both movements, and to the rest of the work, over the course of several years.

The Morgan Library owns nearly all of the surviving manuscript of the *Mémoires*—Chapters 12, 15-27, and 29, and parts of Chapters 28 and 30—and houses the largest collection of Berlioz letters outside France. Sarah C. Fenderson began collecting Berlioz's letters, books, and printed music in the 1940s. Although she always characterized her feelings for Berlioz as an interest, not a passion, she quietly and methodically built one of the most celebrated private collections of Berlioz letters in the world. Her collection was bequeathed to the Morgan Library in 1989.

10 ❧

MIKHAIL GLINKA

[*Zhizn' za tsarya.*] First edition of the full score of *A Life for the Tsar*, 1881. Mary Flagler Cary Music Collection.

This rare first edition of the full score of *A Life for the Tsar* by Glinka (1804-57) was published only in 1881, forty-five years after the opera's première, in St. Petersburg, on 9 December 1836. There had been little need for a published full score, since before the 1880s the opera was heard almost exclusively in St. Petersburg and Moscow, where for many years it opened the opera seasons. (The first volume of the piano-vocal score was published in 1856.) On 9 December 1896, the sixtieth anniversary of the première, the opera received its 660th performance in St. Petersburg.

In 1834, having contemplated for several years the writing of a national opera, Glinka

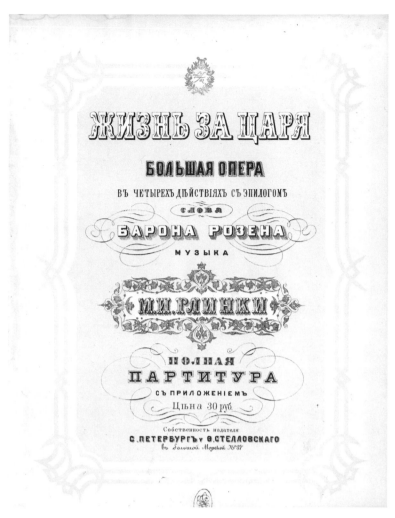

10 Title page from the first edition of Glinka, *A Life for the Tsar*, 1881

Signed photograph of Glinka, 1856
Gift of Mr. Janos Scholz

"came upon the idea for a Russian opera." He mentioned his plan to the poet Vasily Zhukovsky, who approved enthusiastically and suggested the subject of Ivan Susanin, the Russian peasant who, in 1612 or 1613, at the cost of his own life, had saved that of the first Romanov czar by diverting a group of Poles who were hunting him. Zhukovsky was but one of four persons who would eventually contribute to the libretto; most of the work fell to Baron Gregor Rosen, a writer of German extraction who was at that time secretary to the czarevitch (later Alexander II).

But Glinka's imagination "soon ran ahead of the industrious German; as if by an act of magic the plan of the whole opera was suddenly formed.... Many themes and even details of their workings flashed into my head at once. I began to work, but completely haphazardly—to wit, I began with the overture, with which others finish." Glinka had, in fact, completed most of the first two acts before Rosen was

11 Page 1 from Chopin, Polonaise in A-flat Major, op. 53, 1842

finally called upon to rewrite the libretto, fitting his text to music already composed. "Zhukovsky and others used to say jokingly that Rosen had lines already written and distributed among his pockets, and that all I had to do was to say what meter I needed, and how many lines, and he would take out as many of each sort as were required—each variety from a different pocket."

Rehearsals began in the spring of 1836 under the direction of Catterino Cavos, a Russianized Italian who, in 1815, had himself composed an opera, *Ivan Susanin*. Shortly before the première, Nicholas I attended a rehearsal and soon afterward granted Glinka permission to dedicate the work to him—requesting, at the same time, that the title be changed to *A Life for the Tsar*. (The historical czar of the opera was the founder of Nicholas's own dynasty.) After the 1917 Revolution the title reverted to *Ivan Susanin*; the libretto has since been completely rewritten.

11 ❧

FRÉDÉRIC CHOPIN

Polonaise in A-flat Major, op. 53.
Autograph manuscript, 1842. Dannie
and Hettie Heineman Collection.

The classic polonaise originated in Poland at the beginning of the nineteenth century. Many composers wrote polonaises—among them Beethoven, Schubert, Weber, Liszt, Mussorgsky, and Tchaikovsky—but Chopin's are by far the best known, and for many they define the genre. Chopin (1810-49) made the national dance a symbol of heroism and chivalry, and the A-flat Polonaise is the most overtly patriotic of his works. It was written in the summer of 1842 when the composer was living with the novelist George Sand at Nohant. Few pianists since have ventured to omit it from their repertory. We have Chopin's own words on how the work should *not* be performed (and how

Chopin himself played one of its more challenging passages). Sir Charles Hallé, the English pianist and conductor, wrote in his autobiography: "I remember how, on one occasion, in his gentle way he [Chopin] laid his hand upon my shoulder, saying how unhappy he felt, because he had heard his 'Grande Polonaise' in A flat *jouée vite!* [played fast], thereby destroying all the grandeur, the majesty, of this noble inspiration." And Adolf Gutmann, once described as Chopin's favorite pupil, if hardly his best, said that Chopin "could not thunder forth" the Polonaise "in the way we are accustomed to hear it. As for the famous octave passages which occur in it, he began them *pianissimo* and continued thus without much increase in loudness."

Chopin sent this manuscript to Breitkopf & Härtel in Leipzig in October 1843; the Polonaise was published by Breitkopf, and later that year, by Maurice Schlesinger in Paris. The manuscript shown here once belonged to the pianist and composer Clara Schumann, wife of Robert Schumann.

In addition to the Polonaise, the Library has, among other works, the autographs of the Etude in C Major, op. 10, no 7, the Mazurkas op. 50, the Mazurka op. 59 no. 3, and the Polonaises op. 26; manuscripts on deposit include the Etude in E Major, op. 10, no. 3, the Piano Sonata no. 1 in C Minor, the full score of his variations on "La cì darem la mano," op. 2, and a nearly complete draft of the Etude in F Minor, op. 10, no. 9.

12 🙠

GIUSEPPE VERDI

Aida. Milan: Ricordi, 1872. First edition of the libretto for the first performance in Italy, with Verdi's stage directions for the first three acts. Mary Flagler Cary Music Collection.

The première of *Aida* by Verdi (1813-1901) (which the composer did not attend) was on 24 December 1871 in Cairo. It was by all accounts a great success. The second performance took place on 8 February 1872 at La Scala, in Milan. Verdi, as usual, oversaw all aspects of the performance, including the *mise-en-scène*, or staging. He then went to Parma, where he supervised a production on 20 April. It was for this performance that Verdi annotated the libretto shown here, in which he has sketched

12 Pages 28 and 29 from Verdi, *Aida* libretto, 1872

out his staging for the first three acts, specifying in detail the singers' placement, movement, and even gestures. The Verdi scholar Julian Budden observes that "since most of the instructions are carried over word for word into the production book published by Ricordi" in 1873, it is "likely that they were first jotted down during rehearsals for the Italian première, and merely served the composer as an aide-memoire for the Parma performance."

Contrary to popular belief, *Aida* was not composed for the opening of the Suez Canal. The Khedive of Egypt planned to inaugurate a new opera house in Cairo as part of the celebrations surrounding the opening of the canal, on 17 November 1869, and asked Verdi to write an ode in honor of the occasion. Verdi declined (the opera house opened, on 1 November, with his *Rigoletto*), but the Khedive, largely through the celebrated Egyptologist Auguste Mariette, pursued his hopes for a work by Verdi. Mariette sent a synopsis of the Aida story to Camille Du Locle, co-librettist (with Joseph Méry) of Verdi's *Don Carlos;* Du Locle, encouraged by the Khedive's appeals, eventually persuaded Verdi to set the story. Du Locle wrote a prose libretto, in French, based on Mariette's draft. "Now we must think about the libretto, or, to be more precise, about writing the verses since verses are all that are required," Verdi wrote to the publisher Giulio Ricordi in June 1870. "Would Ghislanzoni be able or willing to do this job? It wouldn't be original work, make that quite clear to him; just a matter of writing the verses, which—let me tell you—will be very generously paid."

Antonio Ghislanzoni began work on the verses in mid-July; his collaboration with Verdi can be traced in an important series of letters from composer to librettist, nearly half of which are now in the Morgan Library. It is clear from the correspondence that Verdi took an active part in the final shaping of the libretto. Composition of the opera proceeded very quickly, for by November 1870 Verdi's wife, Giuseppina, reported that the work was complete. Verdi continued to revise the score for nearly a year.

Among the Verdi materials in the Library are several important music manuscripts, including an insert aria for Nicola Ivanoff to sing in *Ernani;* the autograph libretto of *Ernani* and over two hundred Verdi letters are on deposit.

13 ❧

RICHARD WAGNER

Die Meistersinger von Nürnberg. Autograph manuscript of the 1862 version of the libretto. The gift of Arthur A. Houghton, Jr., in honor of the Fiftieth Anniversary of the Morgan Library.

In July 1845, while on a rest cure at the Bohemian town of Marienbad, Wagner (1813-83) wrote the first prose draft of what would become *Die Meistersinger von Nürnberg.* He did not return to the project for sixteen years. He wrote a second and third prose scenario in mid-November 1861; the poem itself was completed between 25 and 31 January 1862 in Paris. On 25 September, Wagner sent a fair copy of the libretto to the publisher Schott, and it is this state of the libretto that is preserved in the Morgan manuscript.

In October 1861 he had proposed to Schott the scheme for a popular comic opera of modest scale that, unlike *Tristan und Isolde* (completed in 1859), would not call for an outstanding tenor or for a great tragic soprano. As it turned out, however, *Die Meistersinger von Nürnberg* called for a tenor and soprano of the first order, included a bass-baritone role that is among the most taxing in the repertory, was the longest opera ever written, and, when published, the largest score yet printed. The opera was completed on 24 October 1867; in the twenty-two years since the Marienbad draft, Wagner had composed *Lohengrin, Das Rheingold, Die Walküre,* two-thirds of *Siegfried,* all of *Tristan und Isolde,* and had prepared the Paris version of *Tannhäuser.* The Morgan manuscript was once owned by Kaiser Wilhelm II, who, according to a long-standing story, showed it to Pierpont Morgan and George Clifford Thomas, a Philadelphia banker and philanthropist. Both men admired the document and Wilhelm (so the story goes) offered it as a gift to one of them—to be decided by the toss of a coin. Thomas won. Dr. A. S. W. Rosenbach, the noted Philadelphia bibliophile and dealer, acquired the libretto from the Thomas estate sometime after 1909, and in 1951 it was purchased from the Rosenbach firm by Arthur A. Houghton, Jr., who gave it to the Morgan Library in 1974.

The Library also has Wagner's own interleaved copy of the first printing of the libretto of *Der Ring des Nibelungen,* with extensive changes and corrections in his hand on the interleaved pages, and about one hundred let-

Ei, 's thät mir um den Lehrbuben leid:
 Der verliert mir allen Respekt;
die Lene macht ihn schon nichts recht g'scheidt,
 dass er Töpf' und Teller all' ableckt!
 Wo Teufel er jetzt wieder steckt?
(Er stellt sich, als wolle er nach David sehen.)
(Hält Sachs, und zieht ihn von Neuem an sich.)
O Sachs! Mein Freund! Du theurer Mann!
Wie ich der Edlen lohnen kann!—
 Was ohne deine Liebe,
 was wär' ich ohne dich,
 ob je auch Kind ich bliebe,
 erwecktest du nicht mich?
 Durch dich gewann ich,
 was man preist,
 durch dich ersann ich,
 was ein Geist!
 Durch dich erwacht,
 durch dich nur dacht'
 ich edel, frei und kühn:
 du liessest mich erblühn!—
O lieber Meister! schilt mich nur!
Ich war doch auf der rechten Spur:
 denn, hatte ich die Wahl,
 nur dich erwählt' ich mir:
 du warest mein Gemahl,
 den Preis nur reicht' ich dir!—
 Doch nun hat's mich gewählt
 zu nie gekannter Qual:
 und werd' ich heut' vermählt,
 so war's ohn' alle Wahl!
Das war ein Müssen, war ein Zwang!
Euch selbst, mein Meister, wurde bang.
 Sachs.
 Mein Kind:
von Tristan und Isolde
kenn' ich ein traurig Stück:
Hans Sachs war klug, und wollte
nichts von Herrn Marke's Glück.—
's war Zeit, dass ich den Rechten erkannt:
wär' sonst am End' doch hineingerannt.—
Aha! da streicht schon die Lene um's Haus.
Nur herein!—He, David! Kommst nicht heraus?

(Magdalene, in festlichem Staate, tritt durch die Laden-
thüre herein; aus der Kammer kommt zugleich David,
ebenfalls im Festkleid, mit Blumen und Bändern sehr
reich und zierlich ausgeputzt.)
 Die Zeugen sind da, Gevatter zur Hand:
 jetzt schnell zur Taufe! Nehmt euren Stand!
 (Alle blicken ihn verwundert an.)
 Ein Kind ward hier geboren:
 jetzt sei ihm ein Nam' erkoren.
So ist's nach Meister Weis' und Art,
wenn eine Meisterweise geschaffen ward:
dass die einen guten Namen trag',
dran Jeder sie erkennen mag.

13 Page from the libretto of the 1862 version of Wagner, *Die Meistersinger von Nürnberg*

Siegfried and the Rhinemaidens, photograph of Josef Hoffmann's painting of
the set design for the first performance of Wagner's *Ring des Nibelungen*, 1876
Mary Flagler Cary Music Collection

14 Page 9 from the fourth movement of Brahms, Symphony no. 1 in C Minor, op. 68, 1876

ters. On deposit are the autograph manuscripts of two librettos: *Siegfried's Tod* (an early version of *Götterdämmerung*) and an early working draft of *Lohengrin*.

14 🐚

JOHANNES BRAHMS

Symphony no. 1 in C Minor, op. 68.
Autograph manuscript of the full score
(first movement lacking), 1876.
Mary Flagler Cary Music Collection.

Brahms (1833-97) had a number of major orchestral works to his credit, including the First Piano Concerto, the two Serenades for orchestra, the Haydn variations, and the German Requiem, before he felt ready, at the age of forty-three, to release to the world his First Symphony. He began work on it in 1862—and possibly as early as 1855—but did not complete the composition until 1876. The pressure to produce a symphony—a genre held in the highest regard by adherents to the classical tradition—was daunting; in the early 1870s, Brahms wrote to his friend Hermann Levi, "I will never compose a symphony! You have no idea how much courage one must have when one hears marching behind him such a giant [as Beethoven]."

The symphony was first performed on 4 November in Karlsruhe, with Brahms's friend Otto Dessoff conducting from this manuscript. The Karlsruhe première was followed by performances in other German cities—reviews were mixed, on the whole more favorable than not—and, in 1877, by three performances in England. But the extensive program notes written by Sir George Macfarren for the performance in Cambridge in March 1877 quote several measures of music that would be unfamiliar to today's audiences. With the help of those program notes, and other, recently discovered sources, the original reading of the second movement can be partly reconstructed. Brahms continued to revise the symphony before submitting it to his publisher Simrock and at some point wrote out a clean copy of the new second movement.

The Morgan manuscript contains the full score of the second, third, and fourth movements; the autograph of the first movement does not survive.

The Morgan Library houses one of the two finest collections of Brahms manuscripts in this country; in addition to the First Symphony the Library has the manuscript of his arrangement for piano four-hands of his String Sextet no. 1 in B-flat Major, op. 18, the Sonata for 2 pianos in F Minor, op. 34b, the Hungarian Dances for piano four-hands, WoO 1, and several songs, including *Botschaft*, op. 47, no. 1, and *Dämmrung senkte sich von oben*, op. 59, no. 1. Among other works on deposit is the autograph manuscript of the Second Symphony.

Drypoint portrait of Gustav Mahler by Emil Orlik
Purchased as the gift of the Ann and Gordon
Getty Foundation

15 🐚

GUSTAV MAHLER

Symphony no. 5. Autograph manuscript
of the full score, 1901-2. Mary Flagler Cary
Music Collection.

The Fifth Symphony by Gustav Mahler (1860-1911), composed in 1901 and 1902, was first performed on 18 October 1904 in Cologne. This symphony, observes Deryck Cooke, the English writer,

marks the beginning of Mahler's full maturity, being the first of a trilogy of "realistic," purely instrumen-

15 Page 43 of the first movement of Mahler, Symphony no. 5, 1901-2

tal symphonies—Nos. 5, 6, and 7—which occupied him during his middle period. The programmes, the voices, the songs, and the movements based on songs have gone; and the delicate or warm harmonic sonorities which formerly brought relief from pain have been largely replaced by a new type of naked contrapuntal texture, already foreshadowed in parts of the Fourth Symphony, but now given a hard edge by the starkest possible use of the woodwind and brass.

Writing to his wife, Alma, after the first rehearsal two days before, Mahler reports:

It all went off tolerably well. The Scherzo is the very devil of a movement. I see it is in for a peck of troubles! Conductors for the next fifty years will all take it too fast and make nonsense of it; and the public—Oh, heavens, what are they to make of this chaos of which new worlds are for ever being engendered, only to crumble in ruin the moment after? What are they to say to this primeval music, this foaming, roaring, raging sea of sound, to these dancing stars, to these breath-taking, iridescent and flashing breakers? . . . Oh that I might give my symphony its first performance fifty years after my death!

But Mahler was never satisfied with the orchestration of the Fifth, and revisions of the symphony occupied him for the rest of his life. On 8 February 1911, just over three months before his death, he wrote in one of his last letters: "I have finished my Fifth—it had to be

almost completely re-orchestrated. I simply can't understand why I still had to make such mistakes, like the merest beginner. (It is clear that all the experience I had gained in writing the first four symphonies completely let me down in this one—for a completely new style demanded a new technique.)''

The Morgan Library houses the most important collection of Mahler manuscripts.

Richard Strauss

Acht Lieder, op. 10. Autograph manuscript of the songs, 1885. Mary Flagler Cary Music Collection.

Although Strauss (1864-1949) had written many songs before them, his eight songs, op.

16 Page of Richard Strauss, *Allerseelen* from *Acht Lieder*, op. 10, 1885

10, are generally regarded as the true beginning of his lieder-writing career. Composed between August and November 1885 to texts by the Tyrolean poet Hermann von Gilm, they were Strauss's first published songs. Three of them— *Zueignung* (Dedication), *Die Nacht* (Night), and *Allerseelen* (All Souls)—are world-famous. Strauss's father, Franz, asked him to dedicate the new songs to Johanna Pschorr, the composer's aunt, for whom most of his early lieder were written. But the opus 10 songs were written for tenor—although they are often sung by sopranos—and were dedicated instead to Heinrich Vogl, a tenor at the Munich Opera.

Although eight songs were published, there are nine in this manuscript; the sixth song, *Wer hat's gethan?* (Who has done it?) was rejected— whether by Strauss or by the publisher Joseph Aibl, and for what reason, is not known. There is no mention of the song in Strauss's correspondence with Aibl, and the composer never included it in later volumes of his songs. Perhaps Aibl was unhappy with nine songs (rather than, say, eight or ten) in one opus, and persuaded Strauss to omit one. And it has been conjectured that *Wer hat's gethan?* was dropped because unlike the other eight songs— and indeed unlike nearly all of Strauss's songs before the very late ones—it has an unusually long postlude for the piano that makes up nearly one-third of the song's length. Whatever the reason for excluding the song, it remained unknown for nearly a century, and was first published only in 1974.

In addition to these songs, the collection includes the autographs of *Don Juan* and *Tod und Verklärung,* two sketchbooks for *Die ägyptische Helena,* his arrangement for voice, harp, horns, and strings of *Morgen* (op. 27, no. 4), and over sixty letters. The manuscripts of *Aus Italien* and *Macbeth,* the Serenade for 13 winds, op. 7, the Lieder op. 27, and *Malven,* Strauss's last song, are on deposit.

17 ❧

ARNOLD SCHOENBERG

Gurrelieder. Autograph manuscript, 1911.
Mary Flagler Cary Music Collection.

Gurrelieder, his first great unqualified success, occupied Schoenberg (1874-1951) intermittently for over a decade. It was written between March 1900 and March 1901; the orchestration was begun in 1901, continued in 1902 and 1903, then put aside until 1910, and finally

Self-portrait of Schoenberg in black chalk
Gift of Mr. Robert Owen Lehman, 1969.21

completed in 1911. The first performance took place in Vienna on 23 February 1913. The vocal and instrumental requirements of the work are so large—six soloists, four choruses, and an orchestra of about 150—that Schoenberg had to order special forty-eight-stave music paper for this manuscript. But despite such enormous forces, much of the score, like so many passages in Wagner's later operas (to which *Gurrelieder* is often indebted), is notable as much for its delicate, chamber-music textures as for its massed sonorities. The text of *Gurrelieder* (Songs of Gurre) is a cycle of poems by Jens Peter Jacobsen.

Five days after the première, Schoenberg's old friend David Josef Bach wrote in the *Arbeiter-Zeitung* that when the work ended

the audience's emotion erupted into an ovation lasting a quarter of an hour. This was genuine rejoicing, even if one or other member of the public may have introduced a jarring note of snobbery. What does it matter? Schoenberg has thirsted for recognition long enough; one may allow him to swallow a drop of harmless poison along with the honey of success.

And in the Berlin periodical *März,* Richard Specht reported that after the performance

a number of young people, complete strangers, came up to me, their cheeks glowing with shame, and confessed that they had brought along house-keys,

17 Page 74 from Schoenberg, *Gurrelieder,* 1911

in order to supplement Schoenberg's music by additions of a kind they had thought appropriate [whistling on keys was an established Viennese way of expressing public displeasure]; now they had been so completely converted to him that nothing could break their allegiance. Their shame and regret were the finest triumph that could have been desired by this artist who painfully wrestles, and who unflinchingly takes upon him all the sorrows of the conquistador.

The Library also possesses the autograph of the monodrama *Erwartung,* an early draft of Act I and part of Act II of the opera *Moses und Aron,* and forty-four Schoenberg letters. The manuscript of the Chamber Symphony op. 9 is on deposit.

18 ❧

Igor Stravinsky

Perséphone. Autograph manuscript of the short score, 1936. Mary Flagler Cary Music Collection.

Perséphone was commissioned in 1933 by Ida Rubinstein, a dancer, actress, and wealthy patroness for whom Stravinsky (1882-1971) had written *Le baiser de la fée* in 1928. It was proposed that he make a musical setting of an early poem by André Gide based on the Homeric hymn to Demeter. (Demeter was the Greek goddess of fertility; her daughter, Persephone, was both queen of the underworld and goddess of the reviving crops.) The collaboration was not an entirely happy one. Stravinsky reports that when he first played the music to Gide at Mme Rubinstein's, Gide would only say "c'est curieux, c'est très curieux." He was displeased with Stravinsky's syllabic treatment of his text and felt that it violated his strongly held views on the nature of French prosody. According to Stravinsky, Gide "had expected the Perséphone text to be sung with exactly the same stress he would use to recite it. He believed my musical purpose should be to imitate or underline his verbal pattern: I would simply have to find the pitches

18 Page 1 from Stravinsky, *Perséphone,* 1936

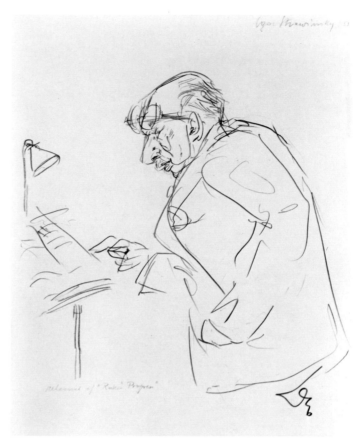

Pencil sketch of Stravinsky made by Benedikt Fred Dolbin during a rehearsal of *The Rake's Progress*, 1953. Gift of Mrs. John H. Steiner, 1978.43

for his syllables, since he considered he had already composed the rhythm. The tradition of *poesia per musica* [poetry written for music] meant nothing to him."

Stravinsky more than once expressed doubts concerning what we might today call the multimedia nature of *Perséphone*—the use of music in context of other dramatic possibilities, such as speech, solo and choral song, mime, and dance. In particular it was the combination of speech and music that he (and others) found troublesome in the work. A year after the première Stravinsky told an interviewer that he preferred the work in concert rather than on stage because the latter "involves too many elements—scenographic, choreographic—that dissipate the center of attention." (There is also a problem of casting the title role, calling as it does for a speaker-dancer—or, as the English

critic and musicologist Jeremy Noble puts it, for "a diseuse who can dance or alternatively a danseuse who can dise.") When asked many years later how he felt about the use of music as accompaniment to recitation, Stravinsky replied, "Do not ask. Sins cannot be undone, only forgiven."

In 1936, Stravinsky gave this short-score manuscript of *Perséphone* to the Argentine author and editor Victoria Ocampo. He met her that year, when she gave the French narration of *Perséphone* at the Teatro Colón in Buenos Aires. The manuscript is nearly complete; it breaks off after the sixth measure of the last number, "Ainsi vers l'ombre souterraine."

The Stravinsky collection at the Morgan Library is one of the two largest collections of the composer's works in this country.

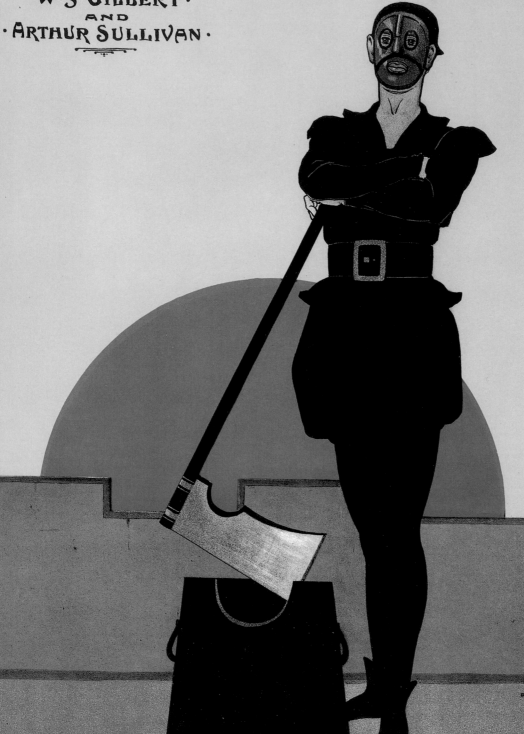

THE YEOMEN OF THE GUARD

BY
·W·S·GILBERT·
AND
·ARTHUR SULLIVAN·

SAVOY THEATRE

Proprietor & Manager R·D'OYLY CARTE.

WATERLOW & SONS LD
LITH.
LONDON WALL
·LONDON·

IX · THE GILBERT AND SULLIVAN COLLECTION

THE FOURTEEN GILBERT AND SULLIVAN OPERAS, which were produced between 1871 and 1896, must be counted among the most characteristic and enduring of Victorian institutions. Considering the enormous legacy the Victorian age has left to following generations, it may seem surprising that the Savoy operas constitute almost the totality of the living heritage of the British musical theater. But whereas the fiction and poetry of the Victorian period can claim the works of Charles Dickens, William Makepeace Thackeray, Anthony Trollope, George Eliot, Alfred Tennyson, and countless others who are assured of places in posterity, the Victorian stage lives on, in a popular sense, only in the plays of George Bernard Shaw and Oscar Wilde, and a few works by such once-esteemed but now less well-known dramatists as Arthur Wing Pinero and Henry Arthur Jones. And Victorian music and opera, notwithstanding their historical interest, have paled beside the music of the Continental composers—Brahms, Wagner, Verdi, Tchaikovsky, Dvořák, Bizet, and dozens of others whose music dominated nineteenth-century concert programs in Britain and North America. Only the Gilbert and Sullivan operas can be compared happily with their European counterparts, the exuberant and tuneful operettas of the likes of Strauss and Offenbach. In their melodic ingenuity, vivacity, colorful settings, and cleverness of parody, the Savoy operas are as enchanting as their Continental contemporaries; but in humor, cleverness with language, plot, strength of characterization, dramatic consistency, musical sophistication, and integration of music and words, the operas of Gilbert and Sullivan have had no equals.

The Library's Gilbert and Sullivan Collection is the most extensive archive of materials relating to the lives and works of the dramatist William Schwenck Gilbert (1836-1911) and the composer Arthur Seymour Sullivan (1842-1900). More than any other composer and dramatist in Britain in their day, Gilbert and Sullivan were celebrities. Their well-publicized lives fascinated contemporaries just as the subsequent documentation of their lives continues to interest us. Sullivan, especially, enjoyed a privileged position in society as well as the patronage and friendship of the royal family. He was active in every sphere of music-making—conducting and performing as well as composing for the concert hall, church, and theater alike. Gilbert, even before becoming Sullivan's librettist, was Britain's most highly regarded dramatist. In his long career he came into contact with virtually every important dramatist and theatrical performer of the time. The diversity of the two men's activities in the pursuit of their professions, as well as in their private lives and wide spheres of contact, is reflected in the depth and variety of the Library's holdings. Founded by Reginald Allen, who brought his extraordinary collection to the Library in 1949 and for many years served as its curator, the Gilbert and Sullivan collection has now grown to several times its original size, through subsequent additions from Mr. Allen and other donors, as well as purchases. Important items have also been given by Gilbert's adopted daughter, the soprano Nancy McIntosh, and by Dame Bridget D'Oyly Carte, the granddaughter of Richard D'Oyly Carte, who produced nearly all of the Gilbert and Sullivan operas and built London's Savoy Theatre expressly for their presentation.

Poster designed by Dudley Hardy for the revival
of *The Yeomen of the Guard*
by the D'Oyly Carte Opera Company, 1897

manuscripts of his speeches and lectures, and legal contracts and agreements with his various managers, collaborators, and music publishers.

3 &

EARLY GILBERT OPERA SCORE

Thomas German Reed. *Our Island Home*, musical entertainment in one act (1870). Libretto by W. S. Gilbert. Autograph manuscript score, [1870]. The gift of Stainer & Bell, Limited, London, 1989.

Gilbert and Sullivan both owed a great deal to the earlier success of the composer-actor-manager Thomas German Reed (1817-88) and his wife, Priscilla, who in 1856 opened the small Royal Gallery of Illustration for programs of one-act musical pieces advertised as "entertainments." The Reeds afforded Gilbert important early opportunities to provide librettos for operatic entertainments, and they commissioned or produced Sullivan's earliest operas. It was also at the Gallery of Illustration that Gilbert and Sullivan were supposed to have been introduced by Frederic Clay, who had been Gilbert's collaborator and Sullivan's closest friend.

Among the most successful of the German Reed entertainments were Gilbert's *Ages Ago* (in collaboration with Clay) and Sullivan's *Cox and Box* (with lyrics by F. C. Burnand, based on the popular old farce by J. Maddison Morton), which appeared as a double bill in the fall of 1869. Commissioned from some of the most talented dramatists and composers, the Gallery of Illustration pieces were stylistic antecedents for the Savoy operas as well: it was Burnand, apparently, who quipped that the Gilbert and Sullivan operas had been "cradled among the Reeds." Indeed, one of the characters in this opera, a pirate called Captain Bang, bears a striking resemblance both to Captain Corcoran in *H.M.S. Pinafore* ("I never go below and I generally know / The weather from the 'lee' / And I'm never sick at sea") and the pirate apprentice Frederic in *The Pirates of Penzance*.

German Reed seems to have been the first impresario to suggest a Gilbert and Sullivan collaboration: in a letter dated 7 March 1870, he invited Sullivan to compose the music to a new piece by Gilbert. If Reed had been able to meet Sullivan's terms, *Our Island Home* would have been the first Gilbert and Sullivan opera; but in the end Reed himself composed the music. Although he was a prolific and respected composer, this is the only manuscript of any of his works that is known to survive. The illustra-

3 "Rise pretty one," from *Our Island Home* by Thomas German Reed and W. S. Gilbert, 1870

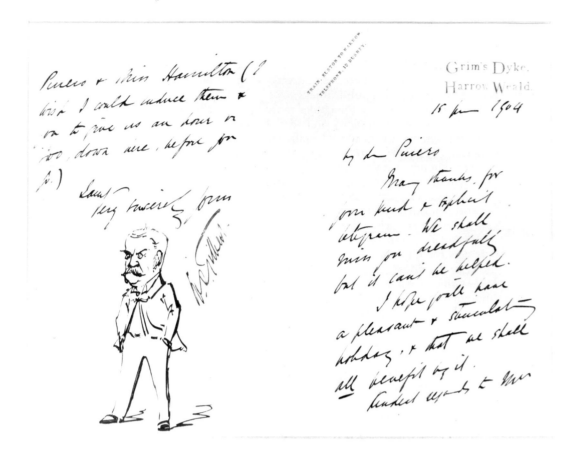

4 W. S. Gilbert letter with self-portrait sketch, 1904

tion shows the opening page of the first number, the quartet "Rise, pretty one." The circled passage (within which Gilbert has written "This autograph score is by W. S. Gilbert Esq.") is the only known example of music written in Gilbert's hand. Not surprisingly, it is nonsense–Gilbert is supposed to have claimed to be able to recognize only two tunes: one of them was "God Save the Queen," and the other one wasn't.

Alone among Gilbert's Gallery of Illustration pieces, neither the score nor the libretto of *Our Island Home* was ever published. The Library's collection includes the complete manuscript material for this chamber opera, including the original score and instrumental and vocal parts as well as the libretto. Manuscripts and papers of other Victorian and Edwardian composers are also found in the collection, including, for example, the autograph score of Edward German's last opera, *Fallen Fairies* (1909), which was his only collaboration with Gilbert.

4 &

LETTER FROM GILBERT TO PINERO

W. S. Gilbert. Autograph letter to the dramatist Arthur Wing Pinero, June 15, 1904, on Gilbert's writing paper, with a self-portrait sketch.

Arthur Wing Pinero (1855-1934), a generation younger than Gilbert, rose from a mediocre acting career (his Claudius, to Henry Irving's Hamlet, was described by a Birmingham critic as the worst ever seen in that city) to become one of the most successful dramatists of the nineteenth century. He is chiefly remembered today for his most famous plays, *The Second Mrs. Tanqueray* (1893) and *Trelawney of the "Wells."* In 1889 his play *The Profligate* was produced for the opening of Gilbert's new Garrick Theatre, for which occasion Sullivan contributed the music. Gilbert greatly admired Pinero's talents and referred to him in one interview as "a giant." The cordial spirit of this brief letter, written late in Gilbert's life, reflects their friendship as well. Gilbert has appended to the letter a rare compliment, a humorous

receive the honour of Knighthood, in recognition of your distinguished talents as a composer and of the services which you have rendered to the promotion of the art of music generally in this country.

I hope it may be agreeable to you to accept the proposal.

Standing beside Sullivan at the investiture were his friend George Grove, compiler of the famous dictionary of music, and the composer George Macfarren. By the time he was knighted, at the age of forty-one, Sullivan had already been awarded honorary doctorates in music by both Oxford and Cambridge Universities and had been awarded the French Legion of Honor. Gilbert was eventually knighted as well, in 1907, at the age of seventy-one.

7 ❧

Iolanthe Program

Iolanthe; or, The Peer and the Peri, comic opera in two acts (1882). Program for first performance, at the Savoy Theatre, London, 25 November 1882.

Iolanthe was the first of the Gilbert and Sullivan operas that can be called a Savoy opera in the strictest sense, by virtue of the fact that it is the first opera to have had its first performance at the new Savoy Theatre. With his profits from the early Gilbert and Sullivan operas, D'Oyly Carte built the Savoy adjacent to his offices in the Strand, expressly for the production of comic opera. The theater was opened on 10 October 1882, at which time *Patience* was transferred from the Opera Comique to the new and larger theater.

This program bears the usual first-night announcement that "On this occasion the Opera will be conducted by the Composer." The bright gold color was not only symbolic of the splendor of the occasion but was in keeping with the comparative simplicity and restraint that distinguished the Savoy's decoration from the gingerbread interiors of most other theaters. The electric-light motif in the design referred to the theater's distinction as the first public building in London, and the first theater anywhere, to be lighted entirely by electricity. The program was designed by Alice Havers Morgan, who was to fashion many of the Savoy programs and souvenirs. Victorian theatrical programs were typically printed in four pages; new programs were printed every week, sometimes every night, and they recorded even temporary substitutions in the cast. For most of the productions at the Savoy Theatre two versions of the program were printed: a plain, typeset version on colored paper was given to occupants of the cheaper seats, and a smaller but more elaborate program, such as this one, printed in color on stiff card, was provided in the stalls, circles, and boxes.

Theatrical programs may provide information about the performance history and cast of a play or opera that is seldom found in other sources. The Library has more than five thousand programs for nineteenth-century performances of the operas of Gilbert and Sullivan (including first-night programs of each of them) as well as of their individual works.

7 Program from first performance of *Iolanthe*, 1882

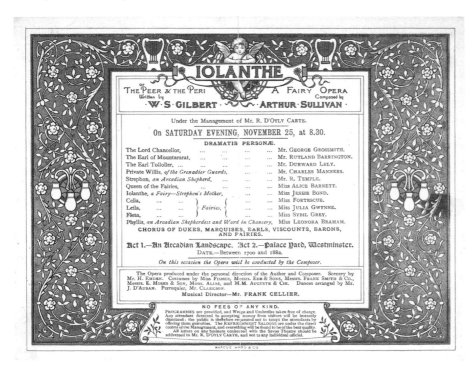

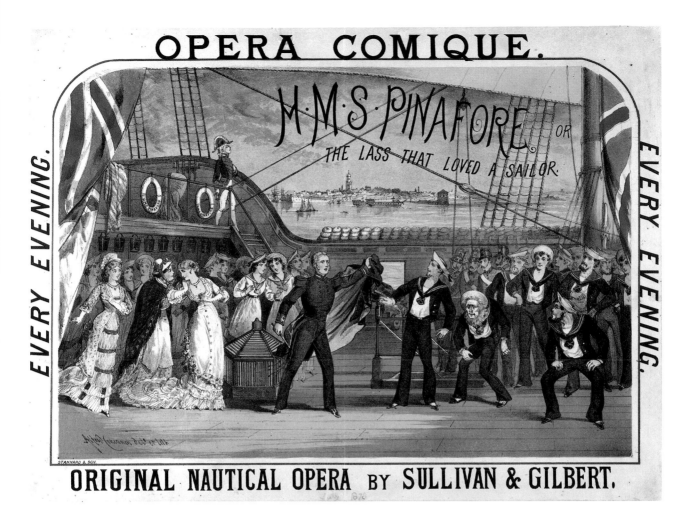

8 Poster from the first production of H. M. S. Pinafore, 1878

8 ❧

H.M.S. PINAFORE POSTER

H.M.S. Pinafore; or, The Lass That Loved a Sailor, comic opera in two acts (1878). Color lithograph poster by Alfred Concanen, printed by Stannard and Son, London, [1878], 17¼ x 13 inches.

This poster was used for the first production of *H.M.S. Pinafore* at the Opera Comique Theatre, London, in 1878. It is believed to be the earliest surviving illustrated poster for any of the Gilbert and Sullivan operas. It depicts the climactic scene in Act II when Captain Corcoran surprises his daughter Josephine and the sailor Ralph Rackstraw as they are about to elope with the complicity of the ship's company.

Alfred Concanen (1835-86) was the best-known of the English artists who produced lithographic sheet music covers and theatrical posters. The exact technique used in printing the poster is not known; in some cases all of the colors were printed lithographically, but in other instances some of the colors were applied by hand. The oblong shape was shortly afterward superseded by the upright, twenty-by-thirty-inch "double-crown" poster.

The colorful images on early posters and sheet music are valuable as realistic representations of sets, costumes, and the arrangement of actors on the stage. (Photographs also survive of the original cast members in costume, but since the backgrounds usually consisted of stock scenes in the photographer's studio, they offer little idea of the original scenery.) The collection includes several hundred pictorial posters and typeset playbills dating from the earliest productions through the last pre-World War I revivals, including some productions of Gilbert's early stage works.

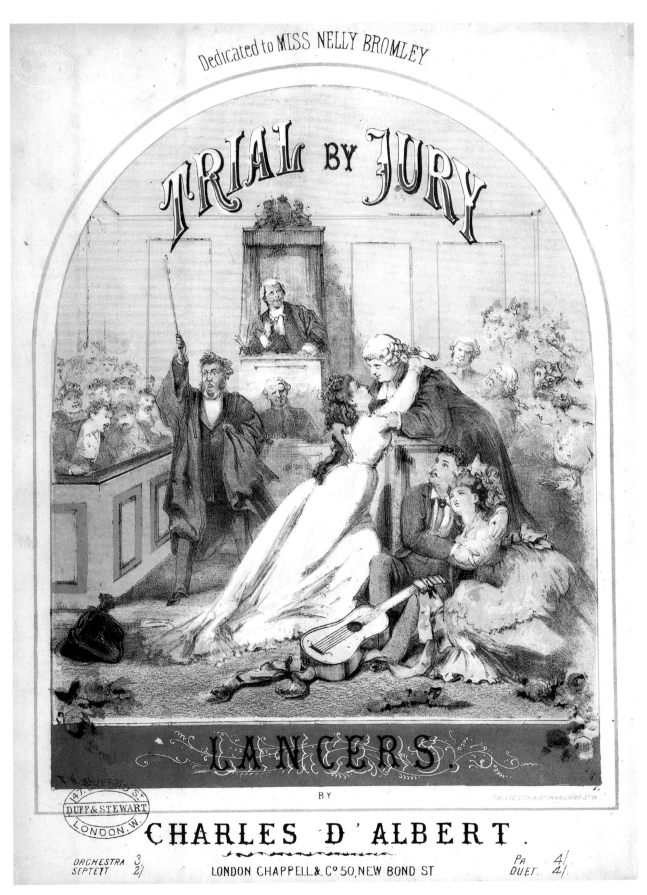

10 Sheet music cover from *Trial By Jury*, 1875

the date that Gilbert and Sullivan always regarded as the opera's official première—that the music and libretto were available for sale to the public.

The music to Victorian operas was published in an interesting variety of forms, including piano-vocal scores, piano-solo scores, individual songs, medleys and fantasias for piano and for other solo instruments, and selections for orchestras, ensembles, and military bands. In addition, it was usual for popular musical works—ballets, operas, and even works as unlikely as Rossini's *Petite Messe Solennelle*—to be attended by the appearance of medleys arranged in popular dance rhythms. Such arrangements nearly always appeared in four forms: the waltz, quadrilles, lancers, and either the polka or galop. Each of these was issued in versions for piano solo, piano duet (two players at one piano), septet or octet, full orchestra, and military band. Curiously, while these adaptations are based on tunes from the opera, the melodies are adapted to the stated dance meter and squared off to conform to the required phrase length, sometimes with little regard for felicity or fidelity.

A further curiosity is that of all of the printed manifestations of the music, only the piano solo dance arrangements were issued with illustrated covers. Every other publication bore a commonplace black-and-white typeset or engraved cover. No doubt these elaborate (and costly) covers were required because these arrangements were considered impulse purchases, for which a striking cover was an attraction. Most of these illustrations are realistic representations of scenes and characters in the original productions of the operas, and sometimes they are the only such illustrations in color. This illustration, by Alfred Concanen, shows the Pirate King in Act I, carrying the Jolly Roger.

Trial By Jury, produced at the Royalty Theatre in London in 1875, is the earliest of the Gilbert and Sullivan operas that has survived intact. (The music of *Thespis*, their first collaboration, has long been lost.) It was commissioned by Richard D'Oyly Carte as a short companion piece to accompany a production of Offenbach's *La Périchole*. Although *Trial By Jury* lasts little more than half an hour, and (uniquely among the Gilbert and Sullivan operas) it has no spoken dialogue, its success led directly, if not immediately, to the long-standing partnership of Carte, Sullivan, and Gilbert.

The illustration shows two scenes from *Trial By Jury*—the opera's closing tableau and the jurors' minstrel number. From this illustration, the original staging of both scenes can be discovered.

The Gilbert and Sullivan Collection contains a comprehensive collection of authorized editions of Sullivan's music published during his lifetime. In a letter to Sullivan after the success of *Patience* in 1881, the publisher Thomas Chappell proposed increasing Sullivan's royalty; in order to manage that he suggested simplifying the covers—not eliminating them altogether, because that would affect sales—and subsequent dance music covers were printed in two or three colors rather than six to ten as had been typical.

X DRAWINGS AND PRINTS

THE DRAWINGS REPRODUCED HERE are intended to give an indication of the scope and strengths of the Morgan Library's collection, which concentrates primarily on European art before 1825. Most of the major schools and periods within these limits are represented, the earliest being a rare example of trecento draughtsmanship attributed to Taddeo Gaddi, the latest being a study of a man by Degas. The selection also offers an opportunity to consider the different types of drawings and the ways in which they reveal an artist's working methods and creative processes. They range from preliminary sketches to final designs for a planned work. In some cases they may preserve discarded ideas and motifs; in others they may be the only surviving record of a lost work. Some drawings, such as the lovely Moreau landscape (x, 27 and detail at left), were clearly intended as independent works of art.

In 1910 Pierpont Morgan effectively established this collection in one stroke by purchasing 1500 old master drawings assembled by the English artist-collector Charles Fairfax Murray. Prior to this Morgan had acquired all of Theodore Irwin's Rembrandt etchings and then those collected by George Vanderbilt. Morgan had also purchased twenty-one William Blake watercolor illustrations to the Book of Job and a few individual drawings, such as the Gainsborough *Study of a Lady* (x, 20) and the Boucher *Cherubim*. Well chosen and comprehensive in its range, Fairfax Murray's collection is considered to be the first great European drawings collection to come to this country. Its special strengths remain unsurpassed in the United States. This is true of the Italian Renaissance and eighteenth-century schools, as it is of Netherlandish drawings of the sixteenth and seventeenth centuries. His collection was especially rich in the great seventeenth-century Dutch and Flemish masters. Fairfax Murray's extensive series of drawings by Rembrandt and his school admirably complemented the etchings Morgan already owned.

Not nearly so complete with respect to drawings of the French school, the Fairfax Murray collection nevertheless included some fine French drawings of the seventeenth and eighteenth centuries, among them a number of sheets by the great expatriate masters Claude Lorrain and Nicolas Poussin. The Fairfax Murray purchase also brought to this country an exceptional group of eighteenth-century English drawings with fine examples by Hogarth, Wilson, and above all, Gainsborough. Although there were a few drawings each by Dürer and Watteau, Pierpont Morgan made several important additional purchases of drawings by these artists before his death in 1913. His son, J. P. Morgan, Jr., continued to add to the Rembrandt etchings, but the Library did not actively collect drawings until the end of World War II, when its first curator of drawings, Felice Stampfle, was appointed. The formation of the Association of Fellows in 1949 provided the financial support needed to develop the collection, and many fine drawings have been purchased since that time. The extraordinary growth of the collection to its present size of around 9,000 sheets, however, is largely due to the private collections that have been presented to the Library. Notable among these was Mrs. J. P. Morgan's collection of more than 500 architectural and garden drawings, including the large series of drawings by Piranesi,

Detail from Louis Gabriel Moreau, *"La Vallée"* [27]

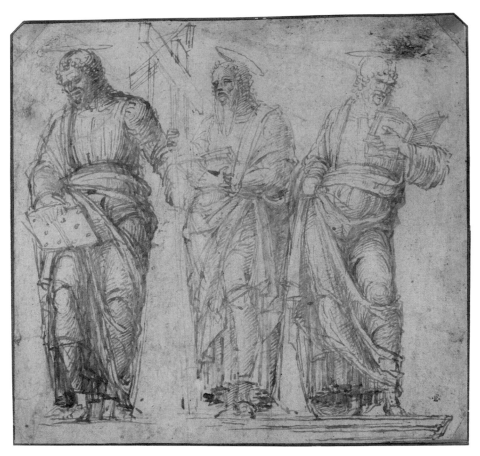

2 Andrea Mantegna, *Three Standing Apostles*

2 ❦

ANDREA MANTEGNA

Three Standing Apostles. Pen and brown ink on paper tinted with red chalk. 7 x 7½ in. (178 x 190 mm). Gift: Collection of Mr. and Mrs. Eugene Victor Thaw. 1985.100.

Mantegna (1431-1506) was one of the most outstanding painters and draughtsmen for engraving in the early Renaissance in northern Italy. Educated in Padua, he spent most of his life at Mantua where he was court painter to the ruling Gonzaga family from 1460 to his death. His drawings are rare and sometimes show close stylistic affinities with those of his brother-in-law Giovanni Bellini, upon whose early career he had an important influence. This drawing belongs to a group formerly attributed to Giovanni. There are only a few drawings preparatory for Mantegna's paintings on which other attributions can be based.

Among them is a drawing for the high altar of Saint Zeno at Verona (1456-59) now in the Getty Museum. The facial types and the rendering of the hair compare especially well in both drawings, while the way the drapery is organized in the Morgan sheet—in long curving folds that allow the forms of the underlying body to clearly show through the garments—is parallel to forms he used throughout his later career as a painter.

Our three saints are probably apostles, but only one of them displays an attribute that may suggest an identification, a cross alluding to the martyrdom of Saint Philip or Saint Andrew, though it is not of the X-shape usually used for Saint Andrew's cross. Since the perspective is from a very low point, it is probable that the figures were prepared for placement above the eye level of the spectator. A sheet in the Museum Boymans van Beuningen, Rotterdam, may have served for the same commission. It contains, alongside two smaller figures of Saint

John the Baptist, four standing apostles. Among them are Saints Peter and Paul and again a saint with a cross. They are stylistically identical to the Morgan figures but are seen from a slightly higher point. The drawing closest to the Morgan's is in the British Museum. Its size, the technique that was used, as well as the style and the low vantage point might indicate that it was a section of the Morgan sheet. The scale of the figure, however, is somewhat larger and the better condition of the drawing makes the connection less obvious. If the assumption is true, the drawing would originally have contained four apostles like the sheet in Rotterdam, though not the same ones. If we think of a painted arrangement of the eight apostles on the three sheets mentioned and four more apostles, for which we have no drawings, we could imagine a mural decoration consisting of three registers with four apostles each, one above the other.

3 &

LUCA SIGNORELLI

Four Demons. Black chalk. 13⅞ x 11⅛ in. (352 x 283 mm). Purchased as the gift of the Fellows. 1965.15.

Signorelli (1445/50-1525), who is said to have been a pupil of Piero della Francesca, developed a highly personal style that later, under the influence of Perugino, acquired some Umbrian features. He painted altarpieces, frescoes, and even portraits. In the beginning of the 1480s he was chosen to contribute to the mural decoration of the Sistine Chapel in the Vatican. His most famous paintings are probably his *Pan*, formerly in Berlin, and his frescoes in the Cappella di San Brizio in the cathedral of Orvieto, commissioned in 1499 and finished in 1504. There he depicted, among other subject matter, the Inferno and Orpheus in Hades. In

3 Luca Signorelli, *Four Demons*

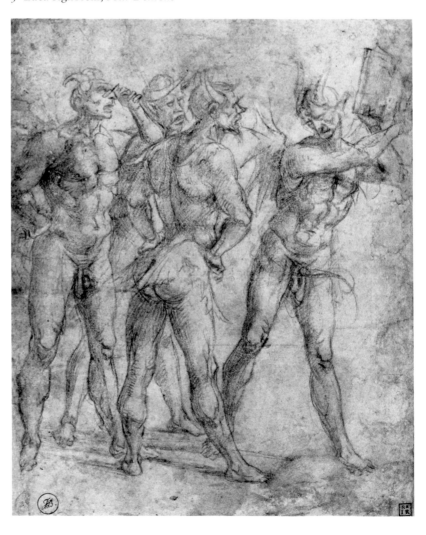

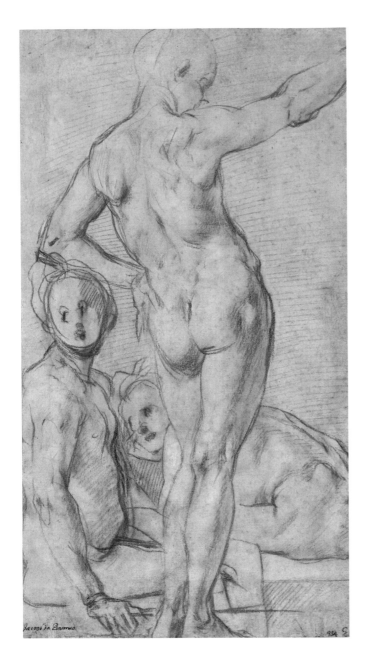

6 Pontormo, *Standing Nude
and Two Seated Nudes*

6 &

Jacopo Carucci, called Pontormo

Standing Nude and Two Seated Nudes. Red
chalk. 16 x 8⅞ in. (406 x 225 mm) Verso: Strid-
ing nude with upraised arms in black chalk,
with vestiges of white, over red chalk. Pur-
chased as the gift of the Fellows with the special
assistance of Mrs. Carl Stern and Mr. Janos
Scholz. 1954.4.

Pontormo (1494-1557) is one of the greatest
figures among the Italian mannerists. He came
to Florence in 1506, entered Andrea del Sarto's
workshop in 1512, and spent his entire life in
and around Florence. Though deeply influ-
enced by Leonardo, Michelangelo, Dürer, and
Lucas van Leyden, he developed a very per-
sonal style of painting and drawing which
was of the greatest importance to the next
generation of Florentine painters, notably
Bronzino.

This drawing, in red and white chalk, depicts
a group of male nudes. On the back is a single
male figure in black, red, and white chalk, who
is possibly an executioner or one of the tormen-

tors in a Flagellation of Christ (not illustrated). None of these figures has been found in extant Pontormo paintings. The bending movement and the proportions of the figures as well as the facial types with large, hollow eye sockets and upraised brows are typical of Pontormo. Similar figural and facial characteristics can be found in his altarpiece of 1518 in San Michele Visdomini, Florence, and other works of his early maturity. The rather angular line still betrays an affinity to Andrea del Sarto, while the heavy influence of Michelangelo's style, which Pontormo would later emulate so strongly, is not yet visible. A dating of around 1520 seems, therefore, the most convincing.

7 &

FRANCESCO MAZZOLA
CALLED PARMIGIANINO

Three Putti. Pen and brown ink, brown wash, over red chalk, some squaring for transfer in lead, black ink ruled border. Verso: Black chalk sketch of Diana and Actaeon. 6³/₁₆ x 6⅛ in. (157 x 156 mm). Purchased by Pierpont Morgan, 1910. I, 49.

A follower of Correggio, Parmigianino (1503-40) is the outstanding master of mannerism in Parma. His drawings are well represented at the Library. The sheet with three putti in triangular spandrels on the recto and Diana and Actaeon on the verso (not illustrated) was done in preparation for his first monumental assignment—the decoration of the ceiling and upper walls in the Camera della Stufetta in the Castle of Fontanellato near Parma.

The decorative scheme with its overgrown trelliswork is dependent upon that of Correggio's Camera della Badessa Giovanna Piacenza in the Convent of St. Paul in Parma. The figural types, faces, and mannerist elegance of the pose are, however, already typical of Parmigianino, as is every other feature of the drawing. The putto on the left, which has been squared for transfer, appears in the painting between the stag-headed Actaeon and the splashing Diana.

7 Parmigianino, *Three Putti*

PIETRO BERRETTINI
CALLED PIETRO DA CORTONA

Woman Holding a Tiara. Black and red chalk. 8¹¹⁄₁₆ x 10⅞ in. (220 x 277 mm). Purchased as the gift of the Fellows with the special assistance of Mr. and Mrs. Carl Stern. 1965.16.

Pietro da Cortona (1596-1669) was a painter and architect. Born and educated in Tuscany, he went to Rome early in his life and became the most prominent decorator of the huge interiors of the Italian high baroque. He worked mainly in Rome but also in Florence where he decorated the rooms of Palazzo Pitti for the Medici. In Rome, from 1633 to 1639 he painted the enormous ceiling fresco of the salone of the Palazzo Barberini which represents the glory of the Barberini family and the virtues of the pontiff. The coat of arms of the Barberini is crowned by two hovering women who hold the keys of Saint Peter and the papal tiara. The drawing is done in preparation for the figure with the papal crown. It is one of Cortona's most impressive and beautiful studies. The arms and face are modeled with black and red chalks while the garment and the crown are only roughly indicated in black.

ALBRECHT DÜRER

Adam and Eve. Pen and brown ink, brown wash, corrections in white. 9⁹⁄₁₆ x 7⅞ in. (243 x 200 mm). Purchased by Pierpont Morgan, 1910. I, 257d.

The great German artist Albrecht Dürer (1471-1527) was surely one of the universally gifted masters of the Renaissance. His woodcuts and intaglio engravings were well known throughout Europe and deeply influenced art for more than a century. *Adam and Eve* is one of his most beautiful drawings. Dürer pieced together two single studies in order to obtain the basic composition of his print of 1504, *The Fall of Man*. In the final print, the human ancestors are shown before a wood populated with animals. Other drawings for Dürer's *Adam and Eve* show the individual figures and Adam's arms and hands. Large watercolors depicting the elk and the parrot in the engraving were done earlier and only reused in the course of the print's preparation.

10 Pietro da Cortona, *Woman Holding a Tiara*

11 Albrecht Dürer, *Adam and Eve*

17 Nicolas Poussin, *The Death of Hippolytus*

way. On the left stands Pilate, wearing a turban and elaborate robes. Christ, bareheaded and with his hands bound in front of him, appears before the people. Later Rembrandt reworked much of the plate, scraping out the entire group in front of the central terrace and adding two sustaining arches instead. He worked with the needle directly on the surface of the copper plate. This technique caused the metal along the furrows of the engraved lines to raise up in burrs that kept much of the ink in early proofs, such as the present one, and is responsible for the soft, dark, velvety effect we can observe over the entire print. The soft yellowish tone of the paper adds another note of warm tonality to the proof. Rembrandt printed on all different kinds of material, using vellum, normal white European paper, oatmill paper, and oriental (among them Japanese) papers. Prints on the latter are rare. In this case, he had to join a small strip to the top in order to get a large enough sheet for the image.

The Morgan Library's collection of Rembrandt's printed *oeuvre* is said to be the best in the country. Morgan acquired his prints from two outstanding American collectors: in 1900 he purchased 272 prints belonging to Theodore Irwin and five years later purchased 112 from George W. Vanderbilt. Under Morgan's son, J. P. Morgan, Jr., the Rembrandt collection con-

tinued to grow, the finest additions coming from the Gerstenberg collection in Berlin.

17 ❧

NICOLAS POUSSIN

The Death of Hippolytus. Pen and brown ink, brown wash, over faint indications in black chalk. Verso: Asclepius Restoring Hippolytus to Life, in pen and brown ink over black chalk. 8⅞ x 13¹⁄₁₆ in. (224 x 332 mm). Purchased by Pierpont Morgan, 1910. I, 267.

This drawing has been described as "one of the freest and most dramatic" the French artist Nicolas Poussin (1594-1665) ever produced. Even in such a dramatic scene as *The Death of Hippolytus*, his style, clarity, and precision of expression is evident. Characteristically for Poussin, the subject is drawn from the antique, in this case Ovid's *Metamorphoses*. Wrongly accused of seducing his stepmother, Hippolytus has incurred the wrath of his father, Theseus, who calls on the sea god Poseidon to destroy him. Illustrated here is the moment after Hippolytus's chariot crashes into a rock, his horses having been frightened by a bull that Poseidon sent from the sea. The two witnesses in the center of the composition rush

to quiet the terrified animals, while on the far right a man pulls Hippolytus's lifeless body from beneath the overturned chariot.

No painting by Poussin is known of this unusual subject. The drawing has been dated between the late 1630s and early 1640s on the basis of stylistic features characteristic of the artist's drawings in both decades. In the thirties, his method was to work first in line to achieve movement and liveliness and then apply broad areas of wash for modeling and dramatic lighting effects. While line is preserved here along with an especially brilliant use of wash throughout the drawing, Poussin—in the manner of his work of the forties—modeled the foreground figures with careful applications of wash and the point of the brush. On the verso of this sheet, sketched only in pen, the narrative continues with the subject of Asclepius restoring Hippolytus to life.

Some of the most remarkable works of seventeenth-century French art were produced not in Paris but in Rome; it was here that Poussin and his fellow expatriate artist Claude spent almost the whole of their careers. Poussin was the leading exponent of French classicism, which was to become the standard for artists to imitate or reject for the next two hundred years.

18 &

CLAUDE GELLÉE
CALLED CLAUDE LORRAIN

Landscape with Shepherd and Flock at the Edge of a Wood. Pen, brush and brown ink, over graphite. 8⁷⁄₁₆ x 13 in. (217 x 330 mm). Signed and dated in pen and brown ink on verso, *Claudio Gellée / fecit et inventor / Roma 1645.* Purchased by Pierpont Morgan, 1910. III, 82.

Like his contemporary Poussin, Claude (1600-82) left France when a very young man and spent most of his active life in Rome.

During his early years in Italy, Claude roamed the Campagna painting and sketching from dawn to dusk. He was particularly attuned to the transforming effects of light at various times of day. The present drawing is not, however, based on direct observation from nature but belongs to a large category of "ideal" landscapes that were composed in the studio. Elements which he invented are arranged to create a mood of idyllic tranquility, underlined here by the solitary shepherd tending his flock. Particularly noteworthy is Claude's subtle use of wash to render the effects of sunlight on massed foliage. With marked contrasts of light and shade, he evokes the long

18 Claude Lorrain, *Landscape with Shepherd and Flock at the Edge of a Wood*

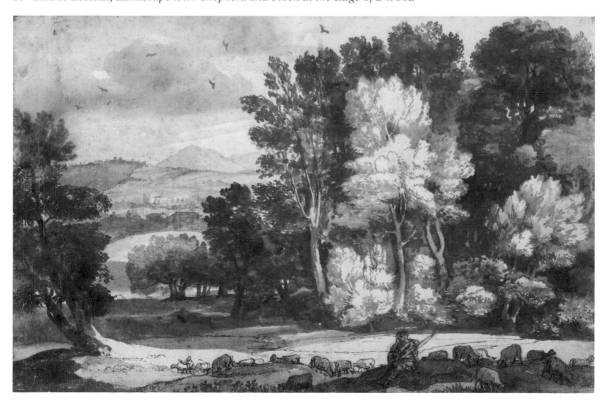

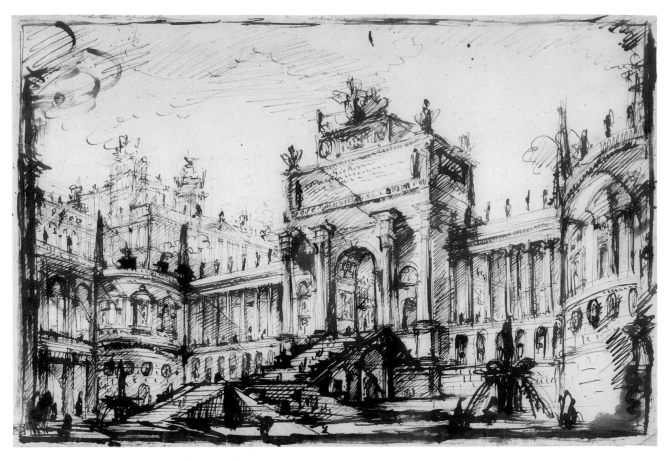

19 Giovanni Battista Piranesi, *Architectural Fantasy*

shadows of late afternoon and the fading pros-
pect of distant hills. His romantic orientation
to the Italian landscape is basically northern in
temperament, recalling the work of such other
northern artists in Rome as Elsheimer and Bril.

Claude had a profound effect on generations
of subsequent artists, particularly in England.
Turner, to mention but one example, aspired to
be as great as Claude. English collectors as well
were drawn to his work. They not only pur-
chased his paintings and drawings, but some
even redesigned their country parks to conform
to the Virgilian rustic ideal of his landscapes. It
became fashionable to carry a Claude glass, a
blackened convex mirror which converted any
landscape to Claudian harmony.

19 ❧

GIOVANNI BATTISTA PIRANESI

Architectural Fantasy. Pen and brown ink,
brown wash. 13 x 19⁵/₁₆ in. (330 x 491 mm).
Gift of Janos Scholz, 1974. 1974.27.

Piranesi (1720-78), received his early training
in Venice but worked mainly in Rome. Though
a trained architect, he executed only one archi-
tectural project, the redecoration of Santa Ma-
ria del Priorato in Rome. He was famous in his
time, and remains so today, as an engraver of
the beauties of Rome, its contemporary build-
ings as well as archeological sites and excava-
tions. In addition his designs for furniture
deeply influenced the development of the Euro-
pean taste for neoclassicism.

This drawing represents an imaginary neo-
classical building. A monumental flight of
stairs, flanked by two fountains, leads up to a
central opening. Piranesi played with similar
ideas in his first important series of engravings,
La prima parte di architettura, published in the
early 1740s, and continued to do so into the
1750s. The Library has one of the major collec-
tions of Piranesi's works, including over one
hundred of his drawings.

20 &

GIOVANNI BATTISTA TIEPOLO

The Figure of Time Holding a Putto. Pen and brown ink, brown wash, over black chalk. 10⁹/₁₆ x 12⁷/₁₆ in. (268 x 315 mm). Purchased by Pierpont Morgan, 1910. IV, 125.

The baroque decoration of huge interiors with illusionistic paintings developed in the seventeenth century and reached its peak in the eighteenth. Giovanni Battista Tiepolo (1696-1770), a Venetian painter who excelled also in easel painting and monumental altarpieces, was its chief representative. He worked extensively in northern Italy. From 1750 to 1753, he created his masterwork, the frescoes in the Kaisersaal and the staircase in the Würzburg Residenz. The end of his life, from 1762 on, he spent in Madrid.

In 1740, before leaving for Germany, Tiepolo painted one of his most monumental secular ceiling decorations, that of the gallery shaped *salone* of the Palazzo Clerici in Milan. There his work reached full maturity. He depicted the course of the sun amidst the continents and mythological personages, representing Time ravishing Beauty in the guise of Saturn abducting Venus. The Library's drawing is connected with the south portion of the fresco. The winged figure seated on a cloud is identified by the scythe and hourglass as Time or Saturn.

It was the custom of Tiepolo and his son to mount their drawings systematically into albums; the present sheet is one of a group of more than one hundred drawings from such an album that later passed intact to the English collector Edward Cheney, then to Charles Fairfax Murray, and from him to Pierpont Morgan in 1910.

21 &

THOMAS GAINSBOROUGH

Study of a Lady. Black and white chalk, some stumping, on buff prepared paper. 19½ x 12¼ in. (495 x 311 mm). Purchased by Pierpont Morgan, 1910. III,63b.

This vibrant drawing in black and white chalks is one of more than twenty sheets in the Library's collection by the brilliant eighteenth-century English portraitist Thomas Gainsborough (1727-88). He seldom chose to portray his sitters in the generalized, classical costumes that Reynolds employed in his paint-

20 Giovanni Battista Tiepolo, *The Figure of Time Holding a Putto*

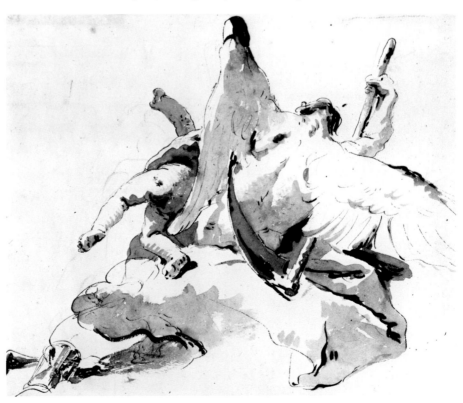

21 Thomas Gainsborough, *Study of a Lady*

ings. Rather, Gainsborough preferred to carefully record the fashions of his time: here, for instance, his close attention to such details as the broad-brimmed picture hat and loose flowing curls helps to date this drawing to about 1785.

It has been argued that the drawing is one of a group of studies of well-dressed ladies that were preparatory for a painting to be called *The Richmond Water-Walk*, or *Windsor*. The

project, which apparently was never carried out, was reportedly commissioned by George III in about 1785 and intended as a companion piece to *The Mall* (now in the Frick Collection, New York). According to Gainsborough's close friend William Pearce, the artist spent one morning in St. James's Park sketching "high-dressed and fashionable" ladies in preparation for the work. The Morgan sketch does indeed appear to have been executed rapidly and on

site. Gainsborough's lively chalk lines integrate the figure and landscape and give an extraordinary sense of movement and vitality. He refrains, however, from any searching study of either the inner life or the anatomical structure of the figure.

For many years the subject was mistakenly thought to be Georgiana, duchess of Devonshire. In 1901 Pierpont Morgan had gone to great lengths to buy Gainsborough's very famous oil portrait of the duchess (now in a private collection). When he bought this drawing in 1904, it was still considered a study for his much-loved painting.

22 ❧

Henry Fuseli

The Portrait of Martha Hess. Black chalk, some stumping, heightened with white, on light brown paper. 20⅜ x 13⅞ in. (518 x 356 mm).

Purchased as the gift of Mrs. W. Murray Crane, 1954. 1954.1.

Martha Hess, described by contemporaries as "ethereal" and "inclined to religious fanaticism," was dying of consumption when Fuseli (1741-1825) drew this portrait of her in late 1778 or 1779. It was one of several portraits that he made of her and her sister Magdalena during a trip to his native Zurich. His great skill as a draughtsman can be seen in the controlled short strokes and very fine cross-hatchings of chalk from which Martha Hess's face fully emerges, framed by a cloud of dark hair. Except for eight years in Rome, the Swiss-born painter spent nearly all of his career in London, where he was an influential figure among English romantic artists and intellectuals.

In the portrait of Martha Hess, Fuseli has used formal precision and clarity of execution to express an emotional state that is mysterious, irrational, and slightly disturbing.

22 Henry Fuseli, *The Portrait of Martha Hess*

23 William Blake, *"When the Morning Stars Sang Together"*

Martha Hess was a niece of his close friend the theologian and mystic Johann Kaspar Lavater. Some of the drawings Fuseli made of Martha and her sister Magdalena were engraved for Lavater's famous book on physiognomy, the *Physiognomische Fragmente*. An edition illustrated by Fuseli brought the artist widespread European recognition.

23 🍋

WILLIAM BLAKE

"When the Morning Stars Sang Together." Pen and brush, black and gray inks and wash, wa-

tercolor, over preliminary indications in graphite. 11 x 7¹/₁₆ in. (280 x 179 mm). Book of Job, No. 14. Purchased by Pierpont Morgan, 1903.

The series of twenty-one watercolor illustrations by William Blake (1757-1827) for the Book of Job are recognized as one of the supreme achievements of that visionary poet and artist. Shown here is the fourteenth in the series, in which God re-enacts the creation of the world while Job and his wife kneel below. The scene follows upon the moment in the story in which Job challenges God to appear and explain why he has deserved the succession of evils that has devastated his life. According to

the biblical text: "Then the Lord answered Job out of the whirlwind...Where wast thou when I laid the foundations of the earth?... When the morning stars sang together, and all the sons of God shouted for joy?" God continues to pose a series of rhetorical questions which concludes, "Shall he that contendeth with the Almighty instruct him?" Humbled, Job acknowledges God's supreme wisdom and power.

The design for this illustration is divided into three horizontal regions. In the lowest register are Job, his wife, and the "false friends" who have assured Job of their knowledge of God's motivations. They are separated from God by a layer of clouds that encase them in a cave-like dwelling. In the central area, God stretches his arms over Helios, the sun god, and Selene, the moon goddess, in a re-enactment of the Creation. In the starry firmament above, angels ("the morning stars") raise their arms in joyful praise.

Blake produced the Job series in about 1805 for Thomas Butts, a minor civil servant who commissioned many works from Blake between 1799 and 1810. The theme of Job was important to Blake, and he returned to it throughout his career. He made a second set of illustrations to the Book of Job in 1821. These he traced and copied for the artist John Linnell, who later commissioned the engravings. In order to produce the engravings, a third series of drawings was created (now in the Fitzwilliam Museum, Cambridge) in which the designs are reduced and have indications for borders. In March 1823 an agreement was made to publish the engravings, and they appeared early in 1826, the year before Blake's death. The Library's Blake collection is extensive and includes his twelve illustrations for Milton's *L'Allegro* and *Il Penseroso*, both of which were also once part of the Butts collection.

For Blake, the spiritual alone was real, and he felt himself completely isolated from the material universe. Even as a child, he had visions. Beginning with the publication of *Songs of Innocence* in 1789 (see IV, 25), he claimed a distinctive mystic vision. Despite the enthusiasm of a circle of devoted friends, neither Blake's poetry nor art found a wide audience, and, after a lifetime of continuous hard work, he spent his last years in obscurity.

24 &.

FRANCISCO GOYA Y LUCIENTES

Pesadilla or *Nightmare*. Point of brush, gray and black washes. 10⅜ x 6¾ in. (264 x 171 mm). Gift of Mr. and Mrs. Richard J. Bernhard, 1959. 1959.13.

Goya (1746-1828) was one of the most remarkable artists of all time. He was an eminent painter of frescoes, altarpieces, and easel paintings, an inventive designer of tapestries, a brilliant portraitist, a prominent etcher and lithographer. Most of his drawings come from eight albums and date from the middle of the nineties to the end of his life. They were clearly intended as independent works of art.

The first outlines of this drawing were made with the point of the brush in a very pale gray ink. Then different shades were applied in many layers, both with the point of the brush and the broad brush, to complete the image.

The drawing is one of a group that comes from the so-called Black Border Album. These drawings have been dated to the period of about 1814 to 1817 on the grounds of politi-

24 Francisco Goya, *Pesadilla* or *Nightmare*

cal allusions to events occurring after the return of Fernando VI from France and the subsequent abrogation of the constitution.

While a woman on a bull generally personifies Europe, here she seems to represent fear and horror. Goya entitled the work *Pesadilla*, meaning "nightmare."

25 🦋

JEAN-ANTOINE WATTEAU

Seated Young Woman. Black, red, and white chalk. 10 x 6¾ in. (254 x 171 mm). Purchased by Pierpont Morgan, 1911. I, 278a.

Watteau (1684-1721) may be regarded as the greatest French artist of his century. He was one of the principal creators of the rococo style. Combining real and imaginary elements in his paintings, he enveloped them in a poetic atmosphere—an atmosphere also present in his drawings. In this study of a casually posed young woman, Watteau's gift for suggesting the bloom and luminosity of flesh is superbly realized in a few crisp but subtle strokes. Using a combination of red, black, and white chalks he deftly produces shimmering, coloristic effects. His adoption of the so-called *trois crayons* technique may well be a result of his study of Rubens's drawings in the collection of his wealthy friend and patron Pierre Crozat. So complete was Watteau's mastery of this technique that it is often associated with him.

Watteau drew incessantly from life, often with no immediate purpose in mind. These figure studies were kept in a book and used and reused when he composed his paintings. The pretty blonde model seen here appears to have sat for him often. She may be the same woman who posed for the nude study of Flora in the Louvre, which was preparatory for a series of paintings of the seasons that Watteau was commissioned to do for Crozat's dining room. Although this drawing of a seated woman does not appear in any surviving paintings by the artist, it was etched by Boucher in the *Figures de différents caractères*, a compendium of 103 prints after Watteau's drawings published as a tribute to the artist soon after his death from consumption at the age of thirty-seven.

25 Jean-Antoine Watteau, *Seated Young Woman*

26 🦋

JEAN-HONORÉ FRAGONARD

Young Woman Seated in a Garden. Red chalk over a few slight indications in graphite. 8¾ x 11¹/₁₆ in. (222 x 281 mm). Purchased by Pierpont Morgan, 1910. I, 289a.

The art of Fragonard (1732-1806), who was one of the supreme exponents of the French rococo style, is filled with scenes of dalliance and youthful merrymaking in luxurious garden settings. A prolific painter, he was also one of the greatest draughtsmen of his time, able to draw almost effortlessly and with equal ease in brush, wash, and chalk. This sheet is one of a series of drawings of fashionable young women, several of which were engraved. Most are sketched in red chalk, a medium especially favored by French artists of the eighteenth century. The Library's drawing begins with a slight sketch in graphite and is generally more fully composed than the others. The garden, however, is suggested in a few rapid strokes. The charming sitter may be a member of the artist's family, possibly his daughter Rosalie. In any event, the small oval face, with its delicate features, is characteristic of his ideal of feminine beauty.

This sheet was acquired by Pierpont Morgan

26 Jean-Honoré Fragonard, *Young Woman Seated in a Garden*

in 1910 as part of the Charles Fairfax Murray collection. Morgan also owned Fragonard's famous Progress of Love series, painted for the comtesse du Barry, mistress of Louis XV, now in the Frick Collection. Fragonard's career was long and covered the extremes of the eighteenth century. He was successively a pupil of Chardin, Boucher, and Van Loo, and also studied in Rome at the French Academy. Much later, after his patronage was swept away by the Revolution, Fragonard ended his career as a member of the commission that established the Louvre Museum.

27 ❧

Louis Gabriel Moreau
called L'aîné

"La Vallée": Pastoral River Landscape with Traveler Accompanying Shepherdess on Horseback with Flock of Sheep and Goats about to Ford a Stream. Gouache over preliminary indications in graphite. 22⅞ x 33⁵/₁₆ in. (593 x 844 mm). Signed with initials in pen and black ink, *L M.* Purchased on the von Bulow Fund, 1981. 1981.11.

The eighteenth-century French landscape artist Louis Gabriel Moreau (1740-1806) was called l'Aîné to distinguish him from his brother, the book illustrator Jean Michel Moreau le Jeune. He often worked in gouache, a difficult medium which gives the look of painting without having its flexibility. Like watercolor, it is water based and dries quickly, but the pigments are opaque rather than transparent. For this large, and wonderfully airy panoramic river view, the artist chose a relatively thin oriental paper, first preparing it with a layer of blue gouache. He then painted in the general outlines of the composition, brushing most of the surface with a broad soft brush to achieve atmospheric effects before the surface dried. Later, once the surface was dry, he added accents in color where needed, including the group of peasants with their sheep and goats in the foreground.

Because of the difficulty of working in gouache, the scenes were probably composed in the studio. Since Moreau apparently never left the Ile-de-France, most of his landscapes must be based on views around Paris. Nevertheless, this large landscape evokes the look and feel of an Italian scene and may reflect knowledge of the work of Marco Ricci, the

seventeenth-century Venetian landscapist who also worked in gouache. Moreau's silvery tones and naturalism look ahead to the landscapes of Corot and the Barbizon painters of the nineteenth century.

Louis Gabriel Moreau devoted himself to landscape painting at a time when the genre was still held in some disdain within the hierarchy of subject matter established by the French academicians. It was not until 1817, eleven years after his death, that landscape painting was officially acknowledged by the academy with the inauguration of a Prix de Rome in the field of historic landscape. Moreau's full recognition as a major artist in this field has only come about in this century.

28 &

PIERRE-PAUL PRUD'HON

Female Nude. Black, white, and pale pink chalk, some stumping, on blue paper. 23 3/16 x 12 7/16 in. (589 x 316 mm). Gift of Mr. and Mrs. Eugene Victor Thaw, 1974. 1974.71.

Although Prud'hon (1758-1823) was ten years younger than the French neoclassicist Jacques-

Louis David, his work in many respects is more easily connected with the elegance and refinement of eighteenth-century rococo. Prud'hon excelled in the depiction of sensuous forms, often employing broad painterly brushstrokes combined with a soft chiaroscuro. It is a style which owes much to the art of Correggio and ultimately to the *sfumato* of Leonardo.

This highly finished nude is one of at least eleven preparatory studies for the figure of Innocence in Prud'hon's *Love Seducing Innocence.* There are four known paintings as well as two oil sketches of the subject. It is clear that when he made this drawing, Prud'hon already knew the pose he intended for the figure in the painted version. There Innocence, her eyes demurely downcast, slips her arm around Love, who resembles an Apollo-like youth. Here, the combination of black, white, and pale pink, almost flesh-colored, chalks creates a soft chiaroscuro effect, which is intensified by the blue paper on which Prud'hon liked to draw.

During his lifetime Prud'hon achieved considerable success not only as a painter but as a book illustrator. He was a favorite of the Empress Josephine, and the Library's group of Prud'hon drawings includes a sketch for the portrait of her in the Louvre. While many of his

27 Louis Gabriel Moreau, *"La Vallée"*

28 Pierre-Paul Prud'hon, *Female Nude*

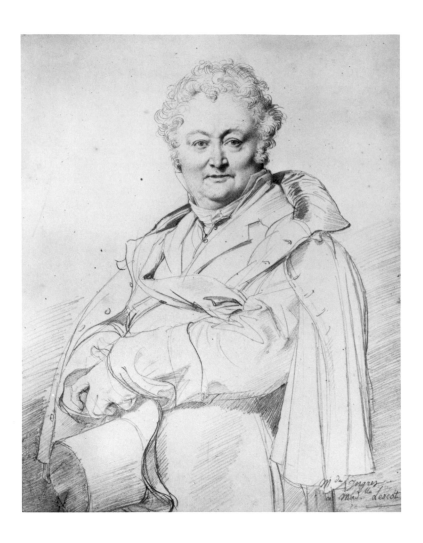

29 Jean-Auguste-Dominique Ingres,
*Portrait of Guillaume Guillon
Lethière*

canvases have lost definition, his drawings, particularly his studies of female nudes, continue to entrance with their beautiful subtlety and refinement.

29 ❧

JEAN-AUGUSTE-DOMINIQUE INGRES

Portrait of Guillaume Guillon Lethière (1760-1832). Pencil on wove paper. 11 x 8¾ in. (280 x 221 mm). Bequest of Therese Kuhn Straus in memory of her husband, Herbert N. Straus, 1977. 1977.56.

In this 1815 portrait of the French neoclassical painter Guillaume Guillon Lethière, Ingres (1780-1867) used a combination of soft and hard pencils to suggest a variety of tonal effects. A tautly stretched paper tablet provided a fine resilient surface, on which he could draw with absolute control. Few artists have employed the pencil with more precision or with greater

sensitivity to its possibilities than Ingres.

The sitter, as is often the case in Ingres's portraits of this period, was a friend and associate. Like Ingres, he had been a pupil of Jacques-Louis David, and by this time he was the director of the French Academy in Rome. Ingres, having received the coveted Prix de Rome, arrived in the city in 1806. His stipend entitled him to only two years' study at the academy, and he financed his continued stay in Italy with pencil portraits such as this one, which he sold at a rate of about forty francs each. Ingres's virtuoso drawing depicts Lethière's facial features precisely and reveals him as an imposing and intelligent man. The bravura handling of the cloak and upturned collar captures some of the dash that was associated with him as well. The drawing is inscribed to Hortense Lescot (later Mme Haudebourt-Lescot), a pupil and friend of the sitter.

Ingres's portraiture, like the whole of his art, was profoundly influenced by his study of Raphael. At a time when Delacroix was revolu-

tionizing French art with his painterly, romantic style, Ingres was the leader of the opposing "classicist" camp. His insistence on the primacy of drawing was legendary; he once gave Degas the now-famous advice, "draw lines, young man, many lines."

30 ❧

HILARE-GERMAIN-EDGAR DEGAS

Standing Man with a Bowler Hat. Essence on brown oiled paper; pentimenti. 12¾ x 7⅞ in. (323 x 201 mm). Bequest of John S. Thacher, 1985. 1985.39.

Degas (1834-1917) is ranked among the finest draughtsmen and painters of the French Impressionists. His work is particularly noted for the subtleties of pose, gesture, and expression that reveal psychological and emotional states. While his pictures frequently suggest a spontaneous or accidental quality, they were in reality carefully planned compositions.

There is some reason to believe that this drawing of a man standing is related to one of his early masterpieces, an enigmatic painting called *Interior (The Rape)* (Philadelphia Museum of Art). The canvas, dated about 1868-69, shows a simple bedroom, illuminated by a single gaslamp. In one corner a half-

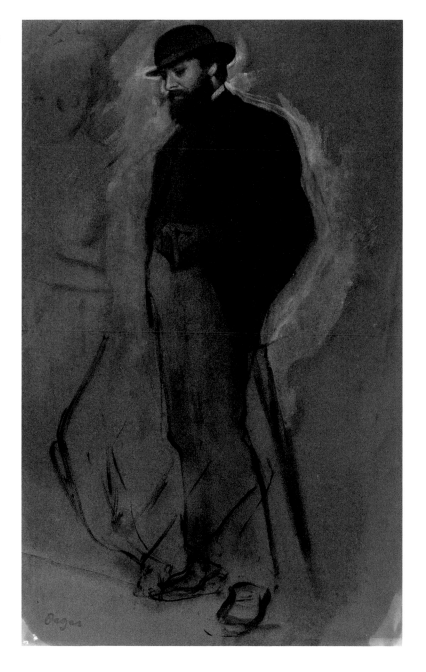

30 Hilaire-Germain-Edgar Degas,
 Standing Man with a Bowler Hat

Compiled by Elizabeth O'Keefe

KEY TO HARDINESS ZONES

This map shows eleven geographical zones based on the average annual minimum temperatures recorded for the years 1974 to 1986. The zone numbers accompanying the plants in this book indicate their lower limits of winter cold hardiness. Extreme summer heat and humidity also play a part in a plant's adaptability; many plants hardy in colder zones grow poorly in warmer, wetter ones.

1	BELOW −50°F BELOW −46°C
2	−50° TO −40°F −46° TO −40°C
3	−40° TO −30°F −40° TO −34°C
4	−30° TO −20°F −34° TO −29°C
5	−20° TO −10°F −29° TO −23°C
6	−10° TO 0°F −23° TO −18°C
7	0° TO 10°F −18° TO −12°C
8	10° TO 20°F −12° TO −7°C
9	20° TO 30°F −7° TO −1°C
10	30° TO 40°F −1° TO 4°C
11	ABOVE 40°F ABOVE 4°C

READER'S DIGEST

COMPLETE GUIDE TO
WATER GARDENING

READER'S DIGEST

COMPLETE GUIDE TO
WATER
GARDENING

Peter Robinson

Reader's
Digest

MONTREAL

A DK PUBLISHING BOOK

PROJECT EDITOR Cangy Venables
PROJECT ART EDITOR Gillian Andrews

MANAGING EDITOR Louise Abbott
MANAGING ART EDITOR Lee Griffiths

US CONSULTANT James A. Lawrie
US EDITORS Barbara Ellis, Mary Sutherland

DTP DESIGNER Chris Clark
PRODUCTION Ruth Charlton
PHOTOGRAPHY Peter Anderson, Steven Wooster
ILLUSTRATIONS Karen Cochrane, Valerie Hill, John Woodcock

Published in Canada in 1997 by
The Reader's Digest Association (Canada) Ltd.
215 Redfern Avenue, Westmount, Quebec H3Z 2V9

Copyright © 1997 Dorling Kindersley Limited, London

Canadian Cataloguing in Publication Data
Robinson, Peter, 1938–
Complete guide to water gardening
Includes index.
ISBN 0-88850-554-X
1. Water Gardens. 2. Aquatic plants. I. Reader's Digest
Association (Canada) II. Title.
SB423.R62 1997 635.9'674 C96-900751-5

READER'S DIGEST and the Pegasus logo are registered
trademarks of The Reader's Digest Association, Inc.
Visit us at the World Wide Web at http://www.readersdigest.ca

Color reproduction by Bright Arts, Hong Kong
Printed and bound by A. Mondadori, Verona

97 98 99 00 / 5 4 3 2 1

KEY TO PLANTING PLANS

In planting plans accompanying
water garden designs, color
coding indicates whether plants
are growing in water, in moist
soil, or in ordinary garden soil.

WATER PLANTS

MOISTURE-LOVING PLANTS

OTHER PLANTS

KEY TO SYMBOLS

The following symbols accompany plant descriptions, indicating
the type of plant and its cultivation requirements.

✹	Prefers a sunny position	◈	Tender perennial grown as an annual in the North
❅	Prefers partial shade	◌	Well-drained but moisture-retentive soil
✺	Tolerates full shade		
⬓	Submerged plant	◑	Moist soil
⬕	Floating-leaved plant	●	Wet soil
⬇	Free-floating plant		
❀	Water Lily		
✿	Lotus		
❁	Marginal Plant		

CONTENTS

CREATING WATER FEATURES

STOCKING &
MAINTENANCE

PLANT CATALOG

AUTHOR'S FOREWORD

THE CURRENT RISE in popularity of water gardening is not difficult to understand. This most beguiling element can be introduced to every size and style of garden. Perhaps surprisingly, water features are one of the most practical and least wasteful ways of transforming a garden into a cooling retreat with lush and varied plant growth.

However, without adequate care being given to the design and construction of a water feature, its full potential may be tantalizingly elusive. The intention of this book is to inspire and inform gardeners at every stage. For the garden owner contemplating a new water feature, it provides a complete practical guide to design and siting, construction, planting, stocking, and maintenance. This book is designed to have equal value to the owner of an existing water feature, offering ideas for improvement, care, and introduction of new plants. In common with so many other aspects of ornamental gardening, a careful mix of

science and art is required to make sure that a water garden achieves, then maintains, visual harmony and ecological balance. The aim here has been to explain and overcome all of the myths and problems so often associated with water features.

Throughout this book, particularly in the section on water garden design, photographs and plans show how water features in a variety of styles may be integrated into overall garden plans. My thanks are due to the designers and owners of these gardens. The practical step-by-step sequences, showing exactly how features are built and equipment installed, were also photographed in private gardens. In order to provide realistic guides to construction, the projects shown were actually built as permanent features, and continue to provide considerable pleasure. I am especially grateful to the owners of these gardens for their help in producing a book that will, I hope, be both a visual and practical inspiration to its readers.

Peter Robinson

PETER ROBINSON

INTRODUCTION

THROUGHOUT HISTORY, WATER has been valued and even revered all around the world – in some cultures rivers, springs, and streams possessed their own deities. The name of France's Seine River, for example, comes from that of the Celtic goddess Sequana. The earliest tradition of building structures that conserved and channeled water is seen in areas where water was scarce – canals that conducted water away from reservoirs to irrigate fields and settlements have been found dating back as far as the 6th century BC.

But even in these very early times, water gradually assumed roles beyond strictly practical uses. Water features became centers for community life and ornamented the pleasure gardens of the rich and powerful. In the Far East, water assumed symbolic significance in the private garden of the philosopher. The decorative possibilities of combining water with plants and ornamental materials were explored in ever greater depth. Because it can add such atmosphere and visual beauty, water has had a profound influence on the development of garden design.

FORMAL ORIENTAL WATER GARDEN
Artful naturalism in Oriental gardens was often balanced with the formal use of water, as in this contemporary interpretation of a straight-edged pool with symmetrical plantings and pergolas.

It is surprising to discover just how central the use of water features is to gardens worldwide at all times in history.

ENCLOSED CHINESE POOL
The traditional Chinese courtyard garden was an enclosed, intimate space for scholarly contemplation, often heightened by the tranquil presence of still, reflecting water.

WATER GARDEN DESIGN AS AN ART FORM

The Oriental style is one the oldest and most influential in water gardening. The Chinese strove to imitate their natural landscape: like poetry or painting, gardening became an artistic emulation of nature. Great care was taken in designing gardens in which water and rocks represented the central principles of *yin* and *yang*. Their placing was crucial in attaining harmony. By the 3rd century AD, the pattern for the Oriental garden, with a lake, island, arched bridges, and subtle planting, was established. By the early 15th century, this had become an art form that was a source of inspiration worldwide.

In Japan, garden design was first influenced by Chinese culture; then the philosophies of Buddhism and Shintoism introduced a strong element of religious symbolism. While Japanese design is much admired and imitated in the West, few Westerners have succeeded in understanding the delicate precision that governs the placing and combining of plants, water, and rock based on religious, historical, and romantic associations.

THEMED LANDSCAPE
The planting around this pond at Coombe Wood in Dorset, England, appears informal, yet is a skillful composition of all the components of Oriental designs – Japanese maples, rhododendrons, and other evergreens. A fountain animates the elegant statues of cranes and the two Oriental bridges. In Japanese style, all is immaculately well kept.

THE EARLY ISLAMIC WATER GARDEN

In addition to containing water essential for practical uses, early Islamic water gardens provided the serenity of still water and the refreshment of gently splashing fountains. Like the early Egyptians, they created enclosed, walled gardens designed to provide relief from the relentless heat of the sun. Unlike designs from the Far East, Islamic gardens were formal and non-representational, with tiling and elaborate stonework often taking the place of plants that would have used up precious water reserves. Gardens were often arranged in four divisions, intersected by canals representing the four rivers of Paradise.

CANAL AT GENERALIFE, GRANADA
This narrow canal, with its arching jets and a brimming dish fountain at its head, highlights the beauty of the stone and ceramic tiling used in this 13th-century Moorish garden.

THE SPREAD OF ISLAMIC INFLUENCE

From the conquest of the Middle East, Islam spread through Egypt and North Africa and from there into southern Spain. Here too, the arid climate necessitated that water be transported to gardens for both decorative and practical purposes. Among the most outstanding water gardens are those at the fortress palace of Alhambra, in Granada, where Moorish gardens and surrounding buildings are subtly integrated. Water for the Alhambra, built in the mid-13th century on a hillside, had to be elevated by aqueduct from the Darro River.

FORMAL COURYARD
The talent for creating perfect gardens with limited water resources is found throughout the Islamic world. The interrelationship of restrained planting and architecture is enhanced by the gentle movement of running water. This small fountain and shallow basin and pool, central to the garden's design, is surprisingly economical with precious water.

The Islamic use of water in the garden was to make a significant impact in the gardens built by the Mogul emperors in northern India between the 15th and 18th centuries. Again, fountains and large sheets of still water were introduced to provide refreshment from the continual heat. Similarly, the gardens were divided into four by canals, which were surrounded by sunken flower beds and raised paths. Gardens such as those of the Taj Mahal and at Nishat Bagh took traditional Persian design to new heights, associating water with spectacular architecture and harnessing water pressure for aesthetic effect.

MOORISH INFLUENCE IN MODERN AMERICA
The use of decorative materials rather than plants to frame water is equally practical in this dry Californian garden. A tiled pool is surrounded by brick terracing, whose abstract patterning is typical of Islamic art and architecture.

ANCIENT ROME

In contrast to the crisp simplicity and decorative function of Islamic gardens, records reveal that the Romans were early pioneers of the modern concept of using water for ornament. Water was brought into the garden solely for the pleasure it gave, especially when associated with lavish, well-tended plantings. Many affluent Roman citizens became early "gentleman gardeners," taking a keen interest in cultivation techniques and in new plants brought back from far parts of the Empire. Statuary, not permitted in the Islamic world but central to the Roman system of beliefs, was often used to ornament gardens and water features.

THE WATER GARDEN IN RENAISSANCE ITALY

Rome also became a center for the exuberant use of water that characterized the gardens of the Renaissance. The hilly terrain north of the city provided ample water pressure, making it an ideal location for water gardens that rapidly became ever grander in scale. Movement and sound could be exploited to the fullest, and fountain design was spectacular, often incorporating statues of human figures, animals, or mythological creatures to create dramatic tableaux. The Villa d'Este remains the most outstanding and imaginative example of the technical brilliance and extravagance of the period: ingenious hydraulics produce a pathway of 100 fountains, a water organ, and a spouting dragon.

PEPSICO GARDENS, NEW YORK
Throughout the world designers now realize the benefits, long recognized in the Arab world, of introducing water as a cooling and refreshing element in public spaces.

POST-RENAISSANCE EUROPE

The influence of the Italian Renaissance reached France in the latter part of the 15th century, when Charles VIII invaded Italy. However, it was not until

the 17th century that classical formality in France really came to the fore. Louis XIV's Versailles, designed by Le Notre, exemplified tasteful flamboyance and was the model to which garden designers all over Europe aspired for the next century or so. No expense was spared to create an extravaganza of water in a garden setting. It was combined with sculpture and architecture and in many cases with the creation of broad, elaborate parterres in order to achieve grand formality.

Le Notre's work inspired other grandiose schemes in Europe. In Russia, his disciple Le Blond created a garden with water tumbling down marble stairways into a huge marble basin. In Spain, Louis XIV's grandson Philip V created a magnificent water garden at La Granja with impressive fountains and cascades. At Herrenhausen, in Germany, water was used to animate and link formal areas within a strictly geometric pattern that epitomizes the more rigid contemporary German and Dutch styles.

A MORE NATURALISTIC APPROACH

During this period many formal water features were brilliantly executed in England, notably at Chatsworth, in Derbyshire. The break with the formal use of water came toward the middle of the 18th century, with the

STATELY STYLE
For centuries in Europe, ornamental gardening was practiced purely for the pleasure of the wealthy. As technical and mechanical skills developed, water features became more powerful and elaborate, reflecting the status of their owners. By the mid-19th century, few large houses were without awe-inspiring jets and cascades to welcome and impress the visitor, as here at Herrenhausen in Germany.

landscape movement in Great Britain. William Kent (1685–1748) was one of the great pioneers of the movement, using Classical buildings in the landscape to great effect. His management of water was his greatest skill; he replaced formal features such as fountains with three-dimensional compositions of woodland, lawn, and water. Contrasts of light and shade superseded tight architectural form. Craggy waterfalls, grottoes, and other follies became popular, taking their cue from the Romanticism evident in Germany during the 18th century. Monet's garden at Giverny, in France, is a landmark in the movement toward planting rather than architecture, which was to gather momentum in the 20th century. It combines extensive informal planting and stretches of water on which reflections, light and shade, and floating water lilies interplay.

ENGLISH VERSATILITY
At Shute House in Dorset, a formal vista with statue is seen beyond a foreground of dense, informal waterside planting in a brilliant and inventive blending of styles.

WATER GARDENS IN NORTH AMERICA

Water features began to make an impact in America at the turn of the 19th century after the upheaval of the Civil War in a period known as the "Country Place Era." Private wealth enabled ornamental gardening to surge in popularity. Islamic features were incorporated with the styles of the Renaissance and the French gardens of the late 16th to early 18th centuries, dominated by still pools and fountains. The "Country Place Era" came to an end as planting became more significant. Gardens filled with bulbs, perennials, and annuals appeared as the domestic garden developed. Between the two world wars, North American gardens developed their own sense of identity, often based on abstract form and landscaping.

CONTEMPORARY WATER GARDENS

As ornamental gardening has become more accessible to a wider section of society, the average garden size has decreased. Modern materials and techniques allow water features to be used in gardens on a small domestic scale. Perhaps the most essential development in the 20th-century water garden, though, has been the breakdown of the traditional differentiation between formal and informal styles. Elements may be freely borrowed from other cultures and eras, then combined and adapted to today's gardens in individualistic and innovative style, making water gardening one of the most exciting aspects of garden design.

MONET'S GARDEN AT GIVERNY
This naturalistic pond with rustic bridge epitomizes the move toward informality that now characterizes most domestic gardens, where water serves to enhance the beauty and color contrasts of luxuriant plantings.

WATER GARDEN DESIGNS

DESIGNING WITH WATER
RAISED DOUBLE POOL • LARGE FORMAL POOL
CONTAINER GARDENS
ORIENTAL-STYLE WATER GARDEN
COURTYARD POOL • INFORMAL POND WITH
PEBBLE BEACH • MILLSTONE FOUNTAIN
WILDLIFE POND WITH BOG GARDEN • STREAM
FOR CITY OR COUNTRY GARDEN

ORIENTAL-STYLE WATER GARDEN (*LEFT*)
The careful placement of water, plants, rocks and other materials, the subtle use of color and foliage, and the contemplative atmosphere of the Oriental garden make it a popular landscaping style.

DESIGNING WITH WATER

W ATER FEATURES CAN BE accommodated in any garden, whether in an urban, suburban, or country setting. Although the site may dictate certain constraints, it is surprising how flexible these limits are. The following pages feature examples of excellent water design in gardens large and small, in formal or informal style – some combining elements of both. All are different, yet all exemplify the exceptional role water can play in a garden setting. Water features can animate and transform a landscape or garden corner with movement and sound or with stillness and reflection. Above all they create settings for new and beautiful plants.

DECIDING ON A DESIGN
To be really satisfying, a water feature requires an initial and quite searching appraisal of what you intend it to bring to your garden. Unlike lawns and borders, which are relatively easy to enlarge, reduce, or alter in shape, a water feature is less easy to change once installed. Each of the features here succeeds through a mix of elements that relate, above all, to the satisfaction of the owner. Some use water to enhance the colors and textures of decorative materials, while in others the water is there to lure wildlife. Some reflect an advanced sense of plantsmanship, while others use plantings simply as a textural element, to break or highlight line and color.

FORWARD PLANNING
A new garden provides the perfect opportunity to incorporate water in a new and complete design. There is an enormous advantage constructing a pond if mechanical equipment is able to maneuver freely, for example. It can achieve in a few hours of

REFLECTING FEATURE
Waterside areas open up exciting planting opportunities: Gunnera manicata is ideally placed where its huge leaves can be seen reflected in the water surface.

ROCKY STREAM
A level garden can be landscaped to create a cascading stream; the new generation of small, self-contained submersible pumps are much easier than older models to install and maintain.

ATTRACTING WILDLIFE
For many, the sight of wildlife around a pond is one of the most rewarding features of a water garden. Providing a feature that is attractive to insects and other creatures needs thought at the planning stage.

LUSH LANDSCAPE
A dedicated area of moist or boggy ground, where moisture-loving plants can thrive is especially satisfying. Such plantings are very practical in areas with dry summers.

excavation what would take days of hand digging. Placing large boulders by mechanical means, such as those used in the Oriental-style garden *(see pp. 28–31)*, would be extremely difficult once the surrounding garden had been made, but they are an essential ingredient if the design is to work well.

But while a new garden is an ideal blank canvas, it is more common to want to add a water feature to an existing garden. There is no reason why this should not work well, provided care is taken to integrate it well into its surroundings; a pond that suddenly appears in a border or lawn invariably looks like an afterthought or impulse decision. Try, therefore, to envision and plan your water garden in its entirety from the start. A feature that is built and added to piecemeal over the years never has the style of one designed and installed as a whole.

LOOKING FOR INSPIRATION

Visits to garden centers and water garden specialists pay dividends when planning a design, although you may not be ready to purchase. They often have demonstration gardens where new materials and the latest technology can be seen in action. Also visit as many gardens containing water as you can in search of ideas. Do not be daunted by large gardens, where abundant resources and protection from mature trees will have made it easy to create and maintain beautiful compositions. Scrutinize the detail, looking for attractive materials and the way these are juxtaposed with water and plants, then relate these to your own site and requirements.

DESIGNING WITH CONFIDENCE

When designing, bear in mind the limitations of your site and climate, and keep the skills needed to install and maintain the feature comfortably within your capabilities. While designs should not be overambitious, there is no need for them to be timid either. Successful designs demonstrate a strong theme, and when executed with confidence, they are satisfying from the day the last stone or plant is in place and improve with time as plants grow. The designs on the following pages have become expressions of their owners' individuality or interest, be it plants, wildlife, or a combination of elements. Their success reflects the thought, investment, and interest the owner has put into them.

RAISED DOUBLE POOL

I N THIS MATURE, STYLISH garden the two interlinked pools in turn link the paved terrace area to the rest of the garden. More skillful connections are made in the plantings, with leaf shapes and colors echoed and blended perfectly in and around the water and beyond.

INTERPLAY OF SHAPES AND COLORS

The general impression here is of calmness and continuity. The double pool, its formal edges softened by plants, is well built using materials that are in keeping with the paving and other stonework. Containers filled with alpines and tender perennials continue the gradation toward ground level. A pump sends water from the lower to the upper pool via a conduit in the shared wall and up through a millstone fountain. The upper pond features double waterfalls of exactly the same height. This requires skillful bricklaying. The slabs over which the water spills can be filed or ground down to perfect the effect. Flowering plants are few; harmony is created by bold positioning of complementary foliage – spiky irises, for example, are echoed by the white-variegated grass to the right, the red cordyline on the left, and the spikes of foxgloves and delphiniums in the bed beyond.

THE GARDEN PLAN

Seen from the house and terrace, the pool is surrounded by plantings that have largely been kept low to avoid blocking views of the lawn and borders beyond. Paving stones leading to the garden continue the theme of the terrace and stonework. The plantings use plenty of bold greenery to capitalize on the backdrop of trees in neighboring gardens.

PLANTING PLAN FOR THE RAISED POOLS

WITHIN THE POOLS, restrained planting leaves areas of open water, displaying gleaming pebbles on the pool floor. These are heaped up around planting baskets positioned in the lower pool, helping to disguise them and preventing soil from being dislodged. Small clumps of submerged plants *(Lagarosiphon major* and *Potamogeton crispus)*, together with the splashing action of the fountain and waterfalls, keep the water oxygenated and clear. The soil surrounding these contained pools is not wet, but by using plants in these beds that are often seen in moist ground – willow, astilbes, hostas, ferns – and keeping them well watered for lush growth, the illusion is created of natural waterside planting.

DYNAMIC PLANTING WITH FORMAL POOL

This design is dominated by foliage: contrasting shades of green interspersed with bright patches of red, yellow, and purple. Water bubbles and trickles in the pools just enough to add movement, while not disturbing plants. A non-return valve prevents the upper pool from draining through the delivery pipe when the pump is turned off.

SOFTENING LINES
Plants are positioned informally, so that they do not look too regimented against the rectangular shapes of the two pools. Vertical-leaved plants such as irises give height and break the lines of straight edges well.

KEY TO PLANTING PLAN

WATER PLANTS
1 *Lobelia* 'Compliment Blue' x 3
2 *Iris pseudacorus* 'Variegata' x 1
3 *Lobelia cardinalis* x 3
4 *Iris laevigata* 'Colchesterensis' x 2
5 *Aponogeton distachyos* x 3
6 *Iris laevigata* 'Snowdrift' x 3
7 *Acorus gramineus* 'Pusillus' x 3
8 *Lobelia* 'Queen Victoria' x 5
9 *Carex elata* 'Aurea' x 3
10 *Iris ensata* x 6
11 *Houttuynia cordata* 'Chameleon' x 3

12 *Eriophorum angustifolium* x 3
13 *Typha minima* x 3
14 *Iris laevigata* 'Dorothy' x 3
15 *Calla palustris* x 2
16 *Saururus cernuus* x 2
17 *Menyanthes trifoliata* x 3
18 *Eichhornia crassipes* x 5
19 *Caltha palustris* 'Flore Plena' x 2
20 *Houttuynia cordata* 'Flore Pleno' x 3
21 *Nymphaea* x *helvola* x 1
22 *Caltha palustris* x 2
23 *Juncus effusus* 'Spiralis' x 1

OTHER PLANTS
24 *Hedera helix* x 2
25 *Salix hastata* 'Wehrhahnii' x 1
26 *Viola odorata* x 3
27 *Potentilla fruticosa* 'Princess' x 1
28 *Astilbe* 'Sprite' x 1
29 *Asplenium scolopendrium* x 1
30 *Polystichum setiferum* 'Divisilobum Densum' x 1
31 *Lobelia* 'Cinnabar Rose' x 5
32 *Onoclea sensibilis* x 1
33 *Asplenium trichomanes* x 1
34 *Lysimachia nummularia* x 3
35 *Uvularia grandiflora* x 3

36 *Epimedium* x *youngianum* 'Roseum' x 2
37 *Omphalodes cappadocica* 'Starry Eyes' x 1
38 *Hepatica nobilis* 'Rubra Plena' x 3
39 *Hosta venusta* x 3
40 *Persicaria tenuicaulis* x 3
41 *Rubus pentalobus* x 1
42 *Geranium macrorrhizum* 'Album' x 3
43 *Paeonia mlokosewitschii* x 1
44 *Astilbe* 'Deutschland' x 5
45 *Yucca flaccida* x 1
46 *Astilbe* 'Irrlicht' x 10
47 *Hemerocallis* 'Frans Hals' x 1

PLANTING PLAN

Salix hastata 'Wehrhahnii'
Deciduous shrub for free-draining or moist soil. White catkins are borne in early spring. Oval green leaves then appear. Propagate from cuttings, semi-ripe in summer or hardwood in winter. Zones 6–9. H and S 5 ft (1.5m).

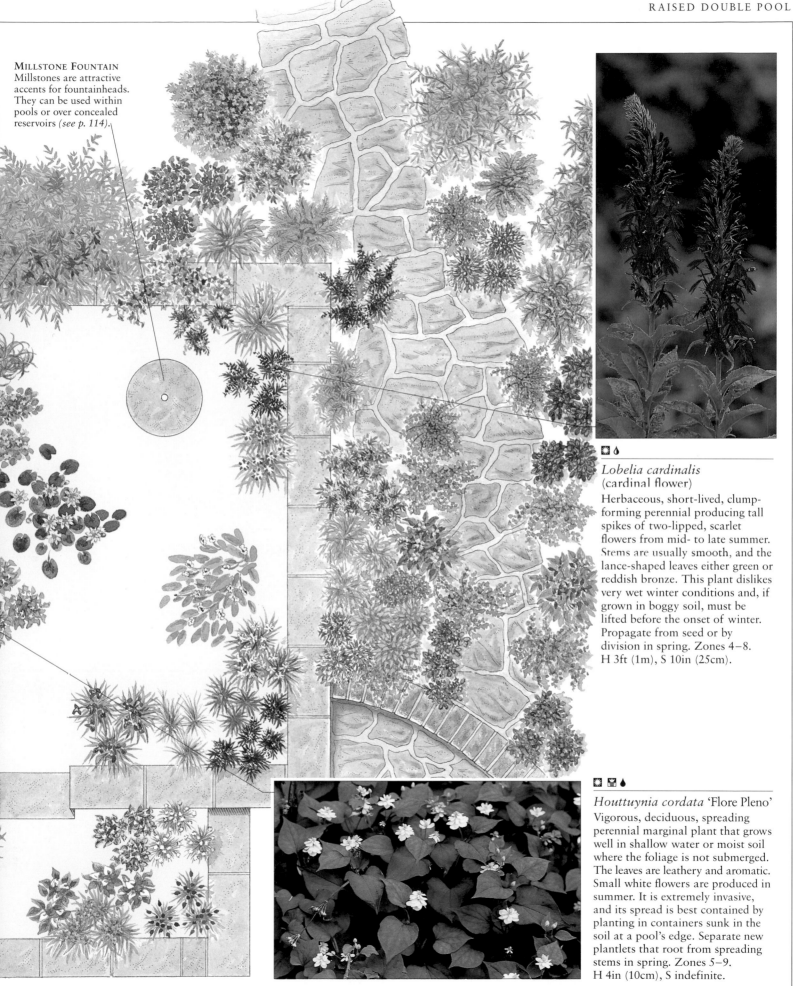

MILLSTONE FOUNTAIN
Millstones are attractive accents for fountainheads. They can be used within pools or over concealed reservoirs (see p. 114).

Lobelia cardinalis
(cardinal flower)
Herbaceous, short-lived, clump-forming perennial producing tall spikes of two-lipped, scarlet flowers from mid- to late summer. Stems are usually smooth, and the lance-shaped leaves either green or reddish bronze. This plant dislikes very wet winter conditions and, if grown in boggy soil, must be lifted before the onset of winter. Propagate from seed or by division in spring. Zones 4–8. H 3ft (1m), S 10in (25cm).

Houttuynia cordata 'Flore Pleno'
Vigorous, deciduous, spreading perennial marginal plant that grows well in shallow water or moist soil where the foliage is not submerged. The leaves are leathery and aromatic. Small white flowers are produced in summer. It is extremely invasive, and its spread is best contained by planting in containers sunk in the soil at a pool's edge. Separate new plantlets that root from spreading stems in spring. Zones 5–9. H 4in (10cm), S indefinite.

LARGE FORMAL POOL

FLOWERHEADS AND SPIKY LEAVES around this formal pool are lit up by late afternoon, late summer sunshine. While earlier in the day the water was a mirror for the sky, now it assumes mysterious depths, with glimpses of submerged plants and fish. Weathered stone, a trickling fountain, and plants that tumble over path edges combine to give an air of faded grandeur.

CLASSIC SIMPLICITY

This is a design that perfectly combines the surfaces of water and stone and the soft color palette of plants that are suited to both aquatic and arid conditions. The large, concrete-lined pool was built some time ago using the skilled and laborious forming method *(see p. 91)*. Today, one option for a formal pool like this one is to build a concrete block shell and line it with a flexible liner – preferably butyl, since this is extremely hard wearing. (For other options, *see pp. 90–91*.) The small, gently brimming fountain sits within its own small concrete pool, completely independent of its larger neighbor.

THE GARDEN PLAN

Classically European yet suitable for a range of climates, this design echoes that of grand country houses, where a formal pool was often situated near the house. Regular paths, trimmed lawns, and an enclosing screen of well-kept formal hedging contribute to the "stately home" illusion.

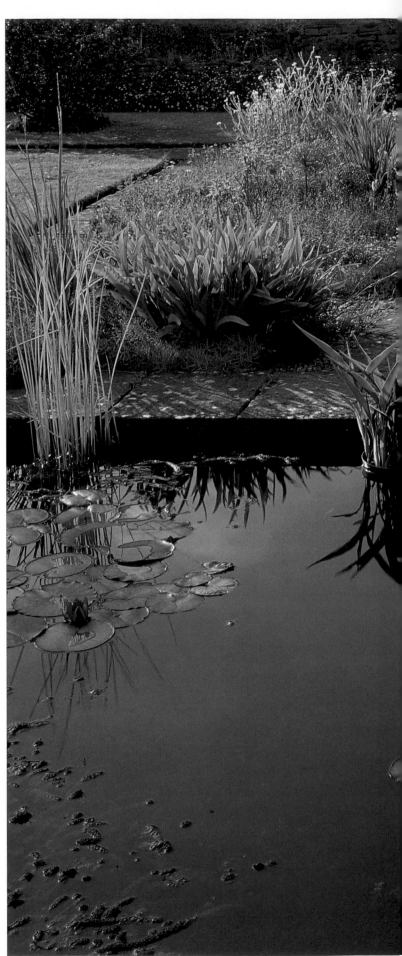

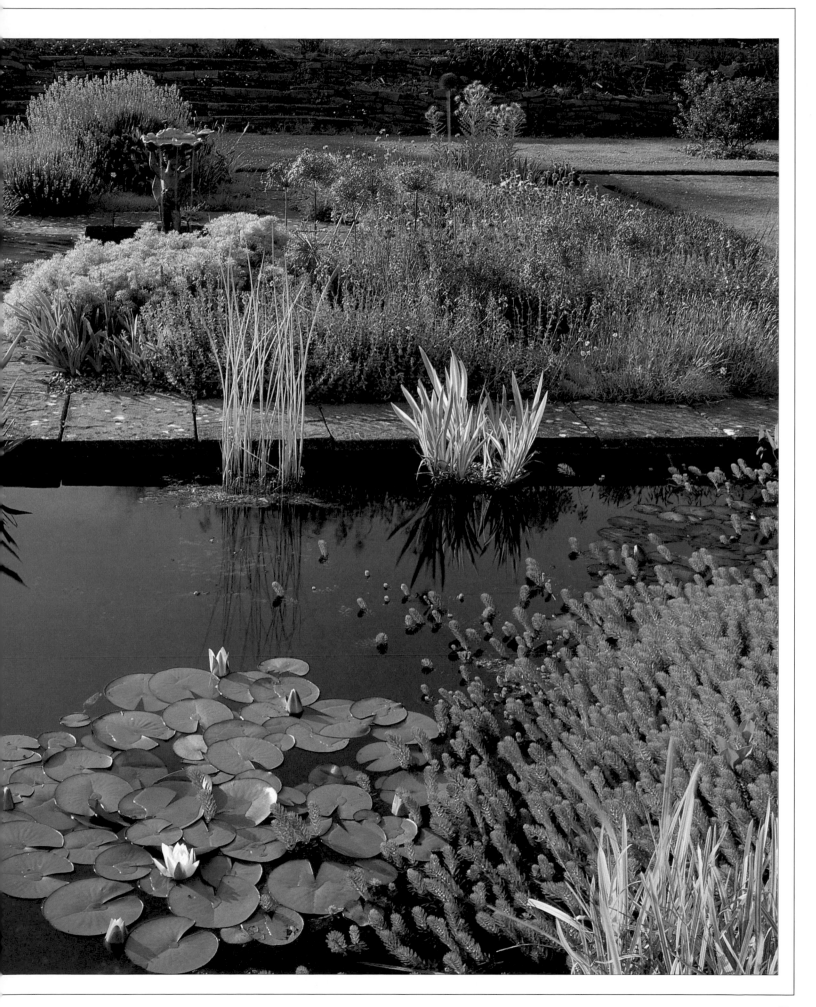

PLANTING PLAN FOR THE LARGE FORMAL POOL

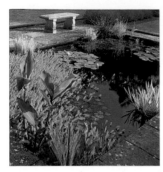

IN THE DRY BEDS surrounding the small pool, a planting palette of pinks and grays is set off by natural stone, water, and the refreshing greens of the aquatic plants. All the plants chosen for these beds tolerate arid conditions and enjoy the reflected heat from the paving. In the large pool, fish may take refuge in the shade of several water lilies.

Together, beds and pool form a feature that is easy to maintain, and where the plants thrive even in the hottest summer. Plants in the dry beds and the submerged plants in the pool have been allowed to spread informally, while the water lilies and marginal plants are contained in planting baskets. Marginal shelves are easy to incorporate in concrete pools, providing a shallower planting depth. Plants in baskets can also be perched on stacks of bricks, which allows more flexibility in moving plants around; this can be convenient when perfecting the final look of a pool. In cool climates, planting baskets also allow tender plants such as cannas to be lifted from the pool and stored over winter to protect them from freezing water temperatures.

INFLUENCE OF THE PAST

Flat terraces make excellent settings for formal pools and beds surrounded by wide paths, traditionally sited near the house in large country-house gardens. Here more relaxed, low-maintenance plantings have replaced the labor-intensive, formal parterres of the past. This arrangement of pool and planting beds could also easily be reduced in scale for a smaller, similarly sheltered patio or terrace, using plants either singly or in groups of two or three instead of the larger, intermingling drifts planted here.

REGULAR SHAPES
A small, square, unplanted pool echoes the shape of the pavers yet forms a small oasis in the middle of the dry beds and pathways.

❄ ❆ ◐ ◐

Iris laevigata 'Snowdrift'
Deciduous perennial forming upright clumps of smooth, swordlike leaves and sparsely branched, erect stems that each bear two to four beardless white flowers in early to midsummer. All cultivars of *Iris laevigata* will also grow well in permanently moist soil. Propagate by dividing rhizomes in late summer. Zones 4–9. H 2–3ft (60cm–1m), S indefinite, water depth to 3–4in (7–10cm).

PLANTING PLAN

KEY TO PLANTING PLAN

WATER PLANTS
1 *Iris laevigata* 'Snowdrift' x 1
2 *Nymphaea* 'Escarboucle' x 1
3 *Schoenoplectus lacustris* x 2
4 *Lagarosiphon major* x 2
5 *Iris laevigata* 'Variegata' x 1
6 *Pontederia cordata* x 1
7 *Iris sibirica* x 3
8 *Nymphaea* 'William Falconer' x 1
9 *Myriophyllum verticillatum* x 1
10 *Menyanthes trifoliata* x 2
11 *Iris ensata* x 1
12 *Lysichiton camtschatcensis* x 1
13 *Nymphaea* 'Marliacea Albida' x 1
14 *Orontium aquaticum* x 1
15 *Caltha palustris* x 1

16 *Canna flaccida* x 3
17 *Canna glauca* x 1
18 *Glyceria maxima* var. *variegata* x 2
19 *Juncus effusus* 'Spiralis' x 1

OTHER PLANTS
20 *Lychnis coronaria* Oculata Group x 1
21 *Dianthus* 'La Bourboule' x 6
22 *Lavandula angustifolia* x 5
23 *Colchicum speciosum* x 1
24 *Allium christophii* x 7
25 *Saxifraga cotyledon* x 5
26 *Iris* 'Matinata' x 1
27 *Ptilostemon afer* x 1
28 *Erodium manescaui* x 3
29 *Centaurea hypoleuca* 'John Coutts' x 1
30 *Diascia flanaganii* x 4

31 *Dianthus* 'Pink Jewel' x 1
32 *Silene vulgaris* subsp. *maritima* x 1
33 *Allium giganteum* x 3
34 *Artemisia alba* 'Canescens' x 1
35 *Iris* 'Brannigan' x 1
36 *Iris* 'Langport Wren' x 1
37 *Dierama pulcherrimum* x 1
38 *Dianthus* 'Old Square Eyes' x 4
39 *Iris sibirica* x 1
40 *Diascia rigescens* x 3

Iris laevigata 'Variegata'
Deciduous perennial forming clumps of smooth, swordlike leaves and erect stems. In early to midsummer two to four blue, beardless flowers appear. This cultivar has variegated leaves; there are others with different flower colors. Will grow in permanently moist soil. Propagate by dividing rhizomes in late summer. Zones 4–9. H 2–3ft (60cm–1m), S indefinite, water depth to 3–4in (7–10cm).

Canna glauca
Rhizomatous perennial with straplike leaves and showy, pale yellow flower spikes. Given full sun, it grows well in shallow water. In cool climates (where it is also a popular summer bedding plant) it must be lifted in fall and stored in a frost-free place. Thrives in a rich, loamy planting medium. Propagate by dividing rhizomes in spring. Zones 10–11. H to 4ft (1.2m), S 2ft (60cm).

CONTAINER GARDENS

A MINIATURE POND in a pot, barrel, trough, or sink can be the central feature on a terrace or balcony, or can be tucked into a corner of a garden. A wide variety of plants thrive in containers, and combining them can yield surprising and satisfying effects. Consider using a watertight container to make an indoor pool for tender plants. There are both tropical and hardy dwarf water

lilies small enough for containers. When combining plants, include tall ones to prevent a squat appearance; papyrus *(Cyperus papyrus)*, for example, adds an attractive vertical accent. Containers also restrain the growth of some beautiful floating-leaved plants that are invasive in open water such as *Eichhornia* and *Azolla*. Remember that submerged plants will still be necessary.

FIBERGLASS PLANTER

This small, lightweight tub is the centerpiece of a sun room used to grow and display frost-tender plants. Warmth and the humidifying effect of the water intensify the scent of the water lily and other flowers. *Myriophyllum* is a good choice of oxgenator, as it also contributes some visible, attractive foliage.

PLANTER IN ITS SETTING
A backdrop of glossy ficus leaves and vivid bougainvillea heightens the tropical look of this container planting. Asparagus fern and a cycad blend with the trailing, feathery stems of Myriophyllum.

PLANTING PLAN

KEY TO PLANTING PLAN

WATER PLANTS	
1 *Colocasia esculenta* 'Fontanesii' x 1	4 *Nymphaea mexicana* x 1
2 *Myriophyllum aquaticum* x 2	5 *Eichhornia crassipes* x 1
3 *Pistia stratiotes* x 1	6 *Thalia dealbata* x 1

FICUS BENJAMINA

CYCAS REVOLUTA

ASPARAGUS SCANDENS

☀ ▼
Eichhornia crassipes
(water hyacinth)
Evergreen or semi-evergreen free-floater forming rafts of foliage on spongy stalks. It flowers only in warmer conditions and is a menace in tropical areas. Separate new plantlets in spring or summer. Zones 8–11. S indefinite.

☀ ▼
Nymphaea mexicana (banana water lily)
Free-blooming species with fragrant, deep yellow flowers opening around noon. Leaves, olive-green when young, are splashed with purple or brown. Can spread rapidly in ponds. Zones 8–11. S 3–4ft (1–1.2m), water depth 18–24in (45–60cm).

HALF-BARREL

Prepared barrels *(see pp. 94)* make excellent miniature ponds. They can be freestanding, surrounded by other plants and perhaps a few stones at the base, or partially or completely sunk into the ground, which gives some frost protection. A variety of planting depths has been achieved here by standing planting baskets on brick stacks of various heights, enabling both marginal and deeper-water plants to be grown. To maximize space, tall, slender plants with attractive straplike leaves or unusual stems have been used, including *Juncus*, *Isolepis*, and *Equisetum*, leaving room for a miniature water lily and free-floating plants; these should be thinned regularly.

BARREL IN ITS SETTING

In this sunny corner, cheerful plantings with colourful flowers surround the barrel. Bidens and plumbago enjoy the sun, while a golden grass lights up the shadier side and echoes the variegated leaves of the Acorus.

PLANTING PLAN

KEY TO PLANTING PLAN

WATER PLANTS

1 *Azolla filiculoides* x 1
2 *Acorus gramineus* 'Variegatus' x 1
3 *Juncus effusus* 'Spiralis' x 1
4 *Isolepis cernua* x 1
5 *Myriophyllum aquaticum* x 2
6 *Hydrocharis morsus-ranae* x 1
7 *Equisetum japonicum* x 1
8 *Acorus calamus* 'Variegatus' x 1
9 *Nymphaea* x *helvola* x 1

Juncus effusus 'Spiralis' (corkscrew rush)
Evergreen, tuft-forming perennial that grows well in shallow water or moist soil. Its semi-prostrate, dark green, leafless stems twist and curl. Dense, greenish brown flower tufts form in midsummer. Propagate by division in spring. Zones 7–9. H 3ft (1m), S 2ft (60cm).

Myriophyllum aquaticum (parrot's feather)
Deciduous perennial for any water depth, with stems covered in finely divided leaves. These can grow to up to 6ft (2m), becoming woody at the base, and will extend above the surface of shallow water, scrambling and softening water edges. Thin regularly. Propagate from cuttings. Zones 6–11. S indefinite.

FUCHSIA 'GENII'

IVY GERANIUM 'MINI CASCADE'

HEDERA HELIX 'GOLDHEART'

PLUMBAGO CAPENSIS

ZONAL GERANIUM 'YALE'

FLOATING LEAVES
Lilypads give cover to two resident goldfish.

BIDENS 'GOLDEN GODDESS'

HAKONECHLOA MACRA 'AUREOLA'

TRAILING STEMS
Myriophyllum must be trimmed regularly.

SLENDER SEDGE
Isolepis cernua forms soft, hairlike tufts of foliage.

ORIENTAL-STYLE WATER GARDEN

THE ORIENTAL-STYLE GARDEN is probably the most popular exotic landscaping style in the West. Moving and still water, rocks, and gravel surfaces have major roles to play in its representation of nature. There is great subtlety in the layout and planting; space, light, shadow, subtle harmonies and contrasts of color, and viewing angles are all given great consideration.

BALANCE AND HARMONY

In this garden, although all the elements seem artlessly placed, a perfect balance exists between the simplicity of the partly raised formal pool and the more naturalistic pond. It is an ambitious design involving rock terracing and heavy boulders that need foundations and plenty of padding beneath to protect the butyl liner. While the liner extends under rocks in the foreground to create an informal outline with planting pockets, the gravel terrace on which the bonsai sits needs a rigid edge for support; a solid retaining wall lies behind the liner on this side. The liner extends under the deck *(see pp. 130–131)*, so that it seems to overhang the water. The garden can be lit up at night.

THE GARDEN PLAN

The overall plan demonstrates the importance placed on views from the windows and deck around the house. Although the areas of clear water are small, they open up this enclosed garden by bringing reflections of the sky and surrounding trees into a very private domain.

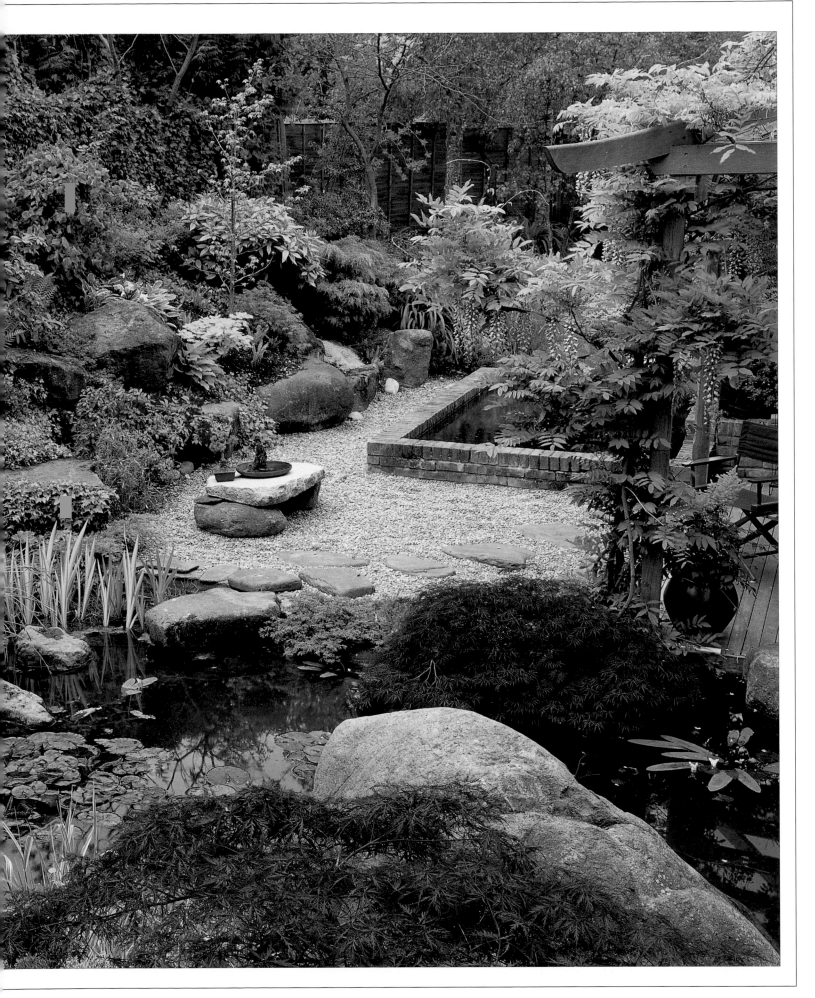

PLANTING PLAN FOR THE ORIENTAL POND

THE PLANTS FOR this garden are low key, with occasional bursts of bright color. Trees and plants are set out asymmetrically in order to imitate the wildness of nature. Planted terraces slope up to tall trees at the perimeter of the garden, providing both privacy and shelter. Soft greens and browns predominate, harmonizing with the colors and textures of the brick, gravel, and boulders, as well as the wooden fences, deck, and pergola. The permanency of the large rocks and the evergreens is given greater impact by the scattering of occasional flowers that help highlight the passing of the seasons. Rocks lead the eye across the pool to the plantings beyond. This line of stepping stones also extends across the gravel, which is kept free of plants because, in Japanese gardens, these carefully raked dry areas are a symbolic representation of water.

PLANTING FOR EFFECT

Mountain ash and silver birch trees look appropriate among the upper rocks, while the elegant foliage of the Japanese maples gives a classically Eastern feel. A dry island *(see pp. 80–81)* in the pond near the pergola pillar enables one of the maples to be planted so that it appears to float on the water surface.

Foliage color is critical in achieving the subtle variations essential to Oriental designs, where flower color is traditionally limited. The red and pinkish purple tones provided by azaleas, rhododendrons, and a Chinese wisteria are complemented by the maples. The oxygenating plants here are all completely submerged, leaving the water surface clear for the clean outlines of lilypads and the leaves of water hawthorn *(Aponogeton distachyos)*.

ENCLOSING OPEN SPACE
The formal pool is clear of plants to give a still, reflective surface, complementing the flat, raked gravel. However, around the informal pond and leading up the rock terracing and on the fences, dense plantings enfold the open space.

Polystichum setiferum 'Divisilobum Densum'
Evergreen or semi-evergreen fern with soft, spreading, finely divided fronds that are white-scaled when young and unfurling, then mature to a matte mid-green. Remove faded fronds regularly. Propagate by division in spring. Zones 5–8. H 24in (60cm), S 18in (45cm).

Hosta undulata var. *albomarginata,* syn. *H.* 'Thomas Hogg'
Clump-forming, shade-tolerant perennial grown chiefly for its foliage. The leaves have irregular cream or white margins, sometimes extending to produce a streaked effect running toward the midrib. Slender-stalked, pale violet flowers are produced in summer. Prone to slug and snail damage. Propagate by division in early spring. Zones 3–8. H 30in (75cm), S 3ft (1m).

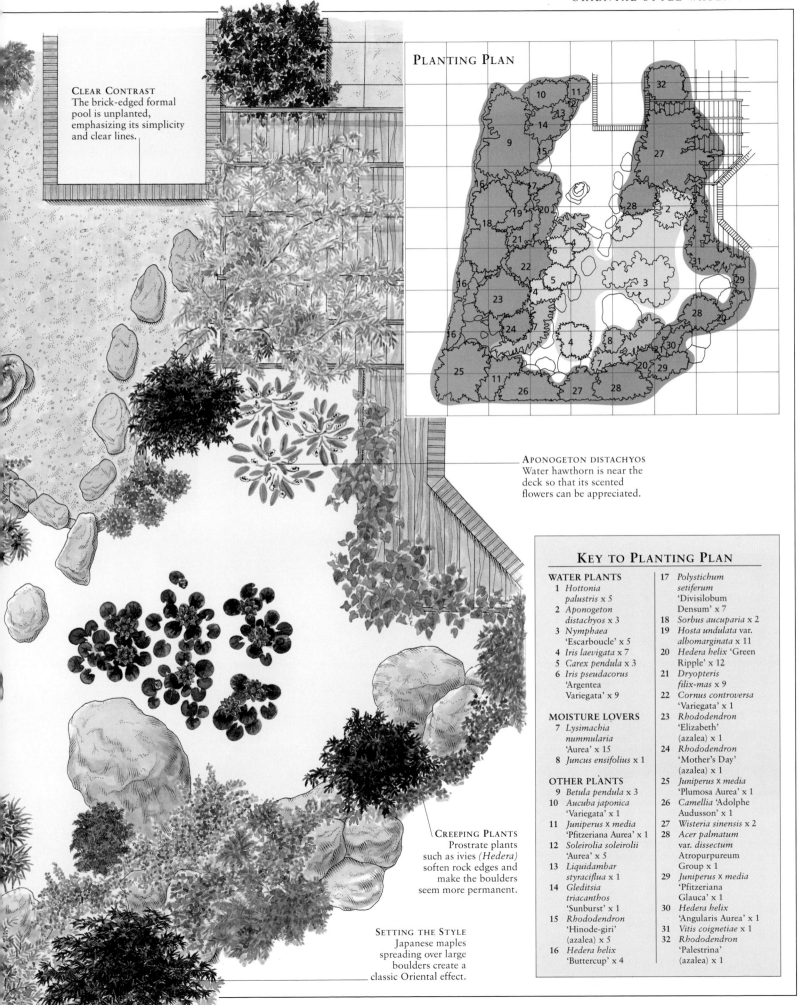

PLANTING PLAN

CLEAR CONTRAST
The brick-edged formal pool is unplanted, emphasizing its simplicity and clear lines.

APONOGETON DISTACHYOS
Water hawthorn is near the deck so that its scented flowers can be appreciated.

CREEPING PLANTS
Prostrate plants such as ivies (*Hedera*) soften rock edges and make the boulders seem more permanent.

SETTING THE STYLE
Japanese maples spreading over large boulders create a classic Oriental effect.

KEY TO PLANTING PLAN

WATER PLANTS
1 *Hottonia palustris* x 5
2 *Aponogeton distachyos* x 3
3 *Nymphaea* 'Escarboucle' x 5
4 *Iris laevigata* x 7
5 *Carex pendula* x 3
6 *Iris pseudacorus* 'Argentea Variegata' x 9

MOISTURE LOVERS
7 *Lysimachia nummularia* 'Aurea' x 15
8 *Juncus ensifolius* x 1

OTHER PLANTS
9 *Betula pendula* x 3
10 *Aucuba japonica* 'Variegata' x 1
11 *Juniperus* x *media* 'Pfitzeriana Aurea' x 1
12 *Soleirolia soleirolii* 'Aurea' x 5
13 *Liquidambar styraciflua* x 1
14 *Gleditsia triacanthos* 'Sunburst' x 1
15 *Rhododendron* 'Hinode-giri' (azalea) x 5
16 *Hedera helix* 'Buttercup' x 4

17 *Polystichum setiferum* 'Divisilobum Densum' x 7
18 *Sorbus aucuparia* x 2
19 *Hosta undulata* var. *albomarginata* x 11
20 *Hedera helix* 'Green Ripple' x 12
21 *Dryopteris filix-mas* x 9
22 *Cornus controversa* 'Variegata' x 1
23 *Rhododendron* 'Elizabeth' (azalea) x 1
24 *Rhododendron* 'Mother's Day' (azalea) x 1
25 *Juniperus* x *media* 'Plumosa Aurea' x 1
26 *Camellia* 'Adolphe Audusson' x 1
27 *Wisteria sinensis* x 2
28 *Acer palmatum* var. *dissectum* Atropurpureum Group x 1
29 *Juniperus* x *media* 'Pfitzeriana Glauca' x 1
30 *Hedera helix* 'Angularis Aurea' x 1
31 *Vitis coignetiae* x 1
32 *Rhododendron* 'Palestrina' (azalea) x 1

COURTYARD POOL

THIS SMALL GARDEN has been transformed by a pond that dominates the limited ground space, yet opens up the vertical dimension of the courtyard, adding another planting level to the surrounding beds and trellises. A pool such as this, where the edging doubles as a path, must have solid walls; since the pool is small, a concrete block shell waterproofed with flexible liner *(see pp. 78–79)* is the easiest construction method. The floor need not be concreted, but a central patch of crushed stone foundation enables strong concealed brick pilings to be built *(see pp. 120–121)* to support an archipelago of "floating" stepping stones. A unified color scheme and continuity in the materials used prevents a fussy look, always a danger in small spaces. The pavers are softened by marginal plants in the water. Careful maintenance, removing faded or untidy foliage, and thinning and dividing plants whenever they threaten to crowd the pool will preserve the clean lines of this cooling retreat.

PLANTING PLAN FOR THE COURTYARD

Courtyards are often warm and sheltered, which allows for growing a wide range of plants, but it is a good idea to keep the planting restrained in such a small space. Plan for areas of clear water and paving to open up the design. In this garden, vertical-leaved plants enhance the clean, straight lines of the paving and the still water surface, while the lilypads echo the stepping stones and the curved contours of the Ali Baba pot. The stepping stones also make the water plants accessible and easy to maintain.

Typha minima (dwarf cattail)
Deciduous perennial forming tufts of slender elegant foliage at the water's edge. Rust-brown flower spikes in late summer mature into decorative, rounded seed heads. It is happy in shallow water, but also grows well in wet soil. Propagate in spring by seed or by division. Zones 6–11. H 2ft (60cm), S 12in (30cm), water depth to 6in (15cm).

PLANTS IN BASKETS
Marginal plants in baskets are placed on brick stacks to obtain the correct planting depth. The water lily is set on the bottom of the pool.

REPEATED PLANTS
Repeating clumps of a small selection of plants helps tie the design together.

Myosotis scorpioides
(water forget-me-not)
Deciduous, marginal perennial wildflower with a creeping rhizome. Stems are first prostrate, then erect, forming sprawling mounds of narrow, mid-green leaves. Loose clusters of small, bright blue flowers with a central eye of pink, yellow, or white appear in early to mid-summer. Zones 4–10. H 6–9in (15–22cm), S 12in (30cm), water depth 0–6in (0–15cm).

POTENTIAL FOR VARIETY

While the strong design of the formal pool with its stepping stones is permanent, the plants in their baskets could be moved around or substituted to vary the effect and extend the season of interest. Changing the color of the trellis and the color-washed pot would also dramatically alter the mood.

KEY TO PLANTING PLAN

WATER PLANTS
1 *Iris sibirica* x 3
2 *Nymphaea* 'Gladstoneana' x 1
3 *Lobelia cardinalis* x 1
4 *Myosotis scorpioides* x 1
5 *Iris pseudacorus* x 1
6 *Schoenoplectus lacustris* subsp. *tabernaemontani* 'Albescens' x 1

7 *Iris pseudacorus* 'Variegata' x 1
8 *Typha minima* x 1
9 *Carex elata* 'Aurea' x 2

OTHER PLANTS
10 *Cryptomeria japonica* 'Spiralis' x 2
11 *Anthemis punctata* subsp. *cupaniana* x 1

12 *Sisyrinchium striatum* 'Aunt May' x 3
13 *Hosta fortunei* var. *aureomarginata* x 1
14 *Elaeagnus* x *ebbingei* x 1
15 *Hosta* 'Hadspen Blue' x 1
16 *Iris pallida* 'Variegata' x 1

PLANTING PLAN

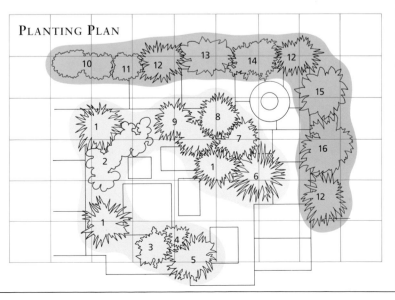

33

INFORMAL POND WITH PEBBLE BEACH

THIS SMALL SUBURBAN GARDEN has been transformed into a green paradise by an informal pond surrounded by lush and varied plantings. While drifts of plants seem to spill down from the veranda to the poolside and merge around it, the tended lawn and clean lines of the well-scrubbed pebbles and decking prevent any sense of neglect.

A View for all Seasons

Planting opportunities have been maximized at the waterside by using a flexible liner to form not only a pool with a variety of planting levels, but also wide areas of damp ground for planting around it *(see p. 78)*. In summer, the graduated heights of aquatic plants and vigorously growing moisture-lovers combine to produce a verdant oasis. Lighting *(see pp. 124–125)* allows the feature to be enjoyed as the long evenings darken. However, on winter days, the view from the house windows skips over the poolside planting, now not at its best, to the more resilient trees and shrubs around the lawn and beyond.

THE GARDEN PLAN

Curving lines, distinct planting areas, and the matching weathered shades of decking, steps, bridge, and bench are crucial to making this garden seem much bigger than it really is. Steps on the right, with a gravel path leading to the utility area, give more practical access between house and garden.

PLANTING PLAN FOR THE INFORMAL POND

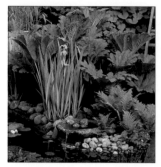

THIS WATER FEATURE derives its impact from the skillful placement of plants against the glassy, still water surface as well as the subtle colors and textures of the hard landscaping materials. Plants and pebbles leading gradually down into the pond, and the echoed roundness of the pebbles and lilypads, blur the distinction between land and water.

Plants with striking foliage such as gunnera and hostas are interplanted with soft, feathery ferns, sword-like irises, and slender grasses. These form a predominantly rich green canvas persisting throughout the season on which vivid splashes of color appear: the yellows of irises, ligularias, and marsh marigolds, scarlet *Geum* 'Borisii' and the plumes of a crimson astilbe. In the water the color is continued with a sequence of white, red, and magenta-toned water lilies.

VIBRANT COLORS AND STRONG FORMS

This is a garden of textures, deriving its impact from the range of edging materials used and the clever choice of plants. To ensure that the plants complement rather than compete with one other, all but the very largest ones are in clumps of three or more, allowing the character of even the most delicate specimen to be clearly determined.

PEBBLE BEACH
The pebble beach *(see pp. 80–81)* gives wildlife access to the water's edge, to be viewed undisturbed from the veranda.

TERRACED BEDS
On the "dry" side of the steps, terracing brings the plants up to form a screen between the veranda and the neighboring garden.

PLANTING PLAN

KEY TO PLANTING PLAN

WATER PLANTS
1 *Hydrocharis morsus-ranae* x 3
2 *Callitriche hermaphroditica* x 3
3 *Nymphaea* 'Attraction' x 1
4 *Nymphaea* 'Firecrest' x 1
5 *Lagarosiphon major* x 7
6 *Nymphaea* 'Laydekeri Fulgens' x 1
7 *Nymphaea* 'Marliacea Albida' x 1
8 *Scrophularia auriculata* 'Variegata' x 3
9 *Iris laevigata* x 6
10 *Caltha palustris* x 3
11 *Iris pseudacorus* 'Variegata' x 5

MOISTURE LOVERS
12 *Glyceria maxima* var. *variegata* x 1
13 *Hosta ventricosa* 'Alba' x 3
14 *Hosta fortunei* var. *albopicta* x 3
15 *Geum* 'Borisii' x 3
16 *Astilbe* 'Fanal' x 4
17 *Lysimachia nummularia* x 10
18 *Rheum palmatum* x 1
19 *Filipendula ulmaria* 'Aurea' x 8
20 *Osmunda regalis* x 3
21 *Miscanthus sinensis* 'Gracillimus' x 6
22 *Carex pendula* x 3
23 *Miscanthus sinensis* 'Zebrinus' x 7
24 *Matteuccia struthiopteris* x 5
25 *Ligularia dentata* 'Desdemona' x 1

26 *Ligularia* 'The Rocket' x 2
27 *Gunnera tinctoria* x 1
28 *Onoclea sensibilis* x 3
29 *Hosta sieboldiana* var. *elegans* x 1
30 *Heuchera sanguinea* x 5

OTHER PLANTS
31 *Origanum vulgare* 'Aureum' x 7
32 *Juniperus x media* 'Pfitzeriana Aurea' x 1
33 *Fargesia murieliae* x 3
34 *Cedrus deodara* x 1
35 *Alchemilla mollis* x 3
36 *Dryopteris filix-mas* x 3
37 *Fatsia japonica* x 2
38 *Chelidonium majus* 'Flore Pleno' x 1

Matteuccia struthiopteris (ostrich fern)
Deciduous rhizomatous fern that can be grown in normal soil or in moist ground. Dark brown, fertile innermost fronds stand erect in the center, surrounded by lance-shaped, sterile fronds, 3–4ft (1–1.2m) in length, that spread outward like feathers. Propagate by division in autumn or winter. Zones 2–8. H 3ft (1m), S 18in (45cm).

WOOD DECKING
Decking made from planks or preformed wooden slabs *(see p. 130)* is best set above the water surface rather than level with it to keep it from becoming wet and allow rain to drain away.

Nymphaea 'Attraction'
Hardy water lily with oval leaves that are light bronze when young, turning dark green in maturity. The cuplike, then star-shaped flowers have inner petals of a rich, deep garnet, and slightly lighter outer petals surrounding orange stamens. Zones 3–11. S 4–5ft (1.2–1.5m), water depth 15–36in (37–90cm).

Ligularia 'The Rocket'
Clump-forming herbaceous perennial with dark green leaves with deeply cut, jagged edges, supported on dark stems. Narrow spikes of small, lemon yellow flowers, also on dark stems, are produced in late summer. Prefers a site with deep, fertile soil, and a mulch around the base to help prevent moisture loss and wilting on bright, windy days. Propagate from seed or by division. Zones 4–8. H 4–6ft (1.2–1.8m), S 3ft (1m).

Caltha palustris (marsh marigold, kingcup)
Deciduous hardy perennial that grows freely along streams and ditches in the northern hemisphere. In spring it produces clusters of waxy, cup-shaped, bright golden-yellow flowers, 1in (2.5cm) across, held above smooth, deep green leaves. Propagate from seed or by division in spring or early autumn. H 24in (60cm), S 18in (45cm), water depth to 6in (15cm).

37

MILLSTONE FOUNTAIN

RESERVOIR FEATURES pump water from a sunken or concealed container up through a decorative outlet such as a millstone or pile of river rocks. The water then spills and drains back into the reservoir *(see pp. 112–115)*. Reservoir features are simple and effective for the smallest spaces, working well either as a tiny garden's main element or as an unexpected accent in a larger one. Here, in an area that is no larger than 6ft (2m) square, there is refreshment, sound, and movement. The unobtrusive informality is carefully crafted, using low-growing plants in the foreground that benefit from the misting effect of the fountain and the moisture-retentive "mulch" of rocks. While the dry millstone on the left is

real, the one forming the fountain is of textured fiberglass. Such features are easy to maneuver and install, and place less strain on the reservoir structure beneath; they are sometimes available in kits, together with a suitable pump. The strength of the pump determines whether the water bubbles gently or spurts from its setting. Varying the depth of the water in the reservoir changes the volume and quality of the sound created.

A TRANQUIL CORNER
This carefully composed water feature does not require full sun; its charm lies in cool, restful greens and the contrast of the plants with the shapes and textures of the rocks, millstones, and seat. The transition of color from dry to wet rocks highlights even further the beauty of natural materials, particularly when wet.

COMPOSITION IN GREEN

Unity has been achieved in this small and subtle planting plan by using similarly toned greens in a variety of shades. Darker color in the background graduates to brighter foliage in the foreground, creating an inviting rather than oppressive atmosphere in this shady corner. Variety has been introduced by using plants with differently textured foliage. There are no bright or showy flowers; instead, a simple and sparingly used palette of white, pale yellow, and mauve ensures that attention is not distracted from the delicate leaf shapes and the way in which they associate with the rocks and stone features.

☀ ◊ ◊

Dryopteris filix-mas (male fern)
Deciduous or semi-evergreen fern, usually well shaped with upright, then elegantly arching mid-green fronds. Grows equally well either in moist or in well-drained moisture-retentive soil, but prefers a shady site. Remove fronds as they fade. Propagate by division in autumn or late winter. Zones 4–8. H 4ft (1.2m), S 3ft (1m).

ORIENTAL TOUCH
Thriving in the shelter of the corner, a Japanese maple falls over the dry millstone.

LONICERA PERICLYMENUM
The scent of honeysuckle can be enjoyed from the seat.

DAMP AREA
Moisture from the fountain increases the humidity to help ferns grow in the damp rocks.

TEXTURED FOLIAGE
The distinctive pinnate leaves of *Mahonia japonica* are shown off to their full potential in such a simple composition.

LINKING PLANTS
Planting and pathway are beautifully brought together by the *Phalaris* in the foreground. A plant that needs keeping in boundaries, it is controlled here between the reservoir beneath the rocks and the path.

☒ ◊ ◊

Brunnera macrophylla
(Siberian bugloss)
Clump-forming, spring-flowering perennial that makes a good groundcover in a sheltered site when planted in groups . The delicate, star-shaped, bright blue flowers, on tall nodding stalks, are followed by heart-shaped, mid-green leaves. Propagate by seed in autumn or by division in spring or autumn. Zones 3–8. H 18in (45cm), S 2ft (60cm).

KEY TO PLANTING PLAN

MOISTURE LOVERS
1 *Dryopteris filix-mas* x 1
2 *Brunnera macrophylla* x 3
3 *Phalaris arundinacea* var. *picta* x 4

OTHER PLANTS
4 *Mahonia japonica* x 1
5 *Iris* 'Wedgwood' x 4
6 *Lonicera periclymenum* 'Belgica' x 1
7 *Heuchera* 'Painted Lady' x 3
8 *Viburnum opulus* x 1
9 *Potentilla fruticosa* 'Abbotswood' x 1
10 *Potentilla fruticosa* 'Elizabeth' x 1
11 *Acer palmatum* var. *dissectum* 'Ornatum' x 2

PLANTING PLAN

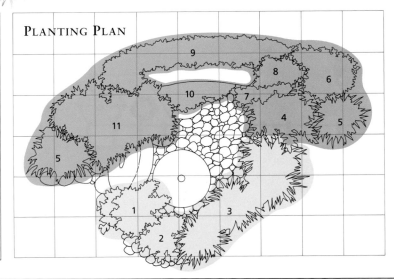

WILDLIFE POND WITH BOG GARDEN

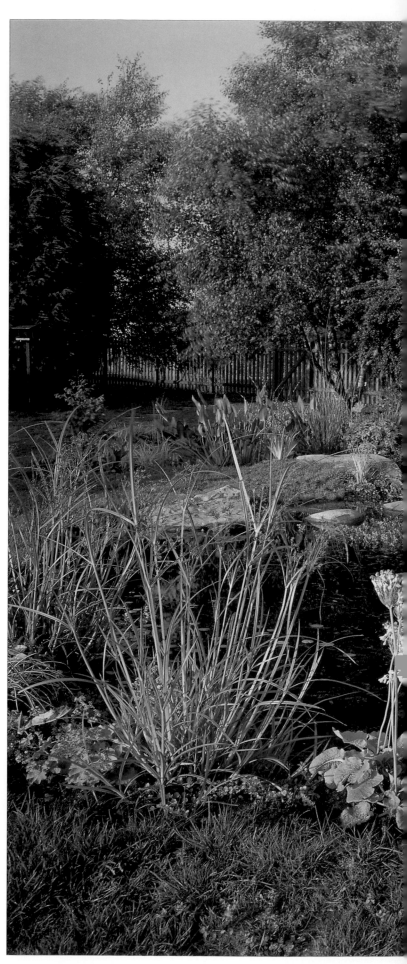

NOT LONG AGO this coastal garden with dry, sandy soil was a completely open, windswept site. It now accommodates a sheltered, well-planted, informal pond surrounded by dense, vigorously growing, moisture-loving plants, making it a magnet for wild creatures from a wide surrounding area.

ENCOURAGING PLANT GROWTH

The plants around this pond are only in their second growing season, but the feature was so well planned to give plants good growing conditions that now little space remains for new specimens. The main pool area has a soil layer placed on top of the flexible liner, supplemented by nutritious waste from several fish. Wide, shallow edges – more than half the pond is less than 12in (30cm) deep – allow aquatic, particularly marginal plants to spread. Around the edges, the flexible liner has been extended under the soil to form a broad band of moist ground; behind the pond, more wet pockets of soil have been created by lining holes with polyethylene. Both these and the shallow, clay-lined depression that forms a boggy pool beyond the main pond must be independently watered. A pebble beach, randomly placed boulders, and a small island ideally suit the needs and habits of birds, amphibians, and water-loving insects. Together with the fish and plants, this sets up a rich food chain that keeps the water and its inhabitants in perfect ecological balance.

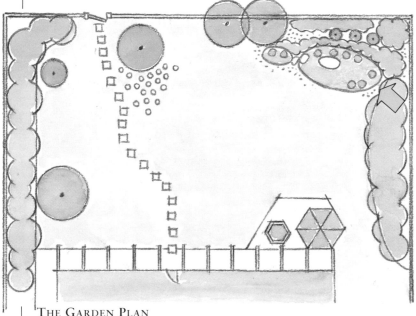

THE GARDEN PLAN

Most of this garden is open in plan to blend with the surrounding gently undulating farmland. On each side, and particularly around the pond (situated away from the house and main pathways to encourage shy creatures), a belt of trees and shrubs provides shelter from the damaging and, equally importantly, drying effects of sea winds.

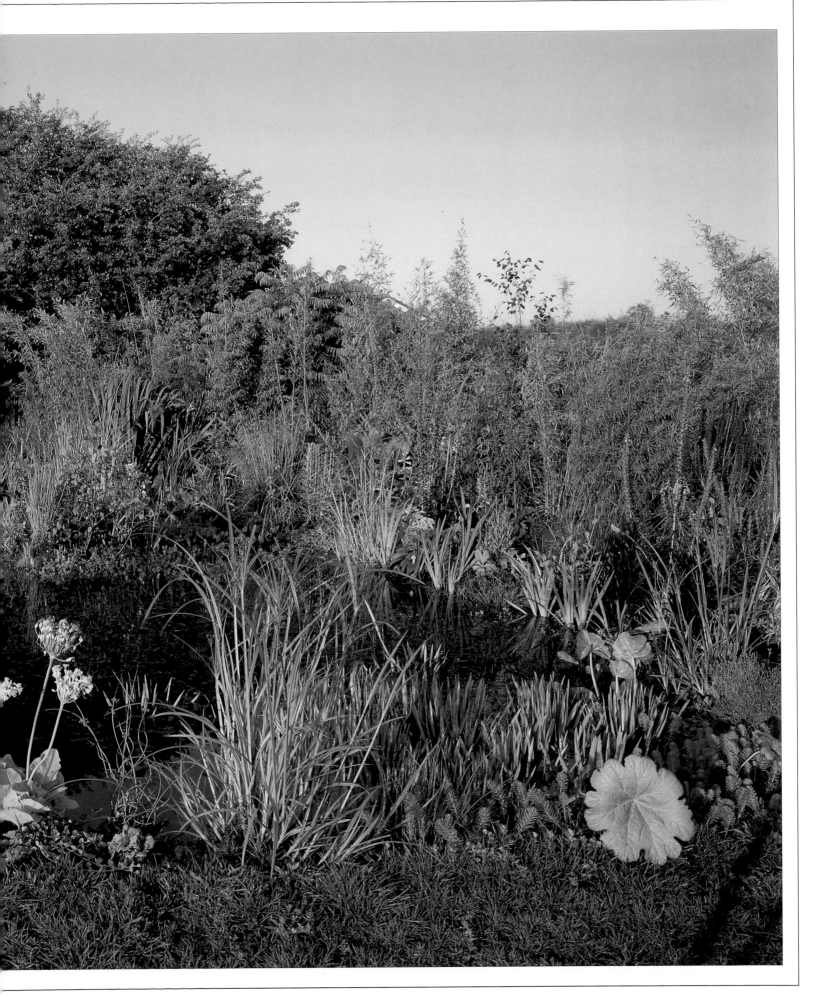

PLANTING PLAN FOR THE WILDLIFE POND

IN ORDER FOR A WILDLIFE pond to be accessible to the maximum diversity of creatures, it is of primary importance to provide ample cover nearby. This will enable birds and animals to approach the water in safety. Here, the side of the pond seen across the lawn is relatively open, so that the feature can be viewed and appreciated, and cover is provided on the far side. Taller, closely spaced plants to the rear of the pond lead right up into the clumps of bamboos (*Fargesia*) and trees such as English hawthorn (*Crataegus laevigata*) that may be used as nesting sites. For other creatures, shelter underwater is important: the underwater stems of submerged plants and a host of marginal plants in the shallows provide cover for fish and amphibians. Leaves of fringed water lily (*Nymphoides*) shade them from the sun – doubly important when water is shallow and heats up quickly.

INFORMAL, MIXED PLANTING

In any water feature designed to attract wildlife, the style should be informal and not too tidy: rigorously removing plant and animal debris deprives creatures of food and shelter. Allow plants to spread and mingle within reason – some lifting and dividing is essential to maintain their health. (Lythrum, because of its highly invasive nature, should not be planted near native wetlands or other ecologically sensitive areas.)

Here, while the planting is mixed, there are enough species to satisfy the dietary needs of a wide range of creatures. Common shrubs such as dogwoods (*Cornus*) and alder (*Alnus incana*) are pruned hard each year to keep them bushy. Perennials such as giant cowslips (*Primula florindae*) and water mint (*Mentha aquatica*) look appropriate and are often more attractive to insects than cultivated varieties. Adding wildflowers native to moist soil, like swamp milkweed (*Asclepias incarnata*) and swamp sunflower (*Helianthus angustfolius*) will attract a variety of creatures.

NATURAL STONE
Rounded sandstone boulders here blend in perfectly with the natural color and texture of the garden's soil.

READY FOR OCCUPATION

This large water feature is a virtual metropolis for insects, birds, visiting animals, and aquatic creatures, with every facility for sheltering, feeding, and bathing provided. Randomly placed boulders accentuate the mound between the main pond and an independent, boggy pool that enables yet more marginal and moisture-loving plants to be grown. The island, an ideal refuge for wildlife, further increases the planting opportunities by extending the area of shallow-water space available.

PLANTING PLAN

KEY TO PLANTING PLAN

WATER PLANTS
1 *Schoenoplectus lacustris* subsp. *tabernaemontani* 'Zebrinus' x 3
2 *Schoenoplectus lacustris* subsp. *tabernaemontani* 'Albescens' x 3
3 *Pontederia cordata* x 7
4 *Alisma plantago-aquatica* x 2
5 *Mentha aquatica* x 3
6 *Lysichiton americanus* x 1
7 *Iris pseudacorus* x 9
8 *Juncus effusus* x 1
9 *Veronica beccabunga* x 5
10 *Sagittaria sagittifolia* x 1
11 *Cyperus longus* x 5
12 *Iris laevigata* x 3

13 *Caltha palustris* var. *palustris* x 1
14 *Stratiotes aloides* x 8
15 *Myriophyllum aquaticum* x 9
16 *Juncus effusus* 'Spiralis' x 1
17 *Nymphoides peltata* x 3
18 *Hydrocharis morsus-ranae* x 3
19 *Aponogeton distachyos* x 1

MOISTURE LOVERS
20 *Metasequoia glyptostroboides* x 1
21 *Carex elata* 'Aurea' x 3
22 *Trollius europaeus* x 1
23 *Gentiana asclepiadea* x 7
24 *Alnus incana* x 3
25 *Crocosmia* 'Lucifer' x 3

26 *Phalaris arundinacea* var. *picta* 'Feesey' x 1
27 *Deschampsia cespitosa* x 1
28 *Lobelia* 'Cinnabar Rose' x 6
29 *Petasites japonicus* x 1
30 *Liatris spicata* x 1
31 *Lobelia* x *gerardii* 'Vedrariensis' x 1
32 *Persicaria amplexicaulis* x 1
33 *Persicaria bistorta* 'Superba' x 1
34 *Lythrum salicaria* x 5
35 *Lobelia cardinalis* x 2
36 *Darmera peltata* x 3
37 *Primula florindae* x 3
38 *Lysimachia nummularia* 'Aurea' x 4
39 *Carex hachijoensis* 'Evergold' x 3

LINKING PLANTS
Iris pseudacorus, which will grow in the shallows and in moist soil, links the aquatic and poolside planting.

INDEPENDENT BOGS
Separately watered planting pockets extend the moist area without depleting the pool's water in dry periods.

LIGHT COVER
Repeated clumps of graceful *Cyperus longus* give height and some shelter without obscuring the view.

Mentha aquatica
(water mint)
Low-growing, spreading perennial with fresh green leaves, fragrant when crushed. The creeping roots are useful for binding wet soil. In summer, it bears small, delicate clusters of flowers in a faded rose pink. Like all mints, it spreads rapidly and should be thinned if it encroachs on other plants. Can be prone to rust. Propagate by division in spring or autumn. Zones 5–9. H 8in (15cm), S 3ft (90cm), water depth 0–6in (0–15cm).

Iris pseudacorus (yellow flag)
Robust, vigorous perennial with sturdy, rhizomatous roots that can be grown in moist soil or shallow water. The broad, ridged leaves are green; those of the cultivar 'Variegata' are striped with yellow. Each tall, branched stem bears up to 10 beardless flowers with large, golden petals that often have a darker patch in the center of the falls. Propagate by dividing rhizomes in late summer to autumn or spring. Zones 4–9. H to 6ft (2m), S indefinite, water depth 0–12in (0–30cm).

STREAM FOR CITY OR COUNTRY GARDEN

WITH A LITTLE INGENUITY, even the smallest plot can accommodate a stream surrounded by lush planting. This small backyard garden is given enormous impact by being entirely devoted to one well-designed water feature, rather than trying to incorporate a number of necessarily scaled-down elements.

STREAMSIDE EDGING AND PLANTING

Water bubbles up slowly among rocks on the left, flowing into a deeper area on the right, where a small submersible pump sends it back to the start again; the stream flows along, rather than down the watercourse. The garden actually slopes upward toward the back and away from the house. The well-mortared bank of irregularly shaped rocks in the foreground acts as a retaining wall for the stream, while on the far side, boulders and the roots of many plants consolidate a bank of rich, moist soil. Since the feature is generally viewed from one side, like a stage set, the slope has been accentuated by planting low alpines in front, medium-height perennials in the middle area (on the far side of the stream), and to the rear, tall conifers and shrubs that also screen neighboring houses. The stream is lined with butyl and edged with a local red sandstone. Local stone, or reconstituted stone crafted to match it, usually complements the colors of local soil and bricks.

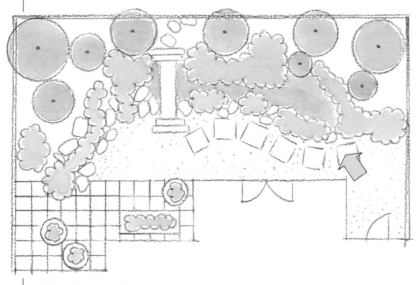

THE GARDEN PLAN
This slow-moving stream can be observed at leisure from a paved patio or, on less pleasant days, from the sun room built onto the back of the house; the slight upward slope brings the stream, plants, and visiting wildlife directly into view from the comfort of window seats. A stone bridge gives access to the far side and also provides a different viewpoint.

PLANTING PLAN FOR THE STREAM

SINCE THIS FEATURE is mainly viewed from only one side, the planting plan has been conceived to create three distinct areas, layered to provide an amphitheater of interest. The foreground plantings are low. With the exception of a planting pocket built to suit moisture-loving *Juncus ensifolius* (an extremely useful and attractive small, spreading rush), the soil is dry between the rocks and makes an excellent home for scrambling and creeping plants such as artemisia and barren strawberry *(Waldsteinia)*. On the near bank of the stream itself, small plants have been chosen that will not obscure the view of the water lilies. Although water lilies dislike fast-moving water, they thrive in this very gentle current. On the far side of the stream, the planting becomes denser and more diverse, with a variety of marginal and moisture-loving perennials dominated by the large leaves of the umbrella plant *(Darmera peltata)*. This moisture-lover forms long surface rhizomes that consolidate the soil, ideal for streamside plantings.

A BACKGROUND OF EVERGREENS

At the back of the garden, conifers, bamboos, and evergreen shrubs form an informal screen and provide natural protection for the lush growth of the marginal and moisture-loving plants. They are a permanent backcloth for the changing display of the perennial plants, although some also change with the seasons: *Pinus sylvestris* 'Aurea' will begin to assume yellow tints in time to echo the bold clumps of Bowles' golden sedge *(Carex elata 'Aurea')*, which lasts well into the autumn. Yellow is an excellent color for bringing light into small enclosed gardens, and here there are splashes of yellow flowers or foliage to be seen all year. The darker greens of other shrubs and trees provide the perfect foil for the autumn's most striking display: the maroon tints taken on by the leaves of the umbrella plants *(Darmera)*.

INFORMAL BOUNDARIES
Plants have a softening effect that is well used here. The plantings give the illusion of continuity to this mock stream, breaking up the hard edges of stonework and, at the back, forming a natural boundary.

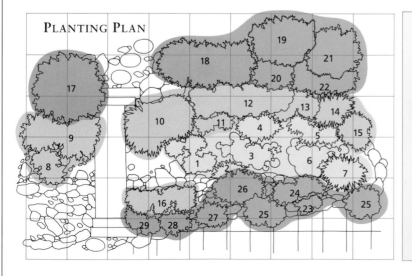

PLANTING PLAN

KEY TO PLANTING PLAN

WATER PLANTS
1 *Mentha aquatica* x 4
2 *Sagittaria sagittifolia* x 2
3 *Nymphaea* 'Escarboucle' x 2
4 *Menyanthes trifoliata* x 2
5 *Iris pseudacorus* 'Variegata' x 3
6 *Nymphaea* 'Gladstoneana' x 1
7 *Acorus calamus* 'Variegatus' x 1

MOISTURE LOVERS
8 *Polystichum setiferum* 'Divisilobum Densum' x 2

9 *Osmunda regalis* x 2
10 *Carex elata* 'Aurea' x 2
11 *Primula florindae* x 2
12 *Darmera peltata* x 5
13 *Mimulus luteus* x 3
14 *Phragmites australis* 'Variegatus' x 1
15 *Iris ensata* x 5
16 *Juncus ensifolius* x 6

OTHER PLANTS
17 *Metasequoia glyptostroboides* x 1
18 *Fargesia murieliae* x 3
19 *Griselinia littoralis* x 1

20 *Pinus sylvestris* 'Aurea' x 1
21 *Erica x veitchii* x 3
22 *Abies koreana* x 1
23 *Alchemilla mollis* x 2
24 *Erodium x variabile* 'Ken Aslet' x 1
25 *Waldsteinia ternata* x 2
26 *Artemisia frigida* x 1
27 *Persicaria affinis* x 2
28 *Hedera helix* 'Heise' x 2
29 *Thymus serpyllum* x 2

❊ ⛉

Sagittaria sagittifolia
(common arrowhead)
Perennial marginal plant whose
leaves are strap-shaped at first,
then arrowhead-shaped. In
summer white, three-petaled
flowers are borne on spikes. It
flowers less readily in water
deeper than 6in (15cm). Propagate
by division in spring or summer,
or break off new plantlets in
spring. Zones 5–11. H 18in
(45cm), S 12in (30cm), water
depth to 9in (22cm).

❊ ◊

Darmera peltata
(umbrella plant)
Spreading, moisture-loving,
herbaceous perennial with creeping,
rhizomatous roots. In spring, while
the leaves are still small, white or
pale pink flowerheads appear. The
leaves then grow large and rounded,
on long stalks, resembling inverted
parasols. They turn copper and
maroon in autumn. Propagate by
division in spring or by seed in
spring or autumn. Zones 5–7.
H 4ft (1.2m), S 3ft (1m).

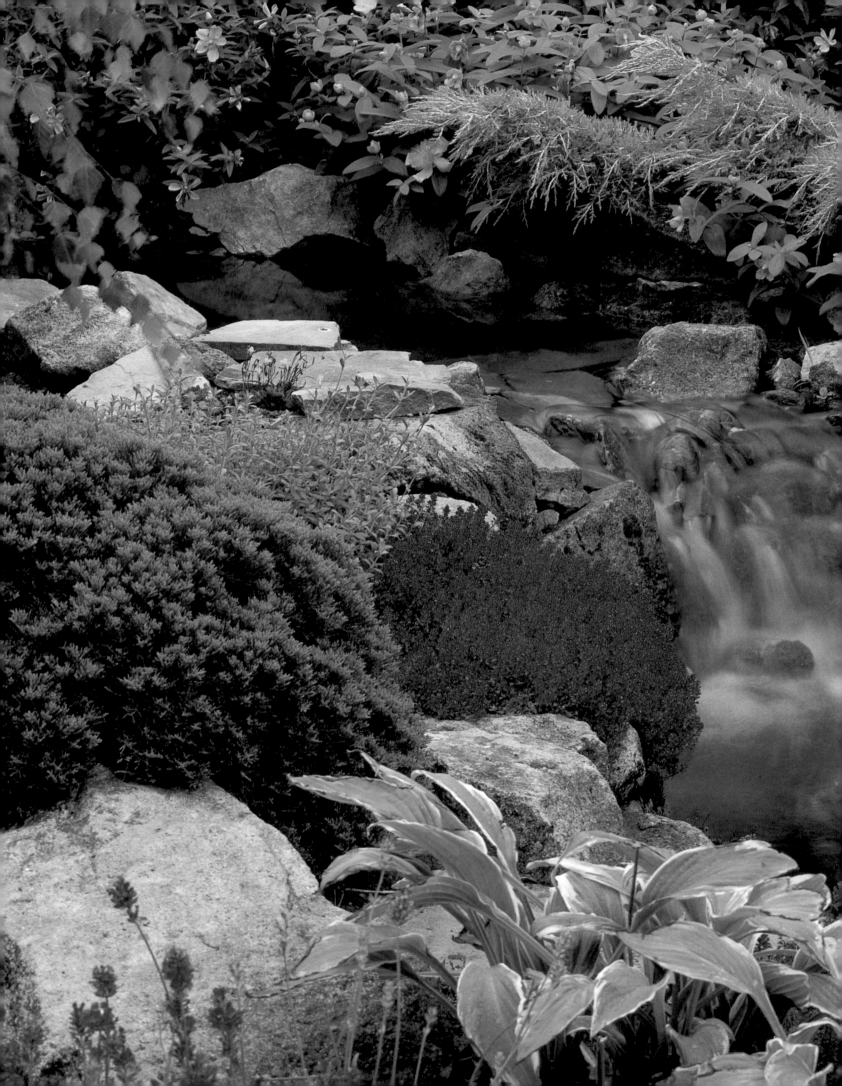

CREATING WATER FEATURES

PLANNING AND PREPARATION

CHOOSING A WATER FEATURE • ENCOURAGING
WILDLIFE • SITING • EXCAVATION • AREAS
AND VOLUMES • CONSTRUCTION MATERIALS
AND TECHNIQUES • PUMPS AND FILTERS

FEATURES WITH STILL WATER

PONDS WITH FLEXIBLE LINERS • BEACHES AND
ISLANDS • BOG GARDENS • RAISED POOLS
SUNKEN CONCRETE POOLS • CLAY-LINED
PONDS • CONTAINER WATER GARDENS

FEATURES WITH MOVING WATER

STREAMS AND WATERFALLS
CONCRETE CANALS • FOUNTAINS
RESERVOIR FEATURES

FINISHING TOUCHES

STEPPING STONES • BRIDGES • LIGHTING
EDGING • DECKING

INFORMAL STREAM *(LEFT)*
*The irregular arrangement of sandstone rocks and the careful
but informal placing of plants gives a natural appearance to an
artificially constructed watercourse.*

PLANNING AND PREPARATION

CAREFUL PLANNING is the key to successful design and construction. Before making any decisions it can be useful to make sketches in order to clarify your ideas. Visit local garden centers specializing in water gardening: given information about your site and requirements, they may be able to offer advice on construction methods and materials that will save time and money.

SITING AND DESIGN

The first major decision to be made is where to site your water feature. There are many factors to be taken into account (*see pp. 56–57*), and drawing up a simple scale plan of your garden can be an invaluable exercise. You may discover that your preferred location is impractical, so be open to the possibility of alternative sites. Consider views both outside and from within the house, especially from favorite garden seats and armchairs.

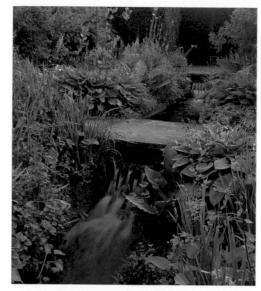

CHOICE OF MATERIALS
Concrete is one of the most versatile and economical of materials: in the right setting, even a concrete-lined stream can be attractive. Remember that setting times for foundations, floors, and walls must be incorporated when planning out construction schedules.

ENCOURAGING WILDLIFE
Wildlife enthusiasts need to take into consideration the needs and preferences of birds, insects, and amphibians from the earliest planning stages (see pp. 54–55) in order to provide an attractive and suitable environment.

SURPRISING SITES
In small spaces, bold designs can be surprisingly effective. In this narrow, enclosed courtyard, the sophisticated raised pool has been styled to complement its urban surroundings.

SAFETY PRECAUTIONS
Bridges (see pp. 122–123) add an extra dimension to a water garden, allowing access across water and providing visual interest. Their safety must be considered: hand-rails need to be sturdy but not obtrusive and can be softened by plantings.

A BOG GARDEN
A bog garden can adjoin a pond or, for plant enthusiasts who do not want to spend too much time on a pond's upkeep, can be a feature in its own right. They are cheap and easy to construct, and are an ideal way of growing moisture-loving plants where water conservation is of prime importance.

The design of the feature will depend very much on personal preference, but it should always be influenced by the site and its surroundings. You may not have the flexibility of incorporating water into a new garden plan, but with careful forethought, your feature will look naturally placed and as if it has always been an integral part of the overall garden design.

CONSTRUCTION AND MATERIALS

There are several methods of construction *(see pp. 64–69)* using a range of materials, each with advantages and disadvantages, so it is worth spending a little time thumbing through suppliers' catalogs. Compare the costs of liners and building materials, and work out how long construction will take. Also assess whether you are physically capable or skilled enough to carry out the work yourself and if not, whether you are prepared to pay someone to do the job for you. Remember to take into account the practicalities of transporting and working with materials. Concrete blocks and slabs, for example, are heavy, and large pieces of flexible liner are difficult to maneuver. If you decide to hire help or rent equipment, think about whether there

are other jobs in the garden that could also be accomplished with an extra pair of hands or piece of equipment available.

Of course skilled labor is expensive, and careful planning can save time and prevent costly errors. If taking on a challenging project yourself, it is worth having the name of a good builder available just in case you encounter unforeseen difficulties; struggling to complete the project yourself without the necessary skills may result in a feature that is never what you hoped it would be.

BRINGING ELECTRICITY TO WATER

The one area in which there is no substitute for professional expertise is the bringing of electricity to a pool, whether it be to power a pump *(see pp. 70–73)* or lighting. Even the installation of relatively risk-free, extra low-voltage equipment can be made easier and safer with advice on weatherproofing connections and how to route buried cable. Only use equipment especially designed for garden and pool use and always carefully follow the manufacturer's instructions. When in doubt, call in a professional electrician to set up the system for you.

Encouraging Wildlife

WATER WILL ALWAYS ATTRACT wildlife, whether birds, insects, amphibians, or mammals. The variety of wildlife will depend somewhat on the site and size of the water feature, but if you create a suitable environment, wildlife will be drawn to even the smallest pond. Careful planting is fundamental; plants should be chosen that not only sustain the water's ecosystem (*see pp. 136–137*) but also provide cover and food. Native plants and flowers are usually more attractive to indigenous wildlife; natural streams and ponds in nearby countryside may suggest planting ideas (do not, however, take plants from the wild). In a successful wildlife pond, all plants and animals play their parts in complex food chains; never use choice plants around a wildlife pond, and do not stock it with costly decorative fish.

Constructing a Wildlife Pond

Natural or clay-lined ponds are ideal, but on a smaller scale, a well-planted pond with flexible liner can be a perfectly acceptable substitute. Make sure that the pond has plenty of variation in depth so that there are several different habitats that may support a wide range of plants and animals. The deep areas of the pond should be at least 18in (45cm), and preferably 36in (90cm), in depth. The sides of the pond should be gently sloping; both sunny areas and cool shade around the edges of the pond are important.

IRIS PSEUDACORUS

DIGITALIS PURPUREA
The flower spires of foxgloves (*Digitalis*) are magnets for bumblebees.

SAGITTARIA LATIFOLIA

SMALL MARGINALS
Grade plants by size, from trees to small marginals, right down to the water's edge to provide continuous cover. Plants with mat-forming roots, such as water forget-me-not (*Myosotis scorpioides*), spread well along the water's edge.

FLOATING LEAVES
Deep-water aquatics provide vital shade, and large, flat leaves also make landing pads for insects. *Nymphoides peltata* (here) and *Nuphar* are less formal-looking alternatives to water lilies for naturalistic settings.

PERCHING PLATFORMS
Flat stones provide perching spots; birds also clean their beaks on the surface of such stones.

SCHOENOPLECTUS LACUSTRIS

NOOKS AND CRANNIES
Hollows among rocks will allow amphibians to shelter during the summer heat and hibernate in winter.

GRASSES AND SEDGES
Evergreen and semi-evergreen grasses and sedges such as *Carex* and *Schoenoplectus* provide cover at the edge of the water for most of the year.

FOOD FOR WATER FOWL
Duckweed (*Lemna trisulca*) and duck potato (*Sagittaria latifolia*) are so called because they are favorite food plants of ducks.

WATER QUALITY
Submerged plants keep the oxygen level sufficiently high to support insect larvae, such as those of the dragonfly, that live on the bottom of the pond.

PEBBLE BEACH
A gentle slope ensures that amphibians, small mammals, and birds can approach the water safely.

LAGAROSIPHON MAJOR
Submerged plants play a practical role, releasing oxygen directly into the water and sheltering fish fry and other tiny creatures.

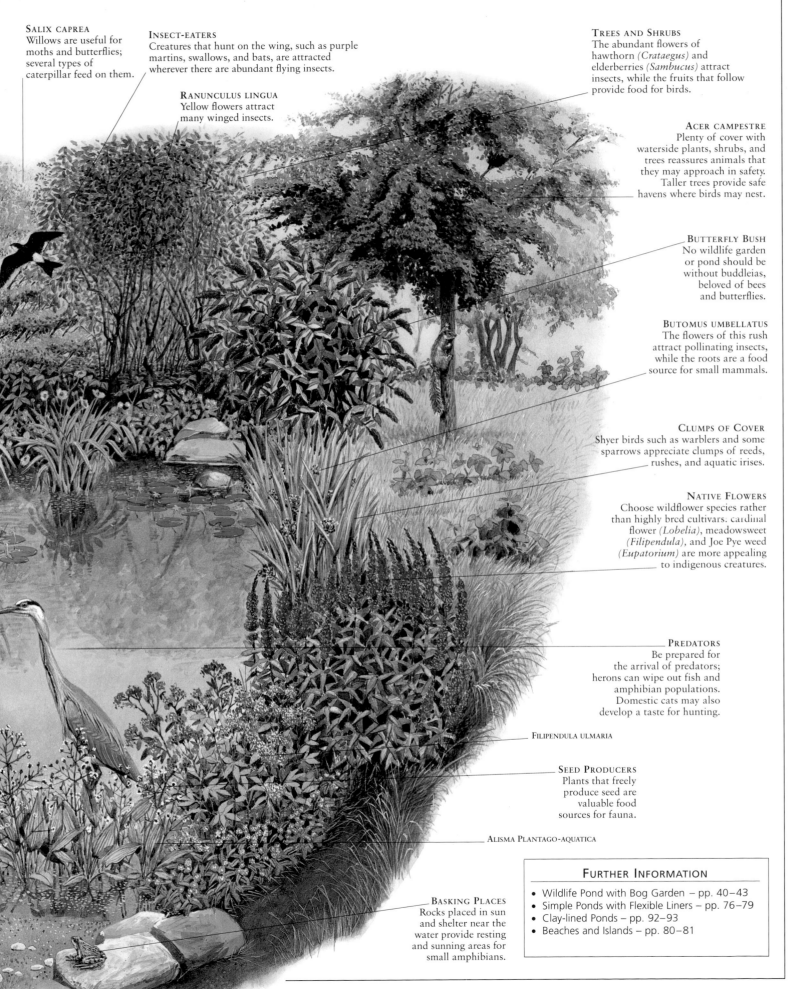

SALIX CAPREA
Willows are useful for moths and butterflies; several types of caterpillar feed on them.

INSECT-EATERS
Creatures that hunt on the wing, such as purple martins, swallows, and bats, are attracted wherever there are abundant flying insects.

RANUNCULUS LINGUA
Yellow flowers attract many winged insects.

TREES AND SHRUBS
The abundant flowers of hawthorn *(Crataegus)* and elderberries *(Sambucus)* attract insects, while the fruits that follow provide food for birds.

ACER CAMPESTRE
Plenty of cover with waterside plants, shrubs, and trees reassures animals that they may approach in safety. Taller trees provide safe havens where birds may nest.

BUTTERFLY BUSH
No wildlife garden or pond should be without buddleias, beloved of bees and butterflies.

BUTOMUS UMBELLATUS
The flowers of this rush attract pollinating insects, while the roots are a food source for small mammals.

CLUMPS OF COVER
Shyer birds such as warblers and some sparrows appreciate clumps of reeds, rushes, and aquatic irises.

NATIVE FLOWERS
Choose wildflower species rather than highly bred cultivars. cardinal flower *(Lobelia)*, meadowsweet *(Filipendula)*, and Joe Pye weed *(Eupatorium)* are more appealing to indigenous creatures.

PREDATORS
Be prepared for the arrival of predators; herons can wipe out fish and amphibian populations. Domestic cats may also develop a taste for hunting.

FILIPENDULA ULMARIA

SEED PRODUCERS
Plants that freely produce seed are valuable food sources for fauna.

ALISMA PLANTAGO-AQUATICA

BASKING PLACES
Rocks placed in sun and shelter near the water provide resting and sunning areas for small amphibians.

FURTHER INFORMATION
- Wildlife Pond with Bog Garden – pp. 40–43
- Simple Ponds with Flexible Liners – pp. 76–79
- Clay-lined Ponds – pp. 92–93
- Beaches and Islands – pp. 80–81

55

SITING WATER FEATURES

SITING CONSIDERATIONS SHOULD be fully explored when making any design and construction decisions. The majority of water plants need plenty of light, but siting is much more than finding the sunniest spot. Locate a feature where it instinctively feels right and where it can be enjoyed to the utmost. There are also many practical factors that must be taken into consideration. If you already have a site in mind with luck it will indeed prove to be the ideal location once you have taken all factors into account. If you have yet to decide, using a process of elimination to remove all unsuitable sites from the available area can be helpful.

PRACTICAL CONSIDERATIONS

AREA AVAILABLE FOR SITING

First of all, you must establish the positions of any drains, pipes, and underground cables crossing the garden. Avoid excavating over or near any of these obstacles. The lay of the land, the position of the water table, and the soil composition (see Drainage and Excavation, pp. 58–59) will give you an idea of how much excavation work construction of the site will entail. Sloping sites, which can be exploited so well by streams and waterfalls, have their own design and building considerations. However, while the lowest point of a sloping garden makes a natural site for a pond, emptying the pond without a pump will be difficult. Low points can also be frost pockets, but more importantly, a rising water table may lift portions of a flexible liner to the pond surface or force a rigid liner out of the ground.

REFLECTIVE POTENTIAL

Place mirrors on the ground to see how much light the pond will reflect and to avoid "doubling" any eyesores. Even a small expanse of water that reflects sky and plants can transform a garden.

CHECKING REFLECTIONS IN A MIRROR

SHADED AREAS AT DIFFERENT TIMES OF THE DAY
Identifying areas of full sunlight, partial shade, and dense shade during the day and early evening is important. A pond in full shade will be visually dull, without character or reflective movement. It will also produce the kind of poor environmental balance that encourages algal growth because it will lack adequate sunlight to penetrate the water and promote plant photosynthesis. Partial shade can be acceptable: there are plants that tolerate these conditions, and dappled shade that produces contrasting patterns of light and dark can create effective mirror images on the water.

SOUTH-FACING GARDEN

PERMANENT SHADE
Do not site ponds where no sunlight will reach them during the day.

PARTIAL SHADE
Shade on part of the proposed pool or for part of the day need not rule out a site for a water garden. Dappled shade can also be attractive, as long as branches do not hang directly over the pool.

KEY TO DAILY SHADE PATTERN

Use string to mark out the areas that are shaded by planting and buildings in the morning, at noon, and in the afternoon.

	EARLY MORNING
	NOON
	EARLY EVENING

Consider, too, whether you will be able to see the feature from the house; this is particularly advisable in family gardens, so adults can keep an eye on children playing near the water.

LIGHT AND SHADE

Choose a sheltered but open site that will afford the feature the maximum amount of sunlight. Avoid extremely hot, sunny sites or you will increase problems with water evaporation in summer; also, fish will not be happy in baking heat. Although it may not be possible to find a spot completely free of shadows, the proximity of nearby tall plants and trees should be carefully considered: in addition to the shade they cast, falling leaves can become a problem. Site features as far as possible from trees with spreading root systems, such as poplars, which may damage foundations; from trees with toxic leaves and seeds, such as yew *(Taxus)*; and from cherries *(Prunus)*, on which water-lily aphids overwinter.

For the best visual impact, try to locate the pond where the reflective qualities of the water can best be enjoyed – a mirror is an invaluable aid *(see facing page)* for this. Experiment with various positions by marking the outline of the proposed pool with rope or hoses; study the direction and quality of light at different times of the day, and observe how well the pond can be seen from different vantage points.

PROVIDING SHELTER

Wind damages the soft, succulent stems of many bog plants, accelerates water evaporation, blows fountain spray out of the pool and, in some exposed sites, can result in the pond freezing over. Shelter can be provided by plantings, or by erecting a trellis or other screen on the windward side of the pool. You can use a windbreak to reduce the speed of the wind before it reaches the plants. A hedge, screen, or a fence with gaps *(see below right)* is a better windbreak than a solid structure, which simply deflects the wind to another part of the garden.

FINDING THE IDEAL SITE
Choosing the optimum location for a pond involves careful consideration of both aesthetic and practical factors.

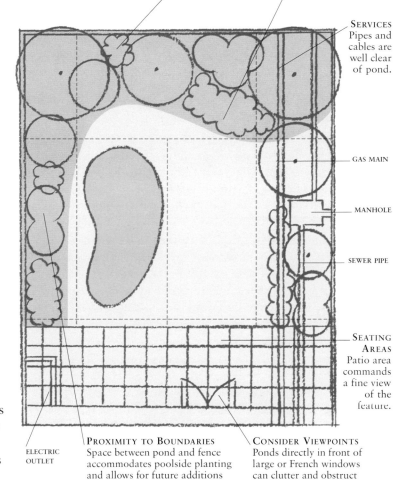

ACCESS TO BORDERS Pond does not restrict access to other areas of planting.

AREA OF SHADE Pond is clear of shade cast by trees and overhanging branches.

SERVICES Pipes and cables are well clear of pond.

GAS MAIN

MANHOLE

SEWER PIPE

SEATING AREAS Patio area commands a fine view of the feature.

ELECTRIC OUTLET

PROXIMITY TO BOUNDARIES Space between pond and fence accommodates poolside planting and allows for future additions such as a rockery or stream.

CONSIDER VIEWPOINTS Ponds directly in front of large or French windows can clutter and obstruct views beyond.

VIEWING A WATER FEATURE ON A SLOPING SITE

Water features on sloping ground must either be cut into, or built up from, the slope *(see* Excavation and Drainage, *pp. 58–59)*; the method will depend on whether you wish to view the feature from farther up, or from farther down, the incline. If you are constructing a retaining wall that extends above ground level, site it on the side of the pond that is farthest away from the house, seating area, or other ideal viewpoint. Otherwise, it will obstruct the view of the water surface.

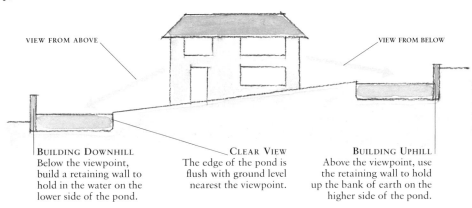

VIEW FROM ABOVE

VIEW FROM BELOW

BUILDING DOWNHILL Below the viewpoint, build a retaining wall to hold in the water on the lower side of the pond.

CLEAR VIEW The edge of the pond is flush with ground level nearest the viewpoint.

BUILDING UPHILL Above the viewpoint, use the retaining wall to hold up the bank of earth on the higher side of the pond.

REDUCING WIND SPEED

For maximum effect, a windbreak should be approximately 50 percent permeable; the gaps in the structure serve to break up the air currents as they pass through.

WIND-BREAK

PREVAILING WIND

FURTHER INFORMATION

- Choosing a Water Feature – pp. 52–53
- Excavation and Drainage – pp. 58–59
- Construction Techniques – pp. 64–69
- Soils and Containers – pp. 150–151

EXCAVATION AND DRAINAGE

Even if your garden is reasonably well cultivated, you may never before have dug as deeply as you will to excavate a pond. Therefore, you may have little idea of the structure of the lower soil levels, and how easy they are to work with – for example, if a compacted or rocky layer exists that might mean extra labor or necessitate renting digging equipment. Since soil can vary from one site to another, dig test holes to determine its structure and composition. Another important consideration is the position of the water table. This, more often than not, does not present a problem; if it is high in your garden, temporary or permanent drainage may be needed.

EXCAVATING A SITE

If you do not have problems with wet ground (*see facing page*), excavation is usually a reasonably simple, if laborious, task. Always stop if you feel any pain, and take breaks before, rather than when, you feel tired. If there is grass on the site, remove strips of sod and stack them upside down in an unobtrusive part of the garden; they will break down into a very good, fibrous loam planting medium. When excavating, first strip off the valuable topsoil to keep for planting areas. Place it separately from excavated subsoil. Use subsoil in the general landscaping of the feature, but always grade topsoil back over the subsoil when digging is complete. Dispose of excess subsoil, rather than dispersing it about the garden; it is of little use to plants.

TEST HOLE
Dig in the center of the proposed site, assess the situation, and adapt construction depending on results.

HIGH WATER TABLE
With water collecting spontaneously at this level, drainage or perhaps a shallower, but semi-raised, pond should be considered.

ESTABLISHING SOIL DRAINAGE AND THE WATER TABLE LEVEL
Dig a hole 18in (45cm) deep and fill it with water. If all the water does not seep away, you have poor drainage or a high water table. Remove the water and dig 18in (45cm) deeper. If the hole begins to fill with water, the water table is high: its level can be gauged when the water stops rising.

SOIL COMPOSITION

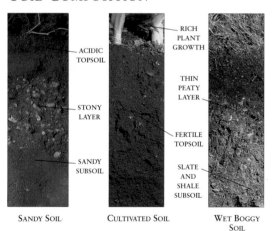

ACIDIC TOPSOIL

STONY LAYER

SANDY SUBSOIL

SANDY SOIL

RICH PLANT GROWTH

THIN PEATY LAYER

FERTILE TOPSOIL

SLATE AND SHALE SUBSOIL

CULTIVATED SOIL

WET BOGGY SOIL

SOIL TYPE
The appearance of soil will tell you a great deal about its structure. Dry, sandy soil is firm and drains well, while wet, spongy soil has poor drainage. The upper levels of cultivated soil should be easy to dig.

SLOPING GROUND
Plants with vigorous root systems will consolidate gently sloping earth banks.

USING RETAINING WALLS ON SLOPING SITES

Unless you are leveling off the site (*see below*) a retaining wall on at least one side will be necessary to stabilize ponds built on a slope. If the wall is to be visible, pay careful attention to achieving a truly horizontal water surface, or the feature will always look askew.

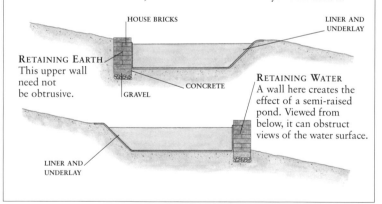

HOUSE BRICKS

LINER AND UNDERLAY

RETAINING EARTH
This upper wall need not be obtrusive.

CONCRETE

GRAVEL

RETAINING WATER
A wall here creates the effect of a semi-raised pond. Viewed from below, it can obstruct views of the water surface.

LINER AND UNDERLAY

LOWER SLOPE
Build up the lower slope first with excess subsoil and cover with topsoil.

LANDSCAPING USING EXCAVATION SOIL
The "cut-and-fill" method is a simple landscaping technique for leveling a sloping site (right), or for creating an earth bank using the soil excavated from a hole. It is essential, however, not to simply mound shoveled earth up as you dig to form the raised areas; sterile subsoil will then be brought to the surface and the valuable topsoil buried where plant roots cannot reach it. Strip off the topsoil first and replace it once you have created the basic contours.

LANDSCAPING
Always build gently sloping banks that will blend naturally into the terrain.

ORIGINAL SLOPE
Before excavation, the sloping ground would only have accommodated a very shallow pond.

CONSTRUCTION ON WET GROUND

You may know without digging a test hole that the water table is close to the ground surface or that drainage is poor. Telltale signs may provide ample evidence, including water pooling on lawns or the presence of water-loving plants such as rushes, sedges, and mosses. A site on a high water table may seem ideal for the construction of a natural pond, but in practice the water table is rarely high enough to create a pond that fills satisfactorily, so a water-retentive liner is still needed. The problem then is that the water in the soil will exert upward and inward pressure on the pond shell, placing structural stress on non-flexible materials such as concrete, and causing flexible linings, such as butyl or PVC, to balloon upward *(see below, top)*.

There are a number of ways of dealing with this. One is to avoid digging down by building a raised pond (for which firm foundations are vital on unstable wet ground) – or, if you want a sunken effect, to raise ground level artificially so that the pond

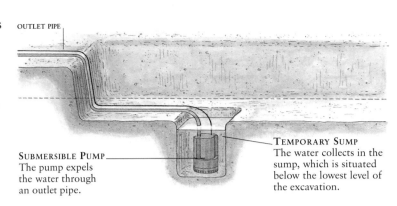

OUTLET PIPE

SUBMERSIBLE PUMP
The pump expels the water through an outlet pipe.

TEMPORARY SUMP
The water collects in the sump, which is situated below the lowest level of the excavation.

TEMPORARY DRAINAGE
A high water table leads to an accumulation of water in holes that makes further digging impracticable. To counteract this, dig a deeper hole to act as a sump; the sump will collect the water as digging continues. If necessary, use a pump with an outlet pipe to expel the water.

LAYING FLEXIBLE LINER ON A HIGH WATER TABLE

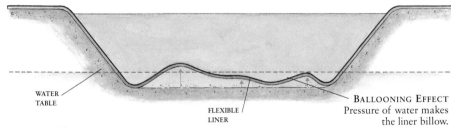

WATER TABLE

FLEXIBLE LINER

BALLOONING EFFECT
Pressure of water makes the liner billow.

BALLOONING EFFECT
If flexible liner is laid below the water table, the accumulation of dissolved air from the ground water below the liner will push up, causing the liner to balloon up from the pool floor. With time, the the pond sides will slip down, causing further distortion.

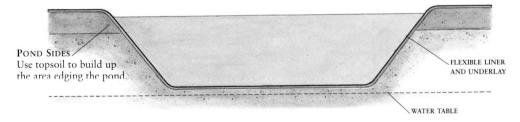

POND SIDES
Use topsoil to build up the area edging the pond.

FLEXIBLE LINER AND UNDERLAY

WATER TABLE

BUILDING A SUNKEN POND ABOVE THE WATER TABLE
To keep the floor of the pond above the water table, build up the surrounding ground until an adequate depth can be achieved for the pond. Unless you are paving around the pond, you must use topsoil, brought in if necessary, or plants around the pool edges will not thrive.

does not dip below the level of the water table *(see left, center)*. To avoid a pond that resembles a volcano, however, it is essential to combine this with more general landscaping of the surrounding area.

The alternative is to install permanent drainage for the ground surrounding the pond. Trenches and pipes can vastly improve poor drainage; very few areas are so constantly rainy that a simple system cannot cope. But on a high water table, a pump will also be necessary *(see left, bottom)* so that water can be removed faster than it seeps back in again.

Even if you plan to build the pond so that it lies above the water table, when digging deeper to lay foundations, you may find that the accumulating water makes it extremely difficult to work. Dig out a small deep hole to act as a sump *(see above)* and, as water fills it, bail or pump it out. Make sure that the water is expelled in a place where it cannot seep back into the hole.

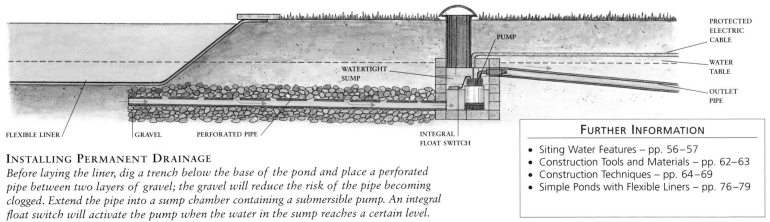

PROTECTED ELECTRIC CABLE

PUMP

WATER TABLE

OUTLET PIPE

WATERTIGHT SUMP

INTEGRAL FLOAT SWITCH

FLEXIBLE LINER

GRAVEL

PERFORATED PIPE

INSTALLING PERMANENT DRAINAGE
Before laying the liner, dig a trench below the base of the pond and place a perforated pipe between two layers of gravel; the gravel will reduce the risk of the pipe becoming clogged. Extend the pipe into a sump chamber containing a submersible pump. An integral float switch will activate the pump when the water in the sump reaches a certain level.

FURTHER INFORMATION
- Siting Water Features – pp. 56–57
- Construction Tools and Materials – pp. 62–63
- Construction Techniques – pp. 64–69
- Simple Ponds with Flexible Liners – pp. 76–79

MEASURING AREAS AND VOLUMES

FROM INITIAL PLANNING to the long-term care of a water feature it will at times be necessary to know its dimensions, including the surface area of the excavation and of the water and the volume of water the feature can contain. These statistics are necessary for estimating quantities and costs of construction materials. Flexible liners, for example, are priced per square foot or meter. They are also used when choosing appropriate pumps and filters, to decide the number of fish that a pond will house *(see p. 171)* and the quantities of submerged plants necessary for a healthy environment *(see pp. 152–153)*, and the dosage rates of chemicals, if needed.

STILL WATER FEATURES

Formal pools in symmetrical shapes such as squares and circles present the least difficulty in calculating dimensions, since they are easy to measure. Informal ponds can be more awkward. For simple informal shapes such as the kidney shape, the surface area can be easily approximated for most practical purposes by drawing a rectangle around its outline, using the width at its widest point and the length of its longest axis. The surface area of this rectangle can be multiplied by the depth to obtain the pool's volume. For more complicated shapes that cannot be "squared off" so easily, divide the pool into sections, each with a regular shape such as a rectangle or semicircle; their dimensions can be added together to give adequate approximate figures. When variations in depth occur, section the pool crosswise (as with the circular pool below). Remember that while marginal shelves make the volume of a pool smaller, they make the surface area of the hole bigger, and you will need to allow for extra liner.

The various formulas for calculating volumes will give measurements in cubic feet or meters. To convert cubic feet to gallons, multiply the figure by 6.25. To convert cubic meters into liters, multiply the figure by 1,000.

SQUARES AND RECTANGLES
It is easiest to calculate dimensions using measurements in meters or in decimal fractions of feet (e.g., 1.5ft for 18in). Multiply the length (l) of the pond by the width (w) to obtain the surface area. Multiply this figure by the depth (d) of the pool to establish its volume. For example, a pool 3ft (0.9m) wide by 4ft (1.2m) long has a surface area of 12sq ft (1.08sq m); with a depth of 18in or 1½ft (0.45m), the pool's volume is 18cu ft (0.486cu m).

CIRCULAR SHAPES
Square the radius of the pool (r x r) and multiply this by the mathematical constant pi (π) – 3.14 – to obtain the surface area. To calculate the volume, multiply this figure by the depth (d). To calculate the volume of a circular pool with a marginal shelf, divide it transversely into two sections, as above, each with its own radius and depth, and add the volumes of the two sections together. To calculate the circumference of a circle, multiply the radius (r) by 3.14, then multiply this figure by 2.

IRREGULAR SHAPES
For simple irregular shapes, use the maximum width, length, and depth to calculate surface area and volume as for a rectangle (above left). For more complex shapes (as right), divide the pond into approximate square, rectangular, or circular or semicircular sections and calculate the surface area of each. Add the figures together to calculate the total surface area. Multiply this figure by the depth of the feature to obtain the volume.

Moving Water Features

A waterfall or stream less than 2ft (60cm) in drop or length generally makes little practical difference to surface area or volume and can be omitted from calculations, but longer streams and waterfalls should be added in. However, the height of the feature, from header pool or waterfall outlet to reservoir pool is always important: known as the "head," it is a factor in determining the power needed from a pump.

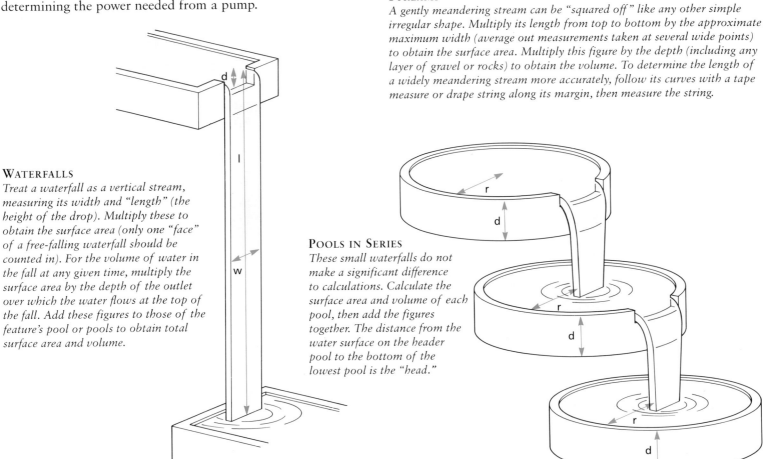

Streams

A gently meandering stream can be "squared off" like any other simple irregular shape. Multiply its length from top to bottom by the approximate maximum width (average out measurements taken at several wide points) to obtain the surface area. Multiply this figure by the depth (including any layer of gravel or rocks) to obtain the volume. To determine the length of a widely meandering stream more accurately, follow its curves with a tape measure or drape string along its margin, then measure the string.

Waterfalls

Treat a waterfall as a vertical stream, measuring its width and "length" (the height of the drop). Multiply these to obtain the surface area (only one "face" of a free-falling waterfall should be counted in). For the volume of water in the fall at any given time, multiply the surface area by the depth of the outlet over which the water flows at the top of the fall. Add these figures to those of the feature's pool or pools to obtain total surface area and volume.

Pools in Series

These small waterfalls do not make a significant difference to calculations. Calculate the surface area and volume of each pool, then add the figures together. The distance from the water surface on the header pool to the bottom of the lowest pool is the "head."

Construction Methods

A water feature with the same approximate surface area and volume, built in different styles, needs varying quantities of different materials; construction times can also vary. These five water features each have a surface area of 96sq ft (10sq m): as a rough guide, the formal pools could be 8ft x 12ft (2.5m x 3.7m) in width and length, and the informally shaped pools could be "squared off" to fit into a rectangle of these dimensions. Each has marginal shelf areas, and a volume of 144cu ft (4cu m): a water capacity of 900 gals (4,000 liters). To give some idea of the weight of water in the pools (and how strong the walls of the raised pool need to be), 1 gallon of water weighs 10lb; 1 liter weighs 1kg.

Style of pool	Digging time (with a helper)	Concrete, for foundations etc	Walling materials	Liner and underlay	Ready-to-mix mortar	Other materials	Coping stones/ edging
Raised oblong pool with double wall and flexible liner.	2 hours to dig foundations (but 20 hours' bricklaying)	110lb (50kg) cement, 1cu yd (1cu m) ballast	80 concrete blocks, 12 x 9in (30 x 22cm); 360 bricks 3 x 12in (8 x 30cm)	17ft x 13ft (5.2m x 3.9m): 221sq ft (20.5sq m)	12 x 55lb (25kg) bags	–	20 coping stones, 24in x 12in (60cm x 30cm)
Oblong concrete pool lined with reinforced cement	10 hours, plus removal of soil	1cu yd (1cu m) sand, 110lb (50kg) cement, 1cu yd (1cu m) aggregate	52 concrete blocks, 18 x 9in (45 x 23cm); 118 house bricks	–	6 x 55lb (25kg) bags	Reinforcing fibers for cement: 3 x 11lb (5kg) bags	20 coping stones, 24in x 24in (60cm x 60cm)
Informal pool with flexible liner and crazy-paving edge	10 hours, plus removal of soil	1½cu yd (1.5cu m) sand, 110lb (50kg) cement, ½cu yd (0.5cu m) aggregate	–	18ft x 14ft (5.5m x 4.3m): 252sq ft (23.4sq m)	3 x 55lb (25kg) bags	–	12sq yd (12sq m) crazy paving
Pool as above, 1ft (30cm) less wide, with small rigid-unit stream	13 hours (inc. bedding in units on soil-based mound)	1cu yd (1cu m) sand, 110lb (50kg) cement, ½cu yd (0.5cu m) aggregate	–	18ft x 14ft (5.5m x 4.3m): 252sq ft (23.4sq m)	2 x 55lb (25kg) bags	Two stream units, one header pool unit, sand for bedding in	10 sq yd (10sq m) crazy paving; 30 x 55lb (25kg) loose rocks
Wildlife pond edged with turf, planting, and pebble beach	10 hours, plus removal of soil	–	–	20ft x 16ft (6m x 4.9m): 320sq ft (29.4sq m) (for varied depths)	–	–	8 x 110lb (50kg) bags of rocks for beach area

Guide to Requirements for Different Pool Styles

CONSTRUCTION TOOLS & MATERIALS

THE TOOLS AND MATERIALS necessary for building water features vary from project to project, although some, such as a carpenter's level, are essential for any construction task. Do-it-yourself enthusiasts may be familiar with many of the techniques used in the step-by-step projects featured in this section and will have used the tools in other situations. It is important to choose the correct implement and materials for the appropriate stage of construction, and to use them with skill and care, in order to guarantee a structurally sound feature. If in doubt, seek professional help; sometimes it is worth the extra investment to obtain a good result.

CONSTRUCTION TOOLS

Using the appropriate tools for a job makes an appreciable difference in the ease with which the task can be accomplished, and in certain situations it is crucial to use the correct equipment. Consider borrowing or renting tools that you might never or rarely need again. If buying, it is well worth investing in good-quality tools if you can. They are usually longer-lasting and more comfortable to use.

BUILDER'S SQUARE

TAPE MEASURE

BAMBOO STAKES

STRAIGHTEDGE

CARPENTER'S LEVEL

MARKING OUT AND LEVELING
Tools for marking out and measuring, and for achieving true horizontals, are essential even for the smallest, simplest ponds. A builder's square, either bought or homemade, ensures accurate right angles.

SPADE

SHOVEL

DIGGING TOOLS
Most gardeners will already own a good sharp-edged spade, but these generally have too small a blade to make large-scale excavation comfortable. Once the hole is big enough to stand in, use the spade to break the soil, then use a shovel, with its wide blade and inrolled edges, to scoop the soil out of the hole.

CORDLESS DRILL

MASONRY BITS

DRILLING HOLES
A cordless drill is much more convenient and safer to work with outdoors. Always use the correct drill bits for wood or stonework.

POINTING TROWEL

BRICKLAYER'S TROWEL

PLASTERER'S TROWEL

RUBBER MALLET

MARKER PEGS

CLUB HAMMER

BOLSTER CHISEL

TOOLS FOR CONCRETE, CEMENT, AND MORTAR
A bricklayer's trowel has a better shape than a garden trowel for handling wet building mixes. Much more skill is required to use pointing and plastering trowels: to create an acceptable finish you will need plenty of practice, since you must work quickly with fast-drying mixtures.

CUTTING BRICKS AND SLABS
A hammer and chisel can be used to cut the odd brick or slab to fit a corner; however, if you have many pavers to cut into precise shapes, it is worth renting a brick-cutter.

MATERIALS FOR CONSTRUCTION

Unlike the decorative materials chosen for edging and other finishing touches, the basic materials used to build water features are often hidden from view. Most items will be available at any building supply store. A water garden specialist will stock a range of pool liners and is also the best source for delivery hoses and other piping: because they specialize in water-feature construction, they will be able to tell you exactly what you need to achieve the desired effect.

STANDARD DELIVERY HOSE

WIDE DELIVERY HOSE

LIGHTWEIGHT PLASTIC PIPE

WIDE-GAUGE COPPER PIPE

NARROW-GAUGE COPPER PIPE

WIDE-GAUGE PLASTIC PUSH-FIT PIPE

NARROW-GAUGE PLASTIC PUSH-FIT PIPE

COPPER ELBOW JOINT

COMPRESSION JOINT

SOLDERED T-FITTING

SOLDERED ELBOW JOINT

PLASTIC ELBOW JOINT

PIPEWORK AND JOINTS

Pipes conduct water and protect electric cables. If pipes have to be visible (for example, on a wall feature), copper piping is more attractive and will take on a weathered appearance. All flexible piping, even if reinforced, must have rigid elbow joints at sharp changes of direction, or the pipe will kink and restrict water flow.

HOUSE BRICK

BUILDING BLOCKS

Common house or clay bricks can be used to build everything from decorative walls to submerged plant bases. Concrete blocks can be used to build concealed walls more quickly and economically.

CONCRETE BLOCK

COARSE SAND

CEMENT

MORTAR

MORTAR

Mortar is a mix that consists of cement, coarse sand, and water. It is available as a ready-made mix, but this is economical only where small quantities are used.

LINING MATERIALS

Flexible liners are generally made of polyethylene, PVC, butyl, or EPDM *(see p. 67)*. It is advisable to use some form of underlay to protect the liner, especially on stony sites. Polyester matting underlay will be available wherever liner is sold and is not expensive. Used carpeting can also be employed. Clay-based bentomat *(see pp. 92–93)* is an attractive alternative to plastic liner with an unobtrusive, textured matt finish.

BENTONITE

BENTOMAT

UNDERLAY

FLEXIBLE LINER

STRENGTHENING ADDITIVES

GRADES OF BALLAST

Adding small stones and sand to cement creates concrete. The larger the size of stone, the stronger the concrete: for very solid foundations concrete is poured over compacted crushed stone.

REINFORCING FIBER

This commercial fiber, similar to fiberglass, makes a cement mix stronger and more flexible; a layer of this mix on a concrete shell (see pp. 90–91) forms a lining that is less susceptible to cracking caused by water pressure and small earth movements.

FURTHER INFORMATION

- Construction Techniques – pp. 64–69
- Pumps and Filters – pp. 70–73
- Edging Materials – pp. 126–129

CONSTRUCTION TECHNIQUES

SOME CONSTRUCTION METHODS are better suited to certain styles of water feature than others and also to the type of job you are prepared to tackle. Rigid units such as preformed fiberglass pools (see below) are an excellent choice for a small to medium size self-contained pool and are relatively quick and simple to install. For a freer hand with the size and shape of pool, plus the option of incorporating customized features such as islands and planting pockets, flexible liner (see pp. 66–67) is the obvious choice. With some basic building skills (see pp. 68–69), formal and raised pools edged with brick, paving, and wood can be considered.

USING PREFORMED POOL UNITS

Installing a rigid container to hold water, whether a fiberglass pool unit or an improvised version such as a plastic tub, involves simply digging a hole of the correct size and shape to house it so that it is absolutely level, both for visual effect and to make sure that planting baskets sit securely on shelves or bases. Small, evenly shaped units with only one depth level may be installed completely above ground level, but it is very difficult to give a larger unit with irregular contouring the support it needs unless the unit, or at least its deeper zone, is sunken into the ground.

DIGGING TIPS

- Place two polyethylene sheets beyond the hole's proposed edges: one for topsoil, the other for subsoil.
- Dig with a straight back and bended knees (see left) to minimize strain on your back.
- Once the hole is big enough, work from inside it to avoid extra bending.
- You may find it easier to dig the hole down to the correct depth and enlarge it: chop at the sides with a sharp-edged spade, then shovel out the soil.
- Only shovel small quantities of soil at a time.
- If you are not accustomed to a lot of digging, wear gloves to prevent blisters; shoes with sturdy soles are also essential. Stop and rest as soon as you begin to feel tired or if you feel pain of any kind.

STAGES OF CONSTRUCTION

Rigid units must be firmly supported and cushioned against sharp objects. Make sure that the base of the hole is firm, level, and free of sharp stones. Make the hole slightly wider than the unit so that you can backfill with ease. Filling the pool partway with water as you backfill will let you make adjustments so that the unit remains level as the weight of water settles it into position.

MARKING OUT
Before digging, you may use bamboo stakes to mark the perimeter of a unit that slopes inward toward the base. Be very careful to avoid eye injury when digging close to stakes.

FIRM SUPPORT
Bed units into a firm layer of sand or sifted soil, free from sharp stones. Do not use coarse sand where plants are to grow.

MARGINAL SHELF
Some trial and error is usually necesssary to contour the hole for marginal shelves.

MARKING OUT

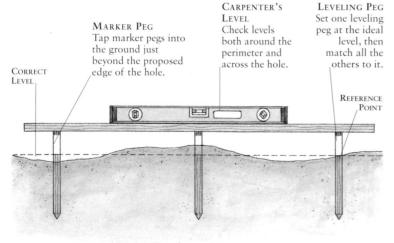

MARKER PEG
Tap marker pegs into the ground just beyond the proposed edge of the hole.

CARPENTER'S LEVEL
Check levels both around the perimeter and across the hole.

LEVELING PEG
Set one leveling peg at the ideal level, then match all the others to it.

CORRECT LEVEL

REFERENCE POINT

USING MARKER PEGS

Marker pegs are used to obtain level, horizontal pool edges on uneven ground. Once the first reference point is established, use a carpenter's level to make sure that the marker level on all subsequent pegs corresponds to that on the first peg, which should act as a reference point.

LEVELING

USING A CARPENTER'S LEVEL
To achieve correct levels across a hole, or across distances wider than the length of a carpenter's level, use a straightedge: a long, straight strip of wood on which the level can be balanced. Check levels frequently at every stage of construction.

TYPES OF PREFORMED POND UNIT

In many ways preformed units make ideal ponds: they are easy both to install and clean. They are generally made of fiberglass or various plastics in a range of shapes and sizes, the maximum size being approximately 12ft (3.5m) across, and are available from most nurseries or garden centers. Fiberglass units are light, strong, and durable; they are recommended for semi-raised ponds. Plastic units tend to be cheaper, and may only last two or three years. Shallow, square, and circular units make ideal small formal features; their bases can be disguised with gravel or pebbles. To accommodate plants and fish, a deeper unit, ideally with marginal shelves, is essential.

SIMPLE SHAPES
The simpler the shape, the easier to install.

MARGINAL SHELF
Shelf space is wide enough for planting baskets.

DEPTH
Unit has a deep zone, essential for fish and for planted ponds.

GRAY COLOR
Neutral colors are the least obtrusive.

STABILIZING THE POOL
Before backfilling, fill the pool with 4in (10cm) of water to increase its stability. Continue to slowly fill the pond with water as you backfill.

WIDE RIM
The rim prevents soil from falling into the pond. It can be disguised with plants (see right) or with mortared-down slabs.

SUPPORTING THE LIP
After backfilling, remember to press sand or soil firmly up under the lip of the unit to support it.

DISGUISING PREFORMED UNITS

SUNKEN POND
One disadvantage of preformed units is that their wide rims form an unnatural edge. Unless you are surrounding the pond with paving, planting is the best way to disguise and soften the rim. Use clump-forming plants, including some moisture-lovers to give a more natural effect.

BACKFILLING AND TAMPING

BACKFILLING
Shovel sand or soil into the gap between the unit and the excavation wall.

TAMPING
Consolidate each layer of backfill so that the unit remains secure.

1 MAKE THE EXCAVATION slightly wider and deeper than the unit so that you can backfill and tamp easily. Always shovel out or rake back soil well clear of the hole so that it cannot slip back in. Shovel a small quantity of sand or sifted soil into the gap all around the unit.

2 A SHORT LENGTH OF WOOD is an ideal tamping tool. Press the sand or soil down firmly all around the unit. Repeat the process, backfilling gradually around the sides. Do not tamp so hard that the unit is distorted; filling partway with water, and checking levels frequently, will help avoid this.

SEMI-RAISED POND
Semi-raised units must have a firm supporting wall of timbers or mortared stones to remain secure. Backfill with rich, moisture-retentive soil and keep well-watered.

USING FLEXIBLE POND LINER

FLEXIBLE LINER IS THE MOST versatile material available to the water gardener. It can be used as waterproof lining for a porous shell – for example, a brick-built reservoir pool or an old half-barrel. An old, cracked concrete pond or rigid pool unit can be instantly "repaired" with a new lining. However, flexible liner comes into its own in the construction of informal ponds, allowing considerable freedom with the design of pools and streams, and the inclusion of a variety of additional features. Liner materials vary in price and quality. Inexpensive polyethylene can be adequate: high-density polyethylene is the least expensive but is of the poorest quality and should be used only in double thickness. It will crack under prolonged exposure to the ultra-

violet rays in sunlight, and any exposed areas must be concealed. Low-density polyethylene is of a slightly higher quality; it is stronger and fairly flexible. For a substantial, durable feature it is well worth investing in good-quality PVC or, better yet, EPDM or butyl liners *(see facing page)*. The latter are far less prone to tearing, puncturing, and ultraviolet deterioration; top-grade PVC, EPDM, and butyl usually carry at least a 10-year guarantee.

Measure the size of your pond carefully using a flexible tape measure to determine the correct size of liner to purchase *(see below left for details)*. Do not join liners unless the joint is above standing water level. Otherwise, leaks are inevitable, and you will have to drain and reline the pond to eliminate them.

LINING AN EXCAVATION

You should ideally unroll liner prior to laying it (see p. 76), but do not then drag it over the hole or you will disturb the underlay. Instead, roll the liner up from both sides toward the middle, lift the roll into position across the center of the hole and unroll carefully, without stretching it.

EXCAVATING THE POND

MARKING OUT AND DIGGING

Rope, hoses, pegs, or sand are perfectly adequate for marking out an informal shape. Excavate the hole, angling the sides slightly inward. Marginal shelves should be at least 12in (30cm) wide to accommodate planting baskets; wider is better. If you are not incorporating a beach, you may wish to leave a sloping ramp on one side as an easy access or exit point for wildlife.

MARGINAL SHELF
Flatten the top and sides of shelves with a spade to compact the soil well.

SLIGHT SLOPE
Pond and shelf sides slope at a 20° angle to prevent earth caving in.

UNDERLAY
Prolong the lifespan of flexible liner by using underlay to cushion and protect it.

TEMPORARY HOLD
Lift the bricks to allow movement of the liner as the pond fills.

FLAT, FIRM BASE
Roots and stones have been removed from the base. If soil is very stony, add a layer of sand. Gently tread the base down, then rake.

LAYING UNDERLAY

CALCULATING THE AMOUNT OF LINER

First determine the maximum length, width, and depth of the pond. The liner should measure the maximum width of the pond plus twice its depth, by the maximum length plus twice its depth. Add another 18in (45cm) to both width and length to allow for a flap overlapping the edge, in order to prevent leakage. If the pond sides are completely vertical, or for additional features such as an island *(see pp. 80–81)* or integral boggy area *(see pp. 82–83)*, extra liner will be necessary.

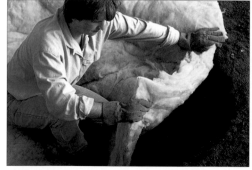

1 SPREAD THE UNDERLAY (here, fiberglass insulation material) over the base and sides of the excavation. Press the material firmly over and into the contours of the hole.

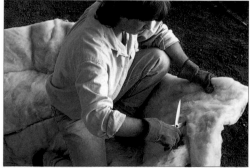

2 KEEPING THE UNDERLAY in position, trim it neatly at or slightly overlapping ground level. Try not to put your full weight on any marginal shelves. Then unroll the liner over it.

FILLING A LINED POND

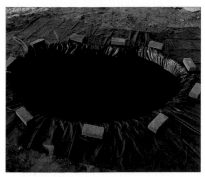

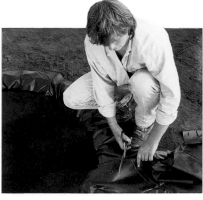

1 USING BRICKS AS temporary weights, fill the pond slowly, gradually moving the bricks to allow the liner to settle down into the hole.

2 ONLY WHEN THE pond is full and the liner has ceased to move, trim off the surplus with scissors or a craft knife.

SMOOTH FINISH
Gentle curving shapes are easy to line; pleat material at sharp angles.

FILLING THE POND
Gently fill the pond, so that the water slowly presses and molds the liner down into the contours of the hole.

EXTRA LINER
A generous margin will allow the liner to be taken up under soil or edging.

PEBBLE BEACH
A gentle slope with a slight rim makes an ideal beach area.

MORTARING STONE ON LINER

1 FOR A SIMPLE EDGING, mortar rounded or flat stones directly onto the liner. More formal paved edging requires foundations (*see p. 68*).

2 FLAT SLABS should overhang the pond by 2in (5cm) to disguise the liner. Do not drop mortar into the pond or it will have to be emptied.

(see p. 68)

GRADES OF LINER AND UNDERLAY

The more expensive pond liners come in different weights and thicknesses, and the larger the area you wish to cover, the thicker the material should be. Black is the most unobtrusive color, although others are sometimes available. If buying good-quality liner, always protect your investment by using underlay beneath it. There are some excellent products available that will prolong the liner's lifespan.

UNDERLAY MATERIAL
Polyester matting underlay comes in rolls up to 6ft (2m) wide. Underlay can also be improvised, using insulation felt or even old synthetic carpet. Newspaper is sometimes recommended, but it tends to disintegrate fast.

CARPET POLYESTER MATTING

PVC POND LINERS *(BELOW)*
Liners made from PVC (polyvinyl chloride) are popular and are more flexible than polyethylene. PVC comes in a number of grades; the thickest grade available (32mils) usually lasts longer and should be sold with a guarantee. Do not use PVC swimming-pool liners. They contain herbicides and biocides that can kill aquatic life.

32 MILS
30 MILS
20 MILS
15 MILS

BUTYL AND EPDM LINERS
The two best lining materials are butyl and EPDM. Both have more elasticity than PVC, which allows them to be installed with fewer creases and folds than other types of liner. They also have greater UV resistance and remain flexible even in cold weather. Both are generally sold with a 20-year warranty. The standard grade of EPDM is 45mils; butyl is generally sold in 60- or 30mils thicknesses.

60 MILS
45 MILS
30 MILS
20 MILS

USING BUILDING MATERIALS

BETWEEN THE TWO EXTREMES of a simple hole lined with polyethylene and a raised pond with brick walls lie a host of water garden projects requiring some knowledge of basic building techniques. Structures that will be concealed, such as foundations, concrete-block shell walls as well as planting beds and shelves must be well built to be durable, but they need not be perfectly finished. Flat paving and edging are not difficult to lay, provided that you work quickly and clean off excess mortar before it dries (dry mortar is almost impossible to remove). However, bricklaying and pouring concrete are skilled tasks that must be done properly or the finished product will be both visually and structurally poor, with no remedy but to have the job redone.

MARKING OUT STRAIGHT-SIDED SHAPES

USING A BUILDER'S SQUARE
Formal shapes must be carefully staked out before construction begins. Check regularly for accuracy during construction. Corners must be perfect right angles or the walls and edging will not meet where they should: this can cause problems during construction whether you are using blocks, bricks, or pavers.

LAYING A FOUNDATION

1 **FOR A SOLID FOUNDATION,** spread a 4in (10cm) layer of crushed stone over the bottom of the hole before pouring in concrete.

2 **CRUSHED STONE** can be compacted with a mallet and block of wood, but if the base area is large, it is worth hiring a compactor. Its vibrating plate consolidates and flattens the stones, shaking smaller pieces into the spaces between larger stones.

SAFETY PRECAUTIONS

• Even small bags of cement, mortar mix, and sand are heavy; take great care when lifting them. Always bend from the knees, rather than bending your back. Also, be careful to protect your back while digging *(see p. 64)*.
• Cement dust is an irritant: wear gloves when mixing mortar and concrete, avoid inhaling dust (wear a filter or cyclist's mask if possible), and never rub your eyes while working.
• String brightly colored or fluorescent tape at waist height between stakes around the hole when you leave it unattended.
• Never let children play alone near holes, tools, or materials.
• Unplug any power tools that you have been using, and never leave them unattended.

CONSTRUCTING A STRAIGHT-SIDED POOL
Pools with straight edges and vertical sides are most effectively constructed using traditional building techniques and materials either beneath, or instead of, flexible pond liners. Firm foundations and solid walls are essential to prevent the soil from settling around the edges of the pool. Retaining walls of concrete blocks can be made watertight either with flexible liner (see pp. 78–79) or, as here, with a layer of cement made strong and flexible with special reinforcing fibers. With bricklaying skills, a low wall could be added around this pool to give a semi-raised effect.

CONCRETE INFILL
Use concrete to fill any space between the blocks and the sides of an excavation, but the mortar between the blocks must first be *completely* set.

CONCRETE BLOCKS
These holes in blocks make them lighter to handle. Once in position they can be filled with concrete for extra strength.

VERTICAL-SIDED HOLES
Use a plumb-line to make walls as vertical and even as possible; compensate for small irregularities by using concrete infill.

CRUSHED STONE AND CONCRETE FOUNDATION
A compacted, 4in (10cm) deep layer of crushed stone with concrete poured on top, makes firm footings for walls and structures such as stepping stones and bridge ends. For maximum stability, cover the entire base of a pool.

LAYING CONCRETE

1 **POUR LARGE QUANTITIES OF** concrete from a wheelbarrow. For even coverage, try to pour the mix in gently overlapping folds.

2 **LEVEL AND FIRM** the concrete, both cross- and lengthwise, with a beam; use a carpenter's level to be sure the mix is level before it dries.

SIMPLE BRICKLAYING

STRING GUIDE

TAPPING
WITH
TROWEL
HANDLE

1 LAY BRICKS, frog downward, in staggered rows (a "bond" pattern). Apply a layer of mortar where the next brick will be placed.

2 "BUTTER" THE END of the next brick by drawing a trowel loaded with mortar across it. Do not overload the trowel.

3 SET THE BRICK down firmly and squarely. Working with the guide and, after every few bricks, a level, tap the brick until it is level. Brush off surplus mortar with a wire brush.

MORTARS AND CONCRETE

Unless specific recipes are given, use a mix of 1 part cement to 3 parts coarse sand for bricklaying, or 5 parts sand for laying paving; for a general purpose concrete mix, use 1 part cement to 2½ parts coarse sand and 3½ parts aggregate.

- Before use, store ingredients in a dry place.
- Avoid cold weather when laying concrete; the cold will cause it to disintegrate before fully hardened.
- Always mix dry ingredients well before adding water.
- Add the water to a well in the center and fold the dry ingredients inward.
- Add water very gradually to avoid an over-wet mix.
- Work as quickly as possible once mixes are made up.
- Colorants can be added to mortar for visual effects.

COPING STONES
Bricks and pavers jutting over the pond edges must be securely mortared down for safety. Check edging regularly with a level.

ADDING WATER
Never fill a cement-lined pool unless its surface has been sealed to lock in harmful chemicals. Or, fill the pool and add potasssium permanganate crystals, leave for a week to "cure" the cement, then empty and refill.

SURFACE LAYER
A rendering of cement can be used on exterior walls as cladding, or to waterproof the interior of a pool.

WORKING WITH WET CONCRETE

A variety of items may need to be embedded into wet mortars and concretes before they set. Wall ties embedded at regular intervals will reinforce a double wall (*see pp. 86–87*). Steel brackets can be fixed onto bolts sunk into wet concrete to secure wood to a concrete base (*see pp. 122–123*). Reinforcing wire can be sandwiched between layers of wet concrete (*see p. 91*). Conduits for water overflows or for wiring can also be hidden between bricks or under coping (*see pp. 86–87*).

WALL TIE

BRACKET

WIRE MESH

OVERFLOW PIPE

CUTTING STONE SLABS

1 PLACE THE SLAB on a flat surface. Score a cutting groove on both sides and edges of the slab with the corner of a bolster chisel.

2 USING THE CHISEL with a mallet, carefully work along to deepen the scored line on both sides and at the edges of the slab.

3 BALANCE THE SLAB on a length of wood. Align the groove with the edge of the wood and tap with a hammer handle until the slab splits.

CUTTING BRICKS

Score the cutting line with the edge of a bolster chisel, then chisel an ⅛in (3mm) deep groove along this line. Raise onto a piece of timber, and tap with the handle of a hammer.

PUMPS AND FILTERS

PUMPS ARE USED IN conjunction with water features in order to recirculate water. An electric motor draws the water in through an inlet to which a strainer is fitted to prevent the system from being blocked by debris. Pressure pushes the water out through a pipe, which is attached to a waterfall, fountain, or filter. There are two types of pump – submersible and surface; submersible pumps run under water, and high-voltage surface pumps are housed above ground. Pumps come in a wide range of models to suit every type of water feature. They fall into two main categories – pumps to run a fountain or waterfall and solids-handling pumps to work a filter.

TYPES OF PUMP

A pump is required to move water either within a feature (through a fountain or filter) or to travel around a watercourse. To operate the pump, electricity will need to be brought to the vicinity of the pond water *(see p. 72)*. Before choosing a pump, decide what you want it to do *(see* Points to Consider, *p. 72)* and consult a specialist with your requirements.

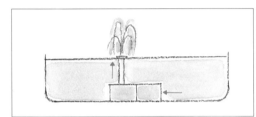

FOUNTAIN PUMP
A small fountain requires a submersible pump that has low output but high pressure. The pump may sit directly under, or away from, the fountain (see pp. 108–111).

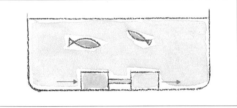

PUMP FOR FILTRATION SYSTEM
A pump is not always installed to produce visible water movement; it may also be used to push or pull water through a filter. Heavily stocked fish ponds require this arrangement.

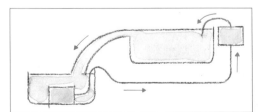

PUMP FOR WATERCOURSES
To move water any distance from a reservoir pool uphill to a header pool with waterfall requires a powerful pump with high output – in some cases, a surface pump.

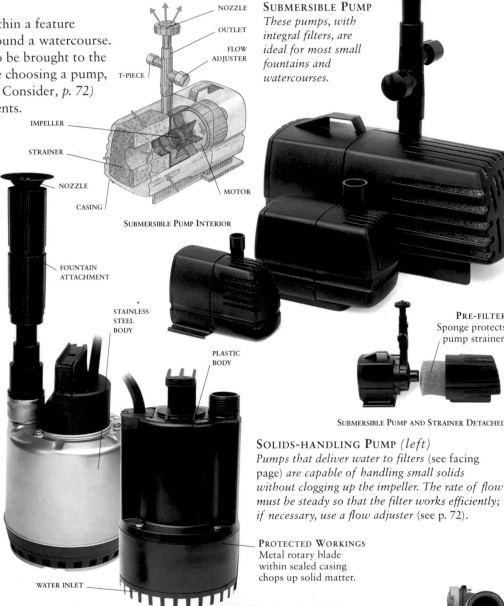

NOZZLE
OUTLET
FLOW ADJUSTER
T-PIECE
IMPELLER
STRAINER
NOZZLE
CASING
MOTOR

SUBMERSIBLE PUMP INTERIOR

SUBMERSIBLE PUMP
These pumps, with integral filters, are ideal for most small fountains and watercourses.

FOUNTAIN ATTACHMENT

STAINLESS STEEL BODY

PLASTIC BODY

PRE-FILTER
Sponge protects pump strainer.

SUBMERSIBLE PUMP AND STRAINER DETACHED

SOLIDS-HANDLING PUMP *(left)*
Pumps that deliver water to filters (see facing page) are capable of handling small solids without clogging up the impeller. The rate of flow must be steady so that the filter works efficiently; if necessary, use a flow adjuster (see p. 72).

PROTECTED WORKINGS
Metal rotary blade within sealed casing chops up solid matter.

WATER INLET

SURFACE PUMP *(right)*
The advantage of a powerful surface pump is that it has high output and is useful for operating large watercourses or a group of fountains. Surface pumps require a dedicated electrical circuit and need to be housed in a chamber that is dry and well ventilated (see p. 73).

FILTRATION IN THE POND

Pond water may be filtered either before it enters, or after it is expelled from, the pump *(right)*. There are two types of filtration materials – mechanical and biological. Mechanical filters simply strain out solid particles; they are effective as soon as the system is switched on and can be run intermittently. Biological filters use materials with very large, complex surface areas on which bacteria collect and flourish; these break down and purify waste products and ammonia gas.

PRE-PUMP FILTER

POST-PUMP FILTER

EXTRA FILTRATION
A larger block of foam may be pushed over the pump inlet of self-contained submersible pumps.

ALL-PURPOSE POND FILTER
A filter chamber is normally housed outside the pond. A pump pushes the water through the filter's inlet pipe; it then passes through several layers of filter media. Once purified, the water returns to the pond via the outlet pipe.

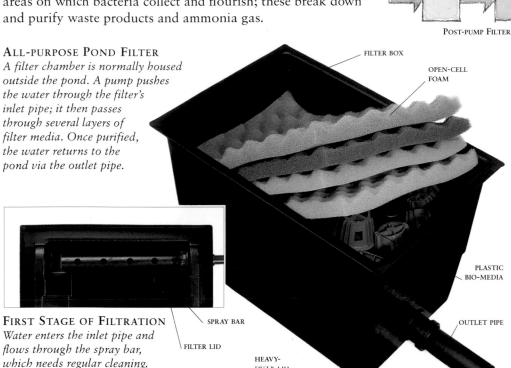

FILTER BOX

OPEN-CELL FOAM

PLASTIC BIO-MEDIA

SPRAY BAR

OUTLET PIPE

FILTER LID

FIRST STAGE OF FILTRATION
Water enters the inlet pipe and flows through the spray bar, which needs regular cleaning.

INTERIOR OF A FILTER
Mechanical and biological filtration is combined in this type of pond filter. Fine layers of open-cell foam and plastic bio-media purify the water, which then passes through the outlet pipe. An overflow system is provided, so that the filter is by-passed when it becomes blocked. The foam sheets should then be removed for cleaning.

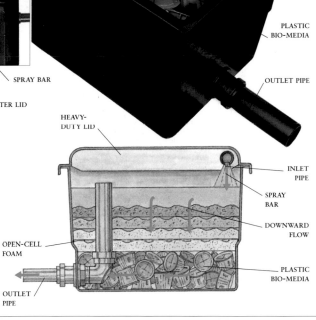

HEAVY-DUTY LID

INLET PIPE

SPRAY BAR

DOWNWARD FLOW

OPEN-CELL FOAM

PLASTIC BIO-MEDIA

OUTLET PIPE

OTHER FILTER MEDIA

BRUSHES AND PADS
Certain filters make use of brushes and pads arranged in the filter box, which catch any solids contained in the water before biological filtration.

ZEOLITES

RING MEDIA

LIGNASITE

BIOLOGICAL FILTERS
These materials are made of clays, glass, carbon granules, and other mineral compounds on which bacteria thrive.

SPECIALTY FILTER SYSTEMS

For crystal-clear water (for example, for a pond in which koi carp are to be displayed to best advantage), attach a UV clarifier and magnet to the existing system between the pump and filter. Ultraviolet radiation makes algae clump together, so that they may easily be strained out by the filter. The magnet is designed to prevent the buildup of minerals on which algae thrive.

UV CLARIFIER

ALL-PURPOSE POND FILTER

PUMP

MAGNET

HOSE TAIL

TEFLON SLEEVE

CABLE

BYPASS VALVE

LAMP

SURFACE UV CLARIFIER
A surface UV clarifier and magnet work in conjunction with a filter and pump to combat algal growth.

SUBMERSIBLE UV CLARIFIER
The newest extra low-voltage UV clarifiers can be placed directly in a pond. They are small, economical, durable, and have a high UV output.

ELECTRICITY AND WATER

All pumps are powered by electricity, either directly from a conventional circuit or passed through a transformer to produce an extra low-voltage current. Extra low-voltage pumps have a limited output and are only suitable for small waterfalls or a single fountain. A regular voltage system, used for large watercourses, must not be run without a circuit breaker and a ground fault interrupter (GFI), which makes electricity much safer to use in the garden. When buying a submersible pump, it should have enough cable attached to extend onto dry land, to avoid having to connect cables underwater *(see facing page)*.

WEATHERPROOF CONNECTOR

EXTRA LOW-VOLTAGE ELECTRICITY
An extra low-voltage system is used in conjunction with a transformer, and presents no danger from shock. The transformer should be located indoors, close to the wall socket.

FULL-VOLTAGE ELECTRICITY
If a pump is connected directly to a full-voltage circuit, the cable should be buried in rigid plastic pipe at least 2ft (60cm) underground.

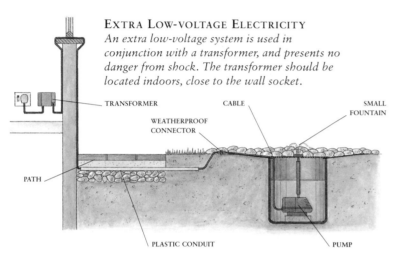

TRANSFORMER — CABLE — SMALL FOUNTAIN
WEATHERPROOF CONNECTOR
PATH
PLASTIC CONDUIT — PUMP

SWITCH
WEATHERPROOF CONNECTOR
LARGE FOUNTAIN
GFI
PLASTIC CONDUIT
APPROVED UNDERGROUND CABLING
PUMP

PUMP FITTINGS AND CONNECTORS

Most submersible pumps can be obtained with a flow adjuster and a T-piece connector, which can easily be fitted between the pump's outlet and the delivery pipe. The T-piece makes it possible to send water in two directions, so that one pump can operate both a waterfall and a fountain. Two flow adjusters may be necessary to control each branch, as more water will go along the one that has the least resistance.

STANDARD FITTINGS
The T-piece and flow adjuster are secured to the delivery pipe with a hoseclip.

FLOW ADJUSTER
T-PIECE
HOSE CLIP

POINTS TO CONSIDER

When selecting a pump, it is advisable to seek help from a specialist. You will need to be able to answer the following questions, where relevant:
• Is the pump required to operate a watercourse, fountain, or filter, or a combination of the three?
• What is the volume of the reservoir pool *(see pp. 60–61)*? The flow rate per hour should not exceed the reservoir pool's volume.
• For features where water runs downhill, what is the height of the header pool above the reservoir pool (known as the "head")?
• What is the width of any streams and spillways?
• What type of fountain spray is required?
• How high do you want the spray to be?

1½ IN (3.5CM) 1IN (2.5CM) ¾IN (2CM) ½IN (1CM)

DELIVERY PIPES
Delivery pipes come in a range of sizes. It is important to be sure that diameter and length are suitable for the pump. Delivery pipes are made of flexible plastic and run directly from the pump to the delivery point: a filter, fountain, or header pool. Always check the dimensions of pump outlets before buying a delivery pipe, and always overestimate the length of pipe you will need.

ROUGH GUIDE TO FLOW RATE
If you can achieve the desired flow of water over a fall or down a stream using a hose, then time how long it takes the hose to fill a container of known capacity, keeping the same flow rate. Use this to estimate the flow rate required of the pump. For example, if the hose fills a 100-gallon/liter container in 10 minutes, then a pumping rate of 10 gallons/liters per minute will be required.

POSITIONING PUMPS AND FILTERS

All submersible pumps should be placed on a base to raise it just above the bottom in order to reduce the amount of sludge being drawn into the strainer. Surface pumps need some kind of housing in order to protect them from the elements and disguise their appearance. Submersible pumps operate silently and do not require priming. Modern surface pumps are also self-priming, but are noisy when operating. A well-built pump chamber will help cut down the noise, or if necessary the pump may be sited some distance from the water feature.

SUBMERSIBLE PUMPS

The positioning of submersible pumps depends on whether a surface filter is being used. Without a surface filter, the general rule is to let the water take the shortest route between pump

FILTER IN SITU
Filters should be at the highest point of circulating features.

and outlet. The farther the water has to travel through a pipe, the more it will be slowed down by friction. To maximize use of a pump's power, delivery pipes should be as short as possible: site pumps directly below fountains or under waterfalls. However, if a surface filter is being used, the rules are reversed: the pump should be as far from where the filtered water enters the pond as possible, or pockets of water that are never drawn around the system, and hence never filtered, will develop.

POSITIONING FILTERS

Surface filters need to be placed at the highest point in the circulation system. They can be disguised with rocks or plantings, or they may be hidden under raised decking or behind walls, the filtered water returning via a culvert *(see p. 103)*. Where it is difficult to site a large filter on dry land, a submerged filter may be used that relies upon the pump's suction to draw water through the filtering media: the drawback is that water circulation may be uneven, which will cause beneficial bacteria to die.

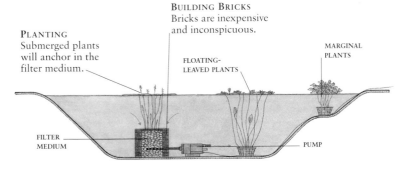

PLANTING
Submerged plants will anchor in the filter medium.

BUILDING BRICKS
Bricks are inexpensive and inconspicuous.

FLOATING-LEAVED PLANTS

MARGINAL PLANTS

FILTER MEDIUM

PUMP

A SUBMERGED BIOLOGICAL FILTER

A submerged filter allows the pump to suck water through the filter media, rather than pushing it through, as in a surface filter. This example is simple and economical to build, using unobtrusive clay bricks and a natural filtering medium (see p. 71), rather than plastic. It may be disguised with shallow-rooting submerged plants that take nutrients up through their stems, not through their roots; these will happily anchor themselves in the upper layer of the filter material.

PREVENTING BACKFLOW

WATERFALL ARRANGEMENT

The pipe should discharge above water level so that the water in the header pool cannot flow back down it.

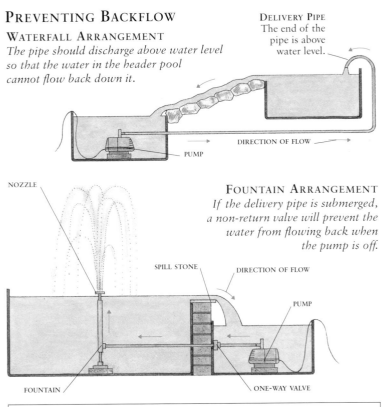

DELIVERY PIPE
The end of the pipe is above water level.

DIRECTION OF FLOW

PUMP

NOZZLE

FOUNTAIN ARRANGEMENT

If the delivery pipe is submerged, a non-return valve will prevent the water from flowing back when the pump is off.

SPILL STONE

DIRECTION OF FLOW

PUMP

FOUNTAIN

ONE-WAY VALVE

SURFACE PUMP CHAMBER

This small, watertight pump chamber has been installed directly beside a pond. The inlet pipe is not visible, having been mortared to the poolside wall and then painted with a commercial sealant. The construction of the pump chamber must allow room for a ventilation brick, and for a large piece of rigid pipe to accommodate both the incoming electricity cable and the inlet pipe. As a precaution against flooding, there should be a drainage hole at the base of the chamber.

1 MARK OUT THE outline of the chamber and lay trench foundations. Build brick walls four courses high, incorporating a ventilation brick and a conduit for the inlet pipe and cable.

2 THREAD THE MAIN electric cord and inlet pipe through the conduit. Then connect these to the surface pump, situated on a small paving slab inside the pump chamber.

3 FIT A LIGHT, wooden lid over the chamber, which can be easily removed for pump adjustment. Paint the lid with exterior-grade paint in a color in keeping with the garden.

FEATURES WITH STILL WATER

STILL-WATER PONDS are ideal for any site and provide a superb setting for a wide range of water plants – in particular water lilies, which dislike water movement. The pond may be formal or informal, raised or sunken, small or large, and can be built using a range of methods and materials. Additional interest can be created with a boggy area for moisture-loving plants or with an island.

FORMAL POOLS

The main characteristics of formal pools are clearly defined edges and geometrical shapes; squares, rectangles, and circles are the most popular. The formal style gives an opportunity to use and display decorative edging material; a formal pond is also often associated with a paved area. Careful attention to measurements, angles, and levels is essential when constructing a formal shape. Water, of course, always finds its own horizontal level, and few things are more revealing of uneven or sloping edges and paving than still water.

REFLECTIVE SURFACE
Use the reflective surface of still water to mirror surrounding plants and the sky, bringing light into enclosed areas. Do not allow floating-leaved plants to spread too abundantly or the effect will be lost.

PLANTING SOLUTIONS
This small informal feature, part pond, part bog garden, transforms what was a difficult planting area of dry semi-shade. The vigorous, paddlelike leaves of Lysichiton and the brightly variegated irises are a welcome respite from the somber background of rhododendrons, whose flower colors are accented by candelabra primroses.

ALONG THE WATERSIDE
A long, narrow pond can create the illusion of a stream flowing across a garden. Use flexible liner to incorporate broad bands of damp ground on each side (see p. 78), so that plenty of moisture-loving plants can be used, such as Gunnera manicata.

FORMAL, SEMI-RAISED POOL
The still surface of this formal, partially raised pool provides an ideal contrast to the rich detail of the surrounding banks.

SLOPING BANK
Do not simply pile up soil from the excavation to create a bank sloping down to a pond. Instead, landscape the whole site, using nutritious topsoil that will help plants grow vigorously, allowing their roots to consolidate the sloping ground.

Concrete is in many circumstances the obvious choice for constructing formal pools, which require straight, solid sides. In the past, concrete mix was used to form a thick shell – a time-consuming task involving building expertise. Today, with the evolution of building materials, it is far easier to construct a simple shell of concrete blocks and line this either with tough flexible material (for the range of liners, *see p. 67*) or with a thin skimming, or layer, of cement to which special reinforcing fiber has been added (*see pp. 90–91*).

INFORMAL PONDS

Informal ponds generally have curving edges. Although clay-lined ponds (*see pp. 92–93*) are the least artificial of all, the majority of gardeners will need to use a waterproof liner, whose edges should be carefully disguised. A kidney-shaped preformed unit (*see pp. 88–89*) can be made to look quite natural if plants are used to cover and soften its hard edge. However, flexible liner (*see pp. 76–79*) gives a great deal more freedom in constructing irregular shapes. It is best to keep the general outline simple: it is far easier to create inlets and promontories using rocks on top of the liner than to excavate and line a complicated shape. Islands (*see pp. 80–81*) may also be added on top of the liner, but incorporating these at the construction stage gives the option of creating either a "wet" or "dry" planting environment. An informal pond that has well-planted, shallow margins is particularly appealing to wildlife (*see pp. 54–55*); formal ponds, with straight edges above the waterline and vertical sides, are less accessible.

AN APPROPRIATE SIZE

Still-water features can be built in any shape or size. In the examples illustrated on the following pages, each feature is given a specific size so that a practical guide to construction can be included. However, using simple calculations (*see pp. 60–61*), the pond size and quantities of materials needed can be adapted to your requirements. Within the limits of site and the available budget, it is advisable to have as large a pond as possible: the smaller the volume of water, the more difficult it becomes to maintain a healthy ecosystem (*see pp. 136–137*). Sufficient depth is particularly important; a large area of shallow water exposed to sunlight will suffer problems due to algal buildup, which are extremely difficult to control (*see pp. 140–141*).

STOCKING AND MAINTENANCE

Knowing the volume and surface area of your pond will enable you to determine the quantity of plants (*see pp. 152–153*) and fish (*see p. 171*) that it can support. This is a useful guide for initial stocking; however, a pond is a dynamic world full of life that must be kept in harmony. Regular attention to maintenance (*see pp. 140–141*) will keep major tasks to a minimum.

SIMPLE PONDS WITH FLEXIBLE LINERS

FLEXIBLE LINERS ARE the most versatile material to use in the construction of pond. When choosing a liner, however, bear in mind that they vary considerably in their quality and durability *(see p. 67)*. Inexpensive polyethylene liners have a life expectancy of only three to five years if exposed to sunlight, while the more expensive PVC, EPDM, and butyl liners will last up to 50 years. When installing liner,

INFORMAL POND

make sure that no part of the material is left exposed above the waterline. This will not only spoil the look of the finished feature, it will also leave an area of liner exposed to sunlight, which will cause cheaper brands to harden and crack, resulting in leaks and a drop in the water level of the pond. To prevent the liner from being punctured by sharp objects such as stones or rocks, always use good quality underlay *(see pp. 66–67)*.

LINING A SIMPLE POND WITH SHELF

CONSTRUCTION GUIDE

To build and line a 10ft x 7ft (3m x 2.2m) pond, you will need:

TOOLS
- Sand or string to mark out pond
- 10 wooden pegs
- Rubber mallet
- Carpenter's level
- Straightedge
- Shovel, spade
- Rake

MATERIALS
- Soft sand or sifted soil: ½cu yd (0.5cu m)
- Polyethylene, geotextile, or old carpet underlay
- Flexible liner: 15ft x 12ft (5m x 4m)
- Bricks to hold liner temporarily in place

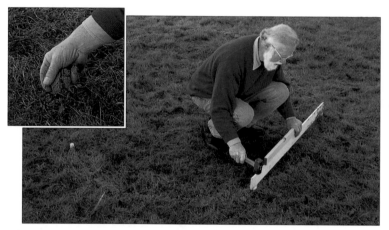

1 MARK THE OUTLINE of the pond *(see inset)*. Position a peg at the edge of the outline to indicate the proposed water level *(see p. 64)*. Position the remaining pegs regularly around the pond. Use a carpenter's level and a straightedge to check that all the pegs are level.

USING FLEXIBLE LINER

Before buying flexible liner and underlay, calculate how much will be needed to line the pond *(see p. 66)*, including enough for a generous overlap. Preferably, unroll the liner and lay it flat in the sun for at least half an hour. The heat will increase the liner's flexibility and help to ease out any stiff creases. Roll it up again to make fitting easier. When fitting liner into an irregularly shaped pond, do not strain it tightly over the contours of the excavation, since this will reduce its natural elasticity and make it more likely to be punctured by sharp objects like stones or rocks.

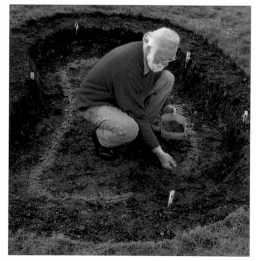

2 REMOVE SOD 2in (5cm) deep and 12in (30cm) wide from the pond edge. Excavate the entire area to a depth of 9in (22cm). Rake the surface, then outline the proposed deep zone with sand. Leave marginal shelf areas that are at least 12in (30cm) wide to accommodate plants. (A separate bog garden or wide shelves are preferable where raccoons may visit ponds.)

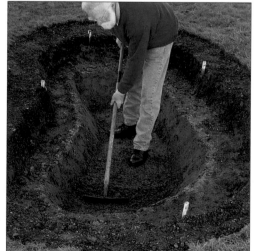

3 EXCAVATE THE MARKED AREA to a depth of at least 18in (44cm). Excavate to a minimum of 30in (76cm) to overwinter goldfish; 3–4ft (90–120cm) for koi. Rake the floor of the hole and remove any large or sharp stones. Then spread a 1in (2.5cm) layer of soft sand at the bottom of the excavation, where the water pressure will be strongest. Remove the pegs.

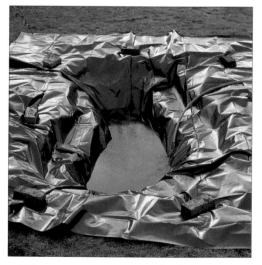

4 DRAPE THE UNDERLAY over the hole, then press firmly into the contours. Unroll the liner over the hole. Use bricks to hold the edges temporarily in place, and slowly fill the pond with water. The increasing weight of the water will settle the liner into the more difficult contours. Pleat any large creases as necessary. Adjust the bricks to allow the liner to settle.

5 THE POND IS NOW ready to be edged (see pp. 126–129). For an informal grass edging, trim the liner to leave a 6in (15cm) overlap. Replace the sod removed earlier; firm it down, and water well. For a formal, sharp-edged grass edge – or if the edge will take heavy traffic – make provision at the planning stage to dig out and add a foundation (see right) as for a paved edge.

INFORMAL AND FORMAL EDGINGS WITH FOUNDATIONS

There is a wide range of edging materials and styles to choose from (see pp. 126–131). For hard edging materials such as paving, or where earth may crumble under turf, foundations are advisable. This involves digging out a strip around the pond to a depth of 6–9in (15–23cm). The liner may be rolled over this outer shelf and the foundation laid on top of it (left). Bear in mind that the foundation will be visible, so choose attractive materials such as granite blocks, mortaring these together to prevent water leakage. To hide a brick and concrete foundation (right), lay the liner on top of it.

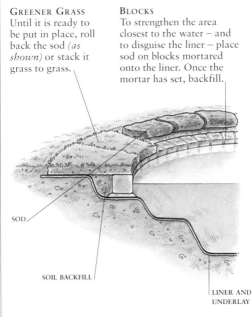

GREENER GRASS
Until it is ready to be put in place, roll back the sod (as shown) or stack it grass to grass.

BLOCKS
To strengthen the area closest to the water – and to disguise the liner – place sod on blocks mortared onto the liner. Once the mortar has set, backfill.

SOD

SOIL BACKFILL

LINER AND UNDERLAY

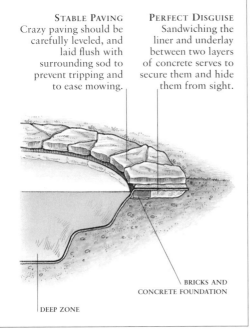

STABLE PAVING
Crazy paving should be carefully leveled, and laid flush with surrounding sod to prevent tripping and to ease mowing.

PERFECT DISGUISE
Sandwiching the liner and underlay between two layers of concrete serves to secure them and hide them from sight.

DEEP ZONE

BRICKS AND CONCRETE FOUNDATION

POND WITH CRAZY PAVING EDGE

Almost any artificially created pond can be transformed by strategic planting. Once the pond and its planted environs are established, it will be virtually impossible to distinguish it from a "natural" water feature. To make it easier for frogs and other water-seeking wildlife to climb out if they fall in, include at least one paving stone that slopes into the water. Overhanging paving stones provide fish with shade, and will help to disguise the liner by casting a shadow.

MULTIPURPOSE FLEXIBLE LINERS

The use of flexible liner has become increasingly popular; it is now so widely available that there is a good case for completing all the necessary pond or stream excavations before buying the liner. By finishing the excavation first, last-minute variations can be made to the depth and shape of the feature without having to take into account the width and length of a liner bought at the planning stage. When the excavation is complete, view it from a distance, or from a window in the house; a fresh perspective might suggest any number of variations and allow you to judge the effect that a differently shaped or enlarged water feature will have on the surroundings.

COMPLEX SHAPES

More complex shapes designed to enhance particular surroundings are easier to create with flexible liner than with materials that require building skills. Liner is generally sold in a wide range of precut sizes, although some dealers sell from rolls of various widths. One length of liner can be made to fit several shapes. If the liner is much too large for a narrow section of pond or stream, plan to use the excess to create peripheral features. It is best to avoid seaming together pieces of liner. For streams, use a separate sheet overlapped by the main pool liner, but only if the overlap is above standing water level.

ADDING PLANTING FEATURES

One of the greatest advantages in using flexible liner is the variety of depths and edges that can be incorporated in one pond (*see below*). By allowing adequate surplus liner around

NATURAL EDGING
It is much easier to disguise the edges of flexible liner than it is to disguise the edges of rigid units or concrete pools. Here, large, rounded stones, along with marginal and moisture-loving plants, make a perfect disguise.

the sides of the pond above the waterline, it is quite simple to incorporate features such as integral planting beds, boggy areas, or a stone beach (*see pp. 80–81*). If the flexible liner is buried beneath the soil, even if above the water level, plants in the surrounding soil will draw moisture from the pond; this is known as the "wick effect." In small planting areas, this is useful for moisture-lovers, as they will take the water they

CREATING PLANTING ENVIRONMENTS WITH FLEXIBLE LINER
This pond was designed to include several planting environments (see pp. 148–149), each of which allows plants to grow without the need for containers. The main pond is deep enough to support submerged plants, the shallower pocket beside it, marginals. A combination of marginal and bog plants grow in the pondside pockets made with surplus liner.

FILLING UP
A rain barrel equipped with a tap and buried hose leading into the pond is an ideal way to replace water lost through the "wick effect" of a large integral bog garden.

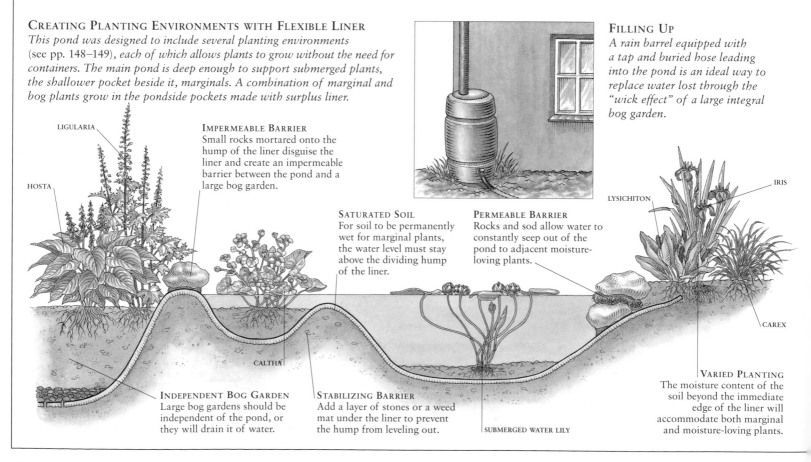

LIGULARIA

IMPERMEABLE BARRIER
Small rocks mortared onto the hump of the liner disguise the liner and create an impermeable barrier between the pond and a large bog garden.

HOSTA

SATURATED SOIL
For soil to be permanently wet for marginal plants, the water level must stay above the dividing hump of the liner.

PERMEABLE BARRIER
Rocks and sod allow water to constantly seep out of the pond to adjacent moisture-loving plants.

IRIS

LYSICHITON

CAREX

CALTHA

INDEPENDENT BOG GARDEN
Large bog gardens should be independent of the pond, or they will drain it of water.

STABILIZING BARRIER
Add a layer of stones or a weed mat under the liner to prevent the hump from leveling out.

SUBMERGED WATER LILY

VARIED PLANTING
The moisture content of the soil beyond the immediate edge of the liner will accommodate both marginal and moisture-loving plants.

need from the pond. If a large bog garden is not independent of the pond, however, the "wick effect" can quickly lower the level of water in the pond. To prevent this, the liner should come up out of the ground, or should have rocks or pavers mortared onto it to stop water from seeping out. Or, install a filling-up system using a rain barrel (see facing page).

LINING FORMAL SHAPES
Liners are often used to waterproof old, damaged concrete pools or containers that leak, such as old barrels. Always use top-grade butyl or EPDM liner where there are sharp edges or corners to be covered; the cheaper PVC liners are liable to tear in these circumstances. However, using top-grade liner in a large pool can be expensive; it is more economical to use a layer of cement mixed with reinforcing fibers over the shell of large, regularly shaped formal pools (see pp. 90–91).

FOLDING A LINER
Sharp curves in informal ponds and the angles of corners in formal rectangular pools, will inevitably result in large creases having to be made in the liner. Careful folding of the liner can, however, make these folds look less conspicuous; the folds may also be disguised with coping stones or, in the case of informal ponds, with stones mortared onto the liner (see p. 67). Once the pond is filled, the weight of water should hold the folds down; alternatively, pleated material can be secured with two-sided

WATERPROOFING A BARREL
Old half-barrels make charming container water features, but they may leak. A lining of inexpensive polyethylene or PVC will make them watertight. Fold the liner neatly around the inside edges of the barrel, as shown here. Then wedge – and disguise – the liner under a small, thin wooden strip fixed to the inside top edge of the barrel with galvanized screws. Secure the strip as near as possible to the top of the barrel, so that the screws do not penetrate the liner and are clear of the water. Then trim back the excess liner.

LINING A BARREL

waterproof tape. When making folds, make sure that there is ample liner at your disposal, so that the material does not have to be stretched too much, as the sheer weight of the water may cause it to split. Whatever the shape of the water feature, formal or informal, always complete the task of folding the liner before releasing water into the pool; the weight of only a few liters/gallons of water will make further manipulation of the liner very difficult, and may cause it to rupture.

FLEXIBLE LINER IN FORMAL POOL
This cross-section of a formal pool demonstrates how basic construction materials and flexible liner can be used to accommodate a variety of planting environments. A marginal shelf, suitable for containerized marginal plants, is created by drawing the liner over loosely mortared bricks. Integral planting beds can also be built on top of the liner, either along the sides of the pool or free-standing in the center.

MAKING FOLDS
Create a neat corner fold by making a diagonal pleat in the liner. Use bricks to secure the liner until the weight of the water can keep the fold in place.

CORNER BED
Loosely mortared clay bricks allow water to seep into the soil of the marginal planting bed.

SUBMERGED PLANTING BED
This planting bed for water lilies, 2ft x 2ft (60cm x 60cm) in size, is built with loosely mortared clay bricks and filled with topsoil.

FOLDING THE LINER
Always finish folding the liner before filling the pool with water.

TOPSOIL

BUILT-IN SHELF
Concrete blocks can be used beneath the liner to construct firm marginal shelves.

CONCRETE BLOCKS

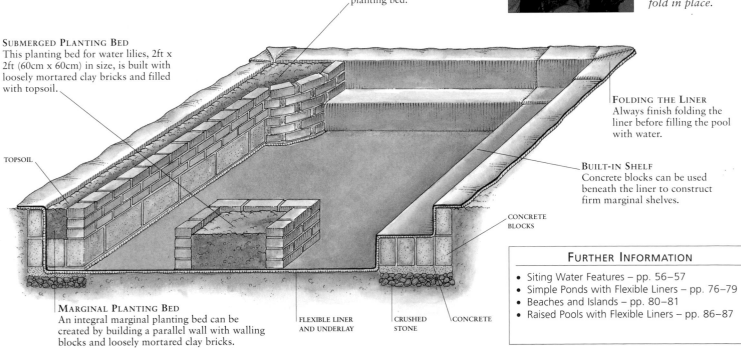

MARGINAL PLANTING BED
An integral marginal planting bed can be created by building a parallel wall with walling blocks and loosely mortared clay bricks.

FLEXIBLE LINER AND UNDERLAY

CRUSHED STONE

CONCRETE

FURTHER INFORMATION
- Siting Water Features – pp. 56–57
- Simple Ponds with Flexible Liners – pp. 76–79
- Beaches and Islands – pp. 80–81
- Raised Pools with Flexible Liners – pp. 86–87

BEACHES AND ISLANDS

ROCKS AND PEBBLES

MANY PONDS FAIL to attain their full potential as wildlife habitats (see also pp. 54–55) because their construction deters wild creatures who will not approach water they might fall into and not be able to get out of. Almost vertical side walls and large gaps between the water surface and overhanging coping stones or paved edges are common obstacles. A beach, gently sloping toward the water, is not only visually appealing but will also allow access for a great variety of wildlife. It is better to make provision for islands at the design stage, although it is possible to install a "wet" island in an existing pond (see facing page). Formal features tend not to have islands, but submerged formal beds can be built (see pp. 78–79) with retaining walls constructed from house or decorative bricks, and filled with topsoil.

MAKING A STONE BEACH
Before positioning the underlay and liner, dig a shallow shelf sloping down to the water. The shelf should be 4–6in (10–15cm) deep at its lowest point and, to achieve a gentle, "natural" gradient, at least 2–3ft (60–90cm) wide. Extend the liner over the prepared area. Build up a "lip" at the edge of the beach – as shown here – by mortaring stones in place.

STONE FLOOR
To protect the liner and underlay, use smooth, rounded river rock.

PLANTING POCKETS
Soil between stones forms wet pockets for marginal plants.

GRAVEL BEACH
A simple, gently sloping pea gravel beach is an inexpensive, easy-to-install feature, which will be welcomed by small creatures attracted to the water's edge by the easily negotiable terrain. Only smooth, washed pea gravel should be used, since sharp stones could damage the liner. To stop the gravel from slipping into deeper water, mortar a retaining row of large river rocks directly onto the liner.

LINER EDGE
Make sure the edge of the liner extends well above the water level, and is concealed with stones.

NATURAL OUTCROPPINGS
Protruding stones provide birds and other creatures with stepping stones, as well as with basking and resting places.

FLEXIBLE LINER AND UNDERLAY

RETAINING WALL
Mortar a row of large river rocks onto the liner to prevent smaller rocks from slipping into deeper water.

CHOOSING STONES

For the most natural effect, select stones local to your area; imported ones can look artificial. Rock collecting is prohibited on many beaches and in natural areas. If you are able to gather stones at the beach, wash them thoroughly before using them in the pond; residual salt on the stones may damage pondlife.

GRADED PEBBLE BEACH
Pebbles and rounded stones both small and large make a natural-looking covering for a shallow beach. Imitate nature by grading the stones, with the smallest nearest the water. Where the beach slopes away into deeper water, mortar down a row of stones to prevent the rest from slipping into the pond. The pebble floor will protect the liner from the claws of birds and animals, and from the damaging effects of ultraviolet light.

CONSTRUCTING ISLANDS

Ideally islands should be incorporated when the pond is built. To ensure stability, they should be at least 4ft (1.2m) across; anything smaller than this will limit the number and variety of plants the island can accommodate. As a result, it will not provide wildlife – primarily birds – with shelter, nesting sites, and protection from predators. The retaining walls can be constructed from sandbags, although polypropylene bags filled with smooth river rocks are longer lasting. Since an island will reduce the volume of water in a pond – thus affecting the pond's ecosystem (*see pp. 136–137*) – the surface area of the water should be a minimum of four times the surface area of the island (*see pp. 60–61*). The inclusion of both a "wet" and a "dry" island in one large pond will provide sites for a wide range of plants with differing moisture requirements.

MAKING DRY ISLANDS

Dry islands, which are designed to provide normal soil conditions, should be pre-planned and constructed at the same time as the pond. In a flexible-liner pond, dig a moat around a flat-topped mound of earth that extends 4–6in (10–15cm) above the proposed waterline. Fit the liner over the contours of the mound; then, to expose the topsoil of the mound for planting, cut away the liner covering the top of the mound above the waterline. Finally, disguise the edges of the liner with topsoil or sod. Remember that it may be necessary to water plants on dry islands in dry conditions.

MAKING WET ISLANDS

To incorporate a shallow wet island in a pond at the design stage, leave a flat-topped mound in the excavation that is at least 9in (22cm) lower than the proposed water level, covering the mound

CROSS-SECTION OF A WET AND A DRY ISLAND

The retaining walls of this shallow wet island (below, left) are constructed with layers of inverted sod. To prevent the topsoil from dispersing before the spreading roots of the plants can knit it together, use heavy soil high in clay content. The flexible liner on the dry island (below, right) extends above the waterline. It is disguised and protected beneath two layers of sod.

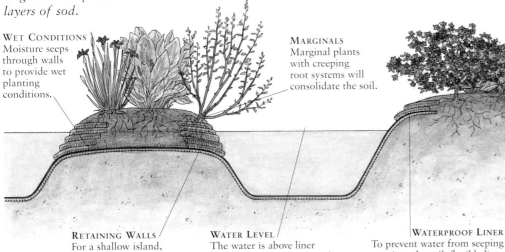

WET CONDITIONS Moisture seeps through walls to provide wet planting conditions.

MARGINALS Marginal plants with creeping root systems will consolidate the soil.

RETAINING WALLS For a shallow island, inverted sod make suitable retaining walls.

WATER LEVEL The water is above liner level for the wet island, and below it for the dry island.

WATERPROOF LINER To prevent water from seeping into the soil, flexible liner extends above the waterline.

BUILDING A WET ISLAND IN AN EXISTING POND

First, drain the pond water, then build up inward-sloping retaining walls with sandbags or polypropylene bags filled with rubble. Once the first three bags are in place, fill the center with 10–12in (24–30cm) of rubble. Build up the walls and fill with topsoil. When they are within 4–6in (10–15cm) of the final water level, disguise them with two layers of inverted sod.

A STABLE ISLAND To ensure stability, the height of an island should not exceed half its width.

FLEXIBLE LINER AND UNDERLAY

MARGINAL PLANTING This dwarf goat willow (*Salix hastata* 'Wehrhahnii') is tolerant of wet soil.

SMOOTH RIVER ROCKS It is cheaper to backfill the base of a large island with river rocks rather than with topsoil.

with the liner and underlay. Build up low walls around the edges of the mound with inverted sod (*see below, left*). Fill with heavy soil, which will not easily disperse. To build a "wet" island in an existing pond, the pond should have a level bottom and a stable base (*see above*). Marginal plants such as *Calla palustris* (hardy calla) will thrive in wet island conditions.

CREATING A WET ISLAND

Provided a flat-topped mound has been left under the liner to within 12in (30cm) of the final water level, a wet island is easy to build with a wall of inverted pieces of sod retaining the topsoil. Once the sod wall is in place, build up the center of the island for planting.

SUCCESSFUL DISGUISE Inverted sod disguise the flexible liner lying above the waterline.

PLANTING MEDIUM Use good-quality topsoil for the planting area.

FURTHER INFORMATION

- Encouraging Wildlife – pp. 54–55
- ConstructionTools and Materials – pp. 62–63
- Construction Techniques – pp. 64–69
- Simple Ponds with Flexible Liners – pp. 76–79

BOG GARDENS

BOG, OR MARGINAL, gardens may be incorporated into an existing water feature by extending the flexible liner out beyond the reaches of the pond. They can also be designed as stand-alone features, completely independent of a pond or water garden. In fact, a bog garden is one of the simplest, cheapest, and most water-efficient ways of creating an environment for plants that demand constantly high soil

BOG GARDEN

moisture. Small boggy areas can be created anywhere in the garden that you would like to add pockets of moisture-loving plants. Simply dig out a depression, line it with polyethylene, fill it with soil, and water by hand as needed. A less laborious option is shown here. The plants are grouped together in an area that has a specially designed irrigation system, so that the entire garden can be watered easily and quickly.

CREATING A BOG GARDEN

CONSTRUCTION GUIDE

To create a round bog garden approximately 8ft (2.4m) across, you will need:

TOOLS
- Spade, rake, garden fork
- Knife or scissors
- Hacksaw, drill

MATERIALS
- Sand or string for marking out
- Heavy-duty polyethylene sheet: 11ft x 11ft (3.5m x 3.5m)
- Bricks or stones to hold liner down temporarily
- Pea gravel: ½cu yd (0.5cu m)
- Rigid plastic pipe: 7ft (2m) long, 1in (2.5cm) in diameter
- 2 elbow joints
- Short length of hose, hose clamp, and hose connector with male/female lock

1 MARK OUT THE REQUIRED SHAPE with string or sand. Dig a hole approximately 2ft (60cm) deep, with sloping sides to minimize the crumbling of light soil. Keep the topsoil nearby on a polyethylene sheet for replacement. Rake the area and remove any large or sharp stones.

LINING AND DRAINING

The lining used in a bog garden that is independent is covered with soil and need not be completely watertight. In fact, since it will have holes pierced in it never use expensive pool liner; polyethylene sheeting will serve the purpose just as well. The holes are necessary to allow water in the soil to drain away, albeit very slowly, otherwise it will become stagnant and anaerobic (allowing harmful bacterial activity). Drainage is vital for the growth of many moisture-loving plants that will not survive in saturated soil. Drainage is aided by the layer of pea gravel, which also prevents the holes in the irrigation pipe becoming blocked.

CONSTRUCTION OF A BOG GARDEN

A bog garden should contain free-draining but moisture-retentive soil; topsoil can be improved by the addition of organic matter (see pp. 150–151) to increase its water-retentiveness. To prevent the bog from drying out too quickly, aim for a minimum depth of 18in (45cm), and plant densely.

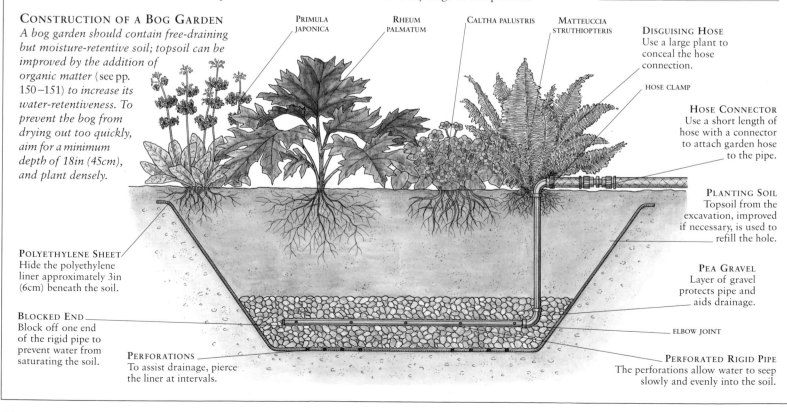

PRIMULA JAPONICA

RHEUM PALMATUM

CALTHA PALUSTRIS

MATTEUCCIA STRUTHIOPTERIS

DISGUISING HOSE
Use a large plant to conceal the hose connection.

HOSE CLAMP

HOSE CONNECTOR
Use a short length of hose with a connector to attach garden hose to the pipe.

PLANTING SOIL
Topsoil from the excavation, improved if necessary, is used to refill the hole.

PEA GRAVEL
Layer of gravel protects pipe and aids drainage.

ELBOW JOINT

PERFORATED RIGID PIPE
The perforations allow water to seep slowly and evenly into the soil.

POLYETHYLENE SHEET
Hide the polyethylene liner approximately 3in (6cm) beneath the soil.

BLOCKED END
Block off one end of the rigid pipe to prevent water from saturating the soil.

PERFORATIONS
To assist drainage, pierce the liner at intervals.

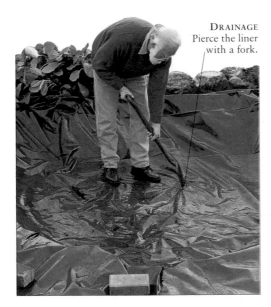

DRAINAGE
Pierce the liner with a fork.

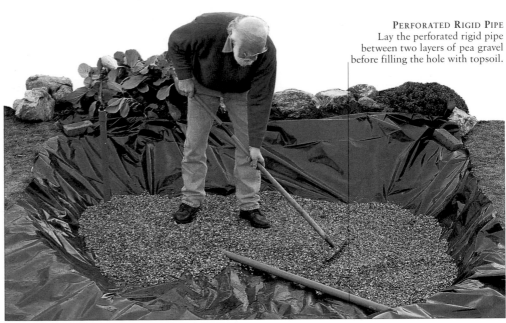

PERFORATED RIGID PIPE
Lay the perforated rigid pipe between two layers of pea gravel before filling the hole with topsoil.

2 DRAPE THE LINING material over the excavation and press it into the contours. Put bricks or stones around the edges of the sheet to keep it in place while you walk on it. To make holes for drainage, pierce the liner at 3ft (1m) intervals with a garden fork.

3 SPREAD A 2IN (5CM) LAYER of pea gravel over the sheet. Then cut a 2ft (60cm) length off the rigid pipe. Drill holes along the longer section at 6in (15cm) intervals, then lay it across the base.

Block one end and, at the other, use an elbow joint to join on the short pipe so that it extends vertically above ground level. Spread another 2in (5cm) layer of gravel over the pipe.

REPLACING TOPSOIL
Rake the top layer of pea gravel level, then replace the topsoil.

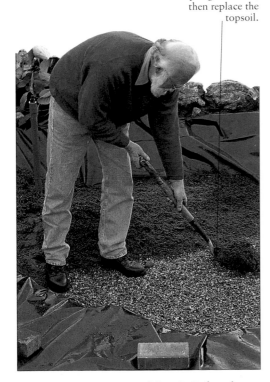

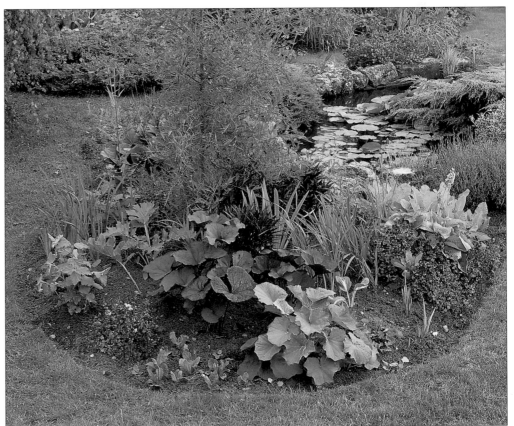

4 SHOVEL IN THE SOIL and firm it. Before the soil reaches the top of the excavation, trim off any surplus liner and hide the edges under a 3in (7cm) layer of soil. Remove the bricks and any excess soil. Attach the second elbow joint to the protruding pipe, creating a right-angle turn. Fit the short length of hose onto it with the hose clamp, and attach the garden hose connector.

PLANTED BOG GARDEN
Fill up the bog garden whenever the soil surface is dry (this could be weekly in hot spells), adding water until the soil surface floods, to keep plants growing well. One of the advantages of a separate bog is that garden fertilizer can be used without the danger of it seeping into the water of a pond and affecting its chemistry.

FURTHER INFORMATION
- Wildlife Pond with Bog Garden – pp. 40–43
- Simple Ponds with Flexible Liners – pp. 76–79
- Soils and Containers – pp. 150–151

RIGID POOL UNITS

PREFORMED RIGID POOL units are easy to install, and can be a good choice for a small water feature. Rigid units are particularly well suited to formal gardens, especially if the surrounding area is to be paved, since it is easier to disguise the smooth, often shiny edges of the unit with paving stones *(see p. 127)* rather than with plants. Many commercially available rigid units incorporate shelves designed to

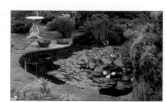

RIGID UNIT IN POSITION

accommodate planting crates that fit into the contours of the unit. Units come in many sizes, styles, and colors; their smooth surfaces make them easy to clean. Although not difficult to install, the units do become very heavy when filled with water. If the site has not been properly prepared *(see also pp. 64–65)*, the build-up of water pressure can cause the unit to fracture as the earth settles under the weight of the water.

INSTALLING A RIGID POOL UNIT

CONSTRUCTION GUIDE

To install a rigid pool unit with marginal shelves, you will need:

TOOLS
- Stakes, string
- Spade, rake
- Straightedge, carpenter's level
- Tamping tool
- Tape measure
- Hose

MATERIALS
- Rigid pool unit
- Bricks to support the unit temporarily
- Soft sand or sifted soil, enough to line the floor of the excavation to a depth of 2in (5cm)

1 IF THE UNIT CHOSEN is completely symmetrical it can simply be turned upside down and its outline marked directly on to the ground. For irregular shapes, supporting the unit in exactly the right position, so that it can be marked around accurately, can be an awkward job and is easier with a helper. You can temporarily support the unit on bricks *(see right)*. Once satisfied with the position of the unit, check that it is level with a carpenter's level, then mark out its shape by pushing stakes into the ground around the perimeter. Lay a length of string around these stakes to indicate the area to be excavated.

CONSTRUCTION TIPS

- Preformed units come in a wide range of sizes and shapes, so shop around for one that matches your requirements.
- Preformed pool units always look smaller after they have been installed and edged, so overestimate the size of unit that you require.
- If you want the pond to be a lasting feature, invest in a good-quality fiberglass unit; these are also easier to repair.
- If intending to stock with fish, check that the unit is of an adequate size and depth. Choose fish species that will be happy in a relatively small pond.
- Check that any marginal shelves are wide enough to accommodate planting baskets securely.
- A non-abrasive bathroom cleaner applied with a soft cloth is ideal for cleaning pool units, but all traces of the cleaner must be rinsed away thoroughly before installing fish and plants.

2 MEASURE THE DEPTH of the unit from the lip to the marginal shelves, and dig a hole to this depth, 4in (10cm) wider than the unit all around. Place the unit (right side up) in the hole and press down gently. The mark left by the deep zone will act as a guide for further digging.

3 EXCAVATE THE DEEP area, checking depths by measuring down from the straightedge *(as above)*. Make the hole 2in (5cm) deeper than the deep zone, and add a 2in (5cm) layer of leveled soft sand or sifted soil. Smooth and firm the sides and shelf areas of the hole, removing all stones.

5 To increase the stability of the pool, fill it with water to a depth of 4in (10cm), then start to backfill around the pool with soft sand or sifted soil *(see p. 65)*. Using the straightedge and the carpenter's level, check regularly that the unit is absolutely level, then tamp down the backfill of soft sand or sifted soil at intervals. Continue to add 4in (10cm) of water at a time and to backfill and tamp around the unit. Once the unit is filled to within 2in (5cm) of its final depth, prepare the surrounding area for whichever edging material has been chosen *(see pp. 126–129)*. If paving stones are to overlap the rim of the pool, it is important to make sure that their weight is supported. You will need to add a foundation of crushed stone topped with a thick layer of sand under the lip of the unit.

4 Lower the unit into place and press it down gently so that the deep zone fits snugly into its hole and the unit is completely level. You may need to remove the unit and make adjustments several times until the unit is fully supported by the contours of the excavation.

Disguising a Rigid Pool Unit

This kidney-shaped pool is cleverly disguised, with paving that overlaps the water around the perimeter of the pond. Both the choice and positioning of plants growing outside the surrounding pavement, such as the bearded iris in the foreground, enhance the informal aspects of the pond. However, plants such as these must be able to grow in normal dry soil, as no moisture will escape from the pool. If the pool has built-in marginal shelves, the plants growing in the planting baskets standing on the shelves will also help to disguise the rim of the unit.

Further Information

- Measuring Areas and Volumes – pp. 60–61
- Semi-raised Rigid Pool Units – pp. 88–89
- Rigid Stream Units – pp. 104–105
- Edging Materials – pp. 126–129
- Decking – pp. 130–131

RAISED POOLS WITH FLEXIBLE LINERS

RAISED AND SEMI-RAISED pools make excellent focal points in formal or courtyard gardens, especially where their low surrounding walls can be used as casual seats from which to observe water plants and aquatic life at close quarters. Because of freezing winter temperatures, raised pools are best for zones 7 and south. In the North, reinforced high-strength concrete would be more suitable. Raised pools need little

DECORATIVE BRICKS

excavation, are less likely to become cluttered with debris and, because their walls can be built to varying heights, they offer a fine design solution on sloping sites. On the other hand, they are more costly than the sunken variety and take more time to build. A raised pool is often set within a paved area. In many cases, the shape of the pavers will suggest the shape of the pool, as with the hexagonal slabs below.

BUILDING A RAISED HEXAGONAL POOL

CONSTRUCTION GUIDE

To build this pool, 2ft (60cm) high, and 9ft 3in (2.8m) between opposite corners, you will need:

TOOLS
- String, stakes, spade, shovel, plank, carpenter's level, straightedge, bricklayer's trowel

MATERIALS
- Concrete mix: ½in (20mm) ballast: ½cu yd (0.5cu m), two 50lb (22kg) bags of cement
- 60 concrete blocks: 12in x 8in x 3in (30cm x 21cm x 8cm); 30 wall ties
- Ready-mix mortar: 10 x 80lb (36kg) bags
- Liner and underlay: 14ft sq (4.2m sq)
- Rigid overflow pipe: 11in (28cm) long, ¾in (2cm) in diameter
- 380 decorative bricks: 12in x 3in x 2½in (30cm x 8cm x 6cm); 18 coping stones: 24in x 10½in x 2in (60cm x 25cm x 5cm)

REINFORCED WATERPROOF CABLE CONDUIT

1 MARK THE PERIMETER OF THE POOL with stakes and string, and install the paving (see p. 127). Dig a trench 18in (45cm) wide and 8in (20cm) deep inside the perimeter. Insert stakes to establish a horizontal level about 1in (2.5cm) below ground or paving level, then pour in concrete, and tamp and level it with a straight plank.

CONSTRUCTION TIPS

Because of the pressure exerted by water, raised pools over 18in (45cm) high should be built with double walls. The foundation trench of this pool's walls is 18in (45cm) wide – twice the width of the 9in (22cm) double wall. The trench is filled with a concrete mix consisting of ballast (a mixture of sand and small stones) and cement, which should be allowed to dry for at least 48 hours before work on the walls begins. Ready-mixed mortar can be used for both walls. Wall ties, set 3ft (1m) apart, will consolidate the strength of the walls. Pavers and coping stones are often available in pre-cut halves. For advice on how to cut stone, see pp. 68–69.

2 WHEN THE CONCRETE IS DRY, build twin walls 2in (5cm) apart. Use two courses of concrete blocks for the inner wall, and the decorative bricks for the outer wall. Work in from each corner; use a line and a carpenter's level regularly to check that the walls are level and vertical. Reinforce with wall ties 3ft (1m) apart (see inset).

3 BUILD THE OUTER WALL to a height of 2ft (60cm), 6in (15cm) higher than the inner wall. Allow 24 hours for the mortar to dry. Drape the underlay and liner in the pool and up and over both walls, and smooth into position (see pp. 76–77). Temporarily secure the overlap of liner on the inner and outer wall with bricks.

DECORATIVE BRICKS
Finish off the inner wall with two courses of decorative bricks.

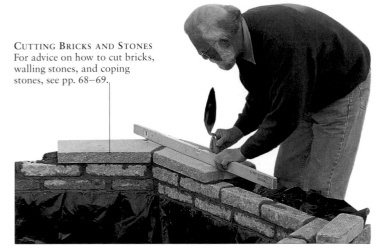

CUTTING BRICKS AND STONES
For advice on how to cut bricks, walling stones, and coping stones, see pp. 68–69.

4 TO MAKE THE WALLS LEVEL, mortar two courses of decorative bricks onto the liner overlapping the top of the inner wall. The coping stones will sit across the two walls, so it is important to keep checking levels along the wall *and* across the gap.

5 MORTAR THE COPING STONES onto the inner wall and the overlapping liner on the outer wall. Below one of them, mortar in the plastic tube as an overflow pipe *(see below)*. Mortar in another one through which to thread electric cable, if desired. Check that the coping stones are level.

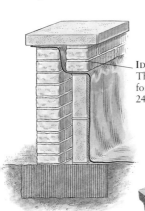

IDEAL HEIGHT
The ideal height for a raised pool is 24–30in (60–75cm).

SECTION THROUGH DOUBLE WALL
This section of a raised pool wall shows how the liner and underlay are hidden by mortaring them beneath the two final courses of decorative bricks on the inner wall.

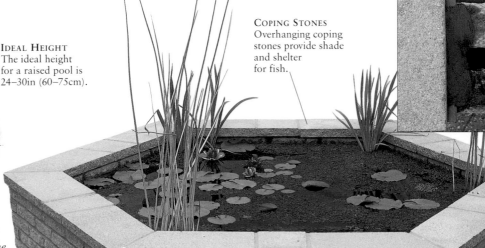

COPING STONES
Overhanging coping stones provide shade and shelter for fish.

OVERFLOW PIPE
An overflow pipe hidden beneath coping stones will prevent water from flooding over the sides of a pool after prolonged or heavy rainfall.

ORNAMENTAL FINISH
For an attractive finish, use decorative bricks for the outer wall.

INSTALLING ELECTRICITY IN A RAISED POOL

If planning to include electrical features such as lighting *(see pp. 124–125)* or a fountain *(see pp. 108–109)*, install the wiring as the pool is being built. When installing electric cables for pumps, fountains, or lighting, safety precautions should be paramount *(see p. 72)*. Use only equipment specifically designed for outdoor or underwater use. All cabling attached to electrical equipment used in water comes ready-sealed. As a further precaution, when the cable is to be embedded in the foundation, mortared between courses of bricks, or under a coping stone, run the cable through a length of reinforced waterproof hose – as shown in step one *(facing page)*.

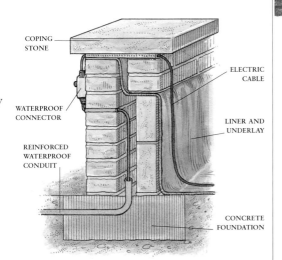

COPING STONE

WATERPROOF CONNECTOR

REINFORCED WATERPROOF CONDUIT

ELECTRIC CABLE

LINER AND UNDERLAY

CONCRETE FOUNDATION

FINISHED POOL WITH PLANTING
Although formal pools are not generally as densely planted as informal ponds, floating-leaved plants, irises, and tall grasses are often introduced. The floating leaves of water lilies (Nymphaea) provide shade and shelter for fish, as well as checking the growth of algae by partly blocking out sunlight.

FURTHER INFORMATION
- Choosing a Water Feature – pp. 52–53
- Siting Water Features – pp. 56–57
- Construction Tools and Materials – pp. 62–63
- Construction Techniques – pp. 64–69

SEMI-RAISED RIGID POOL UNITS

ALTHOUGH PREFORMED RIGID pool units are most commonly sunk in the ground *(see pp. 84–85)*, they can also be used as semi-raised pools provided the sides are given strong support. Although raised pools installed at ground level can make attractive features, they will freeze during the winter. This is less of a problem if the unit is partially buried in a shallow excavation, so that its deep zones are insulated

FORMAL RAISED POOL

by the surrounding earth. Use a pond heater to completely prevent freezing in winter. Materials such as log-roll edging, large rocks, decorative coping stones, or bricks are ideal for surrounding a pool. In addition to concealing the outer surfaces of the raised unit, they can provide support for topsoil packed between the outer wall and the rigid mold; spreading plants grown here will soon cover the lip of the pool.

INSTALLING A SEMI-RAISED RIGID POOL UNIT

CONSTRUCTION GUIDE

To install a 6ft (2m) long, 18in (45cm) deep, 3ft (1m) wide rigid pool unit and log-roll edging, you will need:

TOOLS
- Rake, spade
- Carpenter's level, straightedge
- Tamping tool
- Hammer, wirecutters

MATERIALS
- Soft sand or sifted soil: enough to line the floor of the excavation and for backfilling
- 9 treated, pointed wood stakes: 18in x 1½in (45cm x 4cm)
- Log-roll edging: 20ft x 9in (6m x 22cm)
- Twenty-four 2in (5cm) galvanized nails

RIGID POOL UNIT
This preformed pool unit is of average size: 6ft (2m) long, 18in (45cm) deep, and 3ft (1m) at its widest point. It has two marginal shelves and is made of fiberglass, which has a life expectancy of at least 20 years. The pool's shiny surface makes it easy to clean.

1 WHEN A SITE has been chosen, clear the area of stones and organic debris and rake the surface of the area. To make a clearly visible imprint of the base of the unit, place it on the raked area and press down firmly. The impression left on the soil will show you where to dig.

CROSS-SECTION OF RIGID UNIT IN PLACE

The pool will look more pleasing if the unit is buried to the height of its marginal shelf, leaving only 9in (22cm) of the mold above the ground. Partial burying is also a fairly simple way to install preformed units on a sloping site, as only the upper part of the slope will need to be excavated to ensure that the unit is level.

2 DIG A HOLE with slightly sloping sides, 2in (5cm) wider than the imprint left by the unit's base, and 2in (5cm) deeper than the deep zone of the unit. The extra depth allows for a layer of soft sand or sifted soil, the extra width for backfilling to support the unit sides.

3 PLACE THE UNIT in the hole and use the straightedge and carpenter's level to check that it is level. If adjustments are necessary, remove the unit and add or remove sand beneath it. Begin backfilling around the sides *(see p. 64)* with soft sand or sifted soil.

4 FILL THE UNIT WITH WATER to a depth of approximately 3–4in (7–10cm). This will stabilize the pool while the backfill is being tamped. Use a hammer to drive stakes into the ground around the perimeter of the unit at 3ft (1m) intervals. To ensure that the stakes firmly support the log-roll edging at least as much of the stake should be below as above ground. The top of the stakes should be level with the lip of the unit and with the top of the log roll when it is in place. The height of the edging should equal the depth of the unit from the lip to the marginal shelf (here 9in/22cm).

5 UNROLL THE STRIP OF LOG EDGING and place it in position around the stakes. The logs are attached to each other with wire, so the roll is fairly flexible and should fit easily around the contours of the pool. If at any point the top of the log roll is found to be slightly higher than the rim of the unit and the top of the stakes, dig a narrow trench and partially bury the base of the log roll. Since log rolls are sold in fixed lengths, you will need extra wire to join on another section if the edging comes up short. Use wirecutters to cut the connecting wires if there is surplus log roll.

ADDING PLANTS

Small plants in the free-draining topsoil between the log roll and the rigid unit will soon disguise and soften the shiny rim of the unit. Alpines such as Sempervivum *(houseleek),* Cyclamen, *and* Saxifraga *are ideal. Topdress the soil with grit to conserve moisture and prevent soil dispersal.*

6 ONCE THE LOG ROLL has been wrapped around and cut to length, join the two ends with wire. Then use 2in (5cm) nails to fix the log rolls to the wooden stakes already in place. For extra strength, use two nails, one at the top and one at the bottom of each stake. Keep the level in place to be sure that the sides of the pool are not squeezed inward as the log roll is nailed in place.

7 WITH THE LOG ROLL securely fixed, backfill the area between the logs and the unit with topsoil. Tamp the soil down firmly with a thin piece of wood. When compressed, the soil should be level with the rim of the unit. If soil spills into the unit, bale or siphon out the water, clean the unit's surface with a wet sponge, then refill to the correct depth.

FURTHER INFORMATION
• Siting Water Features – pp. 56–57
• Construction Tools and Materials – pp. 62–63
• Construction Techniques – pp. 64–69
• Rigid Pool Units – pp. 84–85
• Edging Materials – pp. 126–127

SUNKEN CONCRETE POOLS

CONCRETE IS A strong and long-lasting material for formally shaped pools, made either with solid poured concrete or concrete blocks with a cement rendering (as below). Pools made entirely with poured concrete can deteriorate in time, being prone to cracking in severe weather or if the surrounding earth moves. The thin layer of special, fiber-reinforced cement skimming used below dramatically reduces the risk of

SUNKEN CONCRETE POOL

fracturing when the soil swells or shrinks. However, this method is best used only in zones 8 and South. Concrete pools in areas where the ground freezes for considerable periods, must be poured using forms (see facing page). They can also be constructed using gunnite or shotcreting, a technique that involves spraying layers of concrcte over a reinforced wire mesh from from a truck equipped with a pump.

CONSTRUCTING A SUNKEN CONCRETE POOL

CONSTRUCTION GUIDE

To build a 13ft x 10ft x 2ft (4m x 3m x 60cm) pool, you will need:

TOOLS
- Stakes, string, spade, shovel, tamping block, rake, length of timber for leveling concrete, plasterer's trowel, carpenter's level, straightedge, paintbrush

MATERIALS
- Soft sand or sifted soil: 1cu yd (1cu m)
- Concrete mix – ballast: 1cu yd (1cu m); cement: two 50lb (22kg) bag
- Mortar – soft sand: 0.5cu m (½cu yd); cement: two 80lb (36kg) bag
- Cement rendering – sharp sand: 1cu yd (1cu m); cement: 3 x 50lb (22kg) bags; 50lb (225kg) reinforced fibers:
- 64 concrete blocks: 18in x 9in x 4in (45cm x 22cm x 10cm); 128 house bricks; 128 brick-shaped pavers
- Waterproof sealant for water gardens

1 MARK OUT AND EXCAVATE a straight-sided hole 4in (10cm) deeper and 8in (20cm) wider all round than the intended size of the pool. Dig a trench 8in (20cm) wide around the inside of the excavation for poured concrete wall foundations. Presoak the trench; pour in, tamp, and level the wet concrete mix; then leave to dry.

2 RAKE THE POOL'S BASE and remove any stones, then spread, rake level, and firm a 2in (5cm) layer of soft sand or sifted soil level with the foundations. To make a firm, flexible base, use a plasterer's trowel to skim the sand with a ½in (1cm) layer of fiber-reinforced cement, overlapping the concrete of the foundations by 2in (5cm).

CROSS-SECTION, SUNKEN CONCRETE POOL

The walls of this pool are built on a concrete-filled trench, and consist of two courses of concrete blocks and two courses of bricks topped with coping stones. The entire inner surface of the pool is lined with a ½in (1cm) layer of fiber-reinforced cement. Below the floor is a base layer of the cement mix on a firm layer of sand.

BRICKS
FIBER-REINFORCED CEMENT LINING
COPING STONE
CONCRETE INFILL
DECORATIVE BLOCKS
SOFT SAND OR SIFTED SOIL
MORTAR
FIBER-REINFORCED CEMENT BASE
CONCRETE WALL FOUNDATIONS

3 ALLOW AT LEAST 24 HOURS for the cement to dry, then mortar two courses of concrete blocks onto the foundations in the trench. As you go along, fill up the holes in the blocks with a stiffish concrete mix to give them additional strength. When the mortar has set, fill the space between the block wall and the surrounding soil with the same concrete mix (see inset).

SMOOTH FINISH
Use the edge of the trowel to remove any excess mortar.

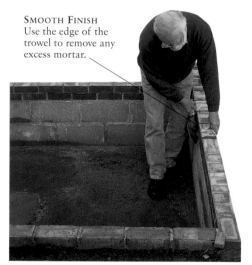

4 MORTAR TWO COURSES of house bricks onto the concrete blocks (see p. 69). Use a carpenter's level to check that each course is level, both vertically and horizontally. As you tap the bricks down with the trowel handle, scoop up the mortar that oozes out with the edge of the trowel. If this mortar is allowed to harden, you will be unable to achieve a smooth finish.

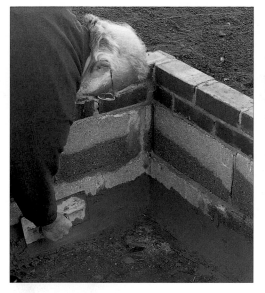

5 ALLOW 48 HOURS for the structure to harden, then, dampening each surface as you proceed, cover the floor and the insides of the walls with a ½in (1cm) layer of fiber-reinforced cement. To give the corners additional strength, build up a furrow where the base and side walls meet.

6 MORTAR THE COPING STONES onto the side walls so that there is a 2in (5cm) overlap on the inside of the pool; this will stop fish from leaping out and provide them with shade and shelter. The coping stones used here are brick-sized concrete paving blocks, laid sideways.

7 HAVING ALLOWED 48 HOURS for drying, brush the inner surfaces of the pool to remove any fine debris. Then paint the whole inside with a waterproof sealant for water gardens. This will prevent any impurities seeping from the cement rendering into the water (see pp. 136–137).

TRADITIONAL CONCRETE-LINED POOL USING FORMS

Without the use of a fiber-reinforced coating, the construction of a concrete pool is a skilled, labor-intensive task, involving the construction of wooden forms that create a mold into which concrete is poured to create the side walls. The base of the pool is formed by concrete poured over crushed stone; flexible wire mesh, sandwiched between two layers of wet concrete, provides extra strength. The wooden forms, erected inside the excavation and braced with wood, are sprayed with water to stop the concrete from sticking to the wood. Once wire mesh has been placed between the forms and the sides of the excavation, layers of concrete are poured in – and firmly tamped – until the walls reach the required height. When the concrete is dry the forms are removed.

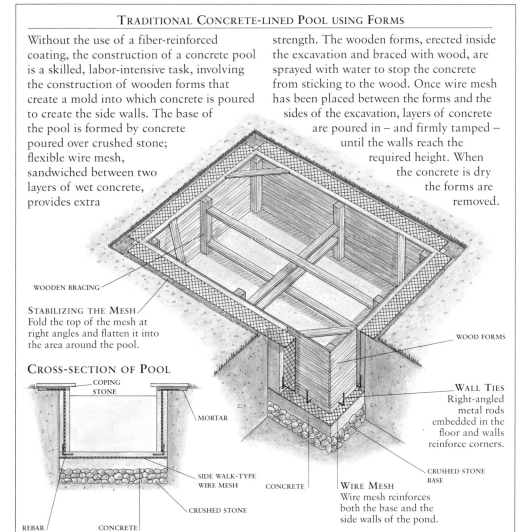

WOODEN BRACING

STABILIZING THE MESH
Fold the top of the mesh at right angles and flatten it into the area around the pool.

WOOD FORMS

CROSS-SECTION OF POOL

COPING STONE

MORTAR

SIDE WALK-TYPE WIRE MESH

CRUSHED STONE

REBAR CONCRETE

CONCRETE

WIRE MESH
Wire mesh reinforces both the base and the side walls of the pond.

WALL TIES
Right-angled metal rods embedded in the floor and walls reinforce corners.

CRUSHED STONE BASE

CONCRETE RESERVOIR POOL
This concrete pool serves as a reservoir for the water flowing down a shallow canal (see pp. 106–107). The water, circulated by a pump housed in a chamber alongside the pool (see p. 73), passes through a surface filter installed at the top end of the canal .

FURTHER INFORMATION

- Large Formal Pond – pp. 24–25
- Construction Tools and Materials – pp. 62–63
- Construction Techniques – pp. 64–69
- Raised Pools with Flexible Liners – pp. 86–87
- Concrete Canals – pp. 106–107

CLAY-LINED PONDS

IT IS RARE TO BE able to construct a truly natural pond, but lining an informal pond with gently sloping sides with a layer of compacted clay gives a near-natural effect. If the existing soil is unsuitable, clay may be bought in. Local clay is usually available at a very modest price; importing clay from a distance, however, is expensive. An excellent alternative is sodium bentonite, a powdered clay available from specialists,

NATURAL CLAY POND

which swells into a water-resistant gel when mixed with water. Bentonite also comes in the much more convenient form of a mat – bentomat – that can be laid in much the same way as flexible pond liner. All types of clay linings should always be completely covered with soil, which will both protect the clay and prevent it from drying out; the soil layer also forms a bed in which plants may spread informally.

USING NATURAL CLAY

If the existing soil is suitable (see right), then, once the hole is excavated, its surface must be very well compacted to make it watertight. This can be done with booted feet, with a heavy wooden post, or rented machinery. If the water table is high, a temporary sump (see p. 59) may be needed to drain away water as you dig and compact soil.

Constructing a clay pond simply involves lining a hole with a thick, well-compacted layer of clay. It is best to build up several thin layers, to at least 6in (10cm) thick on lighter soils. Excavate as for a pond with a flexible liner (see pp. 76–77). Remove all sharp stones or roots, and fork in a layer of bentonite; this deters tunneling animals. Either plaster the clay on by hand or with a flat piece of wood, compacting it thoroughly. For large ponds, it is worth hiring a mechanical roller to do the job. While lining the pond, you must keep the clay wet. Dip your hands in water regularly as you work. As areas are covered, either keep them moist with a sprinkler or cover temporarily with wet burlap. Then, add a 4in (10cm) layer of topsoil and fill the pond with water from a slowly trickling hose.

ASSESSING CLAY CONTENT IN SOIL

A site with soil that is sticky and pliable (as below) may be suitable for lining a pond. To test its suitability more accurately, place a small, sifted sample in a jar, adding water and a teaspoon of dishwasher detergent. Screw the lid on firmly and shake vigorously. Leave the jar undisturbed for at least two days (occasionally, it can take longer to obtain a satisfactory result), until the water has cleared and the soil particles have separated into individual layers of sand and clay. The sand will form the bottom layer, followed by a layer of clay, with organic matter floating on the surface. A suitable soil should have a clay content of approximately two-thirds.

TESTING SOIL CONSISTENCY
Roll and mold some dampened soil in your hand. If it is smooth, pliable, and sticky – holding together well (as above) – it has a high clay content.

PROBLEM SOILS

HARDPAN
This is a virtually impermeable layer of compacted soil. Since clay ponds are generally large, it is advisable to rent a mechanical digger if a hardpan is present.

BLUE MOTTLING
Blue mottling on the soil surface indicates waterlogged soil. It is a good soil for a clay pond, but plan for temporary drainage while work proceeds (see p. 59).

CLAY-LINED POND
All clay-lined ponds must be kept well filled with water at all times. Otherwise the clay will dry out and crack. Deep-rooted and vigorous plants are best kept in containers, or they will penetrate the clay lining, making holes and causing problems if they need to be lifted and thinned. Do not plant trees or shrubs at the water's edge; their roots can penetrate the clay and cause water loss.

DRYING HEAT
Cracks will develop in the clay if the water level drops and the sun dries out the soil.

SHALLOW-ROOTING PLANTS
Plants such as *Myosotis* or *Caltha* (right) can be planted directly in the layer of soil.

SOIL

CLAY

TREE ROOTS
Tree roots can penetrate the clay and cause the pond to leak.

TUNNELING ANIMALS
A layer of bentonite under the clay usually repels moles and worms.

WATER LILY
Vigorous plants can be container-grown to restrict spread.

WATERPROOFING WITH BENTONITE

Bentonite is a clay derived from fossilized volcanic ash and is sold in powdered crystal form or in the form of matting – bentomat – which, although heavy, is as easy to lay as flexible pond liner. In addition, unlike a clay lining, bentomat is not vulnerable to tunneling animals and most plant roots, as the geotextile that forms the base layer is thick and impenetrable.

LAYING BENTOMAT

On very light soils, or where several pieces of matting will overlap, additional waterproofing is advisable (see below). Spread loose bentonite over the surface of the excavation, till into the soil, and compact. Unroll the bentomat evenly over the excavation, as if laying a flexible liner. There should be as few wrinkles or creases as possible; if necessary, either make large, loose pleats or cut and overlap (see right) the matting. Cover the surface with a 12in (30cm) layer of topsoil. Slowly fill the pond with water – the moisture will soon penetrate the bentonite, causing it to swell and form an impermeable layer.

PLANTING A BENTOMAT-LINED POND

The sides of the excavation should not be steep; bentomat will sit more happily on a gentle slope, allowing plenty of informal marginal planting. You may wish to keep vigorous marginals and deep-water plants in containers to make regular maintenance, lifting, and division easier. Tiles prevent the crates from sinking into the soil and the roots escaping.

BENTONITE MATTING

Bentomat consists of bentonite granules sandwiched between two layers of geotextile. Bentomat is easy to handle and environmentally sound. It is ideal for lining large informal ponds, as pieces can be overlapped (see below) to cover an extensive area. Bentomat has a "right" and "wrong" side; always lay the non-woven side downward.

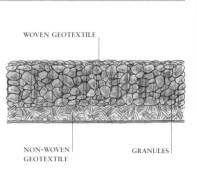

WOVEN GEOTEXTILE

NON-WOVEN GEOTEXTILE

GRANULES

JOINING BENTOMAT

To attach one piece of bentomat to another, spread a layer of bentonite granules onto the edge of the matting. Place the edge of the second piece over the granules, and press firmly. The granules will swell when wet, forming a watertight seal.

CAREX

CANDELABRA PRIMULA

ALISMA PLANTAGO-AQUATICA
Most non-invasive marginal plants need not be kept in containers.

CALTHA PALUSTRIS

EXTRA PRECAUTION
Fork or till loose bentonite into the soil below for extra waterproofing; the granules will swell and form an extra impermeable layer.

LAGAROSIPHON MAJOR

TUNNEL-RESISTANT
Moles are unable to burrow through bentomat.

BENTONITE GRANULES BENTOMAT SOIL

HARD-WEARING
Tree roots cannot penetrate bentomat.

CONTAINERIZED DEEP-WATER PLANT
Vigorous plants in deep zones, such as large water lilies, are easier to lift and divide if kept in containers.

CONTAINERIZED MARGINAL
Typha, Glyceria, and certain other marginals with sharp roots should be confined in crates.

LAYING BENTOMAT

Make sure that the hole is deep enough to accommodate both the required depth of water and the layer of topsoil that will cover the bentomat. Spread the bentomat over the base of the pond, extend it up the sides, and tamp down with boots or, over large areas, a roller. Finally, cover with a layer of topsoil.

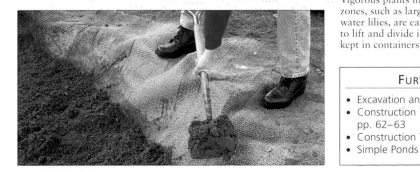

FURTHER INFORMATION

- Excavation and Drainage – pp. 58–59
- Construction Tools and Materials – pp. 62–63
- Construction Techniques – pp. 64–69
- Simple Ponds with Flexible Liners – pp. 76–77

WATER GARDENS IN CONTAINERS

ALTHOUGH LIMITED IN SIZE, containers make water gardening possible in very small gardens and on patios, verandas, and terraces. Even the most modest container, once planted, will quickly become a focal point, especially if it houses a small fountain. The addition of a couple of small fish transforms it into a fascinating feature for children. The only drawback container water gardens have is their

SUNKEN BARREL

susceptibility to rapid fluctuations in temperature; in summer the water can become extremely hot, and in winter, container gardens will freeze solid. Sink the container into the ground so that only 4–6in (10–15cm) remains visible above ground to insulate the water somewhat. In winter north of zone 9, move hardy plants and fish to a larger outdoor pool or overwinter them indoors.

CHOICE OF CONTAINER

Almost any container, from barrels and decorative urns to sinks and homemade hypertufa troughs (see facing page), can be used, as long as they are watertight. Earthenware pots should be glazed, and wooden barrels and tubs should be sealed; older, leaky barrels may also need a waterproof lining (see p. 78). A plastic dishpan makes an ideal, inexpensive miniature water garden that can be sunk into the ground, or surrounded by other containers, to disguise its unattractive exterior. A group of container water gardens makes a striking arrangement, particularly if one of the larger containers is used to house a small pump and fountain. The humidifying effect of the circulating water will benefit surrounding plants and keep the water fresh and sparkling; in containers without a fountain, submerged plants must always be included to keep the water clear. With the exception of this one essential, planting can be as varied as space permits.

WATERPROOFING A BARREL
Always clean tubs and barrels thoroughly. New ones will be watertight, but older ones may leak and require lining (see p. 79). In order to protect the wood and make sure any residues in the wood do not seep into the water, paint the insides of wooden containers with a commercial sealant safe for fish.

PLANTED BARREL
The plants in this barrel are in planting baskets, to prevent their roots from mingling. Marginal plants are placed on bricks or on empty upturned baskets to bring them up to the correct planting depth.

CONTAINER SHAPES
The most popular containers for miniature water gardens are barrels and glazed earthenware pots. To achieve the best effects, select containers with a wide neck, no narrower than 18–24in (45–60cm) across. The depth of the container need be no more than 15–18in (38–45cm).

GLAZED POT

CERAMIC POT

BARREL

EQUISETUM HYEMALE

ISOLEPIS CERNUA

ACORUS GRAMINEUS 'VARIEGATUS'

EICHHORNIA CRASSIPES

PISTIA STRATIOTES

MYRIOPHYLLUM AQUATICUM

VERONICA BECCABUNGA

MAKING A HYPERTUFA TROUGH

CONSTRUCTION GUIDE

To complete this step-by-step sequence, you will need:

TOOLS
- Paintbrush, spade, tamping tool, hammer, wide mason's chisel, wire brush

MATERIALS
- 2 wooden boxes made with inexpensive timber, one box 2–3in (5–7cm) bigger than the other
- Linseed oil
- Hypertufa mix: 2 parts peat substitute, 1 part coarse sand or grit, and 1 part cement made into a stiff mixture with water
- Wire netting: ¾in (2cm) mesh
- Plastic sheet, bricks or stones
- Commercial liquid manure

1 COAT THE INSIDE of the larger wooden box and the outside of the small box with linseed oil *(see inset)* to stop the hypertufa from sticking. Line the base of the larger box with 1in (2.5cm) of hypertufa mix. Put reinforcing wire netting over this layer and around the sides of the box.

COVERING A GLAZED SINK

Thoroughly score the outside and rim with a tile- or glass cutter, then coat with a bonding agent. Working from the bottom up, press hypertufa mix on to the sticky surface. To seal the drainhole, use a drain-plug and cover with waterproof sealant.

2 ADD ANOTHER LAYER of hypertufa to the base, then put the smaller box on top of the base. Make sure that the netting between the sides of the boxes is vertical, then pour hypertufa mix in the cavity between the boxes. To prevent air pockets from forming, keep tamping the mixture.

3 PROTECT THE TROUGH from sunlight, rain, and frost while the hypertufa sets. Do this by covering the top with plastic sheeting, securing it in place with bricks and stones. The hypertufa mix will form a strong shell if it is allowed to dry out slowly; a week or so should be sufficient.

4 WHEN THE MIX has set, use a wide mason's chisel to gently pry the outer, then the inner box free of the hypertufa. For a more natural look, roughen the outside of the trough with a wire brush, then paint it with commercial liquid manure to encourage moss and algae to grow.

PLANTED HYPERTUFA TROUGH

Even in this small trough, a good mix of marginal plants suited to the shallow water level can be included. Always choose some, like the Isolepis here, that will spill and trail down the sides of the trough, otherwise the plants will tend to look as if they are sharing a bath. On the trough's surface, algae and mosses will grow, encouraged by the peat in the hypertufa mix and a coating of liquid manure.

JUNCUS EFFUSUS 'SPIRALIS'

ZANTEDESCHIA AETHIOPICA 'CROWBOROUGH'

EQUISETUM HYEMALE

VERONICA BECCABUNGA

ISOLEPIS CERNUA

ACORUS GRAMINEUS 'VARIEGATUS'

FURTHER INFORMATION

- Container Gardens – pp. 26–27
- Construction Techniques – pp. 64–69
- Routine Plant Care – pp. 158–159

FEATURES WITH MOVING WATER

THE VISUAL EXCITEMENT and refreshing sound of moving water can enhance the smallest garden. Moving water is also beneficial to submerged life in creating additional oxygenation of the water. The range of pumps that is now available enables fountains, reservoir features, streams, and watercourses to be introduced in a wide variety of styles and sizes.

PLANNING AND INSTALLATION

Unless your garden encompasses a natural spring or stream, it will be necessary to create a feature where the water is mechanically recirculated. While gravity will carry water down a watercourse and over falls and cascades, you will need a pump in order to drive the water back to its supposed "source." Distance, gradient, and volume of water will influence the strength of pump that you require *(see pp. 70–73).*

A MILLSTONE
This reservoir feature makes an attractive and compact fountain that is simple to install and easy to maintain. A small pump is housed in the reservoir, which is hidden underneath the fountain.

SIMPLE SPILL STONE
Water trickles over moss-covered stones and then through boggy areas to give the impression of a woodland spring falling into a rocky hollow.

INFORMAL WATERCOURSE
This gentle slope with a cascading stream is enhanced by the use of flat-topped rocks along the sides. The areas immediately surrounding the rock stream are unplanted, allowing access to and over the water and creating the illusion of the stream having weathered the rocks through the years. The water itself is clear and inviting.

TIERED SPRAY

A fountain adds light, sound, and hypnotic movement to a water feature, especially when the sun is shining. Fountains originated in hot climates, where they provided refreshment from the heat. Illuminating a fountain with artificial lighting can be spectacular, especially where the light source highlights fine droplets.

Only the largest features need a pump that cannot be hidden underwater. Today's submersible pumps are small and silent, making them unobtrusive. The delivery pipe can be buried until it reaches the source or header pool. This can then be styled to disguise the water outlet *(see pp. 102–103)*.

INFORMAL STREAMS AND WATERFALLS

A simple stream is created by digging a shallow trench, which may be lined either with flexible liner *(see pp. 98–99)* or rigid units *(see pp. 104–105)*. With more ambitious designs, a stream may meander into a series of pools and waterfalls *(see pp. 100–101)*. In informal settings, make the watercourse as natural as possible by disguising the edges with plants or rocks. The speed of flow and appearance of cascades and falls can be adjusted by narrowing or widening the watercourse or by altering the pump's flow adjuster *(see pp. 70–73)*.

FORMAL CANALS AND FOUNTAINS

A formal watercourse consists of symmetrical lines and straight channels. Materials such as pavers are used for the edging *(see pp. 126–131)*. Canals *(see pp. 106–107)* may be installed in formal gardens, providing a refreshing focal point in hot, sunny situations. Fountains *(see pp. 108–111)* are good focal points and

come in a multitude of styles and sizes. There is a wide variety of sprays to choose from, including tiered and plume sprays, and geysers; a geyser is ideal for hot or windy climates.

SMALL MOVING WATER FEATURES

Small water features *(see pp. 112–117)* can be accommodated in very little space. No pool is necessary to install a reservoir feature such as a river rock fountain or a wall feature, where water falls from an ornamental spout into a basin below.

RECIRCULATING WATER SYSTEMS

The standard terms used below to describe the elements of a feature with recirculating water will help in the choice and purchase of materials.

WATERCOURSE

SPILL STONE

HEADER POOL

DELIVERY PIPE

PUMP

RESERVOIR POOL

SIMPLE STREAMS WITH WATERFALLS

ANY GARDEN CAN incorporate a stream with waterfalls, provided there is a slight change of level between the upper and lower pools. Even where the terrain has no natural incline, it is reasonably simple to create an artificial slope. In the example below, a rigid pool unit with a marginal shelf was already installed *(see pp. 84–85)*. A simple stream made with flexible liner was added to enhance the existing

THE ORIGINAL SITE

feature, using the rigid unit as a reservoir pool. The versatility of flexible liner makes it an obvious choice for the construction of informal streams. Light-weight liners made of butyl rubber, EPDM, or PVC are ideal for novices, because most mistakes can be rectified with some judicious tugging, packing, and filling. Rocks, pebbles, and plantings will disguise the liner and protect it from the damaging effects of sunlight.

CONSTRUCTING A STREAM

CONSTRUCTION GUIDE

To build this header pool and stream with waterfall into an existing pond, you will need:

TOOLS
- Stakes and string for marking, spade, shovel, rake, trowel, watering can or hose, carpenter's level
- Submersible pump

MATERIALS
- Flexible liner and underlay: 13ft x 6ft (4m x 2m)
- 40 large rocks (including spill stones, foundation stones, and retaining wall stones) weighing approximately 55–110lb (20–50kg) each
- Ready-mixed mortar: 8 bags, each weighing 80lb (36kg)
- 7 x 50lb (23kg) bags of smaller rocks

1 MARK OUT THE PROPOSED course of the stream, and the outline of the header pool *(see p. 64)*. Working up from the existing pool, dig out a long trench plus a backward-sloping header pool *(see illustration on facing page)*. Rake the areas to remove large or sharp stones.

2 PARTLY UNROLL THE flexible liner and drape one end over the edge of the pool. Make sure that the liner – although only partly unrolled – is correctly positioned over the excavation, and that there will be enough to overlap the sides of the stream once it has been pressed into the contours *(see pp. 76–79)*.

3 PLACE THE FOUNDATION stone on the marginal shelf in the pool; the stone should be hard up against the liner draped over the edge of the pool. If the foundation stone is not flat-bottomed, the pond will have to be drained and the stone mortared onto the base or marginal shelf.

4 PACK STIFF MORTAR between the foundation stone and the overlapping liner, then roll up the liner again until it is lying over the foundation stone *(see above)*. To further increase the stability of the foundation stone, pack stiff mortar between the liner and the earth bank.

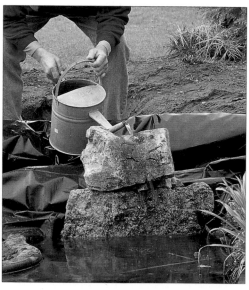

5 PARTLY UNROLL THE liner again. To make an unbroken fall of water into the pool below, place the spill stone on top of, and slightly over-lapping, the foundation stone *(see pp. 102–103)*. Check the flow pattern with a watering can or a hose, then mortar the spill stone in position.

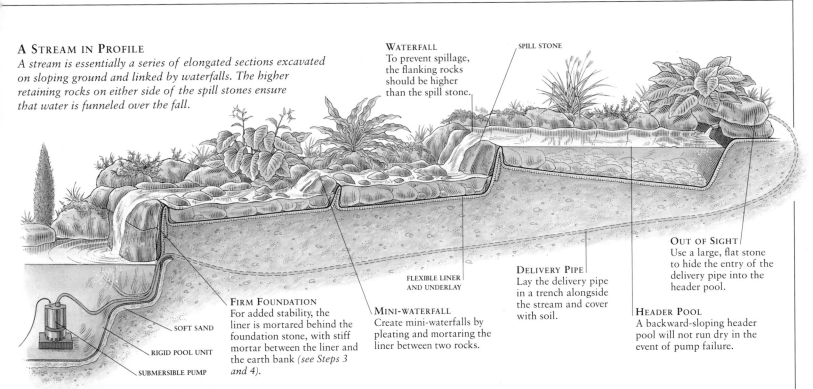

A STREAM IN PROFILE
A stream is essentially a series of elongated sections excavated on sloping ground and linked by waterfalls. The higher retaining rocks on either side of the spill stones ensure that water is funneled over the fall.

WATERFALL
To prevent spillage, the flanking rocks should be higher than the spill stone.

SPILL STONE

OUT OF SIGHT
Use a large, flat stone to hide the entry of the delivery pipe into the header pool.

DELIVERY PIPE
Lay the delivery pipe in a trench alongside the stream and cover with soil.

HEADER POOL
A backward-sloping header pool will not run dry in the event of pump failure.

FLEXIBLE LINER
AND UNDERLAY

MINI-WATERFALL
Create mini-waterfalls by pleating and mortaring the liner between two rocks.

FIRM FOUNDATION
For added stability, the liner is mortared behind the foundation stone, with stiff mortar between the liner and the earth bank *(see Steps 3 and 4)*.

SOFT SAND

RIGID POOL UNIT

SUBMERSIBLE PUMP

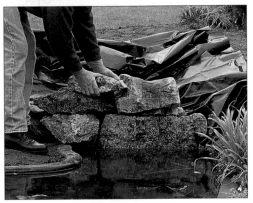

6 WHEN BUILDING UP the side walls, mortar the first layer of retaining rocks securely onto the liner before mortaring the others in place. To create a central channel for the flow of water over the waterfall, make sure that the rocks flanking the spill stone are higher than the spill stone itself.

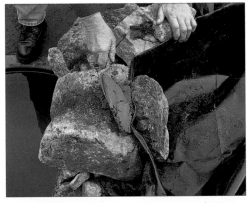

7 CHECK THE water flow again with a watering can or a hose. To prevent the seepage of water, pull the liner level with the top of the spill stone, then pleat and mortar it behind the stone. Next, wedge and mortar another stone behind the pleated liner to keep it in place.

CARPENTER'S LEVEL
Check that stream walls become gradually higher.

8 UNROLL THE LINER completely, and arrange large rocks along the outer edges of the stream and around the header pool. Check regularly to be sure the edges are level with a carpenter's level. Mortar down another spill stone at the header pool's outlet *(see pp. 102–103)*.

9 LOWER A SUBMERSIBLE pump *(see pp. 70–73)* into the reservoir pool and bury the delivery pipe, which will take the water up to the header pool, along the side of the stream. Use a large, flat stone to conceal the delivery pipe where it enters the header pool.

10 FOR ADDED AUTHENTICITY – and to hide the liner – place smaller rocks of mixed sizes and shapes on the floor of the stream. Fill soil pockets between the rocks with plants to soften the edging and emphasize the natural, informal design of the watercourse.

MORE IDEAS FOR STREAM CONSTRUCTION

ALTHOUGH THE BASIC PRINCIPLES of stream construction are quite straightforward, several factors should be considered if the stream is to be a complete success. For example, if you plan to create planting pockets, it is vital to make sure that the pump has sufficient output to maintain an adequate flow rate *(see pp. 70–73)*, and that the reservoir pool is big enough to supply both the header pool and the boggy soil. If the reservoir pool is too small, there will be a dramatic fall in the level of water as it circulates around the system. This will both endanger plants and water life and mar the visual appeal of the feature. For best results, the surface area of the reservoir pool should be approximately equal to or more than the total surface area *(see pp. 60–61)* of the rest of the water feature.

WORKING WITH THE SITE CONTOURS

When determining the course of any informal stream, try to work with the natural contours of the site, especially when deciding the best place for any change of direction or drop in height. A gently meandering stream *(see below)* can be created by using a single broad strip of liner; curved channels can be created for the water by mortaring rocks onto the liner. The outer areas can then be filled with soil to give the appearance of natural banks.

A STAIRCASE OF STONE
Although the principles of stream construction are always the same, the steeper the site of the stream, the more dramatic the effect. Using attractive spill stones for the falls will give the feature added charm.

CREATING AREAS FOR STREAMSIDE PLANTING
In a wide, liner-covered trench, create a stream by mortaring two rows of retaining rocks onto the liner, which will act as a channel for the water. Fill bordering areas with soil for streamside planting.

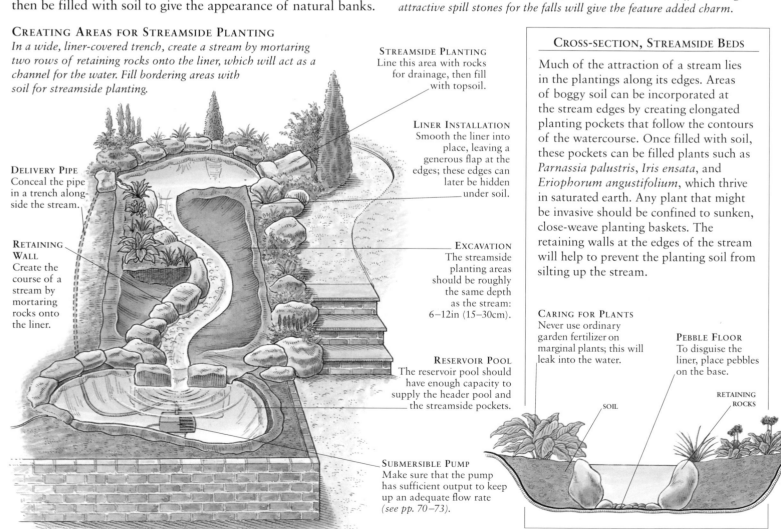

STREAMSIDE PLANTING
Line this area with rocks for drainage, then fill with topsoil.

LINER INSTALLATION
Smooth the liner into place, leaving a generous flap at the edges; these edges can later be hidden under soil.

DELIVERY PIPE
Conceal the pipe in a trench alongside the stream.

RETAINING WALL
Create the course of a stream by mortaring rocks onto the liner.

EXCAVATION
The streamside planting areas should be roughly the same depth as the stream: 6–12in (15–30cm).

RESERVOIR POOL
The reservoir pool should have enough capacity to supply the header pool and the streamside pockets.

SUBMERSIBLE PUMP
Make sure that the pump has sufficient output to keep up an adequate flow rate *(see pp. 70–73).*

CROSS-SECTION, STREAMSIDE BEDS

Much of the attraction of a stream lies in the plantings along its edges. Areas of boggy soil can be incorporated at the stream edges by creating elongated planting pockets that follow the contours of the watercourse. Once filled with soil, these pockets can be filled plants such as *Parnassia palustris*, *Iris ensata*, and *Eriophorum angustifolium*, which thrive in saturated earth. Any plant that might be invasive should be confined to sunken, close-weave planting baskets. The retaining walls at the edges of the stream will help to prevent the planting soil from silting up the stream.

CARING FOR PLANTS
Never use ordinary garden fertilizer on marginal plants; this will leak into the water.

PEBBLE FLOOR
To disguise the liner, place pebbles on the base.

SOIL

RETAINING ROCKS

EXTREME CHANGES OF DIRECTION

When constructing a stream of any kind, always work upward from the reservoir pool. If a meandering watercourse is made with one piece of liner, the liner will have to be folded to incorporate changes of direction *(see pp. 66–67)*. If the stream is to include waterfalls and extreme changes of direction, however, separate pieces of liner may have to be used *(see below)*. Once the overall route has been marked out, you need to decide where the waterfalls are to be sited, since the watercourse should narrow considerably at these points. Where these narrow sections do occur, full use of the width of the liner can be made by incorporating adjacent planting beds.

In measuring for each length of liner, make allowances for an overlap at the end of each section. Measure the length between each waterfall, and the depth of the stream behind the waterfall at the downstream end where the liner will have to overlap another piece of liner *(see below)*. The liner should be long enough to extend above the waterline at the upstream end, where it will be overlapped by the next piece of liner. Once the liner is in position, the rocks that make up the retaining walls of the stream can be mortared onto it. The top of each waterfall spill stone should be high enough to retain at least 4–6in (10–15cm) of water in the stream behind it; this will prevent underwater creatures from being stranded when the pump is switched off. The edges of the stream can then be built up. The edges should be fairly level and at least 2in (5cm) higher than the top of the spill stone; this will ensure that the recirculating water is contained within the system rather than flooding over the sides.

COPING WITH SEASONAL EVAPORATION

Even the most carefully constructed water feature may need filling up, particularly in warm months when evaporation from water surfaces, rocks, and boggy soil takes place. This loss can be replaced with water from a water addition float valve or with tap water trickling from a garden hose *(see pp. 138–139)*. Replace water regularly, rather than leave it until the level is low enough to avoid harming fish and plants.

USING SEVERAL PIECES OF LINER

If a water feature has sharp changes of direction, it can be awkward as well as unnecessarily expensive to use a single piece of liner. Using several overlapping pieces of liner of different lengths and widths will eliminate the problem of difficult folds and will frequently reduce the amount of wasted liner.

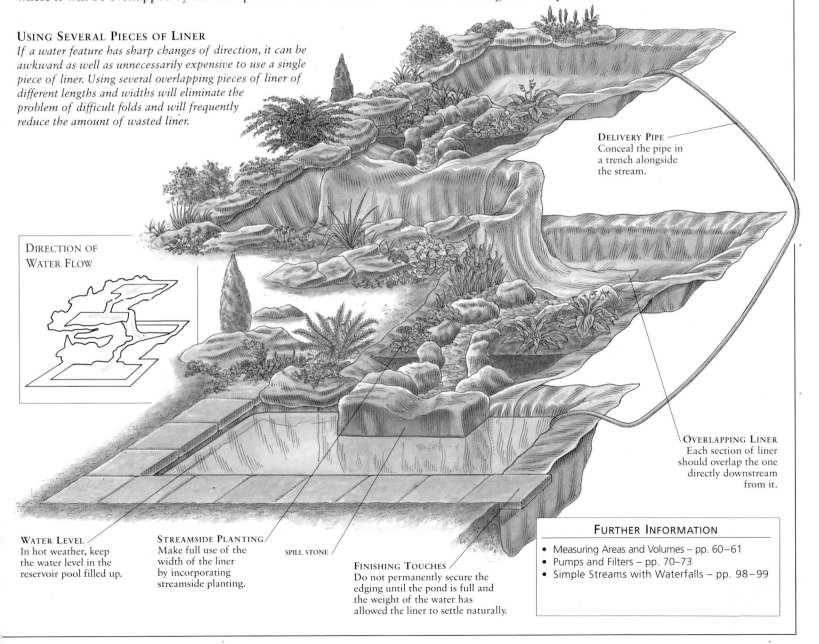

DIRECTION OF WATER FLOW

DELIVERY PIPE
Conceal the pipe in a trench alongside the stream.

OVERLAPPING LINER
Each section of liner should overlap the one directly downstream from it.

WATER LEVEL
In hot weather, keep the water level in the reservoir pool filled up.

STREAMSIDE PLANTING
Make full use of the width of the liner by incorporating streamside planting.

SPILL STONE

FINISHING TOUCHES
Do not permanently secure the edging until the pond is full and the weight of the water has allowed the liner to settle naturally.

FURTHER INFORMATION

- Measuring Areas and Volumes – pp. 60–61
- Pumps and Filters – pp. 70–73
- Simple Streams with Waterfalls – pp. 98–99

HEADER POOLS AND SPILLWAYS

BOTH FORMAL AND INFORMAL watercourses usually terminate in a pond. The pump, which is either in or next to the reservoir pool, draws water from it, sending it up to the head of the feature. At this point the delivery pipe fills a smaller reservoir of water, known as the "header pool," which brims over into the watercourse. This gives a much better effect than if the pipe simply discharges into the start of a channel. The header pool may be concealed, with water spilling out of a culvert, or styled to match the rest of the feature. The header pool, and any intermediate pools along a watercourse, should always be deep enough to retain water when the pump is off.

POSITIONING THE DELIVERY PIPE

Make sure that the end of the delivery pipe is above the water level of the header pool so that it does not siphon water back as soon as the pump is turned off. If it is necessary to keep the end of the pipe under water, a non-return valve should be fitted at a convenient point in the delivery pipe to prevent siphon action (see Preventing backflow, p. 73).

INFORMAL STYLING

Informal header pools and streams are generally flanked by rocks of different sizes and shapes in order to retain surrounding soil and to direct the water along the watercourse. Use more rocks than are necessary; additional stones placed around the

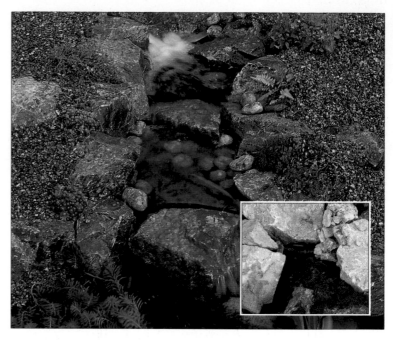

INFORMAL STREAM WITH CHANGES OF LEVEL
The delivery pipe in the header pool is disguised with a pile of large stones and smaller pebbles to fill the gaps (see inset), and the flow adjusted so that water ripples out over the rocks. Flat-topped stones are placed in the stream to create shallow spills of water that are no more than 3–4in (7–10cm) high and achieve a natural effect.

CASCADING WATERFALL

INTERRUPTED FLOW
By using an uneven spill stone that is wider at the bottom than it is at the top, it is possible to create a cascading waterfall, rather than an unbroken curtain of water. It is also possible to create a cascade by using several rocks, each set back slightly from the one below, so that the water spills downward in an uneven way.

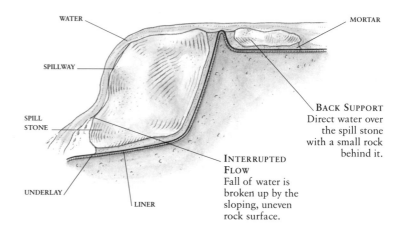

WATER · MORTAR
SPILLWAY
SPILL STONE

BACK SUPPORT
Direct water over the spill stone with a small rock behind it.

INTERRUPTED FLOW
Fall of water is broken up by the sloping, uneven rock surface.

UNDERLAY · LINER

CURTAIN OF WATER

UNBROKEN FLOW
Here, the spill stone projects outward over the fall to produce an unbroken curtain of water. A wide stone set just below the water level to produce a broad film of brimming water is most attractive. Few natural stones jut out this way, so a foundation stone is usually used, with a flat stone mortared on top of and overhanging it.

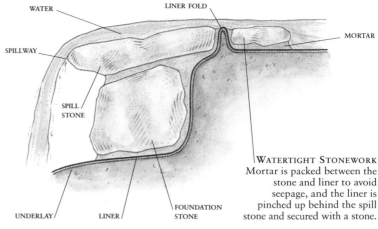

WATER · LINER FOLD
SPILLWAY · MORTAR
SPILL STONE

WATERTIGHT STONEWORK
Mortar is packed between the stone and liner to avoid seepage, and the liner is pinched up behind the spill stone and secured with a stone.

UNDERLAY · LINER · FOUNDATION STONE

sides and upstream of the source will create a more natural effect, which planting will enhance. The shape and arrangement of stones at spill points will determine whether the water descends in a free-falling curtain or cascading rivulets. For the latter, use a garden hose to judge the effect, and reposition stones as necessary before finally mortaring them down.

FORMAL SPILLWAYS

The simplest way of constructing a formal fall of water from a reservoir pool into a canal or another pool is to use a flat paver or tile as an overlapping spill stone: this method is ideal for a split-level pool *(see pp. 106–107)*, where water falls from one level to another over a common dividing wall. In order to construct the spillway, a gap is left in the last course of stone to take the flat spill stone. Any overlapping liner can be tucked under the spill stone. The stone must be precisely horizontal for the effect to be achieved: use a carpenter's level across both axes of the stone. The wall can be built up and around and over the spillway to form a formal culvert *(see below)*.

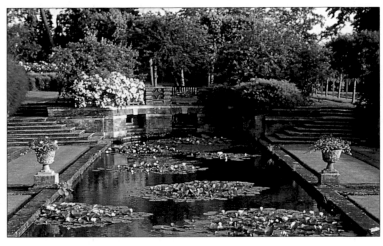

LARGE-SCALE FEATURE
Even when not in use, formal culverts can add a note of classical grandeur. Here, they have been integrated into a double stairway leading down to a broad pool. Remember that for water lilies to thrive in the vicinity of waterfalls, the flow must be little more than a gentle trickle.

FORMAL CULVERT

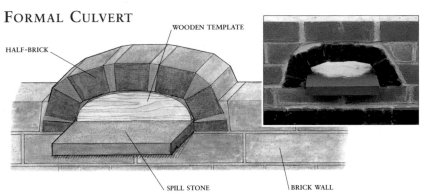

CONSTRUCTING A CULVERT IN A WALL
Culverts allow water to flow out from concealed header pools that are ideal housings for filter boxes (see p. 73). In order to construct a culvert, a wooden template is shaped to the internal measurements of the opening and laid onto the tile mortared on the course of bricks that will support the spillway. Bricks can then be cut and laid to form the arched shape within the next two courses. After about two days, when the mortar is completely hard, the template can be tapped out.

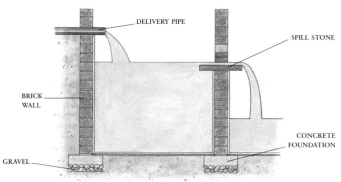

FORMAL HEADER POOL
Even if concealed, a header pool provides a more convincing flow of water than simply positioning the delivery pipe to discharge through a hole in a wall. Careful adjustment of the flow is necessary to be sure that water just brims over the spill stone. The pool's delivery pipe is set at a higher level than the spillway to prevent siphoning back when the pump is turned off.

RECIRCULATING FEATURE

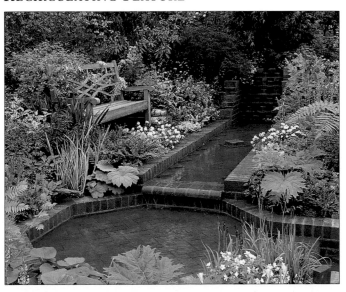

FORMAL SPILLWAYS
In this formal feature, water falls from a raised reservoir through gaps in the top course of bricks. To interrupt the flow and create a splashing cascade rather than a smooth fall, the wall has been built with bricks protruding at intervals. Rounded bricks provide gentle, smooth spillways in this series of coordinated shallow drops. The same type of brick has been used for all the surfaces – edging, spillways, and the base of the canal. Warm-toned terra-cotta, with plants softening the edges, prevents a severe effect.

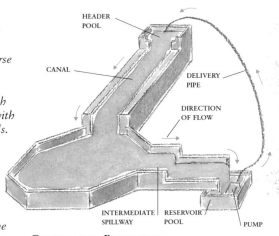

CONCEALED PLUMBING
The reservoir pool can be concealed beneath a path, suggesting an ongoing system of canals rather than a small recirculating feature.

RIGID STREAM UNITS

MOST PREFORMED RIGID stream units provide a relatively easy way to create a stream and a series of waterfalls. Installing fiberglass rigid units is simpler, for example, than making a stream with flexible liner (*see pp. 98–101*). Once units are purchased, hardly any other materials are necessary, although some extra rocks can help blend the feature into its surroundings. Rigid units come in different sizes,

STREAM UNITS IN PLACE

materials, and finishes, including textured rock. Most units are made of fiberglass, which gives them resistance to damaging ultraviolet light. In addition to the bolted type (*see facing page*), units also come in PVC and vacuum-formed plastic molds, which are cheaper but have a limited life. A combination of units can include "connecting" units that link header pools, waterfalls, and miniature rock pools.

INSTALLING FIBERGLASS RIGID STREAM UNITS

CONSTRUCTION GUIDE

To install these rigid stream units (*dimensions given below*) above an existing pond with a submersible pump, you will need:

TOOLS
- String and stakes
- Spade, shovel
- Carpenter's level, straightedge
- Tamping block

MATERIALS
- Soft sand or sifted soil: ½cu yd (0.5cu m)
- 15ft (5m) delivery pipe with flow adjuster
- Topsoil, rocks, and plants

1 AFTER MARKING OUT THE SITE, work from the bottom up and dig a shallow trench with a slight backward slope. Set the first unit on soft sand or sifted soil, its lip slightly overlapping the edge of the pond.

OVERLAPPING OUTLETS
Each section's outlet should overlap the unit below it.

2 REPEAT THE PROCESS up to and including the header pool. The lip of each unit, including that of the header pool, should overhang the unit below it. Hide the delivery pipe in a 6in (15cm) trench alongside the stream.

3 FIRM IN THE UNITS with tamped soft sand or sifted soil, then add a layer of topsoil and some surrounding rocks. Use a flat rock to hide the delivery pipe entering the header pool, then turn on the pump to check the flow of water. Use the flow adjuster to achieve the desired effect.

WATERCOURSE CONSTRUCTED WITH RIGID STREAM UNITS

The addition of randomly placed rocks and plants is the key to making preformed units blend in with their surroundings. The layer of soft sand or sifted soil and the free drainage afforded by the slope make the site ideal for many alpine plants, which look good among rocks.

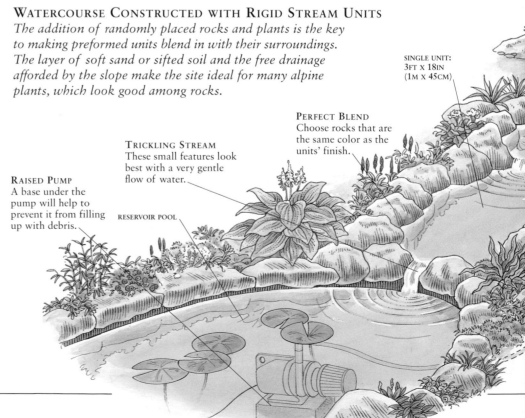

SINGLE UNIT:
3FT X 18IN
(1M X 45CM)

PERFECT BLEND
Choose rocks that are the same color as the units' finish.

TRICKLING STREAM
These small features look best with a very gentle flow of water.

RAISED PUMP
A base under the pump will help to prevent it from filling up with debris.

RESERVOIR POOL

INSTALLING BOLTED RIGID UNITS

Bolted rigid units in regular shapes are available in Great Britain, but not yet in Canada and the United States. They are particularly suited to more formal gardens and can be used to construct interlocking pools at different heights. Cladding with a variety of finishes is available to disguise the connecting plates. Once installed, the units make a more permanent feature than smaller and lighter preformed units, so be sure to create level and stable foundations for them. When excavating, always allow extra depth for a 2in (5cm) layer of sand.

DURABILITY AND PERMANENCE

Strong interlocking and bolted rigid units are not only extremely stable, they are also much less prone to being damaged by soil settling. They are, however, a great deal heavier and sturdier than preformed fiberglass or plastic units and are subsequently more difficult to install. It is advisable, therefore, to enlist the help of at least one other person when lifting, positioning, and backfilling around the units.

Because of their size and bulk, more skill will be required in disguising the hard edges of the units. Since they completely contain the water, no moisture will seep into the surrounding ground. A combination of quick-growing carpeting alpines and small shrubs that tolerate the dry, well-drained soil along the perimeter of the stream will help to integrate the feature into its surroundings. Alternatively, you may use flexible liner to make independent boggy areas (see pp. 82–83).

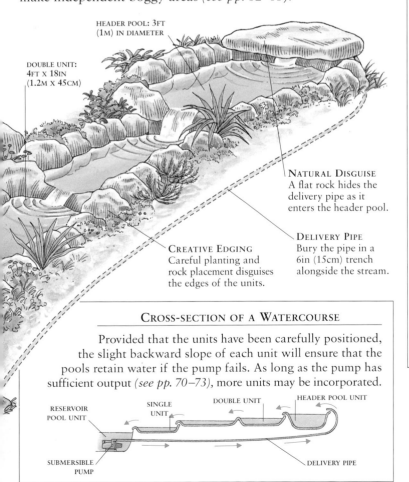

HEADER POOL: 3FT (1M) IN DIAMETER

DOUBLE UNIT: 4FT X 18IN (1.2M X 45CM)

NATURAL DISGUISE
A flat rock hides the delivery pipe as it enters the header pool.

DELIVERY PIPE
Bury the pipe in a 6in (15cm) trench alongside the stream.

CREATIVE EDGING
Careful planting and rock placement disguises the edges of the units.

CROSS-SECTION OF A WATERCOURSE

Provided that the units have been carefully positioned, the slight backward slope of each unit will ensure that the pools retain water if the pump fails. As long as the pump has sufficient output (see pp. 70–73), more units may be incorporated.

RESERVOIR POOL UNIT · SINGLE UNIT · DOUBLE UNIT · HEADER POOL UNIT

SUBMERSIBLE PUMP · DELIVERY PIPE

MAKING A WATERCOURSE WITH BOLTED RIGID UNITS

1 AT THE EDGE OF the pond, here made with flexible liner (see pp. 76–79), dig out a platform for the first unit. Spread 2in (5cm) of soft sand or sifted soil over the base and check that it is level.

2 REMOVE THE UNIT, bolt it to the plate forming the fall, and seal the joins with silicone sealant. Install the unit, making sure it is level. Backfill behind the plate when excavating the header pool.

3 LINE THE BASE of the header pool with soft sand or sifted soil. Bolt its unit to the top of the vertical plate and seal the joins. Check that the unit is level, then backfill around it.

4 INSTALL A SUBMERSIBLE PUMP in the reservoir pool. Connect one end of a delivery pipe to the pump, and bring it up to the header pool, burying it alongside the watercourse.

5 SNAP INTO PLACE the textured cladding, then disguise the edges of the units by placing stones along the edges. Stones placed beneath the lip of the lowest unit will effectively camouflage the flexible liner used in the reservoir pool. Two large, flat stones will also disguise the entry and exit points of the delivery pipe.

FURTHER INFORMATION

- Pumps and Filters – pp. 70–73
- Simple Ponds with Flexible Liners – pp. 76–79
- Simple Streams with Waterfalls – pp. 98–99
- Edging Materials – pp. 126–129

CONCRETE CANALS

STRAIGHT, SHALLOW CANALS of moving water, whether sunken, semi-raised, or completely raised, are ideally suited to flat terrain in formal settings *(see pp. 56–57)*. Canals can be of practical use – forming the boundary of a garden, or linking a formal garden to the more "natural" landscape around it – or they can be purely ornamental. The formal impact of a canal can be heightened by flanking it with symmetrical

FORMAL CANAL

plantings – perhaps of columnar evergreens or trained standards of bushes and trees. The canals themselves are best left free of plants. Bear in mind that the longer a concrete canal, the greater the risk of cracking caused by earth movements. The method shown here uses a skimming of strong but flexible reinforced cement to line the canal, greatly reducing the risk of such damage.

CANAL LINKED TO RESERVOIR POOL

This feature is enhanced by its clear water and by the fact that its workings are concealed. A filter is housed in the upper brick chamber with culvert (see p. 73), *while a surface pump sits in a ventilated chamber* (see pp. 102–103) *to the left of the lower cascade.*

CROSS-SECTION OF A FORMAL CANAL

The decorative pavers used as edging for this canal stand above the surrounding brick-paved area, giving the feature a semi-raised effect. Skimming the floor and walls with a ½in (1cm) layer of cement mixed with coarse sand and reinforcing fibers creates a crack-resistant waterproof lining. Drain concrete canals for winter in northern areas where they will be damaged by freezing weather.

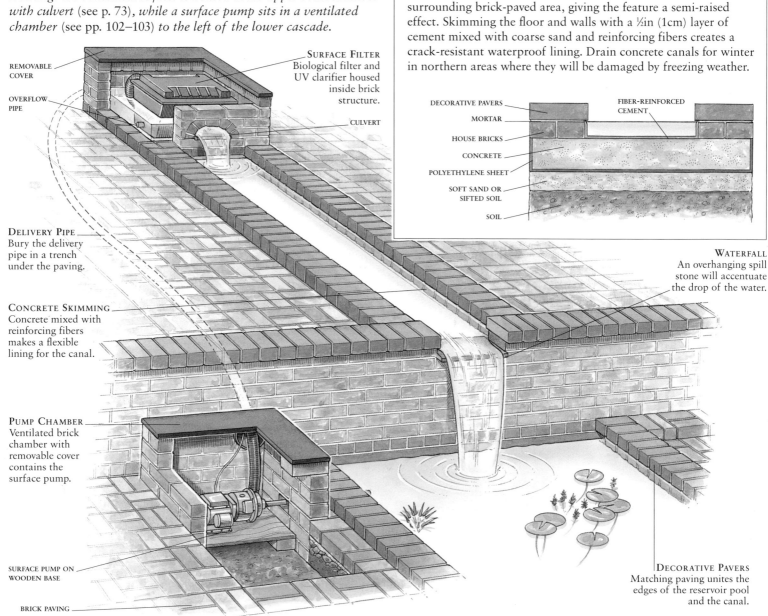

REMOVABLE COVER

OVERFLOW PIPE

SURFACE FILTER
Biological filter and UV clarifier housed inside brick structure.

CULVERT

DELIVERY PIPE
Bury the delivery pipe in a trench under the paving.

CONCRETE SKIMMING
Concrete mixed with reinforcing fibers makes a flexible lining for the canal.

PUMP CHAMBER
Ventilated brick chamber with removable cover contains the surface pump.

SURFACE PUMP ON WOODEN BASE

BRICK PAVING

DECORATIVE PAVERS
MORTAR
HOUSE BRICKS
CONCRETE
POLYETHYLENE SHEET
SOFT SAND OR SIFTED SOIL
SOIL

FIBER-REINFORCED CEMENT

WATERFALL
An overhanging spill stone will accentuate the drop of the water.

DECORATIVE PAVERS
Matching paving unites the edges of the reservoir pool and the canal.

MAKING A CONCRETE CANAL

CONSTRUCTION GUIDE

To build the 8ft (2.5m) x 16in (40cm) concrete canal illustrated *(facing page)* you will need:

TOOLS
- Marking stakes, string, spade, straightedge, level, thin straight plank, pointed trowel, plasterer's trowel

MATERIALS
- Soft sand: ½cu yd (0.5cu m)
- Heavy-duty polyethylene sheet: 8ft (2.5m) x 24in (60cm)
- Concrete: 80lb (36kg) cement; ⅔cu yd (⅔cu m) sand; 330lb (150kg) aggregate
- Mortar: 50lb (23kg) cement; ⅙cu yd (⅙cu m) sand
- Cement rendering: one 18oz (0.5kg) bag reinforcing fibers; 55lb (25kg) cement; ½cu yd (0.5cu m) sand
- 44 house bricks; 48 decorative pavers
- Commercial water sealant

HEAVY-DUTY POLYETHYLENE SHEET

1 MARK OUT THE LENGTH AND WIDTH of the proposed canal. Excavate the area to a depth of 8in (20cm), which includes 2in (5cm) for a lining of soft sand. Rake the sand and check that the site is absolutely level, then line the floor and walls with the polyethylene sheet.

CIRCULATING WATER IN CANALS

Canals rely on pumps to push water along their length, and not on slope; they must be built on level ground, or they will empty too rapidly. The delivery pipe from the pump can discharge into either a header pool or, as shown on the facing page, a concealed brick chamber from which the water emerges via a formal conduit *(see pp. 102–103)*. An enclosed chamber can also be used to house a filter box *(see p. 73)*. It is important to make sure that the pump has sufficient output to maintain an unbroken fall into a reservoir pool *(see pp. 70–73)*.

2 LAY THE FOUNDATION by pouring a 2in (5cm) layer of concrete on to the polyethylene sheet, then firming and leveling it. Use a straightedge and a carpenter's level to check that the sides of the excavation are at exactly the same height. Consolidate the foundation by tamping it down and leveling it with a straight plank.

LEVEL FOUNDATION
Level the concrete with a thin straight plank.

3 ALLOW TWO DAYS for the concrete to harden. Then construct the sidewalls by first mortaring a course of house bricks *(see p. 69)* onto the foundation. Check regularly to ensure that the bricks are level. Mortar the decorative pavers at right angles on top of the bricks. Move the string guide to help lay the pavers overlapping the inside edge of the canal by 2in (5cm).

4 ONCE THE MORTAR HAS SET, use a plasterer's trowel to skim the floor and walls of the canal with the cement rendering mix containing the reinforcing fibers. This forms the canal's watertight lining, so ensure that coverage is complete, particularly up under the decorative pavers. When the skimming is completely dry, paint on a coat of sealant for a water garden to prevent harmful chemicals from seeping from the cement mix into the water and having an adverse effect on fish and plant life.

CANALS LINKING RESERVOIR FEATURES

CANAL IN A GARDEN SETTING
Formal canals need not be associated with paving to have impact. This arrangement of narrow, turf-edged canals linking three sunken reservoir pools, each with its own fountain, culminates in a recessed urn flanked by pergolas.

FURTHER INFORMATION

- Siting Water Features – pp. 56–57
- Construction Tools and Materials – pp. 62–63
- Construction Techniques – pp. 64–69
- Pumps and Filters – pp. 70–73
- Concrete-lined Pools – pp. 90–91

FOUNTAINS

FOUNTAINS DATE BACK to antiquity, and
their design can range from elaborate
displays of hydraulic technology and
ornamental stonework to a simple spray of
water playing on the surface of a pool. In
today's climate of eclectic and individualistic
design, fountains can be installed in order to embellish
all types of water garden, providing movement, sound,
and refreshment in a range of styles. Fountains all work
in the same way; the fountain head is
connected to an electric pump, which drives
water through the head, creating a spray.
There are a range of fountain nozzles that
will produce different spray patterns; the
height of spray will depend on the power of
the pump. In addition to their ornamental attraction,
fountains also have practical value – in creating water
movement they produce oxygen, beneficial to pond life.

FOUNTAIN IN POSITION

INSTALLING FOUNTAINS

The simplest fountains discharge water from a vertical rigid pipe
leading off a submersible pump, which sits on a base at the
bottom of the pond. The pump may be disguised within
an ornamental housing. For larger pools, it may be more
convenient to site the pump close to the poolside *(right)*,
using a delivery hose to connect it to the fountain.

SIMPLE PUMP INSTALLATION
*The easiest method of installing a fountain is to place a pump
on a base in the center of the pond, using a vertical discharge
pipe with a fountain jet. Do not place certain plants too close –
water lilies and free-floaters are disturbed by water movement.*

REMOTE PUMP INSTALLATION

If you wish the pump to be within easy reach for
maintenance, install it at the edge of the pond. The
pump can be concealed by
extending the pond edging
to include an overhanging
paving stone.

FOUNTAIN JET
The pump need not
be directly beneath
the nozzle.

INSTALLING A PUMP IN A SMALL FOUNTAIN ORNAMENT

1 TO INSTALL A SUBMERSIBLE pump inside the
base of an ornamental fountain, first remove
the top section, place the pump inside, and
thread the cable through one of the several
openings. Then attach a short length of hose to
the pump's outlet and secure with a hose clip.

2 INSIDE THE ORNAMENTAL fountain there will
be an integrated, rigid pipe. Using another
hose clip, join this to the hose from the pump
outlet. Then set the top half of the ornament
securely onto the base and test the flow rate,
altering it by using the flow adjuster if necessary.

SAFETY PRECAUTIONS

A fountain may be connected to the main
electrical supply with a waterproof switch
box at the poolside. Or, a waterproof
cable connector can be used, which in
turn is connected to a standard switchbox
inside. Except where the system is extra
low-voltage, it should
be protected by a
circuit breaker and
ground fault
interrupter (GFI).

**WATERPROOF
SWITCHES**
*You must use equipment
designed for outdoor use.*

SPRAY PATTERNS

A standard fountain kit consists of a pump, a rigid pipe, and a nozzle. The spray pattern is affected by the size and placing of holes in the nozzle. Standard nozzles may be connected directly to the pipe; use adaptors to connect more complicated nozzles. The flow adjuster controls the height and width of spray. For spray heights of up to 4ft (1.2m) a small submersible pump; to 7ft (2.2m), a larger submersible pump; over 7ft (2.2m), a high-head exterior pump may be required.

BELL-JET NOZZLE

FOUNTAIN JET
The nozzle should be removed regularly and cleaned with vinegar.

RIGID PIPE
The fountain pipe is usually made of plastic or PVC.

BELL JET
A specially designed nozzle produces a thin, hemispherical film of water that causes little water-surface disturbance.

SINGLE SPRAY NOZZLE

T-PIECE
This enables water to be directed sideways if desired.

FLOW ADJUSTER
This controls the water flow to the fountain.

TWO-TIERED SPRAY NOZZLE

SUBMERSIBLE PUMP
The height and width of fountain spray depends on the power of the pump.

TWO-TIERED SPRAY
By altering the design arrangement and size of the holes in the nozzle of a single spray fountain, it is possible to produce a tiered effect.

SINGLE SPRAY

A single spray pattern can be accommodated in a small pool and can be achieved with a standard nozzle. The narrower the delivery pipe, the higher the spray will lift.

HOW A FOUNTAIN WORKS

The pump sucks water through an inlet pipe and pushes it out through the fountain's rigid pipe to a fitted jet, or to a remote jet via a delivery pipe (see p. 108).

DIFFERENT TYPES OF FOUNTAIN SPRAY PATTERNS

SIMPLE SPRAY
This is the simplest and cheapest of all fountain sprays and suits simple ponds better than the more elaborate types of spray such as a tiffany jet.

ROTATING NOZZLE
To create a whirling effect, pressure from the pump forces the arms of the fountain jet to rotate in a way similar to that of a water sprinkler.

TIERED EFFECT
By arranging the position and size of the holes in the nozzle of a basic surface jet (see left), the spray will reach different heights and tiers.

DOUBLE DOMES
This combines the design of the bell jet fountain and a surface tiered jet to create the effect of a fountain within a fountain.

COLUMN OF WATER
This is a popular fountain for exposed, windy sites, where the dense foaming plume is less likely to be broken up by wind than fine-spray fountains.

SURFACE JET

WHIRLING SPRAY

THREE-TIERED SPRAY

TIFFANY JET

GEYSER FOUNTAIN

CHOOSING FOUNTAIN STYLES

Perhaps more than any other feature, fountains can be used not only for their refreshing effects and inherent beauty but also to influence the style and mood of water in the garden.

STYLES OF FOUNTAIN IN ISLAM

In Islamic gardens attention was focused on the appreciation of water itself. The early technology of fountain design aimed to make minimal disturbance of the natural environment, making the garden a place of contemplation. Elsewhere, simple arching sprays used over long canals drew the eye toward beautiful examples of architecture without ornamental distraction.

FOUNTAINS IN MOGUL INDIA

Innovative fountain technology was taken a stage further in the gardens of Mogul India, where gardens were often associated with places of worship. Many of these gardens used fountain jets in retaining walls, forming chutes of sparkling water flowing into long formal pools beneath. Water pressure was harnessed from reservoirs in surrounding hills: the ample supply enabled water to animate every aspect of these exceptional gardens.

FOUNTAINS TO THE PRESENT

In the more formal approach to gardens in the Renaissance, fountains were sculptural, surrounded by symmetrical pools. As the naturalistic design movement gathered momentum during the 19th century, fountains became less widely used.

FINE, SINGLE SPRAY
An element of formality accents an otherwise informal garden, where the circular outline of the pool lends itself to the fine single spray of a tall fountain. Its height is about equal to the pool's width. In exposed sites, height should not exceed half the pool's diameter.

SIMPLE SPOUT
This type of single fountain spout works in both formal and informal settings. It is best suited to a formal design, as here, where a circular pool is surrounded by clear grass and tightly clipped, specimen yews. The spout is formed by a single jet that is wide enough to release a substantial column of water. This type of fountain must be absolutely vertical; any slight variation would ruin its effect.

FOUNTAIN ORNAMENT
This traditional fountain ornament is perfectly proportioned for this formal pool, edged with decorative half-bricks. The pool is sufficiently large for the turbulence created by the fountain to be limited to the central area, allowing water lilies to thrive nearer the edge. The piping from the pump is hidden inside the base column and statue. The rate of flow is perfectly adjusted so that the water neither drifts away from the pool nor breaks up into small rivulets.

Moving water was more commonly featured in stream, grotto, and waterfall arrangements that convincingly mirrored nature, often with awesome arrangements of boulders.

In the present day, however, good garden design and water features are no longer the preserve of the wealthier classes and are less dominated by prevailing fashions and trends. As a result, there is an enormous range of fountain equipment in "antique," international, and modern styles to complement any garden, be it large or small.

SPRAY FOUNTAINS

These fountains have their source close to or at water level, thus sending the water upward, rather than falling from a receptacle, ornament, or orifice. Spray fountains are ideal for plant-oriented gardens where elaborate fountain ornaments would be lost in the surrounding plantings.

ORNAMENTAL FOUNTAINS

There is a plethora of fountains manufactured in reconstituted stone or concrete, incuding small copies of the huge classical fountains found worldwide. For something more contemporary in style, modern fountains are available, and it is worth seeking out examples from young, innovative designers working in this field. Good design and manufacture will allow ornamental fountains to be assembled with relative ease, requiring only a simple pump, since the piping is built into the framework of the fountain. The main priority in their installation is making sure that they are perfectly level and have a good foundation.

CIRCULAR RING FOUNTAIN

HOW IT WORKS

The pump is powerful enough to drive both the ring and a rose spray. The T-piece on the delivery pipe feeds the jets by a short piece of flexible tubing connected to an inlet spur on the underside of the ring. It is important to have individual control of both central spray and the ring by separate flow adjusters (see p. 72).

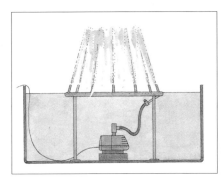

INSTALLING A RING FOUNTAIN

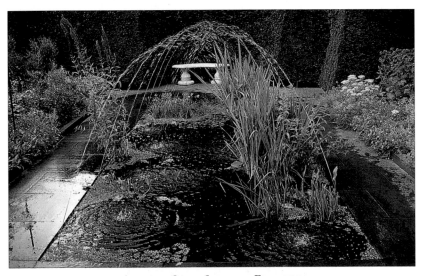

ARCHING SPRAY STYLE OF FOUNTAIN

PRODUCING AN ARCHED SPRAY

HOW IT WORKS

Piping for the spray is fixed at the water surface along each side of the pool. The jets are placed just above water level and angled so that the spout of water forms an arch. To achieve the correct angle for the spouts, the pipe is fixed loosely and turned until the correct position is reached, when the pipe is tightened to the holding clamps. This rule can be applied with the jets turned downward to form a cascade (see right).

CREATING A CASCADING EFFECT

RESERVOIR FEATURES

FOUNTAINS THAT USE the reservoir principle are among the most simple and inexpensive ways to introduce the sound and sparkle of water into a garden. A reservoir fountain using rounded stones, called river rocks, is an ideal first-time construction project. It requires only a small pump and minimal maintenance, is very safe for family gardens, and can easily be integrated into both formal and informal settings. The

MILLSTONE FOUNTAIN

surrounding area can be planted and styled to make the feature's size appropriate to the scale of the site. Changing the positioning of loose rocks or stones close to, or overlapping, the nozzle of the fountain's delivery pipe provides ongoing opportunities to alter and refine the flow of water. An amber spotlight trained on the moving water *(see pp. 124–125)* will create the same relaxing effect as the flickering of a fire.

MAKING A RIVER ROCK FOUNTAIN

CONSTRUCTION GUIDE

To complete this step-by-step sequence, you will need:

TOOLS
- Tape measure, shovel, straightedge, carpenter's level, rake, scissors, wire cutters, tamping tool

MATERIALS
- Large plastic tub or garbage can
- Heavy-duty polyethylene sheet: 6ft x 6ft (2m x 2m)
- Submersible pump with filter *(see pp. 70–73)*
- Delivery pipe with flow adjuster
- Brick base for pump
- Square of galvanized metal mesh, at least 4in (10cm) larger than the diameter of the tub
- Rigid plastic pipe to protect pump cable
- River rocks

1 MEASURE THE DEPTH AND DIAMETER – including the handles – of the tub. Then dig a hole that is slightly wider and deeper than it is. Place the tub or garbage can – which will act as a reservoir pool – in the hole and use a straightedge and a carpenter's level to make sure that it is level, with the rim flush with the ground.

2 ONCE THE TUB IS IN PLACE, backfill the gap around its sides, tamping the soil down firmly. Rake the surrounding area to remove stones, then rake the soil up slightly away from the edges of the sunken tub to create a saucer-shaped depression with the tub at its center. Remove any soil that has fallen into the tub.

3 LAY THE POLYETHYLENE SHEET over the prepared area and cut out a circle 2in (5cm) smaller in diameter than the plastic tub. The purpose of the sheet is to collect the water being pumped out of the fountain and allow it to drain back down the slight slope into the reservoir.

4 CONNECT THE DELIVERY PIPE – complete with flow adjuster – to the pump outlet *(see pp. 70–73)*. Do not trim back the delivery pipe yet *(see Step 6)*. Lower the pump on to a brick base at the bottom of the tub; the base helps to prevent any debris from clogging up the pump.

5 CENTER THE GALVANIZED mesh over the hole in the polyethylene, then use wire cutters to cut a small hole in the middle, wide enough for the delivery pipe. The cable that links the pump to the electrical outlet should be fed through rigid pipe; this will be hidden under the stones.

6 TEST THE FLOW by filling the tub with enough water to cover the pump. Working from the edges inward, start to arrange stones over the mesh. If using a flexible delivery pipe, wedge it upright with stones. Trim the pipe to length. Arrange just enough stones around the feature to assess what the effect will be, then turn on the pump. If the flow needs to be adjusted, the stones and the mesh will have to be removed. Once satisfied with the flow rate, fill the tub with water to a level approximately 2–3in (5–8cm) from the top.

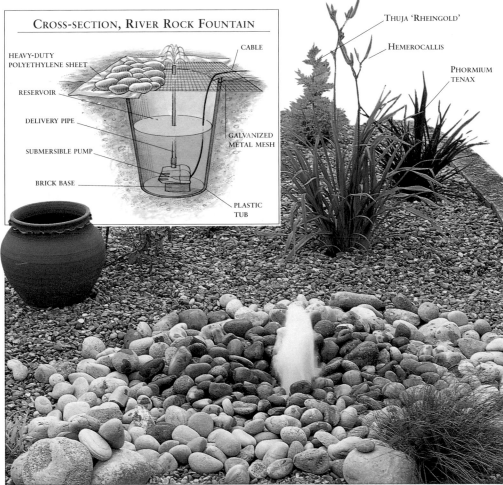

CROSS-SECTION, RIVER ROCK FOUNTAIN

HEAVY-DUTY POLYETHYLENE SHEET
CABLE
RESERVOIR
DELIVERY PIPE
GALVANIZED METAL MESH
SUBMERSIBLE PUMP
BRICK BASE
PLASTIC TUB

THUJA 'RHEINGOLD'
HEMEROCALLIS
PHORMIUM TENAX

7 ARRANGE MORE STONES around the pipe until the desired effect is achieved. Once the area onto which water falls is established, trim surplus polyethylene and bury the edges under soil – or, to allow future enlargement of the feature, fold or roll up the polyethylene before burying it.

STYLING THE FEATURE

This fountain is the centerpiece of a minimalist, low-maintenance design. A landscape fabric, which allows water through but prevents weeds from growing, has been laid over the surrounding soil. Cut small crosses in this material and fold back each corner in order to make planting holes. Once the plants are in place, spread gravel evenly over the surface of the fabric.

113

OTHER RESERVOIR FEATURES

THE SIMPLE PRINCIPLE of recirculating water demonstrated by the river rock fountain *(see pp. 112–113)* can be exploited with a variety of decorative outlets, including urns, bamboo cane, and old cast-iron water pumps. The sound and movement of the water can be controlled and enhanced by increasing or decreasing the flow from the pump.

All the following features have the advantage of minimal maintenance. The growth of algae in most reservoir features is reduced because sunlight makes little contact with the water surface *(see pp. 136–137)*. Any open reservoirs may be covered with fine mesh to prevent debris from falling into the water. If mesh is used, it is important to make sure that it is strong enough to support any ornament. To compensate for the loss of water by evaporation, fill up reservoirs regularly in hot weather.

BUBBLING URNS

The psychological effect of the sound of gentle running water has a major impact upon how a garden is perceived. One of the most calming sights and sounds is of a brimming urn that softly overflows, with the water sparkling in the sunshine and highlighting the rich colors of a terra-cotta or ceramic pot. Urns can either be supported on timbers over a sunken reservoir or raised above ground on supporting bases. Raised urns will be less dominated by surrounding plants and foliage.

MILLSTONES AND HAND PUMPS

A millstone with water rippling over its surface into a reservoir below makes another restful water feature. The hole in the middle of the millstone may have to be widened to accommodate a small delivery pipe from a pump housed in a reservoir below the stone. Genuine millstones can be difficult to obtain and are very heavy. You can, however, buy fiberglass millstones that have coarse sand dusted over and glued to the surface, giving a natural finish. They may be sold complete with a pump as an easy-to-build fountain kit.

MILLSTONE FOUNTAIN
The simplicity of a millstone fountain overflowing into a stone or river rock area is enhanced by a planting of iris, trollius, and bugleweed.

Cast-iron hand pumps make a feature that produces louder splashing sounds than those of urns and millstones. The hand pump can be free-standing over a sunken reservoir or set in or next to a barrel filled with water, in which case it will not require a sunken reservoir. As with all features requiring electricity, it is important to protect the cable leading from the pump to the outlet. As a safety precaution, always use a circuit-breaker and ground-fault interupter (GFI) *(see p. 72)*.

CAST-IRON ORNAMENTS
Cast-iron hand pumps make delightful reservoir features. Here, the spout releasing water is almost hidden by an abundance of flowers and foliage. The pump is not above, but next to, its reservoir pool. Whether raised or sunken, it is advisable to cover reservoirs with fine wire mesh to prevent debris from falling in. If possible, submersible pumps should be placed on a base at the bottom of the reservoir pool; this helps to stop the pump from becoming clogged up. With most ornaments, it is possible to hide the delivery pipe inside the feature.

THE JAPANESE TSUKUBAI

Recirculating water is also used to create many of the symbolic or functional features frequently seen in Japanese gardens. The Japanese use a variety of containers, such as troughs or hollowed-out rocks, to collect water to honor their tea ceremonies and to support other rituals of purification. One of the most popular of these is the *tsukubai*, a low stone basin that is continually refilled with water. This was traditionally used for handwashing before entering the teahouse. In order to make the visitor stoop in humility to use the vessel, it was also traditional for its height to be no more than 8–12in (20–30cm).

Water reaches the stone basin through a bamboo cane spout that conceals, or is attached to, the delivery pipe from the pump housed in the reservoir below. Having been filled with water, the basin gently overflows from one point only. The overflowing water trickles over stones and falls into the reservoir, which is protected from encroaching debris by wire mesh covered with stones. The mesh must be strong enough to support the weight of the stones. Polyethylene sheeting surrounding the feature ensures that any water seepage will be directed back into the reservoir. To complete the feature, appropriate plants such as evergreen grasses and ferns can be added.

THE SHISHI ODOSHI

Another feature using bamboo cane as a water outlet is known as the *shishi odoshi* ("deer scarer"). This was developed by Japanese farmers to ward off wild animals with an intermittent clicking noise, caused when a hinged length of bamboo cane strikes a stone. The *shishi odoshi* works on the same principle as the *tsukubai*. Water from a sunken reservoir is pumped up through a delivery pipe that is concealed within a vertical "post" of hollowed-out bamboo. The delivery pipe is connected to a thinner, hollowed-out bamboo spout set near the top of the post, through which the water runs out.

Approximately halfway up the fixed post a hole is cut, into which another length of bamboo is set to pivot on an axle *(see below)*. This piece of bamboo is hollowed out only as far as its first node or joint, so that the opposite, and heavier, end falls under its own weight to strike a stone positioned beneath it. The hollow, lighter end lies beneath the spout to receive water pouring from it. The weight of the water accumulating in the hollowed section of the pipe eventually overbalances the pipe, the water runs out, the pipe swings back up, and the far end strikes the stone as it falls.

STYLING JAPANESE WATER FEATURES

Water, foliage, and stone are the main elements in Oriental-style gardens. To achieve a subtle balance between the existing landscape and the newly planned elements, water features like the *tsukubai* and *shishi odoshi* should be integrated with great care. With the exception of evergreen azaleas, flowering plants do not play a major role in the overall design of a Japanese garden; plants such as bamboos and Japanese maples are chosen for their ornamental stems and leaf interest.

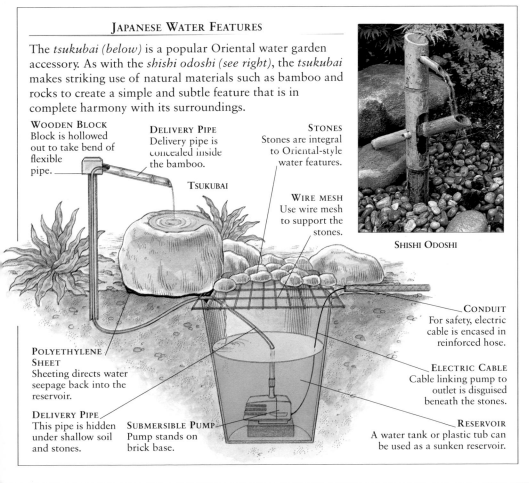

JAPANESE WATER FEATURES

The *tsukubai (below)* is a popular Oriental water garden accessory. As with the *shishi odoshi (see right)*, the *tsukubai* makes striking use of natural materials such as bamboo and rocks to create a simple and subtle feature that is in complete harmony with its surroundings.

WOODEN BLOCK
Block is hollowed out to take bend of flexible pipe.

DELIVERY PIPE
Delivery pipe is concealed inside the bamboo.

STONES
Stones are integral to Oriental-style water features.

TSUKUBAI

WIRE MESH
Use wire mesh to support the stones.

POLYETHYLENE SHEET
Sheeting directs water seepage back into the reservoir.

DELIVERY PIPE
This pipe is hidden under shallow soil and stones.

SUBMERSIBLE PUMP
Pump stands on brick base.

CONDUIT
For safety, electric cable is encased in reinforced hose.

ELECTRIC CABLE
Cable linking pump to outlet is disguised beneath the stones.

RESERVOIR
A water tank or plastic tub can be used as a sunken reservoir.

SHISHI ODOSHI

A BRIMMING URN
This urn, with water moving gently over its surface, is a very restful water feature. The weight of the urn is supported on lengths of wood over a sunken reservoir. A rigid delivery pipe is fed through the bottom of the urn.

FURTHER INFORMATION
- Pumps and Filters – pp. 70–73
- Reservoir Features – pp. 112–113
- Lighting Water Features – pp. 124–125
- A Balanced Ecosystem – pp. 136–137

WALL FOUNTAINS

Wall fountains bring water to patios, courtyards, conservatories, and small, enclosed gardens – anywhere, in fact, where there is insufficient room for a full-scale pool. Stone masks and other decorative forms are popular as outlets. Antique stone features are expensive, but new terra-cotta and convincingly textured plastic and fiberglass versions are not, and since they are lighter, do not need such a strong

ORNAMENTAL MASK

supporting wall. The water falls into a reservoir pool, which may take various forms: a small brick tank, an old sink or cistern disguised with plants, or a decorative stone bowl. The pump may be submerged in the pool, or in a chamber to the side of it; a small, extra low-voltage pump is easily powerful enough for most wall features. Also available are preformed, easy-to-install kits, with built-in pump and reservoir pool.

INSTALLING A MASK FOUNTAIN OUTLET

CONSTRUCTION GUIDE

To install a mask on a brick wall approx. 4ft (1.2m) above a reservoir pool, you will need:

TOOLS
- Electric drill with ¾in (2cm) masonry bit
- Mortaring trowel
- Screwdriver
- Hacksaw

MATERIALS
- Small submersible pump
- 4ft (1.2m) length of ¾in (2cm) copper piping
- Two ¾in (2cm) elbow joints
- Three ¾in (2cm) hose clips
- 6ft (2m) length of ¾in (2cm) flexible plastic delivery pipe
- Small quantity of mortar mix

1 At the height that the mouth will be, drill a hole between bricks. Outlets usually look best just below eye level. Drill a second hole about 4ft (1.2m) below it where the pipe will come back through the wall to enter the reservoir pool.

2 Cut lengths of copper pipe for the two holes, the lower one 2in (5cm) longer than the width of the wall, the upper one 2in (5cm) longer than the width of the wall and the mask; angle the end of this pipe and smooth its edges with a file.

3 Thread the pipes through the holes in the wall. The burred end of the pipe at the front of the wall should fit into the mouth of the mask. The protruding end of the pipe at the back of the wall will be attached to the delivery pipe.

4 Where the copper pipes appear behind the wall, attach an elbow joint (the upper one turning down and the lower one up) and another 8in (20cm) length of copper pipe. Clip flexible delivery pipe between them.

5 Mix the mortar into a stiffish paste. Wet the back of the mask so that the mortar will stick more effectively to its surface. When spreading the mortar, do not cover the area around the mouth opening. Also leave the edges of the mask clear, so that mortar will not escape when the mask is pressed against the wall.

6 Slide the mask over the copper pipe, and press it firmly against the wall. Wipe up spilled mortar. While waiting for the mortar to dry (this can take up to 36 hours), install and connect the pump, using flexible delivery pipe to run from the pump's outlet to the lower protruding end of copper pipe, securing with a hose clip.

4ft (1.2m)

WATER FLOW

The flow of water issuing from the mouth of the mask should be strong enough to allow the water to spout into the center of the reservoir pool without splashing over the sides. If the force of the water is too strong, turn down the flow adjuster on the outlet of the pump (see pp. 72). Depending on the distance between the spout and the reservoir pool, there will inevitably be a degree of splashing against the brickwork. This will encourage the growth of mosses and algae that will, in time, make the feature look attractively weathered.

TIERED FOUNTAIN

The delivery pipe, which feeds into the back of the upper triangle of this tiered wall fountain, is hidden behind the trellis supporting a variety of climbing plants. This feature works with the merest trickle of water; short lengths of chain have been added to create links of water between the tiers.

WALL FOUNTAIN WITH SPILL BASIN

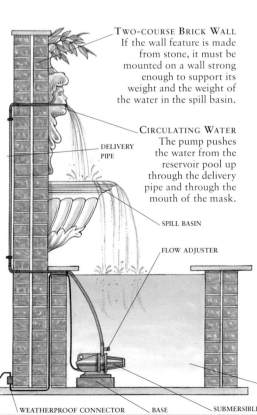

TWO-COURSE BRICK WALL
If the wall feature is made from stone, it must be mounted on a wall strong enough to support its weight and the weight of the water in the spill basin.

CIRCULATING WATER
The pump pushes the water from the reservoir pool up through the delivery pipe and through the mouth of the mask.

DELIVERY PIPE

SPILL BASIN

FLOW ADJUSTER

WEATHERPROOF CONNECTOR BASE RESERVOIR POOL SUBMERSIBLE PUMP

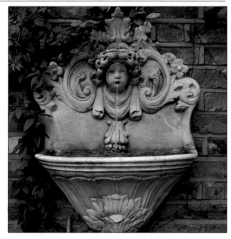

PREFORMED WALL FOUNTAIN

To consolidate the visual appeal of this type of wall feature, it is important to disguise the pipes used in its installation. One way is to fit and mortar the pipe into a channel chiseled into the wall. Another way is to camouflage the pipe with climbing plants, such as ivy and Virginia creeper, which will complement the bricks and stonework.

SPILL BASIN WITH INTEGRAL T-BLOCK

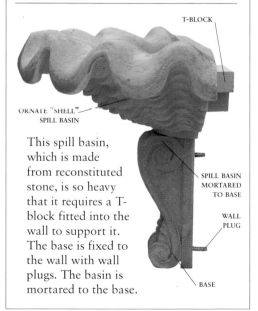

T-BLOCK

ORNATE "SHELL" SPILL BASIN

SPILL BASIN MORTARED TO BASE

WALL PLUG

BASE

This spill basin, which is made from reconstituted stone, is so heavy that it requires a T-block fitted into the wall to support it. The base is fixed to the wall with wall plugs. The basin is mortared to the base.

FURTHER INFORMATION

- Pumps and Filters – pp. 70–73
- Fountains – pp. 108–111
- Reservoir Features – pp. 112–115

FINISHING TOUCHES

EXTRA FEATURES THAT enhance the look of a pond can also be functional: bridges and stepping stones, for example, add interest and provide access across a pond. Lighting brings a magical quality to a garden and allows one to see at night. Edging materials such as paving and wooden decking not only strengthen pond edges but add enormously to their aesthetic appeal.

STEPPING STONES AND BRIDGES

Stepping stones are popular additions to informal ponds and streams but can also be incorporated in a formal pool. Use the same, or complementary, materials as the edging for a unified effect. Stepping stones require a firm foundation and, if necessary, should be set on stone or brick piers *(see p. 122)*. They should be considered carefully in sites where children play regularly – a large, flat boulder at the poolside may be more appropriate. Avoid crumbly or porous stone, even if well out of the water, as it encourages the growth of algae and moss.

STONE STATUETTE
The focal point of this feature is the stone statuette positioned in the center of the pond. A stone table toward the back of the garden continues the use of ornament, and informal planting complements the figure's naturalistic pose. Planting in the pond is restrained, leaving clear areas of water so that the figure's reflection can be seen.

INFORMAL STEPPING STONES
The ornamental use of rocks and stones is an important element in Oriental-style gardens. Beyond the huge boulder in the foreground, lily pads echo the natural placement of stepping stones.

FORMAL STEPPING STONES
Squares of wood decking on piers form a pathway over a large pond, their clean lines flattered by the neat definition of Pontederia foliage. The wood is in good condition, having been regularly scoured with a wire brush to make sure that it is free of slippery mosses and algae.

LIGHTING A WATER GARDEN
Here, powerful lighting brings boulders, stones, and leaf shapes into focus, contrasting with the darkness of the water. The pond can also be approached in safety.

INFORMAL WOODEN BRIDGE
This simple bridge is made from two parallel thick wood planks. Bridges can be used to divide as well as cross the water. Here, young fish, tadpoles, and any other small creatures are separated from the main pool by a submerged barrier of fine mesh underneath the bridge, retaining them in the smaller pool area behind and protecting them from predators.

A bridge *(see pp. 122–123)* may serve a functional purpose, allowing access from one side of a pond or stream to the other, as well as adding visual interest to a water garden. In order to make sure that a bridge is completely safe, the construction must be sturdy and its surface nonslip; if necessary, firm handrails should be installed. There are a number of building materials from which a bridge can be constructed, including traditional stone, thick wood planks, concrete, steel, and iron. To a certain extent, the material used will be determined by both the style of garden and the available budget. If the sides of the bank are soft, foundations will be necessary to stabilize the bridge.

EXTERNAL AND SUBMERSIBLE LIGHTING
Carefully positioned lighting *(see pp. 124–125)* can transform a feature; illuminating a water garden also enables people to use the area at night. A water garden can be lit with both surface and underwater lights. Surface lighting accentuates pool surroundings; underwater lighting is ideal for fountains or waterfalls. All lighting should be well concealed so that the source is not visible. It is essential that lighting is installed correctly, since the combination of electricity and water can be extremely dangerous. Installing an efficient lighting system requires expert advice – if you have any doubts it is advisable to employ a qualified electrician to set up the system. A dedicated circuit may be necessary for powerful lighting; a wide range of extra low-voltage lighting is also available and requires a transformer to step down the voltage.

EDGING MATERIALS
Edging *(see pp. 126–131)* provides a means of blending a water feature with its surroundings; in many cases it also has a practical function, consolidating a feature and keeping soil out of the pond. Decoration is provided by choice of materials – even cement can be enlivened by mosaic tiles or shells. Edging materials for formal ponds include bricks, tiles, and slabs, and these surfaces need regular cleaning and maintenance to remain nonslip *(see pp. 140–141)*. Formal edging may either echo or contrast with the surroundings in both color and texture. Informal edging should provide as natural a finish as possible – materials include gravel, pebbles, sod, and wood.

STEPPING STONES

STEPPING STONES LEAD the eye from one part of the garden to another, and offer an irresistible invitation to cross water. Keep this fact in mind in gardens used by small children. They also make it possible to tend plants in the center of a pond. Consider carefully both the size and placing of stepping stones at the design stage; to install them later may entail draining the water feature. Each stone should be at least 18in

FORMAL STEPPING STONES

(45cm) square, and the gaps between stones no wider than 15–18in (38–45cm). If in doubt as to how many stones to use, it is better to err on the side of too many. The crisp outlines of paving slabs particularly suit formal ponds; they will, however, need strong supporting piers, installed as the pool is being built. Large, rounded or flat-topped boulders, irregularly placed, suit more informal ponds.

BUILDING FORMAL STEPPING STONES

CONSTRUCTION GUIDE

To build each of these stepping stones with pier, you will need:

TOOLS
- Carpenter's level
- Shovel
- Pointing trowel and mortar board
- Wire brush to clean up mortar droppings

MATERIALS
- 32 water-resistant bricks
- Ready-mix mortar: 44lb (20kg)
- One 2ft x 2ft (60cm x 60cm) paving stone

1 IN THIS CONCRETE-LINED POOL, the piers can built directly onto the pool floor (for flexible-liner ponds, see box, below right). For a small slab, 2ft (60cm) square, in water no deeper than 2ft (60cm), make a slender pier using courses of four bricks butted at right angles to each other; this will eliminate the need to cut bricks and allow the slab to conceal the pier by overhanging it slightly. Lay the first course of bricks onto a mortar base ½in (1cm) thick. Press the bricks down firmly until a little mortar is squeezed out. Use a carpenter's level to make sure that this first course of bricks is absolutely level.

FORMAL MATERIALS

For safety, when building stepping stones on piers, make the piers tall enough to allow the stepping stone to sit at least 2in (5cm) above the water surface, to keep it dry. If using concrete slabs, choose those with a nonslip, textured surface. Square paving stones are used mainly in formal designs that have square or rectangular outlines. Round pavers are particularly attractive in water gardens, echoing the shape of water-lily leaves. Irregularly-shaped concrete paving stones are manufactured in pleasant colors for use in more informal gardens. Make sure that each stone is big enough to stand on comfortably.

2 LAY THE REMAINING bricks in seven more courses, alternating the direction in which the bricks run. Use a carpenter's level to check that each course is level. Retain enough mortar for a ½in (1cm) layer on top of the pier, and pile any surplus into the center for extra strength.

3 SPREAD THE REMAINING mortar over the top course of bricks, and position the paving stone squarely over the bricks. Tap it down evenly onto the soft mortar (see p. 69), checking that it is absolutely level. Let it dry for at least two days before filling the pool.

FORMAL PIER WITH FOUNDATION

Piers installed in pools or bog gardens that have a flexible liner will need a solid base to make them stable. Pour concrete into an excavation lined with crushed stone. Make sure that the surface of the concrete is absolutely level. When the concrete is dry, lay the liner and underlay, then mortar the first course of bricks onto the liner.

BRICKS MORTARED TO LINER

PAVING STONE

FLEXIBLE LINER AND UNDERLAY

CRUSHED STONE AND CONCRETE FOUNDATION

INFORMAL STEPPING STONES

Flat stones and sections of wood make perfect stepping stones in shallow water, and are by far the safest option in family gardens. Rounded boulders suit the Oriental style, and look particularly good in slightly deeper water in which they can be partially submerged. The top of a waterfall is an excellent point at which to introduce a few stepping stones that will give a view of the clear, still water of the header pool as well as the more turbulent water falling over the spill stone.

It is important to select hard-wearing, nonporous stone such as granite. Softer stones, in particular limestone and certain sandstones, will crumble in time and are notorious for attracting slippery algae. While softwood will eventually rot, sections of round, hardwood tree trunks are likely to last for several years. Treat wooden rounds with a fish- and plant-friendly wood preservative at least once a year.

SAFETY PRECAUTIONS

It is imperative that informal stepping stones do not slide or wobble underfoot. In shallow water, flat stones or wooden rounds can be mortared directly to pool bases. Irregular boulders must be either sunken well into the floor of a natural or clay-lined pond, or, in flexible-liner or concrete ponds, mortared onto a concrete base (see below right). Staple chicken wire over wooden rounds to give a more secure footing, and clean all stepping stones regularly with a stiff brush to remove slime and algae.

WOODEN STEPPING STONES
Irregularly placed rounds of hardwood can be used to make an attractive and unusual ford over shallow water. These sections, about 6in (15cm) thick and 20–24in (50–60cm) in diameter, have been mortared directly onto flexible liner, which is hidden under a layer of pea gravel.

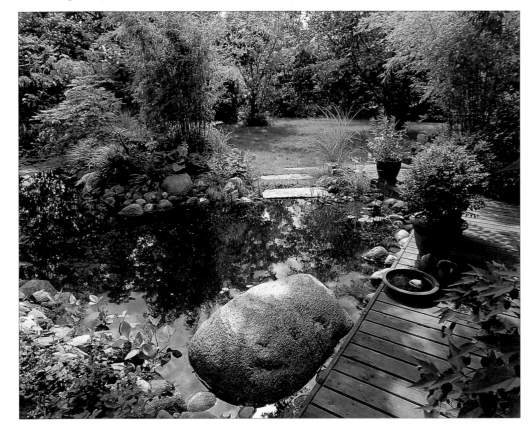

FORMING A LINK
Large, flat or gently rounded boulders make "natural" stepping stones which can provide a link between different parts of a pond or stream, or make a shortcut across the corner of a pond, *as above, where the mass of the boulder also provides continuity between the broad wooden deck and the stones at the poolside. Clean algae off stones regularly with a stiff brush.*

STABILIZING BOULDERS

Unless the size, shape, or weight of a boulder precludes movement, it will need a foundation to make it stable and safe to step on. Make a concrete "nest" that approximates the contours of the bottom of the boulder. Allow the concrete to dry for a day, then mortar the boulder onto it. Extra layers of underlay can be used under the concrete to protect the liner.

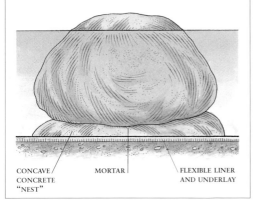

CONCAVE/CONCRETE "NEST"　　MORTAR　　FLEXIBLE LINER AND UNDERLAY

FURTHER INFORMATION

- Courtyard Pool – pp. 32–33
- Siting Water Features – pp. 56–57
- Construction Tools and Materials – pp. 62–63
- Construction Techniques – pp. 64–69

BRIDGES

BRIDGES, LIKE PONDS and streams, can be as simple or as ornamental as the setting suggests. Although ready-made bridges are available in a range of materials, such as iron and steel, they can be expensive: a simple wooden bridge (*see below*) is both easy and economical to build, and can be up to 8ft (2.5m) wide without requiring a central pier or support. A bridge should be functional as well as decorative; bridges

BRIDGE IN POSITION

installed solely for visual effect can look contrived and may actually spoil the feature they are meant to enhance. If possible, design and build a bridge at the same time as you install a pond or a watercourse. The pond or stream can be "waisted" to create a narrower width to span with the bridge: if its ends are surrounded with plants, the bridge will make the water appear wider than it really is.

SIMPLE TIMBER BRIDGE

CONSTRUCTION GUIDE

To build this 8ft x 2ft (2.5m x 60cm) bridge, you will need:

TOOLS
• Spade, shovel, straightedge, level, screwdriver, drill

MATERIALS
• 8 rough boards: 4in x 2in (10cm x 5cm); four 2ft (60cm) long, four 4ft (1.2m) long
• Ready-mixed concrete: three 80lb (36kg) bags
• 2 treated wooden joists: 8ft x 6in x 2in (2.4m x 15cm x 5cm)
• Four 5in (12cm) galvanized brackets with 8 galvanized 2in (5cm) bolts and nuts
• 15 cross-planks: 2ft x 6in x 1in (60cm x 15cm x 2.5cm)
• 68 countersunk 2in (5cm) 8-gauge screws

1 TO MAKE FORMS for semi-raised concrete block foundations at the bridge's ends, dig two holes 6ft (2m) apart on either side of the water, 4ft (1.2m) x 8in (20cm) x 4in (10cm) deep. Surround the holes with the rough boards to make two rectangular forms (*right*), and hold them in place with bricks and shovel in concrete. Use a carpenter's level and a long straightedge to make sure the two foundation blocks are level with each other.

FIRM FOUNDATIONS
Foundations should be built at least 9in (22cm) from the water's edge so that sloping poolsides do not affect their stability.

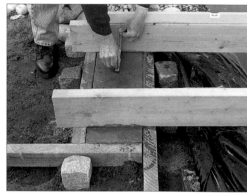

2 BEFORE THE CONCRETE DRIES, set the two joists 20in (45cm) apart, hold the brackets against them and mark through the holes to show where to put the bolts. Embed bolts in the concrete, screw end protruding by 1in (2.5cm). Bolt the brackets onto the concrete when dry.

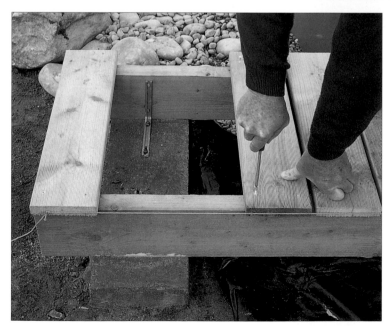

3 REMOVE THE FOUNDATION forms, and screw the joists to the brackets. Pull up and secure any liner under the bridge. Lay treated cross-planks over the joists, ½in (1cm) apart to allow expansion when wet. Fix each end plank first, and stretch string between them as a position guide for the rest.

CONSTRUCTION OF A TIMBER BRIDGE

This simple bridge is easy-to-make even for an amateur. A well-made bridge of thick, good-quality wood (consider using rot-resistant wood such as cedar) with firm foundations at each end, will be solid and durable. For safety, make any steps leading up to bridge ends firm and conspicuous, or build earth or wooden ramps.

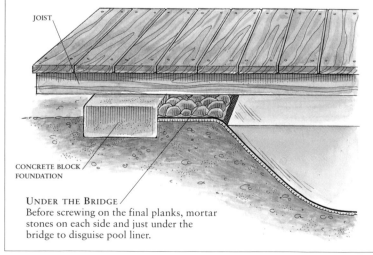

JOIST

CONCRETE BLOCK FOUNDATION

UNDER THE BRIDGE
Before screwing on the final planks, mortar stones on each side and just under the bridge to disguise pool liner.

SERVING A PURPOSE

To make them practical and safe, bridges should be at least 2ft (60cm) wide; wider, if it is necessary to cross them with garden equipment such as lawn mowers or wheelbarrows. Always make sure that paths and paving are absolutely flush with the ends of the bridge to avoid tripping. In addition to providing a path across water, bridges offer excellent viewpoints from which to watch fish, or simply enjoy the reflection of light and color on the surface of the water; adding a handrail will make pausing on the bridge more inviting and comfortable.

HANDRAILS

Like the bridge itself, rails should blend as naturally as possible into the surroundings. Thin, overly ornate handrails usually tend to clutter an otherwise restful scene. In addition, they may be unsafe: handrails should always be strong enough to bear the weight of an adult leaning against them. A height of at least 3ft (1m) is essential if a bridge is very narrow or crosses particularly deep water. If the bridge is to be used by young children, it is a good idea to cover the space between the rails with wire netting.

Try to merge the ends of the rails into plantings, rather than coming to an abrupt, vertical stop. The vertical uprights of a bridge can be extended upward and joined over the top to form a frame, so that the bridge resembles a tunnel. The impact can be dramatically increased by festooning the uprights and top rails with climbing plants such as wisteria and clematis.

SAFETY

For safety reasons, the maximum span of an unsupported bridge should be 8ft (2.5m). Wider bridges need additional supporting piers or posts (minimum size 4in x 4in/10cm x 10cm). Either build brick piers like those used to support stepping stones (see p. 120), or drive supporting posts deep into the floor of the pond – this will involve renting a pile driver.

Any materials used for walking on should have a textured rather than a varnished or glazed finish. To ensure a safe, non-slip surface on a wooden bridge, firmly nail in place a covering of fine wire mesh (see p. 140), and prevent the growth of moss or algae by regularly scrubbing with water to remove dirt.

WOODEN BRIDGE

This zigzag wooden bridge over shallow water is not used to cross the pond, but to tend the plants in the center with ease. A brick pier supports the central section where the timbers meet. The plants softening the sides of the bridge give added emphasis to the rustic simplicity of the wood.

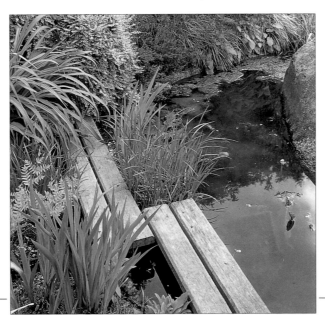

ARCHED BRIDGES

Arched bridges built from scratch demand very skilled construction techniques. They can, however, be bought ready-made. Choose one with a gentle gradient; a handrail is also recommended. Ask for installation advice: a good supplier will tell you what type of foundation is necessary.

Although they are the simplest and often the most successful, bridges made from wood have a shorter lifespan (10–15 years), and require more maintenance than those made from concrete, stone, or metal; eventually rotting wood will become weak and slippery. Treat lumber with a wood preservative at least once a year, and scrub all exposed areas with a wire brush at least twice a year to prevent the buildup of slippery algae. Be sure to check that the wood preservative will not affect plants and fish.

Finally, remember that the temptation to not only cross but also dangle feet and hands from a bridge is often more than young children can resist. A flat bridge set low over shallow water is the safest, nevertheless, it is advisable to supervise children as they play.

FURTHER INFORMATION
• Construction Tools and Materials – pp. 62–63
• Construction Techniques – pp. 64–69
• Stepping Stones – pp. 120–121
• Decking – pp. 130–131

LIGHTING WATER FEATURES

LIGHTING NOT ONLY extends the hours of viewing pleasure, it also brings a new dimension to the appeal of a water garden. When darkness falls, textures and contrasts dulled by sunlight are newly defined, greatly enhancing the appearance of plants and ornaments. Surface lighting will sharpen any image, and can be more effective when it does not shine directly on the water. Underwater lighting, though, produces the

UNDERLIT FOUNTAIN

most atmospheric results, illuminating fish, plants, and features such as fountains. For safety, durability, and strength of illumination, use good-quality equipment made for this purpose. If a pump (see pp. 70–73) is already in place, the main work and expense of bringing electricity to the feature will already have been incurred, but even if you are adding lighting to an existing system, professional advice is advisable.

TYPES OF INSTALLATION

Lighting a large area or feature usually demands standard-voltage lighting. (Do not light up the entire pond, as this might disturb the fish). Only a qualified electrician should install these systems (see p. 72). A circuit breaker is essential, as well as a ground fault interrupter (GFI). The in-ground cable also must be protected (see box, below right). However, an inexpensive extra low-voltage system, which reduces the current through a transformer, is powerful enough to light a group of plants or a small pool with a small fountain. Extra low-voltage systems come in simple kit form (see facing page), often sold complete

with pump and attachments. For any system, it is preferable to site switches indoors; switches outside must be encased in a safety-approved waterproof switch box (see p. 108).

GAUGING THE EFFECT

Restraint and subtle placing are the keys to successful lighting. Experiment with underlighting by using a powerful flashlight or a spotlight on a long cord (never place it in water). Do not let lights shine directly on water; indirect lighting turns the surface into a dark mirror, reflecting plants and ornaments.

TRANSFORMING A FEATURE
A low spotlight creates a sense of drama and mystery, throwing shadows over the water, foliage, and rocks in this pond. Subdued lights that point down in the background illuminate pathways beyond the pond.

UNDERLIGHTING A FOUNTAIN
Use a high-intensity submersible light to illuminate water gushing from a fountain. Make sure that the beam is pointing upward into the spray – this will create the illusion that the light is "moving" with the water.

SAFETY PRECAUTIONS

For high-intensity lighting, use only equipment specifically designed for outdoor or underwater use. Have a qualified electrician install the system. Always include a circuit breaker and a ground fault interrupter (GFI); these cut off power immediately if a problem occurrs. Never use any lights or electrical equipment designed for indoor use outdoors. The sealed cable leading from the light must be connected to the main supply cable with a waterproof connector located near the pool – most ready-to-use systems come complete with connectors. The cable between the connector and the main socket must be suitable for outdoor use as well. Bury this cable at least 18in (45cm) underground. For extra safety, place roofing tiles over the cable or run in steel conduits. Put bright warning tapes on the tiles before filling the trench (see also Pumps and Filters, pp. 70–73). There is little danger of serious electric shock from an extra low-voltage system, provided that it is properly installed.

CABLE

CHOOSING AND POSITIONING LIGHTING EQUIPMENT

Choose subdued colors for bulbs, lenses, and the casings of the lights; shiny stainless steel or bright white casings can be obtrusive in daylight. If possible, conceal equipment and casings behind rocks or plants. External or underwater spotlights trained on a specific area are the simplest forms of lighting. A spotlight behind a waterfall or cascade can be dramatic; underlighting a fountain *(see facing page)* is also very effective. Make sure that the beam is pointing upward into the spray to create the illusion that the light is traveling in the same direction as the spurting water. Floating lights *(right)* add an informal note of unpredictability, they may also be submerged to reveal the underwater world usually hidden by the glare of day.

FLOATING SPOTLIGHT
Most of the lights sold in kit form can be detached from the pump to be used as either floating or submerged illumination. To submerge, place a heavy object on the power cable to anchor the light in position.

TRANSFORMER
A transformer greatly reduces the voltage of an alternating current, making it safe in case equipment beyond it is damaged. Transformers should be weatherproof or installed indoors so that only extra low-voltage cable is used in the garden.

EXTRA LOW-VOLTAGE CABLE

PUSH-CONNECTOR FOR EXTRA LOW-VOLTAGE LEAD

FULL-VOLTAGE CABLE

TRANSFORMER IN SEALED CASING

PUMP AND LIGHTS IN KIT FORM
This lights on this kit need not be attached to the pump. Extra low-voltage cables from the pump and each light are joined in a waterproof connector box outside the water, from which one cable runs to a transformer.

FOUNTAIN NOZZLE

BEZEL

MOUNTING BRACKET

LIGHTS MOUNTED ON SUBMERSIBLE PUMP

LENS

SUBMERSIBLE PUMP

LIGHTING CABLES LEADING TO TRANSFORMER

PUMP CABLE LEADING TO TRANSFORMER

KIT ILLUMINATING FOUNTAIN
The three evenly spaced lights around the fountain nozzle provide even uplighting for the spray. For a more diffuse effect, the lamps can be detached to float around the fountain.

LIT STONE FOUNTAIN
Small, bubbling fountains can be illuminated by an angled spotlight at ground level. With suitable connectors lights can use the same extra low-voltage power source as the small pump. Choose a lens color that will complement the color of the stones. Use plants to disguise the casing or hide it in rounded stones.

BULBS AND LENSES
Tungsten bulbs, such as those used indoors, are the most popular extra low-voltage bulbs for lighting water gardens. If a more intense light is required, halogen bulbs are ideal, as they provide more light for the same wattage. As technology evolves, new techniques involving laser lighting and fiber optics will become more common. Although lenses are available in a variety of colors, white is the most popular and is usually the most effective. Avoid using too many different-colored lights.

COLORED LENSES

WROUGHT IRON CANDLE HOLDER

HANDLE

GLASS CASING

PORTABLE CANDLE HOLDER
The simplest way to light small areas is with candles in windproof casings; this holder has a tall ground spike so that it can be moved around. Citronella-scented candles will also discourage gnats and mosquitos, which congregate by water.

FURTHER INFORMATION
- Siting Water Features – pp. 56–57
- Construction Techniques – pp. 64–69
- Pumps and Filters – pp. 70–73

EDGING MATERIALS

Edging is vital to the durability of water features, consolidating poolsides to give a firm footing and also disguising pond linings. It also contributes greatly to the visual impact of the feature. Always consider the edging you will use from the earliest planning stages, so that it will suit the style both of the water feature and of existing garden materials. The more adventurous range of colors and textures now available means that even the most traditional or inexpensive materials can, with imaginative use, give a completely fresh look.

EDGING WITH NATURAL STONES AND ROCKS

INFORMAL STONE
Sandstone of varying sizes creates a natural-looking edge to this pond, echoed by a stepping stone path to the beach.

Informal ponds and streams can be enhanced by the placing of natural rocks or stones around the edges. Large retailers supply a wide range of stone types. Local stone is generally the least expensive and will blend most effectively with its surroundings. The two most common types of stone available are limestone and sandstone, both of which come in a variety of colors.

Rocks and stones should be placed as naturally as possible around an informal pond; where stones have clearly defined strata lines, aligning these *(see below and facing page)* will create the illusion that the rocks are naturally outcropping the water. Use loose, small pieces of stone to fill any gaps. To create extra cushioning and protect the liner, place extra pieces of underlay on top of the liner.

Rounded pebbles, river rocks, and cobblestones make good informal edging. River rocks are especially effective when wet, as the water brings out their natural colors. Where they are likely to slip, press them into a layer of mortar. Gravel and stone beaches *(see pp. 80–81)* also complement informal ponds, and provide an excellent textural contrast to the water.

INFORMAL STONE EDGING
Rocks, pebbles, and gravel create an informal transition from dry ground to water. The materials are easy to place and come in a variety of colors and sizes, making it possible to choose an edging material that will match existing materials. If used to disguise a liner, place pieces of underlay on top of the liner in order to prevent it from tearing.

RED GRAVEL

GRAVEL GRAY GRAVEL SLATE CHIPS

PEBBLES AND STONES GRANITE

LAYING ROCKS AND STONES

AN INFORMALLY LAID BEACH
The rocks and stones that edge this pond gradually decrease in size as they get closer to the water, creating a natural effect. Rocks and stones have been placed at the edge of the liner to secure and disguise it. The gradual slope provides both an informal finish and invites wildlife to approach the water.

MORTARED ABSORBENT ROCK
Position absorbent rocks so that the strata lines run along the sides, and are invisible from above (as left). A gently overlapping diagonal arrangement enhances the weathered appearance.

MORTARED NON-ABSORBENT ROCK
Most nonabsorbent rocks, such as granite, have cleavage planes rather than strata lines; try and make these appear broadly parallel. They look better angled more acutely than softer stones.

USING ROCKS WITH STRATA LINES ON SLOPES

When positioning rocks with strata lines down a slope or along the edge of a stream, make sure the strata lines are visible from the side, as in nature, not from above. After positioning the first rock, make sure that the strata lines of each successive rock are parallel. Again, the angle at which each rock is set must be the same. This may involve burying some of the stone or fitting small pieces of rock among larger stones to set them at the proper angle.

STRATA LINE

SLATE SLABS
Dark, wet slate is a good foil for cascading water. Position it so that any natural veining runs parallel with the water flow.

INFORMAL ROCK WALLS

Where rock walls are built up as internal edges to hide liner, use flattish stones mortared together for stability. Disguise the mortar at the front with small pebbles wedged in to create a "dry stone" effect.

BALLAST BACKFILL

EXTRA CUSHIONING UNDERLAY

FORMAL EDGING AND PAVING

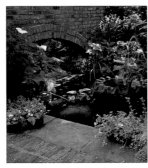

FORMAL PAVING
Bricks and paving slabs have been combined to produce an effective edge to this formal stream; the bricks also echo the wall and arch.

Bricks, slabs, setts, and pavers are available in many different materials, colors, and textures. Large paving slabs are easier to lay regularly, but their sheer weight makes them difficult to handle. Concrete is the most cost-effective material to use and is also extremely hard-wearing, although not particularly decorative. Concrete pavers are simple to lay; just place them side by side and spread dry mortar over the surface. Alternatives to costly natural stone slabs are granite or clay setts, clay pavers, or terra-cotta tiles. Always lay bricks, slabs, setts, or tiles on a leveled crushed-stone base *(see p. 68)* with mortar on top for a firm finish; if necessary, fill the joints with bedding mortar. Note that sedimentary rock as well as concrete bricks around a pond will raise pH, thus harming fish. Test and adjust pH regularly.

TYPES OF BRICK

Be sure to use weatherproof bricks as edging, such as those shown below. Different colors are available that can be used singly or together. When using bricks with "frogs" – hollows – lay the the brick with the frog facing downward.

ENGINEERING BRICK

COMMON HOUSE BRICK

"FROG"

TERRA-COTTA HOUSE BRICK

PATTERNS IN BRICK

Brick edging can be extended to form a broad surrounding or terrace, which will be enhanced by laying the bricks in patterns *(see below)*. A simple theme is often more effective than an over-ornate one – a complicated design may lessen the overall impact of the feature. Do not let the cut edges of bricks show at the water's edge, as they do not make an attractive finish.

"BASKETWEAVE"

"INTERLOCKING BOXES"

"INTERLOCKING BOXES"

"HERRINGBONE"

LAYING BRICKS AS A POOL EDGING

1 EXCAVATE AROUND THE pool, allowing for a 4in (10cm) layer of crushed stone and 1in (2.5cm) of mortar. Lay the perimeter bricks first, using string and stakes to make sure that they are level.

2 AFTER MORTARING the perimeter bricks, bed the remaining bricks onto a layer of mortar, spacing them evenly. Using a carpenter's level and straightedge, tap down until the bricks are level.

3 SPREAD A LAYER of dry mortar over the surface and brush it between the joints. Use a watering can to sprinkle the bricks with water in order to set the mortar. Brush over the surface thoroughly.

LAYING CRAZY PAVING

CRAZY PAVING MATERIALS
Sandstone is particularly suitable for crazy paving, since it breaks up easily into flat, thin pieces. More random shapes must be carefully positioned for a level surface.

1 USE STAKES AND string to establish a level, horizontal surface. Spread a layer of crushed stone and compact firmly. Lay the edging pieces first, with their straight edges facing outward.

2 FILL IN THE rest of the area with large slabs infilled with smaller ones. Check that all the stones are level. To adjust the height, tap with a mallet over a wood block.

3 FILL THE JOINTS with almost dry mortar or brush in sand. To achieve a good finish, use a trowel to bevel mortar so that any surface water will drain away.

NATURAL FINISH
The range of reconstituted stone slabs now available provides far more convincing substitutes for natural stone than previously. Even cement slabs are now textured and colored to be more compatible with the existing landscape.

GRANITE SLABS

CUT SLABS

RECONSTITUTED STONE

TEXTURED RED CEMENT

LAYING SQUARE SLABS

WATERTIGHT EDGE
In order to disguise the liner, lay it under two widths of granite blocks and wedge the edges upright with a paving slab. Trim the liner level with the top of the paving slabs and infill with mortar between the slabs and the blocks.

BLEND OF MATERIALS
Concrete setts form the edge of this pool, and are surrounded by larger, traditional paving stones that have a rough, non-slip finish. The dark color of the concrete contrasts with the light paving slabs; both blend well with the water.

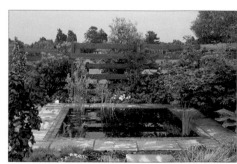

MAKING CURVED EDGES FOR FORMAL PONDS

PAVING BLOCKS

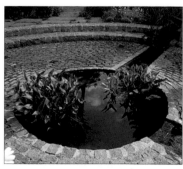

CONCRETE BLOCKS
In addition to being inexpensive, formed concrete blocks are versatile, coming in a wide range of shapes and sizes. These blocks are convincingly textured and have been produced in a "keyed" shape that makes them ideal for curved pond edges.

USING SMALL BLOCKS
The smaller the blocks, the easier it is to fit them closely around curving edges, filling the gaps with mortar (see p. 126).

SOFT AND HARD TEXTURES
Square slabs arranged in a circular pattern inevitably leave key-shaped gaps. These can be turned to advantage as planting spaces.

FORMAL EDGING
To avoid the labor and expense of hand-cut "keyed" slabs, buy pavers that are produced specially shaped for circular pond edges.

USING WOOD TO EDGE A POND

Wood edging is a popular choice for both formal and informal water features and combines particularly well with turf. Hardwood or treated softwood planks may be arranged horizontally; strips of log roll, vertically *(see pp. 88–89)*. Wooden edging can also be extended to create a deck for seating or a patio *(see pp. 130–131)*. Railroad ties make very durable edges, but are usually too heavy to use on top of the walls of raised pools. When exposed to water, wood tends to warp and rot, and should be treated with a preservative. To make sure that harmful chemicals do not seep into the water, a commercial sealant should always be applied. Make sure that all wood is held firmly in place, whether nailed to a wood support or fixed to a wall or a concrete foundation *(see below)*.

WOODEN EDGING
Treated railroad ties create completely watertight edging for this spillway. Wood also creates a discreet finish.

DECKING SQUARES

WOOD EDGINGS
Due to its versatility and natural look, wood has become very popular as an edging material. Decking squares and planks that overlap the edge of the water can hide unsightly liner and provide partial shade and shelter for fish. Log rolls, easy to install, can enhance the simplest pond. Planks and railroad ties are hard-wearing but heavy to handle – do not attempt to install them single-handed.

LOG ROLL

WOOD PLANK

DECKING SQUARES
Here, decking squares make attractive and serviceable edging for a concrete pool. Diagonally grooved tiles laid at right angles to each other make the surface less slippery.

DECKING SQUARES

TREATED WOOD
Preservative prevents the wood from rotting.

COUNTERSUNK SCREWS

WALL SCREWS

FASCIA BOARD

LOG ROLLS
Because they are flexible, log rolls are easy to install around irregularly shaped ponds. They can be attached to wooden stakes driven into the ground outside the pool (see pp. 88–89) or embedded in concrete, as shown here.

GRAVEL SOD LOG ROLL

FLEXIBLE LINER

UNDERLAY

CONCRETE

SECURING THE EDGING
Galvanized, countersunk screws secure edging to vertical support posts.

RAILROAD TIE WOOD PLANK COUNTERSUNK SCREW

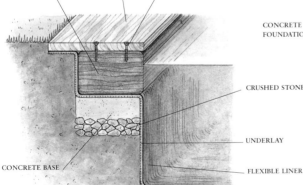

CONCRETE BASE

UNDERLAY

FLEXIBLE LINER

RAILROAD TIES
To stabilize a railroad tie, install it on a concrete foundation. Use countersunk screws to fix planks over the ties in order to make an even surface for walking on.

WOOD PLANK

CONCRETE FOUNDATION

CRUSHED STONE

FASCIA BOARD

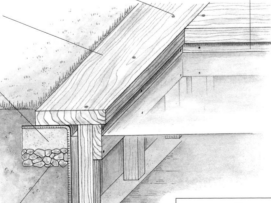

CRUSHED STONE

WOOD POST LINER UNDERLAY

WOOD PLANKS
These treated wood planks border a regularly shaped pool constructed with flexible liner. Use countersunk screws to attach the plank to vertical support posts, which are set into concrete at 2in (6cm) intervals. Use thin wooden planks as fascia boards to disguise the supports.

FURTHER INFORMATION

- Construction Tools and Materials – pp. 62–63
- Construction Techniques – pp. 64–69
- Raised Pools with Rigid Units – pp. 80–81
- Decking – pp. 130–131

DECKING

ONE OF THE many advantages of using wooden decking as edging is that it is easier to overlap the edge of the water with wood – thus providing a platform to view and feed fish from – than with paving or other hard-edged material. Decking not only makes an ideal edging, it can also be designed to form a seating area at the waterside or a jetty extending well over the edge of the water. Wooden decking squares with

WATERSIDE DECKING

a diagonal pattern are particularly attractive when laid at right angles to each other. If possible, use rot-resistant wood, but if cheaper wood is used, make sure that it is pressure-treated with a preservative that will not adversely affect plants, fish, or wildlife. As with bridges and stepping stones (see pp. 120–123), carefully consider the safety aspects of wooden decking, especially if young children are likely to play on it.

LAYING DECKING AT THE WATERSIDE

CONSTRUCTION GUIDE

To build a 10ft x 6ft (3m x 2m) deck with jetty, you will need:

TOOLS
- Spade, straightedge, level, tape measure, saw, screwdriver, hammer

MATERIALS
- 10 pressure-treated wood posts: 3in sq (8cm sq); 10 steel supports; 40 wall bolts 2in (5cm); galvanized nails: 1lb (½ kilo) 3in (75mm); 250 2in (5cm) 8-gauge screws; battens, fascia boards
- Ready-mixed concrete: 6 bags 80lb (36kg); crushed stone: 1cu yd (1cu m); sand: 1cu yd (1cu m); 10 house bricks
- 4in x 2in (10cm x 5cm) beams: two at 10ft (3m) long, two at 6ft (2m) long
- 4in x 2in (10cm x 5cm) joists: five at 10ft (3m) long, two at 6ft (2m) long, five at 3ft (1m) long; 28 decking squares: 20in sq (50cm sq)

1 WOOD POSTS IN steel supports bolted onto concrete foundations provide the firmest underpinning for a framework of beams and joists. Lay foundations – consisting of 4in (10cm) of concrete above the same depth of crushed stone – in holes 1ft x 1ft (30cm x 30cm) at the ends of each bearer, at 4ft (1.2m) intervals. Let the concrete harden, then place the steel supports on the concrete, and mark the four bolt positions. Drill four corresponding holes and insert and tighten four 2in (5cm) commercial wall bolts into the foundations. Use a straightedge and a carpenter's level to make sure that the uprights are completely level, then nail the beams, wider side down, on the uprights.

ALTERNATIVE FOUNDATION

Bed the beams on firm soil in excavated channels containing crushed stone covered with a 2in (5cm) layer of sand. If necessary, use bricks to adjust the height of the beams.

JOIST

BEAM

SAFETY FIRST
Use grooved wooden tiles to reduce the risk of slipping.

2 NAIL THE THREE middle joists diagonally – 18in (45cm) apart – to the beams. If joists have to be joined, make a 2in (5cm) horizontal cut and a 4in (10cm) vertical cut at one end of each joist, and half-lap them at the point where they cross the beam. Then nail the two end joists in place.

3 FOR ADDITIONAL SUPPORT, wedge bricks underneath beams where they are crossed by joists. Check levels along and across joists as you do so, so that you can make adjustments to height where necessary by varying the depth of the depressions you scrape out for the bricks.

4 USE EIGHT 2in (5cm) screws to fasten each grooved, nonslip decking square to the joists. To achieve a checkerboard effect, as well as to further reduce the chance of slipping, position the tiles so that the diagonal treads are at right angles to each other.

5 IF USING FLEXIBLE liner and underlay, pull these materials up over the top of the joists, and secure them well above the waterline with wood battens nailed horizonally behind the joist *(see also illustration below, left)*. This step should be completed before screwing the decking squares that overlap the edges of the structure in place.

6 ONCE THE OVERLAPPING wooden tiles are in place, screw on a wood fascia board to hide the liner and the rough wood of the beams from side view. If desired, the fascia board can be wide enough to extend down to the waterline. Where the edge of the pond meets the decking, mortar a row of rounded rocks onto it well below the waterline. Then add smaller river rocks.

CONSTRUCTION OF DECKING WITH JETTY

To incorporate this small jetty over water, two of the beams should be 3ft (1m) longer than the others. To support the ends of the beams, bolt steel supports with wooden posts (see Step 1) onto brick piers (see pp. 120–121). The positioning of three 34in (85cm) joists will ensure a firm base on which to screw the last four decking squares: nail the first joist where the jetty joins the main structure, the next 18in (45cm) away and, to provide for a 2in (5cm) tile overhang at the end of the jetty, position the last joist 16in (40cm) away. Then nail in place the two 3ft (1m) long end joists on eitherside of the jetty (see illustration, right).

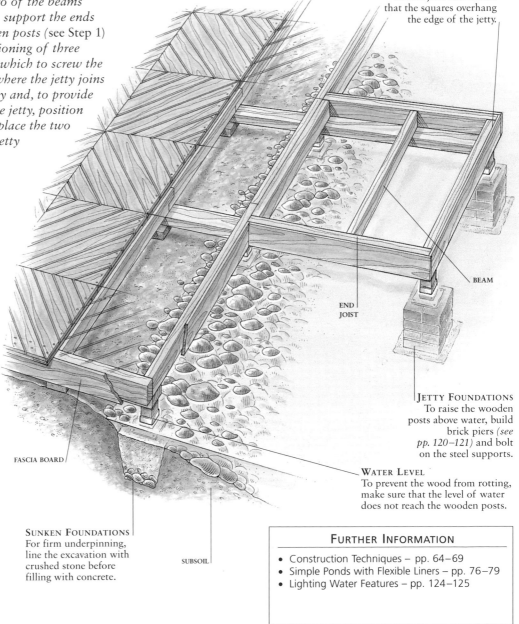

PLANNED OVERHANG
Positioning this last joist just 16in (40cm) from the middle joist will ensure that the squares overhang the edge of the jetty.

BEAM

END JOIST

JETTY FOUNDATIONS
To raise the wooden posts above water, build brick piers *(see pp. 120–121)* and bolt on the steel supports.

WATER LEVEL
To prevent the wood from rotting, make sure that the level of water does not reach the wooden posts.

SECURING THE LINER

Decking that forms a right angle over the water creates the illusion that water laps up to and beneath the decking. Where the liner has to fit around a sharp corner, it should be carefully pulled and pleated *(see pp. 78–79)* before being secured with battens, and hidden from side view by wood fascia boards.

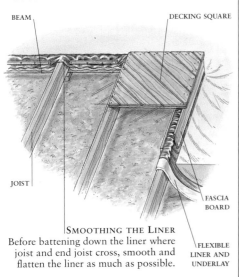

BEAM

DECKING SQUARE

JOIST

FASCIA BOARD

SMOOTHING THE LINER
Before battening down the liner where joist and end joist cross, smooth and flatten the liner as much as possible.

FLEXIBLE LINER AND UNDERLAY

FASCIA BOARD

SUNKEN FOUNDATIONS
For firm underpinning, line the excavation with crushed stone before filling with concrete.

SUBSOIL

FURTHER INFORMATION

- Construction Techniques – pp. 64–69
- Simple Ponds with Flexible Liners – pp. 76–79
- Lighting Water Features – pp. 124–125

STOCKING & MAINTENANCE

ORNAMENTAL FISH *(LEFT)*
*Goldfish are among the most popular fish for ponds and have been
kept in captivity longer than any other fish. They are hardy and
easily cared for and come in a wide variety of decorative types.*

MAINTAINING A HEALTHY POND

Provided that a pond has been well sited, designed, and built, and that care is taken to ensure a healthy balance when stocking with plants *(see pp. 152–153)* and fish *(see pp. 170–171)*, it should not be difficult to tend. Major emptying and cleaning of a water feature *(see pp. 142–144)* is really not necessary or advisable, in the majority of cases, for at least two or three years.

CREATING A HEALTHY POND

The planning, construction, and stocking of a pond is crucial to the ecological balance or ecosystem *(see pp. 136–137)* that exists within it. The well-being of plant and animal life depends upon many factors, including light levels, water temperature, and the proportions of the various gases dissolved in the pond's water. Appropriate functional planting *(see pp. 152–153)* will help initially to achieve a natural balance and clear water.

CLEAR WATER
The condition of this cascading waterfall is very satisfactory; the water is extremely clear, with no sign of algal growth allowing the decorative pebbles to be seen. The bubbles show how the splashing is increasing the oxygen content of the water.

THE POND IN WINTER
In cold climates precautions must be taken to make sure that ice does not completely cover the water surface. Not only does a solid sheet of ice exert pressure on the pond edges, it also traps waste gases that may build up in the water and harm fish and other animal life.

SUMMER REFRESHMENT
A well-kept feature needs little attention in the summer months, allowing time for relaxation and enjoyment of the water. In prolonged hot weather, be aware of the need for frequent filling, particularly if a fountain is increasing the rate of evaporation.

GREEN WATER
Small, free-floating plants such as duckweed multiply extremely rapidly and may soon choke a pond. Although useful additions to a new pond, providing temporary shade and shelter, they should be rigorously controlled as the pond becomes established. Over-hanging trees and shrubs should be avoided when siting a pond, or they will, as here, shed leaves into the water. These will eventually sink and decompose if they are not removed.

Routine maintenance *(see pp. 140–141)* is necessary to make sure that the water remains healthy – in particular, the regular thinning of plants so that the pond does not become blocked up. While all water features benefit from a major clean up from time to time, it is vital not to do this too often. Each time a pond is emptied and refilled, it can take up to two years for a balanced ecosystem to reestablish itself.

WATER FEATURES THROUGH THE YEAR
The structure of a water feature and the surrounding area should be inspected regularly throughout the year to make sure that leaks have not appeared. Other tasks are appropriate only in various seasons. In winter, fish become dormant at the bottom of the pool. Water plants are largely herbaceous, dying back in winter and remaining dormant until regrowth begins in the spring. Therefore, pond life is best left undisturbed in winter. Before cold winter weather arrives, take steps to protect the pond and its residents from freezing. A stock tank deicer, which floats on the water's surface, will keep temperatures just above freezing, thus protecting fish and other pond life.

When the pond warms up again in spring, plants and fish should be checked for health, and any restocking done so that the feature looks its best for summer. Prolonged spells of hot

weather can damage pond life – the pond should be filled up regularly *(see p. 138)* to combat water loss caused by evaporation. Remember that over the years, debris accumulating at the bottom of a pond will gradually make it more shallow, leaving fish with no cool, deep water where they can escape the heat. The removal of this layer of sludge is one of the principal reasons for emptying and cleaning a pond. Pumps, filter, and other equipment need regular maintenance to function well. Check them regularly in summer and clean off debris, especially from the pump intake.

STRUCTURAL REPAIRS
Pond repairs may become urgently necessary if a large leak develops, but more often small underwater punctures and cracks go unnoticed until a pond is drained for cleaning. Most of the materials used to line ponds can be repaired quite satisfactorily *(see p. 145)*. However, year-round attention must also always be paid to the condition of any structures above water, such as wooden edging, bridges, or stepping stones. If not kept in good condition, they are a threat to safety. Keep wooden surfaces clean and free of moss and algae; otherwise they can be extremely slippery. Also check stepping stones for stability and joints on wooden structures to make sure they do not wobble.

A BALANCED ECOSYSTEM

THE ECOSYSTEM OF A POND involves the interaction of many factors – water, gases, minerals, sunshine, plants, and animals. In every pond, a balance must be found between clinically clean water that offers no hospitality to submerged and amphibious creatures, and a murky, crowded environment that begins to stifle life. The health of a pond is affected by its size and shape, the surface area exposed to the air and to the sun, the acidity or alkalinity (pH level) of the water, the type of plants used, and the presence of pond life. If the ecological balance is disrupted, green algae will spread, and the water quality will deteriorate rapidly.

LIFE IN THE WATER

Most ponds must initially be filled with tapwater, which is generally alkaline and may contain additives. It is advisable to treat the water for chlorine and other additives, then let the pond settle for a week or so and become more hospitable to life before stocking with plants or fish. Wherever possible, use rainwater for filling up the pond, although it can be acidic.

The larger the pond, the more likely it is that a balanced ecosystem, in which many varied life forms interact, will develop naturally. The deeper the water, the less likely it is that water temperatures will fluctuate and disturb the ecosystem.

EXCHANGE OF GASES

Healthy water contains enough oxygen to support life. Fish and other aquatic creatures consume oxygen and produce carbon dioxide. In sunlight, submerged plants absorb carbon dioxide and release oxygen back into the water in a process called photosynthesis. The action of sunlight on mineral salts also causes algae to spread; these microscopic plants can rapidly deplete the water of oxygen, harming wildlife. As the water becomes murky with algal growth, plants starved of light will also begin to decay. Dead and decomposing plant and animal matter release poisonous methane into the water, further endangering life. It is essential, therefore, to partially shade a pond with floating-leaved plants to prevent too much sunlight from reaching the water, and that submerged plants *(see pp. 148–149)*, which compete with algae for nutrients, are present.

A HEALTHY POND
Water quality is a good indicator of pond health. This pond's clear bright water and healthy plantings indicate that it has been well tended. The water is free of algae – due in part to the shade provided by both water lilies and marginal plants, and in part to submerged plants that have absorbed the nutrients on which algae thrive.

GUIDELINES FOR A BALANCED ECOLOGY

The following tips will help to create and maintain a healthy ecosystem:
- Site pond in the optimum position *(see pp. 56–57)*
- Make sure that part of the pond has a minimum water depth of 18in (45cm)
- Use floating plants and water lilies to shade about half the pond *(see p. 152)*
- Add submerged plants *(see p. 152)*
- Do not overcrowd with plants or fish
- Do not overfeed fish *(see pp. 172–173)*
- To boost oxygen levels, install a fountain or waterfall *(see pp. 108–115)*
- Regularly check pH levels *(see p. 151)*
- Carry out seasonal tasks on time

AN UNHEALTHY POND
The appearance of this pond indicates neglect. Due to the lack of floating or submerged plants, algae has been allowed to spread over much of the water surface. No sunlight is able to reach the water, causing a further fall in the level of oxygen. Evaporation has also occurred – evident in the drastic drop in the water level. A layer of scum suggests that the water is also polluted, which may have been caused by a number of factors (see facing page). Because of these unhealthy conditions, the plants have not been able to survive.

NATURAL POND CYCLE

In a healthy pond, plants and animals coexist within an efficient and interconnected food chain. The process involves the interaction of bacteria, plants, herbivores, and carnivores with inorganic matter. The water level may be affected by the pH level: municipal tapwater tends to be alkaline; rainwater can be acidic. All pond life will suffer if the water quality is poor, so be sure to keep a regular check on the pH level (see p. 151).

INSECT-EATING BIRDS
Dragonflies are easy prey for swiftly moving birds such as swallows and martins.

MARTIN

SUNLIGHT

TAPWATER

RAINWATER

DRAGONFLY

Small amphibians eaten by birds.

Winged insects eaten by amphibians.

Small insects eaten by larger predators.

Sunlight absorbed by plants.

HERON

Algal growth stimulated by sunlight.

WATER SKATER

OXYGEN & CARBON DIOXIDE

Fish eaten by predatory birds.

FROG

METHANE GAS

Methane gas is a by-product of decay.

Water flea eaten by water skater.

WATER FLEA

ALGAE

Algae eaten by water flea.

Plants absorb carbon dioxide and release oxygen.

Tadpoles and young newts eaten by fish.

NEWT

Algae eaten by water snail.

FISH

Crustacean eaten by fish.

Insects eaten by aquatic amphibians.

Water flea eaten by water beetle.

WATER SNAIL

Insect larvae eaten by fish.

Algae eaten by beetle.

Plants eaten by snails and other insects.

WATER BEETLE

Plankton feed on algae.

Mineral salts absorbed by algae.

MINERAL SALTS

SHELLFISH

Detritus eaten by crustaceans.

Plankton eaten by crustaceans.

Plants eaten by plankton.

Submerged plants absorb mineral salts.

DETRITUS

PLANKTON

SUBMERGED PLANT

BLOODWORM

Detritus eaten by insect larvae.

FEEDING AND WASTE

Most ponds support a complex food chain. Bacteria, snails, and worms feed on organic debris; they are then eaten by water beetles and dragonfly larvae, which in turn are eaten by fish and frogs. In all but large wildlife ponds, fish may need additional feeding. The plants feed on nutrients such as mineral salts dissolved in the water: they will, however, benefit from slow-release plant fertilizers *(see p. 150)* from time to time.

MAINTAINING A BALANCED ECOSYSTEM

Regular maintenance is necessary *(see pp. 140–141)*, but avoid emptying the pond too often. Do not overstock with plants – their dying leaves will create much decomposing matter that releases methane. A surplus of fish will deplete the pond of oxygen; overfeeding will leave surplus food to rot. If the water freezes over, make sure that there is an ice-free area so that waste gases can escape *(see p. 139)*. Avoid using pesticides and do not use ordinary fertilizers on water plants. Finally, test the water pH regularly *(see p. 151)* – an imbalance can harm pond life.

POOR WATER QUALITY

	Symptoms	Possible Causes
PH OUT OF BALANCE	• Fish more prone to disease • Plant growth diminished • Biological filters less effective	• Tapwater, lime seeping from cement or decorative limestone (high alkalinity) • Rainwater, decomposing plants or fish waste, nitrites building up (high acidity)
LOW OXYGEN LEVEL	• Fish gasp for breath at pond surface • Fish start to die with no symptoms of disease • Water blackens or becomes malodorous	• Too many floating plants or fish • Decomposing organic waste • Prolonged hot weather • Excessive algal growth
POLLUTION	• Dead fish • Discoloration of water • Yellowing of plants • Numerous bubbles (particularly noticeable under ice)	• Buildup of methane • Buildup of nitrites and ammonia • Run-off from local farmland using nitrogenous fertilizers • Overfeeding fish

SEASONAL CHANGES

In MILD WEATHER CONDITIONS routine attention and occasional pond cleaning *(see pp. 142–145)* will maintain a healthy and attractive water environment. However, when weather becomes severe – long, hot summers and bitterly cold winters – special care must be taken to ensure that both the structure and the plant and animal inhabitants of a pond are not harmed. In climates or sites that are regularly subject to extreme weather, careful siting and design and appropriate choice of plant and fish species are necessary preventive measures. In temperate climates, there are many practical tips that will protect a pond from fluctuations in temperature.

HOT, DRY WEATHER

Long periods of hot sun with little rain will cause the water level to drop through evaporation. If the pond is not filled up, this will result in warmer water, which will encourage the growth of algae and reduce the level of oxygen *(see pp. 136–137)*. Lack of oxygen may be manifested by distressed fish gulping for air. There may also be structural problems – a severe drop in water depth will expose flexible liner to sunlight, for example, which will eventually cause less expensive brands to crack.

MAINTAINING A POND IN HOT WEATHER

Keep the pond filled throughout summer from a slowly trickling hose. Whenever you need to add more than 20 percent tapwater to a pond, treat it with one of the products that eliminate chlorine, chloramine, and ammonia from the water, which are toxic to fish. If algal growth becomes excessive, you may need to use an algicide. Oxygen levels can be increased by creating water movement: either spray the surface with a garden hose or, better still, install a low-bubble fountain. If necessary, transfer fish to a temporary cool tank and move plants to lower depths, or shade them.

SEVERE HOT-WEATHER PRECAUTIONS

During prolonged spells of hot, dry weather there are a number of ways to protect fish and plants and improve the condition of a pond. Remember when building a fish pond that a deep area of cool water where the fish may retreat is essential.

DESIGNS FOR HOT, DRY GARDENS

An informal pond with shallow margins and a large surface area is particularly vulnerable to water loss. In hot, sunny sites, it is worthwhile considering a more formal design, with a deeper pool that has overhanging edges to further minimize water loss through evaporation.

DECORATIVE CANAL
Canals originated in cultures with hot climates, such as those of ancient Egypt, Persia, and Rome. With their small surface area, they conserve water extremely efficiently.

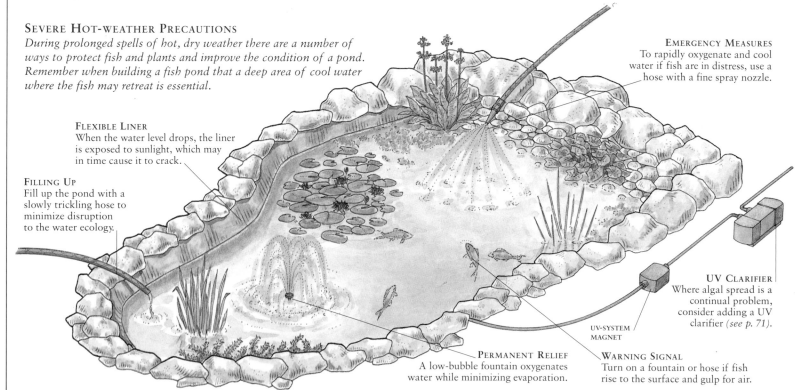

EMERGENCY MEASURES
To rapidly oxygenate and cool water if fish are in distress, use a hose with a fine spray nozzle.

FLEXIBLE LINER
When the water level drops, the liner is exposed to sunlight, which may in time cause it to crack.

FILLING UP
Fill up the pond with a slowly trickling hose to minimize disruption to the water ecology.

UV CLARIFIER
Where algal spread is a continual problem, consider adding a UV clarifier *(see p. 71)*.

UV-SYSTEM MAGNET

PERMANENT RELIEF
A low-bubble fountain oxygenates water while minimizing evaporation.

WARNING SIGNAL
Turn on a fountain or hose if fish rise to the surface and gulp for air.

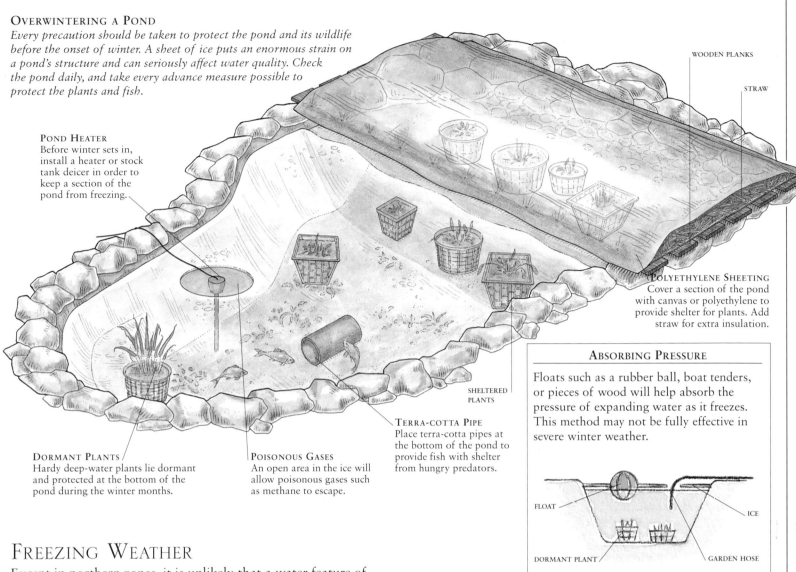

OVERWINTERING A POND

Every precaution should be taken to protect the pond and its wildlife before the onset of winter. A sheet of ice puts an enormous strain on a pond's structure and can seriously affect water quality. Check the pond daily, and take every advance measure possible to protect the plants and fish.

POND HEATER
Before winter sets in, install a heater or stock tank deicer in order to keep a section of the pond from freezing.

WOODEN PLANKS

STRAW

POLYETHYLENE SHEETING
Cover a section of the pond with canvas or polyethylene to provide shelter for plants. Add straw for extra insulation.

SHELTERED PLANTS

TERRA-COTTA PIPE
Place terra-cotta pipes at the bottom of the pond to provide fish with shelter from hungry predators.

DORMANT PLANTS
Hardy deep-water plants lie dormant and protected at the bottom of the pond during the winter months.

POISONOUS GASES
An open area in the ice will allow poisonous gases such as methane to escape.

ABSORBING PRESSURE

Floats such as a rubber ball, boat tenders, or pieces of wood will help absorb the pressure of expanding water as it freezes. This method may not be fully effective in severe winter weather.

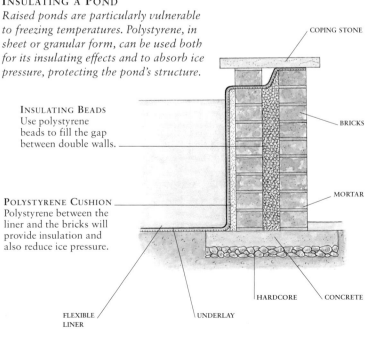

FLOAT

ICE

DORMANT PLANT

GARDEN HOSE

FREEZING WEATHER

Except in northern zones, it is unlikely that a water feature of adequate depth will freeze solid, but when water surface freezes, the ice expands, placing great pressure on the sides of a pond. Flexible-liner ponds resist this pressure better than concrete, particularly if the sides are slightly sloping. When building with concrete, reinforcing fibers will give flexibility and strength (*see pp. 90–91*). Where walls are vertical and made of bricks, a polystyrene layer that will compact under pressure (*see right*) is invaluable. Floating objects placed on the water surface before the pond freezes absorb some of the stress, but a stock tank deicer is the most effective protection.

POISONOUS GASES

When ice seals a pond, the exchange of gases is prevented. Removing snow from the surface will allow light to reach the pond, increasing oxygen levels, but methane released by decomposing organic matter is trapped under the ice, and a hole must be created to allow it to escape. Never smash the ice: the vibrations will shock and may even kill the fish. Always melt the ice gently – use a pond heater or stand a pan of boiling water on the ice. Siphoning off a small quantity of water under the ice creates an insulating layer of warmer air beneath the ice that will protect pond life.

INSULATING A POND

Raised ponds are particularly vulnerable to freezing temperatures. Polystyrene, in sheet or granular form, can be used both for its insulating effects and to absorb ice pressure, protecting the pond's structure.

COPING STONE

INSULATING BEADS
Use polystyrene beads to fill the gap between double walls.

BRICKS

POLYSTYRENE CUSHION
Polystyrene between the liner and the bricks will provide insulation and also reduce ice pressure.

MORTAR

HARDCORE

CONCRETE

FLEXIBLE LINER

UNDERLAY

ROUTINE TASKS FOR POND HEALTH

PROVIDED THAT A POND is well constructed and sensibly stocked, it should not be too difficult to care for and maintain. It is important to ensure that the water is at the correct level at all times; insufficient depth will cause temperature fluctuations, which will affect the water quality and consequently the well-being of plants and

fish. Structural damage to the pond may occur and thus necessitate repair work *(see p. 145)*. Lining materials are especially vulnerable in extreme weather conditions *(see pp. 138–139)*. Any surrounding structures such as paving and bridges should be checked regularly; this is especially important for safety reasons.

MAINTAINING A WATER FEATURE

Pond care involves maintaining every component of a water feature, and this includes both the plants and wildlife within the pond, the quality of the water, and all surrounding surfaces and structures.

STRUCTURAL CARE

Any structures incorporated by and over the water such as bridges, stepping stones, and decking should be checked regularly for structural damage. A screw missing on the handrail of a bridge, for example, could be potentially dangerous. Make sure that supporting foundations are sound; check also for rusting ironwork, and make sure that brickwork does not need repointing, especially after freezing weather.

REGULAR CLEANING
With a formal feature such as this, any neglect in the maintenance of water clarity, plants, and surroundings will be apparent.

Any surfaces should be regularly cleaned. Wood should be treated with preservatives once a year and any wooden or stone surfaces scoured with a wire brush in order to remove moss or algae. A slippery surface could be extremely dangerous – if necessary, cover the surface with fine wire mesh *(see below)*.

WATER LEVEL
During periods of hot weather when water evaporation is likely to occur, fill up the pond regularly with a slowly trickling hose (see inset). *Failure to do this will allow the water level to drop, as is evident here in the water marks on the stepping stones. If the water level remains low for too long a period, pond life will suffer, and flexible liner may crack.*

A NATURAL WATER BALANCE

Pond water is host to a community of microscopic organisms that are an important part of the water's ecology *(see pp. 136–137)*. In early spring, as the water begins to warm up and receives higher levels of sunlight, it becomes rich in minerals; phytoplankton (free-floating algae) feed on these minerals, and their presence causes the water to turn green and cloudy. This is only a temporary condition, indicating that the microscopic pond life is starting to reemerge, after having been dormant

SAFETY AND GENERAL CARE

WOODEN DECKING

Wooden decking complements water well. It may be used in any climate, provided that it has been treated with a wood preservative. Bear in mind that all wooden surfaces need regular maintenance, even in hot, dry climates. Check surface areas for any splits or cracks at least once a year, and make sure that no screws or brackets have rusted. Wooden surfaces require regular cleaning with a scrub brush, especially in damp climates. Chicken wire tacked to the decking (see inset) *will provide an unobtrusive, nonslip surface.*

SECURING AND CLEANING STONES
Any stones used as stepping stones must be completely stable and, if necessary, secured with mortar (see pp. 68–69). Surfaces should also be scrubbed regularly with a wire brush, to make sure that they are free of algae and not slippery.

SEASONAL TASKS FOR POND CARE			
Spring	**Summer**	**Autumn**	**Winter**
• Clean out the pond, if necessary (see pp. 142–144). • Carry out any repair work (see p. 145). • Clean off algae from surrounding paving, decking, or stepping stones • Remove water heater for storage. • Reinstall pumps, filters, and lights. • Check the water chemistry with a commercial test kit (see p. 151) and, if necessary, treat water with a pH adjuster. • If plants are diseased, treat water with fungicide (see pp. 136–137).	• Check water chemistry with a commercial test kit (see p. 151). • Clean the pump's strainer to make sure that it remains unclogged. Do this once a week (see below). • Control algae with algicide, if necessary. • Remove blanketweed regularly (see below). • To combat blanketweed add barley straw in nets (the type of bacteria attracted to the straw feed on algae). • Keep the water free from decaying foliage (see pp. 158–159). • Check the water level weekly, and fill up if necessary (see p.138). • If herons are preying on fish, fence the pond or cover with netting. • Keep any fountains on all night in sultry weather (see p. 138).	• Secure a net over the pond to collect falling leaves and debris (see p. 159). • Keep the water clear of dying foliage (see pp. 158–159). • Cut down foliage of marginal plants (see pp. 158–159). • Cut back excess growth of submerged oxygenators (see pp.158–159).	• Install a pond heater or stock tank deicer (see p. 139). • If not being used, remove, clean, and store pumps, filters, and lights. • If the pump is still operating, add extra bricks to its base to raise it nearer to the surface of the water. • Remove any dead leaves from water. • In warmer zones, place a floating object on the water to stop the water from freezing (see p. 139). • Remove snow from ice sheets, if necessary, to allow light to enter (see p. 139).

during the winter months. Algae play an important role in forming the first link in the food chain. As they use up nutrients and other creatures devour them, the algae will slowly diminish, leaving the pond water clear.

MAINTAINING CLEAR WATER
Functional planting (see pp. 152–153) and regular care should maintain clear water, but a long period of hot weather could disrupt the ecological balance, encouraging algal growth (see pp. 136–137), particularly of blanketweed. For quick results, algicides are available, but be sure to follow the instructions carefully. For a long-term solution, a biological pond filter and a UV clarifier with a magnet (see p. 71) is appropriate. To prevent water evaporation in long periods of hot weather (see p. 138), keep the pond filled up with a slowly trickling hose. Decomposing plant tissue will cloud or even blacken the pond,

polluting the water with toxic by-products and creating an unhealthy environment for fish. By regularly thinning and cutting back plants (see pp. 160–161) – especially in late summer when plants are beginning to die back – this potential problem may be averted. During autumn, place a net over the pond to catch the accumulation of fallen leaves before they enter the water (see p. 159). Before turning off the pump and installing a heater or stock tank deicer for winter, clear away any dead leaves in the water.

REMOVING EXCESS PLANT GROWTH
BLANKETWEED
Blanketweed, a mat of filamentous algae, should be removed regularly. To do this, rest a long stick on the water surface, turn gently, and pull out the strands of blanketweed that wrap around the stick.

CLEANING ACCESSORIES
PUMP MAINTENANCE
Clean the pump and strainer as recommended by the manufacturer; this may be as often as once a week during summer. Pumps should also be stripped and serviced once a year.

NOZZLE

FOUNTAIN ADJUSTMENT

MOTOR

OPEN-CELL FOAM

PRE-FILTER

STRAINER

FILTER FOAM
Filter foam will clog rapidly if water becomes dirty and should be cleaned twice a month.

ORNAMENTAL PLANTING
Make sure that no more than half of the pond surface is covered with floating-leaved plants. If the plants become invasive, thin them in order to to allow sunlight to enter.

CLEANING OUT A POND

EVERY POND NEEDS periodic emptying and cleaning, the frequency depending on its size. Small ponds require attention every two to three years, while large ponds may need cleaning less frequently. The process involves emptying the pond of water and its inhabitants in order to remove the layer of decomposing debris lying on the bottom of the pond. The debris mainly consists of rotting leaves; but there may also be dead creatures. The clean-out also provides an opportunity for dividing established clumps of deep-water plants, such as water lilies, which may have become overgrown. While the pond is empty, examine its structure for cracks or punctures. Late spring is the best time to clean out a pond, allowing time for plants and wildlife to recover and reestablish over the summer. If you have large or expensive fish, it is worthwhile seeking advice from a specialist supplier on temporary holding facilities that will keep them safe and stress-free.

HOW TO EMPTY YOUR POND

YOU WILL NEED

TOOLS
- Pump or length of flexible tubing to siphon water
- Garden hose
- Several plastic buckets
- Dustpan
- Soft broom or brush

MATERIALS
- Rubber boots or waders, with cleated rather than studded soles
- Old newspapers
- For fish, a wading pool or large holding container, e.g., plastic garbage can
- Large, soft fish net
- Net or towel for covering fish
- Water treatment product for chlorine, chloramine, and ammonia

AN UNTENDED POND
When a pond becomes overgrown, it is advisable to carry out a major clean-up. This will provide the opportunity to control the plants' growth by dividing or thinning where necessary.

1 IF THE POND HAS a submersible pump, you can drain the pond by disconnecting the delivery pipe and connecting a hose in its place: otherwise, start to siphon away the water. If the pond contains fish, remove just enough water at first to make it easier to catch them. Fill a holding container for fish with pond water.

2 REMOVE CONTAINERIZED PLANTS from the margins of the pond; integral planting beds need not be disturbed, unless plants need dividing. Wrap planting crates in wet newspaper and place in a shady area. Water the plants and wet the newspaper every few hours.

CONTAINERIZED PLANTS
Remove any aquatic plants that are in containers.

3 CATCH AS MANY FISH as are visible with a net and bowl *(see facing page)* and place them in the holding container in the shade. Remove containerized deep-water plants and water lilies, wrap the containers in wet newspaper, and place them with the marginals. Remove floating plants and submerged plants, retaining a few bunches of each in a bucket of water.

4 REMOVE ANY DECAYING plant matter that may be concealing more fish. Trawl the net through the water to catch any remaining fish. Place them in the holding container *(see inset)* and cover with a net or wet towel. Switch off the pump and remove it.

5 USE A PLASTIC BUCKET to remove the remaining water. Check the bucket for any beneficial creatures, such as frogs or tadpoles, and place them in the holding container. The water may be used on adjacent borders – do not pour it down a drain – it will clog the silt traps.

6 SCOOP UP THE MUD with a dustpan. Take care not to score the surface of any lining material. Reserve a small amount of mud and water in a bucket to help reacclimatize the fish when releasing them into the clean pond. The remaining mud can be added to compost.

7 WITH THE POND now empty of fish, plants, and most of the mud, add a little water and brush away any remaining algae, mud, or plant debris. Then bail or siphon out the dirty water. Inspect the surface of the lining for damage and carry out repairs, if necessary *(see p. 145)*.

8 PARTIALLY REFILL THE POND to a depth that will allow you to stand in the water in rubber boots or waders. Unwrap the water lilies and other deep-water plants. Divide them *(see pp. 160–161)* and trim them in order to remove any damaged stems and foliage.

9 SUBMERGE THE WATER PLANTS in the deeper areas of the pond. Any new, small plants should initially be placed on stacks of bricks *(see p. 157)* so leaves can reach the surface. Position ornamental plants like water lilies first, then add submerged plants. *(Continued overleaf.)*

10 ONCE THE DEEP-WATER plants have been installed, add the bucket full of reserved mud and original water *(see p. 143)*. This will help fish and any other pond life resting in the holding container to reestablish themselves quickly when put back in the pond.

11 BEFORE TRANSFERRING THE FISH from the bucket into the pond, examine them carefully. Check that they have not been damaged in any way, and look for signs of fungal growth or other disorders *(see pp. 174–175)*. Then reintroduce them to the pond.

12 UNWRAP THE MARGINALS, divide or thin them *(see pp. 160–161)* if necessary, and repot in their baskets on the marginal shelves. Then refill the pond to its correct level and treat the water for chlorine and other additives. Reconnect and position the pump.

A WELL-TENDED POND
This pond is no longer filled with overcrowded, congested plants, which have either been removed, divided, or thinned. The pond is now refilled with clean water, to which a small quantity of the original water and mud is added to reintroduce the microscopic life that allows a working ecosystem to become established again. The floating-leaved plants have been drastically thinned, retaining only the healthiest portions; while they grow, fish can take advantage of the shade cast by the overhanging juniper. Turn on a fountain, if you have one, to give maximum oxygenation to the water.

POND REPAIRS

POND CLEANING PROVIDES an ideal opportunity to inspect pond linings for structural damage, because a pond must be empty in order repair it. Large holes or cracks are usually obvious, because the water drops to their level. Minimal damage, however, will cause only very slow seepage, and may be hard to locate. Damage may be accidental or caused by extreme weather conditions *(see pp. 138–139)*. Inexpensive flexible and rigid liners are more likely to develop cracks than good-quality ones. Reinforced concrete pools *(see pp. 90–91)* are extremely resilient, but ordinary concrete will deteriorate within a few years.

REPAIRING FLEXIBLE LINERS

The simplest way to repair butyl, EPDM, or PVC liners is with double-sided, adhesive PVC tape *(see right)*, which can be obtained from suppliers of aquatic goods. It is probably not worthwhile repairing an inexpensive polyethylene liner. Before repairing a liner, it is important to clean the surrounding area thoroughly with a scrub brush and water. When the repair work is complete, wait at least 12 hours before refilling the pond.

REPAIRING PREFORMED RIGID UNITS

If a preformed rigid unit is not level, or if the ground underneath and the backfilling around it has not been thoroughly compacted, the unit is likely to crack eventually under the weight of the water. This applies particularly to cheaper plastic units. The crack can be repaired with a motor repair kit containing fiberglass matting. First, roughen the surrounding area with coarse sandpaper and clean it with water. Allow the area to dry, and apply a patch of fiberglass matting that is one-and-a-half times larger than the damaged area. Wait 24 hours for the compound to set. Check that the ground around the unit is well compacted.

REPAIRING CONCRETE PONDS

It is possible to repair cracks and fractures in concrete ponds, although this is not a long-term solution. First, clean the damaged area thoroughly with a scrub brush and water, and

REPAIRING A FLEXIBLE LINER

1 ALLOW THE DAMAGED area to dry, and clean with a soft cloth, dampened with alcohol.

2 PLACE DOUBLE-SIDED adhesive tape over the puncture and allow two minutes for it to become "tacky."

3 CUT A PATCH from a spare piece of liner and press firmly onto the tape, ensuring that the edges are flat.

allow it to dry. Then fill the crack with a commercial, fast-hardening sealant. If there is any likelihood of rain, cover the area with a sheet of polyethylene. Then apply a waterproof sealant and allow at least 24 hours for the compound to dry.

If a concrete pond is irreparable, lining the shell with butyl or EPDM and underlay will prevent the pond from leaking. (These are the most suitable types of lining material for a concrete pond, as they are less likely to be damaged by rough edges than PVC or polyethylene.) Lay the liner and underlay over the shell *(see also pp. 78–79)*, allowing for an overlap of about 4in (10cm); bury the edges of the liner in the surrounding earth. If the pond is surrounded by edging, trim the liner and mortar it to the paving at the point where it meets the edge of the pond.

REPAIRING CRACKS IN CONCRETE

1 TO MEND A FINE crack, first use a thin stone chisel and a club hammer to widen the gap, tapping very gently.

2 CLEAN OFF DUST and debris by brushing vigorously in the crack and surrounding area with a stiff wire brush.

3 USING A SMALL pointed trowel, fill the crack with a concrete sealant. Allow at least two days for the sealant to dry.

4 BRUSH THE AREA with a commercial pool-sealing compound. This will prevent toxins from leaking into the water.

PLANTS FOR WATER GARDENS

FOR GARDENERS, the chief excitement of creating water features is the opportunity they provide to use a new range of plants that need special growing conditions, and to grow and display more commonly seen garden plants in a new and attractive environment. The pleasure of watching the birds, insects, and other wildlife attracted by the water and its planting is a valuable bonus.

PLANTING NEW WATER FEATURES

Of all the specialty plant groups, water plants are among the easiest to grow successfully. Given the correct planting site and healthy water conditions, they will thrive with a vigor that is extremely satisfying. Provided that initial stocking is done with care, the majority of water features will look respectably furnished by the end of the first growing season and positively well established by the end of the second.

UNDERWATER PLANTS
Submerged plants play an important role in water health and, seen waving under the surface, heighten the effect of a natural pond. The roots and partially submerged leaves of Stratiotes aloides, *the water soldier, provide food and shelter for wildlife dwelling below the water surface.*

FLOATING LEAVES
Water lilies not only have superb ornamental value but also perform a functional role: the floating lily-pads shade the water, helping to restrain the growth of algae.

INFORMAL PLANTING
To create an informal effect, allow plants to spread and mingle. Marginal beds permit grasses, reeds, and sedges to grow freely within the limitations of the site. Free-floating plants form changing patterns on the water, moving gently with winds and water currents. They multiply readily and, like vigorous marginals, need regular thinning.

EXOTIC DISPLAY
If climatic conditions do not allow tropical plants to be used outdoors year-round, they can be used in exotic container displays. Here, the pink of Nymphaea *'Emily Grant Hutchison' contrasts strikingly with pea-green* Pistia stratiotes *(water lettuce).*

FORMAL PLANTINGS
The restrained use of well-tended plants both in and around the pool enhances a formal setting. A raised pool always gives a formal effect, and makes plant care easier too. Here, the plantings soften without subduing the impact of the elegant stonework and a surrounding parterre of formally shaped clipped hedging and topiary.

ESTABLISHED WATER PLANTINGS

Because plants in and around water grow with such vigor if plantings are left untended, soil and water space will become extremely congested and unhealthy. As plantings mature, steps must be taken to ensure that plants do not become crowded. The free circulation of water or air around and within plants is important; a stagnant environment encourages the growth of fungal spores and other harmful organisms. Also, more dominant specimens will stifle smaller plants and upset the balance between different plant types that is so crucial to pond health. Thin floating-leaved plants regularly through the summer, and divide overly vigorous species to keep them contained. In warmer areas, or where water features are sited under glass, care must be taken that evergreen plants do not take over, because of the head start they have over herbaceous plants that must regrow each spring.

THE RANGE AVAILABLE

Although the range of plants that will grow in water is limited when compared to what is available when designing a border, for example, there are an increasing number of plants to choose from each year, particularly as more non-native plants are introduced for sale. Even if you are restricted by climate to only the hardiest of plants, there are still many options to choose from. Consider combining hardy species with tender perennials that can be replaced annually or if necessary overwintered indoors. When it comes to choosing moisture-lovers for the area around a pond, the range is wide enough for any taste, and includes not only traditional favorites such as hostas, iris, and primroses, but increasing numbers of new cultivars of plants such as lobelia and mimulus.

Most general garden centers now have a small section that is devoted entirely to water plants. However, you will find a wider choice of well-grown plants at nurseries specializing in water gardening. Remember that it is, in many cases, illegal to collect plants from the wild, and in all cases most inadvisable. Even though some very common, unendangered species of submerged plants can often be found in natural ponds on farms or public land, they may carry blanketweed, pests, and diseases, all of which will have a detrimental effect on a garden pond and its plant and animal inhabitants.

PLANTING ENVIRONMENTS

PLANTS USED IN AND AROUND water features may be divided into two broad groups: those that will survive with their roots under water or in permanently saturated soil, and moisture-loving plants that enjoy a high moisture content in soil but must have some drainage to create air pockets in the soil structure. The first category contains two types of truly aquatic plants that are essential to a healthy pond: those that have submerged foliage, and those that have floating leaves. Marginal plants and moisture-loving plants for moist to wet soil around the water's edge are used largely for ornamental effect or to create wildlife habitats.

SUBMERGED PLANTS

Plants that have underwater leaves play a vital role in aquatic ecosystems. These plants usually have fine, feathery foliage to provide a large leaf surface area, which compensates for the reduction in light levels below water (they will tolerate a maximum depth of 3ft/90cm in full sun). The oxygen released from their leaves as a by-product of photosynthesis (the process by which plants gain energy) passes directly into the water. The water is then able to support other life forms, and a healthy ecosystem develops from which the plants also benefit.

Submerged plants also absorb minerals dissolved in the water, competing with algae and suppressing their growth. Their roots play a much less significant role in absorbing nutrients and tend to be shallow, frequently acting as little more than light anchors. There is equipment available that will carry out the purely functional role of submerged plants; however, plants have other

WELL-BALANCED PLANTING
Here, sensitive planting has produced a lush setting that is dense without being too crowded. Deep-water aquatics play a functional role, moisture-loving plants such as astilbes create a soft edge to the pond, and the clump of Iris sibirica *provides color.*

advantages; apart from their attractively textured foliage, they are essential for wildlife ponds, providing cover in which creatures may shelter and breed. They grow rapidly but can be controlled very simply by removing handfuls of surplus stems.

DEEP-WATER AQUATICS

Water lilies are by far the most popular plants among those that root in deep water. While their roots and tough, flexible stems are submerged, their leaves and flowers must be above water,

GUNNERA MANICATA

IRIS ENSATA

CANDELABRA PRIMULA

CALTHA PALUSTRIS

LAGAROSIPHON MAJOR

DEEP ZONE
Most water lilies prefer to be sited where they can enjoy the full depth of the pond.

WAVING STEMS
The long, fleshy stems of pond weed need the support of surrounding water.

WICK EFFECT
Large plants will suck water over liner edges, and regular refilling (*see pp. 158–159*) may be needed.

SATURATED SOIL
Boggy soil beds must be planted with true marginal plants, not moisture-lovers.

SHELF LIFE
Marginal plants in containers are easy to tend.

A POND DESIGNED FOR PLANTS
Not every pond will encompass the full range of planting sites that water plants and moisture-lovers may occupy; the types of plant you wish to grow will influence both the design and choice of construction method of a water feature.

usually floating on the surface. They must be given a planting depth suitable for their size and vigor so that leaf and flower stalks can reach the surface, otherwise the plant will drown. A number of water lilies, such as the vigorous *Nymphaea alba*, thrive in water that is up to 10ft (3m) deep. Those more suited to medium-sized pools generally prefer a depth of 1½–2ft (45–60cm). In all but large informal ponds, the growth of deep-water plants needs to be controlled by root restriction, regular division or, in small ponds, a combination of both.

FREE-FLOATING PLANTS

These plants absorb all their nourishment from the water through fine roots that hang suspended from leaf clusters or rosettes that float on the water surface. They perform the same function as rooted plants with floating foliage, and many that are semi-submerged also play an oxygenating role. If chosen correctly for the prevailing climate, they need virtually no attention, with the important exception that their sometimes invasive vigor and spread will need regular control. Surplus plants can simply be scooped off the water with a rake or net.

MARGINAL PLANTS

Warm shallows and waterlogged soil at the edges of informal ponds can be populated with a variety of plants that thrive with their roots in depths of water up to 6–9in (15–22cm). Submerged plants, most free-floating plants, and some floating-leaved plants, including dwarf water lilies, will thrive in shallow water. Marginal plants, which generally hold their foliage well above water, are more commonly chosen for the vertical interest they bring to the edges of the pool.

Although they do not contribute to the balance of the water chemistry, marginal plants contribute to a pond's ecosystem, providing an excellent refuge for wildlife, especially aquatic insect life *(see pp. 54–55)*; they are also a key ornamental element in most water features. Many marginal plants are vigorous growers; using planting baskets helps restrict growth

FUNCTIONAL PLANTS

SUBMERGED PLANTS
Submerged pond weeds such as Myriophyllum aquaticum *release oxygen directly into the water during daylight hours. They also compete with algae for minerals.*

FLOATING-LEAVED PLANTS
Water lilies are the most popular aquatics for the deep, central areas of a pond. In addition to their ornamental value, their floating foliage provides essential shade.

and protects the pond structure (in particular, flexible liner) from certain species, including *Typha latifolia* and *Glyceria maxima,* which have sharp, penetrating roots.

MOISTURE-LOVING PLANTS

The range of moisture-lovers includes not only traditional waterside species but also a broad variety of plants, such as hostas and astilbes, that may be used in any bed or border that contains well-watered, water-retentive soil. It must be remembered that moisture-loving plants differ from marginals in requiring oxygen at their roots; the majority will not tolerate waterlogged, boggy areas. However, with some form drainage system provided *(see pp. 58–59)*, they bring a welcome variety of plantings to pond edges, and play an important role in blending water features into the garden as a whole.

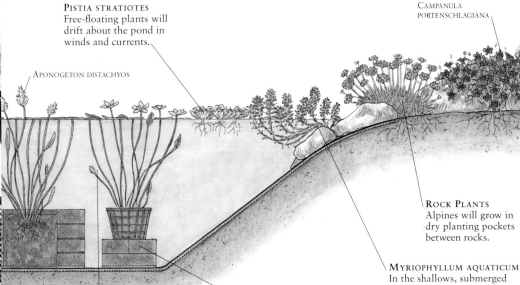

PISTIA STRATIOTES
Free-floating plants will drift about the pond in winds and currents.

APONOGETON DISTACHYOS

CAMPANULA PORTENSCHLAGIANA

HOSTA

MATTEUCCIA STRUTHIOPTERIS

TRANSITIONAL BEDS
Well-watered beds surrounding the pond will enable broad plantings of moisture-lovers.

ROCK PLANTS
Alpines will grow in dry planting pockets between rocks.

MYRIOPHYLLUM AQUATICUM
In the shallows, submerged plants may grow above the water, rooting lightly in mud or among rocks.

PLANTING DEPTHS
Bricks under younger and less vigorous deep-water plants keep them closer to the surface.

NYMPHOIDES PELTATA

FURTHER INFORMATION

- Encouraging Wildlife – pp. 54–55
- A Balanced Ecosystem – pp. 136–137
- Routine Plant Care – pp. 158–159
- Plant Catalog – pp. 178–207

SELECTING PLANTS

Deciding which plants to choose for a water garden may at first seem a little daunting; there are, however, some fundamental rules to follow, which should make choosing easier. The first priority is to provide an adequate number of functional plants in order to establish a well-balanced pond as quickly as possible. It is important to achieve the correct numbers and balance of these plants, avoiding understocking or overcrowding. Ornamental planting may be more flexible, depending to a large degree on personal taste, but it is important to consider flowering seasons to provide variety and create a long period of interest.

Essential Plants

In order to develop and maintain a healthy environment within a pond, it is vital to have some submerged plants and floating-leaved plants, whose role is to filter and oxygenate the water and, by competing successfully for sunlight and nutrients, to minimize algal growth in the water. Floating leaves will help to reduce the inevitable greening of the water with algae that occurs in high light conditions when the pool has inadequate surface cover. It occurs temporarily both in new ponds and each spring, before other plants have a chance to grow, but once they do, a balance is restored and the water clears.

To help this process, a third to half of the pond's surface should be covered by the leaves of free-floating and deep-water plants. In established ponds, water lilies are especially important, since they are among the first plants to spread their leaves in spring. However, they and other deep-water plants take time to establish. Free-floating plants are especially useful in the early establishment of a new pool, or in prolonged hot, sunny weather. *Azolla filiculoides*, for example, spreads rapidly and will provide enough cover within three months in a small pond. Its growth will soon need to be strictly controlled, however. In features with limited surface areas you may wish to remove the floaters in favor of the more permanent ornamental plants once water lilies and other deep-water plants have grown.

STOCKING LEVELS FOR NEW PONDS			
Pond size	Oxygenating plants	Temporary cover	Water lilies
Small 8ft x 6ft (2.5m x 2m)	15 bunches	6 free-floaters	1 water lily
Small to medium 12ft x 8ft (4m x 2.5m)	30 bunches	9 free-floaters	2 water lilies
Medium 15ft x 9ft (5m x 2.75m)	45 bunches	9–12 free-floaters	3 water lilies
Medium to large 20ft x 12ft (6m x 4m)	60 bunches	12–15 free floaters	4 water lilies
Large 30ft x 15ft (10m x 5m)	75 bunches	20–30 free-floaters	5 water lilies

Submerged plants, such as *Lagarosiphon* and *Myriophyllum*, also play an essential role. Not only do they compete with algae for nutrients, they also release oxygen into the water, enabling it to support life. In a new pond, it is vital to add enough plants *(see above)* to provide an adequate density of submerged foliage.

OTHER PRACTICAL CONSIDERATIONS

Once functional plants have been chosen, the design and surroundings of the individual feature may be considered in more detail. Certain plants, notably water lilies, do not tolerate

PLANTS FOR INITIAL STOCKING

SUBMERGED PLANTS
An adequate quantity of submerged plants such as Lagarosiphon major *or* Elodea canadensis *should be added to new ponds, so that their leaves may begin to produce oxygen to aerate the water and enable a healthy ecosystem to develop.*

FAST-GROWING FLOATING PLANTS
Small free-floating plants such as Azolla filiculoides *spread rapidly, and are extremely useful for providing initial cover. By mid-summer, they will probably need thinning so that surface cover is not too dense.*

CONSOLIDATING WET GROUND
If your pond is surrounded by boggy areas, plants with creeping, mat-forming root systems, such as Houttuynia cordata *(above),* Carex, *and* Persicaria *will soon grow to hold soil together and reduce surface evaporation.*

moving water, for example, so plants must be chosen with care for streams and around waterfalls. Ponds with informal beds filled with soil require some plants that will root strongly and knit together the edges. For small ponds, marsh marigolds (*Caltha palustris*) are ideal; for larger ponds, *Iris pseudacorus* or *Cyperus longus* could be used. If you want to attract wildlife, this will also affect plant choice (*see pp. 54–55*).

ORNAMENTAL PLANTING

Although you will be choosing plants for their visual contribution, you must bear in mind their suitability. The plants you choose and the way you arrange them may be restricted by the style of water feature and by climate and site.

Try to keep planting as simple as possible so that the water remains the focus of attention – planting should enhance rather than dominate the surroundings. Avoid using very vigorous plants in proximity to less robust species, and be especially careful in small areas to choose plants that can be kept within their allotted space. Large species can be used as specimen plants, but smaller plants often look better grouped in twos and threes.

SELECTING COLORS

Some gardeners enjoy bright colors, others prefer subdued shades – it is entirely a matter of taste. Color designs can continue a theme throughout the season (*below*), or become progressively richer: yellow *Ranunculus* and white callas and bogbean (*Menyanthes trifoliata*) will give a fresh look in spring, while in summer, vivid blue *Pontederia cordata* and rich red *Lobelia cardinalis* stand out against a lush, leafy background. Plants with attractive foliage are particularly well complemented by water. Grasses, sedges, and ferns can be used to create both formal and informal looks.

PLANTING FOR STYLE

FORMAL POOL
As demonstrated above, restrained planting is especially important to the clear symmetrical shapes of a formal pool.

INFORMAL POND
This water garden makes generous use of plants; bear in mind, however, that oxygenators in particular will grow rapidly.

PLANTING FOR COLOR

BOLD COLORS
Dark water and the lush greens of vigorously growing moisture-lovers are perfect backgrounds against which to use rich, bold color.

SIMPLE PASTELS
This low-key planting uses limited space effectively by featuring white flowers, silvery foliage, and pale pebbles to light up a dull corner.

FLOWER COLOR THROUGH THE SEASON			
	Early spring	**Late spring to early summer**	**Midsummer to early autumn**
White to cream	Caltha palustris var. alba Leucojum aestivum Petasites japonicus Primula denticulata var. alba	Aponogeton distachyos Calla palustris Menyanthes trifoliata Ranunculus aquatilis	Aponogeton distachyos Filipendula ulmaria 'Aurea' Miscanthus sinensis 'Zebrinus' Sagittaria sagittifolia
Yellow to orange	Caltha palustris 'Flore Pleno' Lysichiton americanum Primula veris Ranunculus ficaria	Iris pseudacorus Narthecium ossifragum Nymphaea 'Odorata Sulphurea Grandiflora'	Inula hookeri Ligularia 'Gregynog Gold' Lysimachia nummularia 'Aurea' Myriophyllum verticillatum
Pink to red	Anagallis tenella 'Studland' Darmera peltata Nymphaea 'Laydekeri Fulgens' Primula rosea	Alisma plantago-aquatica Nelumbo nucifera 'Momo Botan' Nymphaea 'James Brydon' Nymphaea 'Marliacea Carnea'	Astilbe 'Venus' Butomus umbellatus Filipendula purpurea Lythrum salicaria
Purple to blue	Myosotis scorpioides Primula denticulata Trillium erectum	Iris versicolor Hosta fortunei Nymphaea 'Blue Beauty' Nymphaea capensis	Lobelia x gerardii 'Vedrariensis' Phragmites australis 'Variegatus' Pontederia cordata Veronica beccabunga

YEAR-ROUND INTEREST

Foliage plants provide a changing, colorful seasonal display. Most aquatic plants are herbaceous, but evergreen marginal plants include *Thalia, Acorus gramineus, Equisetum hyemale,* and *Carex*. There are many attractive variegated irises and grasses in particular, and for autumn color, *Darmera peltata* and *Lobelia cardinalis* will provide a boost for the garden once the main flowering season is over. The texture of plants can be varied too, from feathery astilbes and swordlike irises and reeds to the broad-leaved gunneras and rheums. The seedheads of many plants can also add a decorative element.

PLANTING TECHNIQUES

WATER PLANTS MAY be planted in aquatic containers, in deep-water beds, or directly into soil on the bottom of a pond or on marginal shelves; some, such as free-floating plants and some submerged plants, are simply placed on the surface of the water. Containers are particularly useful for restricting plants with vigorous growth, although many will rapidly outgrow their containers, especially some of the more vigorous marginals. These will need to be lifted and divided regularly. The condition of the water will influence the health of aquatic plants; check the water quality *(see p. 151)* before introducing them.

PREPARING THE POND
Fill the pond at least three days before planting to allow the water temperature to reach that of the surrounding atmosphere. Aquatic plants absorb nourishment through their top growth as well as their roots, so the condition of the water is important *(see pp. 136–137)*. Do not spray water directly onto a soil-bottomed pond or a marginal soil bed – this will disrupt the soil. Cover the soil with a sheet of polyethylene, and rest the end of the hose upon it. The action of the water spreading out over the sheet will help keep the soil in place. As the pond fills, the polyethylene should float up and can be retrieved.

PLANTING UNDER WATER
When planting in submerged soil layers and beds it is generally best to work standing directly in the pond. In fact, when planting marginal beds, standing in the deep zone usually enables you to work at a more comfortable height. Provided that the soil is of a suitable consistency *(see p. 150)* you should be able to firm it down adequately.

PLANTING IN CONTAINERS
Most water gardeners find planting baskets and crates more manageable for deep-water plants than a layer of bottom soil, except in very large informal ponds. Marginals also grow well in containers, which can be positioned in groups to give a more natural, mingled effect. An added advantage is that the plants

POND ACCESS
In order to introduce planting baskets into the pond, it may be necessary to wade in and place the basket by hand. Thigh or, better still, chest waders will allow you to move in the pond freely. Try to move as gently as possible – any vigorous movement may stir up mud and distress fish.

can be moved around until the desired effect is achieved. Deep-water plants are best spaced evenly around the base of the pond to prevent stems growing through each other and tangling.

Purchased plants may already be in containers, but these can be rather small since display space is often limited in stores. It is worth moving them to a larger pot to allow their roots to develop well. Any aquatic plant sold in an ordinary pot should be transferred into one with openwork sides. Choose a basket appropriate to the size of the plant (as a guide, a vigorous water

PLANTING SUBMERGED PLANTS

PLANTING METHODS
Submerged plants can be planted directly into the soil beds of large, natural ponds; they will be able to root freely and their spread will be unrestricted. In smaller ponds, it is better to plant in containers (right) *so that their growth can be controlled.*

LEAD CLASP
The weight of the lead pulls the submerged plant down to the bottom of the pond, where it can root.

1 LINE A PLANTING container with burlap and fill with damp soil. Firm down lightly. Make evenly spaced holes 2in (5cm) deep and insert bunches of cuttings (here *Lagarosiphon major*).

2 FIRM IN THE PLANT with your fingers and trim off any excess burlap. Topdress the plants with a ½in (1cm) layer of pea gravel to keep the soil in place. Lower the basket gently into the pond.

lily needs a crate that is 16in/40cm across and 8in/20cm deep). If you need to add ballast to a container in order to keep large marginals stable *(see below)*, then choose a larger container to accommodate the extra material. Line the baskets if necessary *(see p. 151)*, fill with well-dampened soil *(see pp. 150–151)*, firm lightly and make planting holes. Container-grown plants should be planted at the same depth they were growing in their original containers; most bare-root plants are tuberous or rhizomatous, and these need to be positioned fairly near the soil surface *(see right)*. Firm them in well, and add a layer of stones or pea gravel that is approximately ½in (1cm) thick to prevent soil from drifting away. This layer of gravel is particularly necessary in ponds containing koi and other bottom-feeders, which can uproot plants as they nose around for food.

Either position containers by hand or, if you have a helper, thread two lengths of string through opposite sides of the basket. Holding the ends, you and your partner can stand facing each other across the pond and lower the plant into position. Depending on the depth of your pond, young deep-water plants may need a temporary stack of bricks *(see right)* or an inverted basket to allow the new shoots to reach the surface quickly.

SUBMERGED AND FREE-FLOATING PLANTS

In ponds with a layer of bottom soil, bunches of submerged plants can simply be dropped in the water. The lead clasp around the bunches will pull them down to the bottom, where they will root. They may also be planted in containers. A 12in (30cm) crate will accommodate several bunches. If several species are planted, keep each one in a separate crate.

For free-floating plants such as *Azolla filiculoides* and *Stratiotes aloides* simply float the plants from your hand on the surface of the water.

PLANTING IN SURROUNDING SOIL AND IN BOG GARDENS

Planting in permanently moist soil is no different from planting in any bed or border. Planting crates are not necessary; plant directly into the soil. Do not add fertilizer or handfuls of rotted or concentrated manures where they may leach into water, and be careful not to compact the wet ground when working. Remember that in permanently moist soil plants will grow very vigorously: give them plenty of room to spread, especially giants such as *Gunnera manicata* and *Rheum*, which will develop extensive root systems.

PLANTING BARE-ROOT DEEP-WATER PLANTS

1 **LINE THE BASKET** if needed and fill three-quarters full with dampened soil. Trim the tuber or rhizome, if necessary *(see p. 155)*, then position it so that it is within 1½in (4cm) of the rim.

2 **ADD MORE SOIL** and use your fingers to firm the soil, being very careful not to damage new shoots. Topdress with stones or pea gravel to prevent soil floating off the container once under water.

3 **PLACE THE CONTAINER** on a stack of bricks so that it is initially supported close to the water surface. As new leaves appear, remove bricks gradually until the plant sits on the bottom of the pond.

PLANTING IN MOIST AND WET SOIL

1 **DIG A HOLE** in the soil bed large enough to accommodate the root ball of the plant. Support the plant (here *Caltha palustris*) with one hand, and gently ease the root ball out of the container.

2 **PLACE THE PLANT** in the hole at the same depth as it was in the container. Using your hands, thoroughly firm the soil all around the crown of the plant. Soak the entire area with water.

STABILIZING PLANT CONTAINERS

USING A BRICK
If a planting basket is to be used to house a tall, top-heavy marginal, place a brick or half-brick in the bottom of the container before introducing soil. This will anchor the basket so that it will be less likely to tip over.

USING PEBBLES
Pebbles placed on top of the soil in the planting basket are even better than bricks for weighting down plants. This method does not use up soil space and provides a decorative finish.

ROUTINE PLANT CARE

PLANTS MUST BE WELL cared for in order to ensure healthy and vigorous growth. Routine maintenance includes many tasks common to all garden plants, although the techniques used may be modified. In this special environment, it is very important to remove any dying plant material or it will decompose and cloud the water, affecting other life. Regular pond care *(see pp. 140–141)* will also help maintain clear, well-oxygenated water, essential to successful growth. If you have to enter the water to work, try to accomplish several tasks in one session: repeated excursions into the water, however careful your movements, will disrupt it and its inhabitants.

WATER PLANTS THROUGH THE YEAR

Spring is the busiest time of the year for the water gardener, with many key tasks to be performed. If attended to now, plants are more likely to be vigorous and trouble-free during summer, when they can be enjoyed at leisure. Remember that algae are among the first "plants" to grow, and pond water will temporarily be green and cloudy each spring until the pond's ecosystem adjusts itself to the start of a new growing season.

CUTTING BACK AND THINNING

Most plants used in and around water are herbaceous. In cold climates, where old foliage has been left to shelter the crown of the plant over winter, spring is the time to cut all dead and dying leaves and stems back, together with remaining seedheads of grasses and similar plants. Be sure not to damage the growing points of new, emerging shoots.

Spring is also a good time to thin or divide many plants *(see pp. 160–161)* if they have begun to outgrow their allotted space. Submerged plants may be thinned at any time they begin to choke the pond. Hardy, free-floating plants sink to the bottom of the pond during the winter, reappearing in spring. Divide the clump-forming ones such as *Stratiotes aloides* when they return to the surface. Most floaters grow rapidly, and may need thinning again by summer. Water lilies and deep-water plants

WORKING IN WET SOIL
Fork over footprints made in damp soil to prevent compaction, being careful to avoid plant roots. In very wet conditions, work as much as possible from a wooden board laid over the soil, in order to distribute body weight evenly.

will need to be divided every three to four years – this will be evident the preceding summer when leaves become congested, with far fewer flowers appearing. Marginal plants will require more regular division, perhaps every other year, or they will outgrow containers and crowd the limited space on the edge of the pond. Moisture-lovers will also need to be divided quite frequently; if not, they will weaken and produce fewer flowers.

INTRODUCING PLANTS

Mid- to late spring, as growth begins and any danger of late frost is past, is an ideal time to introduce new plants to the pond *(see pp. 156–157)* and to the surrounding soil, so that they are able to benefit from the full growing season. Also, reintroduce any plants that have been protected from cold during winter *(see overleaf)*. When planting moisture-loving and marginal plants, it may be necessary to stand on the soil. Be sure to fork over any footprints afterward; this will prevent the earth from compacting, thereby making it more accessible to growing roots.

FEEDING

Established water plants will benefit from the addition of slow-release fertilizers in spring; water lilies in particular need large amounts of nutrients in order to thrive. Some garden centers and all water garden specialists will stock suitable slow-release fertilizers. These are generally sold in pellet form, and the pellet is pushed well into the soil to prevent its contents from leaking into the water. The fertilizer is released only at the rate that the plant can absorb it; very little surplus enters the water to nourish the growth of algae.

CUTTING BACK GRASSES

Grasses and sedges will benefit from annual pruning in spring: cut the whole plant close to the base, and remove any debris to let light and air into the center of the plant. Many species have sharp leaves, so wear thick gloves.

REMOVING UNWANTED GROWTH

CUTTING OFF DECAYING LEAVES
Hold the plant firmly and use a sharp knife to remove any yellowing or dead leaves, until you reach healthy, green stems. If yellowing is excessive, lift the plant to see if it is diseased in any way (see pp. 164–165).

DUCKWEED AND SURPLUS FLOATERS
Hold a plank vertically and draw it across the surface of the water to skim off duckweed, which is often naturally introduced into the pond by birds or on new plants. Dispose of the weed carefully, as it spreads easily.

PROTECTING POND LIFE
When thinning pond weed, drape it for a while on an edge or rock to allow small creatures to crawl or fall back into the water before disposal. In modest quantities, it can usefully be added to compost heaps.

SUMMER TASKS

Lushly growing plants may renew their leaves frequently, and it is important to regularly pick off or trim with a sharp knife at the stem base those that are yellowing and dying. Deadhead all flowering water plants: in some, this encourages further flowers while in others it removes potential decaying material.
If you wish to collect seed for propagation *(see pp. 162–163)* remember that seeds of aquatic plants need to be sown when freshly gathered, so collect the seed when there is still sufficient warmth for germination to occur, preferably in mid- to late summer. In moist soil around the pond, do not deadhead plants with decorative seedheads unless self-seeding plants are problematic. Weed regularly. Watch water level for any fall in long dry spells. Be sure that the floating plants do not smother the crowns of containerized marginals. Examine plants for signs of pests and diseases *(see pp. 164–165)*; they are susceptible to infections in summer, encouraged by the warm, humid conditions, and recognizing symptoms at an early stage is necessary for effective control.

PREPARING FOR WINTER

As the growing season ends, collect any young plantlets, plant material, or winter buds *(see pp. 160–163)* intended for propagation purposes that require shelter during the winter months. Store in moist soil in frost-free conditions.

Tender aquatics will also need to be lifted from the pond in the autumn. Remove any dying foliage and insert the plants in containers filled with moist soil or sand, which will prevent them from rotting when daylight intensity is low. Place them under glass in a frost-free place until the following spring.

Once winter sets in, take any precautions necessary to protect the pond and its plants from freezing weather *(see pp. 138–139)*, such as installing a stock tank deicer. A thick mulch of clean straw around bog-garden and moisture-loving plants will help to protect their roots.

AUTUMN NETTING
In autumn, lay fine-mesh plastic netting over the pond, securing the edges with bricks or stakes. This will prevent leaves that are shed by the plants surrounding the pond from entering the pond and decomposing. Every week or so, remove the netting, dispose of the leaves, and replace securely.

PLANT PROTECTION
Damp soil or sand will prevent plants from rotting.

FROST-TENDER PLANT

WATERTIGHT CONTAINER

TENDER PLANTS
Overwinter tender plants in a container filled with damp sand. Do not close the lid, but cover with a polyethylene bag with a few holes in it to allow air to enter.

PLANT PROPAGATION

DESPITE CAUTIOUS INITIAL planting, it is likely that plants will outgrow their sites. In a container or small pool this can happen in a single season; in a large informal pond it can take years. Division is one of the most common propagation techniques both in water and out. Use it to control plant size by digging an overgrown clump and discarding the older, less productive growth in favor of young, healthy portions of the plant. This is perhaps the easiest method of propagation. Other methods of propagating water garden plants (see pp. 162–163) include taking root or stem cuttings or, provided that the plant breeds true, growing from seed.

THINNING AND DIVIDING PLANTS

Many of the plants used in and around water features spread and multiply readily by vegetative means, producing new plantlets either from the rootstock or on runners. Sometimes these detach naturally from the parent plant, often sinking to the bottom to remain dormant over winter where they are hardy, then growing the next spring (these may be known as "winter buds"). Sometimes they must be physically separated. Clump-forming plants that have a mass of roots may also be physically divided; provided each has a portion of root and one or more shoots, small parts of the plant will grow independently of the parent. Whether these methods are used to control size, or to produce several new plants, depends entirely on how much space is available. If you do not have space to replant all the pieces, discard the older portions and retain the new growth.

Thinning and division should take place when plants are in active growth, ideally in spring so that any cut surfaces will heal quickly. Some moisture-lovers may also be divided in late summer or autumn (see pp. 196–207). Dividing water plants in the dormant season is not recommended, as low water temperatures may cause the newly divided plants to rot.

THINNING OXYGENATORS AND SMALL FLOATERS

1 IN SPRING OR AUTUMN, thin out overgrown submerged and small floating plants by "combing" the water with a rake. For containerized plants, lift out the basket and trim some stems off with a sharp knife.

2 BE SURE TO leave enough of the plants so they can regrow. If possible, thin little and often. Drape surplus plants on the side temporarily (see p. 159) to allow any inhabitants to escape.

SEPARATING RUNNERS AND PLANTLETS

1 IN SPRING, remove young vigorous plantlets from the parent, either snapping them off carefully from the perimeter of the parent, or severing the connecting stem on each side of the plantlet.

2 PLACE THE PLANTLET directly on the water surface, supporting it gently with your hand until it floats upright. Air sacs in the spongy leaf bases of water hyacinths keep plants buoyant. Roots will soon develop.

DIVIDING WATER LILIES

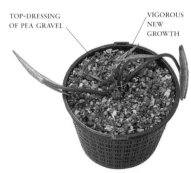

OVERGROWN PLANT
A water lily in need of thinning has few flowers and crowded leaves that thrust out of the water, rather than floating on it. Its roots have exhausted the soil nutrients, so it produces more leaves and stems, which in aquatic plants can absorb food from the water.

CONGESTED CROWN
Young stems and leaves have difficulty reaching the water surface when crowded by older foliage.

TOP-DRESSING OF PEA GRAVEL

VIGOROUS NEW GROWTH

1 CAREFULLY LIFT THE plant and rinse off the soil. Remove all opened leaves, and cut the rhizome in two, retaining the part with the most vigorous young, emerging shoots. If desired, remove any suitable bud cuttings (see p. 162) for propagation.

2 TRIM LONG COARSE roots, replant with the crown just below soil level, and reposition the water lily in the pond just as for a new young plant (see pp. 156–157). Discard the old portion of the rhizome.

DIVIDING RHIZOMATOUS PLANTS

1 LIFT THE PLANT (here, *Iris pseudacorus*) and rinse soil off the roots. Large masses of fleshy rhizomes can be split apart with your hands; otherwise, use a knife to separate vigorous portions of the rhizome, each with a number of fibrous roots, strong young leaves, and shoots.

2 USE A SHARP KNIFE to trim the rhizome neatly, removing any isolated portions that do not show any new shoot growth *(inset)*. Trim all of the top growth back to 3–4in (6–9cm), and cut back long roots so that they can be comfortably accommodated in the container.

3 REPLANT CAREFULLY, filling fresh soil around the rhizome, rather than pressing it into a hole, so that the roots are not compressed. Top-dress with pea gravel and reposition in the pond, on bricks if necessary to raise the trimmed top growth just above water.

SUBMERGED AND FREE-FLOATING PLANTS

Submerged plants are very easy to thin. Surplus stems can either be pulled out by hand or raked out *(see facing page)*. These plants are extremely resilient, and will regrow no matter how roughly they are treated. If they are in containers, lift the container out of the pond and remove old growth with a sharp knife. The smaller free-floating plants can also be raked off, or hosed to the edge of the pond and scooped out. The larger, more succulent floaters such as *Pistia* and *Stratiotes* are worth handling with more care. Separate and refloat only as many young plantlets as are required.

TUBEROUS AND RHIZOMATOUS PLANTS

Plants such as water lilies and most irises have tuberous or rhizomatous roots: that is, shoots grow up and fibrous roots grow down from a swollen, fleshy storage organ just below the soil surface. These organs grow and branch, developing new growing points at their tips from which fresh shoots emerge. As the new leaves grow to maturity, energy is stored in the new portion of the rhizome or tuber until it is capable of surviving independently of the parent root system. The plants are easy to divide *(see above and facing page, below)*. Either replant the best new portion and discard the rest, or retain more than one piece for replanting elsewhere in your pond.

FIBROUS-ROOTED PLANTS

The majority of moisture-loving plants form thick clumps that expand in rich, moist soil to form a circular mass of fibrous roots. The older roots inside the clump become progressively less productive, and flowers appear only on the young growth around the edges. The whole clump may be lifted and divided into sections. Grasses and sedges often have quite shallow root masses that can be pulled apart by hand *(right, above)*; other herbaceous plants form dense, bulky root balls *(right)* that must be separated with a garden fork or with a knife.

DIVIDING CLUMP-FORMING PLANTS

DIVIDING GRASSES

Cut down taller grasses to 6–8in (15–20cm), then lift the clump with a mass of soil adhering to the root ball. From the edge of the clump, where growth is youngest and most vigorous, pull away sections with a root ball of about a handful in size. Discard the older, tired central portion, and replant the new portions.

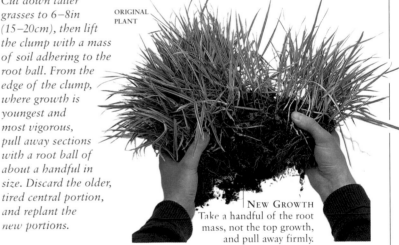

ORIGINAL PLANT

NEW GROWTH
Take a handful of the root mass, not the top growth, and pull away firmly.

DIVIDING DENSE CLUMPS OF TOUGH ROOTS

Plants such as hostas develop into substantial clumps (left) *that may be too tough to divide by hand. Use a garden spade (or lever with two forks back to back) or cut through the mass with a sharp knife. With the root ball in pieces of a more manageable size, carefully separate small sections* (right) *with a good root system and several plump buds or shoots and replant.*

OTHER METHODS OF PROPAGATION

THE CONVENIENCE OF PROPAGATION by division *(see pp. 160–161)* is that the young plants obtained can immediately be planted out into the garden. Propagation by other means, such as by taking root or stem cuttings, or from seed, tends to produce very young plants that, with a few exceptions, will not survive if planted directly into the pond. They must be cared for in a separate environment, usually under glass, until they have grown sufficiently to survive. If you have the facilities to care for these young plants, however, the techniques involved are not difficult and can produce a great many new plants.

ROOT BUD CUTTINGS

When tuberous or rhizomatous plants are lifted in spring, or bought bare root, there may be tiny new growing points visible on the rootstock where shoots are only just emerging. While a section of the rootstock with only this growing point is unlikely to survive if planted out, it can be potted up and grown on. On rhizomes, cut off a 3–4in (7–10cm) portion of the rootstock behind the growing point. On tuberous water lilies, and at the base of plants such as flowering rush *(Butomus umbellatus)*, the new growth may be emerging from a protruding nodule, or root bud; in this case, snap off the entire bud.

Root buds and cuttings should be planted either individually in small pots or in seed trays with the growing tip just visible. The pots are then placed in a greenhouse or under lights in a shallow tray with enough water in it to cover the soil. As the shoots grow they will need to be potted on, and the water level will need to be raised accordingly. The young plants should be kept in cool but frost-free conditions over winter, and may be introduced to the pond as growth begins the following spring.

On some plants, such as *Hydrocharis morsus-ranae* and *Hottonia palustris*, pebble-like root buds *(see above right)* detach naturally and sink to the bottom of the pond and stay dormant over winter where they are hardy; otherwise they are winter-killed (they are known as "winter buds"). These root buds may also be collected, potted up, and grown on in the same way as for root buds and cuttings.

WINTER BUDS

Some water plants, such as frogbit (Hydrocharis morsus-ranae), produce swollen buds on their roots that naturally detach at the end of the growing season, over-wintering at the bottom of the pool and developing into plants in spring where they are hardy; some float to the surface and grow roots downward, while some root into bottom mud and send shoots upward.

WINTER BUD

PROPAGATION BY ROOT-BUD CUTTINGS

1 CUT OUT THE swollen bud with its growing point from the rootstock. It may be necessary to cut through neighboring leaf stalks to obtain all of the bud. Use a sharp knife; fungal infections are less likely to enter clean cuts. Rinse the bud thoroughly.

2 FILL A 4IN (10CM) pot with potting soil or sifted topsoil, and firm. Firm the bud into a small indentation so that it sits securely on, rather than in, the soil; topdress with pea gravel to hold the bud in place.

3 STAND THE POT in water that just covers the gravel. Keep in a greenhouse and repot as necessary. Gradually stand the pot in deeper water, but keep the shoot tips above water. Plant the following spring.

TAKING SOFT STEM CUTTINGS

1 WITH A SHARP KNIFE, detach a non-flowering shoot about 6in (10cm) long from the parent plant (here *Veronica beccabunga*). Carefully remove the lower leaves and any low sideshoots.

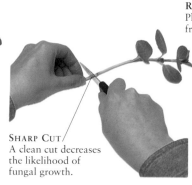

SHARP CUT
A clean cut decreases the likelihood of fungal growth.

2 WITH THE LOWER portion of the stem clear of leaves and sideshoots, cut the stem squarely across with a sharp knife to just below a node, or swollen area, where a leaf was removed.

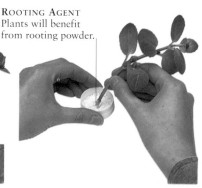

ROOTING AGENT
Plants will benefit from rooting powder.

3 DIP THE PREPARED cutting into hormone rooting powder, which will encourage roots to grow from the nodal area. The cut surface will be sufficiently moist to allow enough powder to stick.

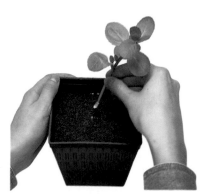

4 TAKE A FINE MESH container, approximately 4in (10cm) square, and fill it with potting soil. Insert the cutting into the container, firm it in, and keep under glass until rooted.

STEM CUTTINGS

New submerged plants can easily be obtained from cuttings if they are looking ragged after winter, after emptying and cleaning a pond, or if more plants are required. They do not need to be rooted before being introduced into the water. Simply cut or pinch off healthy young shoots, 4–6in (10–15cm) long, and tie them in bunches of six to eight with florist's or garden wire. As with purchased submerged plants *(see p. 155)*, either weight the bunches and throw them into the water, or plant several bunches in a container and immerse it.

Many marginal and moisture-loving plants may also be propagated from individual soft stem cuttings *(see facing page, below)*. These cuttings should be rooted under glass, with the soil kept either moist or wet, depending on the plant's needs. Cuttings from creeping bog plants such as *Veronica beccabunga*, *Ludwigia palustris*, and *Mentha aquatica* root particularly easily and should take only two to three weeks.

PROPAGATION BY SEED

Most moisture-lovers and some deep-water plants, including *Aponogeton distachyos*, *Orontium aquaticum*, and some lotus and tropical water lilies, may be grown from seed *(see right)*. Plants will take some time to develop and flower, so this method of propagation it is recommended only for the patient gardener or where lots of plants are required. Seed of most aquatic plants must be collected when ripe in summer or autumn and if not sown immediately, should be stored in jars of water. The seedlings must be grown in moist or permanently wet soil depending on the plant's natural growing environment.

Seeds of cultivars may not grow true to type; variation in offspring is likely unless precautions have been taken to prevent cross-pollination. This is difficult in open environments. However, many species grow well from seed, particularly native plants. Marginals such as the water plantain *(Alisma plantago-aquatica)* are prolific seed producers, whose seed often floats for some distance to achieve effective spread.

PROPAGATION BY SOWING SEED

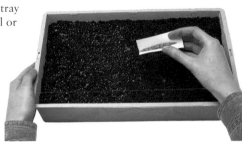

1 FILL A STANDARD seed tray with heavy garden soil or sifted garden loam, and water and compress it. Use a piece of folded paper to distribute the seeds evenly on the soil surface.

2 SIEVE A LAYER of fine sand or peat over the seed. This will help to retain moisture around the seed coat. For aquatic plants, stand the seed tray in a deep tray of water, keeping it filled up to just below soil level. Keep seed of moisture-lovers well watered.

3 PLACE THE TRAY in full light in a greenhouse until the seeds have germinated. When seedlings have two or three leaves, prick them out into individual pots. Pot on again when a good root system has developed. Keep young aquatic plants immersed in water as they grow. Overwinter in frost-free conditions and plant out the following spring.

PLANT CARE THROUGH THE YEAR

Spring	Summer	Autumn	Winter
• Trim off all dead and winter-damaged foliage from perennial plants. • If removing winter casualties, check first that there is no new growth at the base of the plant. If not, remove, and work compost into the soil before replanting. • Once the danger of frost has passed, introduce new plants, and reintroduce plants that were removed for protection over winter. • Divide crowded or overgrown plants as necessary (see pp. 160–161). • Feed aquatic plants, especially water lilies, with slow-release fertilizer. Ordinary garden fertilizers may be applied only where they will not leach out into water. • Once all planting, replanting, and feeding has been done, mulch boggy areas of soil to conserve soil moisture. • Remember that a temporary "greening" of the water is natural in spring; do not take action unless it persists.	• Deadhead flowering plants where decorative seedheads are not desired. • Where plants are in containers, move them around if large plants grow to dominate smaller specimens. • Remove any dying or disease-affected foliage (see p. 159). Congested foliage may be lightly thinned. • Make a note of plants that are becoming overgrown and congested, so that they may be thinned in autumn or the following spring. • Note gaps in plantings where new plants could be accommodated when dividing crowded plants. • Check plants for symptoms of pests and diseases, and treat as necessary (see pp. 164–165). • If algal growth is a problem, consider whether there are enough submerged and floating-leaved plants in the pond; it is not too late to introduce more.	• Collect and either plant or store any material for propagation, such as ripe seed or winter buds. • Check plants for symptoms of pests and diseases, and treat as necessary (see pp.164–165). • If you have a greenhouse (or indoor light garden), take cuttings of tender and borderline hardy perennials, in case the parent plants do not survive the winter. • Remove frost-tender plants for overwintering (see p. 159). Wash, dry, and store any containers from which plants have been removed. • In extremely exposed areas, cut back tall grasses, reeds, and other plants, reducing their height by about half, to prevent wind damage. • Protect moisture-loving plants against cold weather with a mulch of straw.	• As severe weather sets in, take measures (see p. 139) to protect plants. • Float an electric stock tank deicer in ponds to keep the water from freezing over completely. • If you have a cool, light place where plants may be stored over winter, bring in marginally hardy plants and keep them evenly moist over winter in trays of water. • Leave dying and frost-damaged foliage on perennial plants until spring to protect new growth below. • To make sure that the water environment remains healthy for dormant plants, make holes in ice sheets, and brush off snow to let light in. • Browse through plant catalogs and order attractive new plants for your pond.

FISH FOR WATER GARDENS

THE ORNAMENTAL ATTRIBUTES of fish have been recognized and appreciated for centuries. The first people to keep and breed fish for their decorative qualities were the ancient Egyptians. There is also strong evidence to suggest that the most popular of ornamental fish, the goldfish – which is closely allied to the carp – was selectively bred in China as far back as AD 970.

CREATING A BALANCED ENVIRONMENT FOR FISH
With the availability of exotic fish from habitats all around the world, it has become even more important to create an environment suitable for mixed populations of fish *(see pp. 168–169)*. Whether a garden water feature is large or small, formal or informal, the basic requirements for keeping fish remain the same – clear, well-oxygenated water, varied depths, adequate shelter and shade, and food.

WILDLIFE POND
Much of the charm of a wildlife pond lies in the sheer variety of wildlife it attracts. Unfortunately, this variety means that the inhabitants of such a pond, including its fish, are susceptible to a range of predators. Because they are not highly colored ornamental fish – and hence cheaper to replace – native varieties such as minnows and sunfish are ideally suited to wildlife ponds.

GOLDFISH FEEDING
Although a well-planted pond should guarantee that these goldfish obtain most of the food they need, some supplementary feeding will be necessary. Fish that become used to regular feeding at the same place each day will soon learn to assemble at the surface of the water at the right time and in the right spot.

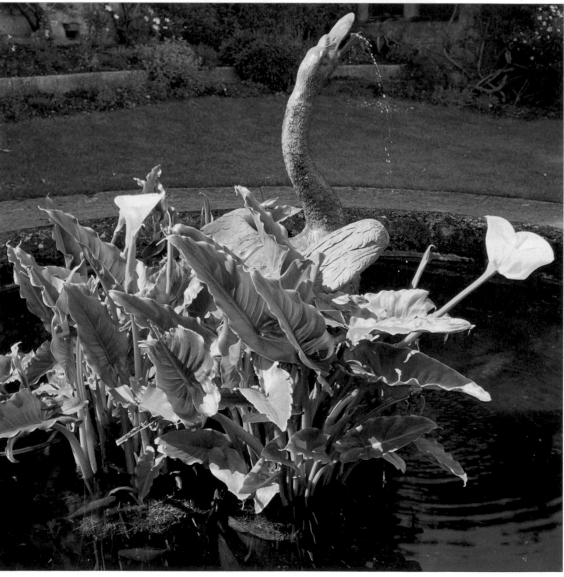

FISH IN FORMAL POOL
Much of the pleasure of fish-keeping derives from viewing the fish at close quarters. This raised formal pool with its submerged and floating-leaved plants provides an ideal environment for fish, as well as an ideal platform from which to view them.

INFORMAL POND

Although clear water allows an unimpeded view of fish, crystal clear water is not necessarily the kind of environment fish prefer. Many species feel insecure in water that leaves them clearly visible to aerial predators such as herons and kingfishers. Carp, for instance, will disturb mud at the bottom of a pond in order to create a more opaque habitat.

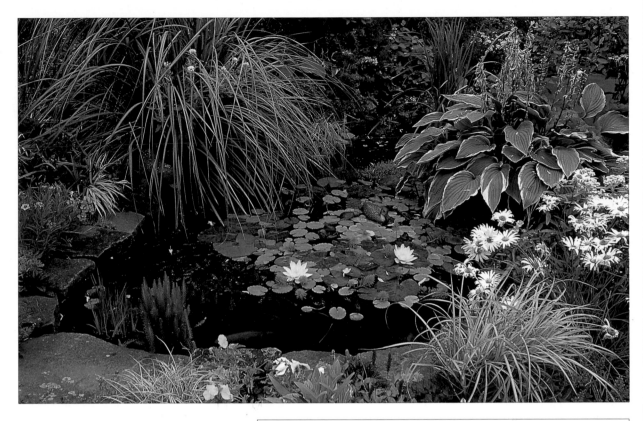

Although fish need room in which to swim around freely, even a barrel will accommodate one or two small goldfish. Deep-water ponds have distinct advantages over shallow ponds: not only are they suitable for fish that feed at different levels *(see pp. 168–169)*, but the water remains at a more constant temperature and retains more dissolved oxygen during hot weather. If a pond is too shallow, and there are no places to hide, fish will become stressed and dart about, stirring up mud at the bottom of the pond and disturbing plants.

Provided that fish are fed, a suitably constructed pond without plants, but with a sophisticated filtration system *(see right, below)*, will give fish all they need. However, most gardeners prefer a more natural, "planted" environment in which the plants themselves fulfill the fish's requirements for clear water, food, shelter, and shade *(see right, above)*. Even algae, which can become a problem if allowed to spread unchecked, are useful components in the ecology of a fish pond; not only are algae the first link in the food chain, they also provide a breeding ground for creatures on which fish can feed.

FISH BEHAVIOR

Like all vertebrates, the behavior of fish comprises two components: instinct and learning, the latter demonstrated by a fish's ability to appear at the same time and in the same place for feeding – one of the pleasures of fish-keeping. Although many species prefer to remain solitary – except in the spawning season – other species, such as minnows, form schools and must spend their lives in the company of their own species. Solitary species tend to be predatory and are often large. In contrast, schooling species tend to be smaller and, most commonly, omnivorous. They gather together for mutual protection and to share food.

KEEPING THE WATER CLEAN

USING PLANTS AS NATURAL FILTERS
Plants can be used to create a healthy environment for fish. Aside from their "filtering" qualities, submerged plants (see pp. 148–149, 178–179) and floating-leaved plants provide vital shade for fish.

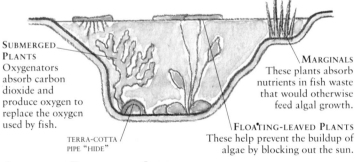

SUBMERGED PLANTS Oxygenators absorb carbon dioxide and produce oxygen to replace the oxygen used by fish.

MARGINALS These plants absorb nutrients in fish waste that would otherwise feed algal growth.

TERRA-COTTA PIPE "HIDE"

FLOATING-LEAVED PLANTS These help prevent the buildup of algae by blocking out the sun.

ARTIFICIAL FILTRATION SYSTEM
If a crystal-clear, heavily stocked pool is desired, supplement a biological filtration system (see pp. 70–73) with a UV clarifier (to keep the water clear of algae), which has a magnet designed to prevent the buildup of mineral deposits on which algae thrive.

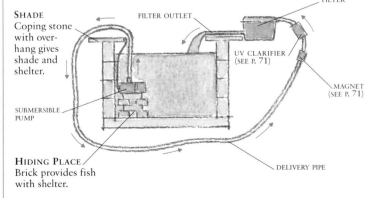

SHADE Coping stone with overhang gives shade and shelter.

FILTER OUTLET

FILTER

UV CLARIFIER (SEE P. 71)

MAGNET (SEE P. 71)

SUBMERSIBLE PUMP

HIDING PLACE Brick provides fish with shelter.

DELIVERY PIPE

FISH SPECIES AND THEIR REQUIREMENTS

DIFFERENT SPECIES OF FISH have different environmental preferences. Wildlife ponds, for example, are more suitable for hardy, native fish, while exotic fish will look their best in the sheltered environs of informal or formal ornamental ponds. Since fish feed at different water levels, establish the preferences of your chosen fish before buying and introducing them to the pond. Koi, which require a water depth of at least 3ft (1m), would be unsuited to a shallow pond, while orfe, which swim in the upper layers of the water, require a pond with a large surface area. A pond with adequate depth and surface area can accommodate several species.

VARIETIES OF GOLDFISH

The many types of goldfish all belong to the same species, *Carassius auratus*. They like rich, weedy ponds that have plenty of cover and a muddy bottom. They breed easily and can often live for more than 10 years. The single-tailed varieties are the hardiest, but all can live in 39°F (4°C) water provided adequate oxygen is available. A pond heater *(see p. 139)* or running pump in winter will provide this.

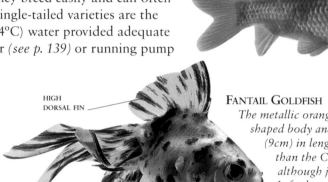

SINGLE CAUDAL FIN (TAIL)

COMMON GOLDFISH
Usually orange-red in color, this fish feeds at all levels. It is generally no longer than 6in (15cm), and is easily bred. Being hardy, it is ideal for most garden ponds, and will tolerate water as warm as 95°F (35°C), but not for extended periods.

HIGH DORSAL FIN

FANTAIL GOLDFISH
The metallic orange Fantail has an egg-shaped body and seldom exceeds 3½in (9cm) in length. It is less hardy than the Common Goldfish, although just as easily bred. It feeds at all levels.

DOUBLE CAUDAL FIN

MOTTLED COLORS
The coloration of shubunkins depends on both their strain and on the formation of their scales.

EXOTIC GOLDFISH

For the more adventurous fish-keeper, there are many exotic forms of goldfish to choose from. Originally bred in China and Japan, they are available in many different shapes, sizes, and colors. The more popular varieties include the Celestial, with its peculiar upturned eyes, the Bubble-eye, with enlarged fluid-filled sacs beneath its eyes, the Oranda, with a "hood" that covers its entire head, and the short, plump Pearlscale. All these fantails prefer very clean water. They should be brought indoors during the winter.

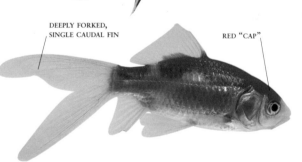

DEEPLY FORKED, SINGLE CAUDAL FIN

RED "CAP"

BRISTOL SHUBUNKIN
Shubunkins can grow to lengths of 15in (38cm). The popular varieties, like this one, feature black, red, purple, blue, and brown scales beneath pearly scales. Most shubunkin types are hardy, and feed at all levels. They also breed easily.

SARASA COMET (RED CAP)
A comet's colors depend on its strain. Sarasas have a white or silver base color, feed at all levels, and breed easily. Although hardy, they thrive best in temperatures of 46–68°F (8–20°C).

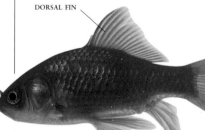

DORSAL FIN

FORKED TAIL
All comets have one deeply forked caudal fin, which may be almost as long as their bodies.

GOLD COMET
Growing to lengths of up to 15in (38cm), the Gold Comet needs a lot of space to swim in. It is very hardy, and can tolerate temperatures as low as 32°F (0°C) and as high as 104°F (40°C). Comets breed easily and, like most goldfish, feed at all levels.

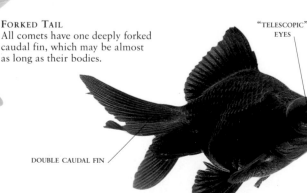

"TELESCOPIC" EYES

MOOR
The egg-shaped Moor should ideally have a velvety, jet-black body with no silver showing through. Some Moors have normal eyes, and some have "telescopic" eyes, which protrude on conical supports. They grow to approximately 4½in (11cm), feed at all levels, and are easily bred. They should be kept indoors in winter.

DOUBLE CAUDAL FIN

THE CARP FAMILY

The size and shape of carp vary enormously, as do their habits, habitats, and choice of food. Most carp will eat small invertebrates rather than other fish, whle some are omnivorous, eating both plants and invertebrates. Others, including the popular Grass Carp, are completely herbivorous.

CRUCIAN CARP
(Carassius carassius)
This boisterous fish is not suited to small ponds. It is a bottom-level feeder that can grow up to 24in (60cm) long. It thrives in weedy habitats, is easily bred, and will tolerate temperatures of 32–68°F (0–20°C).

SPECIALITY KOI

The more exotic, highly bred koi carp are classified by scale types, patterns, and colors – single-color, two-color, and multicolor. Because koi are viewed from above by show judges, their colors and patterns have been specifically developed for this purpose. To house and display koi well, pools must be deep, with crystal-clear water.

ORNAMENTAL KOI

PLANT EATER
The wide-mouthed Grass Carp feeds on vegetative matter.

REFLECTIVE SCALES
This carp boasts unusually large, shiny scales.

LATERAL LINE

GRASS CARP *(Ctenopharyagodon idella)*
The silver-gray Grass Carp has a wide mouth adapted for feeding on plants. It has a huge appetite, and grows very quickly up to a length of 24in (60cm). A middle-to bottom-level feeder, it is easily bred, and will thrive in large ponds in temperatures of 32–68°F (0–20°C).

MIRROR CARP *(Cyprinus carpio)*
This domesticated form of Common Carp has very large scales on parts of its body. Up to 24in (60cm) long, it is unsuitable for small ponds. It is a bottom-level feeder, easily bred, and tolerant of temperatures of 32–68°F (0–20°C).

KOI *(Cyprinus carpio)*
Not all koi are expensive, only those intensively bred for special colors and patterning (see box, left). Because they grow to 24in (60cm) in length, koi are unsuitable for very small ponds. Hearty eaters, especially of plants, they need an efficient filtration system to deal with their waste. Koi feed at all levels, are easily bred, and prefer temperatures of 39–68°F (4–20°C).

OTHER FISH

Decorative alternatives to goldfish and koi include lively orfe, while more subtly colored fish for large, natural ponds include comets *(Carassium auratus)*, which dart about just beneath the water's surface. Smaller wildlife ponds can accommodate a variety of species including minnows, sunfish, bluegills, all of which are popular with children; minnows, best introduced in groups of at least 8 to 10 also will thrive in a stream if the water is deep enough.

ROACH *(Rutilus rutilus)*
Roach, which grow to a length of 10in (25cm), are a European species not found in North America. They tolerate clear and muddy water, but prefer well-oxygenated water. They are middle-level feeders, and spawn when the water temperature rises above 54°F (12°C).

RUDD *(Scardinus eryphtyhrophthalmus)*
This lively gold or silver fish reaches 10in (25cm) in length. This European species will breed freely in a spacious pond that has plenty of under-water foliage. It is a surface-feeder and tolerates a wide range of temperatures, up to a maximm of about 102°F (38°C).

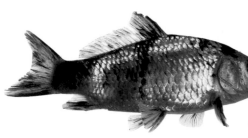

GOLDEN ORFE *(Leuciscus idus)*
Unsuitable for small ponds, these hardy fish grow to 18in (45cm) or larger. Active surface-feeders, orfe spawn when the water temperature rises above 50°F (10°C).

BITTERLING *(Rhodes ceriseus)*
This bottom feeder grows to 2–3½in (5–9cm) in length, and prefers temperatures of 50–68°F (10–20°C). Breeding is complex, as the female needs a freshwater mussel in which to lay her eggs.

SCAVENGING FISH

All pond fish, including koi and carp, are scavengers and will clean filamentous algae from the pond. A good filtration system should be able to remove debris. Clams or mussels, if placed in a tray on the bottom, can help keep the water clear. Be wary of adding the carnivorous catfish, which can grow up to 12in (30cm) long. Catfish are aggressive and will eat other decorative pondfish.

BUYING AND INTRODUCING FISH

THE IDEAL TIME TO buy fish is late spring or early summer, when the water temperature reaches about 50°F (10°C). The conditions under which the fish are transported and introduced into the pond, and the readiness of the pond itself, are as important as the

selection of healthy fish. Always test the acidity or alkalinity of pond water with a pH test kit *(see p 151)*, and use a pH adjuster, available in powder form, to remedy any imbalance. As a precaution, fish can be disinfected with a commercial fungal cure before introducing them.

SELECTING FISH

The first step to buying healthy fish is to choose a reputable supplier, who will allow you to pick out and inspect individual fish, and who will have an oxygen cylinder on site to inflate a carrying bag with enough oxygen *(see facing page)* for the journey home. Avoid buying fish from tanks that are connected to each other; this exchange of water increases the risk of waterborne diseases. Also avoid buying fish from a crowded selling tank, as this environment provides ideal conditions for the incubation of many pests and

diseases *(see pp. 174–175)*. If possible, buy fish that are no more than 3–5in (7–12cm) long. Bigger fish not only cost more; some may find it harder to acclimatize to a new environment. Inexperienced fish-keepers should not invest in exotic and expensive varieties of fish at the outset, as these fish often have special requirements. If a fish becomes ill, a good supplier or a water garden center will be able to offer advice; failing this, they will be able to recommend a veterinary practice specializing in fish.

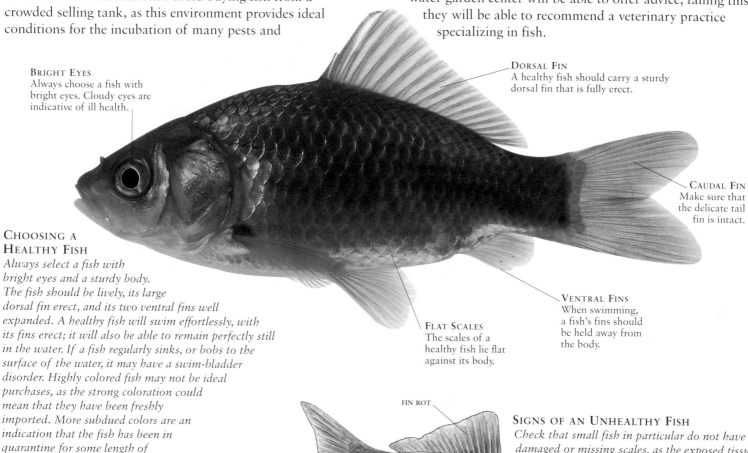

BRIGHT EYES
Always choose a fish with bright eyes. Cloudy eyes are indicative of ill health.

DORSAL FIN
A healthy fish should carry a sturdy dorsal fin that is fully erect.

CAUDAL FIN
Make sure that the delicate tail fin is intact.

CHOOSING A HEALTHY FISH
Always select a fish with bright eyes and a sturdy body. The fish should be lively, its large dorsal fin erect, and its two ventral fins well expanded. A healthy fish will swim effortlessly, with its fins erect; it will also be able to remain perfectly still in the water. If a fish regularly sinks, or bobs to the surface of the water, it may have a swim-bladder disorder. Highly colored fish may not be ideal purchases, as the strong coloration could mean that they have been freshly imported. More subdued colors are an indication that the fish has been in quarantine for some length of time – probably under cover – and will therefore be less prone to disease.

FLAT SCALES
The scales of a healthy fish lie flat against its body.

VENTRAL FINS
When swimming, a fish's fins should be held away from the body.

FIN ROT

FUNGUS (COTTON DISEASE)

INTERNAL AILMENT
Fish with an internal ailment may trail colorless excreta.

DROPSY
Bristling scales are one indication that a fish has dropsy.

WHITE SPOT

DULL EYES

MOUTH FUNGUS

SIGNS OF AN UNHEALTHY FISH
Check that small fish in particular do not have damaged or missing scales, as the exposed tissue beneath the scales will be vulnerable to secondary fungal infection. Because larger fish are more aggressive, it is more common for them to have some missing scales. If the spine of a fish appears to be bent, it could be the result of damage to its nervous system. A bloated body, bulging eyes, and bristling scales are indicative of dropsy (see pp. 174–175).

TRANSPORTING AND INTRODUCING FISH

1 TRAWL A WIDE, soft mesh net underneath the selected fish. To prevent the fish from panicking and damaging itself, be as gentle as possible. Do not take the fish out of the water.

2 TO MAKE THE plastic bag more manageable, roll down the top as shown. Fill the bag with 2–3in (5–8cm) of water from the holding tank. Tip the fish gently from the net into the bag.

3 IF THE JOURNEY HOME will take more than four hours, ask the dealer to inflate the bag with oxygen from a cylinder, then seal. Do not leave fish in a sealed bag for more than 36 hours.

4 TO SUPPORT THE BAG and maintain the level of the water inside it, place it in a cardboard or styrofoam box for the journey home. Cover the box: light can cause the fish stress.

5 FLOAT THE UNOPENED bag on the pond until the water temperature in the bag matches that of the pond. To further acclimatize the fish, add a little pond water to the bag a few times, and reseal.

6 BY NOW THE POND WATER should have the same chemical composition as the water in the bag. Release the fish. Once it swims around happily, give it small quantities of food.

GUIDE TO STOCKING LEVELS

To achieve a healthy balance of submerged pond life, stock with a number of small fish rather than a few large ones that will swiftly devour other members of the food chain.

The number of fish your pond will support depends on its surface area (because it is this factor that chiefly determines how much oxygen will be available to them) and the length of the fish when mature (because their size determines their oxygen needs). An area of 1ft x 1ft (30cm x 30cm) will support a fish 2in (5cm) long, from nose to tail. While an area three times as big will accomodate three such small fish, it could instead be allocated to one 6in (15cm) fish. You can therefore divide your pond into equal portions to support a number of same-sized fish, or, for a mixed population of differently sized fish, allocate an appropriate area to each (see right) as space allows.

4in (10cm)

6in (16cm)

1ft (30cm)

16in (40cm)

2in (5cm)

8in (20cm)

12in (30cm)

HOW MANY FISH?
Exclude areas of marginal planting when calculating the surface area of clear water (this can include areas covered by floating foliage). Never overstock a pond. All fish, large or small, need enough space in which to swim freely.

ROUTINE FISH CARE

THE NATURAL ECOLOGY of a pond takes months, if not years, to establish itself *(see pp. 136–137)*. However, while it is advisable to wait several weeks before putting fish into a newly constructed pond, the addition of a dechlorinator and water conditioner, stocked by fish suppliers, can eliminate any wait.

AN IDEAL HABITAT

A well-planted pond makes an ideal habitat for fish. Submerged plants provide a spawning ground, cover, and food, as well as oxygen during the daylight hours, while floating-leaved plants create shade. Additional cover can be provided by placing corrugated tiles or terra-cotta piping on the bottom of the pond. The pond should not have any rough edges that fish could rub themselves raw against; this could lead to infection. If planning to keep boisterous fish such as koi, which tend to stir up mud at the bottom of the pond, it is essential to install a mechanical filter *(see pp. 70–73)*. In hot weather, a hose with a spray attachment or sprinkler can be used in an emergency, if fish are distressed and gasping for air. The pH levels of pond water should be maintained between 6.8 and 7.5 *(see p. 151)*. To lower the risk of diseases being transmitted, avoid overstocking.

FEEDING FISH

During winter, fish are semi-dormant and will not require feeding. They will live off reserves of fat and occasional stray food items. As spring advances and fish become more active, they will need an increasingly rich diet. If the pond is not yet well-enough established to satisfy their food requirements, most good-quality, prepacked fish food will adequately supplement any diet deficiencies. Feed fish once a day as the temperature rises and the fish begin to actively search for food. This frequency can be reduced gradually to several feeds per week as the season progresses. Foods such as frozen or freeze-dried shredded shrimp, which are rich in protein, will provide a dietary boost during the breeding period. Never overfeed fish, since uneaten food will decompose and pollute the water.

A WELL-PLANTED POND
Fish are happiest in a pond that provides shade and shelter and has a variety of submerged, floating, and deep-water plants. The pond should not be overstocked and should be well maintained so that the fish are less susceptible to waterborne diseases (see pp. 174–175). *Clean water is not only beneficial to their health; it also allows them to be seen.*

PREPARED FISH FOODS

FROZEN FOOD

Frozen or freeze-dried natural aquatic foods such as shredded shrimp, dried flies, and ants' eggs are rich in protein and contain all the nutrients that fish need.

DRIED FISH FOOD
Floating pellets and flakes are prepared to provide a balanced and nutritious diet for fish. Crumb food, although less nutritious, does give fish essential roughage.

PELLETS

CRUMB FOOD

FLAKED FOOD

EATING HABITS
A useful rule is to provide fish with no more food than they can eat within 10–15 minutes per day. All fish, even bottom-feeders, can be tempted to the surface with floating pellets of food. Even if fish are fed regularly, they will supplement this diet with live foods including gnats and mosquito larvae.

INSPECTING FISH

To remove a fish from the pond, always have a large bowl or bucket ready. Rather than chase fish around the pond, causing them stress, it is advisable to attract them to a secluded area with a sprinkling of food. If the fish is a small specimen – say, 4in (10cm) long – gently trap it in a soft net, then lift the net out of the water and release the fish into a bowl filled with pond water. Alternatively – and preferably – scoop the fish out of the net with a small bowl, without removing the net from the water, and release it into the larger holding bowl.

Under no circumstances should large fish (carp, for example) be lifted out of the water in a net. First net the fish gently, then lower the holding bowl into the pond and guide the fish into it.

BREEDING FISH

Whether or not fish breed depends on the population of the pond. If it is overstocked, the female will reabsorb her own eggs; if fry develop, most will not survive. The breeding season occurs between spring and midsummer, but unless they have reached a certain size, fish will not breed. Goldfish, shubunkin, and carp, for instance, must be at least 3in (8cm) long. Most pond fish lay and fertilize their eggs externally. Three or four days after the male has fertilized the female's eggs by spreading his milt over them, the fry begin to develop. During summer, professional fish breeders use a method known as hand-stripping to selectively breed fish. This should not be attempted by novice fish-keepers, as it involves the delicate task of removing the female fish's ova and the male's milt.

LIGHTING AND FISH

Only use lighting in a fish pond if the pond is large enough to allow fish to take refuge in other, unlit nooks and crannies in the pond if disturbed by the light. Never light up the entire area of a fish pond, or leave the lights on all night.

SIGNS OF ILL HEALTH
When inspecting a fish for signs of ill health, it will be necessary to look at it closely and in reasonably clear water. Small fish may be lifted out of a pond in a soft net and placed in a holding bowl filled with pond water. Net large fish, but rather than lifting them out of the water, guide them into a holding bowl.

BABY FISH
Baby fish, called fry, start out as minute and transparent organisms, and only begin to look like fish after two or three weeks. Depending on her size, a female may lay between 5,000 and 200,000 eggs, which hatch in 5–10 days depending on the temperature of the water. Males usually mature in their second or third year, females in their third or fourth year.

SEASONAL CHECKLIST FOR FISH CARE

Spring	Summer	Autumn	Winter
• Use a testing kit *(see p. 151)* to evaluate the water's pH levels.	• Introduce new fish *(see pp. 170–171)*.	• Feed fish when the weather is warm and bright *(see p. 172)*.	• Cease feeding fish as they become semi-dormant.
• Introduce new fish *(see pp. 170–171)*.	• Replace water lost through evaporation *(see pp. 138–141)*.	• To build up fish for the winter months, supplement their diet with high-protein foods *(see p. 172)*.	• Place terra-cotta pipes at the bottom of the pond to provide fish with shelter from predators.
• When the water temperature reaches 50°F (10°C), begin feeding high carbohydrate diet (wheat germ etc.). Do not begin feeding high-protein diet until the water temperature is 60°F (15°C).	• Check water-lily leaves for pests, then hose them into the water for the fish to eat.	• Remove tender species of fish and keep under cover for the winter *(see pp. 168–169)*.	• If freezing temperatures are forecast, install a stock tank deicer, pool heater *(see p. 139)*, or place one or more floats in the water, or cover a section of the pond *(see pp. 138–139)*.
• Reintroduce fish overwintered indoors *(see p. 139)*.	• Regulate feeding, since more natural foods are available to the fish.	• Net the pond to protect it from falling leaves and debris. Keep an eye out for herons as they prey more heavily on fish to build up their own reserves for the winter months *(see p. 174)*.	• If a pond ices over, make an air hole by placing a pan of boiling water on the ice. Never break ice with a hammer; the shock vibrations are harmful to fish.
• Inspect fish for parasites or disorders they may have picked up during the winter *(see pp. 174–175)*.	• Check fish regularly for pests and diseases, especially in very hot weather *(see pp. 170–171, 174–175)*.		
• Remove algae *(see pp. 140–141)*.	• If necessary, remove fry to a separate pond or to a bucket of water taken from the pond until they grow larger.		
• Keep an eye out for herons, which become active in the spring when food is not yet plentiful *(see p. 174)*.	• In hot spells, if fish are surfacing and gasping, use a hose with a spray attachment or a sprinkler to rapidly increase the oxygen content of the water.		
• Take precautions against predators by erecting a netting fence, approximately 18–24in (45–60cm) high, around the perimeter of the pond *(see p. 174)*.			

FISH PESTS AND DISEASES

ALTHOUGH FISH ARE vulnerable to a range of pests and diseases, a healthy pond environment can minimize these hazards. Be sure that the pond has different depths and varied planting, and avoid overstocking with fish *(see pp. 170–171)*. Cleaning the pond regularly *(see pp. 140–141)* and maintaining a balanced ecosystem *(see pp. 136–137)* are equally important. Most fish diseases are curable, and treatments for many are available from pet shops or garden centers. If a fish displays symptoms or behaves abnormally, move it into a separate container *(see p. 171)* away from other fish, while you seek advice and treatment.

FISH PESTS

DRAGONFLY AND DAMSELFLY LARVAE

Dragonflies can spend up to five years as nymphs (larvae) underwater, but only have one or two months of adult life. The color of these scorpion-like nymphs *(right)* varies from green to brown and gray. They spend most of their time at the bottom of the pond, where they prey on small fish and insect larvae. They catch the fish by shooting out their "mask," an extension of the lower jaw that resembles the claws of a lobster. These claws grip the prey and draw it back into the mouth, where it is injected with digestive fluids. Although both dragonfly and damselfly larvae prey on small fish, they themselves are important food for larger fish and birds. The adults are an attractive and interesting addition to the life of a pond.

HERON

A variety of herons, including great blue herons and green herons, will eat pond fish. Herons obtain food by wading in shallow water or standing in the water on one leg, head hunched into the tops of their wings. Without warning, these birds will stretch out their long necks and stab passing fish and other aquatic animals with their long, sharp, daggerlike beaks. Having identified a fish pond, stream, or bog garden as an excellent source of food, a heron will hunt relentlessly. Control is not easy, and if visits persist, it may become necessary to erect a netting fence, 18–24in (45–60cm) high, around the edges of the pond. The fence should be strong enough to keep these large birds out; a netting roof spread across it will also stop small diving birds getting through. Koi keepers often build ornamental pergola-like structures over their ponds; this structure can then easily be covered with netting when necessary.

FISH LICE

Fish lice can affect most pond fish, irrespective of size. Lice attach themselves to the body of the fish and cause damage to the tissues. Sometimes this results in death. It is possible to remove the clearly visible parasites by lifting them off gently with a pair of tweezers. Another method of removing them is to hold the fish in a soft net and dab a little kerosene on the lice with a small paint brush. Dip the fish in a solution of appropriate antiseptic to reduce the risk of secondary infection.

WATER BOATMAN

The most common species of water boatman is oval, with a brown back and a black underbelly with a conspicuous brown triangular mark in the center. The water boatman is often called a back-swimmer because of its habit of swimming upside down. Although it is only ½in (1.5cm) long, it can kill a small fish by injecting poison through its piercing mouthparts. Control is very difficult because the adults fly from pond to pond on summer evenings. Regular netting is the only effective control.

WHIRLIGIG BEETLE

Only ⅛–¼in (3–6mm) long, these black, oval beetles congregate in groups and gyrate on the surface of the water. Although they are air-breathing insects, they spend nearly half their lives in water and can, when necessary, create an air bubble to keep themselves supplied with oxygen as they dive to the bottom of the pond in search of food. They feed on other aquatic insects, but will also attack fish fry. The only method of control is to net off the adults from the water surface.

GREAT DIVING BEETLE

This insect, which is capable of storing oxygen in its wing cases, spends most of its three-year lifespan in water. It flies at night, and swims on the surface of the water before diving for prey. It has a dark brown body with a distinctive yellow or gold edge, and reaches a length of 2in (5cm). In addition to preying on newts and tadpoles, this beetle can kill small fish with its ferocious bite. There are no effective methods of control; if a beetle is seen, remove it with a net.

WATER SCORPION

Although these creatures resemble land scorpions, the tail of a water scorpion is a harmless breathing tube. About 1in (2.5cm) long, the water scorpion lives in shallow water and watches for prey from the leaves of plants. When a small fish passes by, the insect grabs and holds the victim with its pincerlike front legs, while its sharp mouthparts pierce and kill it. Rigid pond hygiene is one method of control; the other is to remove the insect by hand when its tail is seen on the surface.

OTHER PESTS

Amphibians such as frogs will eat fish. A bullfrog can eat a fish up to one-third its size. Various snakes also will prey on fish, including water snakes and the normally land-dwelling garter snake. Small, airborne predators such as kingfishers will also prey on fish. It is advisable to construct a strong netting fence around the pool approximately 18–24in (45–60cm) high. This will help to keep out herons as well as fish-loving cats and, in certain areas, "escaped" pests such as mink and turtles.

FISH DISEASES

DROPSY

FISH AFFECTED Dropsy is an uncommon disease, but it is, unfortunately, one that can affect most pond fish.
SYMPTOMS The body of an affected fish becomes severely bloated and the eyes protrude. The most distinctive symptom to look for is bristling scales that, once the disease has taken hold, resemble an open pine cone.
TREATMENT Treatment is difficult to prescribe, owing to the many possible causative agents. One of the most common causes of dropsy is bacterial septicemia. Broad-spectrum type antibiotics – prescribed by a vet specializing in fish – administered to the affected fish and its contacts may be beneficial in some cases. Improved water quality, reduction of stress, and good-quality food also sometimes help.

WHITE SPOT

FISH AFFECTED A widespread disease affecting most pond fish, especially newly purchased fish.
SYMPTOMS A number of white spots resembling grains of salt will be found on the body, fins, and tail of the fish. The spots are caused by tiny parasites burrowing into the skin of the fish. However, do not confuse this with the white pimples that appear on the gill plates of male fish during the mating season. Because of the itchiness caused by white spot, fish will rub themselves against objects.
TREATMENT Treatment is only effective in the very early stages of the disease. Place the fish in a holding tank and, by adding warm water, gradually raise the temperature to 60–65°F (16–18°C) to encourage the parasites to swarm. Then add a commercial remedy to the water. Change the water every three days and continue treatment until the fish is healthy. Effective and easy-to-use "whole-pond" treatments against white spot are now available; these present more practical alternatives than the treatment of individual fish, especially if more than one specimen in the pond is affected.

FIN OR BODY ROT

FISH AFFECTED This is a fairly common disease that mainly affects long-finned goldfish and shubunkins.
SYMPTOMS A whitish line develops along the outer fin and tail. The area also becomes ragged and bloodshot. This is due to the disintegration of the soft tissue between the bony rays of the tail. The condition may be complicated further by a fungal attack.
TREATMENT The disease is progressive and will cause death if the condition reaches other parts of the fish's body. However, treatment is effective if administered at the early stages of the disease. Capture the fish in a soft net then remove the damaged tissue carefully with a pair of sharp scissors. Afterward, use a fungal cure based on malachite green or methylene blue.

SKIN AND GILL FLUKES

FISH AFFECTED All types of fish.
SYMPTOMS Invisible to the naked eye, flukes are microscopic flatworms that use hooks to attach themselves to the fish. The skin fluke causes irritated patches on the skin and fins, while the gill fluke causes inflamed gill tissues and loss of color. Both lead to excessive production of mucus and scratching against objects. The breathing rate of the fish will increase, its fins will twitch, and it will swim about in an agitated state, often rushing to the surface of the water as if short of air.
TREATMENT Commercial medications are available, including a parasite cure based on dimethyltrichlorohydroxyethyl-phosphonate. Salt baths containing ¼–½oz (10–15g) salt (pure sodium chloride or rock salt, *not* household salt) to 35fl oz (1 liter) of water are also effective, as is immersion in a very dilute formalin solution: 7fl oz (20ml) formalin in 11 gallons (100 liters) of water. Formalin is stressful to fish; they should only remain in the solution for 30–40 minutes. Immersing fish in a dilute methylene blue solution over an extended period may also produce results.

ULCER DISEASE

FISH AFFECTED All types of fish are susceptible to this bacterial disease.
SYMPTOMS Pathogenic bacteria are very common in pond water and will cause disease if the fish are at all vulnerable. The bacteria associated with ulcer disease can produce a wide range of symptoms that are easily detected, from shredded dorsal, tail, and ventral fins, to ulcers on the body, hemorrhagic (bloody) spots, and a "pop-eye" appearance.
TREATMENT Like many of the diseases that affect pond fish, this one can be cured if it is caught early enough and treated – under the guidance of a vet specializing in fish – with antibiotics such as tetracyline or chloramphenicol. Fish foods that contain antibiotics are also available from vets and good fish stockists.

FISH TUBERCULOSIS

FISH AFFECTED All types of fish.
SYMPTOMS This common fish disease is caused by bacteria. Symptoms can range from the development of ulcerated swellings and "rotting" fins, to the loss of coloration. Gradual consumption, causing the fish to lose weight and condition progressively, is also symptomatic of the disease.
TREATMENT The tuberculosis bacteria will spread very quickly through the pond; it is essential, therefore, to remove affected fish from the pond as soon as the symptoms become evident. In cases of suspected tuberculosis, always consult a vet specializing in fish. Some commercial antibiotics may produce a cure during the early stages of the disease. However, in the long term, fish almost invariably die.
WARNING When treating fish affected by this disease, always wear protective gloves, especially if there are cuts or scratches on your skin. Fish tuberculosis can, albeit rarely, affect humans, resulting in localized nodular growths that, while not normally presenting a major health problem, can nevertheless prove stubborn to treat.

OTHER FISH DISEASES

Mouth fungus affects all types of fish. The area round the mouth develops white or cream-colored growths that, in severe cases, can extend to the jaw bones, killing off tissue as the disease progresses. Treat with a medication based on malachite green, phenoxethol, and acriflavine. Antibiotics can also be effective; always consult a vet specializing in fish before using them.

Fungus or *cotton disease* affects all types of fish, but usually only fish already weakened by stress, injury, or infection. Cottonlike growths appear on the fins, gills, eyes, and mouth of the fish, usually at a point where damage to the tissues has already occurred. Commercial treatments are available, but these are only effective for large fish. Follow the instructions carefully.

FURTHER INFORMATION

- Fish Species and their Requirements – pp. 168–169
- Buying and Introducing Fish – pp. 170–171
- Routine Fish Care – pp. 172–173

THE PLANT CATALOG

SUBMERGED PLANTS • FLOATING-LEAVED PLANTS
WATER LILIES • LOTUSES • MARGINAL PLANTS
MOISTURE-LOVING PLANTS

THROUGHOUT THE CATALOG, symbols are
used for a quick reference to plants' growing
requirements; a key to these plant symbols can
be found on page 4. Detailed descriptions of a
number of other plants can be found in
Water Garden Designs (pp. 16–44).

BLENDING INTO THE GARDEN (*LEFT*)
*Carefully chosen and positioned plants will soon make a water
feature look established. A wide range of moisture-loving
plants can be used to soften and disguise pond edges.*

SUBMERGED PLANTS

Unless an advanced filtration system is to be installed in a pond, plants whose leaves are at least partially submerged in the water are essential to maintain clear, well-oxygenated water *(see pp. 152–153)*. These plants are often listed as "oxygenators" in plant catalogs. Most such plants root at the bottom of the pond in a soil layer or in baskets and are entirely submerged. Their stems are not robust enough to be self-supporting out of the water although they occasionally thrust flower spikes above the surface. Others, such as *Myriophyllum aquaticum*, are able to grow above and below the water. An oxygenating role also can be performed by certain free-floating plants that float not on, but just below the surface, with only part of their leaves above water. Their floating leaves provide valuable shade, and their suspended roots absorb nutrients from any fish waste, thus helping to prevent a build-up of toxic material in pond water. All plants in this category can be fast-growing, and must be regularly thinned *(see pp. 160–161)* so that they do not dominate the pond; during the night, they deplete the water of oxygen and produce carbon dioxide. A fountain or waterfall running at night can effectively combat this effect.

Fontinalis antipyretica (water moss)
Mosslike evergreen perennial with branched stems bearing olive-green, scalelike leaves. Best in cold streams (it is much less vigorous in still water). Plant by weighting the plants between boulders, on which roots will cling. Propagate by division in spring. Zones 4–10. H 3in (8cm), S indefinite, water depth to 18in (44cm).

Hottonia palustris (water violet)
Deciduous perennial forming masses of light green, deeply divided foliage held both below and above the water. Pale lilac flower spikes emerge above water in spring. Thin periodically. Propagate by stem cuttings in spring or summer. Zones 5–9. H 1–3ft (30–90cm), S indefinite, water depth to 18in (45cm).

Ceratophyllum demersum (hornwort)
Deciduous submerged perennial with slender stems and whorls of forked leaves. Tolerant of shade and deeper water than many submerged plants. Propagate by softwood cuttings in summer, or break young plantlets away from the main plant. Zones 8–10. S indefinite, water depth to 24in (60cm).

Lagarosiphon major, syn. *Elodea crispa*
Semi-evergreen perennial forming dense, submerged masses of branching, fragile stems covered in reflexed, linear leaves. Tiny, translucent flower spathes develop in summer. Thin in summer and cut back in autumn. Propagate by stem cuttings in spring or summer. Zones 4–9. S indefinite, water depth to 3ft (1m).

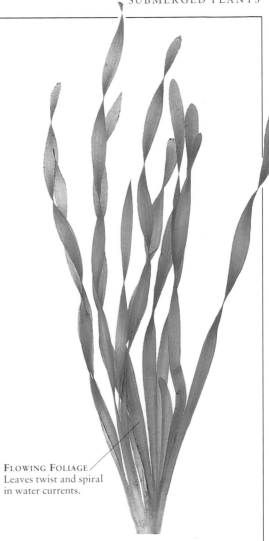

Flowing Foliage
Leaves twist and spiral
in water currents.

Ranunculus aquatilis (water crowfoot)
Annual or perennial, holding its white flowers
and some of its leaves just above water. Best in
large wildlife ponds or streams at a depth of
6–24in (15–60cm), where it can spread and
root in mud bottoms. Propagate by fresh seed
or by division in spring or summer. Zones 5–10.
S indefinite, water depth to 3ft (1m).

Myriophyllum verticillatum (milfoil)
Perennial with spreading stems and tightly
packed, delicate, bright green leaves. Ideal for
shallow water. Stems extend above the surface
with spikes of inconspicuous, yellowish
flowers. Propagate by stem cuttings in spring
or summer. Zones 4–10. S indefinite, water
depth to 18in (44cm).

Stratiotes aloides (water soldier, water aloe)
Semi-evergreen, free-floating perennial forming
"pineapple-top" rosettes of spiky, dark olive-
green leaves held partly below and partly above
the water. Thin regularly. New plants form as
small water buds on spreading stems: they may
be separated in summer. Zones 6–9. H 16in
(40cm), S indefinite, water depth to 3ft (1m).

Vallisneria spiralis (eelgrass, tape grass)
Submerged perennial, evergreen in the tropics,
grown for its spiraling, strap-shaped, mid-green
leaves, which can be 32in (80cm) long. Greenish
flowers are produced year-round. Propagate by
division in spring or summer or by separating
runners that appear. Zones 8–10. S indefinite,
water depth at least 12in (30cm).

Potamogeton crispus (curled pondweed)
Perennial with seaweedlike submerged leaves,
bearing crimson and creamy white flowers just
above the water in summer. Spreads rapidly in
mud-bottomed pools. Tolerates cloudy or
shady water. Propagate by stem cuttings in
spring or summer. Zones 7–10. S indefinite,
water depth to 3ft (1m).

Utricularia vulgaris (greater bladderwort)
Deciduous, frost-hardy, free-floating perennial
with feathery, bronze-green, bladderlike leaves
that trap insects. Pouched, bright yellow
flowers with red-brown streaks are held above
the water in summer. Propagate by separating
young plantlets in spring or summer. Zones
5–9. S 2–3ft (60–90cm), water depth to 3ft (1m).

Also Recommended

Callitriche hermaphroditica, syn.
C. autumnalis (zones 6–10)
Ceratopteris pteridioides (zones 9–10)
Egeria densa, syn. *Anacharis densa*, *Elodea
densa* (zones 9–10)
Hygrophila polysperma rubra (zones 10–11)
Myriophyllum aquaticum (zones 6–11)

Where specific page references are not given for
descriptive plant entries found in other sections,
brief details are given in the Plant Index (*see
pp. 210–213*).

FLOATING-LEAVED PLANTS

PLANTS WITH FOLIAGE FLOATING on the water surface are essential to maintain clear water. By blocking a proportion of sunlight they check the growth of algae, which thrive only in well-lit water. They also provide shade and shelter for pond life. Among those that are anchored by their roots in bottom soil or planting crates, the true water lilies (Nymphaea) are the most popular. In conditions where they are unsuitable, however, there are other more adaptable plants such as pond and fringe lilies (Nuphar and Nymphoides), or plants such as water hawthorn (Aponogeton distachyos). Other plants in this category, such as Azolla filiculoides, float completely, their suspended roots absorbing dissolved nutrients and any fish waste. Floaters tend to multiply rapidly and should be used and controlled with care. Some, such as water hyacinth (Eichhornia) (see p. 26) and water lettuce (Pistia stratiotes), while not invasive in temperate climates, are so vigorous in tropical waters that their introduction may be prohibited in certain areas; for example, in parts of southern North America. In northen zones, the majority of floaters are winter killed. Where they are hardy, plants sink to the bottom in winter and float back to the surface in spring.

Azolla filiculoides, syn. *A. caroliniana* (fairy moss, water fern)
Tiny, free-floating perennial fern that forms clusters of soft leaves, each with a single fine root, that turn purplish-red in autumn. Useful for rapid, temporary cover in a new pond while other plants grow. Can be invasive: in summer, thin regularly. Zones 7–10. S indefinite.

Hydrocharis morsus-ranae (frogbit)
Perennial free-floater with rosettes of kidney-shaped, shiny leaves and papery white flowers with a yellow center. It prefers still, shallow water (it may root in mud), providing useful shelter for creatures, but is vulnerable to snail damage. New plantlets form on runners. Zones 7–10. S indefinite, water depth to 12in (30cm).

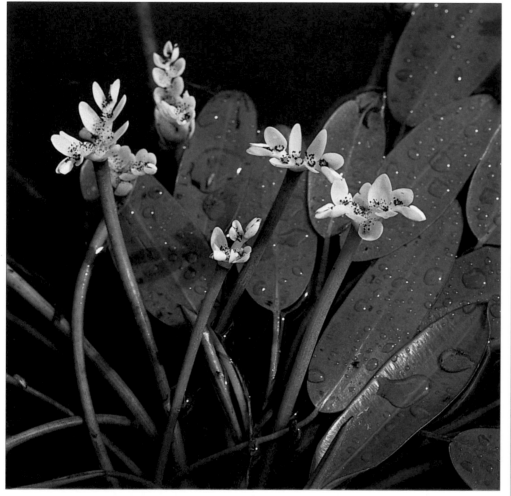

Aponogeton distachyos
(Cape pondweed, water hawthorn)
Deep-water perennial with floating, oblong, mid-green leaves. Heavily scented white flowers in forked racemes appear either in two flushes or throughout the summer. Propagate by fresh seed or by division in spring. Zones 9–10. S 4ft (1.2m), water depth to 2ft (60cm).

Marsilea quadrifolia (water clover)
Scrambling perennial fern with long, creeping roots and clover- or shamrock-shaped leaves. The leaves either float on the surface on stalks 3–6in (8–15cm) long, or stand above the water in muddy shallows. Propagate by division in either spring or summer. Zones 6–11. S indefinite, water depth to 24in (60cm).

Nuphar japonica (Japanese pond lily)
Deciduous perennial with heart-shaped floating leaves and round yellow flowers held just above the surface in summer. Grows in still or slowly moving water in full sun or partial shade. Can become invasive. Propagate and thin by division in spring. Zones 6–10. S 3ft (1m), water depth to 12in (30cm).

Nymphoides peltata
(fringed water lily, water fringe)
Deciduous rhizomatous perennial with small, floating, mid-green leaves often splashed with brown. Small yellow flowers held 2–3in (5–8cm) above the water appear throughout summer. Propagate by division in spring. Zones 7–10. S 24in (60cm), water depth 6–18in (15–45cm).

Pistia stratiotes (water lettuce)
Deciduous free-floating aquatic with slightly overlapping, velvety, pale green leaves arranged like lettuce. Leaves are whitish-green on the underside. Produces tiny greenish flowers. Thin and separate new plantlets in summer. Zones 8–10. H 9–12in (22–30cm), S indefinite, water depth to 3ft (1m).

Polygonum amphibium
(willow grass, amphibious bistort)
Amphibious perennial with long-stalked, floating leaves borne on stems that root at the nodes. In midsummer pink flowers are held above the water. Will also grow in boggy margins. Propagate by division. Zones 5–9. S indefinite, water depth to 18in (45cm).

Salvinia auriculata (butterfly fern)
Free-floating tender perennial fern forming spreading colonies. The pale green or purplish-brown leaves are covered in silky hairs and tightly packed on branched stems. Remove faded foliage and thin when overcrowded by separating young plants in summer. Zones 10–11. H 1in (2.5cm), S indefinite.

Victoria amazonica
(Amazon water lily, royal water lily)
Tropical perennial often grown as an annual with rimmed leaves up to 6ft (2m) across. The night-blooming flowers last two days; they open white then turn pink. Propagate by seed in winter or early spring. Zones 10–11. S 20ft (6m), water depth 2–3ft (60–90cm).

WATER LILIES

THE RANGE OF WATER LILIES *(Nymphaea)* available is increasing, with new cultivars continually being developed, many in North America. All have flowers that either float, or (particularly the tropical water lilies) stand just above the water surface. Many are delicately perfumed, and some change color as they open and mature. There are species and cultivars to suit most climatic conditions, size of pond, and planting depth, although all share a need for a sunny, sheltered position and still or nearly still water. Hardy water lilies will survive outside in zones 3–11, even if the surface of the pond is frozen. The old foliage sinks and dies in winter; new leaves appear in the following spring. Tropical water lilies are perennial in frost-free areas. They may bloom by day or by night. In cool climates they are commonly grown as annuals. If neglected, water lilies become coarse and congested, with few flowers. Removing fading leaves and flowers, and regularly lifting, dividing, and replanting *(see pp. 160–163)*, will preserve an elegant display. Water lilies may be propagated *(see p. 160)* by division, separating root buds or plantlets in spring or early summer; species may also be grown from seed.

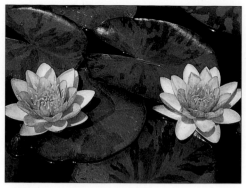

Nymphaea 'Aurora'
Of all the lilies whose flowers change color, this has the widest range of shades. It is a small cultivar, with olive-green leaves mottled with red-purple. The semi-double flowers, cream in bud, open to yellow, then turn orange to flecked blood-red, with orange stamens. Hardy. S 30in (75cm), water depth 12–18in (30–45cm).

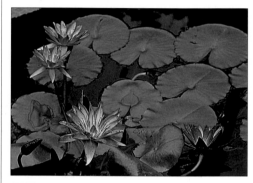

Nymphaea 'Blue Beauty'
A free-flowering cultivar with wavy-edged leaves that may be brown-flecked, with purplish undersides. The sweetly scented, semi-double, day-blooming flowers have rich blue petals and deep yellow stamens. Plant only once the weather becomes warmer in spring. Tropical. S 4–7ft (1.2–2.2m), water depth 1–2ft (30–60cm).

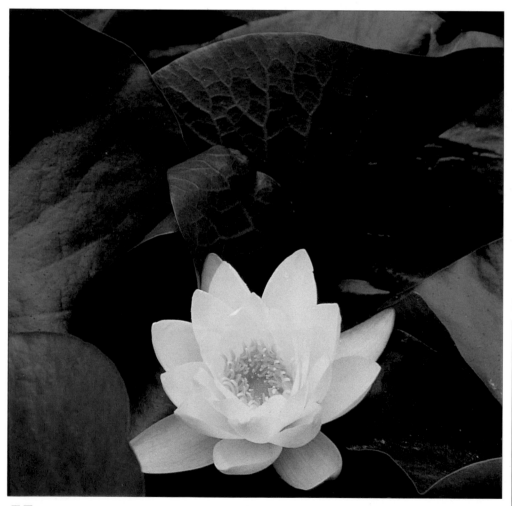

Nymphaea alba (common white water lily)
One of the few water lilies indigenous to Europe, *N. alba* is a prolific flowerer and is best in a large pond. Its round, dark green pads are 12in (30cm) in diameter. The semi-double flowers, 8in (20cm) across, are magnolia-white with yellow stamens. Hardy. S 5–6ft (1.5–2m), water depth 1–3ft (30–90cm).

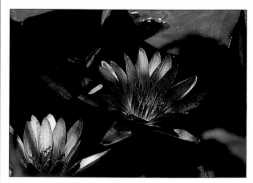

Nymphaea capensis (Cape blue water lily)
This adaptable species will grow well in any size pond. Its large, wavy-edged leaves can be 16in (40cm) in diameter. The semi-double, star-shaped flowers, up to 10in (25cm) across, are light blue with yellow stamens, and held well above the water. Tropical. S 5–8ft (1.5–2.5m), water depth 1–2ft (30–60cm).

☀ ✳

Nymphaea 'Caroliniana Nivea'
This cultivar is suited to larger ponds, performing best when planted in a large crate or basket that allows a substantial root system to develop. The leaves are almost round; the flowers semi-double, star- to cup-shaped, fragrant, ivory-white, with yellow stamens. Hardy. S 4–5ft (1.2–1.5m), water depth 1–2ft (30–60cm).

☀ ✳

Nymphaea 'Escarboucle'
Excellent for most ponds in cool climates, and stays open later in the afternoon than most red-flowered cultivars. Brown-tinged young leaves mature to deep green; the semi-double flowers are bright crimson with golden stamens, their outer petals tipped white. Hardy. S 4–5ft (1.2–1.5m), water depth 1–2ft (30–60cm).

☀ ✳

Nymphaea 'Froebelii'
A good choice for shallow water, ideal for barrels or small ponds. Bronzed young leaves mature to small, round or heart-shaped, pale green pads. The deep red flowers, 4–5in (10–13cm) across, are first cup-shaped, then star-shaped, with orange-red stamens. Hardy. S 3ft (1m), water depth 6–12in (15–30cm).

☀ ✳

Nymphaea 'Firecrest'
Needs ample space and a planting basket at least 2ft (60cm) wide and 1ft (30cm) deep. Its deep purple young leaves mature to green. The semi-double, star-shaped pink flowers, held just above the water, have orange inner stamens and outer stamens tipped with deep pink. Hardy. S 4ft (1.2m), water depth 12–18in (30–45cm).

☀ ✳

Nymphaea 'Gladstoneana'
A vigorous, free-flowering cultivar that will grow large unless regularly thinned. The bronzed young leaves mature to almost round, dark green pads, with crimped edges. Flowers are semi-double, star-shaped, waxy-petaled, with bright yellow stamens. Tropical. S 5–8ft (1.5–2.4m), water depth 18–24in (45–60cm).

☀ ✳

Nymphaea 'Gonnère'
This magnificent white cultivar is ideal for any size of pond. Its slightly bronzed young leaves mature to round, pea-green pads up to 9in (22cm) across. The fully double, globe-shaped, fragrant white flowers, 4–6in (10–15cm) across, stay open until late afternoon. Hardy. S 3–4ft (1–1.2m), water depth 12–18in (30–45cm).

Nymphaea pygmaea 'Helvola'
A small, free-flowering water lily ideal for small, shallow ponds or containers. The oval, heavily mottled, purplish leaves have purple undersides. The small, semi-double, clear yellow flowers are cup-shaped at first, opening to a star shape. Semi-hardy. Zones 6–11. S 2ft (60cm), water depth 6–9in (15–22cm).

Nymphaea 'James Brydon'
A popular red-flowered cultivar for barrels or small to medium-sized ponds. Resistant to crown rot. Its purplish-brown young leaves mature to dark green pads. The double flowers, their petals suffused with brilliant rose-red, are 4–5in (10–12cm) across. Hardy. S 3–4ft (1–1.2m), water depth 12–18in (30–45cm).

Nymphaea 'Lucida'
This free-flowering cultivar is suitable for any size pond. Its large leaves are heavily marked with dark purple, and the star-shaped flowers, 5–6in (12–15cm) in diameter, have red inner petals and outer petals of pale pink with deeper pink veins. Hardy. S 4–5ft (1.2–1.5m), water depth 12–18in (30–45cm).

Nymphaea 'Laydekeri Fulgens'
One of the first cultivars to bloom in spring, flowering freely through the summer, and suitable for any size pond. The young leaves are blotched with purple, maturing to plain green. Semi-double, burgundy-red flowers have orange-red stamens. Hardy. S 4–5ft (1.2–1.5m), water depth 12–18in (30–45cm).

Nymphaea 'Marliacea Albida'
Popular cultivar that reliably produces a high proportion of blooms for its limited spread of leaves. Slightly bronzed young foliage matures to deep green pads, tinged red-purple beneath. The cup-shaped, semi-double flowers are white with yellow stamens. Hardy. S 3–4ft (1–1.2m), water depth 12–18in (30–45cm).

Nymphaea 'Marliacea Carnea'
A vigorous pink-flowered cultivar only suitable for medium-sized to large ponds. The purplish young leaves mature to large, deep green pads. The light pink, semi-double flowers with yellow stamens can be up to 8in (20cm) in diameter. Hardy. S 4–5ft (1.2–1.5m), water depth 12–18in (30–45cm).

Nymphaea 'Marliacea Chromatella'
One of the most reliable yellow water lilies for
any size pond. Also shade tolerant. Its coppery
young leaves, with purple streaks, mature to a
purple-mottled mid-green. Semi-double
flowers, 6in (15cm) in diameter, are borne in
abundance. Hardy. S 4–5ft (1.2–1.5m), water
depth 12–18in (30–45cm).

Nymphaea 'Odorata Sulphurea Grandiflora'
Cultivar whose yellow flowers tend to open
only from late morning to early afternoon, but
are reliably produced throughout summer. Its
dark green leaves are speckled with maroon; the
semi-double flowers are sweetly scented and
have yellow stamens. Hardy. S 3–4ft (1–1.2m),
water depth 12–18in (30–45cm).

Nymphaea 'Pearl of the Pool'
This cultivar flowers best when given a large
planting basket or crate. Its bronzed young
leaves mature to plain green pads, their lobes
sometimes overlapping. The star-shaped,
fragrant, pink flowers are 5–6in (12–15cm) in
diameter, with orange stamens. Hardy. S 4–5ft
(1.2–1.5m), water depth 12–18in (30–45cm).

Nymphaea 'Pink Sensation'
One of the finest pink cultivars, with flowers
that stay open late into the afternoon. Leaves
are purplish when young, later turning deep
green. The pink flowers open to a star shape,
5–6in (12–15cm) across, with yellow inner and
pink outer stamens. Hardy. S 4ft (1.2m), water
depth 12–18in (30–45cm).

Nymphaea 'Ray Davies'

A recently introduced cultivar suitable for small or medium-sized ponds noted for its evenly colored and shaped flowers. Its leaves are a glossy plain deep green and the fully double flowers are pale pink with a showy ring of golden stamens in the center. Hardy. S 3ft (1m), water depth 12–18in (30–45cm).

Nymphaea 'Rose Arey'

Best in a large planting container that will allow a substantial root system to develop. Its purple young leaves mature to green. Anise-scented, semi-double flowers open deep pink, paling with age, and have golden stamens, orange-pink toward the edges. Hardy. S 4–5ft (1.2–1.5m), water depth 14–24in (35–60cm).

Nymphaea 'Sunrise'

Although hardy, this cultivar needs a warm climate to flower well. Purple-mottled when young, the leaves mature to plain green, round to oval pads, up to 8in (20cm) across. The flowers are semi-double with long yellow petals and yellow stamens. Hardy. S 4–5ft (1.2–1.5m), water depth 14–18in (35–45cm).

Nymphaea 'René Gérard'

A large-leaved cultivar that looks best in medium-sized to large pools. Its bronzed young leaves mature to round, plain green pads, up to 12in (30cm) in diameter. The flowers are rose-red, their outer petals heavily flecked with pale pink; the stamens are yellow. Hardy. S 5ft (1.5m), water depth 12–18in (30–45cm).

Nymphaea 'Robinsoniana'

A free-flowering cultivar with contrasting flowers and foliage. Its light purple leaves have deep purple blotches and deep red undersides. Star-shaped flowers with cupped centers, 4½–5in (11–13cm) across, have orange-red petals and orange stamens. Hardy. S 4–5ft (1.2–1.5m), water depth 12–18in (30–45cm).

Nymphaea 'Saint Louis Gold'

Tropical cultivar with smaller but more richly-colored flowers than the similar 'Saint Louis'. The purple-blotched young leaves become large, plain green pads. Semi-double, fragrant flowers held above the water are first mustard-gold, fading to lemon. Tropical. S 8–10ft (2.4–3m), water depth 15–24in (37–60cm).

Nymphaea 'Vésuve'
Cultivar with a long flowering season; in addition, its blooms are open for much of the day. The dark green leaves are almost circular, up to 10in (25cm) across. The star-shaped flowers are an even glowing cerise with orange stamens and inward-curving petals. Hardy. S 4ft (1.2m), water depth 12–18in (30–45cm).

Nymphaea 'Virginalis'
One of the most reliably free-flowering white cultivars for a cool climate. The purple or bronzed young leaves mature to plain green pads with overlapping lobes. The cup-shaped, day-blooming, fragrant white flowers have yellow stamens. Hardy. S 3–4ft (1–1.2m), water depth 15–18in (37–45cm).

Nymphaea 'Virginia'
A free-flowering cultivar with purplish deep green leaves and star-shaped, semi-double, very pale yellow (often near white) flowers 4–6in (10–15cm) across that are distinctively star-shaped, with many narrow chrysanthemum-like petals. Hardy. S 5–6ft (1.5–1.8m), water depth 14–20in (35–50cm).

Nymphaea 'William Falconer'
A compact, vividly colored cultivar that is suitable for a medium-sized pond. Its leaves are maroon when young, maturing to dark green with heavy purple veining. The medium-sized, rounded, deep cherry red flowers open to reveal yellow stamens. Hardy. S 4ft (1.2m), water depth 18–30in (45–75cm).

Nymphaea 'Wood's White Knight'
A vigorous, night-blooming cultivar for a large, tropical pond. The almost circular leaves, up to 15in (37cm) across, have unusual scalloped edges. The large, narrow-petaled flowers open wide around central yellow stamens, giving a daisylike effect. Tropical. S 8–10ft (2.4–3m), water depth 16–24in (40–60cm).

ALSO RECOMMENDED

N. 'Amabilis' Pink flowers. Hardy, S 5–7ft (1.5–2.3m), WD 12–18in (30–45cm).

N. 'American Star' Salmon flowers. Hardy, S 4–5ft (1.2–1.5m), WD 12–18in (30–45cm).

N. 'Attraction' *(see p. 37)*

N. *caerulea* Pale blue flowers. Semi-hardy, S 8–10ft (2.4–3m), WD 18–36in (45–90cm).

N. 'Charlene Strawn' Lemon flowers. Hardy, S 3–5ft (1–1.5m), WD 12–18in (30–45cm).

N. 'Charles de Meurville' Pink flowers. Hardy, S 4–5ft (1.2–1.5m), WD 12–18in (30–45cm).

N. 'Ellisiana' Red flowers. Hardy, S 3ft (90cm), WD 9–16in (22–40cm).

N. 'Emily Grant Hutchings' Deep pink flowers. Tropical, night-blooming. S 6ft (2m), WD 2–3ft (30–60cm).

N. 'General Pershing' Lilac flowers. Tropical, S 5–6ft (1.5–2m), WD 12–18in (30–45cm).

N. *gigantea* Purple-blue flowers. Tropical, S 6–9ft (2–3m), WD 18–36in (45–90cm).

N. 'Indiana' Apricot to orange flowers. Hardy, S 30in (75cm), WD 6–12in (15–30cm).

N. 'Louise' Red flowers. Hardy, S 4–5ft (1.2–1.5m), WD 12–18in (30–45cm).

N. *mexicana* *(see p. 26)*

N. 'Splendida' Pink flowers. Hardy, S 4–5ft (1.2–1.5m), WD 15–24in (37–60cm).

N. *tetragona alba* White flowers. Semi-hardy, S 2–3ft (60–90cm), WD 6–9in (15–22cm).

LOTUSES

WITH THEIR STRIKING LEAVES and exquisite midsummer flowers, lotuses *(Nelumbo)* are exceptionally beautiful plants, and have been cultivated for thousands of years. They require an open, sunny position, and many need at least semi-tropical conditions. Most lotuses are hardy in zones 5 through to 11, although in order to bloom well, they require several weeks of hot (90°F/32°C or higher), sunny weather in July. The rhizomatous roots may also be stored over winter *(see p. 158)*. Lotuses can be planted in water 6–24in (15–60cm) deep, and are thus suitable both for the margins and deeper, central areas of the average pond. However, the roots spread rapidly, and are best confined in planting baskets or crates. At first, the young leaves lie on the water surface; however, the stout leaf stalks soon thrust the foliage into the air. The leaves are large, bluish green, and platelike, with a waxy coating. The flowers, usually held just above the leaves, last for about three days, opening in the morning and closing by mid-afternoon. The petals fall to expose a delightful seedhead resembling a watering-can rose. Lotus species are grown from seed in spring; selections and cultivars must be propagated by division in spring.

Nelumbo nucifera 'Alba Grandiflora'
Vigorous deciduous perennial with wavy-edged leaves. Its large, white flowers have broad, oval petals and tufts of golden stamens. Sometimes referred to as the "magnolia lotus," 'Alba Grandiflora' is widely held to be the finest white-flowered cultivar. H 4–6ft (1.2–2m), S indefinite.

Nelumbo lutea (American lotus, water chinquapin)
Vigorous deciduous perennial with rounded leaves and yellow flowers, their petals fading gently toward the tips. The seedheads, 4in (10cm) in diameter, are a traditional food of native Americans. Grows well in shallow water. H 2½–5ft (0.7–1.5m), S indefinite.

Nelumbo nucifera (sacred lotus, Asian lotus)
Very vigorous deciduous perennial holding its leaves, which can be 3ft (90cm) across, very high above the water. The flowers have a pleasant fragrance and are large, opening rose-pink then fading to a pale flesh tone. The seed capsule turns from yellow to brown. H 5–7ft (1.5–2.2m), S indefinite.

Nelumbo nucifera 'Momo Botan'
Deciduous perennial, smaller than most lotuses, needing water no deeper than 12in (30cm). The peony-like double flowers are rose pink with yellow at the petal bases. It has a longer flowering season than most lotuses, and the flowers also stay open longer, sometimes all night. H 2–4ft (0.6–1.2m), S 3ft (1m).

Nelumbo nucifera 'Rosea Plena'
Vigorous, free-flowering deciduous perennial with leaves 18–20in (45–50cm) in diameter. The double, rose-pink flowers turn yellow toward the petal bases. While the flowers are large, up to 13in (33cm) across, the seed capsule is unusually small, only 1in (2.5cm) in diameter. H 4–5ft (1.2–1.5m), S indefinite.

Nelumbo 'Perry's Super Star'
Deciduous perennial with blue-green leaves. The sweetly scented flowers change from rich pink to yellow, culminating in a creamy white color with pink tips. They are very unusual in having six to eight green-tipped petals near the center of the flower. H 3–4ft (1–1.2m), S indefinite.

Nelumbo nucifera 'Mrs Perry D Slocum'
Deciduous perennial with glaucous leaves. It is exceptionally free-flowering with blooms that in many ways resemble those of the rose 'Peace'. The petals are pink-flushed yellow on the first day, pink and yellow on the second day, and cream-flushed pink on the third day. H 4–5ft (1.2–1.5m), S indefinite.

Nelumbo 'Shiroman', syn. var. *alba plena*
Vigorous deciduous perennial with leaves 24in (60cm) in diameter. The slightly fragrant, large, double flowers, 10in (25cm) across, are creamy white in color with golden stamens in the center. This rapidly spreading lotus should only be sited in a medium to large pond. H 3–5ft (0.9–1.5m), S indefinite.

ALSO RECOMMENDED

N. 'Alba Striata' White-flowered, with jagged red petal margins.
N. 'Angel Wings' White-flowered.
N. 'Baby Doll' White-flowered.
N. 'Ben Gibson' Pink-flowered.
N. 'Charles Thomas' Pink-flowered.
N. 'Debbie Gibson' Cream-flowered.
N. 'Empress' White-flowered.
N. 'Kermesina' Rose pink- to bright red flowered.
N. *lutea* 'Flavescens' Yellow-flowered.
N. 'Maggie Belle Slocum' Pink-flowered.
N. *nucifera* 'Chawan Basu' Cream-flowered.
N. 'Sharon' Pink-flowered.
N. 'Shirokunshi' (tulip lotus) White-flowered.
N. 'Suzanne' Pink-flowered.
N. 'The Queen' Ivory-flowered.

Nelumbo nucifera 'Pekinensis Rubra' (red lotus)
Deciduous perennial with leaves 20–24in (50–60cm) across. The slightly fragrant flowers, 8–12in (20–30cm) in diameter, are deep rose-red, later turning pink. The large, yellow seed capsules develop a green rim. H 4–6ft (1.2–2m), S indefinite.

Nelumbo 'Perry's Giant Sunburst'
Deciduous perennial with blue-green leaves, 17–21in (43–53cm) across. The pleasantly fragrant, large flowers are 10–14in (25–35cm) in diameter and have a rich creamy color, with buttery yellow stamens. They are held well above the leaves on robust, erect stalks. H 4½–5½ft (1.4–1.7m), S indefinite.

MARGINAL PLANTS

Marginal plants inhabit shallow water, usually around the edges of a water garden. While most of their top growth is visible above the water surface, their bases and roots are under water, although many also grow well in marshy, saturated soil. Their vertical presence contrasts well with the flat water surface and the floating leaves of plants such as water lilies. Marginals planted around wildlife ponds can provide cover for birds, aquatic insects, and other small creatures. Generally used in informal ponds, marginals placed in baskets on shelves break the rigidity of formal edges. It is important to position marginals in the depth of water that best suits each individual plant. Some prefer a water depth of only 1–2in (2.5–5cm), while others tolerate a depth of up to 12in (30cm). Lotuses *(see pp. 188–189)* may also be used as marginals, given a minimum water depth of 6in (16cm). Many marginal plants grow extremely quickly, and where space is limited they should be contained in isolated planting beds or planting crates. Some of the more robust rhizomatous species, such as cattails *(Typha)*, develop sharply pointed roots that can pierce flexible liners. Planting crates will protect the liner.

Calla palustris (hardy call, water arum)
Deciduous or semi-evergreen perennial with long, creeping rhizomatous roots. In spring, white, arumlike flower spathes appear that echo the leaves in shape, followed by red or orange berries. Propagate by seed in late summer or by division in spring. Zones 3–8. H 10in (25cm), S 12in (30cm), water depth to 2in (5cm).

Acorus calamus 'Variegatus'
(variegated sweet flag)
Deciduous rhizomatous perennial with irislike leaves, mid-green with cream stripes, with some wrinkling along the edges. Small conical flowers emerge just below the leaf tips. Propagate by division in spring. Zones 4–10. H 30in (75cm), S 24in (60cm), water depth to 9in (22cm).

Alisma plantago-aquatica (water plantain)
Rhizomatous perennial with rosettes of oval leaves held on long stalks above the water. Dainty, pinkish white flowers open in summer. Self-seeds readily in wet soil. Propagate by seed in late summer or by division in spring. Zones 5–8. H 30in (75cm), S 18in (45cm), water depth to 10in (25cm).

Butomus umbellatus (flowering rush)
Perennial with bronze shoots that develop into thin, olive-green leaves. Rose-pink flowers are borne above the leaves on tall stems in summer. Best grown in open ground; if containerized it needs regular dividing and repotting. Propagate by division. Zones 3–7. H 2–4ft (60cm–1.2m), water depth 2–16in (5–40cm).

Cyperus papyrus (papyrus, paper reed)
Evergreen perennial sedge with stout, leafless stems, triangular in cross-section. Tufts of fine, pendulous leaves and flower sprays with as many as 100 rays develop in summer. Best sheltered from wind. Propagate by seed or by division in autumn. Zones 9–10. H 10–15ft (3–5m), S 3ft (1m), water depth to 10in (25cm).

Eriophorum angustifolium
(common cotton grass)
Evergreen marsh or marginal plant forming dense tufts of grasslike leaves. Flowers form as white "cotton balls." Best in acid conditions, such as peaty soil. Propagate by seed or by division in autumn. Zones 4–11. H 12–18in (30–45cm), S indefinite, water depth to 2in (5cm).

❄ ✺ ◊

Glyceria maxima var. *variegata*
(variegated grass, sweet manna grass)
Deciduous perennial aquatic grass with leaves
striped with creamy white, often flushed pink at
the base. Flowers are heads of greenish spikelets
in summer. Propagate by seed or by division in
autumn. Zones 5–9. H 32in (80cm),
S indefinite, water depth to 6in (15cm).

❄ ✺ ◊ ◊

Iris laevigata 'Mottled Beauty'
Deciduous perennial forming clumps of sword-
shaped, soft green leaves without a midrib. The
white flowers are broad-petaled and beardless;
the falls are spotted pale blue. Also grows well
in moist soil. Divide rhizomes in late summer to
propagate. Zones 4–9. H 2–3ft (60cm–1m),
S indefinite, water depth 3–4in (7–10cm).

❄ ✺ ◊ ◊

Houttuynia cordata 'Chameleon', syn.
H. cordata 'Variegata'
Spreading, often invasive perennial. Red stems
bear aromatic leaves splashed with yellow and
red. Insignificant flowers with white bracts are
produced in spring. Propagate by lifting runners
in spring. Zones 5–9. H 6–24in (15–60cm),
S indefinite, water depth no more than 2in (5cm).

❄ ✺ ◊ ◊

Iris laevigata 'Alba'
Deciduous perennial forming clumps of sword-
shaped leaves with no midrib. Sparsely branched
stems bear white, broad-petaled, beardless
flowers. Grows in standing water or constantly
moist soil. Divide rhizomes in late summer to
propagate. Zones 4–9. H 2–3ft (60cm–1m),
S indefinite, water depth to 3–4in (7–10cm).

❄ ✺ ◊

Iris versicolor (blue flag, wild iris)
Deciduous clump-forming perennial with
narrow, gray-green leaves. Each branched stem
bears three to five violet-blue flowers. Falls are
white veined with purple, yellow-blotched at
the base. Also grows in wet soil. Divide
rhizomes in late summer to propagate. Zones 2–8.
H 2ft (60cm), water depth to 2–3in (5–7cm).

Ludwigia palustris (water purslane)
Deciduous semi-hardy perennial that forms
mats of branched, creeping stems in shallow
water or mud. The leaves may become suffused
with purple, particularly in full sun. Tiny, bell-
shaped flowers appear in summer. Propagate by
seed in spring. Zones 4–10. H 20in (50cm),
S indefinite, water depth to 12in (30cm).

Lysichiton camtschatcensis
Vigorous deciduous perennial with a stout
rhizome. White, arumlike spathes surrounding
erect spikes of small flowers appear in early
spring, before the bright green, paddlelike,
leathery leaves. Propagate by fresh seed in late
summer. Zones 6–8. H 30in (75cm), S 24–36in
(60–90cm), water depth 1in (2.5cm).

Narthecium ossifragum (bog asphodel)
Deciduous perennial with rigid fans of reddish
green leaves and erect spikes of star-shaped,
yellow flowers in summer that mature to orange.
Needs acid conditions; grow in peaty soil or
pure sphagnum moss. Propagate by division or
by seed. Zones 4–9. H 8–12in (20–30cm),
S 8–12in (20–30cm), water depth 1in (2.5cm).

Lysichiton americanus (yellow skunk
cabbage)
Vigorous deciduous perennial that grows well
in deep, moist soil and in still or moving water.
Yellow spathes appear in early spring, followed
by large leaves. Propagate by fresh seed in late
summer. Zones 4–8. H 4ft (1.2m), S 2½ft
(75cm), water depth 1in (2.5cm).

Menyanthes trifoliata (bog bean,
buckbean, marsh trefoil)
Deciduous perennial with three-lobed, olive
green leaves on tall, sheathed stalks. White to
purplish flowers open from pink buds in late
spring. Divide congested plants or propagate
by stem cuttings in spring. Zones 4–8. H 9in
(23cm), S indefinite, water depth 2in (5cm).

Orontium aquaticum (golden club)
Deciduous rhizomatous perennial. The bluish green leaves have an attractive silvery sheen on the underside and will float in water. The pokerlike flowerheads stand well above the water. Propagate by fresh seed or by division in spring. Zones 6–11. H 12–18in (30–45cm), S 24in (60cm), water depth to 12in (30cm).

Phragmites australis 'Variegatus'
Variegated reed grass with leaves striped with bright yellow, fading to white and, in summer, heads of soft purple flowers. Also grows well in moist soil, but will be invasive. It is only suitable for large, natural poolsides. Propagate by division in spring. Zones 4–10. H 4–6ft (1.2–1.8m), S indefinite, water depth 3in (7cm).

Ranunculus lingua 'Grandiflorus' (greater spearwort)
Deciduous perennial with yellow flowers in late spring. Leaves are heart-shaped and long-stalked on nonflowering shoots; pointed and short-stalked on flowering ones. Propagate by fresh seed or by division in spring. Zones 4–8. H 2–5ft (1.5m), S 6ft (2m), water depth 3–6in (7–15cm).

Peltandra undulata, syn. *P. virginica* (green arrow arum)
Deciduous perennial with arrow-shaped, bright green leaves. Narrow yellow or white flower spathes appear in summer, followed by green berries. Propagate by seed or by division in spring. Zones 5–9. H 3ft (90cm), S 2ft (60cm), water depth 2–3in (5–7cm).

Pontederia cordata (pickerel weed)
Robust deciduous perennial that forms dense clumps of stems bearing smooth, narrowly heart-shaped leaves. In late summer, compact spikes of blue flowers develop from within a leaf at the stem tip. Propagate by fresh seed or by division in spring. Zones 3–6. H 30in (75cm), S 18in (45cm), water depth 5in (13cm).

Sagittaria latifolia (American arrowhead, duck potato, wapato)
Deciduous perennial with soft green leaf-blades and whorls of white flowers in summer. Develops tubers at the ends of subterranean runners that may be separated from the parent for propagation purposes. Zones 4–11. H 5ft (1.5m), S 2ft (60cm), water depth 6in (15cm).

Schoenoplectus lacustris subsp. *tabernaemontani* 'Zebrinus'
Perennial bulrush with a tough, creeping rhizome. Dark green stems have horizontal cream banding. Flowers are white and brown, in spikelike heads, in summer. Propagate by division in spring. Zones 4–11. H 5ft (1.5m), S indefinite, water depth 3–6in (7–15cm).

Scrophularia auriculata 'Variegata' (water figwort)
Evergreen perennial with striking, cream-edged foliage. The greenish purple flowers may be removed to prevent rampant self-seeding. Propagate by division or by softwood cuttings in summer. Zones 5–9. H 3ft (90cm), S 2ft (60cm), water depth 3in (7cm).

Saururus cernuus (lizard's tail, swamp lily, water dragon)
Deciduous perennial with erect stems carrying heart-shaped, bright green leaves. Spikes of waxy, fragrant flowers appear in summer. Looks best surrounded by water. Propagate by division in spring. Zones 4–9. H 9in (23cm), S 12in (30cm), water depth 4–6in (10–15cm).

Thalia dealbata (hardy canna)
Evergreen perennial with long-stalked, blue-green leaves with a white, mealy coating. Spikes of tubular, violet flowers are carried above the leaves in summer, followed by decorative seedheads. Propagate from seed or by division in spring. Zones 6–11. H 5ft (1.5m), S 2ft (60cm), water depth to 6in (15cm).

❀ 🌿 💧

Typha latifolia 'Variegata'
Deciduous perennial forming large clumps of
wide, cream-striped leaves. Cylindrical
"bulrush" heads among the foliage comprise
light brown male flowers held above the dark
brown female flowers. Propagate by seed or
by division in spring. Zones 3–10. H 3–4ft
(1–1.2m), S indefinite, water depth 10in (25cm).

❀ 🌿 💧 ◊

Zantedeschia aethiopica 'Crowborough'
Semi-hardy tuberous plant (hardier under
12in/30cm of water), ideal in a formal setting,
with dark, glossy leaves. Large, fragrant, white
flower spathes with a central yellow spike appear
in summer. Propagate by offsets in winter.
Zones 5–11. H 1½–3ft (45cm–1m), S 14–18in
(35–45cm), water depth to 12in (30cm).

❀ 🌿 💧

Veronica beccabunga (European brooklime)
Semi-evergreen perennial with white-centered
blue flowers and fleshy, creeping, rooting
stems; an excellent scrambling plant for the
water's edge. Replace old, straggly specimens;
propagate by cuttings in summer, or by seed or
division in autumn. Zones 5–7. H 4in (10cm),
S indefinite, water depth 3in (7cm).

❀ 🌿 💧 ◊

Zantedeschia aethiopica 'Green Goddess'
Semi-hardy tuberous plant with white-splashed
green, arumlike flower spathes in summer, each
with a central yellow spike. It is ideal for a
sunny corner of a formal pool. Propagate by
separating offsets in winter. Zones 8–11.
H 1½–3ft (45cm–1m), S 18–24in (45–60cm),
water depth 6–9in (15–22cm).

ALSO RECOMMENDED

Acorus gramineus 'Pusillus'
Caltha palustris (see p. 37)
Colocasia esculenta 'Fontanesii' (frost-
tender)
Equisetum japonicum
Houttuynia cordata 'Flore Pleno' (see p. 21)
Iris pseudacorus 'Variegata' (see p. 43)
Isolepis cernua
Juncus effusus 'Spiralis' (see p. 27)
Juncus ensifolius
Mentha aquatica (see p. 43)
Myosotis scorpioides (see p. 32)
Sagittaria sagittifolia (see p. 47)
Typha minima (see p. 32)

Where specific page references are not given for
plant entries found in other sections, brief details
are given in the Plant Index (see pp. 210–213).

MOISTURE-LOVING PLANTS

THERE IS A WIDE RANGE OF PLANTS that tolerate and positively thrive in moist soil. These moisture-lovers include not only those plants seen growing naturally by streams, boggy areas, and poolsides, but also many that, although traditionally raised in more normal soil conditions, will excel in this fringe environment, growing with a vigor and lushness they seldom exhibit in drier soil in high summer. Moisture-loving plants are often referred to and sold as "bog plants," but this is a misleading description. While boggy soil saturated with water is ideal for a large number of shallow-water aquatic plants (*see* Marginal Plants, *pp. 190–195*), nearly all moisture-lovers need good drainage and will not tolerate waterlogged soil. They can be used in surrounding beds to bridge the gap between aquatic plants contained in formal, enclosed pools and the rest of the garden, provided that they are given moisture-retentive soil and are well-watered in dry spells. They can be used to edge informal clay-bottomed or lined ponds, planted above the waterline but where the soil is still naturally damp. Many moisture-lovers are spreading and will mingle informally.

❋ ◊

Arisaema candidissimum
Tuberous perennial that appears in early summer; erect stems support hooded spathes that are pink-and-white striped inside, followed by large, three-lobed leaves that fade in autumn to a straw color, surrounding spikes of red fruits. Propagate by seed or offsets. Zones 7–9. H 6in (15cm), S 12–18in (30–45cm).

❋ ◊

Ajuga reptans 'Multicolor', syn. 'Rainbow', 'Tricolor'
Evergreen perennial with stems that spread to form a creeping mat. The blue spring flowers with purple bracts are carried on spikes 4–5in (10–13cm) above bronze-pink leaves splashed with gold. Propagate by division in spring. Zones 3–9. H 4–5in (10–13cm), S 18in (45cm).

VIVID LEAVES
Bright, striking foliage borne on upright stems.

EDIBLE STEM
Stem may be candied for culinary use.

❋ ◊

Anagallis tenella 'Studland' (bog pimpernel)
Creeping perennial that roots freely as its stems spread. Mats of small, rounded leaves are brightened by a profusion of star-shaped, sweetly scented, deep pink flowers in spring. Plants are short-lived; propagate from soft tip cuttings in spring or early summer. Zones 5–7. H 2–4in (5–10cm), S 6–12in (15–30cm).

❋ ◊

Angelica archangelica (angelica)
Short-lived perennial, often grown as a biennial, that grows rapidly into a very large plant. It self-seeds freely; deadheading may prolong its lifespan. The bright green, deeply divided leaves are aromatic; yellow-green flowerheads appear in late summer. Propagate by seed. Zones 4–9. H 6ft (2m), S 3ft (1m).

❋ ◊

Aruncus dioicus (goat's beard)
Herbaceous perennial forming dense mounds of broad, fernlike leaves, bronze-green in spring, turning light green by summer. Large, creamy plumes of flowers gradually turn brown on the more feathery male plants; seed pods form on females. Propagate by seed or by division. Zones 3–9. H 5–6ft (1.5–1.8m), S 1m (3ft).

❋ ◊

Chelone obliqua (turtle head, shellflower)
Herbaceous perennial with upright stems
supporting serrated, dark green leaves. In late
summer and autumn it produces terminal heads
of rich reddish purple, two-lipped flowers.
Propagate by seed or by division in spring or
autumn, or from soft tip cuttings in summer.
Zones 4–9. H 3ft (1m), S 20in (50cm).

❋ ◊

Astilbe 'Venus'
Summer-flowering perennial with plumes of
shell pink flowers. The dark green foliage has
a coppery tint when young. The dried
flowerheads are attractive in winter, so should
not be removed until the following spring.
Propagate by division in spring or autumn.
Zones 3–8. H 3ft (1m), S 3ft (1m).

❋ ❋ ◊ ◊

Carex elata 'Aurea', syn. *Carex stricta*
'Bowles' Golden' (Bowles' golden sedge)
Evergreen perennial with golden yellow tufts of
grassy foliage. Inconspicuous brown flowers
forming blackish spikelets are held among the
leaves in summer. Will also grow well in
shallow water. Propagate by division in spring.
Zones 5–9. H 15in–3ft (38cm–1m), S 3ft (1m).

❋ ❋ ◊ ◊

Carex pendula (pendulous sedge)
Perennial with grasslike leaves. Tall, triangular
stems support graceful, pendulous spikes of
brown flowers, very striking when reflected in
still water. Will also grow well in very shallow
water and is ideal for the margins of a wildlife
pool. Propagate by division in spring. Zones
5–9. H 2–3ft (60–90cm), S 18in (45cm).

❋ ◊

Cimicifuga simplex (bugbane)
Herbaceous perennial that will grow well in
light shade. This species is one of the last to
flower, sometimes well into late autumn. The
flowers are slightly fragrant, held in delicate
spikes on wiry stems; plants benefit from staking
in open sites. Propagate by seed or by division in
spring. Zones 3–8. H 4ft (1.2m), S 18in (45cm).

✱ ◊ ◊

Filipendula ulmaria 'Aurea'
Herbaceous perennial with beautifully divided
leaves, golden-green in spring, turning to pale
green. Branching heads of creamy flowers are
carried above the foliage in midsummer.
Deadhead promptly to encourage new growth.
Propagate in autumn by seed or by division.
Zones 3–9. H 2ft (60cm), S 18in (45cm).

✱ ◊ ◊

Cornus stolonifera 'Flaviramea'
Deciduous spreading shrub suited to moist or
well-drained soils, chiefly grown for its bright,
greenish yellow young stems, which can be
renewed by hard pruning in early spring.
Propagate from softwood cuttings in summer,
or hardwood cuttings in autumn or winter.
Zones 2–8. H 4–6ft (1.2–2m), S 12ft (4m).

✱ ◊ ◊

Crocosmia 'Lucifer'
Clump-forming cormous plant that grows in
moist or dry soils. Erect, swordlike, bright
green leaves surround purple, wiry stems that
support dense, branching spikes of brilliant
flame red flowers in midsummer. Propagate
by division in spring. Zones 5–9. H 4ft (1.2m),
S 10–12in (25–30cm).

✱ ◊

Filipendula purpurea
Herbaceous perennial forming informal clumps
of deeply divided leaves and dense clusters of
tiny, fragrant, rose-pink flowers in summer
followed by bronze-red seedheads. It is
susceptible to mildew if soil becomes dry.
Propagate in autumn by seed or by division.
Zones 4–9. H 4ft (1.2m), S 2–3ft (60–90cm).

✱ ◊ ◊

Filipendula vulgaris (dropwort)
Interesting perennial for the fringes of moist
soil with mat-forming, carrotlike foliage that is
edible. Flowers are borne in branching, creamy
heads, tinged pink on the undersides.
'Multiplex' is a fine, double-flowered cultivar.
Propagate in autumn by seed or by division.
Zones 3–8. H 2–2½ft (60–75cm), S 2ft (60cm).

❊ ◊◊◊

Gunnera manicata

Large perennial with enormous, jagged leaves borne on thick stems. Conical clusters of green flowers appear in spring followed by rust-brown seeds. Protect from wind and mulch for protection in winter in the northern part of its range. Zones 7–11. Propagate by seed or by division in spring. H and S 7–10ft (2.1–3m).

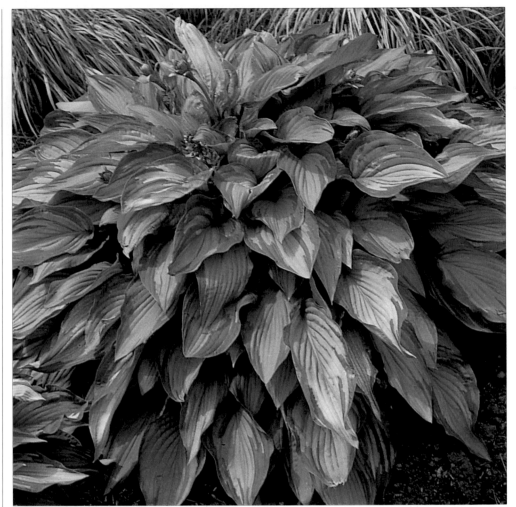

❊ ◊◊

Hosta fortunei 'Albo Picta'

Clump-forming perennial with spectacular leaves nearly 12in (30cm) long. These are pale green, with dark veins and creamy yellow centers fading to dull green. Pale violet flowers are borne on graceful stalks in early summer. Propagate by division in spring. Zones 3–8. H 2½ft (75cm), S 3ft (1m).

❊ ◊◊

Hemerocallis fulva 'Flore Pleno'

Herbaceous perennial forming mounds of light green, straplike leaves. In mid- to late summer it produces spikes of rich orange-buff, trumpet-shaped, double flowers, longer-lasting than the blooms of many other daylilies. Propagate by division in autumn or spring. Zones 3–9. H 3–4ft (1–1.2m), S 2½ft (75cm).

❊ ◊◊

Hosta fortunei 'Aureo-Marginata'

Herbaceous clump-forming perennial. This cultivar has large leaves that are smaller than many *H. fortunei* cultivars, but larger than many other hosta species. Pale violet, trumpet-shaped flowers are held well above the foliage in midsummer. Propagate by division in spring. Zones 3–8. H 2½ft (75cm), S 3ft (1m).

❊ ◊◊

Hosta 'Frances Williams'

Herbaceous clump-forming perennial. The large, heart-shaped, deeply ribbed and puckered leaves are glaucous blue, with a wide, creamy margin. In early summer, the pale lavender flowers make a cool contrast to the foliage. Propagate by division in spring. Zones 3–8. H 3ft (1m), S 5ft (1.5m).

✳ ◊ ◊

Inula hookeri

Herbaceous perennial that forms spreading clumps of branched stems. It has oval, light green to yellow leaves and a mass of woolly buds that open into slightly scented, greenish yellow, daisylike flowers in mid- to late summer. It can be invasive. Propagate by seed or by division. Zones 4–8. H 2½ft (75cm), S 3ft (1m).

✳ ◊ ◊

Iris ensata 'Blue Peter' (Japanese iris)

Rhizomatous herbaceous perennial with dense clumps of bold, sword-shaped leaves and blue flowers, 3–6in (8–15cm) across. Dislikes alkaline soil. Can be used as a shallow marginal if it is removed from saturated soil in winter. Propagate by division in late summer. Zones 4–9. H 2–3ft (60–90cm), S indefinite.

✳ ◊ ◊

Kirengeshoma palmata

Herbaceous perennial forming clumps of large, rounded hairy leaves with irregular edges. The funnel-shaped flowers, pale yellow and waxen, hang in loose sprays on purplish stems in late summer. Dislikes alkaline soil. Propagate by seed or by division in autumn or spring. Zones 5–8. H 3ft (1m), S 2ft (60cm).

✳ ◊ ◊

Iris sibirica (Siberian iris)

Rhizomatous herbaceous perennial with sheaves of grasslike leaves. Each stem bears two or three dark-veined blue or blue-purple flowers, 2–4in (5–10cm) across. An adaptable plant that will also flourish in dry soil. Propagate by seed or by division in late summer. Zones 4–9. H 18in (45cm), S 3ft (90cm).

✳ ◊

Leucojum aestivum (summer snowflake)

Bulb with glossy, strap-shaped, daffodil-like leaves. In springtime, sturdy green stems produce loose clusters of bell-shaped flowers resembling large snowdrops, with white petals tipped with green. Propagate by seed in autumn, or by division in autumn or spring. Zones 4–9. H 6–24in (15–60cm), S 6–12in (15–30cm).

✳ ◊

Ligularia 'Gregynog Gold'

Clump-forming herbaceous perennial with large, richly veined, deep green leaves. In mid- to late summer, daisylike, orange-yellow flowers are borne in large, pyramidal spikes. Tends to wilt quickly on bright, windy days or in dry spells. Propagate by seed or by division in spring. Zones 3–8. H 6ft (2m), S 2ft (60cm).

❄ ◊ ◊

Lobelia 'Cherry Ripe'
Herbaceous clump-forming perennial with
spikes of scarlet flowers from mid- to late
summer. The fresh green leaves are often tinged
with bronze. Like 'Bees' Flame', this cultivar
should be given a protective winter mulch in
temperate climates. Propagate by division in
spring. Zones 4–8. H 3ft (1m), S 10in (25cm).

❄ ◊ ◊

Lobelia 'Will Scarlet'
Herbaceous clump-forming perennial with dark
green leaves tinged with red. It produces tall
spikes of bright scarlet, two-lipped flowers in
late summer. In temperate climates, protect
with winter mulch, or lift from wet soil and
overwinter in pots. Propagate by division in
spring. Zones 4–8. H 3ft (1m), S 12in (30cm).

❄ ◊ ◊

Ligularia przewalskii
Elegant, clump-forming perennial with dark
green, deeply lobed basal leaves. The stems are
dark purple and carry narrow spikes of small,
ragged, daisylike yellow flowers in mid- to late
summer. Plants tend to wilt in bright sunshine.
Propagate by seed or by division in spring.
Zones 5–8. H 6ft (2m), S 3ft (1m).

❄ ◊ ◊

Lobelia 'Bees' Flame'
Clump-forming perennial with oval or
lanceolate, bronze-red leaves and tall, strong
spikes of large, velvety, luminous scarlet flowers
in late summer. Do not leave in wet soil over
winter, and provide a protective winter mulch in
cool temperate climates. Propagate by division
in spring. Zones 4–8. H 3ft (1m), S 12in (30cm).

❄ ◊ ◊

Lobelia x *gerardii* 'Vedrariensis'
Clump-forming herbaceous perennial. Produces
long-lasting, dense spikes of two-lipped flowers
on stout stems in late summer and early autumn
in varying tones of rich violet-purple. The basal
rosettes of oval leaves are dark green tinged
with red. Propagate by division in spring.
Zones 4–8. H 3ft (1m), S 12in (30cm).

❋ ◊ ◊

Lysimachia nummularia 'Aurea'
(creeping Jenny, moneywort)
Prostrate herbaceous perennial with bright
yellow flowers in summer. The rooting stems
produce soft yellow leaves that darken in late
summer or in shade. Can be invasive. Propagate
by division in spring or by seed in autumn.
Zones 4–10. H 1–2in (2.5–5cm), S indefinite.

❋ ◊ ◊

Mimulus cardinalis
Erect, branching perennial producing sprays
of snapdragon-like flowers from midsummer
onward. It can become untidy in late summer
and should be cut back to prompt new growth.
Propagate by seed or by division in spring, or
grow as an annual where winters are severe.
Zones 5–8. H 2–3ft (60–90cm), S 3ft (90cm).

❋ ◊ ◊

Mimulus luteus (yellow musk)
Spreading perennial with prolific snapdragon-
like yellow flowers, sometimes with brownish
red spots, produced from midsummer onward
above lush, hairy, mid-green foliage. A rampant
self-seeder, ideally suited for a large, informal
wildlife pond. May also be propagated by
division. Zones 5–8. H and S 18in (45cm).

❋ ◊ ◊

Macleaya microcarpa 'Kelway's
Coral Plume'
Imposing herbaceous perennial with spikes
of cream or white flowers. Leaves are gray or
olive green above and downy white below.
Chop through roots to control spread. Divide in
spring or take root cuttings in winter. Zones
4–9. H 6–8ft (2–2.5m), S 3–4ft (1–1.2m).

❋ ◊ ◊

Miscanthus sinensis 'Zebrinus'
Clump-forming perennial grass that makes a
distinctive specimen plant. Tough stems and
leaves develop transverse yellow bands from
midsummer onward. The flowers are silky-
white fan-shaped heads borne in autumn.
Propagate by division in spring. Zones 5–9.
H 4ft (1.2m), S 18in (45cm).

Osmunda regalis (royal fern)
Elegant deciduous fern. Mature plants bear sterile fronds to 5ft (5m) that are pinkish when young and mature to bright green. Pale brown, fertile flower spikes appear at the tips of taller fronds. Protect the base with mulch in winter. Propagated by division in early spring. Zones 3–9. H 6ft (2m), S 3ft (1m).

Persicaria bistorta 'Superba'
Vigorous, clump-forming herbaceous perennial with dense, docklike basal foliage. Erect, broad, bottlebrushlike spikes of soft pink flowers are produced over a long period. Plants can become invasive. Propagate by seed or by division in spring or autumn. Zones 3–8. H 2–2½ft (60–75cm), S 2ft (60cm).

Parnassia palustris (grass of Parnassus)
Small perennial, often evergreen, with low tufts of heart-shaped, pale or mid-green leaves. Buttercup-like white flowers, with dark green or purplish green veins, are borne on erect stems in late spring and early summer. Not easy to establish in cultivated conditions. Sow seed in autumn. Zones 3–6. H 8in (20cm), S 2½in (6cm).

Persicaria campanulata (lesser knotweed)
Stout mat-forming herbaceous perennial with attractively crinkled, dark green leaves that are silver or buff on the underside. From mid-summer onward it produces a long-lasting display of small, pale pink or white, bell-shaped flowers. Propagate by seed or by division in spring or autumn. Zones 5–9. H and S 3ft (1m).

Petasites japonicus (butterbur)
Rhizomatous perennial with stout roots. Dense cones of small, greenish white, daisylike flowers are followed by impressive leaves, up to 3ft (1m) across. A dramatic specimen for informal ponds, but can be difficult to control. Propagate by division in spring or autumn. Zones 5–9. H 3ft (1m), S 5ft (1.5m).

❄ ◊ ◊

Phalaris arundinacea var. *picta*
(gardener's garters, ribbon grass)
Rhizomatous grass with broad, brightly white-
striped leaves that turn biege in winter. Bears
narrow clusters of flower spikelets in summer.
Contrasts well with green or purple foliage, but
can be invasive. Propagate by division in spring.
Zones 4–9. H 3ft (1m), S indefinite.

❄ ◊

Phlox paniculata 'Norah Leigh'
Herbaceous perennial with attractive cream
leaves with a thin central zone of green.
Pyramidal heads of fragrant, pale pink flowers
appear in summer. Propagate by seed in
autumn or spring, by division in spring, or
from root cuttings in winter. Dislikes alkaline
or clay soils. Zones 4–8. H and S 2ft (60cm).

❄ ◊ ◊

Physostegia virginiana subsp. *speciosa*
'Variegata' (obedient plant)
Erect perennial with toothed, cream-edged
leaves and spikes of hooded, purple-pink
blooms in late summer. These have hinged
stalks, allowing the flowers to be moved into
different positions. Propagate by division in
spring. Zones 3–9. H 3ft (1m), S 2ft (60cm).

▨ ◊ ◊

Primula beesiana
Perennial "candelabra" primrose with rosettes
of oval, slightly toothed leaves, waxy white-
powdered below. Midsummer-flowering in
rose-purple with a yellow eye. Mixes well with
other candelabras, particularly *P. pulverulenta*.
Propagate by seed when fresh or in spring.
Zones 6–8. H 2–3ft (60–90cm), S 1ft (90cm).

▨ ◊

Primula bulleyana
Compact herbaceous perennial with rosettes
of oval or lance-shaped, dark green, toothed
leaves. The candelabra flowers, deep orange or
sometimes mauve, appear in early summer and
maintain a vivid display for many weeks. Seeds
readily, making good ground cover on moist
soil. Zones 6–8. H 2ft (60cm), S 1ft (30cm).

Primula florindae (giant cowslip)
Bold, clump-forming herbaceous perennial, one of the most vigorous waterside primroses. Established plants produce several stems with long, drooping heads of fragrant, white-powdered, sulphur yellow bells. Propagate by seed when fresh or in spring. Zones 6–8. H 2–3ft (60–90cm), S 1–2ft (30–60cm).

Primula prolifera
Vigorous herbaceous perennial. Basal rosettes of rich green leaves surround tall, green flower stems with orange buds. The golden yellow, white-powdered flowers open in early summer. A good choice for mass planting by streams. Propagate by seed when fresh or in spring. Zones 6–8. H 3ft (90cm), S 2ft (60cm).

Primula japonica 'Miller's Crimson'
Vigorous, clump-forming herbaceous perennial with pale green leaves that are oval to lance-shaped, toothed, and coarse. Sturdy spikes of intense crimson flowers appear in early summer. Unlike many selected cultivars, it breeds true from seed. May also be divided. Zones 5–8. H 1–2ft (30–60cm), S 1–1½ft (30–45cm).

Primula pulverulenta
One of the most elegant candelabra primroses, although slightly smaller than many. This clump-forming species has red tubular flowers with purple-red eyes. The mid-green leaves are broadly lance-shaped and toothed. Propagate from seed when fresh or in spring. Zones 6–8. H 2ft (60cm), S 1–1½ft (30–45cm).

Primula rosea
Clump-forming perennial that bears small, flat heads of rose-pink flowers in early spring. Less vigorous than most primroses and waterside plants; care is required to prevent it from being smothered. Propagate by seed when fresh or in spring. Zones 5–8. H 4–6in (10–15cm), S 6–8in (15–20cm).

❄ ◊ ◊

Pulmonaria angustifolia subsp. *azurea*
(blue lungwort)
Herbaceous perennial that makes a slow-growing
ground cover in a wide range of conditions.
As rich blue flowers, sometimes pink-tinged,
appear, narrow, lance-shaped leaves open.
Propagate by division in spring or autumn.
Zones 2–8. H 9in (23cm), S 8–12in (20–30cm).

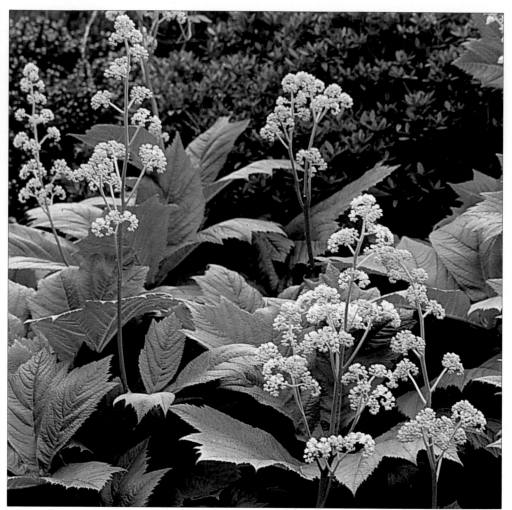

❄ ◊ ◊

Rodgersia podophylla
Clump-forming perennial with large, attractive
leaves, bronze-veined when young, turning
green, then copper. The flowers are cream. A
good substitute for *Gunnera* in a small garden.
Must have shelter from wind. Propagate by
division in spring or by seed in autumn. Zones
5–8. H 4ft (1.2m), S 3ft (1m).

❄ ◊

Rheum palmatum 'Atrosanguineum'
Stout, clump-forming cultivar grown for its
large, deeply cut leaves. Rich red-purple when
young, they retain this color on the undersides
in maturity. Spikes of small, rust-red flowers
appear in early summer. Grows best in deep,
moist soil. Propagate by seed in autumn or by
division in spring. Zones 5–9. H and S 6ft (2m).

❄ ◊ ◊

Rodgersia sambucifolia
Rhizomatous perennial forming clumps of
emerald green, sometimes bronze-tinged leaves.
Astilbe-like heads of pink or white flowers
appear in summer. Ideal for woodland water
gardens or the side of a stream. Propagate by
division in spring or by seed in autumn. Zones
5–8. H 3–4ft (1–1.2m), S 3ft (1m).

❄ ◊

Senecio smithii
Bushy herbaceous perennial with woolly stems
and long, serrated, leathery, dark green leaves.
Terminal clusters of white, daisylike flowers
with yellow centers are held above the foliage in
early summer, followed by attractive, fluffy
white seed heads. Propagate by division in spring.
Zones 7–9. H 3–4ft (1–1.2m), S 3ft (1m).

Trillium erectum (stinking Benjamin, birthroot, squawroot)
Clump-forming perennial wildflower with mid-green leaves borne in whorls of three. Maroon-purple spring flowers are unpleasant-smelling but attractive. Propagate by division in late summer or by seed in spring. Zones 5–7. H 12–18in (30–45cm), S 12in (30cm).

Trollius europaeus (globe flower)
Compact herbaceous perennial resembling a large, double buttercup, with thick, fibrous roots and rounded, deeply divided, mid-green leaves. Solitary, many-petaled, lemon to mid-yellow flowers appear in spring. Propagate by division or by seed in early autumn. Zones 5–7. H 24in (60cm), S 18in (45cm).

Trollius pumilus
Small, tuft-forming perennial with fibrous roots and basal green leaves that are crinkled and finely divided. Solitary, cup-shaped flowers, yellow on the interior and dark wine-red or crimson outside, appear through late spring and early summer. Propagate by division or seed in early autumn. Zones 5–7. H and S 6in (15cm).

Veratrum album (white false helleborine)
Clump-forming, potentially poisonous perennial with oval, deeply pleated, dark green leaves. These form arching mounds of foliage below dense terminal heads of pale green summer flowers. Ideal in a woodland setting. Propagate by division or by seed in autumn. Zones 5–9. H 6ft (2m), S 2ft (60cm).

ALSO RECOMMENDED

Alnus incana
Arundo donax
Astilbe 'Fanal'
Brunnera macrophylla
Carex hachijoensis 'Evergold'
Darmera peltata (see p. 47)
Deschampsia cespitosa
Dryopteris filix-mas (see p. 39)
Eupatorium purpureum
Gentiana asclepiadea
Geum 'Borisii'
Gunnera tinctoria (frost-hardy)
Heuchera sanguinea
Hosta undulata var. *aureomarginata* (see p. 30)
Juncus ensifolius
Liatris spicata
Ligularia dentata 'Desdemona'

Ligularia 'The Rocket' (see p. 37)
Lobelia cardinalis (see p. 21)
Lobelia 'Cinnabar Rose'
Lysimachia nummularia
Matteuccia struthiopteris (see p. 36)
Metasequoia glyptostroboides
Miscanthus sinensis 'Gracillimus'
Persicaria amplexicaulis
Phalaris arundinacea var. *picta* 'Feesey'
Primula denticulata
Rheum palmatum
Onoclea sensibilis
Salix hastata 'Wehrhahnii' (see p. 20)

Where specific page references are not given to plant entries found in other sections, brief details are given in the Plant Index (pp. 210-213).

GLOSSARY

Words that appear in italics in a definition are also defined in the glossary.

ACIDIC (of soil, water) With a *pH* value of less than 7.

AGGREGATE Similar to *ballast*, a loose mixture of crushed stone and sand used to reinforce *cement*.

ALGAE Microscopic, non-flowering plants that lack true stems and roots.

ALGICIDE A product sold for controlling algae in ponds.

ALKALINE (of soil, water) With a *pH* value more than 7.

ALPINE A term loosely applied to rock-garden plants.

AMPHIBIOUS Able to live both on land and in water.

ANAEROBIC An environment low in or free of oxygen, conducive to certain bacterial activity.

ANNUAL Plant that flowers, sets seed, and dies within one growing season.

ANTHER The part of a stamen that produces pollen (the male cells).

AQUATIC PLANT Any plant that can grow with its roots surrounded by water, either free-floating or in saturated soil.

ARMORED CABLING Electric cable with reinforced protective covering for safety.

AXIL The upper angle formed where a leaf joins a stem, or where a stem joins a branch.

BACKFILL To fill in a hole around the object occupying it, for example, a rigid pool unit or a plant's root ball.

BALLAST A sand and gravel mix used in making *concrete*.

BARBELS The spines or bristles hanging down from the jaws of certain fish.

BARE-ROOT Plants sold with their roots bare of soil.

BASAL Growing at the base of a stem or from the *crown* of a plant.

BATTEN A narrow strip of wood.

BEARER A supporting beam or plank on which *joists* rest.

BEDDING MORTAR A mixture of sand and *cement* used for laying paving stones.

BENTOMAT A waterproof lining material containing *bentonite*.

BENTONITE A powder derived from fossilized volcanic ash which, when mixed with water and added to clay, swells into a water-resistant gel.

BIENNIAL A plant that flowers and dies in its second growing season.

BLEED (of plants) To lose sap from a cut or wound.

BLUE MOTTLING An indication on the surface that the soil below is waterlogged.

BOG GARDEN An area where the soil is permanently damp.

BOG PLANT Plants that will grow and thrive with their roots in wet soil; many will also grow in shallow water, and are more properly called *marginal plants*.

BOLSTER CHISEL A steel chisel with a wide blade used with a *club hammer* for cutting bricks, pavers, or blocks.

BRACT A modified leaf at the base of a flower. Bracts may resemble normal leaves, or be small and scalelike, or large and brightly colored.

BREEZE BLOCK An undecorative, molded concrete block.

BRICKLAYER'S TROWEL A pointed, flat-bladed trowel used to lift, shape, and apply mortar to brickwork.

BUD A condensed shoot containing an embryonic leaf, leaf cluster, or flower.

BUILDER'S SQUARE Wood triangle used to check the accuracy of right angles.

BULB A modified, usually underground, stem acting as a storage organ, generally comprising layers of tightly packed, fleshy scale leaves on a basal plate from which roots grow downward. An outer papery layer called the *tunic* may be present.

BULBIL A small, bulblike organ usually borne in a leaf axil or occasionally on a stem or in a flower head. Can be separated and used for *propagation*.

BULBLET A small bulb that develops from the basal plate of a mature bulb, usually outside the *tunic*. Can be separated and used for *propagation*.

BUTYL Strong, durable, waterproof liner made of rubber.

CALYX The collective term for the sepals; the outer whorl of usually green segments that enclose a flower in bud.

CARPENTER'S LEVEL A tool for checking horizontal levels.

CEMENT A fine, gray powder containing calcined limestone and clay that is mixed with sand and water to make *mortar* or *concrete* with the addition of *ballast*.

CHAMFER To bevel a right-angled edge or corner symmetrically.

CIRCUIT BREAKER An automatic switch that halts the flow of electricity in the event of a short-circuit, or if the current exceeds a pre-set safe value.

CLUB HAMMER A heavy, mallet-shaped hammer used with a *bolster chisel* to cut decorative bricks.

COARSE SAND A sand composed of hard, angular particles, used in specific mixes with cement and water for rendering walls and similar surfaces.

COCOON A protective envelope secreted by an insect *larva* in which a *pupa* develops.

CONCRETE A mixture of sand, *cement*, water, and small stones that sets to form an extremely strong, durable building material; often used to make foundations.

CONDUIT A tube or duct conducting water or enclosing cables.

CONIFER Cone-bearing tree, usually evergreen, but occasionally deciduous.

COPING The top course of stones or bricks in a wall; often flat or sloping stones that differ from those used in the wall for decorative effect or to allow rainwater to run off.

CORM A bulblike, underground organ, consisting of a swollen stem or stem base, often surrounded by a papery *tunic*.

COUNTERSUNK SCREW A screw with a head that lies flush with the surface when fully screwed down.

CROWN The basal part of an *herbaceous* plant where roots and stems join at soil level and from where new shoots are produced.

CULTIVAR A distinct plant variation that has originated in cultivation, not in the wild. An abbreviation of "cultivated variety," often itself abbreviated to "cv."

CULVERT An aperture in brickwork that allows water to flow out from a concealed header pool or tank.

CUTTING A portion of a plant (a leaf, stem, root, or bud) that is cut off to be used for propagation. A hardwood cutting is taken from mature wood of both deciduous and evergreen plants at the end of the growing season; a semi-ripe cutting is taken from half-ripened wood during the growing season, while a softwood, softwood stem, or tip cutting is taken from young, green growth during the growing season.

CV Abbreviation of *cultivar*.

DEADHEADING The removal of spent flowers or flower heads.

DECIDUOUS Plants that shed their leaves at the end of the growing season and renew them at the beginning of the next.

DECORATIVE BRICK A dense, hard, water-resistant brick, often dark in color and hence inconspicuous under water.

DELIVERY PIPE The pipe that runs from a pump to the water outlet in a recirculating feature.

DIBBER A tool used for making holes in soil into which seedlings or cuttings are inserted.

DIEBACK The progressive death of shoots from the tip downward as a result of damage or disease.

DIVISION A method of thinning or increasing plants by dividing them into pieces, each with a portion of the root system and one or more shoots (or dormant buds).

DORMANCY The state of temporary cessation of growth in plants, and slowing down of other activities, usually during winter.

DOUBLE FLOWER A flower with more than the normal number of petals in several rows, with few or no stamens visible or present.

ELBOW JOINT A length of connecting pipe bent to form a right-angle.

EPDM (thylene, propylene, diene, monomer) A synthetic rubber liner material with more stretch and greater UV resistance than PVC.

EVERGREEN Plants that retain their foliage for more than one growing season.

FALLS (fall petals of irises) The horizontal or more often, pendent petals at the base of the flower.

FAMILY In plant classification, a grouping together of related plant genera.

FLEXIBLE LINER A waterproof *butyl*, *EPDM*, *PVC*, or plastic material.

FLOW ADJUSTER An adjustable valve used to control water flow.

FOOTING A narrow trench *foundation*, usually for a wall.

FOUNDATION A solid base, often of *concrete*, on which a structure stands.

FROG The hollow in a brick.

FROND The leaflike organ of a fern. Some ferns produce both sterile and fertile fronds, the latter bearing spores.

FROST TENDER A plant vulnerable to frost damage.

FRY Young fish.

FUNGICIDE A substance for controlling diseases caused by fungi.

GALVANIZED Of metal objects such as nails, with a protective coating of zinc to protect them from rusting.

GENUS A category in plant classification between *family* and *species*, denoting a group of related species linked by a range of common characteristics. For example, all species of forget-me-not belong to the genus *Myosotis*.

GERMINATION The starting of a seed into growth.

GILL The breathing organ of a fish.

GLABROUS Completely smooth.

GLAUCOUS With a blue-green, blue-gray, gray, or white bloom.

GLOBOSE Shaped like a globe.

GROUND FAULT INTERRUPTER (**GFI**) An electrical device that shuts off power to a pump or other electrical device the instant it senses water in contact with the wiring.

HABIT Characteristic, natural form of growth of a plant – upright, prostrate, weeping, etc.

HARDPAN A virtually impermeable layer of compacted soil.

HARDWOOD CUTTING See *Cutting*.

HARDWOOD LUMBER Wood cut from deciduous trees.

HEAD The height of a water outlet above the level of the *reservoir pool*.

HEADER POOL The uppermost pool in a recirculating water feature.

HERBACEOUS A non-woody plant whose upper parts die down to a rootstock at the end of the growing season.

HOSE CONNECTOR A molded plastic joint used to join two pipes together.

HUMUS Decomposed *organic* matter that enriches soil.

HYBRID The offspring of genetically different parents, which are usually of distinct species.

HYPERTUFA A *concrete* mix incorporating some *organic* matter, encouraging mosses and algae to grow on its surface for an "antique" effect.

INFLORESCENCE A group of flowers borne on a single stem.

INVASIVE Tending to spread.

JOIST A wooden supporting beam that runs beneath and usually perpendicular to planks, used e.g. for flooring, decking, or bridges.

LARVA The active immature stage of some insects.

LEACHING The loss of nutrients from the *topsoil*, carried downward by water.

LEAF AXIL See *Axil*.

LOAM A term used for soil of medium texture, often easily worked, which contains more or less equal parts of sand, silt, and clay, and is usually rich in *humus*.

LOBE Of a leaf shape, where the margin is indented at one or more points.

LOG ROLL Edging material made from wooden stakes.

MARGINAL PLANTS Plants that grow partially submerged in shallow water or in boggy soil at the water's edge.

MARGINAL SHELF A shallow planting area created for marginal plants.

MEALY A sprinkling or covering of powder resembling meal.

MIDRIB The primary, usually central vein of a leaf or leaflet.

MOISTURE-LOVERS Plants that thrive in moist soil. Unlike bog plants, moisture-lovers need some soil drainage and do not tolerate waterlogged conditions.

MORTAR A mixture of *cement*, sand, and water used to bond bricks and stones, and for *pointing* and *rendering*.

MULCH Various materials, for example bark chips, applied in a layer to the soil surface in order to suppress weeds, conserve moisture, and maintain a cool, even root temperature.

NACREOUS A mother-of-pearl sheen.

NATIVE Plants originating in the country where they are grown.

NECTAR Sugary liquid secreted by flowers, which is often attractive to pollinating insects.

NEUTRAL (of soil) With a *pH* value of 7, i.e., neither acid nor alkaline.

NODE The point on a stem where leaves, shoots, or flowers arise.

NON-RETURN VALVE A valve that allows water to flow in one direction only.

OFFSET A young plant that arises by natural, vegetative reproduction, usually at the base of the parent plant.

ORGANIC 1) Chemically, referring to compounds containing carbon derived from decomposed plant or animal organisms. 2) Loosely applied to *mulches*, or similar materials derived from plant materials that have the effect of improving soil texture and quality.

ORNAMENTAL A plant grown for its decorative qualities.

OVERWINTER (of plants) Usually, to survive the winter by being given some protection against cold weather: for example, a *mulch*, or cover under glass.

PANICLE A branched *inflorescence* often consisting of several racemose branches (see *Raceme*).

PEA GRAVEL Fine, rounded gravel often used as a top-dressing for soil.

PERENNIAL A plant that lives for more than two seasons, commonly applied to herbaceous plants.

pH A measure of *acidity* or *alkalinity*.

PHOTOSYNTHESIS The production of organic compounds required for growth in plants by a complex process involving chlorophyll (the principal green plant pigment), light energy, carbon dioxide, and water.

PINNATE Leaves with leaflets arranged on either side of a central stem, usually in opposite pairs.

PLANTLET Usually used to describe a small plant produced naturally by the parent plant that can be detached and grown on separately as a method of propagation.

PLUMB-LINE A length of string with a metal weight attached, used to determine vertical alignment.

POINTING Filling the joints in brickwork and stonework with mortar.

POLLINATION The transfer of pollen from *anthers* to *stigmas*.

POLYETHYLENE A flexible waterproof liner material used for low-cost pond liners and other applications.

POTBOUND A plant whose growth is restricted by the size of its container; its roots become congested and tangled.

POTTING ON Transferring a young plant to a larger container once it has outgrown its module or original pot.

PREFORMED UNIT Ready-made, rigid moldings for pools and streams.

PRICKING OUT The transplanting of seedlings from their germinating bed, tray, or pot to positions where they have more room to grow.

PROPAGATION The increase of plants by seed (usually sexual) or by vegetative (asexual) means.

PUDDLING Coating with a mixture of wet clay that is impervious to water.

PUPA The inactive, immature stage of an insect, during which it metamorphoses into the adult stage, often in a *cocoon*.

PVC A strong, durable waterproof material made of polyvinyl chloride.

RACEME An unbranched flower cluster, usually with many stalked flowers borne on a long stem.

RECONSTITUTED STONE Natural stone *aggregate* cast in preformed shapes such as slabs or blocks.

REINFORCING FIBERS Synthetic fibers – based on polypropylene – which are mixed with cement-based materials to provide extra strength and elasticity.

RENDER To cover a surface with *mortar* or *cement* in order to produce a smooth finish.

RESERVOIR POOL A pool at the lowest point of a water feature.

RHIZOME A specialized, usually horizontally creeping, swollen or slender, underground stem that acts as a storage organ and produces aerial shoots at its apex and along its length.

ROOT BALL The roots and accompanying soil visible when a plant is removed from a container or lifted from open ground.

ROSETTE A circular cluster of leaves growing from the base of a shoot.

RUBBER MALLET See *Club hammer*.

RUNNER A horizontally spreading stem that runs above ground and roots at the *nodes* to form new plants.

RUST A fungal disease affecting plants.

SEALANT, SEALING COMPOUND A compound used to waterproof cement, wood, etc.

SEDGE A grasslike plant with triangular stems, usually growing in wet areas.

SELF-SEEDING Shedding fertile seeds that grow into young plants around the parent plant.

SEMI-DOUBLE FLOWER With two or three times the normal number of petals, usually in two or three rows.

SEMI-EVERGREEN Plants that retain some leaves or lose older leaves only in winter.

SEMI-RIPE CUTTING See *Cutting*.

SETT A granite paving block, often cuboid in shape.

SOFT SAND Fine sand.

SOFTWOOD CUTTING See *Cutting*.

SOFTWOOD LUMBER Wood cut from coniferous trees.

SPATHE A large *bract* that encloses an *inflorescence*.

SPAWN The mass of eggs deposited by fish or amphibians.

SPECIES A category in plant classification denoting closely related plants within a single *genus*.

SPHAGNUM Mosses common to bogs; their moisture-retentive character makes them ideal components of some growing media.

SPILL STONE A flat stone set at the point at which water falls from one level to another.

STAMEN The male organ of a flower.

STERILE Infertile, not bearing spores, pollen, or female reproductive organs (the pistil). Also, not producing flowers or viable seeds.

STIGMA The part of the female portion of the flower that receives pollen.

STOCK TANK DEICER A floating heater designed to keep water a few degrees above freezing in winter.

STRAIGHTSEDGE A straight length of timber on which to rest a carpenter's level.

SUBMERGED PLANTS Plants that for the most part have totally submerged foliage and, in many cases, emergent flowers whose leaves and stems release oxygen into the water as a by-product of photosynthesis.

SUBMERSIBLE PUMP A water-recirculating pump that is housed, and runs, under water.

SUBSOIL The layer of soil beneath the *topsoil*, usually less fertile and of poorer structure.

SUMP A pool or container into which water drains.

SURFACE PUMP A water-recirculating pump housed and running on dry land.

TAMP To compress firmly.

TERMINAL At the tip of a shoot, stem, or branch.

THINNING The removal of a proportion of a plant to improve the vigor and quality of the remainder.

TIP CUTTING See *Cutting*.

TOOTHED Small or narrow indentations around the margin of a leaf or flower.

TOPSOIL The top layer of soil, which contains plant nutrients.

TRANSFORMER An apparatus for reducing or increasing the voltage of electrical currents.

TRANSPIRATION Loss of water by evaporation from the leaves and stems of plants.

TRIFOLIATE With leaflets in threes.

TRUE Of plant breeding, plants that reliably produce offspring very similar to their parents when self-pollinated.

TUBER A thickened, usually underground, storage organ derived from a stem or a root.

TUNIC The papery outer layer of a *bulb* or *corm*.

TURION See *Winter bud*.

ULTRAVIOLET LIGHT (UV) Radiation with a wave-length less than that of visible light; a component of sunlight.

UNDERLAY Cushioning material laid under flexible liner as a form of protection.

UV FILTER AND MAGNET A combination filter system that prevents the buildup of minerals on which algae thrive.

VARIEGATED Marked with various colors in an irregular pattern, particularly of leaves with yellow or white markings.

VARIETY Botanically, a naturally occurring variant of a wild *species*.

WALL TIE A metal strip or wire figure-eight mortared into brickwork to cross the gap between double walls, giving them more stability.

WATER TABLE The level in soil below which water will not drain away; hence, the water level of natural ponds in the locality.

WICK EFFECT Tendency of water to move from a pond to surrounding soil, drawn by plants' root systems.

WINTER BUD A fleshy bud that detaches from the parent aquatic plant, overwintering at the bottom of a pond and growing into a new plant the following spring. Also called a turion.

WHORL A cluster of three or more flowers, buds, leaves, or shoots that are arranged around a stem at about the same level.

X Sign denoting a hybrid, produced from crossing two genetically distinct plants.

PLANT INDEX

—A—

Abies (firs) Tall, stately conifers with whorled branches and soft needles. *A. koreana*, the Korean fir (H to 30ft/10m), bears upright, violet-blue cones from early maturity.

Acer (maples) Deciduous or evergreen shrubs and trees for well-drained soil grown for their foliage or decorative bark; many, particularly the Japanese maples (*A. palmatum*), display brilliant autumn color.

Acorus Semi-evergreen marginal perennials grown for their often aromatic grass- or irislike foliage. Need an open, sunny position. Both *A. calamus* and *A. gramineus* can grow in moist soil to 6in (15cm) of water.
calamus 'Variegatus' 190

Ajuga Annuals and perennials for moist soil and sun or shade. Small, semi-evergreen *A. reptans* and its cultivars make excellent groundcovers.
reptans 'Multicolor' 196

Alchemilla Perennials bearing sprays of tiny, greenish yellow flowers in summer. *A. mollis* (H & S 20in/50cm) tolerates shade and moist, but not wet, soil.

Alder see *Alnus*

Alisma Deciduous perennial marginals grown for their handsome foliage and airy white flower clusters. Require a sunny position.
plantago-aquatica 190

Allium (ornamental onions) Perennials or bulbs needing sun and well-drained soil. Most have small flowers packed together in dense, spherical heads on stout stalks. Stalks and foliage are onion-scented when bruised.

Alnus (alders) Deciduous trees and shrubs that thrive in any soil and in wet conditions.

Amazon water lily see *Victoria amazonica*

American arrowhead see *Sagittaria latifolia*

American lotus see *Nelumbo lutea*

Amphibian bistort see *Polygonum amphibium*

Anagallis Annuals and creeping perennials grown for their flowers. Need an open, sunny position. All enjoy moist soil, particularly perennial *A. tenella* (H 2–4in/ 5–10cm, S 6–12in/ 15–30cm), or bog pimpernel.
tenella 'Studland' 196

Angelica Summer-flowering, often short-lived perennials with flat-topped flower clusters. Some have culinary/ medicinal uses.
archangelica 196

Anthemis Carpeting and clump-forming perennials, some evergreen, grown for their daisylike flower heads and fernlike foliage. Need sun and well-drained soil.

Aponogeton Tender perennial deep-water plants grown for their floating foliage and scented flowers. Need an open, sunny position.
distachyos 180

Arisaema Tuberous perennials grown for their large, hooded spathes. Need sun or partial shade and moist, humus-rich soil.
candidissimum 196

Artemisia Evergreen, semi-evergreen, or deciduous shrubs, sub-shrubs, and perennials grown for their silvery, aromatic foliage. All enjoy well-drained soil and a sunny position.

Aruncus Perennials forming mounds of broad, fernlike leaves and plumes of white flowers in summer.
dioicus 196

Arundo Large perennial grasses for full sun and moist or well-drained soil. *A. donax*, giant reed, can reach 20ft (6m) in height and will spread vigorously.

Asian lotus see *Nelumbo nucifera*

Asplenium Semi-evergreen or evergreen moisture-loving ferns. Most prefer partial shade and are suitable for woodland gardens, but *A. trichomanes* (H 6in/15cm, S 6–12in/15–30cm) tolerates full sun.

Astilbe Summer-flowering perennials preferring moist soil and, usually, partial shade. Will also tolerate full sun with moist soil. Flower heads remain handsome even when brown in winter.
'Venus' 197

Aucuba Bushy, evergreen shrubs for sun or shade and any but waterlogged soil, grown for their glossy foliage and fruits (formed only where plants of both sexes grow).

Azalea see *Rhododendron*

Azolla Deciduous free-floating ferns. Can be invasive.
filiculoides 180

—B—

Banana water lily see *Nymphaea mexicana*

Betula (birches) Handsome deciduous trees, most upright and slender; *B. pendula* is the weeping birch. Prefer a sunny position and any moist but well-drained soil.

Birthroot see *Trillium erectum*

Blue flag see *Iris versicolor*

Bog arum see *Calla palustris*

Bog asphodel see *Narthecium ossifragum*

Bog bean see *Menyanthes trifoliata*

Bowles' golden sedge see *Carex elata* 'Aurea'

Brooklime see *Veronica beccabunga*

Brunnera Spring-flowering perennials, suited to light shade and moist soil.
macrophylla 39

Buckbean see *Menyanthes trifoliata*

Bugbane see *Cimicifuga simplex*

Butomus One species of hardy, rushlike marginal.
umbellatus 190

Butterbur see *Petasites japonicus*

Butterfly fern see *Salvinia auriculata*

—C—

Calla One species of perennial marginal plant.
palustris 190

Callitriche Perennial, submerged oxygenating plants needing full sun. *C. hermaphroditica* thrives in up to 20in (50cm) of still or moving water.

Caltha Deciduous perennials including some bog plants, grown for their yellow flowers. *C. palustris* is the marsh marigold; var. *palustris* (H 24in/60cm, S 18in (45cm) is more creeping in habit; 'Flore Pleno' has double flowers.
palustris 37

Camellia Evergreen shrubs and trees grown for their glossy leaves and attractive flowers, borne from late winter to spring. Must have well-drained soil.

Canna Tender, rhizomatous perennials grown for their striking flower spikes. Require a warm, sunny position and humus-rich, moist soil. Some species, such as *C. flaccida* and *C. glauca* can be grown as marginal plants, but must be lifted and overwintered indoors.
glauca 25

Cape blue water lily see *Nymphaea capensis*

Cape pondweed see *Aponogeton distachyos*

Cardinal flower see *Lobelia cardinalis*

Carex (sedges) Evergreen, rhizomatous perennials that form dense, grasslike tufts. Several have variegated or golden foliage.
elata 'Aurea' 197
pendula 197

Cedrus (cedars) Evergreen conifers or shrubs for warm, well-drained sites in full sun. *C. deodara* (H to 80ft/25m) has gray-green leaves and glaucous cones; branch tips have an elegant, arching habit.

Centaurea Annuals and perennials for any well-drained soil grown for their flowers, which have slender ray petals around a thistlelike center.

Ceratophyllum Submerged perennials preferring sun, but tolerating shade better than most oxygenators.
demersum 178

Ceratopteris Tender, free-floating, spreading aquatic ferns needing full sun. Grown as annuals in the north.

Chelidonium (celandine) One species, *C. majus* (H 24–30in/60–90cm, S 12in/30cm), of hardy, yellow-flowered perennial that rapidly forms a groundcover, thriving in moist but not wet soil. The cultivar 'Flore Pleno' has double flowers.

Chelone Summer- and autumn-flowering, moisture-loving perennials.
obliqua 197

Cimicifuga Moisture-loving perennial wildflowers grown for their flowers, despite their unusual, slightly unpleasant smell.
simplex 197

Colchicum Spring- and autumn-flowering cormous perennials whose short-stalked, goblet-shaped flowers usually appear before their straplike leaves. Need full sun and well-drained soil.

Colocasia Tender deciduous or evergreen perennials grown for their foliage. *C. esculenta* 'Fontanesii' (H 3½ft/1.1m, S 2ft/60cm) will grow in shallow water or wet soil, in sun or light shade.

Common cotton grass see *Eriophorum angustifolium*

Common white water lily see *Nymphaea alba*

Corkscrew rush see *Juncus effusus* 'Spiralis'

Cornus (dogwoods) Deciduous shrubs and deciduous or evergreen trees needing moist but well-drained soil. Trees, such as *C. controversa* (H & S 50ft/15m), are grown for their habit, foliage, and pink, cream, or white bracts; the shrubs are often regularly cut back to renew their colorful, red or yellow young stems.
stolonifera 'Flaviramea' 198

Crocosmia Cormous plants grown for their brightly colored flowers produced mainly in summer. Thrive in moist but well-drained soil and an open, sunny site.
'Lucifer' 198

Cryptomeria One species, *C. japonica*, a conifer with both tree and shrub forms (H 50–70ft/ 15–20m). Noted for its tolerance of heavy clay soils. There are several small cultivars with attractive foliage colors.

Curled pondweed see *Potamogeton crispus*

Cyperus Clump-forming sedges, grown for their slender leaves and flower spikelets. *C. papyrus* is tender, but *C. longus* (H 5ft/1.5m, S indefinite) and the smaller *C. latifolius* are hardy to zone 7. All prefer full sun and moist soil.
papyrus 190

—D—

Darmera A genus of only one species of moisture-loving perennial.
peltata 47

Daylily see *Hemerocallis*

Deschampsia Perennial grasses. *D. cespitosa* has dense, dark green leaves and pale brown flower spikelets in summer. Tolerates sun or shade.

Dianthus (pinks, carnations) Evergreen or semi-evergreen perennials, annuals, and biennials grown for their mass of late spring to summer flowers, often scented. All need sun and well-drained soil.

Diascia Summer- and autumn-flowering annuals and perennials grown for their racemes of flowers in shades of pink. Need sun and moisture-retentive but well-drained soil.

Dierama (wandflowers) Tender evergreen, moisture-loving cormous plants with rows of pendent flowers on long, arching, wiry stems borne in summer.

Dropwort see *Filipendula vulgaris*

Dryopteris (wood ferns) Deciduous or semi-evergreen ferns. Must have shade and moist soil.
filix-mas 39

Duck potato see *Sagittaria latifolia*

—E—

Eelgrass see *Vallisneria spiralis*

Egeria Tender, semi-evergreen or evergreen floating or submerged aquatics. *E. densa* forms thick masses of long, wiry stems with small, whorled leaves; white flowers are held above water in summer.

Eichhornia Tender, evergreen or semi-evergreen aquatic plants, needing an open, sunny position in warm water.
crassipes 26

Elaeagnus Deciduous or evergreen shrubs and trees for well-drained soil. The usually fragrant flowers are followed in many cases by showy fruits. Can reseed excessively. Evergreen species such as *E. x ebbingei* (H & S 15ft/5m) make good hedges in sun or shade.

Epimedium Spring-flowering perennials, some evergreen. Make good groundcovers in partial shade and moist, humus-rich but well-drained soil. Tolerate dry shade once established.

Equisetum (horsetail) Primitive, rushlike, non-

flowering rhizomatous perennials with curious jointed stems. E. japonicum is one of several species that will grow in water. Best containerized as can be extremely invasive.

Erica (heaths, heathers) Ericaceous, evergreen shrubs for well-drained soil, many low-growing with wiry stems. Tender E. x veitchii is one of the larger tree heaths (H to 6ft/2m, S 3ft/1m), with dense clusters of white, bell-shaped flowers from mid-winter to spring. E. carnea and its cultivars are hardy to zone 6.

Eriophorum Perennial grasslike plants often remaining green in winter with the leaves dying at flowering time, when they bear spikelets of cotton-like tufts. Enjoy full sun and boggy, acidic conditions.
angustifolium 190

Erodium Mound-forming perennials suitable for rock gardens. Require sun and well-drained soil.

Eupatorium Perennials, sub-shrubs, and shrubs. E. purpureum is an upright native perennial (H to 7ft/2.2m, S to 3ft/1m) with pink flower heads on purplish stems that thrives in moist soil and in sun or partial shade.

—F—

Fairy moss see Azolla filiculoides
False helleborine see Veratrum album
Fargesia Bamboos remaining evergreen in mild winters, forming large, dense clumps of arching stems. F. murieliae (H 12ft/4m, S indefinite) thrives in moist but well-drained soil and in full sun or partial shade.
Fatsia One species, F. japonica, of evergreen shrub, grown for its glossy foliage and flowers. Grow in sun or shade, in fertile, well-drained soil.
Filipendula (meadowsweets) Spring- and summer-flowering perennials, many species thriving in moist soil.
purpurea 198
ulmaria 'Aurea' 198
vulgaris 198
Flag see Iris
Flowering rush see Butomus umbellatus

Fontinalis Hardy, evergreen, submerged oxygenating plants.
antipyretica 178
Fringed water lily see Nymphoides peltata
Frogbit see Hydrocharis morsus-ranae

—G—

Gardener's garters see Phalaris arundinacea
Gentiana Annuals, biennials, and perennials, many suitable for rock gardens. The perennial G. asclepiadea (H 3ft/90cm, S 2ft/60cm) will grow in sun or partial shade, in moist but well-drained soil.
Geranium (cranesbills) Perennials, some semi-evergreen, grown for their attractive flowers and mounds of deeply cut leaves. Many make good groundcovers in any but waterlogged soil.
Geum Summer-flowering perennials. Best in sun and moist but well-drained soil.
Giant cowslip see Primula florindae
Gleditsia Deciduous, usually spiny trees grown for their foliage. G. triacanthos 'Sunburst' (H to 40ft/12m) has bright yellow leaves in spring.
Globe flower see Trollius europaeus
Glyceria Deciduous, sun-loving grasses with creeping roots, arching leaves, and feathery flower heads. G. maxima can form large stands in pool margins.
maxima var. variegata 191
Goat's beard see Aruncus dioicus
Golden club see Orontium aquaticum
Grass of Parnassus see Parnassia palustris
Greater bladderwort see Utricularia vulgaris
Greater spearwort see Ranunculus lingua
Green arrow arum see Peltandra undulata
Griselinia Tender genus of evergreen shrubs and trees with inconspicuous flowers, grown for their foliage. Require sun and fertile, well-drained soil. G. littoralis (H 20ft/6m, S 15ft/5m) thrives in exposed, coastal sites.
Gunnera Summer-flowering perennials, the larger, clump-forming species grown mainly for their huge leaves. G. tinctoria

(H & S at least 5ft/1.5m) is more compact in habit than G. manicata.
manicata 199

—H—

Hedera (ivies) Evergreen, self-clinging climbers grown for their foliage. All prefer well-drained soil; variegated ivies need more light than those with plain green leaves, which tolerate deep shade. Small, yellowish-green flowers are produced on mature plants only, followed by black or yellow fruits.
Hemerocallis (daylily) Perennials, some semi-evergreen, for full sun and moist soil. Flowers are borne in succession, each one lasting for only a day.
fulva 'Flore Pleno' 199
Hepatica Perennial wildflowers, some semi-evergreen, flowering in early spring before new leaves are formed. Must have partial shade and moist, humus-rich soil.
Heuchera (coral bells) Evergreen, summer-flowering perennials forming large clumps of leaves, often, as with H. americana (H & S 2ft/60cm), tinted with bronze or purple. Make good groundcovers.
Hornwort see Ceratophyllum demersum
Hosta Shade- and moisture-loving perennials, grown mainly for their decorative foliage. They form large clumps, making excellent groundcovers that bear white or lavender summer or autumn flowers.
'Frances Williams' 199
fortunei var. albopicta 199
fortunei var. aureomarginata 199
undulata var. albomarginata 30
venusta 20
Hottonia Submerged perennials for still or moving water, grown for their handsome foliage and flowers.
palustris 178
Houttuynia One species, H. cordata, of perennial for moist or wet soil, or shallow water. With its spreading rhizomes, it makes a very good groundcover, although it can be extremely invasive.
cordata 'Flore Pleno' 21
cordata 'Chameleon' 191

Hydrocharis One species of free-floating perennial.
morsus-ranae 180
Hygrophila Tender, deciduous or evergreen, aquatic perennials; H. polysperma is a spreading, submerged oxygenator with pale green leaves.

—I—

Inula Summer-flowering, clump-forming, sometimes rhizomatous perennials.
hookeri 200
Iris Upright, rhizomatous or bulbous (occasionally fleshy-rooted) perennials, some evergreen, grown for their straplike leaves and distinctive, colorful flowers. Many prefer well-drained, sun-baked soil, but beardless species such as I. pseudacorus, I. sibirica, and the Japanese irises I. laevigata and I. ensata, will thrive equally well in shallow water or moist soil.
ensata 'Blue Peter' 200
laevigata 'Alba' 191
laevigata 'Mottled Beauty' 191
laevigata 'Snowdrift' 24
laevigata 'Variegata' 25
pseudacorus 43
sibirica 200
versicolor 191
Isolepis I. cernua is a grass-like perennial that will grow in shallow water or wet soil, forming tuftlike clumps up to 12in (30cm) in height.
Ivy see Hedera

—J—

Japanese maple see Acer
Japanese pond lily see Nuphar japonica
Juncus Perennial grasses for full sun or partial shade. Both J. effusus and the smaller J. ensifolius (H 32in/80cm, S 18in/45cm) will thrive in shallow water or moist, heavy soil.
effusus 'Spiralis' 27
Juniperus (junipers) Evergreen conifers, with a variety of forms and foliage colors. While J. x media grows to heights of up to 50ft (15m) it has many cultivars that make excellent small garden trees: 'Pfitzeriana' grows to 10ft (3m), while 'Plumosa' is no taller than 3ft (1m), although it is widely spreading.

—K—

Kingcup see Caltha palustris
Kirengeshoma Late summer- and autumn-flowering, moisture-loving perennials.
palmata 200

—L—

Lagarosiphon Semi-evergreen submerged perennials, with attractive foliage; L. major is one of the most popular and widely available submerged plants.
major 178
Lavandula (lavenders) Evergreen shrubs or herbs for sun and well-drained soil. Grown for the scented flowers and aromatic, usually gray-green leaves.
Leucojum (snowflakes) Bulbs grown for their pendent, bell-shaped, white or pink flowers borne in autumn or spring. Some species prefer sun and well-drained soil; others thrive in damp ground and partial shade.
aestivum 200
Liatris (gay feathers) Summer-flowering native perennials with thick rootstocks. Prefer full sun and moist but well-drained soil. L. spicata (H 24in/60cm, S 12in/30cm) bears erect spikes of densely packed, rose-purple flowers.
Ligularia Perennials grown for their foliage and large, daisylike flower heads.
'Gregynog Gold' 200
przewalskii 201
'The Rocket' 37
Liquidambar (sweet gums) Deciduous trees with inconspicuous flowers grown for their maplelike foliage and brilliant autumn color.
Lobelia Perennial species and hybrids such as L. cardinalis and L. x gerardii, and many perennial named cultivars, such as 'Queen Victoria' and 'Cinnabar Rose', thrive in moist but well-drained soil. Unlike the creeping and trailing annuals, perennials grow to around 3ft (1m) in height, with brilliantly colored flower spikes.
'Bees' Flame' 201
cardinalis 21
'Cherry Ripe' 201

x gerardii 'Vedrariensis' 201
'Will Scarlet' 201
Lonicera (honeysuckles) Deciduous, semi-evergreen or evergreen shrubs and, mainly, twining climbers, grown for their tubular, usually fragrant flowers.
Lotus see Nelumbo
Ludwigia Tender, floating or creeping aquatic plants, forming partially submerged mats of foliage in shallow water.
palustris 192
Lychnis (campion, catchfly) Summer-flowering perennials, annuals, and biennials grown for their attractive flowers. The perennial L. coronaria (H 18–24in/45–60cm, S 18in/45cm) bears rose-pink flowers on branching stems above gray foliage.
Lysichiton Deciduous perennials for shallow water or boggy soil grown for their handsome flower spathes and foliage. Tolerate light or partial shade (although they grow better in sun) and both still and moving water.
americanus 192
camtschatcensis 192
Lysimachia Fully to half-hardy, summer-flowering perennials, some creeping in habit, such as the green-leaved L. nummularia with its yellow flowers; its cultivar 'Aurea' has yellow foliage.
nummularia 'Aurea' 202
Lythrum Summer-flowering perennials that are extremely invasive in wetland conditions and are prohibited in many areas. Remove flower and destroy before seed sets. Do not plant near wetland areas. The pink-flowered L. salicaria (H 3ft/1m, S 18in/45cm), which readily self-seeds and is very invasive, is nevertheless a popular nectar source for winged insects.

—M—

Macleaya Summer-flowering perennials for sun and moist but well-drained soil. M. microcarpa, plume poppy, has spreading rhizomatous roots and can be invasive.
microcarpa 'Kelway's Coral Plume' 202
Mahonia Evergreen, shade-tolerant shrubs for well-drained soil, grown for their whorls of deeply cut,

spiky leaves, spikes of scented, yellow spring flowers and attractive fruit.

Male fern see *Dryopteris filix-mas*

Manna grass see *Glyceria maxima* var. *variegata*

Marsh marigold see *Caltha palustris*

Marsh trefoil see *Menyanthes trifoliata*

Marsilea Mostly tropical aquatic ferns needing full sun, rooting in shallow water or boggy ground.
quadrifolia 180

Matteuccia Deciduous, rhizomatous ferns for moist or wet soil.
struthiopteris 36

Mentha (mints) Spreading perennials, grown for their aromatic foliage; many are culinary herbs. They are adapted to a wide range of habitats, and can be quite invasive, although only one or two may be grown in water.
aquatica 43

Menyanthes Deciduous, perennial marginal plants grown for their foliage and flowers. Prefer an open, sunny position.
trifoliata 192

Metasequoia (dawn redwood) One species, *M. glyptostroboides*, of fast-growing, deciduous conifer (H to 50ft/15m) that thrives in wet soil and can even be planted in shallow water; in its native China, it is used to stabilize river banks and the margins of paddy fields. Does best in a warm, sunny site.

Milfoil see *Myriophyllum verticillatum*

Mimulus (monkey flowers) Annuals, perennials, and evergreen shrubs, most preferring sun and moist or wet soil, grown for their brightly colored flowers.
cardinalis 202
luteus 202

Miscanthus (ornamental grasses) Grasses grown for their robust, clump-forming habit, late summer flower spikelets, and foliage colors, the latter especially attractive in the many variegated cultivars of the hardy *M. sinensis*. Prefers moist soil in full sun.
sinensis 'Zebrinus' 202

Mountain ash see *Sorbus*

Myosotis (forget-me-nots) Small annuals, biennials, and perennials, grown for their flowers. Except for *M. scorpioides*, water forget-me-not, they prefer well-drained soil.
scorpioides 32

Myriophyllum Deciduous submerged plants with attractive foliage held partly above the surface in shallow water. Require full sun.
aquaticum 27
verticillatum 179

— N —

Narthecium Rushlike, herbaceous perennials native to acid bogs. Require full sun.
ossifragum 192

Nelumbo (lotus) Deciduous, perennial marginal plants, grown for their large leaves, exquisite flowers, and distinctive seedheads. Need an open, sunny position and warm weather to bloom well.
lutea 188
nucifera 188
nucifera 'Alba Grandiflora' 188
nucifera 'Momo Botan' 189
nucifera 'Mrs Perry D. Slocum' 189
nucifera 'Pekinensis Rubra' 189
nucifera 'Rosea Plena' 189
'Perry's Giant Sunburst' 189
'Perry's Superstar' 189
'Shiroman' 189

Nuphar Deciduous, perennial deep-water plants grown for their floating foliage and spherical flowers. Will grow in shade or sun and in running or still water.
japonica 181

Nymphaea (water lilies) Deciduous, summer-flowering, aquatic perennials grown for their floating, usually rounded leaves and brightly colored cup- or star-shaped flowers. Need an open, sunny position and still water.
alba 182
'Attraction' 37
'Aurora' 182
'Blue Beauty' 182
capensis 182
'Caroliniana Nivea' 183
'Escarboucle' 183
'Firecrest' 183
'Froebelii' 183
'Gladstoneana' 183
'Gonnère' 183
x *helvola* 184
'James Brydon' 184
'Laydekeri Fulgens' 184
'Lucida' 184
'Marliacea Albida' 184
'Marliacea Carnea' 184
'Marliacea Chromatella' 185
mexicana 26

'Odorata Sulphurea Grandiflora' 185
'Pearl of the Pool' 185
'Pink Sensation' 185
'Ray Davies' 186
'René Gérard' 186
'Robinsoniana' 186
'Rose Arey' 186
'Saint Louis Gold' 186
'Sunrise' 186
'Vésuve' 187
'Virginalis' 187
'Virginia' 187
'William Falconer' 187
'Wood's White Knight' 187

Nymphoides Deciduous, perennial, deep-water plants with floating foliage grown for their flowers held just above the water surface in summer. Require an open, sunny position.
peltata 181

— O —

Omphalodes Creeping annuals and perennials, some evergreen or semi-evergreen. Most prefer sun and well-drained soil; *O. cappadocica* will grow in moist soil, in light or partial shade.

Onoclea (sensitive ferns) One species, *O. sensibilis* (H & S 18in/45cm) of deciduous fern that rapidly colonizes wet areas in sun or shade.

Origanum (oreganos) Deciduous perennials and sub-shrubs with usually pink flowers, most low-growing and prostrate in habit. Some are grown as culinary herbs. All prefer sun and well-drained soil.

Orontium One species of deciduous, perennial deep-water plant grown for its floating foliage and flower spikes.
aquaticum 193

Osmunda Deciduous ferns for moist to wet soil. All except *O. regalis* must have a shady site.
regalis 203

Ostrich fern see *Matteuccia struthiopteris*

— PQ —

Paeonia (peonies) Late spring- and summer-flowering perennials and shrubs for well-drained soil, valued for their bold foliage, showy spring blooms and, in some cases, colorful seed pods.

Paper reed see *Cyperus papyrus*

Papyrus see *Cyperus papyrus*

Parnassia Mainly summer-flowering perennials grown for their saucer-shaped flowers. Need sun and wet soil.
palustris 203

Parrot's feather see *Myriophyllum aquaticum*

Peltandra Perennial, marginal plants for shallow water, grown for their white, sometimes yellow-margined flower spathes.
undulata 193

Pendulous sedge see *Carex pendula*

Persicaria Moisture-loving, summer- to autumn-flowering perennials forming dense clumps with tightly-packed spikes of flowers, mostly in shades of pink to deep red formerly included in *Polygonum*.
bistorta 'Superba' 203
campanulata 203

Petasites Perennials for moist but well-drained soil grown for their usually large leaves. Make good groundcovers but can be invasive.
japonicus 203

Phalaris Evergreen, spreading, annual and perennial grasses. The perennial species have narrow flower spikelets in summer. Tolerant of dry or wet soil. 'Feesey' is a less invasive, slightly more brightly colored cultivar of *P. arundinacea* var. *picta*.
arundinacea var. *picta* 204

Phlox Mainly late spring- or summer-flowering annuals and perennials. The taller perennials, such as *P. paniculata* (H 4ft/1.2m, S 2ft/60cm) and *P. maculata* (H 3ft/1m, S 1½ft/45cm), thrive and flower freely in moist, rich soil. *P. paniculata* has many cultivars, with flowers in white, pinks, crimsons, and purples.
paniculata 'Norah Leigh' 204

Phragmites Only *P. australis*, common reed, is widely grown. A deciduous, quite invasive sun-loving perennial grass with feathery flower heads that remain attractive through winter.
australis 'Variegatus' 193

Physostegia (obedient plant) Summer- to early autumn-flowering, moisture-loving perennials, the flowers of which can be moved into, and will remain in, different positions.

P. virginiana (H 3ft/1m, S 2ft/60cm) can be invasive.
virginiana subsp. *speciosa* 'Variegata' 204

Pickerel weed see *Pontederia cordata*

Pinus (pines) Small to large conifers with spirally arranged leaves. *P. sylvestris* (H to 50–80ft/15–25m) has blue-green needles and attractive bark; the needles of its cultivar 'Aurea' are golden in winter and spring.

Pistia One species of tender, deciduous, perennial floating plant.
stratiotes 181

Polygonum Many moisture-loving perennial polygonums are now reclassified under *Persicaria*; the genus still contains some aquatic species for shallow water or boggy ground.
amphibium 181

Polystichum Evergreen, semi-evergreen, or deciduous ferns that do best in semi-shade and moist, humus-rich soil.
setiferum 'Divisilobum Densum' 30

Pontederia Deciduous, perennial marginal plants, grown for their foliage and flower spikes. Need full sun.
cordata 193

Potamogeton Deciduous, perennial submerged plants with broad, wavy-edged leaves. Best in full sun.
crispus 179

Potentilla (cinquefoils) Shrubs and perennials for well-drained soil grown for their clusters of small, flattish to saucer-shaped flowers and for their foliage. *P. fruticosa* is a dense, bushy, yellow-flowered shrub (H 3ft/1m, S 5ft/1.5m), with many attractive cultivars.

Primula (primroses) Primroses are mainly small perennials, some evergreen, with attractive rosettes of basal leaves and colorful flowers. Drumstick primroses such as *P. denticulata* (H 12–24in/30–60cm, S 12–18in/30–45cm) are hardy and have compact, spherical flower heads; candelabra primroses, such as *P. japonica* are also hardy and have tiered whorls of flowers.
beesiana 204
bulleyana 204
florindae 205
japonica 'Millers Crimson' 205
prolifera 205

pulverulenta 205
rosea 205

Ptilostemon Shrubs and often spiny annuals, biennials, and perennials with tubular, purple or white flowers and leaves with snowy, white undersides. Mediterranean in origin: prefer dry soil and a sunny site.

Pulmonaria (lungworts) Mainly spring-flowering, clump-forming perennials, some semi-evergreen. Make good groundcovers in shade and moist soil.
angustifolia subsp. *azurea* 206

— R —

Ranunculus (buttercups) Annuals and perennials for sun or shade, some evergreen or semi-evergreen grown mainly for their yellow flowers. There are a small number of aquatic species, often growing larger than those normally grown in well-drained soil.
aquatilis 179
lingua 'Grandiflorus' 193

Red lotus see *Nelumbo nucifera*

Rheum Genus of perennials that includes the edible rhubarb. Grown for their large leaves, borne on robust, fleshy, often colored stalks. Some species, including *R. palmatum*, are very large and require plenty of space.
palmatum 'Atrosanguineum' 206

Rhododendron Evergreen, semi-evergreen, and deciduous shrubs of varying sizes, grown for their showy flowers. They need acid to neutral, well-drained soil. The Japanese azaleas are compact evergreens, bearing masses of small, brightly colored flowers in late spring.

Rodgersia Summer-flowering, rhizomatous, moisture-loving perennials for sun or semi-shade.
podophylla 206
sambucifolia 206

Royal fern see *Osmunda regalis*

Royal water lily see *Victoria amazonica*

Rubus (brambles) Deciduous, semi-evergreen, or evergreen shrubs and scrambling climbers, some grown for their edible fruits, most preferring moist but well-

GENERAL INDEX

HARDINESS ZONES OF
NORTH AMERICA